PAINTINGS

FROM THE SAMUEL H·KRESS COLLECTION

ITALIAN SCHOOLS

XIII–XV CENTURY

BY FERN RUSK SHAPLEY

PUBLISHED BY THE PHAIDON PRESS
FOR THE SAMUEL H·KRESS FOUNDATION

CONTENTS

THE SAMUEL H. KRESS COLLECTION
by David E. Finley p. vii

INTRODUCTORY NOTE I

CATALOGUE

LUCCHESE, ARETINE, AND UMBRIAN SCHOOLS,
XIII CENTURY. FLORENTINE, VENETIAN, PADUAN,
MODENESE, AND SIENESE SCHOOLS, XIII–XIV CENTURY 3

FLORENTINE SCHOOL, XIV CENTURY 20

SIENESE SCHOOL, XIV CENTURY 48

RIMINESE, BOLOGNESE, PISAN, LUCCHESE, UMBRIAN,
VENETIAN, LOMBARD, FERRARESE, AND PADUAN
SCHOOLS, XIV AND XV CENTURIES 68

FLORENTINE SCHOOL, XV CENTURY 89

SIENESE SCHOOL, XV CENTURY 140

ILLUSTRATIONS 165

INDEXES

INDEX OF CHANGES OF ATTRIBUTION 403

ICONOGRAPHICAL INDEX 405

INDEX OF PREVIOUS OWNERS 413

NUMERICAL INDEX 425

INDEX OF PLACES 429

INDEX OF ARTISTS 433

THE SAMUEL H. KRESS COLLECTION

Long before it attained its present size the Samuel H. Kress Collection could have formed, in itself, a distinguished Museum of Italian Art. In fact, it was Mr. Kress's original intention to establish such a museum, but soon he became convinced that he could render better service by contributing his works of art to the newly established National Gallery in Washington. The Gallery had been founded by Andrew W. Mellon, who had agreed to provide the building and to give his important collection of paintings and sculpture, which he hoped would become the nucleus of a great and growing National Collection. With the Kress donation in 1939, the National Gallery at once became what it was intended to be – a joint enterprise on the part of the Federal Government and generous and patriotic individuals, intent on giving America the best obtainable in the field of art.

The Kress gift included 416 paintings and 35 pieces of sculpture – all by Italian masters. Mr. Kress thought of the donation as a basis on which he would build a Kress Collection of superb quality at the National Gallery. And this was not the limit of his interest. His support of art had already been far-reaching; he had financed restorations of art monuments in Italy, and some of his earliest gifts of paintings were made to several museums in the United States. This was the kind of gift that was to develop later into the large Kress donations to museums and colleges in all parts of the country.

Fortunately, at the beginning of the 1940's the art market still offered a choice of many important works of art. Foreign restrictions on art export were less stringent than now; and paintings from some outstanding English collections, notably the Cook, Benson, and Allendale collections, were available. Other important paintings came from Italian and French collections, and occasionally a fine example was acquired from the Liechtenstein Collection. It was a time also when some of the earlier American collections were being dispersed, notably the Mackay, Platt, Goldman, and Pratt collections. Mr. Kress made wise use of these remarkable opportunities. Later, during his long illness and after his death in 1955, the work of improving and broadening his collection was carried on by the Samuel H. Kress Foundation, which he had established and endowed in 1929. The chief responsibility now fell upon his brother Rush H. Kress, who became President of the Foundation in 1946, and on Guy Emerson, who was appointed Art Director in 1947.

From the generous funds provided by Samuel H. Kress and supplemented by his brother, Claude W. Kress, the Foundation continued to make important purchases until, by the second half of the 1950's, the Kress Collection comprised about 1500 paintings, more than 150 sculptures, over 1300 small bronzes, medals and plaquettes, and many examples of decorative and graphic arts. It became one of the most comprehensive art collections ever assembled by a private citizen and one of the most important gifts of works of art ever presented to a nation. Looking back over what was accomplished in so few years, the achievement seems almost incredible, especially when one considers the difficulties of acquiring great works of art under present conditions.

How could one hope to acquire today such outstanding Flemish, Spanish, and German paintings as Bosch's *Death and the Miser*, Petrus Christus' *Donor and His Wife*, Rubens' *Sketch for the Last Supper*, El Greco's *Laocoön*, Dürer's *Portrait of a Clergyman*, and Grünewald's *Small Crucifixion*? And in the French

School, there are many masterpieces, such as Clouet's *Diane de Poitiers*, Poussin's *Baptism of Christ*, and some of the finest works of Chardin, Boucher, Fragonard, David, and Ingres, together with an important group of French sculpture.

Yet even with its many brilliant examples from other schools, the collection is still pre-eminently Italian in both painting and sculpture, and it is best known for its Italian paintings. These cover a remarkably wide range, with examples by most of the important early Italian and Renaissance painters, including a formidable number of masterpieces. To name but a few: there is a panel from Duccio's *Maestà*, a *Madonna* by Giotto, a *Madonna* and a *Miracle of St. Nicholas* by Gentile da Fabriano, some of the best work by Sienese artists such as Sassetta, Giovanni di Paolo, and Neroccio de'Landi; there is the great tondo of *The Adoration of the Magi* by Fra Angelico and Fra Filippo Lippi, Domenico Veneziano's *St. John in the Desert*, Botticelli's *Giuliano de' Medici*, and the famous painting of the *Madonna and Child* from the Dreyfus Collection attributed to the circle of Verrocchio, but thought by many to have been painted by the young Leonardo da Vinci. Then there are classical and religious paintings, as well as portraits, by Giovanni Bellini, and allegorical paintings by Lorenzo Lotto, the *Portrait of a Man* by Andrea Mantegna, the beautiful *Adoration of the Shepherds* and *Holy Family* by Giorgione; and a most remarkable group of Ferrarese paintings. Still we have arrived only at the turn of the fifteenth century. The sixteenth century is represented by such masterpieces as Dosso Dossi's *Circe*, Titian's ceiling painting of *St. John on Patmos*, Tintoretto's *Conversion of St. Paul*, Paolo Veronese's *Rebecca at the Well*, Pontormo's *Monsignor della Casa*, Sodoma's *St. George and the Dragon*, and Luini's frescoes, transferred to canvas, from a house near Milan. Then there are excellent later examples by Strozzi, Sebastiano and Marco Ricci, Magnasco, Piazzetta, Tiepolo, Panini, Canaletto, and Guardi.

As new donations from the Kress Collection were made to the National Gallery, some that had come earlier could be given to collections which the Kress Foundation was gradually forming in 18 museums in all parts of the United States. And eventually, in addition to these museums, more than 20 colleges and universities and a few churches and other institutions shared in the Kress donations. In the process of making these selections, many of the paintings and sculptures were exhibited provisionally in the various institutions. Final disposition of almost the entire Kress Collection was made by deeds of gift dated December 9, 1961.

The occasion of the distribution of these deeds of gift was marked by the publication of *Art Treasures for America*, an anthology of the Kress Collection, written by Charles Seymour, Jr. At the same time work was begun on a nine-volume definitive catalogue, originally planned by Dr. W. E. Suida, who unfortunately did not live to carry on the work. Three volumes of this catalogue have already been published: *Tapestries*, by David DuBon; *Decorative Art*, by Carl Christian Dauterman, James Parker, and Edith Appleton Standen; and *Renaissance Bronzes*, by John Pope-Hennessy.

The present volume is the first of three cataloguing the nearly 1200 Italian paintings in the Collection and written by Fern Rusk Shapley, former Curator of Paintings at the National Gallery of Art, who has long been familiar with the Kress paintings now in the National Gallery and with those which have gone elsewhere.

DAVID E. FINLEY
Director, National Gallery of Art, 1938–1956

INTRODUCTORY NOTE

THE large number of Italian paintings in the Kress Collection has made it a matter of practical convenience to catalogue them in three volumes. The first of these is designed to include the older paintings down to the fulfillment of the realistic objectives of the early Renaissance. Respect for stylistic continuity has to some extent involved the sacrifice of chronological sequence. Thus the Bellini and Vivarini groups have been postponed to the second volume because their Venetian usages, particularly of color as conveyor of mood, were carried on unbroken to full development in the High Renaissance. A similar postponement has been that of a few Umbrian paintings which show the preoccupation with reflected light without which the spatial structure of later Umbrian painting is unintelligible. The Lombard School, because of the dominant position of Leonardo, has for convenience also been assigned to the second volume. The net result is that this first volume covers the Italian schools from the thirteenth century to the middle of the fifteenth, with the addition of paintings which continue to represent the early Renaissance traditions of Florence, Siena, and Ferrara through the second half of the fifteenth century.

The order in which the artists are arranged in each volume has resulted from considerations of style as well as chronology. Each artist is accorded a brief biography, his paintings are catalogued in approximately chronological sequence, and their titles are preceded by the Kress inventory numbers. Following each title are recorded the present location (with accession number and date of acquisition), the support on which the picture is painted, and the measurements (height first, width second). Legible inscriptions are quoted and their sources are cited or translations offered. Then follow summary condition reports, kindly drawn up by the Kress Foundation's Conservator, Professor Mario Modestini.

As a rule, attribution and dating are the first topics in the commentary. Pertinent historical data, such as the original association of the painting with others in an altarpiece, are explained. But although saints and other personages in a picture are identified where possible, descriptions of composition are omitted since each painting is reproduced.

In the section headed *Provenance* the peregrinations of the painting are traced in all available detail. Dealers as well as collectors (and it has not always been possible to differentiate) are included chronologically. To help verify the chronological order, exhibitions in which the painting has appeared are cited immediately following the designation of the owner-lender.[1]

1. Some of the early acquisitions of Samuel H. Kress were included in an exhibition which was shown in twenty-four American galleries and institutions on the following dates: Atlanta Art Association Galleries, Atlanta, Ga. (Oct.–Nov. 1932); Brooks Memorial Art Gallery, Memphis, Tenn. (Dec. 1932–Jan. 1933); Birmingham Public Library, Birmingham, Ala. (Jan.–Feb. 1933); Isaac Delgado Museum of Art, New Orleans, La. (Feb.–Mar. 1933); Museum of Fine Arts, Houston, Tex. (Mar.–Apr. 1933); Museum of Fine Arts, Dallas, Tex. (Apr.–May 1933); Art Museum, Denver, Colo. (May–June 1933); Broadmoor Art Academy, Colorado Springs, Colo. (June–Aug. 1933); Utah Art Institute, Salt Lake City, Utah (Aug.–Sept. 1933); University of Washington, Seattle, Wash. (Sept.–Oct. 1933); Art Museum, Portland, Ore. (Nov. 1933); E. B. Crocker Art Gallery, Sacramento, Calif. (Dec. 1933); California Palace of the Legion of Honor, San Francisco, Calif. (Jan.–Feb. 1934); County Museum, Los Angeles, Calif. (Feb.–Apr. 1934); Fine Arts Gallery, San Diego, Calif. (Apr.–May 1934); Witte Memorial Museum, San Antonio, Tex. (June–July 1934); The Parthenon, Nashville, Tenn. (July–Oct. 1934); Woman's College of Alabama, Montgomery, Ala. (Oct.–Nov. 1934); Wesleyan College, Macon, Ga. (Nov.–Dec. 1934); Students' Art Club, Tampa, Fla. (Dec. 1934–Jan. 1935); Rollins College, Winter Park, Fla. (Jan.–Feb. 1935); Telfair Academy of Arts and Sciences, Inc., Savannah, Ga. (Mar. 1935); Gibbes Art Gallery, Charleston, S.C. (Apr.–May 1935); Mint Museum of Art, Charlotte, N.C. (May–June 1935). These exhibitions are cited in the sections headed *Provenance*.

The section headed *References* is self-explanatory. The citations there of my sources of information and advice[1] will be accepted, I hope, in lieu of detailed acknowledgments in this introductory note. What cannot be omitted here is an expression of gratitude to the staff of the Samuel H. Kress Foundation and the staff of the National Gallery of Art.

Mr. Guy Emerson, now Director Emeritus of Art at the Foundation, and Miss Mary Davis, Assistant to the President, have facilitated my work in every possible way, especially in my use of the Foundation's archives, which contain documentary photographs, laboratory reports, and other material collected by members of the staff in their study of the paintings. Dr. Alessandro Contini Bonacossi, Curator, has generously aided me with his research. And my great debt to the former Curator of Research, the late Dr. William E. Suida, is indicated by numerous references in my notes, especially to his scholarly catalogues of two Kress exhibitions at the National Gallery and of Kress collections in many of the regional galleries.

Mr. John Walker, Director of the National Gallery of Art, and Dr. Perry B. Cott, Chief Curator, and all members of the staff have made my working atmosphere at the National Gallery as nearly as possible ideal, lessening no whit the sympathetic cooperation which I enjoyed before my retirement from the staff. Miss Carlson, Miss Link, Mrs. Caritas, and Mr. Corcoran, of the Gallery library, have been tireless and even indulgent in meeting my requests for books. Finally, I am especially indebted to Miss Anna Voris, Museum Curator, who has not only prepared the various indexes but has assisted me efficiently throughout.

<div align="right">FERN RUSK SHAPLEY</div>

1. Undated manuscript opinions cited in this section were generally given near the time the painting entered the Kress Collection. Not identified in the pages of the catalogue are the numerous instances in which the text has benefited from the encyclopedic knowledge and wise counsel of my husband, John Shapley.

LUCCHESE, ARETINE, AND UMBRIAN SCHOOLS
XIII CENTURY

FLORENTINE, VENETIAN, PADUAN, MODENESE, AND SIENESE SCHOOLS
XIII–XIV CENTURY

LUCCHESE SCHOOL, *c.* 1200

K1715 : Figure 6

MADONNA AND CHILD. El Paso, Tex., El Paso Museum of Art (1961–6/1), since 1961.[1] Transferred from wood to masonite (1950–51). 46½×30¾ in. (118·2×78·2 cm.), without moldings. Good condition; cleaned very slightly 1953.

Lucca was the center of the most important Tuscan School of painting during the twelfth century and well into the thirteenth. The work of the early period was varied and rich; by the early thirteenth century it had become less exuberant, more stereotyped and uniform. Though executed by a heavier hand, K1715 seems to go back for inspiration to the figures of the holy women in scenes on the earliest surviving panel from the School of Lucca, the painted cross signed by Guglielmo and dated 1138 in the Cathedral of Sarzana.[2] K1715 has been classified as one of the most important examples of the Pre-Berlinghieresque period.[3]

Provenance: Said to have been for some time on the altar of the Church of Santa Domenica, in Zara; and then, when the church was closed because of disrepair, to have been acquired by the Castellani family, who kept it in the chapel of their castle on the Island of Birbigno, not far from Zara; and, finally, from the last surviving member of this family, inherited by a nephew, Mariano Rovaro Brizzi.[4] Contini Bonacossi, Florence. Kress acquisition, 1950.

References: (**1**) Catalogue by F. R. Shapley, 1961, no. 1, as Master of the School of Lucca. (**2**) The Sarzana *Crucifix* is reproduced by E. Sandberg-Vavalà, *La Croce dipinta italiana,* 1929, fig. 225. (**3**) R. Longhi (in ms. opinion). Berlinghiero, active *c.* 1215–1240, was head of the thirteenth-century School of Lucca. (**4**) V. Brunelli (*Storia della città di Zara,* 1913, pp. 257f.) mentions a *Madonna d'imagine greca* which was once in Santa Domenica, Zara, and cites tenuous traditions regarding its source. The twentieth-century owner Brizzi seems to be the only authority for connecting K1715 with the reference in Brunelli and for the subsequent provenance of the picture.

MARGARITONE

Margarito d'Arezzo, called by Vasari Margaritone. School of Arezzo. Active second half of thirteenth century. There is only one documentary reference to him, in 1262; but he signed a number of paintings. Probably trained in Florence, he progressed from a very flat style to a somewhat more plastic manner.

K1347 : Figure 1

MADONNA AND CHILD ENTHRONED. Washington, D.C., National Gallery of Art (807), since 1945. Wood. 38⅜×19½ in. (97×49.5 cm.). Inscribed, with the artist's signature, at bottom: MARGARIT' [de a] RITIO ME FECIT (Margaritus of Arezzo made me).[1] Fair condition.

The lack of perspective in this painting – only the footstool and the cushioned seat of the throne give appreciable indication of third dimension – places this in the artist's early period, about 1270.[2] Even at this date, the work is considered *retardataire,* for the throne is of the earliest type used in the thirteenth century: backless and made up of alternating long and short horizontal flat bands decorated with abstract designs;[3] and the Virgin's crown is like those worn at the beginning of the century by Byzantine queens.[4] Margaritone frequently repeated his compositions with only slight variations. Closely similar versions of this *Madonna* are in the Church of Santa Maria at Montelungo[5] and the National Gallery, London; the chief variations are in the small flanking figures. In K1347 they are silhouetted against a patinated silver background and are possibly to be identified as St. John the Evangelist, St. Benedict, and two Wise Virgins.[6] The signature (see inscription, above) appears in almost the same form on several other paintings by the master.

Provenance: General Fox Pitt-Rivers, Rushmore, Wilts. Ralph Wornum, London. Philip Lehman, New York (catalogue by R. Lehman, 1928, no. 1, as Margaritone). Kress acquisition, 1943.

References: (**1**) For assistance in deciphering and translating

many of the inscriptions recorded in this catalogue I am grateful to my daughter Dora Shapley van Wijk. (2) E. B. Garrison (*Italian Romanesque Panel Painting*, 1949, p. 94, no. 237) dates K1347 *c.* 1270. (3) J. H. Stubblebine (in *Marsyas*, vol. VII, 1954–57, p. 28) analyzes the throne. (4) This is observed by C. H. Weigelt (in Thieme-Becker, *Allgemeines Lexikon*, vol. XXIV, 1930, p. 88). (5) P. d'Ancona (*Les Primitifs italiens*, 1935, p. 92) cites the similarity of K1347 to the one at Montelungo. (6) R. Lehman (Lehman catalogue cited under *Provenance*, above) follows Crowe and Cavalcaselle (*History of Painting in Italy*, R. L. Douglas ed., vol. I, 1903, p. 167) in identifying the flanking figures as St. Bruno, St. Benedict, and two Cistercian monks. L. Venturi (*Italian Paintings in America*, vol. I, 1933, no. 8) thinks them to be St. John the Evangelist, St. Benedict, and possibly Mary Magdalene and Martha. R. van Marle (*Italian Schools of Painting*, vol. I, 1923, p. 336) merely cites Crowe and Cavalcaselle. That the two lower figures may be Wise Virgins is indicated by the fact that each carries a lighted lamp.

MASTER OF THE FRANCISCAN CRUCIFIXES

Umbrian School. Active second half of thirteenth century. The designation given this anonymous master derives from the association of his style with *Crucifixes* painted for Franciscan churches.[1] He has also been called the Borgo Crucifix Master,[2] from his best-known work. His classification in the Umbrian School is somewhat arbitrary; for he also shows Pisan and Bolognese characteristics. Giunta Pisano and the Master of St. Francis are his closest parallels, but he is more suave, more gentle in expression than either of these.

K1357 : Figure 4
THE MOURNING MADONNA

K1358 : Figure 5
ST. JOHN THE EVANGELIST

Washington, D.C., National Gallery of Art (808 and 809), since 1945. Wood. K1357, $31\frac{7}{8} \times 12\frac{3}{8}$ in. (81 × 31·5 cm.); K1358, $31\frac{5}{8} \times 12\frac{1}{2}$ in. (80·5 × 31·5 cm.). Good condition except for a few losses of paint.

That these pendants were originally parts of a wooden *Crucifix* has never been doubted. The suggestion that they come from the apron of the cross,[3] where they would have flanked the torso of Christ, should have been excluded by the contemporary practice of curving Christ's body far to the left on the cross, so that it projects into the apron. Almost certainly the two panels once terminated the arms of the large *Crucifix* from the Church of Santa Maria in

Borgo, Bologna, now in the Pinacoteca in that city.[4] With them the Borgo *Crucifix*, with which they agree precisely in style and proportion, could be restored to very nearly its original composition. This composition parallels that of the closely contemporary *Crucifix*, dated 1272, by the Master of St. Francis in the Pinacoteca, Perugia.[5]

Provenance: Probably Church of Santa Maria in Borgo, Bologna. Private Collection, Stockholm. Philip Lehman, New York (catalogue by R. Lehman, 1928, nos. LIX and LX, as Master of the Franciscan Crucifix). Kress acquisition, 1943.

References: (1) O. Sirén (*Toskanische Maler im XIII. Jahrhundert*, 1922, pp. 223 f.) coins this name for the artist and describes K1357 and K1358 among his paintings. (2) So called by E. B. Garrison (*Italian Romanesque Panel Painting*, 1949, p. 221, no. 605), who designates the master as Bolognese and describes the panels as coming from a *Crucifix* apron dating 1265/75. L. Venturi (*Italian Paintings in America*, vol. I, 1933, no. 6) attributed the panels to a Pisan master. (3) Garrison, *loc. cit.* in note 2, above. (4) Reproduced by E. Sandberg-Vavalà, *La Croce dipinta italiana*, 1929, fig. 536 (Villani & Figli, Bologna, have photographed the painting and details since its recent restoration and cleaning). Vavalà (*op. cit.*, pp. 855 f.) discusses K1357 and K1358 in connection with the Borgo *Crucifix*; but G. Coor (verbally) probably was the first to suggest that they actually belonged to it. Mrs. Coor further suggests that a medallion of *Christ Blessing* now lost but reproduced by Garrison (p. 219, no. 595 of *op. cit.*, in note 2, above) may have terminated this *Crucifix* at the top. (5) Reproduced by J. Schultze in *Wallraf-Richartz-Jahrbuch*, vol. XXV, 1963, p. 139.

MASTER OF ST. FRANCIS

Umbrian School. Active second half of thirteenth century: his one dated work, a *Crucifix* in the Perugia Gallery, was painted in 1272; but it is from his portrait of St. Francis in Santa Maria degli Angeli, Assisi, that his designation derives. He was perhaps less a direct follower of Giunta Pisano, as formerly assumed, than a product of Byzantine influence in general. In turn his work exercised marked influence on Cimabue.

K1360 : Figure 2
ST. JOHN THE EVANGELIST

K1359 : Figure 3
ST. JAMES MINOR

Washington, D.C., National Gallery of Art (810 and 811), since 1945. Wood. K1359, $19\frac{5}{8} \times 9\frac{1}{2}$ in. (50 × 24 cm.); in-

scribed on arch: SANCTUS JACOB . . . K1360, 19½×9½ in. (49·5×24 cm.); inscribed on arch: SANCTUS JOHANNES . . . Both in fair condition except for some abrasions and a few losses of paint.

It is now reasonably certain that these two panels originally formed part of a large altarpiece, tentatively dated c. 1270/80, which was in the shape of a low dossal and was decorated on both front and back. Reconstruction[1] shows the altarpiece to have been approximately 12 ft. wide and 22¾ in. high (the middle panel probably somewhat higher). The *Madonna* was likely represented in the middle section of the front, while at each side of this were a prophet and a Franciscan saint in narrow compartments and two scenes from the Passion in wider compartments. The *Enthroned Christ Blessing* probably occupied the middle panel on the back of the altarpiece and six narrow panels were at each side, accommodating, in all, the twelve apostles and one, or probably two, Franciscan saints. From the front of the altarpiece are now known the following panels: the *Prophet Isaiah* (Church of San Francesco, Assisi), *St. Anthony of Padua* (Pinacoteca, Perugia), the *Deposition*, and the *Lamentation* (both in the Pinacoteca, Perugia). From the back are preserved *St. Francis* (Pinacoteca, Perugia), *Sts. Simon and Bartholomew* (in a single panel, Lehman Collection, New York), *St. James Minor* (K1359), *St. John the Evangelist* (K1360), *St. Andrew* (Pinacoteca, Perugia), and *St. Peter* (Stoclet Collection, Brussels). The fact that most of these panels are now or were formerly in Assisi or nearby Perugia, that the Master of St. Francis painted frescoes in the Lower Church of San Francesco at Assisi, and that the high altar in the crossing of the Lower Church agrees in width with that of the reconstructed altarpiece all but definitely settles the question of original provenance. K1359 and K1360 are, except for the inscriptions, in a fair state of preservation, although the medallions which once decorated the spandrels of the painted frames are now missing. Their effect may be judged from the medallions preserved in the frames of the Passion scenes: roundels of colored glass through which shine gold quatrefoils.[2]

Provenance: Probably high altar of the Lower Church of San Francesco, Assisi. Seminario Teutonico, Rome. Monseigneur Del Val. Philip Lehman, New York (catalogue by R. Lehman, 1928, nos. LXI, LXII, as Master of St. Francis). Kress acquisition, 1943.

References: (1) E. B. Garrison (*Italian Romanesque Panel Painting*, 1949, pp. 161–163, nos. 424–429) suggests a reconstruction which accounts for six of the known narrow panels, including K1359 and K1360. J. Schultze (in *Mitteilungen des Kunsthistorischen Instituts in Florenz*, 1961, pp. 59 ff.) offers the more acceptable reconstruction, in which all known panels are included. G. Coor (verbally) rearranges some of the apostles in Schultze's reconstruction, which failed to match some of the capitals and bases of the columns painted at the sides of the narrow panels. In a recent study of the art of the Master of St. Francis (in *Wallraf-Richartz-Jahrbuch*, vol. XXV, 1963, p. 141), Schultze alters his arrangement of the panels to agree with Mrs. Coor's suggestion, which is followed in this catalogue. (2) The medallions are described by R. van Marle in *Rassegna d'Arte*, 1919, p. 13. P. d'Ancona (*Les Primitifs italiens*, 1935, p. 76) cites K1359 and K1360 as by the Master of St. Francis, the attribution followed by other scholars. The awkward arrangement of the saint's right hand and arm in K1359 may be due to the intention of showing him holding the fuller's club, symbol of the martyrdom of James Minor.

CIMABUE

Cenni di Pepi, called Cimabue. Florentine School. Recorded as early as 1272, when he was in Rome, and as late as 1302, when he was cited as director of the mosaic work in the Cathedral of Pisa. His stern, monumental rendering of the Byzantine style marks him as the successor of Coppo di Marcovaldo; and his profound expression and masterly technique rank him as a culminating figure of medieval Italian painting. Dante refers to him as the most celebrated painter before Giotto.

Attributed to CIMABUE

K1549 : Figure 9

MADONNA AND CHILD WITH ST. JOHN THE BAPTIST AND ST. PETER. Washington, D.C., National Gallery of Art (1139), since 1956.[1] Wood. 13½×9¾ in. (34·3×24·8 cm.). Very good condition except for head of angel at top right.

Whether painted as the model for a large altarpiece or as a wing for a portable diptych,[2] this small panel is monumental in conception. Judging from a reproduction one might imagine the original to be about the size of the great *Madonnas* in the Uffizi and the Louvre.[3] It is not a study for either of these although reports of a now lost inscription[4] indicate that it came from the same Pisan church as the Louvre painting. Strongly supporting the attribution to Cimabue is the similarity of the dramatic figures of Sts. John the Baptist and Peter to the prophets at the base of the throne in the Uffizi altarpiece. Offered as evidence against the attribution are the small size of the panel and its combination of the styles of Cimabue and Duccio.[5] The iconographical type is a modification of the *Hodegetria* ('She who points the way'); the Madonna's right hand, instead of pointing to the Child, rests protectingly on His leg. The poses of both the Virgin and the Child are as closely paralleled in Duccio's Rucellai altarpiece as in Cimabue's

altarpiece in the Louvre. K1549 probably dates from about 1290.

Provenance: Sacristy of the Church of San Francesco, Pisa.[6] Colnaghi's, London (bought at country sale at Patterdale Hall, Ullswater, England, Aug. 8, 1934, as Italian School;[7] sold Apr. 8, 1935). Contini Bonacossi, Florence. Kress acquisition, 1948.

References: (**1**) *Paintings and Sculpture from the Kress Collection,* 1956, p. 50 (catalogue by W. E. Suida and F. R. Shapley), as Cimabue. (**2**) E. B. Garrison (*Italian Romanesque Panel Painting,* 1949, p. 100, no. 251A) suggests the panel may have been the left wing of a diptych and attributes it to the Florentine School of about 1285/95, under the influence of Cimabue and Duccio. (**3**) As suggested by R. Longhi (in *Proporzioni,* vol. II, 1948, p. 16), who attributes the painting to Cimabue, as do G. Fiocco, R. van Marle, W. E. Suida, E. Sandberg-Vavalà, and A. Venturi (in ms. opinions). (**4**) Suida and Longhi (see notes 1 and 3, above) cite the inscription as formerly on the back of the painting, written by the engraver Carlo Lasinio (1759–1838), giving the provenance San Francesco, Pisa. (**5**) See note 2, above. (**6**) See note 4, above. (**7**) Letter fr. Colnaghi's, May 16, 1963.

Follower of CIMABUE

K1716 : Figure 7

MADONNA AND CHILD WITH TWO ANGELS. Columbia, S. C., Columbia Museum of Art (54–402/1), since 1954.[1] Wood. $11\frac{1}{4}\times7\frac{3}{4}$ in. (28·5×19·7 cm.). Good condition except slightly abraded; cleaned slightly 1953.

Cut down from a larger panel of the late thirteenth century, K1716 may once have been a full-length *Enthroned Madonna* like K1549 (Fig. 9). But instead of the *Hodegetria* of K1549, here is a version of the *Glykophilousa* iconographical type: Mother and Child are shown in a more intimate, affectionate relationship. A curious medieval feature is the Child's mantle, reminiscent of the Romanesque flying fold.[2]

Provenance: Contini Bonacossi, Florence. Kress acquisition, 1950 – exhibited: National Gallery of Art, Washington, D.C., 1951.[3]

References: (**1**) Catalogue by W. E. Suida, 1954, p. 9, and by A. Contini Bonacossi, 1962, p. 35, as school of Cimabue. (**2**) E. B. Garrison (*Italian Romanesque Panel Painting,* 1949, no. 638) classifies K1716 as Florentine, end of thirteenth century. R. Longhi (in ms. opinion) points out the influence of Cimabue and dates the painting *c.* 1290. Such details as the flying fold and the heads of the angels suggest relating K1716 to the group of Romanizing Florentines and followers of the Magdalen Master whom Garrison discusses in

Gazette des Beaux-Arts, 1946, pp. 321 ff. (cf. the Tuscan *Madonna,* K1189, Fig. 8). (**3**) *Paintings and Sculpture from the Kress Collection,* 1951, p. 24 (catalogue by W. E. Suida), as school of Cimabue.

TUSCAN SCHOOL, Late XIII Century

K1189 : Figure 8

MADONNA AND CHILD WITH SAINTS. Birmingham, Ala., Birmingham Museum of Art (61.112), since 1952.[1] Wood. $6\frac{7}{8}\times4\frac{3}{4}$ in. (17·5×12 cm.). Much abraded.

Evidently influenced by Cimabue and more remotely by the Magdalen Master, the painter of K1189 is nevertheless classified here under the more general term of Tuscan, since he shows Sienese influences in addition to Florentine.[2] Iconographically, the picture affords a characteristic example of the *Glykophilousa* type of Madonna ('She who is sweetly loving'). The saints flanking the Madonna are probably two of the Evangelists.

Provenance: Taddei, Florence. Contini Bonacossi, Florence. Kress acquisition, 1939 – exhibited: National Gallery of Art, Washington, D.C. (527), 1941–51.[3]

References: (**1**) Catalogue by W. E. Suida, 1952, p. 11, and 1959, p. 7, as Tuscan painter, contemporary of Cimabue. (**2**) B. Berenson, G. Fiocco, R. Longhi, F. M. Perkins, and A. Venturi (in ms. opinions) relate the painting to Cimabue. E. B. Garrison (in *Gazette des Beaux-Arts,* vol. XXIX, 1946, pp. 337 f.) cites the panel as by a remote follower of the Magdalen Master, and later (*Italian Romanesque Panel Painting,* 1949, p. 67, no. 135) he calls it Florentine, *c.* 1285/95, under the remote influence of the Magdalen Master. (**3**) *Preliminary Catalogue,* 1941, p. 42, as contemporary of Cimabue.

ITALIAN SCHOOL, *c.* 1300

K361 : Figure 11

THE LAST SUPPER. New Orleans, La., Isaac Delgado Museum of Art (61.59), since 1953.[1] Wood. $6\frac{3}{4}\times7\frac{1}{8}$ in. (17×18 cm.). Abraded throughout; some losses of paint.

For the commentary, etc., see K324, below.

K324 : Figure 12

THE CAPTURE OF CHRIST IN THE GARDEN. Portland, Ore., Portland Art Museum (61.55), since 1952.[2] Wood. 7×$6\frac{1}{4}$ in. (17·8×15·9 cm.). Generally good condition except for abrasion throughout.

Together with two other paintings of approximately the same size and date, c. 1300 (the *Nativity* in the collection of Roberto Longhi, Florence, and the *Last Judgment* in a private collection in Milan), K324 and K361 probably once belonged to an extensive series of panels depicting scenes from the life of Christ. Opinions as to style have differed widely, giving the paintings to Cimabue, to a Roman artist, to a Greek, and, most convincingly, to a Venetian.[3] Byzantine influence is obvious, in the iconography as well as in style: compare, for example, K324 with almost the same composition in tenth-century churches of Cappadocia.[4]

Provenance: Amadeo, Rome. Contini Bonacossi, Florence. Kress acquisition, 1935 – exhibited: National Gallery of Art, Washington, D.C. (311, 288), 1941–52;[5] after entering the Portland and New Orleans museums: 'Art Treasures for America,' National Gallery of Art, Washington, D.C., Dec. 10, 1961–Feb. 4, 1962 (nos. 48, 49, as Italian, thirteenth century).

References: (**1**) Catalogue by W. E. Suida, 1953, p. 6, as Italian, thirteenth century. (**2**) Catalogue by W. E. Suida, 1952, p. 10, as Italian, thirteenth century. (**3**) G. Fiocco, G. Gronau, W. E. Suida, and A. Venturi (in ms. opinions) have attributed K324 and K361 to Cimabue; also R. Longhi (in *Proporzioni*, vol. II, 1948, pp. 16 ff.) attributes the series to Cimabue; he reproduces the four panels now known. In ms. opinions R. van Marle labels K324 and K361 Tuscan, close to Cimabue; F. M. Perkins thinks them by a Roman painter; and B. Berenson favors a Greek, possibly from Crete. E. B. Garrison (*Italian Romanesque Panel Painting*, 1949, nos. 703, 704) labels them Venetian, c. 1315/35, by a painter whom he designates as the 'Speaking Christ Master.' R. Offner (*Corpus of Florentine Painting*, vol. III, sec. V, 1947, p. 254 n. 10) refers to them as thirteenth-century Venetian. (**4**) A Cappadocian example is reproduced in *Burlington Magazine*, vol. LV, 1929, p. 161, pl. I-B. (**5**) *Preliminary Catalogue*, 1941, pp. 41 f., as Cimabue (?).

VENETIAN SCHOOL, c. 1300

K431 : Figure 14

SCENES FROM THE PASSION OF CHRIST. Williamstown, Mass., Williams College Museum of Art, Study Collection (60.10), since 1960. Wood. 13⅞×10⅞ in. (35·2×27·6 cm.). Worn throughout, especially in lower part.

The former attribution of K431 to the thirteenth-century Pisan School[1] was based on a relationship to the work of Giunta Pisano. But the influence of this artist spread northward, to Venice, where the Byzantine characteristics of K431 were at home and where certain details of iconography, such as the anguished gesture of St. John, who stands at the right of the Crucified Christ, were typical.[2] It has been noted that in the scene of the *Crucifixion* the posture of Christ, the group of the Virgin and Holy Women, and also the Evangelist and the Centurion are almost exactly the same as in the famous early fourteenth-century Venetian altarpiece with scenes from the *Life of Christ* in the Museo Civico, Trieste.[3] The scenes represented in K431 are easily recognized: the *Crucifixion*, the *Kiss of Judas*, *Christ before Pilate*, and, in the spandrels, the *Annunciation*. The half-length figure at the left of the *Crucifixion* is St. Francis; the corresponding half-length at the right has not been identified.

Provenance: Amaro, Rome. Contini Bonacossi, Florence. Kress acquisition, 1936 – exhibited: National Gallery of Art, Washington, D.C. (350), 1941–51.[4]

References: (**1**) K431 has been attributed (in ms. opinions) to the Pisan School by G. Fiocco, R. Longhi, W. E. Suida, and A. Venturi; tentatively to Central Italy by F. M. Perkins. (**2**) The influence of Giunta Pisano and the gesture of St. John are found, e.g., in the *Man of Sorrows*, a Venetian painting of about 1300 in the Torcello Museum, reproduced in *Burlington Magazine*, vol. LXXXIX, 1947, p. 213, pl. IA. E. B. Garrison (*Italian Romanesque Panel Painting*, 1949, no. 343) assigns K431 to the Venetian School, 1320/40, group of the Leningrad Diptych, which he reproduces as no. 245. (**3**) Reproduced by G. Caprin, *Trieste*, 1906, p. 62. The relationship of K431 to the Trieste painting was noted by G. Coor (in ms. opinion, 1962), who attributed K431 to the Venetian School. (**4**) *Preliminary Catalogue*, 1941, p. 158, as Pisan School.

PAOLO VENEZIANO

Venetian School. Active 1324–58. The foremost Venetian master of the fourteenth century, Paolo was so close a follower of the Byzantine tradition as to suggest that he may have visited Constantinople. Even the new style of Giotto, whose frescoes in Padua inevitably impressed him, was given an amazingly Byzantine interpretation by Paolo.

K1895 : Figure 13

THE CORONATION OF THE VIRGIN. Washington, D.C., National Gallery of Art (1166), since 1956.[1] Wood. 39× 30½ in. (99·1×77·5 cm.). Inscribed at bottom: MCCCXXIIII. Very good condition; cleaned 1953; arch moldings and foliate carving within the spandrels are original.

Probably once the central panel of a large polyptych, the painting still retains parts of the original frame. The inscription (below the feet of Christ and the Virgin), which was misread as 1323 before the picture was cleaned, is now

clearly legible: MCCCXXIIII. If we follow the present trend in excluding from the artist's oeuvre the Dignano altarpiece, of 1321, K1895 is then his earliest dated painting.[2] The scene of the coronation of the Virgin, which is believed to have made its first appearance in Italian painting about 1270/80 in a picture attributed to Guido da Siena,[3] became a favorite subject in Venice. Paolo Veneziano repeated it several times.[4] His last version, dated 1358, in the Frick Collection, New York, was painted in collaboration with his son Giovanni and shows a trend away from his Byzantine manner of 1324, toward the Gothic style.

Provenance: Dal Zotto, Venice. Knoedler's, New York. Kress acquisition, 1952.

References: (**1**) *Paintings and Sculpture from the Kress Collection,* 1956, p. 138 (catalogue by W. E. Suida and F. R. Shapley), as Paolo Veneziano. (**2**) R. van Marle (*Italian Schools of Painting,* vol. IV, 1924, p. 5), having seen only the photograph, labels K1895 Venetian. E. Sandberg-Vavalà (in *Burlington Magazine,* vol. LII, 1930, p. 165), G. Fiocco (in *Dedalo,* vol. XI, 1931, pp. 884 ff.), G. Gronau (in Thieme-Becker, *Allgemeines Lexikon,* vol. XXVI, 1932, p. 214), S. Bettini (in *Bollettino d'Arte,* vol. XXVIII, 1935, p. 477), V. Lasareff (in *Arte Veneta,* vol. VIII, 1954, p. 88), B. Berenson (*Italian Pictures . . . Venetian School,* vol. I, 1957, p. 129), R. Pallucchini (*La Pittura veneziana del trecento,* 1964, pp. 24 f.), and G. Gamulin (in *Emporium,* vol. CXL, 1964, pp. 147 ff.) accept K1895 (tentatively, in the cases of those critics who had seen only photographs of it) as by Paolo Veneziano. Lasareff (*loc. cit.*) and E. Arslan (in *Commentari,* vol. VII, 1956, pp. 21 f.) exclude the Dignano altarpiece, of 1321, from the artist's oeuvre. (**3**) See G. Coor (in *Burlington Magazine,* vol. XCIX, 1957, pp. 328 ff.) for Guido's *Coronation,* Courtauld Institute, London. (**4**) That the representation of the coronation of the Virgin as early as 1324 in Venice may have been connected with anti-heretical propaganda is proposed by G. Francastel in *Annales Économies-Sociétés-Civilisations,* vol. XX, 1965, pp. 1 ff.

PAOLO VENEZIANO

K285 : Figure 10

THE CRUCIFIXION. Washington, D.C., National Gallery of Art (254), since 1941.[1] Wood. $12\frac{1}{2} \times 14\frac{3}{4}$ in. (32 × 37 cm.). Inscribed above cross: I.N.R.I. (Jesus of Nazareth, King of the Jews). Fair condition except for abrasion throughout.

Now generally accepted as the work of Paolo Veneziano, this panel has been much discussed, especially as regards its original use. Analogy with the *Crucifixion* in an intact triptych by Paolo in the Parma Gallery[2] suggests that K285 may have formed the top of the middle panel of such a triptych. The Parma example is arranged as follows: in the middle panel there is a half-length *Madonna and Child* below the *Crucifixion;* in the left wing, divided horizontally into three sections, are the *Angel Annunciate* (at the top), *Sts. Michael and John the Baptist* (in the middle), and *Sts. George and Francis* (at the bottom); in the right wing, likewise divided horizontally into three sections, are the *Virgin Annunciate* (at the top), the *Levitation of the Magdalen* (in the middle), and *Sts. Barbara and Anthony Abbot* (at the bottom). An almost exact duplication of this arrangement can be achieved if we associate K285 with a half-length *Madonna and Child* in the Campana Collection, Musées Nationaux, Paris (formerly at Montargis),[3] panels of the *Annunciation* in the former Loeser Collection, Florence,[4] and seven panels in the Worcester Museum (six standing saints, identified as in the Parma triptych, and the *Levitation of the Magdalen*).[5] We should then date the whole complex about 1340.

Provenance: Achillito Chiesa, Milan. Contini Bonacossi, Florence. Kress acquisition, 1934.

References: (**1**) *Preliminary Catalogue,* 1941, p. 149, as Paolo Veneziano. (**2**) The Parma triptych is reproduced by R. Pallucchini in *Scritti di storia dell'arte in onore di Lionello Venturi,* vol. I, 1956, p. 126. (**3**) The Campana *Madonna* is reproduced by R. Longhi (*Viatico per cinque secoli di pittura veneziana,* 1946, pl. 4). Longhi (p. 45) accepts K285 as by Paolo Veneziano but does not associate it with the group here listed. Another *Crucifixion* attributed to Paolo Veneziano, with fewer figures, but with the same trilobate top and the same crenellated wall in the background is in the Lord Lee Collection, Courtauld Institute, London. It is, again, the upper section of what apparently was once the middle panel of a triptych; a *Madonna of Humility* is in the lower section. (**4**) For Loeser panels see pl. 6 of Longhi, *op. cit.* in note 3, above. (**5**) The Worcester panels are reproduced by Pallucchini (*op. cit.* in note 2, above, pp. 124 and 125, figs. 5 and 6), who, however, believes K285 to have been painted about 1350, some ten years later than the Worcester panels and therefore probably not to be associated with them. E. Sandberg-Vavalà (in an unpublished article of many years ago) was the first to suggest a connection of the Worcester panels with K285. M. Laclotte (in *Revue des Arts,* 1956, p. 78, fig. 4 [reconstruction], and in *Arte Veneta,* vol. X, 1956, p. 226) completes the triptych with the panels listed above. B. Berenson (*Italian Pictures . . . Venetian School,* vol. I, 1957, p. 129) lists K285 as Paolo Veneziano; E. Arslan (in *Commentari,* 1956, p. 21 n. 8) seems to be the only critic who doubts the attribution; he suggests the panel may be by an assistant of the master.

VENETIAN SCHOOL, Early XIV Century

K 1225 : Figure 23

ST. URSULA AND ST. CHRISTINA. Bloomington, Ind., Indiana University, Study Collection (L62.161), since 1962. Wood. 11⅝×8 in. (29·5×20·3 cm.). Inscribed at the bottom: s̄. VRSVLA; s̄. CRISTINA. Slightly abraded; frame and moldings original.

These two panels follow the early Byzantine tradition of Venice so faithfully as to have been attributed by some critics to Paolo Veneziano.[1] It is their less precise execution which throws doubt on that ascription. In size, proportions, composition, as well as style, they are closely related to the panels of saints by Paolo Veneziano in the Worcester Museum; originally they may well have been components of such an altarpiece as the one in which those saints and Paolo's *Crucifixion* in the National Gallery of Art are believed to have been associated.[2] St. Ursula, at the left, carries, as symbol of her martyrdom, an extraordinarily long arrow, while St. Christina, at the right, carries the millstone used in one of the unsuccessful attempts on her life. Her martyrdom was finally accomplished by transfixing her with a javelin or an arrow; hence her association with St. Ursula.

Provenance: Cav. Enrico Marinucci, Rome. Contini Bonacossi, Florence (1939). Kress acquisition, 1939.

References: (**1**) In ms. opinions R. Longhi, G. Fiocco, and F. M. Perkins have attributed the panels to Paolo Veneziano; while A. Venturi has given them to Lorenzo Veneziano; and W. E. Suida, to the Venetian School, first half of fourteenth century. B. Berenson (*Italian Pictures . . . Venetian School*, vol. I, 1957, p. 128) lists them as Paolo Veneziano. (**2**) For the Worcester panels and the National Gallery *Crucifixion* see K 285, by Paolo Veneziano (p. 8, above).

LORENZO VENEZIANO

Venetian School. Active 1356–72. He may have been a pupil of Paolo Veneziano, but working in Bologna as well as in Venice he was influenced also by the Bolognese and his style is less Byzantine, more Italian, than Paolo's.

Attributed to LORENZO VENEZIANO

K 568 : Figure 24

ST. ANDREW. Atlanta, Ga., Atlanta Art Association Galleries (58.56), since 1958.[1] Wood. 40¼×11 in. (102·2× 28 cm.). Inscribed at sides of the saint's head: ANDRE/AS. Spandrels are part of original panel; good condition.

The head of the saint is paralleled fairly closely in Lorenzo's *St. Anthony Abbot* in the Bologna Pinacoteca; but the drapery finds no parallel in the artist's work. It harks back to the Byzantine style but is clearly only an adaptation of that style, for neither here nor in the face of the saint is the coloring Byzantine; it is all lighter in tone. If by Lorenzo Veneziano,[2] K 568, which undoubtedly comes from some dismembered altarpiece, should date about 1360.

Provenance: Private Collection, Capri.[3] Contini Bonacossi, Florence. Kress acquisition, 1939 – exhibited: National Gallery of Art, Washington, D.C. (858), 1945-52, as Lorenzo Veneziano.

References: (**1**) Catalogue by W. E. Suida, 1958, p. 40, as Lorenzo Veneziano. (**2**) G. Fiocco, F. M. Perkins, A. Venturi (in ms. opinions), R. Longhi (*Viatico per cinque secoli di pittura veneziana*, 1946, p. 46), and B. Berenson (*Italian Pictures . . . Venetian School*, vol. I, 1957, p. 99) attribute K 568 to Lorenzo Veneziano. (**3**) Perkins (in ms. opinion) cites this provenance.

Attributed to LORENZO VENEZIANO

K 526 : Figure 20

MADONNA AND CHILD. Birmingham, Ala., Birmingham Museum of Art (61.100), since 1952.[1] Wood. 34½×25 in. (87·6×63·5 cm.). Poor condition; very much worn and heavily restored and varnished.

The attribution to Lorenzo Veneziano has found general acceptance,[2] in spite of the fact that the figures are on a larger scale than the *Madonnas* signed by that artist and the expression is less animated. Caterino Veneziano could be considered if his paintings were not so inferior in execution. The erroneous conception of K 526 as less than half its actual size has led (in spite of adverse evidence of decorative details) to an attempt to include it in a reconstruction of the middle section of Lorenzo Veneziano's Ufficio della Seta triptych of 1371.[3] Yet a date about this time seems suitable for K 526.

Provenance: Achillito Chiesa, Milan. Contini Bonacossi, Florence. Kress acquisition, 1938 – exhibited: National Gallery of Art, Washington, D.C. (411), 1941-51.[4]

References: (**1**) Catalogue by W. E. Suida, 1952, p. 21, and 1959, p. 18, as Lorenzo Veneziano. (**2**) G. Fiocco, F. M. Perkins, and A. Venturi (in ms. opinions) attribute K 526 to Lorenzo Veneziano, as does R. Longhi (*Viatico per cinque secoli di pittura veneziana*, 1946, p. 46). B. Berenson (*Italian Pictures . . . Venetian School*, vol. I, 1957, p. 99) lists it, with a question mark, as Lorenzo Veneziano. (**3**) This suggestion

was made by R. Longhi (in *Arte Veneta*, vol. I, 1947, pp. 80 ff.), who cites the measurements of K526 as 35×25 centimeters instead of inches. R. Pallucchini (*La Pittura veneziana del trecento*, 1964, pp. 176 ff.) cites Longhi's suggestion with tentative approval. (4) *Preliminary Catalogue*, 1941, p. 114, as Lorenzo Veneziano.

GIOVANNI DA BOLOGNA

Bolognese-Venetian School. Retaining few characteristics from his presumably early Bolognese training, Giovanni seems to have been chiefly influenced in Venice by Lorenzo Veneziano. He signed a painting in Venice in 1377 and is recorded as still there in 1389.

K428 : Figure 22

THE CORONATION OF THE VIRGIN. Denver, Colo., Denver Art Museum (E-It-18-XIV-926), since 1954.[1] Wood. 43¼×23⅜ in. (109·8×59·4 cm.). Inscribed with the artist's signature on base of throne: IOHES · PINTOR · DE · BOLOGNA. Principal figures in good condition; angels above Coronation and Madonna's mantle had been repainted in the late Renaissance; cleaned 1954.

From a very small oeuvre and less than half a dozen signed paintings by the artist, this panel was the object of much search and speculation from the time it disappeared, in the late nineteenth century, until it was rediscovered in 1936.[2] It is less harsh than the *St. Christopher* of 1377, now in the Museum at Padua, and may date as early as 1365/70.

Provenance: Michelangelo Gualandi, Bologna (sold 1890). Contini Bonacossi, Florence. Kress acquisition, 1936 – exhibited: National Gallery of Art, Washington, D.C. (347), 1941–52.[3]

References: (1) Catalogue by W. E. Suida, 1954, pp. 12 f., as Giovanni da Bologna. (2) Crowe and Cavalcaselle (*Storia della pittura italiana*, vol. IV, 1887, p. 87 n. 1; Hutton ed., vol. II, 1909, p. 163 n. 2), mention seeing a photograph of the painting, then in the Gualandi Collection, and describe its composition and the signature. Subsequently, the following scholars complain of being unable to find it: A. Moschetti (in *Rassegna d'Arte*, vol. III, 1903, pp. 36 f.), L. Venturi (*Origini della pittura veneziana*, 1907, p. 36), L. Testi (*Storia della pittura veneziana*, vol. I, 1909, p. 301), F. Filippini (in *Rassegna d'Arte*, vol. XII, 1912, p. 103), R. van Marle (*Italian Schools of Painting*, vol. IV, 1924, pp. 81 f.), and F. Filippini and G. Zucchini (*Miniatori e pittori a Bologna*, 1947, p. 87). The painting was first published by the National Gallery (see note 3 below). It was discussed by R. Longhi (*Viatico per cinque secoli di pittura veneziana*, 1946, p. 47), who dates it before the *St. Christopher*, at Padua, of 1377. F. Bologna

(in *Arte Veneta*, vol. V, 1951, p. 23) thinks that K428, along with the same artist's similar *Coronation* in the Pinacoteca, Bologna, was painted about 1365. G. Fiocco, F. M. Perkins, E. Sandberg-Vavalà, A. Venturi (in ms. opinions), and B. Berenson (*Italian Pictures ... Venetian School*, vol. I, 1957, p. 87), concur in attributing K428 to Giovanni da Bologna. (3) *Preliminary Catalogue*, 1941, pp. 82 f., as Giovanni da Bologna.

GUARIENTO

Guariento d'Arpo. Paduan School. First mentioned 1338; died 1368/70. In Guariento's Venetian training, based principally on the style of Paolo Veneziano, there is still a reflection of the Byzantine manner. But the influence of Giotto's frescoes in the Arena Chapel, at Padua, was also strongly felt by Guariento, who may be considered one of the founders of the Paduan school.

K1091 : Figure 19

MADONNA AND CHILD WITH FOUR SAINTS. Raleigh, N.C., North Carolina Museum of Art (GL.60.17.17), since 1960.[1] Wood. 16⅛×9⅛ in. (41×23·2 cm.). The four saints, Anthony of Padua, John the Baptist, Francis, and Giles, are identified by partly legible inscriptions at their feet; John the Baptist's scroll is inscribed: ECCE AGNVS DEI ECCE QVI TOLIT PECATA MONDI (from John I : 29). Very good condition.

This elegant little panel was described by Baruffaldi[2] more than a century ago, when it was in a private Ferrarese collection,[3] as being a pendant to a *Crucifixion* which was then, and is still, in the Ferrara Picture Gallery. Baruffaldi treated the two panels, which must originally have formed a diptych, under the name of the Bolognese-Ferrarese Cristoforo, to whom the *Crucifixion* was still tentatively assigned when shown in the Ferrarese exhibition of 1933. More recently the tendency has been to refer the panels to Guariento or to his circle, with a date of about 1365.[4] Good comparative material is offered by Guariento's series of angels in the Museo Civico, Padua, which repeat the figure types and style of modeling of the features in K1091 and also such peculiar details as the flattened fold at the lower left in the Madonna's robe.

Provenance: Probably from the Church of San Gilio (Egidio) in the neighborhood of Ferrara.[5] Casa Boschini, Ferrara (in 1846).[6] Achillito Chiesa, Milan (sold, American Art Association, New York, Apr. 16, 1926, no. 22 of catalogue, as Cristoforo da Ferrara; bought by Haas). F. Kleinberger (sold, American Art Association, New York, Nov. 18, 1932, no. 32 of catalogue, as Cristoforo da Ferrara). Contini Bonacossi, Florence. Kress acquisition, 1937 –

exhibited: National Gallery of Art, Washington, D.C. (459), 1941–52.[7]

References: (1) Catalogue by F. R. Shapley, 1960, pp. 46 f., as Guariento. (2) G. Baruffaldi, *Vite de' pittori e scultori ferraresi*, vol. II, 1846, p. 544. (3) See *Provenance*, above. (4) R. van Marle (*Italian Schools of Painting*, vol. IV, 1924, p. 498, with good reproduction, fig. 252) labels the *Crucifixion* Ferrarese; E. Sandberg-Vavalà (in *Art in America*, vol. XXII, 1933, pp. 10, 13, fig. D) attributed the *Crucifixion* (neither she nor van Marle knew its pendant, K 1091) to the last phase of Guariento, *c.* 1365; and R. Longhi (*Officina ferrarese*, 1934, pp. 9 f., 157 n. 10 f., figs. 8 ff.; ed. of 1956, pp. 9 f., 93 n. 10 f., p. 193 n. 3, figs. 15 f.), without excluding the possibility of Guariento's authorship, thought the two panels more likely by an anonymous Paduan in the circle of Guariento. In ms. opinions B. Berenson, G. Fiocco, F. M. Perkins, W. E. Suida, and A. Venturi attribute K 1091 to Guariento. (5) See Baruffaldi, *loc. cit.* in note 2, above. (6) *Ibid.* (7) *Preliminary Catalogue*, 1941, p. 94, as Guariento.

VENETIAN SCHOOL, Late XIV Century

K 65 : Figure 16

MADONNA AND CHILD, THE CRUCIFIXION, AND SAINTS. Allentown, Pa., Allentown Art Museum, Study Collection (60.06.KBS), since 1960.[1] Wood. 30¼×23⅜ in. (76·8×59·5 cm.). Inscribed on the Baptist's scroll: [ec]CE AGNUS DEI (from John 1 : 29). Badly abraded throughout.

This small polyptych has been classified as a Venetian work of the late fourteenth or early fifteenth century, with similarities to paintings by Caterino (active 1367–82), Lorenzo Veneziano (active 1356–72), and Jacobello del Fiore (*c.* 1370–1439).[2] Attention should be called also in this connection to paintings signed as by Stefano Plebanus di Sant'Agnese (signed and dated paintings from 1369 to 1385).[3] A particularly striking parallel is the *Coronation* in the Accademia, Venice, which is signed as by Stefano and dated 1381. And, again, especially for the delight in arabesque design evident in the mantle of the Virgin in K 65, compare the *Madonna and Child* signed as by Stefano in the Correr Museum, Venice.

Provenance: Contini Bonacossi, Rome. Kress acquisition, 1929 – exhibited: 'Italian Paintings Lent by Mr. Samuel H. Kress,' Oct. 1932, Atlanta, Ga., through June 1935, Charlotte, N.C., p. 38 of catalogue, as manner of Jacobello del Fiore.

References: (1) Catalogue by F. R. Shapley, 1960, p. 46, as Venetian, early fifteenth century. (2) In ms. opinions K 65 has been classified by B. Berenson as Bolognese-Venetian; by

G. Fiocco and W. E. Suida as Venetian between Lorenzo Veneziano and Jacobello del Fiore; by R. van Marle as Giovanni da Bologna; by R. Longhi as Venetian, *c.* 1370; by F. M. Perkins as first half of fifteenth century; and by A. Venturi as early fifteenth century, close to Caterino. (3) R. van Marle (*Italian Schools of Painting*, vol. IV, 1924, pp. 66 ff.) notes that Stefano Plebanus' signatures are doubted.

VENETIAN SCHOOL, Late XIV Century

K 560 : Figure 21

MADONNA AND CHILD. Allentown, Pa., Allentown Art Museum, Study Collection (60.26.KBS), since 1960. Wood. 16¼×12¼ in. (41·2×31·1 cm.). Inscribed in upper right background with the Greek monograms for MHTHP ΘEOT (Mother of God). Flesh tones slightly abraded; panel probably rectangular originally.

This type of Madonna, called the *Glykophilousa* – the cheek of the Child affectionately pressed against that of the Mother and His arm thrown round her neck – seems to have had its greatest vogue in the thirteenth century (compare K 1189 and K 1716, Figs. 8 and 7). The painter of K 560 looks to the past also for his stylistic model – to the paintings, probably, of Lorenzo Veneziano, and even as early as Paolo Veneziano.

Provenance: Dan Fellows Platt, Englewood, N.J. (sold by estate trustee to the following). Kress acquisition, 1939.

VENETO-BYZANTINE SCHOOL
Late XIV Century

K 1109 : Figure 26

ST. JEROME. New York, N.Y., Samuel H. Kress Foundation, since 1937. Wood. 27¾×19 in. (70·5×48·2 cm.). Inscribed at left above the saint's throne: S. IERONIMS'. and on his open book: IRAM. VINCE PATIENCIA. AMA SCIĒTIAM SCRIPTVRARVM. CARNIS. VICIA. NŌ AMABIS. (Overcome anger with patience; love the study of the Scriptures; you will not love the vices of the flesh) – from the writings of St. Jerome. Good condition.

This is so closely similar to a smaller painting of *St. Jerome* in the National Gallery, London,[1] as to suggest that the two may have had a common model, probably a Byzantine painting. K 1109 has kept especially close to the Byzantine model in the fantastic formation of the mountains, but both paintings exhibit a softness in drapery treatment that is Italian rather than Byzantine. It seems likely that K 1109 may

have been painted in the late fourteenth century in Venice, where native artists had an abundance of Byzantine models.[2]

Provenance: Principe Trivulzio, Milan. Contini Bonacossi, Florence. Kress acquisition, 1937.

References: (1) Catalogue by M. Davies, 1961, p. 548, no. 3543, as Venetian School. (2) In ms. opinions B. Berenson, G. Fiocco and R. Longhi classify K1109 as Veneto-Cretan School; F. M. Perkins, as Dalmatian or Italian; W. E. Suida and A. Venturi, as Venetian.

ITALO-BYZANTINE SCHOOL
XIV Century Style

K112 : Figure 15

THE CRUCIFIXION. Claremont, Calif., Pomona College, Study Collection (61.1.1), since 1961. Wood. 54¾×32 in. (139·1×81·3 cm.). Abraded throughout, especially on cross and ground; hair of Christ and St. John badly damaged.

Classification as a *retardataire* provincial work harking back to an earlier Byzantine style is clearly indicated for this panel; but suggestions as to its dating have varied widely, from the mid-fourteenth century to the late sixteenth or even early seventeenth.[1] The composition is close to a *Crucifixion* from the Volpi sale (1927) which has been assigned to the second quarter of the fourteenth century in the Adriatic region.[2] K112 is less consistent in style and apparently much later.

Provenance: Contini Bonacossi, Rome. Kress acquisition, 1930 – exhibited: Metropolitan Museum of Art, New York (32.59), 1932–61.[3]

References: (1) K112 has been attributed, in ms. opinions, to the Italo-Byzantine School of the fourteenth century by R. Longhi, W. E. Suida, and A. Venturi; of the fifteenth century by G. Fiocco; of the fifteenth or sixteenth century by F. M. Perkins; of the late sixteenth century or early seventeenth by A. Avinoff. R. Offner (verbally) has suggested that it is Dalmatian rather than Italian. (2) Reproduced by E. B. Garrison, *Italian Romanesque Panel Painting*, 1949, no. 658. (3) Catalogue of *Italian, Spanish and Byzantine Paintings*, by H. B. Wehle, 1940, p. 2, as Italo-Byzantine, sixteenth century.

BARNABA DA MODENA

School of Modena. He is recorded from 1361 to 1383 as active in Genoa and Pisa; but he was probably trained in Modena, in a strongly Byzantine tradition, and he kept up connections with Modena.

Follower of BARNABA DA MODENA

K495 : Figure 18

MADONNA AND CHILD. Claremont, Calif., Pomona College, Study Collection (61.1.4), since 1961. Wood. 20⅞×12 in. (53×30·5 cm.). Inscribed on the scroll held by the Child: BEATI QUI AUDIUNT UERBUM DEI (from Luke 11 : 28); and on the Virgin's halo: AUE GRATIA PLEN[a] (from Luke 1 : 28). Fair condition except for abrasion throughout.

The modeling is less precise and the expression less lively than is characteristic of the signed paintings by Barnaba, but since his style became progressively weaker, K495 is sometimes attributed to him,[1] and would date toward 1370. In the bottom compartment, which serves as predella, are St. Anthony Abbot, the Virgin, the Man of Sorrows, St. John the Evangelist, and St. Catherine of Alexandria.

Provenance: Julius Böhler's, Munich (1918). Bachstitz', The Hague (1922). Spink & Sons, London, 1924 – exhibited: 'A Few Fine Examples of Early Masters,' Spink & Sons, London (catalogue, n.d., pp. 22 f., as Barnaba da Modena). Contini Bonacossi, Florence. Kress acquisition, 1937 – exhibited: National Gallery of Art, Washington, D.C. (388), 1941–52.[2]

References: (1) K495 is attributed to Barnaba da Modena by B. Berenson, tentatively, G. Fiocco, W. E. Suida, A. Venturi (in ms. opinions), M. Meiss (verbally) and G. Biermann (in *Der Cicerone*, vol. XIV, 1922, p. 463). R. Longhi and F. M. Perkins (in ms. opinions) have attributed it to an artist close to Barnaba; D. C. Shorr (*The Christ Child in Devotional Images*, 1954, p. 42) attributes it to a follower of Barnaba; and S. Reinach (*Répertoire de peintures*, vol. IV, 1918, p. 417) gives it to the Sienese School. (2) *Preliminary Catalogue*, 1941, p. 12, as Barnaba da Modena.

Follower of BARNABA DA MODENA

K527 : Figure 17

THE CRUCIFIXION. Brunswick, Me., Walker Art Museum, Bowdoin College, Study Collection (1961.190.2), since 1961.[1] Wood. Including moldings, 23½×14⅜ in. (59·7×36·6 cm.). Fair condition except for abrasion throughout and some losses of paint.

The arrangement of the composition, with the cross topped by the pelican feeding her young on her life's blood (symbol of Christ's passion) is typical in Barnaba's work, but the execution, especially of the body of Christ, suggests a follower.[2] The date is probably about 1370. The saints who accompany the Virgin and St. John beneath the cross are easily recognized as St. Catherine of Alexandria and St. Christopher.

Provenance: Contini Bonacossi, Florence. Kress acquisition, 1938 – exhibited: National Gallery of Art, Washington, D.C. (412), 1941–52.[3]

References: (**1**) *Bulletin of the Walker Art Museum*, vol. I, no. 1, 1961, p. 8, as Emilian School, *c.* 1370. (**2**) In ms. opinions K527 is attributed to Barnaba da Modena by G. Fiocco, R. Longhi, W. E. Suida, and A. Venturi; to an anonymous Emilian by B. Berenson and F. M. Perkins. (**3**) *Preliminary Catalogue*, 1941, p. 12, as Barnaba da Modena.

NICOLÒ DA VOLTRI

Genoese School. Active 1385–1417. Presumably born in Voltri, on the gulf coast a few miles west of Genoa, Nicolò worked chiefly in the neighborhood of Genoa and in towns along the coast as far away as Nice. He was strongly influenced by Barnaba da Modena and Taddeo di Bartolo, both of whom worked in Liguria.

K1747 : Figure 29

MADONNA AND CHILD. El Paso, Tex., El Paso Museum of Art (1961-6/3), since 1961.[1] Wood. $17\frac{3}{8} \times 12\frac{1}{4}$ in. (44×31 cm.). Fragment; cut down at some time into oval shape and then refashioned into the presumably original shape; fair condition.

This has not unreasonably been attributed to Barnaba da Modena,[2] whose influence was especially strong on the early Nicolò da Voltri, around 1385, the approximate date of K1747. A close parallel is the polyptych, signed by Nicolò, in the collection of Marchese Negrotti Cambiaso, Castello Gabbiano, Piedmont.[3]

Provenance: Contini Bonacossi, Florence. Kress acquisition, 1950.

References: (**1**) Catalogue by F. R. Shapley, 1961, no. 3, as Nicolò da Voltri. (**2**) R. Longhi (in ms. opinion) states that K1747 has been attributed to Barnaba da Modena but that he cannot agree. He considers it Emilian, about 1370/80, either Modenese or Ferrarese. (**3**) Robert Manning kindly called my attention to the parallel with the Castello Gabbiano polyptych, a photograph of which is in the Kress Foundation archives.

MASTER OF THE CLARISSE PANEL

Sienese School. Late thirteenth century. This anonymous master derives his pseudonym from the location of the panel of the *Lord and Virgin Enthroned* in the Church of the Convent of the Clarisse, Siena. He was a follower of Guido da Siena, in whose studio he may have worked around 1270. He was also strongly influenced by Coppo di Marcovaldo.

K1930 : Figure 34

MADONNA AND CHILD WITH FOUR SAINTS. Memphis, Tenn., Brooks Memorial Art Gallery (61.210), since 1958.[1] Wood. $39\frac{1}{2} \times 75\frac{1}{4}$ in. ($100\cdot3 \times 191\cdot1$ cm.). Abraded throughout; Madonna and Child better preserved; molding around figures is original, also gold background; slightly cleaned 1957–58.

Formerly referred to the painter of a Guidesque panel at Montaione, K1930 has now been convincingly associated with a group of paintings attributable to the Clarisse Master.[2] The date is probably about 1285, some fifteen years later than the Clarisse panel itself. K1930 is an altarpiece of horizontal shape known as a dossal. Its general composition, as well as the style of the figures, is closely paralleled in two dossals in the Accademia, Siena, one by Guido da Siena, to whom K1930 was at one time attributed;[3] the other, by an assistant of Guido.[4] The female saint at the left is the Magdalen; the one at the right is probably Margaret of Antioch. The bishop saint may be Sabinus,[5] a patron saint of Siena, and the male saint at the right is probably John the Evangelist. The frame moldings are modern, but probably follow the original form.

Provenance: Palazzo Piccolomini, Siena.[6] Odescalchi (?), Rome. Stettiner, Rome. Principe del Drago, Rome. Avv. Lodovico Rosselli, Rome. Dedalo Gallery, New York. Kress acquisition, 1952 – exhibited, after entering the Brooks Memorial Gallery: 'Art Treasures for America,' National Gallery of Art, Washington, D.C., Dec. 10, 1961–Feb. 4, 1962, no. 68, as Montaione Master.

References: (**1**) Catalogue by W. E. Suida, 1958, p. 8, as Montaione Master. (**2**) E. B. Garrison publishes the Montaione *Madonna* and K1930 in *Burlington Magazine*, vol. LXXXIX, 1947, pp. 300 ff. See also his *Italian Romanesque Panel Painting*, 1949, no. 434. He dates K1930 in the decade 1275–85. R. Offner (in *Gazette des Beaux-Arts*, vol. XXXVII, 1950, p. 65) mentions K1930 (when in the Rosselli Collection) in his discussion of altarpieces by Guido and his workshop. J. H. Stubblebine (*Guido da Siena*, 1964, cat. no. XVII) attributes it to the Clarisse Master, dating it in the 1280's. He reproduces it before and after restoration. (**3**) A. Venturi, in *Gemme d'arte antica italiana*, 1938, no. XLVI. (**4**) The two panels in Siena are reproduced by Stubblebine, figs. 7 and 33 of *op. cit.* in note 2, above. (**5**) So identified by Stubblebine, p. 90 of *op. cit.* (**6**) A. Venturi (*loc. cit.* in note 3, above) cites this former location. The two following owners are cited by Stubblebine, p. 89 f. of *op. cit.* in note 2, above.

DUCCIO

Duccio di Buoninsegna. Sienese School. Active from 1278; died 1318/19. Duccio, the greatest master of the Sienese School, tempered the traditional severity of the Byzantine manner with the linear lyricism and decorative grace of the Northern Gothic style. He was influenced also by contemporary Florentine art, especially by Cimabue's early work.

K283 : Figure 28

THE CALLING OF THE APOSTLES PETER AND ANDREW. Washington, D.C., National Gallery of Art (252), since 1941.[1] Wood. 17⅛×18⅛ in. (43·5×46 cm.). Good condition; needs cleaning.

This panel comes from the great altarpiece known as the Maestà, which was commissioned of Duccio (to be painted entirely by his hand) in 1308 and was finished and signed by him and carried in joyous procession to the high altar of the Cathedral of Siena in 1311. It was an elaborate altarpiece, painted on both sides and terminated in painted pinnacles. The decoration of the latter included, besides angels, scenes from the life of the Virgin, the Apparitions of Christ, and, in a larger middle section, now lost, probably the Assumption and the Resurrection. In the main part of the front of the altarpiece was the Madonna in majesty with saints and angels and with half-length figures of apostles above; on the back of this were scenes from the Passion of Christ. The double predella was decorated on the front with scenes from the infancy of Christ in seven or, more probably, only six compartments, separated from each other by figures of prophets. On the back of the predella were scenes from Christ's ministry in ten or, more probably, only nine compartments.[2] Removed from the high altar in the early sixteenth century, the great altarpiece was set up in another part of the Cathedral. In 1771 the two faces of the altarpiece were split apart, after the main panel had been cut into seven vertical strips, and finally, in 1878, the altarpiece was further dismembered and transferred from the Cathedral to the Opera del Duomo, where most of it may be seen today.[3] A few small compartments have been lost. Ten sections of the predella, including the present panel and the Nativity with the Prophets Isaiah and Ezekiel (Mellon Collection, National Gallery of Art), are now in England and the United States. The Calling of the Apostles Peter and Andrew comes from the back of the predella, where it may have been the fifth or, more probably, the fourth scene from the left. Its composition is no doubt modeled on that of the same subject in the famous altarpiece of St. Peter, from the second half of the thirteenth century, in the Accademia, Siena.[4]

Provenance: Cathedral, Siena. Probably Giuseppe and Marziale Dini – exhibited: 'Mostra Communale di Colle di Val d'Elsa,' Sept. 6–8, 1879, one of nos. 80–83.[5] Charles Fairfax Murray, London. Robert H. and Evelyn Benson, London (catalogue by T. Borenius, 1914, no. 4, as Duccio) – exhibited, always as Duccio: 'Early Italian Art,' New Gallery, London, 1893–94; 'Pictures of the School of Siena,' Burlington Fine Arts Club, London, 1904, no. 2; 'Old Masters,' Grafton Galleries, London, 1911; 'Benson Collection,' Manchester, 1927. Duveen's, New York (bought from Benson Collection, 1927; Duveen Pictures in Public Collections of America, 1941, no. 8, as Duccio). Clarence H. Mackay, Roslyn, N.Y. Kress acquisition, 1934.

References: (1) Preliminary Catalogue, 1941, p. 60, as Duccio. (2) C. Brandi (Duccio, 1951, pp. 143 ff., and Il Restauro della Maestà di Duccio, 1959) discusses the original arrangement of the various scenes and the architectural construction of the altarpiece. See also E. T. DeWald (in Late Classical and Mediaeval Studies in Honor of Albert Mathias Friend, Jr., 1955, pp. 362 ff.), who offers some changes in the reconstruction. Further revisions are suggested by F. A. Cooper (in Art Bulletin, vol. XLVII, 1965, pp. 155 ff.). (3) For an outline of the vicissitudes of the altarpiece see the books and article cited in note 2. (4) The altarpiece of St. Peter is reproduced by R. van Marle, Italian Schools of Painting, vol. I, 1923, opposite p. 378. (5) See M. Davies, National Gallery Catalogues: The Earlier Italian Schools, 1961, p. 174.

Follower of DUCCIO

K2063 : Figure 27

MADONNA AND CHILD ENTHRONED WITH ANGELS. Washington, D.C., National Gallery of Art (1629), since 1960. Wood. 90¾×55⅞ in. (230·4×141·8 cm.). Very much worn; some losses of paint; head of angel at upper right almost entirely a restoration.

The poses, the solemn, reserved expression of the faces, the reminiscence of Byzantine style in the gold feathering of the draperies, and the Gothic sweep of the turned-back edge of the Virgin's mantle place the style of this work in the milieu of Duccio and date it in the early fourteenth century. But it does not conform to our understanding of the style of Duccio himself at any period in his career. If it were by the Badia a Isola Master, to whose work it bears considerable resemblance,[1] he would not be identifiable with Duccio in a phase of the latter's development, as has been suggested.[2] Especially monumental, with its boldly modeled throne, K2063 is one of only very few large Maestà panels still extant. Johann Anton Ramboux included a sketch of it among the drawings which he made in the early nineteenth century after examples of medieval art in Italy.[3] The painting was then in San Quirico d'Orcia. The panel is badly cracked and has suffered some paint losses. There

SIENESE : XIV CENTURY

have also been later changes in the composition, as is proven, e.g., by the double halo behind each head. The smaller halo, not concentric with the larger one and not painted at the same time, is placed in such relationship to the head it adorns as is characteristic of a later period, perhaps not earlier than the mid-fifteenth century, at which time the original, large halo was probably painted over.

Provenance: Cloister of the Collegiata, San Quirico d'Orcia (early nineteenth century). Pompeo Lammi, San Quirico d'Orcia (early twentieth century). Baron Fassini, Rome. Sestieri's, Rome (1951). Contini Bonacossi, Florence. Kress acquisition, 1954.

References: (1) The *Madonna* from the Badia a Isola is reproduced by E. Carli, *La Pittura senese*, 1955, pl. 12. Cf. especially the *Maestà* attributed to this master in the Cini Collection, Venice, reproduced by D. Cooper, *Great Private Collections*, 1963, p. 90. (2) Carli, *op. cit.*, pp. 41 ff., where a case is made for the attribution to Duccio, about 1285, of the group of paintings commonly assigned to the Master of the Badia a Isola. (3) G. Goor (in *Art Bulletin*, vol. XLII, 1960, p. 143 n. 6) cites this sketch (of which she kindly gave a photograph to the National Gallery of Art) as to be found on p. 20 of vol. III of the unpublished Ramboux drawings, which are now in the Städelsches Kunstinstitut, Frankfurt. Ramboux cites the painting as in a 'Kreuzgang der Hauptkirche zu S. Quirico.'

Follower of DUCCIO

K1289 : Figure 25

MADONNA AND CHILD WITH SAINTS AND THE CRUCIFIXION. Memphis, Tenn., Brooks Memorial Art Gallery (61.200), since 1960. Wood. $10\frac{3}{8} \times 16\frac{3}{4}$ in. (26·4×42·5 cm.). Inscribed on the cross, above Christ's head: $\overline{IC} - \overline{XC}$ (Jesus Christ). Good condition except for some abrasion.

This small portable triptych, painted probably in the first quarter of the fourteenth century, is perhaps best classified as Sienese, although it exhibits Florentine traits also, especially in the frontal figures of saints.[1] The main influence is that of Duccio. But the painter seems to have admired Segna di Buonaventura[2] also and may have had some contact with the Riminese School.[3] In the milieu of Duccio and Segna, the artist is close to the Goodhart Ducciesque Master.[4] The arrangement of the arms of the cross, to form a V, is unusual, but is not without Sienese precedent. The subordinate figures of saints – the Virgin and the Evangelist flanking the cross, Sts. Peter and John the Baptist at the sides of the throne, and the Holy Bishop above the strikingly characterized donor at the left – are progressively more hieratic from right to left. For a similar contrast between a naturalistically treated *Madonna and Child* and small,

hieratic subordinate figures compare the Ducciesque *Madonna* in the Rabinowitz Collection at Yale University, New Haven, Connecticut.

Provenance: Paolo Paolini, Rome (sold, American Art Galleries, New York, Dec. 10–11, 1924, no. 91, as Duccio [?]; bought by E. L. Craven). Mortimer L. Schiff, New York (sold, Christie's, London, June 24, 1938, no. 83, as Sienese School). Contini Bonacossi, Florence. Kress acquisition, 1939 – exhibited: National Gallery of Art, Washington, D.C. (510), 1941–52;[5] Staten Island Institute of Arts and Sciences, Dec. 1955, as contemporary of Duccio.[6]

References: (1) G. Fiocco, R. Longhi, F. M. Perkins, W. E. Suida, and A. Venturi (in ms. opinions) have credited the triptych to a follower of Duccio. B. Berenson (in *Dedalo*, vol. XI, 1930, pp. 266, 269, and in *International Studio*, Oct., 1930, pp. 32 ff.) labels the painting Tuscan School, early fourteenth century, finding in it both Sienese and Florentine characteristics; it is classified in his posthumous *Italian Pictures . . . Florentine School*, vol. I, 1963, p. 83, under Giotto's anonymous contemporaries and immediate followers. (2) Parallels for the St. John the Baptist and the kneeling donor are especially close in Segna's *Maestà* in the Collegiata at Castiglione Fiorentino (reproduced by R. van Marle, *Italian Schools of Painting*, vol. II, 1924, figs. 81, 82). (3) G. De Nicola, in the Paolini sale catalogue (see under *Provenance*, above) notes the Riminese relationship. (4) Cf. K592, p. 18, below. (5) *Preliminary Catalogue*, 1941, p. 61, as by a contemporary of Duccio. (6) *The New Bulletin*, vol. V, 1955, p. 25.

Follower of DUCCIO

K577 : Figure 33

MADONNA AND CHILD WITH ST. PETER AND ST. JOHN THE BAPTIST. Ponce, Puerto Rico, Museo de Arte de Ponce, Study Collection (62.0255), since 1962.[1] Wood. Left panel, $34\frac{1}{4} \times 12$ in. (87×30·5 cm.); middle panel, $44\frac{1}{2} \times 19\frac{1}{2}$ in. (113×49·5 cm.); right panel, $34\frac{1}{8} \times 12$ in. (86·7×30·5 cm.). Flesh tones slightly abraded; large losses of paint across Child's leg and drapery; St. Peter much restored at lower right; silver foil background oxidized; of framework, only the parts above arch moldings are original; cleaned 1951.

Within the early fourteenth-century following of Duccio,[2] Ugolino da Siena (active 1317–27) is perhaps the master to whom the painter of this triptych is most closely related.

Provenance: Private Collection, Siena. Private Collection, Paris. Contini Bonacossi, Florence. Kress acquisition, 1939.

References: (**1**) Catalogue by J. S. Held, 1962, no. 1, as Sienese School, beginning of fourteenth century. (**2**) G. Fiocco, R. Longhi, F. M. Perkins, W. E. Suida, and A. Venturi (in ms. opinions) have labeled the painting Ducciesque.

SIENESE SCHOOL, Early XIV Century

K219 : Figure 35

CHRIST BLESSING. Raleigh, N.C., North Carolina Museum of Art (GL.60.17.2), since 1960.[1] Wood. $17\frac{7}{8} \times 14\frac{1}{4}$ in. (45·4×36·2 cm.). Good condition.

The touchstone for the style of Ugolino da Siena (Ugolino di Nerio), to whom K219 has been attributed, is the dismembered altarpiece from Santa Croce, Florence, parts of which are now in the National Gallery, London, and elsewhere; it was signed by him and is his only certain work known.[2] K219, which comes from some other dismembered altarpiece, is probably not close enough in serious, tragic expression and firmness of modeling to warrant an unqualified attribution to Ugolino;[3] yet it is the work of an artist close to Duccio and may be dated about 1320.

Provenance: Contini Bonacossi, Florence. Kress acquisition, 1932 – exhibited: 'Italian Paintings Lent by Mr. Samuel H. Kress,' Atlanta, Ga., and elsewhere, 1932–34, p. 1 of catalogue, as Ugolino da Siena; National Gallery of Art, Washington, D.C. (215), 1941–52.[4]

References: (**1**) Catalogue by F. R. Shapley, 1960, p. 20, as Sienese, early fourteenth century. (**2**) See G. Coor, in *Art Bulletin*, vol. XXXVII, 1955, pp. 153 ff., for the Santa Croce altarpiece and a study of Ugolino's style. (**3**) R. van Marle (in *La Diana*, 1931, p. 58) attributes K219 to Ugolino, as do G. Fiocco, R. Longhi, W. E. Suida, and A. Venturi (in ms. opinions). F. M. Perkins (in ms. opinion) attributes it to an anonymous Ducciesque artist, and B. Berenson (in ms. opinion) suggests Lippo Vanni. (**4**) *Preliminary Catalogue*, 1941, p. 204, as Ugolino da Siena.

SEGNA DI BUONAVENTURA

Sienese School. Active by 1298; died 1326/31. Probably a nephew of Duccio, Segna was one of his chief followers, although in his later work he shows the influence of Simone Martini.

K1349 : Figure 31

MADONNA AND CHILD. Raleigh, N.C., North Carolina Museum of Art (GL.60.17.1), since 1960.[1] Wood. $35\frac{5}{8} \times 22\frac{1}{4}$ in. (89·9×56·5 cm.). Fair condition.

This painting has been well known since it was shown in the large exhibition held in Siena in 1904.[2] Critics have agreed in attributing it to Segna, differing only as to whether it is to be placed early or late in his career.[3] Compared with the artist's *Maestà* at Massa Maritima, of 1316, it seems more closely related to Duccio and likely, therefore, to be a little earlier. The most striking parallel for the composition is offered by a *Madonna* in the Metropolitan Museum, New York, which is one of the rare signed works by Segna. Like the latter, the present painting must once have been the middle panel of a triptych, or polyptych, where it was framed at the top by a round-arch molding.[4]

Provenance: Tito Giuggioli, Siena – exhibited: 'Mostra dell'Antica Arte Senese,' Siena, April–August, 1904, no. 1698, p. 302 of catalogue, as Segna; Siena Gallery, from *c.* 1904 for several years, no. 588, p. 25 of catalogue of 1909, as Segna; 'Mostra delle Pitture di Duccio di Buoninsegna e della Sua Scuola,' Siena, Sept. 1–Dec. 1, 1912, no. 69 of 1913 catalogue, as Segna.[5] Philip Lehman, New York (catalogue by R. Lehman, vol. I, 1928, no. XVIII, as Segna) – exhibited: 'Loan Exhibition of Italian Primitives,' F. Kleinberger Galleries, New York, November 1917, p. 117, no. 42 of catalogue by O. Sirén and M. W. Brockwell, as Segna. Kress acquisition, 1943 – exhibited: National Gallery of Art, Washington, D.C. (819), 1945–59.

References: (**1**) Catalogue by F. R. Shapley, 1960, p. 18, as Segna. (**2**) See *Provenance*, above. (**3**) F. M. Perkins (in *Rassegna d'Arte*, vol. IV, 1904, p. 145; vol. XIII, 1913, p. 35; in *Burlington Magazine*, vol. V, 1904, p. 582; in *Art in America*, vol. VIII, 1920, pp. 194, 196) favored at one time an early date in Segna's career, at another time, a late date. R. L. Douglas (in Crowe and Cavalcaselle, *A History of Painting in Italy*, vol. III, 1908, p. 28 n. 1) favors a late date; while E. Hutton (in *ibid.*, *A New History of Painting in Italy*, vol. II, 1909, p. 22 n. 3) favors an early date. C. H. Weigelt (*Duccio di Buoninsegna*, 1911, p. 263), R. van Marle (*Italian Schools of Painting*, vol. II, 1924, p. 139), and B. Berenson (*Italian Pictures of the Renaissance*, 1932, p. 524; Italian ed., 1936, p. 450) list the painting as by Segna. (**4**) This is pointed out by V. Lusini, in the catalogue published by the Società degli Amici dei Monumenti, *In Onore di Duccio di Buoninsegna e della sua scuola*, 1913, p. 130, no. 69. (**5**) See the catalogue citation in note 4, above.

SEGNA DI BUONAVENTURA

K3 : Figure 32

MADONNA AND CHILD. Honolulu, Hawaii, Honolulu Academy of Arts (2977.1), since 1952.[1] Wood. $29\frac{3}{4} \times 19\frac{1}{2}$ in. (75·5×49·5 cm.). Flesh tones well preserved; draperies and gold background extensively abraded and restored. Inscribed frame not original.

It is not surprising that, although usually attributed to Segna,[2] K3 has been attributed also to Ugolino da Siena.[3] It finds parallels in the Ducciesque oeuvre of both. The head of the Virgin is nearly identical with that in Segna's panel (K1349), of about 1315 (see Fig. 31). The less majestic effect of the painting and the weaker drawing of the hands and the Child suggest the possible assistance of Segna's studio and a slightly later date, perhaps about 1325/30.

Provenance: D'Atri, Rome. Contini Bonacossi, Rome. Kress acquisition, 1927 – exhibited: National Gallery of Art, Washington, D.C. (115), 1941–51.[4]

References: (**1**) Catalogue by W. E. Suida, 1952, p. 8, as Segna. (**2**) G. Fiocco, R. van Marle, F. M. Perkins, and A. Venturi (in ms. opinions) attribute K3 to Segna; R. Longhi (in ms. opinion) attributes it to Segna or a forerunner of Segna, closer to Duccio. (**3**) B. Berenson (*Italian Pictures of the Renaissance*, 1932, p. 583; Italian ed., 1936, p. 501) and L. Venturi (*Italian Paintings in America*, vol. I, 1933, no. 32) attribute K3 to Ugolino. (**4**) *Preliminary Catalogue*, 1941, p. 204, as Ugolino da Siena.

Follower of
SEGNA DI BUONAVENTURA

K1102 : Figure 30

ST. MARGARET. Portland, Ore., Portland Art Museum (61.41), since 1952.[1] Wood. 24×12 in. (61×30·5 cm.). Good condition except for slight damages.

Except for an early attribution to Ambrogio Lorenzetti, studies of K1102 have placed it in the milieu of Segna di Buonaventura, usually suggesting Ugolino da Siena[2] or Segna's son, Niccolò di Segna.[3] The attribution to Ambrogio was offered by Ramboux, who in the mid-nineteenth century owned this panel and three others of the same size, all apparently from the same altarpiece.[4] Of these, the *St. Lucy* is now in the Art Museum in Budapest,[5] while the other two, described in Ramboux's catalogue as *St. Ambrose* and *St. Augustine*, have disappeared. The date of the panels is probably about 1330.

Provenance: Johann Anton Ramboux, Cologne (from first half of nineteenth century). Wallraf-Richartz-Museum, Cologne (1867–shortly after 1920).[6] Contini Bonacossi, Florence. Kress acquisition, 1937 – exhibited: National Gallery of Art, Washington, D.C. (468), 1941–52.[7]

References: (**1**) Catalogue by W. E. Suida, 1952, pp. 28, 29, as Sienese painter, *c.* 1330, close follower of Segna. (**2**) G. Fiocco, R. Longhi, and A. Venturi (in ms. opinions) attribute the painting to Ugolino da Siena. (**3**) B. Berenson (in ms. opinion) attributes it to Niccolò di Segna. F. M. Perkins (in ms. opinion) classifies it as Sienese, close to Segna; and R. van Marle (*Italian Schools of Painting*, vol. II, 1924, p. 144) as school of Segna. (**4**) Nos. 38–41 in Ramboux's catalogue, concerning which see G. Coor, in *Wallraf-Richartz-Jahrbuch*, vol. XVIII, 1956, pp. 111 ff. Mrs. Coor attributes the *St. Margaret* to the workshop of Segna. (**5**) Reproduced by Coor, fig. 91 of *op. cit.* in note 4, above. It is attributed to Segna in the 1954 catalogue of the Budapest museum. (**6**) Coor, p. 114 n. 9 of *op. cit.* in note 4, above. It is attributed in the 1910 catalogue of the Wallraf-Richartz Museum to Sienese School, fourteenth century. (**7**) *Preliminary Catalogue*, 1941, p. 185, as Sienese School (Niccolò di Segna?).

NICCOLÒ DI SEGNA

Sienese School. Active first half of fourteenth century. Aside from two signed paintings, dated 1336 and 1345, there is one dated document, of 1331; it witnesses that Niccolò was an independent painter by this time and that his father, Segna di Buonaventura, who must have been his first teacher, was already dead. Niccolò's style developed out of the school of Duccio, under the influence of Simone Martini and Pietro Lorenzetti.

K40 : Figure 36
ST. VITALIS

K41 : Figure 37
ST. CATHERINE OF ALEXANDRIA

Atlanta, Ga., Atlanta Art Association Galleries (58.51 and 58.52), since 1958.[1] Wood. K40, 27¼×17 in. (69×43·2 cm.); K41, 26⅞×16⅝ in. (68·3×42·5 cm.). Extensively abraded, especially K40; both cleaned 1956.

Formerly treated as anonymous work within the Sienese School,[2] K40 and K41 have been convincingly attributed to Niccolò di Segna and associated with other panels which probably come from the same dismembered altarpiece, of about 1340.[3] The other panels are a *St. Lucy*, in the Walters Art Gallery, Baltimore; a *St. Bartholomew*, in the Siena Pinacoteca, both corresponding in shape and size to K40 and K41; and six small panels of half-length saints, two of them formerly in the Albert Keller Collection, New York, and four in the Siena Pinacoteca. Two of these last four are still attached to the top of the *St. Bartholomew* panel, thus indicating that each of the large panels originally had a pair of small saints above it. It is suggested that the middle panel of the now-dismembered altarpiece may have been a *Madonna* once in the Church of San Francesco, Prato.[4]

Provenance: Lord Holland, London. Contini Bonacossi, Rome. Kress acquisition, 1929 – exhibited: National Gallery of Art, Washington, D.C. (138, 139), 1941–51.[5]

References: (1) Catalogue by W. E. Suida, 1958, pp. 8 ff., as Sienese, *c.* 1340. (2) G. Fiocco, R. Longhi, F. M. Perkins (in ms. opinions), and W. E. Suida (see note 1, above) attribute the two paintings to the Sienese School, recognizing relationships to Segna di Bonaventura and Pietro Lorenzetti, while B. Berenson, R. van Marle, and A. Venturi (in ms. opinions) suggest the possibility of Lippo Vanni's hand in the work. G. Kaftal (*Iconography of the Saints in Tuscan Painting,* 1952, p. 1026, identifying the saint in K40 as Vitalis – formerly called Sigismund of Burgundy), lists the panel as School of Duccio. (3) G. Coor, in *Journal of the Walters Art Gallery,* 1955, pp. 78 ff. The other panels associated with K40 and K41 are here reproduced. (4) *Ibid.* (5) *Preliminary Catalogue,* 1941, p. 184, as Sienese School, fourteenth century.

MASTER OF THE GOODHART MADONNA

Sienese School. Active first quarter of fourteenth century. A *Madonna and Child* by this anonymous follower of Duccio was formerly in the collection of Mrs. A. E. Goodhart, of New York; hence the designation.[1] The influences of Duccio, Segna di Buonaventura, Simone Martini, and other Sienese artists are seen in his work.

K592 : Figure 40

MADONNA AND CHILD WITH FOUR SAINTS. Birmingham, Ala., Birmingham Museum of Art (61.104), since 1952.[2] Wood. Middle panel, 30×19½ in. (76·2× 49·5 cm.); side panels, each, 24⅛×13⅝ in. (61·3×34·6 cm.). Inscribed on the scroll held by John the Baptist: ECCE ANGNUS DEI ECCE QUI TOLLIS PECATA MU[n]DI (from John 1 : 29). Fair condition.

This altarpiece has been cited as the most accomplished example of the master's work.[3] It must date from his maturity, probably in the 1320's. Originally terminated, probably, by five triangular panels, it follows a typical Ducciesque form. The panels preserved represent a bishop saint, John the Baptist, the Madonna with the Child holding a goldfinch, the archangel Michael, and possibly[4] Dionysius the Areopagite.

Provenance: An unidentified Tuscan Villa.[5] Contini Bonacossi, Florence. Kress acquisition, 1941.

References: (1) The *Madonna and Child* formerly owned by Mrs. Goodhart is now in the Robert Lehman Collection, New York. R. Offner coined the name, attributing a *Madonna* in the Metropolitan Museum (see *Metropolitan Museum Catalogue of Italian, Spanish, and Byzantine Paintings,* 1940, pp. 71 f.) to the master. G. Coor (in *Art Bulletin,* vol. XXXVII, 1955, pp. 163 f.) gives a list of most of the paintings now attributed to the Goodhart Master and of the publications in which reproductions are to be found. Among the group she cites the Birmingham polyptych as 'a product of the 1320's' and the 'most accomplished' example. (2) Catalogue by W. E. Suida, 1952, p. 15, as follower of Duccio; 1959, pp. 11 f., as Goodhart Ducciesque Master. (3) So cited by Coor, see note 1, above. D. C. Shorr, *The Christ Child in Devotional Images,* 1954, pp. 154, 156 (as type 23, Siena 8, whereabouts unknown), seems to have been the first to include the Birmingham painting in the Goodhart Master's oeuvre. (4) See Coor, note 1, above. (5) According to F. M. Perkins (in ms. opinion), who finds the painting of exceptionally high quality among Ducciesque examples.

MASTER OF SAN TORPÈ

Sienese-Pisan School. Active early fourteenth century in Pisa, but probably originally from Siena, where he was influenced by Duccio and Guido da Siena. His designation derives from the location of one of his paintings, in the Church of San Torpè, Pisa. Recent cleaning of some of his paintings has greatly enhanced his reputation.[1]

K309 : Figure 38

MADONNA AND CHILD. Seattle, Wash., Seattle Art Museum (It 37/D8554.1), since 1952.[2] Wood. 21⅛×14⅛ in. (53·7×35·9 cm.). Fair condition except that bottom part and background are heavily restored.

The shape of the panel and the half-length composition of the Madonna suggest that this may have been originally the middle section of a polyptych such as K592 by the Goodhart Master (Fig. 40). The motive of the Child grasping His mother's robe is typical in the early Sienese School. Formerly attributed to an anonymous follower of Duccio,[3] K309 has now been convincingly associated with the follower known as the Master of San Torpè, in his later period, probably about 1325.[4]

Provenance: Contini Bonacossi, Florence. Kress acquisition, 1935.

References: (1) E. Sandberg-Vavalà (in *Burlington Magazine,* vol. LXXI, 1937, pp. 234 f.), the first to reconstruct an oeuvre for this artist, whom she called the Master of San Torpè, saw a provincial rudeness in his work. M. Bucci (in *Paragone,* no. 153, 1962, pp. 3 ff.) and R. Longhi (in *ibid.,* pp. 10 ff.) now give him first place among Pisan painters of the beginning

of the fourteenth century. (2) Catalogue by W. E. Suida, 1952, p. 11, and 1954, p. 12, as follower of Duccio. (3) See note 2, above; also B. Berenson, G. Fiocco, R. Longhi, R. van Marle, F. M. Perkins, and A. Venturi (in ms. opinions) have approved the attribution to a follower of Duccio. (4) Bucci and Longhi, pp. 8 and 14 of the issue of *Paragone* cited in note 1, above.

Attributed to the
MASTER OF SAN TORPÈ

K 292 : Figure 39

MADONNA AND CHILD WITH ST. BARTHOLOMEW AND ST. JOHN THE BAPTIST. Raleigh, N.C., North Carolina Museum of Art (GL.60.17.3), since 1960.[1] Transferred from wood to canvas. 19×14¾ in. (48.3×37.5 cm.). Inscribed on the saints' pedestals: .s̄. BARTHOLOMEU' and .s̄. IOH'ES. BAP̄A; and on St. John's scroll: ECCE AGNUS DEI ECCE QUI TOL[li]S PECCATA MUNDI (from John I : 29). Very good condition except for Madonna's mantle.

Because of its excellent quality and close relationship to Duccio, K 292 has attracted much attention since it was included in a Sienese exhibition more than fifty years ago. Its painter, frequently designated as the Master of the Melzi Madonna, from a former owner of the picture, has usually been classified as a Sienese follower of Duccio.[2] Recently a general Tuscan and, more specifically, a Pisan source has been proposed for the style of the painting, and its attribution to the Master of San Torpè is now strongly defended,[3] although the work is more elegant and refined than any other thus far attributed to him. The date is probably about 1320.

Provenance: Duchessa Melzi d'Eril, Milan – exhibited: 'Mostra dell'Antica Arte Senese,' Siena, Apr.–Aug. 1904, no. 1703, p. 311 of catalogue, as manner of Duccio. Contini Bonacossi, Florence. Kress acquisition, 1934 – exhibited: National Gallery of Art, Washington, D.C. (259), 1941–59.[4]

References: (1) Catalogue by F. R. Shapley, 1960, p. 22, as Sienese Master. (2) B. Berenson, G. Fiocco, R. Longhi, W. E. Suida, and A. Venturi (in ms. opinions) have considered the work Sienese, of the school of Duccio. R. van Marle (*Italian Schools of Painting*, vol. II, 1924, p. 97) notes its importance among Ducciesque works and (in ms. opinion) suggests it may be the masterpiece of Segna di Buonaventura. F. M. Perkins (in *Rassegna d'Arte*, vol. IV, 1904, pp. 145 f.; vol. XIII, 1913, p. 39; in *Burlington Magazine*, vol. V, 1904, p. 582) cites it as among the most interesting Ducciesque works and likens it to a *Madonna* formerly in the Platt Collection, Englewood, which Berenson (*Italian Pictures of the Renaissance*, 1932, p. 523; Italian ed., 1936, p. 450) lists as by Segna. (3) D. C. Shorr (*The Christ Child in Devotional Images*, 1954, pp. 10, 13), probably following her mentor Offner, labels the painting as by a Ducciesque Pisan Master, a suggestion offered also by F. Zeri (in ms. opinion), who was the first to note a close relationship of the work with that of the Master of San Torpè. E. Sandberg-Vavalà (in ms. opinion) concedes the possibility of a Pisan connection but notes that the work is superior to that which she had attributed (in *Burlington Magazine*, vol. LXXI, 1937, pp. 234 f.) to the Master of San Torpè. M. Bucci (in *Paragone*, no. 153, 1962, pp. 3 ff.) and R. Longhi (in *ibid.*, pp. 10 ff.) believe that K 292 finds a place in the oeuvre of the Master of San Torpè since the superior quality of this artist has appeared in recently cleaned paintings. (4) *Preliminary Catalogue*, 1941, p. 184, as Sienese School, fourteenth century.

FLORENTINE SCHOOL
XIV CENTURY

GIOTTO

Giotto di Bondone. Florentine School. Born 1266(?); died 1337. He is believed to have been a pupil of Cimabue but an early trip to Rome brought him under the influence of Classical antiquity and of Cavallini. Then came his adaptation of the Gothic style, as it appears in the sculpture of Giovanni Pisano. He infused new life into painting, rounding the forms and humanizing the gaze of his figures. Starting with his contemporary Dante, competent critics have always accorded him the highest praise. He painted in Rome, Naples, Avignon, Florence, Padua, and Milan.

K473 : Figures 41–42

MADONNA AND CHILD. Washington, D.C., National Gallery of Art (367), since 1941.[1] Wood. $33\frac{5}{8} \times 24\frac{3}{8}$ in. (85·5×62 cm.). Very good condition; heavily varnished; needs cleaning.

When this painting first came to the attention of modern critics, in 1920, it was attributed to Daddi, but to Daddi under the exclusive influence of Giotto.[2] After vacillating between attributions to Giotto and his followers, it has for the last thirty years been generally accepted as the work of the master himself.[3] Three other panels – one, of *St. Stephen*, in the Horne Museum, Florence, and two, of *St. John the Evangelist* and *St. Lawrence*, in the Musée André, Châalis – have been recognized as parts of an altarpiece of which K473 was the middle panel.[4] One of the originally four flanking panels is now lost; but those of *St. John* and *St. Lawrence* still have their crowning pinnacles (each with a hieratic half-length figure of an angel) intact. Probably a *Blessing Christ* terminated K473. There has been an unsuccessful attempt to identify the polyptych as the one which Ghiberti and Vasari cite as painted by Giotto for the Church of the Badia in Florence.[5] It has also been proposed as one of the four altarpieces credited by Ghiberti to Giotto in Santa Croce, Florence, where, with its panel of the elderly John the Evangelist, it would have been especially appropriate for the Peruzzi Chapel.[6] In any case its style agrees with that of Giotto's frescoes in the Peruzzi and Bardi Chapels of Santa Croce, painted in Giotto's late period, probably between 1320 and 1330.

Provenance: Édouard-Alexandre Max (died 1924), Paris.[7] Henry Goldman, New York (catalogue by W. R. Val-

entiner, 1922, no. 1, as Daddi) – exhibited: 'Fiftieth Anniversary Exhibition,' Metropolitan Museum of Art, New York, 1920, no. 16, as Daddi;[8] 'Early Italian Paintings,' Duveen Galleries, New York, Apr.–May 1924, no. 2 of catalogue of 1926, by W. R. Valentiner, as Giotto or an assistant;[9] 'Exhibition of Italian Art,' Royal Academy, London, 1930, no. 16, as attributed to Giotto. Duveen's, New York (*Duveen Pictures in Public Collections of America*, 1941, no. 11, as Giotto). Kress acquisition, 1937.

References: (1) *Preliminary Catalogue*, 1941, pp. 80 f., as Giotto. (2) Published as by Bernardo Daddi in *Bulletin of the Metropolitan Museum of Art*, vol. XV, 1920, p. 160. W. R. Valentiner (*The Henry Goldman Collection*, 1922, no. 1) catalogues K473 as by Bernardo Daddi, citing the authority of Berenson; but in his catalogue of the 1924 exhibition at Duveen's, Valentiner attributes the painting to Giotto or an assistant. R. van Marle (*Italian Schools of Painting*, vol. III, 1924, p. 190) attributes it to an assistant of Giotto. R. Offner (in *The Arts*, vol. V, 1924, p. 244, as assistant of Giotto), C. Weigelt (*Giotto*, 1925, pp. 204, 205, 241 f., as pupil of Giotto), and F. J. Mather, Jr. (in *Art Studies*, 1925, pp. 25 ff., as Giotto) independently recognized K473 as having been originally associated in an altarpiece with the Horne *St. Lawrence*. P. Hendy (in *Burlington Magazine*, vol. LII, 1928, p. 289) gives the painting to Taddeo Gaddi. R. Longhi (in *Dedalo*, vol. XI, 1930, pp. 285 ff.) attributes it to Giotto and is the first to add the two panels at Châalis to the reconstruction of the original altarpiece, which, agreeing with an earlier suggestion by Horne, he thinks may have been painted for the Church of the Badia. C. Gamba (in *Dedalo*, vol. XI, 1931, p. 570) agrees with the attribution to Giotto. B. Berenson (*Italian Pictures of the Renaissance*, 1932, p. 236) gives it to Giotto; a few years later (*op. cit.*, Italian ed., 1936, p. 203) he gives it to an immediate follower; and most recently (*Italian Pictures . . . Florentine School*, vol. I, 1963, p. 81), again to Giotto. L. Venturi (*Italian Paintings in America*, vol. I, 1933, no. 32) gives it to Giotto, as do E. Cecchi (*Giotto*, 1937[?], pp. 127 f.), G. Sinibaldi and G. Brunetti (*Pittura italiana del duecento e trecento* – catalogue of the 1937 'Mostra Giottesca' at Florence, 1943, pp. 323 ff.), L. Coletti (in *Bollettino d'Arte*, vol. XXXI, 1937, p. 58; *I Primitivi*, 1941, p. LVI), and F. Zeri (in *Paragone*, no. 85, 1957, p. 78). C. Brandi (in *Le Arti*, vol. I, 1939, pp. 125 ff.) believes that K473 and the three associated panels are worthy of Giotto in quality but unlike him in certain details, especially color, and so are by a follower. Finally, C. Gnudi (*Giotto*, 1959, pp. 198, 218 ff., 248 f.), accepting the attribu-

tion to Giotto, goes into the question of original provenance more closely. He believes the altarpiece was almost certainly painted for Santa Croce and that a series of scattered smaller panels with scenes from the life of Christ, painted in the same style may have belonged to the same altarpiece. (3) See note 2, above. (4) See reference to Longhi in note 2, above. (5) *Ibid*. See also F. M. Perkins (in *Rassegna d'Arte*, vol. v, 1918, pp. 39 ff.). However, U. Procacci (in *Scritti di storia dell'arte in onore di Mario Salmi*, 1962, pp. 9 ff.) convincingly identifies a polyptych in the Opera di Santa Croce, Florence, as the one which Giotto painted for the Badia. (6) See reference to Gnudi in note 2, above. See also note 3 to K1441–1444 (Giotto and Assistants, below), where the ambiguity in Ghiberti's account is noted. (7) E. Fowles, of Duveen's, states that he was told by Max, the famous actor of the Comédie Française, that he (Max) had inherited the painting from a great-aunt, to whom it had been given by the Pope. (8) See the beginning of note 2, above. (9) See reference to Valentiner in note 2, above.

GIOTTO and Assistants

K1441 : Figure 45
ST. JOHN THE EVANGELIST

K1442 : Figure 43
THE VIRGIN

K1424 : Figure 47
CHRIST BLESSING

K1444 : Figure 44
ST. JOHN THE BAPTIST

K1443 : Figure 46
ST. FRANCIS

THE PERUZZI ALTARPIECE. Raleigh, N.C., North Carolina Museum of Art (GL.60.17.7), since 1960.[1] Wood. Middle panel, $26\frac{1}{4} \times 19\frac{1}{4}$ in. (66·7×49 cm.); side panels, each, $24\frac{1}{2} \times 16\frac{1}{2}$ in. (62·3×42 cm.). Abraded throughout; small losses of paint; gold background in very good condition.

Because Sts. Francis, John the Evangelist, and John the Baptist are represented in this altarpiece, it has been proposed[2] that it may have been painted for the Peruzzi Chapel in Santa Croce, Florence, the chapel which Giotto frescoed with scenes from the lives of the two Johns and for which he most likely painted one of the four altarpieces credited to him in Santa Croce by Ghiberti.[3] Hence the polyptych has become known in recent years as the *Peruzzi Altarpiece*. Against this identification are dissenting opinions as to Giotto's execution of the altarpiece and the fact that the

Evangelist is here shown as young, whereas he is elderly and bearded in the Peruzzi Chapel frescoes.[4] After having been separated for an unknown length of time, the five panels as now shown are believed to present the altarpiece in its original form, except for the frame. Their date may be in the 1330's.

Provenance: Middle panel (K1424): Private Collection, Florence. Mrs. Frederic Stephens, New York. Kress acquisition, 1946. Side panels (K1441–1444): C. W. Mori, Paris (*c*. 1920). J. Goudstikker, Amsterdam, Apr.–May, 1930, nos. 18 and 19A, B, C of catalogue, the St. Francis as Giotto, the others as school of Giotto – exhibited (K1443 only): 'Italiaansche Kunst in Nederlandsche Bezit,' Stedelijk Museum, Amsterdam, July 1–Oct. 1, 1934, no. 153 of catalogue, as Giotto. Leon Schinasi, New York (K1441, K1442, K1444 only); they were sold from the Schinasi Collection at Parke-Bernet's, New York, Nov. 4, 1944, nos. 312–314, as school of Giotto. Private Collection, New York. Wildenstein's, New York – exhibited: 'Italian Paintings,' Wildenstein's, New York, 1947, nos. 1–3, as Maso di Banco (K1441, K1442, K1444 only). Kress acquisition, 1947 – exhibited (the entire altarpiece): National Gallery of Art, Washington, D.C. (1084) 1951–60;[5] after entering the North Carolina Museum of Art: 'Art Treasures for America,' National Gallery of Art, Washington, D.C., Dec. 10, 1961–Feb. 4, 1962, no. 36, as Giotto and assistants.

References: (1) Catalogue by F. R. Shapley, 1960, pp. 30 f., as Giotto and assistants. (2) W. E. Suida (in *Burlington Magazine*, vol. LIX, 1931, pp. 188 ff., and *Paintings and Sculpture from the Kress Collection*, 1951, pp. 26 ff.), the first to recognize that all five panels were originally parts of the same altarpiece, attributes the *Christ*, the *St. Francis*, and the head of the *Baptist* to Giotto and suggests the identification of the polyptych as the Peruzzi altarpiece. (3) The original of Ghiberti's *Commentari*, written in the middle of the fifteenth century, is lost and the surviving fifteenth-century copy is so carelessly written and punctuated that, as J. von Schlosser (*Lorenzo Ghibertis Denkwürdigkeiten*, vol. I, 1912, pp. 36, 117 n. 15) notes, the passage here involved may be, implausibly, interpreted as meaning that the four altarpieces were painted for the church of the Franciscans in Padua. (4) O. Sirén (in *Burlington Magazine*, vol. XLIII, 1923, pp. 259 ff.), the first to publish the four side panels, attributes them to a follower of Giotto, whom he identifies tentatively as Stefano Fiorentino. R. van Marle (*Italian Schools of Painting*, vol. v, 1925, p. 468) thinks they may be by Pacino di Buonaguida (in *Bollettino d'Arte*, vol. XXVIII, 1934, pp. 301 f., van Marle modifies his opinion to admit one panel, the St. Francis, as the work of Giotto), a view opposed by R. Offner (*Studies in Florentine Painting*, 1927, p. 21 n. 21), who (in ms. opinion) attributes the panel of Christ to Giotto, as do also (in ms. opinions) G. Fiocco, R. Longhi, F. M. Perkins, P. Toesca, and A. Venturi. In *Corpus of Florentine Painting* (sec. IV, vol. I, 1962, p. 30 n. 7) Offner refers to the

polyptych as Giottesque, painted for the Peruzzi Chapel. F. Zeri (in ms. opinion) refers to the polyptych as in large part by Giotto. B. Berenson (*Italian Pictures . . . Florentine School*, vol. I, 1963, p. 136) attributes it to Maso di Banco. E. Schaffran (in *Weltkunst*, vol. XXIII, June 15, 1953, p. 4) attributes it to a pupil of Giotto (*c.* 1340/45), possibly Maso di Banco, suggesting that it may be that artist's documented altarpiece of 1346 in which both Johns and Francis figure. C. Gnudi (*Giotto*, 1959, pp. 248 f.) classifies the work as by a pupil of Giotto and neither typologically nor stylistically appropriate for the Peruzzi Chapel. (5) See catalogue by Suida cited in note 2, above.

Follower of GIOTTO

K 537 : Figure 51

CRUCIFIX. Tucson, Ariz., St. Philip's in the Hills, since 1951. Wood. 72¾ × 56⅜ in. (184·8 × 143·2 cm.). Inscribed on plaque above Christ: HIC EST IESV[s] NAZERENVS REX IVDEOR[vm] (from John 19 : 19). Very much restored throughout, especially in bottom part.

The outline of the panel, the iconographical details, the figure types, and the style of the work in general indicate a dating about the middle of the fourteenth century and an artist close to Giotto.[1] The Giottesque *Crucifix* in San Marco, Florence,[2] may be cited for comparison. There one finds the same arrangement of Christ on the cross, a closely similar arrangement of His loincloth, similar figures (in this case half-length) of the Virgin and John at the ends of the arms, and the pelican feeding her young above the inscription plaque. The fact that the pelican scene in K 537 appears to be cropped at the sides may indicate that the *cimasa* of the *Crucifix* is placed too high in the restoration; it probably enclosed the pelican scene originally, as shown in old photographs,[3] and the cross may have been terminated by a *tondo* of Christ blessing.

Provenance: Conestabile, Perugia. Contini Bonacossi, Florence. Kress acquisition, 1938.

References: (1) G. Fiocco, R. Longhi, F. M. Perkins, W. E. Suida, and A. Venturi (in ms. opinions) classify this as by a fourteenth-century follower of Giotto, Longhi placing it close to Niccolò di Pietro Gerini or Agnolo Gaddi. B. Berenson (*Italian Pictures . . . Florentine School*, vol. I, 1963, p. 106) attributes it to Jacopo di Cione. (2) The San Marco *Crucifix* and also K 537 as it appeared when in the Conestabile Collection are reproduced by R. van Marle (*Italian Schools of Painting*, vol. III, 1924, pp. 255 f., figs. 148 and 149), who classifies both *Crucifixes* among the work of Giotto's assistants and immediate followers. (3) See reproduction cited in note 2, above.

Follower of GIOTTO

K 539 : Figure 48

THE CRUCIFIXION. Raleigh, N.C., North Carolina Museum of Art (GL.60.17.8), since 1960.[1] Wood. 7 × 5½ in. (17·8 × 14 cm.). Good condition except for slight abrasions and a few losses of paint.

Painted about 1350, K 539 is the middle compartment of a wing of a diptych. Originally there were probably ten other compartments arranged around it (one at each side, four above, and four below), each about half the width of K 539 and each decorated with a full-length figure of a saint. This is the arrangement of the companion wing, which still exists from the original diptych. The intact wing, which is in the Vatican Pinacoteca (no. 170), has the *Enthroned Madonna and Child* in its middle compartment. Although the Vatican painting has usually been attributed in the past to Pietro Lorenzetti or to his school, the Giottesque characteristics of both paintings seem dominant, and an attribution to Stefano Fiorentino has been suggested.[2]

Provenance: Alberti, Florence. Contini Bonacossi, Florence. Kress acquisition, 1938 – exhibited: National Gallery of Art, Washington, D.C. (423), 1941–51.[3]

References: (1) Catalogue by F. R. Shapley, 1960, pp. 34 f., as follower of Giotto. (2) R. Longhi (in *Critica d'Arte*, July-Dec. 1940, p. 180 n. 4), recognizing the association of K 539 with the Vatican diptych wing, suggests the attribution to Stefano Fiorentino. L. Coletti (in *Critica d'Arte*, Mar., 1950, pp. 445 f.), disagreeing with Longhi's characterization of Stefano Fiorentino, proposes for some of Longhi's attributions to Stefano a 'Maestro Colorista d'Assisi.' It is thus that Coletti labels his reproductions of K 539 and the Vatican wing of the diptych; but in his text he indicates that they do not entirely correspond to this master's style; he suggests that they are, rather, by a Po Valley master, who was in touch with Siena and was himself a very fine colorist. G. Fiocco, W. E. Suida, A. Venturi (in ms. opinions) attribute K 539 to Maso di Banco; F. M. Perkins (in ms. opinion) gives it to an unidentified Florentine; and B. Berenson (*Italian Pictures . . . Florentine School*, vol. I, 1963, p. 216) to an unidentified Florentine between Maso and Daddi. (3) *Preliminary Catalogue*, 1941, p. 81, as follower of Giotto.

PACINO DI BUONAGUIDA

Florentine School. Active 1310–30. A contemporary of Giotto, Pacino seems to have been more influenced by the St. Cecilia Master. He was an illuminator, a painter of lively, if somewhat superficial, narrative, developing however in his later work a more monumental style.

K 1717 : Figure 50

CUSTODIAL. Tucson, Ariz., University of Arizona (61.118), since 1951.[1] Wood. $17\frac{1}{2} \times 25$ in. ($44 \cdot 5 \times 63 \cdot 5$ cm.). Good condition.

Formerly attributed to a close follower of Pacino, K 1717 is now attributed to the master himself,[2] whether or not assisted in his workshop. The date is probably about 1325, for the style is more developed, the action of the figures more measured and reserved than in the *Tree of Life*, an early series of scenes in the Accademia, Florence, generally attributed to Pacino, which are, like those in K 1717, from the life of Christ and represent the artist's style as an illustrator. Further, K 1717 shows a number of new iconographical details, such as the kiss in the *Visitation* and the kneeling postures in the *Baptism*.[3] The arrangement of the panels to form flexible shutters indicates that the complex was designed as a custodial, to enclose some sacred object, possibly the Chalice and Host or a relic of the Holy Cross.[4] The Franciscan habit of the nun at the foot of the cross suggests that the custodial was commissioned for Franciscan use. The scenes represented are, at the left: the *Visitation, Nativity, Presentation in the Temple, Adoration of the Magi, Flight into Egypt, Christ among the Doctors, Baptism of Christ, Christ in the Garden of Gethsemane*; at the right: the *Betrayal of Judas, Christ before Pilate, Flagellation, Mocking of Christ, Crucifixion, Entombment, Christ in Limbo, Resurrection of Christ.*

Provenance: Contini Bonacossi, Florence (1950). Kress acquisition, 1950.

References: (1) Catalogue by W. E. Suida, 1951, no. 5, and 1957, no. 3, as close follower of Pacino di Buonaguida. (2) R. Longhi (in ms. opinion) attributes K 1717 to the circle of Pacino di Buonaguida. R. Offner (*Corpus of Florentine Painting*, sec. III, vol. VI, 1956, pp. 149 ff., pls. XLIII ff.) attributes it to Pacino di Buonaguida. (3) R. Offner, *loc. cit.*, discusses the iconographic details at length. (4) The rare occurrences of this type of custodial are traced by Offner, *loc. cit.*, and by Suida in the catalogues cited in note 1, above.

Follower of
PACINO DI BUONAGUIDA

K 1262 : Figure 49

CRUCIFIX. Ponce, Puerto Rico, Museo de Arte de Ponce, Study Collection (62.0259), since 1962.[1] Wood. $54\frac{5}{8} \times 13\frac{3}{4}$ in. ($138 \cdot 8 \times 35$ cm.). Abraded throughout.

This fragment, dating about 1350, has been cut from such a *Crucifix*, probably, as the one in a convent at Careggi,[2]

which is likewise from the milieu of Pacino. Both follow the type of sculpturesque figure of Christ popularized by Pacino[3] in independent *Crucifixes* and in scenes of the *Crucifixion*.

Provenance: Contini Bonacossi, Florence. Kress acquisition, 1941 – exhibited: National Gallery of Art, Washington, D.C. (734), 1945–52, as Pacino di Buonaguida.

References: (1) Catalogue by J. S. Held, 1962, no. 2, as follower of Pacino di Buonaguida. (2) Reproduced by R. Offner, *Corpus of Florentine Painting*, sec. III, vol. VI, 1956, pls. L f. (3) K 1262 is attributed by L. Venturi (in ms. opinion) and Offner (*op. cit.*, p. 178) to a follower of Pacino di Buonaguida. It is attributed by B. Berenson (*Italian Pictures . . . Florentine School*, vol. I, 1963, p. 164) to Pacino himself.

TADDEO GADDI

Florentine School. Active *c.* 1330–66. He was a pupil of Giotto and is said to have worked with him for many years. Best known are his frescoes in the Baroncelli Chapel, Santa Croce, Florence. In his panel paintings, especially, he follows the monumental conception of Giotto modified by the flowing line and gentle expression of Bernardo Daddi.

K 1372 : Figure 52

ISAIAH. Williamstown, Mass., Williams College Museum of Art, Study Collection (60.11), since 1960. Wood. Diameter 8 in. (20·3 cm.). Inscribed on scroll: ECCE UIRGO CONCIPIET ET PARI[et] FILIŪ [et] UOC . . . (from Isaiah 7 : 14). Fair condition except for abrasions.

The inscription on the prophet's scroll indicates that the quatrefoil was probably once part of an altarpiece of the Virgin. The style of the work places it in Taddeo Gaddi's maturity, about 1350.[1]

Provenance: Dan Fellows Platt, Englewood, N.J. (sold by estate trustee to the following). Kress acquisition, 1943 – exhibited: National Gallery of Art, Washington, D.C. (803), 1945–52, as Taddeo Gaddi.

Reference: (1) F. M. Perkins (in *Rassegna d'Arte*, vol. XI, 1911, p. 1), O. Sirén (*Giotto and Some of His Followers*, vol. I, 1917, p. 268), B. C. Kreplin (in Thieme-Becker, *Allgemeines Lexikon*, vol. XIII, p. 32), R. van Marle (*Italian Schools of Painting*, vol. III, 1924, p. 344 n. 1) tentatively, not having seen the painting, and B. Berenson (*Italian Pictures . . . Florentine School*, vol. I, 1963, p. 71) attribute K 1372 to Taddeo Gaddi.

Follower of TADDEO GADDI

K1348 : Figure 53

MADONNA AND CHILD ENTHRONED WITH DONORS. Bloomington, Ind., Indiana University, Study Collection (L62.162), since 1962. Wood. Including molding, $20\frac{3}{16} \times$ $9\frac{7}{8}$ in. (51·3×25·1 cm.). The base, with its inscription, is not original. Some losses of paint; abraded throughout, especially in Madonna's robe; cleaned 1961.

Attributed sometimes to Taddeo Gaddi himself,[1] K1348 is almost a repetition of the middle panel of a triptych by Taddeo Gaddi in the Berlin Museum.[2] The Berlin triptych, dated 1334, is, in turn, strongly influenced by a painting of 1333 by Bernardo Daddi. It is possible that K1348 was painted about 1335 in Gaddi's studio and that it also was once the chief panel in a triptych.

Provenance: Philip Lehman, New York (catalogue by R. Lehman, 1928, no. IV, as Taddeo Gaddi). Kress acquisition, 1943 – exhibited: National Gallery of Art, Washington, D.C. (802), 1945–52, as Taddeo Gaddi.

References: (**1**) F. M. Perkins (in ms. opinion), R. van Marle (*Italian Schools of Painting*, vol. III, 1924, pp. 315 f., and in *Art in America*, vol. XIII, 1925, p. 57), R. Offner (*Studies in Florentine Painting*, 1927, p. 64), and B. Berenson (*Italian Pictures of the Renaissance*, 1932, p. 215; Italian ed., 1936, p. 185) accept K1348 as a youthful work by Taddeo Gaddi; in a later ms. opinion Berenson considers it close to, but not by Gaddi; in his posthumous *Italian Pictures . . . Florentine School* (vol. I, 1963, p. 69) it is again entered as Taddeo Gaddi. (**2**) Reproduced by van Marle, *op. cit.*, p. 313.

JACOPO DEL CASENTINO

Florentine School. Active first half of fourteenth century. In 1339 Jacopo was one of the founders, along with Bernardo Daddi and others, of the painters' Corporation of St. Luke in Florence. Vasari says that he was a pupil and assistant of Taddeo Gaddi, whom he resembles stylistically; but he was also influenced by the Master of St. Cecilia, by Giotto, and later by Bernardo Daddi and Sienese painters. He was perhaps the most prolific panel painter in fourteenth-century Florence. Undoubtedly, he made much use of studio assistants.

K446 : Figure 56

THE PRESENTATION IN THE TEMPLE. Kansas City, Mo., William Rockhill Nelson Gallery of Art (61–59), since 1952.[1] Wood. $29\frac{3}{8} \times 23\frac{1}{2}$ in. (74·6×59·7 cm.). Inscribed on base of frame: ANO M·CCC·XXX. Fair condition except for abrasion throughout and a few losses of paint; cleaned 1952.

The date 1330 may well be correct even if, as some critics believe, the inscription is a later addition. The style of the work is thoroughly characteristic of Jacopo del Casentino,[2] who was at his best in painting small figures in animated scenes of this kind. Even the mixture of Byzantine, Romanesque, and Gothic styles in the architectural setting seems to echo the discursive character of the narrative. The panel probably comes from the center of a polyptych.

Provenance: G. Salvadori, Florence. Achillito Chiesa, Milan. Contini Bonacossi, Florence. Kress acquisition, 1936 – exhibited: National Gallery of Art, Washington, D.C. (359), 1941–52.[3]

References: (**1**) Catalogue by W. E. Suida, 1952, p. 24, as Jacopo del Casentino. (**2**) R. van Marle (*Italian Schools of Painting*, vol. V, 1925, pp. 473 f.) attributed K446 to Taddeo di Bartolo; but H. D. Gronau (in *Burlington Magazine*, vol. LIII, 1928, p. 82), B. Berenson (in *International Studio*, vol. XCVII, 1930, p. 35; in *Dedalo*, vol. XI, 1930, pp. 270 ff.; *Italian Pictures . . . Florentine School*, vol. I, 1963, p. 102), R. Offner (*Corpus of Florentine Painting*, sec. III, vol. II, pt. II, 1930, p. 116), and G. Fiocco, R. Longhi, F. M. Perkins, and A. Venturi (in ms. opinions) give it to Jacopo del Casentino. (**3**) *Preliminary Catalogue*, 1941, p. 101, as Jacopo del Casentino.

JACOPO DEL CASENTINO
and Assistant

K1296 : Figure 54
ST. JOHN THE BAPTIST

K1297 : Figure 55
ST. LUCY

El Paso, Tex., El Paso Museum of Art (1961–6/2a and 1961–6/2b), since 1961.[1] Wood. K1296, $26\frac{3}{4} \times 19$ in. (68× 48·3 cm.); K1297, $26\frac{3}{4} \times 18\frac{1}{2}$ in. (68×47 cm.), including original frames. Inscribed on St. John's scroll: EGO VOX CLAMĀTIS IN DESER[to] (from John 1 : 23); and across the original frame: S. JOHS BATTISTA. Inscribed (later, probably over original inscription) on lower panel of St. Lucy's frame: SCA. LVCIA. Abraded throughout except in background; frames original.

Although probably produced in the same workshop[2] and at approximately the same date, about 1330, it is unlikely that these panels come, as was once suggested,[3] from the same altarpiece as K446 (p. 24, above). It has been pointed out that the angels in the spandrels were a rare motive in fourteenth-century Florence and that this motive may have been borrowed from Siena.[4]

Provenance: Contessa Righini, San Giovanni Valdarno. Contini Bonacossi, Florence. Kress acquisition, 1939– exhibited: National Gallery of Art, Washington, D.C. (516 and 517), 1941–51;[5] Honolulu Academy of Arts, Honolulu, Hawaii, 1952–60.[6]

References: (1) Catalogue by F. R. Shapley, 1961, no. 2, as Jacopo del Casentino and assistants. (2) G. Fiocco, R. Longhi, A. Venturi (in ms. opinions), and B. Berenson (*Italian Pictures . . . Florentine School*, vol. I, 1963, p. 101) have attributed K1296 and K1297 to Jacopo del Casentino; F. M. Perkins (in ms. opinion) suggests Jacopo may have been assisted in the work; R. Offner (*Corpus of Florentine Painting*, sec. III, vol. VII, 1957, p. 100) attributes them to Jacopo and workshop; Offner's pl. XXXV reproduces the two panels before the removal of repaint, with St. Lucy shown carrying, instead of the lighted lamp, a crudely painted, even if more usual, attribute of a bowl containing eyes. (3) Suggested by Longhi (in ms. opinion). (4) See Offner, *loc. cit.* in note 2, above. (5) *Preliminary Catalogue*, 1941, p. 102, as Jacopo del Casentino. (6) Catalogue by W. E. Suida, 1952, p. 12, as Jacopo del Casentino.

JACOPO DEL CASENTINO
and Assistant

K572 : Figure 57

MADONNA AND CHILD ENTHRONED. Tucson, Ariz., University of Arizona (61.107), since 1951.[1] Wood. Middle panel, $18\frac{1}{2} \times 8\frac{1}{2}$ in. (47×21·6 cm.); each wing, $16\frac{1}{2} \times 4\frac{3}{4}$ in. (42×12·1 cm.). Moldings and carvings regilded; base, later addition.

This small portable triptych, which dates from about 1340, has usually been attributed to Jacopo del Casentino, who was probably assisted, however, by some pupil in his workshop.[2] The red, ermine-bordered costume of the kneeling donor at the foot of the Virgin's throne probably indicates that this is a significant dignitary, with his wife; the donors are presented to the Virgin by St. John the Baptist and St. Catherine of Alexandria. Other recognizable saints surrounding the throne are Peter and Francis, at the left, and Paul, at the right. *St. Catherine Disputing with the Philosophers before the Emperor*, shown in the left wing of the triptych, is one of the few early representations of this scene. It is found also in another Florentine triptych of this period in the Kress Collection, K33 (Fig. 73), which is similar in all three panels to K572, but is not a copy.

Provenance: Contini Bonacossi, Florence. Kress acquisition, 1939 – exhibited: National Gallery of Art, Washington, D.C., 1951.[3]

References: (1) Catalogues by W. E. Suida, 1951, no. 2, and 1957, no. 4, as Jacopo del Casentino. (2) G. Fiocco, R. Longhi, F. M. Perkins, A. Venturi (in ms. opinions), and B. Berenson (*Italian Pictures . . . Florentine School*, vol. I, 1963, p. 102) attribute K572 to Jacopo del Casentino. R. Offner (*Corpus of Florentine Painting*, sec. III, vol. VII, 1957, pp. 112 f.) attributes it to Jacopo and workshop. (3) *Paintings and Sculpture from the Kress Collection*, 1951, pp. 34 f., no. 5 (catalogue by W. E. Suida), as Jacopo del Casentino.

Follower of
JACOPO DEL CASENTINO

K1138 : Figure 58

ST. PROSPER. Staten Island, N.Y., Staten Island Institute of Arts and Sciences, Study Collection (61.17.2), since 1961. Wood. $25\frac{1}{2} \times 11$ in. (64·8×28 cm.). Good condition except for slight damages throughout.

Undoubtedly from the mid-fourteenth-century milieu of Jacopo del Casentino,[1] K1138 is believed to have been the extreme left panel in a five-part polyptych, of which a *Madonna* by Jacopo del Casentino in the Vatican Pinacoteca was the middle panel and three saints now in Cambiano, attributed to Jacopo and workshop, were the other side panels.[2] K1138 is the only one of the five companion panels that has not been truncated at the top. The possible original location of the polyptych in the Church of San Prospero, Cambiano, has suggested the identification of the bishop saint represented in K1138 as St. Prosper.[3]

Provenance: Mr. Zink, London (1923). Contini Bonacossi, Florence. Kress acquisition, 1938 – exhibited: Traveling Exhibition, University of Arizona, Tucson, Ariz., Apr.–Sept. 1960, as Florentine School, fourteenth century.

References: (1) Attributed to Jacopo del Casentino by G. Fiocco, R. Longhi, F. M. Perkins, W. E. Suida, A. Venturi (in ms. opinions), and B. Berenson (*Italian Pictures . . . Florentine School*, vol. I, 1963, p. 102); to a follower of Jacopo del Casentino by R. Offner (*Corpus of Florentine Painting*, sec. III, vol. II, pt. II, 1930, p. 174) and by L. Berti (in *Bollettino d'Arte*, vol. XXXVII, 1952, pp. 55 f.). (2) For a reconstruction of the polyptych see Berti (*loc. cit.* in note 1, above) and Offner (*op. cit.*, sec. III, vol. VII, 1957, pp. 116 ff.). The Vatican *Madonna* is reproduced in Offner's sec. III, vol. II, pt. II, pl. LV, and the three Cambiano panels in his sec. III, vol. VII, pl. XXXIX. (3) See Berti, *loc. cit.* in note 1, above.

BERNARDO DADDI

Florentine School. Active from 1312; died probably 1348. Although often said to have been a pupil of Giotto, Daddi

seems to have been strongly influenced by the Sienese, whose lyricism and sweetness of mood were most congenial to him. He painted a number of monumental altarpieces but scenes on a small scale seem especially well adapted to his style. It is this small-scale work that was most frequently emulated by his many followers in the second half of the fourteenth century.

K1718 : Figure 61

MADONNA AND CHILD WITH SAINTS AND ANGELS. Washington, D.C., National Gallery of Art (1140), since 1951.[1] Wood. $19\frac{3}{4} \times 9\frac{1}{2}$ in. (50.2 × 24.2 cm.); including original frame, $22\frac{1}{2} \times 12$ in. (57.2 × 30.5 cm.). Good condition except for face of Madonna; cleaned 1948.

Originally this must have been the main panel of a winged triptych, as we conclude from some Daddi tabernacles that have survived intact, those, for example, in the Altenburg Museum and the collection of Count Seilern, London.[2] In the Accademia, Florence,[3] and in the Kress Collection at Kansas City[4] are other single panels closely similar to K1718. The Accademia panel is signed and dated, the date usually being read as 1334, while Count Seilern's triptych is inscribed with the year 1338. K1718 also would seem to belong to the 1330's. The six saints at the foot of the throne are identifiable, left to right, as the Magdalen, John the Baptist, Andrew, Paul, Peter, and Agnes.

Provenance: Monastery of Vallombrosa, near Florence (given by the abbot to the artist and restorer J. Stark). Sir Henry Doulton (after his death, in 1897, to his daughter, Mrs. Buckland). Commander Virgoe Buckland, R.N.R., Hove, Sussex – exhibited: 'Mostra Giottesca,' Florence, Apr.–Oct., 1937, no. 165A, as Daddi.[5] Buckland sale, Sotheby's, London, Nov. 2, 1949, no. 76, as Daddi; bought by Manenti. Contini Bonacossi, Florence. Kress acquisition, 1950.

References: (1) *Paintings and Sculpture from the Kress Collection,* 1951, pp. 32 f. (catalogue by W. E. Suida), as Daddi. (2) These two triptychs are reproduced by R. Offner (*Corpus of Florentine Painting,* sec. III, vol. III, 1930, pl. XII, and sec. III, vol. VIII, 1958, pl. IV), who attributes Count Seilern's triptych to Daddi 'assisted,' as he does K1718 (sec. III, vol. VIII, 1958, pp. 16 f.; his pl. III shows K1718 before the disfiguring repaint was removed in 1948). B. Berenson (*Italian Pictures . . . Florentine School,* vol. I, 1963, p. 58) also has given K1718 to Daddi. (3) The Accademia panel is reproduced by Offner, *op. cit.,* sec. III, vol. III, pl. VI. (4) See K1300 (Fig. 62). For the persistence of this type of triptych among Daddi's contemporaries and followers, see K572 (Fig. 57) by Jacopo del Casentino and assistant. (5) G. Sinibaldi and G. Brunetti, *Pittura italiana del duecento e trecento,* 1943, catalogue of the 1937 'Mostra Giottesca,' p. 499, no. 157, as Daddi.

BERNARDO DADDI and Assistant

K1300 : Figure 62

MADONNA AND CHILD ENTHRONED WITH SAINTS AND ANGELS. Kansas City, Mo., William Rockhill Nelson Gallery of Art (61–61), since 1952.[1] Wood. $21\frac{1}{2} \times 12$ in. (54.6 × 30.5 cm.). Good condition; frame original.

Like K1718 (Fig. 61), by Daddi, K1300 was no doubt originally the center of a small portable triptych and on the analogy of similar panels that are dated[2] it was probably painted in the late 1330's. While Daddi can be credited with the supervision of the work, an assistant may have had a hand in the execution.[3] The saints at the left of the throne are identified by their symbols as St. Elizabeth or St. Dorothy, with flowers, St. Lucy, with lamp, St. John the Baptist, and St. Francis; at the right are St. Catherine (?), St. Margaret, St. Paul, and St. Peter.

Provenance: Captain Stirling, Glentyan, Renfrewshire. Graham Charles Somervell, Edinburgh – exhibited: 'Loan Exhibition of Works of Old Masters,' Edinburgh, 1883, no. 500, as Taddeo Gaddi. Somervell sale, Christie's, London, Apr. 23, 1887, no. 151, as Taddeo Gaddi; bought by Butler. Charles Butler, London – exhibited: 'Exhibition of Works of Old Masters,' Royal Academy, London, 1896, no. 154, as Taddeo Gaddi. Butler sale, Christie's, London, May 26, 1911, no. 128, as Taddeo Gaddi; bought by Wallis. Henry Charles Somers Somerset, Reigate Priory, Surrey. Duveen's, New York (c. 1925). Henry Goldman, New York. Duveen's, New York (*Duveen Pictures in Public Collections of America,* 1941, no. 15, as Daddi). Kress acquisition, 1940 – exhibited: National Gallery of Art, Washington, D.C. (519), 1941–51;[4] after entering William Rockhill Nelson Gallery of Art: 'Art Treasures for America,' National Gallery of Art, Washington, D.C., Dec. 10, 1961–Feb. 4, 1962, no. 20, as Bernardo Daddi.

References: (1) Catalogue by W. E. Suida, 1952, p. 22, as Daddi. (2) See text to K1718 (p. 26, above), by Daddi, for dated parallels. (3) Crowe and Cavalcaselle (*A History of Painting in Italy,* vol. II, 1903, p. 140) attribute K1300 to Taddeo Gaddi. L. Venturi (*Italian Paintings in America,* vol. I, 1933, no. 37) and B. Berenson (*Italian Pictures . . . Florentine School,* vol. I, 1963, p. 55) attribute it to Daddi. R. Offner (*Corpus of Florentine Painting,* sec. III, vol. IV, 1934, p. 96, and sec. III, vol. V, 1947, p. 157) attributes it to the close following of Daddi. (4) *Preliminary Catalogue,* 1941, pp. 52 f., as Daddi.

Attributed to BERNARDO DADDI

K1369 : Figure 69

THE CRUCIFIXION. Washington, D.C., National Gallery of Art (795), since 1945.[1] Wood. $14\frac{1}{8} \times 9\frac{1}{4}$ in. (36 × 23.5 cm.). Good condition except for a few abrasions.

The painting has usually been attributed to Daddi himself;[2] but an artist close to the Master of San Martino alla Palma has also been suggested.[3] The date may be about the same as that of the *Crucifixion* attributed to Daddi and assistant in the Bigallo tabernacle, Florence,[4] which is inscribed as painted in the year 1333. K1369 may have fitted into the wing, or shutter, of some such tabernacle as the one proposed for K197, by the Master of San Martino alla Palma.[5]

Provenance: Van Slochem's, New York (sold 1908, to the following). Dan Fellows Platt, Englewood, N.J. – exhibited: 'Loan Exhibition of Italian Primitive Paintings,' Fogg Art Museum, Cambridge, Mass., Feb. 25–Mar. 18, 1915, as Daddi; 'Loan Exhibition of Italian Primitives,' Kleinberger Galleries, New York, Nov., 1917, no. 3 of catalogue by O. Sirén and M. W. Brockwell, as early Daddi; 'Exhibition of Italian Paintings of the Renaissance,' Century Association, New York, March 1935, no. 4, as early Daddi; 'Masterpieces of Art,' New York World's Fair, New York, 1939, no. 72 of catalogue by G. H. McCall and W. R. Valentiner, as Daddi; 'Seven Centuries of Painting,' California Palace of the Legion of Honor, San Francisco, Calif., Dec. 29, 1939–Jan. 28, 1940, no. L-3 of catalogue, as Daddi. Sold by Platt estate trustee to the following. Kress acquisition, 1943.

References: (**1**) As by Daddi. (**2**) K1369 is attributed to Daddi by the following: F. M. Perkins (in *Rassegna d'Arte*, vol. II, 1911, p. 1), O. Sirén (in *Art in America*, vol. II, 1914, p. 264, and *Giotto and Some of His Followers*, vol. I, 1917, p. 270), G. H. Edgell (in *Art and Archaeology*, vol. II, 1915, p. 13), M. E. Gilman (in *Art in America*, vol. VI, 1918, p. 213), R. van Marle (*Italian Schools of Painting*, vol. III, 1924, p. 378), A. v. V. Brown and W. Rankin (*A Short History of Italian Painting*, 1926, p. 358), L. Venturi (*Italian Paintings in America*, vol. I, 1933, no. 44), and B. Berenson (*Italian Pictures of the Renaissance*, 1932, p. 165; Italian ed., 1936, p. 142; *Italian Pictures . . . Florentine School*, vol. I, 1963, p. 58). (**3**) R. Offner (*Corpus of Florentine Painting*, sec. III, vol. VIII, 1958, pp. 142 f.) attributes K1369 to a painter close to the Master of San Martino alla Palma. (**4**) The Bigallo *Crucifixion* is reproduced by Offner, *op. cit.*, sec. III, vol. III, 1930, pl. VII. (**5**) See reference to Offner in note 3, above. For K197 see p. 30, below.

Attributed to BERNARDO DADDI

K198 : Figure 59

A CROWNED VIRGIN MARTYR. San Francisco, Calif., M. H. De Young Memorial Museum (61-44-1), since 1955.[1] Wood. 24¼ × 12 in. (61·6 × 30·5 cm.). Excellent condition.

This painting of a martyr, probably St. Catherine of Alexandria, is a leaf from the left side of a polyptych, in which a corresponding right leaf was the St. Peter now in the Musée Communal, Malines, Belgium.[2] The combination of Giottesque and Lorenzettian characteristics suggests paintings of Daddi's full maturity, in the 1340's, such as the *Madonna* in the Berenson Collection, Settignano.[3] But K198 is slightly less reserved in spirit than the *Madonna* and shows greater emphasis upon physique, suggesting that it may be by a close follower rather than by the master himself.

Provenance: Ancient Florentine family.[4] Contini Bonacossi, Florence. Kress acquisition, 1932 – exhibited: National Gallery of Art, Washington, D.C. (196), 1941–51.[5]

References: (**1**) Catalogue by W. E. Suida, 1955, pp. 28 f., as Daddi. (**2**) Reproduced by R. Offner, *Corpus of Florentine Painting*, sec. III, vol. VIII, 1958, pl. XII, as following of Daddi. (**3**) Reproduced, *ibid.*, sec. III, vol. III, 1930, pl. XIII. G. Fiocco, R. Longhi, F. M. Perkins, A. Venturi (in ms. opinions), and B. Berenson (*Italian Pictures . . . Florentine School*, vol. I, 1963, p. 57) have attributed K198 to Daddi. Offner (*op. cit.*, sec. III, vol. IV, 1934, addenda, pl. IV) classifies it in the close following of Bernardo Daddi. Compare also Offner's pl. XXII. (**4**) According to Perkins (in ms. statement). (**5**) *Preliminary Catalogue*, 1941, pp. 51 f., as Daddi.

Studio of BERNARDO DADDI

K1089 : Figure 64

MADONNA AND CHILD ENTHRONED WITH SAINTS. Columbia, S.C., Columbia Museum of Art (54-402/2), since 1954.[1] Wood. 15⅞ × 8⅞ in. (40·3 × 22·5 cm.), not including the molding, which except for the base is original. Inscribed at foot of throne: AVE MARIA GRATIA PRENA . . . (from Luke 1 : 28). Faces of Virgin and saints badly damaged.

Like K1718 (p. 26 and Fig. 61), K1089 was no doubt originally the main panel of a winged triptych. It follows the style of Daddi's paintings of the 1330's and if executed in his studio it may have had the master's supervision.[2] The three most prominent saints at the left are George, Peter, and John the Baptist, the last shown as the patron of the kneeling donor. The corresponding saints at the right are two apostles and a bishop, the last probably Zenobius, who, like the Baptist, is a patron saint of Florence.

Provenance: Baron Sergardi-Biringucci, Siena. Newhouse's, New York. Kress acquisition, 1937 – exhibited: National Gallery of Art, Washington, D.C. (457), 1941–52.[3]

References: (**1**) Catalogue by W. E. Suida, 1954, p. 11, and by A. Contini Bonacossi, 1962, pp. 9 f., as studio of Daddi.

(2) G. Fiocco, F. M. Perkins (with reservations), P. Toesca, and A. Venturi (in ms. opinions) have attributed K1089 to Daddi; B. Berenson (*Italian Pictures . . . Florentine School*, vol. I, 1963, p. 53) lists it as studio of Daddi. (3) *Preliminary Catalogue*, 1941, p. 52, as Daddi.

Studio of BERNARDO DADDI

K1290 : Figure 66

MADONNA AND CHILD WITH DONOR. Seattle, Wash., Seattle Art Museum (It 37/D1225.1), since 1954.[1] Wood. 43×18½ in. (109·2×47 cm.). Good condition except for heavy restoration of Virgin's mantle; top part of panel, above Virgin's halo, modern; cleaned 1953–54.

This panel was probably once the center of an altarpiece on which Daddi may have supervised work in the late 1340's.[2] The Virgin's face finds a reasonable parallel in the St. George of Daddi's polyptych in Highnam Court, Gloucester,[3] dated 1348; and the Christ Child is the strongly Daddesque type of the Uffizi polyptych.[4]

Provenance: English Private Collection. Prince Vladimir Galitzin (sold, 1927). Durlacher's, New York – exhibited: 'Exhibition of Old Masters and Works of Art,' Art Institute, Kansas City, Mo., 1928, no. 3. Marquis de Talleyrand, Rome. Contini Bonacossi, Florence. Kress acquisition, 1939 – exhibited: National Gallery of Art, Washington, D.C. (511), 1941–52.[5]

References: (1) Catalogue by W. E. Suida, 1954, pp. 18 f., as Daddi and assistants. (2) G. Fiocco, R. Longhi, R. van Marle, F. M. Perkins, A. Venturi (in ms. opinions), and B. Berenson (*Italian Pictures . . . Florentine School*, vol. I, 1963, p. 57) have attributed K1290 to Daddi, as has L. Venturi (*Italian Paintings in America*, vol. I, 1933, no. 48). R. Offner (*Corpus of Florentine Painting*, sec. III, vol. IV, 1934, p. x and sec. III, vol. VIII, 1958, p. 106, pl. XXVII) places it in the following of Daddi, as does D. C. Shorr (*The Christ Child in Devotional Images*, 1954, p. 174). (3) Reproduced by Offner, *op. cit.*, sec. III, vol. III, 1930, pl. XIX. (4) *Ibid.*, pl. XIV. (5) *Preliminary Catalogue*, 1941, p. 52, as Daddi.

Follower of BERNARDO DADDI

K1925 : Figure 63

THE ALDOBRANDINI TRIPTYCH. Portland, Ore., Portland Art Museum (61.51), since 1952.[1] Wood. 37½×26 in. (95·7×66 cm.). Good condition except for a few abrasions.

The design of K1925, with the *Madonna* surrounded by saints (Paul, Margaret, Nicholas, John the Baptist, Catherine of Alexandria, Peter, Anthony Abbot, and James Major) and angels in the middle panel and the *Nativity* and *Crucifixion* in the wings, is typical in the circle of Daddi.[2] Compare, for example, the approximately contemporary triptych in the Siena Pinacoteca, dated 1336.[3] Almost close enough stylistically to be by the same hand as K1925 is part of the left wing of such a triptych, by an anonymous follower of Daddi, in the Ventura Collection, Florence.[4] A coat of arms, of the Aldobrandini family,[5] on the base of the middle panel, gives K1925 its name.

Provenance: Oscar Bondy, Vienna (sold, Kende Galleries, New York, Mar. 3, 1949, no. 86 as Master of the Aldobrandini Triptych). J. Weitzner, New York. Kress acquisition, 1952.

References: (1) Catalogue by W. E. Suida, 1952, p. 40, as Florentine, *c.* 1350. (2) R. Offner (in ms. opinion cited in Bondy sale catalogue – see *Provenance*, above) places the triptych close to the workshop of Bernardo Daddi. B. Berenson (*Italian Pictures . . . Florentine School*, vol. I, 1963, p. 216) lists it as unidentified Florentine, after 1350, by the master close to Giovanni del Biondo who painted the St. Catherine panel formerly in the Kahn Collection, New York. (3) The Siena triptych is reproduced by Offner, *Corpus of Florentine Painting*, sec. III, vol. IV, 1934, pl. XLI. (4) The Ventura panel is reproduced by Offner, *op. cit.*, sec. III, vol. VIII, 1958, pl. XXI. (5) Identification cited in the Bondy sale catalogue.

Follower of BERNARDO DADDI

K204 : Figure 60

MADONNA AND CHILD WITH SAINTS. New Orleans, La., Isaac Delgado Museum of Art (61.60), since 1953.[1] Wood. 50⅝×101¾ in. (128·6×258·4 cm.), including present frame. Inscribed on open book held by St. Benedict: ASCULTA O FILII PRECEPTA MAGISTRI ET INCLINA AUREM CORDIS TUI ET AMMONITIONEM PII[patris] LIBE[nter excipe] ET EFICACITER COMPLE UT AD EUM PER OBEDIENTIE LABOREM REDEAS. A QUO PER IN-OBOBEDIENTIE [*sic*] DESIDEAM RECESSERAS (Harken, O son, to the precepts of the master and incline the ear of your heart and willingly receive the admonition of the pious father and carry it out efficiently in order that through industrious obedience you may reach that goal from which you would recede through slothful disobedience) – from the Benedictine Rule. Small losses of paint throughout, especially in Madonna and Child; frame partly original; cleaned 1953.

When this painting was first published, in 1914, it was attributed to Jacopo del Casentino; but since then, because of its obvious stylistic dependence on Bernardo Daddi, it has been quite generally classified as the work, dating about 1340, of a follower of Daddi, sometimes designated as the Master of the Rucellai Polyptych.[2] This designation was suggested by the fact that K204 was formerly in the Rucellai Palace, Florence, and came there, presumably, from the Rucellai Chapel in San Pancrazio, Florence. In turn, the probable connection with San Pancrazio explains the usual interpretation of the second saint from the left (with martyr's palm) as St. Pancras. The saint at the extreme left has been identified as St. John Gualbert; at the right of the middle panel are St. Michael and St. Benedict, the latter exhibiting the Rule of the Benedictine order. In the pinnacles are half-length figures of prophets.

Reproductions made before the altarpiece was acquired by the Kress Foundation show it in an incongruous fifteenth-century frame, with large cherubs painted in the spandrels between terminal pinnacles of the small busts of prophets. The frame as now restored is similar to the one on an altarpiece in the Galleria Comunale, Prato,[3] which resembles K204 so closely in composition and style as to suggest that the two are probably from the same workshop, possibly even by the same artist.

Provenance: Probably Rucellai Chapel, San Pancrazio, Florence. Rucellai Palace, Florence. Achillito Chiesa, Milan (sold at American Art Galleries, New York, Apr. 16, 1926, no. 53 of catalogue, as Bernardo Daddi; bought by Mrs. L. W. Hitchcock). Contini Bonacossi, Florence. Kress acquisition, 1932 – exhibited: National Gallery of Art, Washington, D.C. (200), 1941–52.[4]

References: (**1**) Catalogue by W. E. Suida, 1953, p. 8, as follower of Giotto, contemporary of Daddi. (**2**) O. Sirén (in *Burlington Magazine*, 1914, pp. 78 ff.) attributes K204 to Jacopo del Casentino; but later (*Giotto and Some of His Followers*, vol. I, 1917, p. 272) he lists it as workshop of Daddi. R. van Marle (*Italian Schools of Painting*, vol. III, 1924, p. 402) notes its close relationship to the second half of Daddi's career and to Pacino di Buonaguida. H. Comstock (in *International Studio*, vol. LXXXIX, 1928, p. 90) cites it as Daddesque. R. Offner (*Corpus of Florentine Painting*, sec. III, vol. IV, 1934, p. 48) catalogues it in the close follow-ing of Daddi, and G. Fiocco, R. Longhi, F. M. Perkins, A. Venturi (in ms. opinions), and B. Berenson (*Italian Pictures . . . Florentine School*, vol. I, 1963, p. 56) give it to Daddi's studio or a close follower. (**3**) The Prato altarpiece is repro-duced by Offner (*op. cit.*, pl. xv), who catalogues it in the close following of Daddi. (**4**) *Preliminary Catalogue*, 1941, p. 53, as follower of Daddi.

Follower of BERNARDO DADDI

K463 : Figure 67

ST. JAMES MAJOR. Seattle, Wash., Seattle Art Museum (It 37/T8712.1), since 1952.[1] Wood. $36\frac{1}{2} \times 11\frac{5}{8}$ in. (92·7× 29·6 cm.). Inscribed on the saint's scroll: ADSCENDIT AD CELOS SEDET A DEXTERA DEI PATRIS ŌIPOTENTIS (He ascended into Heaven; sitteth at the right hand of God the Father Almighty) – from the Apostles' Creed. Good condi-tion; a few restorations in gold background; cleaned 1952.

This panel, dating about 1370, was probably once the right side in a large altarpiece like the Carmine polyptych from the workshop of Daddi.[2] K463 could almost have served as the now-missing right leaf of that complex. Staff and shell identify the figure as James Major, although the inscription on the scroll is the one of the twelve articles of the Apostles' Creed usually associated with James Minor.[3]

Provenance: Contini Bonacossi, Florence. Kress acquisition, 1936.

References: (**1**) Catalogue by W. E. Suida, 1952, p. 12, and 1954, p. 20, as Tuscan painter, second third of fourteenth century. (**2**) The Carmine polyptych is treated by R. Offner, *Corpus of Florentine Painting*, sec. III, vol. VIII, 1958, pp. 39 ff. K463 is attributed to Niccolò di Tommaso by R. Longhi (in ms. opinion); to Allegretto Nuzi by G. Fiocco, R. van Marle, W. E. Suida, and A. Venturi (in ms. opinions); to an artist reminiscent of Nuzi by F. M. Perkins (in ms. opinion); to an Umbro-Florentine, *c.* 1380, by B. Berenson (in ms. opinion); and to the following of Daddi by Offner (*op. cit.*, p. 108 f.). (**3**) See Offner, *op. cit.*, p. 108, and Mrs. Jameson, *Sacred and Legendary Art*, vol. I, 1857, pp. 177 f.

MASTER OF THE FABRIANO ALTARPIECE

Florentine School. Active probably *c.* 1335–*c.* 1365. An altarpiece of St. Anthony, dated 1353, in the Pinacoteca Civica at Fabriano has suggested the now-familiar designa-tion for this painter.[1] There has recently been an attempt to identify him as Puccio di Simone and to recognize in him a master superior to Daddi, closer to Maso.[2] It seems more likely that his style is based on Daddi's oeuvre of the late 1330's, with modifications introduced later under the influence of Orcagna and Nardo di Cione.

K263 : Figure 68

THE CRUCIFIXION. Notre Dame, Ind., University of Notre Dame, Study Collection (61.47.4), since 1961.[3]

Wood. $15\frac{1}{2} \times 5\frac{9}{16}$ in. ($39\cdot4 \times 14\cdot2$ cm.). Good condition except for robe of figure on extreme right.

Formerly attributed to Andrea da Firenze, K263 is now more convincingly given to the Master of the Fabriano Altarpiece, with a probable date late in his career, c. 1360.[4] It was once the right wing of a triptych, of which the middle panel is now lost and the left wing, representing the *Adoration of the Magi*, is in the Worcester Art Museum, Worcester, Mass.[5]

Provenance: A. Morelli, Florence. Giuseppe Bellesi, London (bought at Christie's, London, Apr. 11, 1930, no. 18, as Giotto). Claudio Gallo (sold, Galleria Scopinich, Milan, Nov. 22, 1932, no. 130, as Bernardo Daddi).[6] Contini Bonacossi, Florence. Kress acquisition, 1933 – exhibited: National Gallery of Art, Washington, D.C. (241), 1941–51;[7] Traveling Exhibition, University of Arizona, Tucson, Ariz., Apr.–Sept. 1960.

References: (1) R. Offner (*Corpus of Florentine Painting*, sec. III, vol. V, 1947, pp. 141 ff.) has characterized the artist and reconstructed his oeuvre. (2) R. Longhi, in *Paragone*, no. III, 1959, pp. 9 f. (3) Catalogue, 1962, p. unnumbered, as follower of Daddi. (4) G. Fiocco, R. Longhi, W. E. Suida, A. Venturi (in ms. opinions), and B. Berenson (*Italian Pictures . . . Florentine School*, vol. I, 1963, p. 5) have assigned K263 to Andrea da Firenze; R. van Marle and F. M. Perkins (in ms. opinions) attribute it to an anonymous Florentine. Offner (*op. cit.*, p. 214, pl. XLIX) attributes it to the Master of the Fabriano Altarpiece. (5) The original association of the Kress and Worcester panels was recognized by E. Sandberg-Vavalà, as reported by P. B. Cott, in *Worcester Art Museum Annual*, vol. IV, 1941, p. 7. See Offner, *op. cit.*, pl. XLVIII, for a reproduction of the Worcester panel. (6) Cited by Offner, *loc. cit.* in note 1, above. (7) *Preliminary Catalogue*, 1941, p. 4, as Andrea da Firenze.

MASTER OF SAN MARTINO ALLA PALMA

Florentine School. Active second quarter of fourteenth century. This is one of the few followers of Daddi whose style has been characterized in detail and for whom a very considerable oeuvre has been identified.[1] His paintings are usually small and full of movement, with the draperies emphasizing the action of the bodies.

K197 : Figure 71

THE FLAGELLATION. Berea, Ky., Berea College, Study Collection (140.9), since 1961.[2] Wood. $11\frac{1}{2} \times 8\frac{5}{8}$ in. ($29\cdot2 \times 22$ cm.).[3] Abraded throughout; cleaned 1961.

This probably dates from the middle of the artist's career, about 1340, when the movement in his compositions is most tense and rhythmic.[4] *The Mocking of Christ* in the Collection of Sir Thomas Barlow, Manchester, England, is obviously a companion to K197. That these two panels may once have been associated with the *Last Judgment* and the *Madonna and Child Enthroned with Angels* belonging to the New York Historical Society is less obvious but possible. If the four belonged together in a triptych, the left wing would probably have shown the *Flagellation* above the *Mocking*, and the right wing would have shown the *Last Judgment* above the *Madonna and Child Enthroned with Angels*, while the middle panel would probably have been a now-lost *Crucifixion*.[5] An interesting variant of K197, almost amounting to a copy, is to be seen in a fourteenth-century Florentine embroidery now in the Metropolitan Museum, New York.[6]

Provenance: Fejer de Buck, Rome. Contini Bonacossi, Florence. Kress acquisition, 1932 – exhibited: 'Mostra Giottesca,' Uffizi, Florence, Apr.–Oct. 1937, p. 543 of 1943 catalogue, by G. Brunetti, as Master of San Martino alla Palma; National Gallery of Art, Washington, D.C. (195), 1941–52.[7]

References: (1) R. Offner (*Corpus of Florentine Painting*, sec. III, vol. V, 1947, pp. 1 ff.) treats the master in detail. (2) Catalogue, 1961, p. 8, as follower of Bernardo Daddi. (3) A strip of about 2 cm. has been cut from the top of the panel. (4) Before this master's oeuvre had been identified, the *Flagellation* was attributed, in ms. opinions, by W. E. Suida and A. Venturi to Daddi; by B. Berenson (who later, *Italian Pictures . . . Florentine School*, vol. I, 1963, p. 214, lists it as unidentified Florentine, between 1350 and 1420) and G. Fiocco to a master close to Daddi. Since the picture was shown in the 1937 exhibition cited in *Provenance*, above, the attribution to the Master of San Martino alla Palma seems to have been accepted (see L. Coletti, in *Bollettino d'Arte*, vol. XXXI, 1937, p. 70, and Offner, *op. cit.*, in note 1, above, pp. 21 ff.). (5) Offner, *op. cit.*, p. 18 n. 1. (6) The embroidery is reproduced in *Mitteilungen des Kunsthistorischen Instituts in Florenz*, May 1961, p. 52, fig. 10. (7) *Preliminary Catalogue*, 1941, p. 51, as Daddi.

TUSCAN SCHOOL
First Half of XIV Century

K201 : Figure 70

THE CRUCIFIXION. Coral Gables, Fla., Joe and Emily Lowe Art Gallery, University of Miami (61.10), since 1961.[1] Wood. $24\frac{3}{4} \times 16\frac{9}{16}$ in. ($62\cdot9 \times 42\cdot3$ cm.). Good condition except for badly abraded Christ; cleaned 1961.

When first studied, in the mid-1930's, K201 seems to have been unanimously attributed to the Riminese School under the influence of Giotto.[2] Its Giottesque character has never been questioned; but from comparative material at present available, the closest stylistic parallels seem to be found in the close following of the St. Cecilia Master and in the circle of Bernardo Daddi (compare K1369, Fig. 69), and the Master of San Martino alla Palma.[3] The date is probably toward 1350.

Provenance: Stefani, Florence. Contini Bonacossi, Florence. Kress acquisition, 1932 – exhibited: 'Mostra Giottesca,' 1937, no. 190 of 1943 catalogue (note on this picture by G. Brunetti), as School of the Romagna; National Gallery of Art, Washington, D.C. (198), 1941–57;[4] after entering the Joe and Emily Lowe Art Gallery: 'Art Treasures for America,' National Gallery of Art, Washington, D.C., Dec. 10, 1961–Feb. 4, 1962, no. 96, as Tuscan painter, first half of fourteenth century.

References: (1) Catalogue by F. R. Shapley, 1961, p. 16, as Tuscan School. (2) B. Berenson, G. Fiocco, R. Longhi, F. M. Perkins, W. E. Suida, and A. Venturi (in ms. opinions) have classified the painting as Riminese. (3) L. Coletti (in *Bollettino d'Arte*, 1937, pp. 66 f.), while noting Sienese reminiscences, considers K201 Florentine. M. Salmi (in *Emporium*, 1937, p. 363), G. Brunetti (in 'Mostra' catalogue cited under *Provenance*), and L. Servolini (*La Pittura gotica romagnola*, 1944, p. 35, pl. XXVII) classify it in the School of the Romagna. O. Morisani (in *Art Quarterly*, vol. XX, 1957, pp. 156–162) tries to integrate it in the oeuvre of the Neapolitan Roberto d'Odorisio. R. Offner (in ms. opinion) suggests that the rectilinear draperies, the Kufic borders, and the halos in K201 betoken a Tuscan artist working in the tradition of the St. Cecilia Master. (4) *Preliminary Catalogue*, 1941, pp. 171 f., as School of Rimini, fourteenth century.

TUSCAN SCHOOL, XIV Century

K1430 : Figure 65

THE CRUCIFIXION WITH SCENES FROM THE PASSION AND THE LIFE OF ST. JOHN THE BAPTIST. Memphis, Tenn., Brooks Memorial Art Gallery (61.201), since 1958.[1] Wood. Middle panel, with moldings, $25\frac{1}{2} \times 13\frac{1}{2}$ in. ($64 \cdot 8 \times 34 \cdot 3$ cm.); left wing, $25\frac{1}{2} \times 6\frac{7}{8}$ in. ($64 \cdot 8 \times 17 \cdot 5$ cm.); right wing, $24\frac{3}{4} \times 6\frac{1}{2}$ in. ($62 \cdot 9 \times 16 \cdot 5$ cm.). Many losses of paint throughout, especially in the wings; gold background of middle panel new; cleaned 1950.

This is stylistically related to two well-known panels of the *Deposition*, one in the Fogg Museum, Cambridge, Mass., the other in the Stoclet Collection, Brussels. The latter, especially, offers a close parallel in composition to the scene of the *Deposition* in K1430. The triptych is therefore related to the other two panels in the problem of attribution: the Fogg and Stoclet *Depositions* have been attributed to both the Florentine and the Sienese School.[2] All three paintings show the influence of the International Style. It is especially obvious in the curved pose of St. John in K1430's scene of the *Baptism*, such a pose as Ghiberti later (in the early 1400's) used most effectively in the same scene on his first doors of the Florentine Baptistry. We see it also in the miniature that Simone Martini painted in Petrarch's Virgil codex in the early 1340's. The date of K1430 would fall somewhere between these two.

Provenance: Rev. Dr. Ash, Hungershall Park, Tunbridge Wells, England – exhibited: Royal Academy, 1879, no. 185, as Giottino.[3] Arthur Brentano, New York (bought in the 1880's; sold to the following). Kress acquisition, 1947 – exhibited: National Gallery of Art, Washington, D.C., 1951–55.[4]

References: (1) Catalogue by W. E. Suida, 1958, p. 18, as school of Giotto. (2) Most critics place them in the Florentine School; Berenson (*Italian Pictures of the Renaissance*, 1932, p. 9) gives them to Andrea di Bartolo. (3) The size noted by Graves (in *A Century of Loan Exhibitions*, vol. I, 1913, p. 423) for the triptych, $23 \times 11\frac{1}{2}$ in., raises doubt as to reference to K1430 in this exhibition. (4) *Paintings and Sculpture from the Kress Collection*, 1951, p. 30 (catalogue by W. E. Suida), as school of Giotto.

ORCAGNA

Andrea di Cione, called Orcagna (presumably a corruption of Arcangelo). Florentine School. Active 1344–68. A painter, sculptor, and architect, Orcagna was the outstanding artist of his time in Florence. His brothers Nardo di Cione and Jacopo di Cione (see biographical notes below) are known to have collaborated with him and only one extant panel painting, the Strozzi altarpiece in Santa Maria Novella, Florence, is documented as by him alone. The style of the work suggests the strong influence of Bernardo Daddi, under whom Orcagna may have studied.

ORCAGNA and JACOPO DI CIONE

K1363 : Figure 76

MADONNA AND CHILD WITH ANGELS. Washington, D.C., National Gallery of Art (814), since 1945. Wood. $55\frac{1}{2} \times 27\frac{1}{8}$ in. (141×69 cm.). Vertical split left of center; otherwise good condition; a few small retouchings; cleaned 1962.

That K1363 must originally have had a prominent location and have been highly regarded is indicated by the existence of a considerable number of contemporary and nearly contemporary free copies, among them the middle panel of an altarpiece at Loro Ciuffenna.[1] Even Masolino used it as model for his beautiful *Madonna* in the Munich Gallery.[2] Critics differ as to Orcagna's share in K1363.[3] Since the general style, the figure types, and such detail as the halo decoration show a close relation to Orcagna's Strozzi altarpiece, of 1357, attempts to divide the figures between the master and a collaborator are not satisfactory. Rather, it would seem that the design is to be attributed to Orcagna and the execution, at least in part, to a collaborator, most likely his brother Jacopo. The date may be toward 1370.[4]

Provenance: Art market, Florence. Philip Lehman, New York (catalogue by R. Lehman, 1928, no. 5, as Orcagna with possible assistance of Jacopo di Cione) – exhibited: 'Italian Primitives,' Kleinberger Galleries, New York, Nov. 1917, no. 5 of catalogue by O. Sirén and M. W. Brockwell as Orcagna. Kress acquisition, 1943.

References: (**I**) Reproduced in *Rivista d'Arte*, vol. xxvi, 1950, p. 201, fig. 2. For reference to other copies see R. Offner and K. Steinweg (*Corpus of Florentine Painting*, sec. iv, vol. iii, 1965, pp. 107 ff.), where there is also an analysis of the iconography of K1363 and an extensive bibliography. (**2**) Reproduced in R. van Marle, *Italian Schools of Painting*, vol. ix, 1927, pl. opposite p. 258 (M. Meiss has kindly called my attention to this instance of the remarkable influence of K1363). (**3**) O. Sirén (*Giotto and Some of His Followers*, vol. i, 1917, pp. 220, 224 f.), R. van Marle (*op. cit.*, vol. iii, 1924, pp. 466 ff.; vol. v, 1925, fig. 284), F. M. Perkins (in ms. opinion), and L. Venturi (*Italian Paintings in America*, vol. i, 1933, no. 53) attribute K1363 to Orcagna, Venturi with reservations as to the execution. R. Offner (as quoted in Lehman catalogue cited under *Provenance*) attributes it to an unknown assistant of Orcagna, using Orcagna's design. Offner attributes the closely related *Madonna and Angels* in Budapest (reproduced by Sirén, *op. cit.*, vol. ii, pl. 186) to the same assistant. B. Berenson (*Italian Pictures of the Renaissance*, 1932, p. 275; Italian ed., 1936, p. 236) lists it under Jacopo di Cione; and later, in the posthumous edition, *Italian Pictures . . . Florentine School*, vol. i, 1963, it is listed on p. 105 (under the former location, Lehman Collection) as Jacopo alone, and on pp. 106 and 163 as Orcagna and Jacopo. M. Meiss (*Painting in Florence and Siena*, 1951, p. 138) speaks of it as designed by Orcagna and finished by Jacopo di Cione. D. C. Shorr (*The Christ Child in Devotional Images*, 1954, p. 80) labels it Jacopo di Cione, as does M. Levi D'Ancona (in *Rivista d'Arte*, vol. xxxii, 1957, p. 11). See D'Ancona's fig. 1 for the attribution to 'Silvestro dei Gherarducci' of a copy, in the Accademia, Carrara, of K1363. A. Parronchi (*Studi su la dolce prospettiva*, 1964, pp. 120 ff.) attributes the Carrara *Madonna* to Taddeo Gaddi, dates it 1332, and proposes it as the prototype of K1363 and other versions of the composition. Offner

(*Corpus of Florentine Painting*, sec. iv, vol. i, 1962, p. 73) attributes K1363 to Jacopo di Cione, after Orcagna's design, and in the latest volume of the *Corpus* (cited in note 1, above) K1363 is attributed to Jacopo and his workshop and dated about 1380, as Jacopo's most mature surviving work. (**4**) An attribution to Jacopo di Cione alone would date K1363 after his St. Matthew altarpiece, of 1368 (see K. Steinweg, in *Rendiconti della Pontificia Accademia Romana di Archeologia*, vol. xxx–xxxi, 1957–59, p. 244).

Studio of ORCAGNA

K156 : Figure 77

THE ANNUNCIATION WITH DONOR. Ponce, Puerto Rico, Museo de Arte de Ponce, Study Collection (62.0268), since 1962. Wood. 51¾×52 in. (131·5×132·1 cm.). All figures except Madonna badly abraded; Christ Child in sky very much damaged; gold background completely new; cleaned 1961–62.

The plentiful use of lapis lazuli indicates that K156 was probably executed in an important studio and the style points to the studio of Orcagna, toward 1370.[1]

Provenance: Achillito Chiesa, Milan. Contini Bonacossi, Florence. Kress acquisition, 1931 – exhibited: 'Italian Paintings Lent by Mr. Samuel H. Kress,' Oct. 1932, Atlanta, Ga., through June 1935, Charlotte, N.C., p. 11 of catalogue, as Agnolo Gaddi; National Gallery of Art, Washington, D.C. (181), 1941–52.[2]

References: (**1**) In ms. opinions, G. Fiocco and R. van Marle attribute K156 to Agnolo Gaddi; F. M. Perkins, to a contemporary of Agnolo; R. Longhi, to Jacopo di Cione; W. E. Suida places it near Spinello Aretino. M. Meiss (*Painting in Florence and Siena*, 1951, p. 168 n. 4) attributes it to Giovanni del Biondo. B. Berenson (*Italian Pictures . . . Florentine School*, vol. i, 1963, p. 105) attributes it tentatively to Jacopo di Cione. (**2**) *Preliminary Catalogue*, 1941, p. 70, as Agnolo Gaddi.

Follower of ORCAGNA

K64 : Figure 72

THE CORONATION OF THE VIRGIN. Tulsa, Okla., Philbrook Art Center (3346), since 1953.[1] Wood. 34⅜×22 in. (87·3×55·9 cm.). Abraded throughout; upper termination shortened and changed from shouldered pointed arch; cleaned 1953.

This painting, which must originally have been the middle panel of a triptych, probably dates about 1370/80 and belongs stylistically to the circle of the Cione brothers.[2] By raising the Gothic throne above the ground, the artist has characterized the Coronation as a celestial ceremony, succeeding the Assumption of the Virgin.[3] Among the saints flanking the throne are, at left: Paul, Peter, Lucy, Anthony Abbot, and Bartholomew; at right: John the Baptist, John the Evangelist, Andrew, a bishop, and Catherine of Alexandria.

Provenance: Contini Bonacossi, Rome. Kress acquisition, 1929 – exhibited: 'Italian Paintings Lent by Mr. Samuel H. Kress,' Oct. 1932, Atlanta, Ga., through June 1935, Charlotte, N.C., p. 9 of catalogue, as school of Orcagna; National Gallery of Art, Washington, D.C. (146),1941–52.[4]

References: (1) Catalogue by W. E. Suida, 1953, pp. 16 f., as Florentine painter, *c.* 1370/80. (2) In ms. opinions, B. Berenson, W. E. Suida, and A. Venturi have attributed K64 to the school of Orcagna; G. Fiocco has attributed it to Jacopo di Cione; and R. Longhi and F. M. Perkins have placed it close to Jacopo di Cione. R. Offner (*Corpus of Florentine Painting,* sec. III, vol. V, 1947, p. 249) calls it Cionesque, by the same hand that painted a *Coronation* in Christ Church Library, Oxford. (3) Compare the combination of Assumption and Coronation in the *Mary, Queen of Heaven* by the Master of the St. Lucy Legend (K1689), National Gallery of Art, Washington, D.C. (4) *Preliminary Catalogue,* p. 146, as school of Orcagna.

JACOPO DI CIONE

Also called Robiccia.[1] Florentine School. Active *c.* 1368–98. Jacopo was probably the youngest of three brothers, the other two known as Andrea Orcagna and Nardo di Cione. The brothers collaborated, and no extant painting is documented as the work of Jacopo alone. Both he and Nardo obviously followed the style of their elder brother, Andrea.

Attributed to JACOPO DI CIONE

K74 : Figure 82

MADONNA AND CHILD WITH SAINTS. San Francisco, Calif., M. H. De Young Memorial Museum (61-44-2), since 1955.[2] Wood. 18½×8½ in. (47×21·6 cm.). Good condition except slightly abraded; frame original.

Originally probably the middle section of a small triptych, K74 has usually been attributed to an Orcagnesque artist, especially to Jacopo di Cione, with a date in the 1360's; but

it has also been connected with Giottino and with Maso di Banco.[3] Maso's style shows closer relation to Giotto, with more emphasis upon three-dimensional, monumental figures, while the more fragile, yet charming character of the figures usually attributed to Jacopo is seen here. At the left are St. John the Baptist, a bishop saint, and St. Lucy; at the right, St. Peter, a bishop saint, and a virgin martyr.

Provenance: Ugo Jandolo, Rome (as Taddeo Gaddi). Max Bondi, Rome (sold, Galleria Lurati, Milan, Dec. 9–20, 1929, no. 44 of catalogue, as Bernardo Daddi). Contessa Giustiniani, Genoa. Contini Bonacossi, Rome. Kress acquisition, 1930 – exhibited: National Gallery of Art, Washington, D.C. (149), 1941–52.[4]

References: (1) *Robiccia* probably has reference to the small size of Jacopo's paintings, and thus may signify what we mean by the term 'Little Master' as applied to certain seventeenth-century Dutch artists. Suida (see note 2, below), interpreting *Robiccia* in a derogatory sense, probably mistook the word for *Robaccia.* (2) Catalogue by W. E. Suida, 1955, pp. 30 f., as Maso. (3) A. Venturi (*Italian Paintings in America,* vol. I, 1933, no. 57), R. van Marle (in ms. opinion), and B. Berenson (in *Dedalo,* vol. XI, 1931, pp. 1040 ff.; *Pitture italiane del rinascimento,* 1936, p. 236), the last tentatively, attribute K74 to Jacopo di Cione; Berenson later (*Italian Pictures . . . Florentine School,* vol. I, 1963, p. 106) lists it without question as early Jacopo di Cione. G. Fiocco and R. Longhi (in ms. opinions), the latter tentatively, attribute it to Giottino. F. M. Perkins (in ms. opinion) classifies it as Orcagnesque; and D. C. Shorr (*The Christ Child in Devotional Images,* 1954, p. 107), as Florentine School. (4) *Preliminary Catalogue,* 1941, p. 103, as Jacopo di Cione.

Attributed to JACOPO DI CIONE

K296 : Figure 78

THE EUCHARISTIC ECCE HOMO. Denver, Colo., Denver Art Museum (E-IT-18-XIV-925), since 1954.[1] Wood. 12¼×26 in. (31·1×66 cm.). Very good condition.

This was probably once the middle panel of a predella: compare the similar composition in the predella of the altarpiece attributed to Nardo di Cione now in the Národní Gallery, Prague.[2] The style of K296 connects it with the Cione brothers; it has been attributed to Jacopo di Cione and to Orcagna himself.[3] The date may be about 1370.

Provenance: Contini Bonacossi, Florence. Kress acquisition, 1934 – exhibited: National Gallery of Art (262), 1941–52.[4]

References: (1) Catalogue by W. E. Suida, 1954, pp. 10 f., as Orcagna. (2) Reproduced by R. Offner, *Corpus of Florentine*

Painting, sec. IV, vol. II, 1960, pls. V ff. (3) In ms. opinions G. Fiocco, R. van Marle, F. M. Perkins, W. E. Suida, and A. Venturi have attributed K296 to Jacopo di Cione; R. Longhi (in ms. opinion) has attributed it to Orcagna, as does C. M. Bach (*Materials and Techniques*, Denver Art Museum, 1964, p. 15); B. Berenson (*Italian Pictures . . . Florentine School*, vol. I, 1963, p. 103) attributes it to Jacopo di Cione. (4) *Preliminary Catalogue*, 1941, p. 103, as Jacopo di Cione.

See also ORCAGNA and JACOPO DI CIONE (K1363, p. 31, above).

NARDO DI CIONE

Florentine School. Active from *c.* 1343; died 1365/66. He was a brother of Andrea Orcagna, head of the Orcagnesque school. Extant frescoes in the Strozzi Chapel of Santa Maria Novella, Florence, are identified by Ghiberti as Nardo's work and therefore serve as touchstone for further attributions.

K478 : Figure 75

MADONNA AND CHILD WITH ST. PETER AND ST. JOHN THE EVANGELIST. Washington, D.C., National Gallery of Art (372), since 1941.[1] Wood. 30×25¾ in. (76·4× 65·6 cm.). Inscribed on base of frame: AVE · GRATIA · PLENA · DO (abbreviated passage from Luke I : 28). One of the best preserved paintings of the fourteenth century; moldings regilded; cleaned 1955.

K478 is remarkable for its excellent preservation, for its complete retention of its original triptych form, and for the unusual combination of three-quarter-length figure in the middle panel with full-length figures in the side panels.[2] Comparison with Nardo's documented frescoes[3] has definitely established K478 in that master's oeuvre.[4] It probably dates about 1360.

Provenance: Count Gustav Adolf Wilhelm von Ingenheim and family, Schloss Reisewitz, Silesia (acquired *c.* 1840). Henry Goldman, New York (acquired 1923). Duveen's, New York. Kress acquisition, 1937.

References: (1) *Preliminary Catalogue*, 1941, p. 140, as Nardo di Cione. (2) R. Offner (in *Art in America*, vol. XII, 1924, p. 106, cites K478 as the unique Florentine example of this combination. (3) In the Strozzi Chapel of Santa Maria Novella, Florence. (4) Offner (*op. cit.*, pp. 99 ff.) was the first to publish K478 as by Nardo; it had been previously attributed to Orcagna. See also Offner's *Studies in Florentine Painting*, 1927, pp. 97, 100 f., 103 ff.; *Italian Primitives at Yale University*, 1927, p. 16; *Corpus of Florentine Painting*, sec. III, vol. V, 1947, pp. 150, 296; *ibid.*, sec. IV, vol. II, 1960, pp. 24 ff. In ms. opinions G. Fiocco has attributed K478 to

Jacopo di Cione; A. Venturi, to Orcagna; R. Longhi and F. M. Perkins, to Nardo di Cione. Others recognizing the work as Nardo's are R. van Marle (*Italian Schools of Painting*, vol. III, 1924, p. 655), G. Gombosi (in *Budapest Jahrbuch*, vol. V, 1927–28, p. 220; reference cited by Offner, *Corpus...*, sec. IV, vol. II, 1960, p. 24), L. Venturi (*Italian Pictures in America*, vol. I, 1933, no. 54), H. D. Gronau (in Thieme-Becker, *Allgemeines Lexikon*, vol. XXVI, 1932, p. 40; *Andrea Orcagna und Nardo di Cione*, 1937, p. 86 n. 152), W. E. Suida (in *Pantheon*, vol. XXVI, 1940, p. 274), L. Coletti (in *Critica d'Arte*, Mar. 1950, p. 447), P. Toesca (*Il Trecento*, 1951, p. 638 n. 159), and B. Berenson (*Italian Pictures... Florentine School*, vol. I, 1963, p. 152).

FLORENTINE SCHOOL
Mid-XIV Century

K33 : Figure 73

MADONNA AND CHILD WITH SAINTS. Allentown, Pa., Allentown Art Museum, Study Collection (60.03.KBS), since 1960. Wood. Middle panel, 20×10½ in. (50·8× 26·7 cm.); left panel, 20¾×5⅝ in. (52·7×14·3 cm.); right panel, 20½×5¼ in. (52·1×13·4 cm.). Very poor condition, especially middle panel; frame original.

This is a variant, but not a copy, of K572 by Jacopo del Casentino and Assistant (Fig. 57). While the same scenes (including, in the left wing, *St. Catherine Disputing with the Philosophers before the Emperor*) are represented, there are changes in details and even in choice of saints; for example, a bishop and Anthony Abbot are here given the places of honor at the sides of the Virgin's throne. Stylistic relationship to Jacopo di Cione, Daddi, Giovanni da Milano, and Nuzi have been suggested;[1] the painter has been called the Orcagnesque Infancy Master,[2] and he has been tentatively identified with the anonymous Florentine who painted nos. 1141A and B in the Berlin Museum.[3] In support of the last suggestion the striking similarity of ornament should be noted. X-ray reveals that lozenge-shaped designs once decorated the backs of the wings, while two concentric circles, filled with designs that are now unrecognizable, were on the back of the middle panel.

Provenance: Prince Léon Ouroussoff, Vienna (later, Cannes, France). John E. Murray, Florence. Charles Fairfax Murray, London. Contini Bonacossi, Rome. Kress acquisition, 1927 – exhibited: 'Italian Paintings Lent by Mr. Samuel H. Kress,' Oct. 1932, Atlanta, Ga., through June 1935, Charlotte, N.C., p. 10 of catalogue, as Florentine School, *c.* 1350.

References: (1) In ms. opinions, F. M. Perkins and W. E. Suida have placed the artist close to Jacopo di Cione; G. Fiocco sees an affinity to the late Daddi; R. van Marle and

A. Venturi see influence of Giovanni da Milano; and R. Longhi sees Marchegian traits, but believes the triptych to be by the Florentine who painted nos. 1141A and B in Berlin. B. Berenson (*Italian Pictures . . . Florentine School*, vol. I, 1963, p. 213) lists it as unidentified Florentine between 1350 and 1420. (2) R. Offner, *Corpus of Florentine Painting*, sec. III, vol. VII, 1957, p. 112 n. 1, 2; here it is stated that the triptych will be treated in section IV. (3) See Longhi's opinion in note 1, above.

NICCOLÒ DI TOMMASO

Florentine School. Active *c.* 1343–1405. He is now credited with some paintings which were formerly attributed to Giovanni da Milano; but the strongest influence upon his style came from Nardo di Cione.

Follower of NICCOLÒ DI TOMMASO

K44 : Figure 74

MADONNA AND CHILD IN GLORY. Allentown, Pa., Allentown Art Museum, Study Collection (60.04.KBS), since 1960. Wood. $14\frac{1}{4} \times 8\frac{7}{8}$ in. (36·2 × 22·6 cm.). Most of the top angel's face gone; abrasions and small losses throughout; cleaned 1955; enframing moldings original.

Remarkable for its original composition, showing the Madonna and Child against an aura borne aloft by a bevy of angels and flanked by saints, K44 has been attributed to Bernardo Daddi, but more convincingly to the ambient of Nardo di Cione,[1] about 1370. The almond-shaped aura appears again in two paintings of the *Nativity* attributed to Niccolò di Tommaso, one in the Vatican Pinacoteca, the other in the Johnson Collection, Philadelphia Museum.[2] Niccolò's penchant for projecting scroll designs into empty areas of his composition is evidenced in the Vatican and Johnson paintings by the arrangement of the inscriptions, in K44 by a scarf flying out from the Child's dress and by the tassels of the cushion on which the Virgin sits. The saints are identified, left to right, as James Major (?), Anthony Abbot, Catherine of Alexandria, and John the Evangelist (?).

Provenance: Marchese Bourbon del Monte, Rome. Contini Bonacossi, Rome. Kress acquisition, 1927.

References: (1) In ms. opinions G. Fiocco, R. Longhi, and A. Venturi attribute K44 to Bernardo Daddi; F. M. Perkins attributes it to the school of Nardo di Cione and Orcagna; W. E. Suida, tentatively, to Nardo di Cione. B. Berenson (in *Dedalo*, vol. XI, 1931, pp. 1057 f.; see also *Italian Pictures . . . Florentine School*, vol. I, 1963, p. 213) suggests that a

masterpiece of Nardo di Cione's may have inspired this version by a painter close to Niccolò di Tommaso and less close to Jacopo di Cione. M. Eisenberg (in *Art Quarterly*, vol. XXVI, 1963, p. 305 n. 13) refers to it as Cionesque. (2) These paintings are reproduced by R. Offner, *Studies in Florentine Painting*, 1927, figs. 8 and 9, following p. 126.

MASTER OF THE RINUCCINI CHAPEL

Florentine School. Active second half of fourteenth century. This anonymous painter's style is revealed in the lowest tier of frescoes in the Rinuccini Chapel of Santa Croce, Florence. He was influenced by Orcagna and even more by Nardo di Cione.

K1171 : Figures 79–81

ST. COSMAS AND ST. DAMIAN. Raleigh, N.C., North Carolina Museum of Art (GL.60.17.9), since 1960.[1] Wood. $52\frac{3}{4} \times 30\frac{5}{8}$ in. (134 × 77·8 cm.). Good condition except for slight abrasions.

Unusual in having its predella still attached, K1171 probably once formed a wing of a large altarpiece similar to the Rinuccini Master's St. Bernard polyptych in the Accademia, Florence.[2] Sts. Cosmas and Damian in K1171 are strikingly similar to the figures in the wings of that altarpiece, and the predella panels in the two paintings are also closely related – especially in the plausible attempts at realism in the architecture and landscape and in the action of the figures. The date of K1171 is, however, probably a little later, about 1370, and the style is further from Orcagna. The predella panel at the left shows the miracle of the missing leg of a white man replaced by a leg taken from a dead Moor. The right panel has the scene of the martyrdom of the two saints.

Provenance: Private Collection, Budapest – exhibited: 'Early Italian Art,' Budapest, Dec. 1937–Jan. 1938, as Florentine School, second half of fourteenth century. Contini Bonacossi, Florence. Kress acquisition, 1939 – exhibited: National Gallery of Art, Washington, D.C. (867), 1945–54, as Rinuccini Master.

References: (1) Catalogue by F. R. Shapley, 1960, p. 36, as Rinuccini Master. (2) G. Fiocco, R. Longhi, W. E. Suida, A. Venturi (in ms. opinions), and B. Berenson (*Italian Pictures . . . Florentine School*, vol. I, 1963, p. 143) attribute K1171 to the Rinuccini Master; F. M. Perkins (in ms. opinion) attributes it to a fourteenth-century Florentine; and C. L. Ragghianti (in *Critica d'Arte*, vol. III, 1938, p. 1, at end of vol.) thinks it a typical and important work by Nardo di Cione. M. Boskovits (in letter of Apr. 13, 1964) attributes

the standing saints to the Rinuccini Master and the predella panels to a collaborator. R. Offner and K. Steinweg (*Corpus of Florentine Painting*, sec. IV, vol. III, 1965, p. 116 n. 3) attribute K 1171 to an artist whom they call the Master of the Prato Annunciation.

GIOVANNI DEL BIONDO

Florentine School. Active from 1356; died 1399. He was early influenced by Bernardo Daddi and later by the Cione brothers, especially Nardo, whom he seems to have assisted in the Strozzi Chapel of Santa Maria Novella, Florence. He was a prolific painter, characterized by sweet, mystic expression.

K 66 : Figure 83
K 67 : Figure 84

HEBREW PROPHETS. Ponce, Puerto Rico, Museo de Arte de Ponce, Study Collection (62.0257 and 62.0258), since 1962.[1] Wood. Each, $13\frac{7}{8} \times 7$ in. ($35 \cdot 2 \times 17 \cdot 8$ cm.). Scrolls inscribed with simulated lettering. Good condition; cleaned 1961; enframing moldings original.

In recent years K 66 and K 67 have been attributed to Giovanni da Milano,[2] but that they are by Giovanni del Biondo is indicated by the fact that in the Alinari photograph 8909 and in a reproduction made in 1924 they are still shown in their original position as side pinnacles on the polyptych of the *Coronation* of about 1370, regularly attributed to Giovanni del Biondo, in San Giovanni Valdarno.[3] A close stylistic parallel for K 66 and K 67 is seen in Giovanni del Biondo's two panels of saints in the Vatican Pinacoteca (nos. 13 and 15).

Provenance: Oratorio della Madonna, Santa Maria delle Grazie, San Giovanni Valdarno (altarpiece removed, 1920,[4] to the Oratorio di San Lorenzo, San Giovanni Valdarno). Contini Bonacossi, Rome. Kress acquisition, 1929.

References: (1) Catalogue by J. S. Held, 1962, no. 4, as Florentine School, last third of fourteenth century. (2) In ms. opinions K 66 and K 67 are attributed tentatively to Spinello Aretino by B. Berenson; to the Florentine School, close to Giovanni da Milano, by R. Longhi; to the school of Lorenzo Monaco by G. Fiocco, F. M. Perkins, W. E. Suida, and A. Venturi. B. Berenson (*Italian Pictures . . . Florentine School*, vol. I, 1963, p. 89) attributes them tentatively to Giovanni da Milano. (3) R. van Marle, *Italian Schools of Painting*, vol. III, 1924, fig. 291, where the whole altarpiece is labeled as by Giovanni del Biondo. This is the attribution given the altarpiece also by, among others, C. Gamba (in *Rivista d'Arte*, vol. V, 1907, pp. 23 f.) and B. Berenson (*Italian Pictures . . .*

Florentine School, vol. I, 1963, p. 86), who (*ibid.*, p. 84) recognizes the *Annunciation* panels at Detroit as coming from the Valdarno altarpiece; but see note 2, above. A summary is published by F. Zeri in *Bollettino d'Arte*, vol. XLIX, 1964, pp. 127 ff. (4) This information is given in the archives of the Frick Art Reference Library. Very likely at this time, 1920, K 66 and K 67 and also the Detroit panels were separated from the altarpiece.

GIOVANNI DEL BIONDO

K 1161 : Figure 91

THE ANNUNCIATION. Lewisburg, Pa., Bucknell University, Study Collection (BL-K6), since 1961.[1] Wood. $8\frac{3}{8} \times 16\frac{3}{4}$ in. ($21 \cdot 3 \times 42 \cdot 5$ cm.). Slightly abraded; cleaned 1961.

When in the Volpi sale, K 1161 was still attached, as predella, to an arched composition of the enthroned Madonna and Child flanked by Sts. James Major, Thomas, the Magdalen, Lucy (?), and four angels. The reproduction in the Volpi catalogue[2] shows the predella disfigured by repaint, which has since been removed, revealing the balustrade in the background and the rug on the floor.[3] The rug, of which an almost exact duplicate appears in a fresco of the *Annunciation* attributed to Neri di Bicci, about 1450, in Santa Maria Novella, Florence, is apparently an Anatolian import. K 1161 seems to belong with Giovanni del Biondo's work of about 1370.[4]

Provenance: Pini, Florence. Comm. Elia Volpi (sold, American Art Association, New York, Apr. 2, 1927, no. 373 of catalogue, as Giovanni del Biondo. The whole altarpiece is here reproduced). Contini Bonacossi, Florence. Kress acquisition, 1938 – exhibited: National Gallery of Art, Washington, D.C. (486), 1941–52;[5] Finch College Museum of Art, New York, Dec. 3, 1959 – Mar. 17, 1960; Traveling Exhibition, University of Arizona, Tucson, Ariz., Apr. – Sept. 1960.

References: (1) Catalogue by B. Gummo, 1961, pp. 6 f., as Giovanni del Biondo. (2) See reference to Volpi catalogue under *Provenance*, above. K. Steinweg informs me (letter of Nov. 16, 1965) that the upper part of the Volpi altarpiece is now in an Italian private collection. (3) The repaint had been removed from K 1161 before it entered the Kress Collection; X-ray confirms the present composition as original. (4) G. Fiocco, R. Longhi, F. M. Perkins, W. E. Suida, A. Venturi (in ms. opinions), M. Meiss (*Painting in Florence and Siena*, 1951, p. 168 n. 4) and R. Offner (in *Mitteilungen des Kunsthistorischen Instituts in Florenz*, vol. VII, 1956, p. 189) attribute K 1161 to Giovanni del Biondo; B. Berenson (*Italian Pictures . . . Florentine School*, vol. I, 1963, p. 51) attributes it to

Giovanni di Bartolommeo Cristiani. (5) *Preliminary Catalogue*, 1941, p. 82, as Giovanni del Biondo.

GIOVANNI DEL BIONDO

K1150 : Figure 87

THE MYSTIC MARRIAGE OF ST. CATHERINE. Allentown, Pa., Allentown Art Museum (61.40.KG), since 1960.[1] Wood. 50⅜×26¾ in. (127·8×67 cm.). Good condition except for slight damages; cleaned 1960.

Cited, when it was first published, as an example of Giovanni del Biondo's expression of comfortable well-being,[2] this panel, dating probably about 1380, is also one of the rare representations of the *Marriage of St. Catherine* in which Christ is shown as an adult. Usually He is a small child in His mother's lap, and even here His mother serves as intermediary, holding the hand of the saint. The substitution of the adult Christ for the Child seems to have been an invention of the Cione studio,[3] although examples come from both Siena and Florence.[4]

Provenance: Newman, Florence. Charles Fairfax Murray, London (sold, Cassirer & Helbing's, Berlin, Nov. 6/7, 1929, no. 276 of catalogue, as Giovanni del Biondo). Contini Bonacossi, Florence. Kress acquisition, 1938.

References: (1) Catalogue by F. R. Shapley, 1960, pp. 44 f., as Giovanni del Biondo. (2) B. Berenson (in *Dedalo*, vol. XI, 1931, p. 1288; *Italian Pictures . . . Florentine School*, vol. I, 1963, p. 84), G. Fiocco, R. Longhi, F. M. Perkins, W. E. Suida, A. Venturi (in ms. opinions), R. Offner (*Corpus of Florentine Painting*, sec. III, vol. V, 1947, p. 228 n. 1; also in *Mitteilungen des Kunsthistorischen Instituts in Florenz*, vol. VII, 1956, p. 189), and M. Meiss (*Painting in Florence and Siena*, 1951, p. 110) attribute K1150 to Giovanni del Biondo. (3) Offner, *loc. cit.* (4) Meiss, *loc. cit.*

GIOVANNI DEL BIONDO

K259 : Figure 85

MADONNA AND CHILD, ST. JOHN THE BAPTIST AND ST. CATHERINE. Memphis, Tenn., Brooks Memorial Art Gallery (61.191), since 1958.[1] Wood. 33⅞×30¼ in. (86·1× 76·9 cm.). Inscribed on base of frame: SCS · JOHES · BAPTISTA · AVE DULCIS VIRGO MARIA SUCCHURRE NOBIS MATER PIA · SCA · KATERINA · VIRḠ · (St. John the Baptist; Hail, sweet Virgin Mary; succor us, pious Mother; St. Catherine, Virgin). Good condition; frame original; cleaned 1956–57.

The artist's affinity with Nardo di Cione and Niccolò di Tommaso is obvious in this painting,[2] which is characteristic of Giovanni del Biondo's maturity and dates probably about 1385. The motive of the Virgin teaching the Child to read gives the work an original touch of intimacy.

Provenance: Prince Galitzin, St. Petersburg. L. Currie, Combe Warren, Kingston Hill, England. Contini Bonacossi, Florence. Kress acquisition, 1933 – exhibited: 'Italian Paintings Lent by Mr. Samuel H. Kress,' Oct. 1932, Atlanta, Ga., through June 1935, Charlotte, N.C., p. 12 of catalogue, as Giovanni del Biondo; National Gallery of Art, Washington, D.C. (238), 1941–52;[3] after entering the Brooks Memorial Art Gallery: 'Religion in Painting,' Arkansas Arts Center, Little Rock, Ark., Dec. 7, 1963–Jan. 30, 1964, no. 18, as Giovanni del Biondo.

References: (1) Catalogue by W. E. Suida, 1958, pp. 20 f., as Giovanni del Biondo. (2) First attributed to Giovanni del Biondo by B. Berenson (in *Dedalo*, vol. XI, 1931, pp. 1290, 1292; see also *Italian Pictures . . . Florentine School*, vol. I, 1963, p. 86), who notes the relationship to the work of Nardo di Cione and Niccolò di Tommaso. In ms. opinions G. Fiocco, R. van Marle, F. M. Perkins, and A. Venturi attribute K259 to Giovanni del Biondo, while R. Longhi thinks it may be an early work by Niccolò di Pietro Gerini. (3) *Preliminary Catalogue*, 1941, p. 82, as Giovanni del Biondo.

Attributed to
GIOVANNI DEL BIONDO

K63 : Figure 86

MADONNA NURSING HER CHILD. New Orleans, La., Isaac Delgado Museum of Art (61.62), since 1931.[1] Wood. 31×22⅜ in. (78·8×57 cm.). Very bad condition; extensively restored; cleaned 1953; bottom section of frame original but restored.

Praised as one of the most inspired of Giovanni del Biondo's paintings,[2] K63 reflects his style of about 1370 and is similar in composition and sentiment to the upper part of the Madonna panel to which the *Annunciation*, K1161 (p. 36, above), once formed the predella. The dignity and the intensity of expression of K63 have suggested that it may be a free version of a composition by Ambrogio Lorenzetti.[3]

Provenance: Contini Bonacossi, Rome. Kress acquisition, 1929.

References: (1) Catalogue by W. E. Suida, 1953, pp. 12 f., as Giovanni del Biondo. (2) G. Fiocco, R. Longhi, F. M. Perkins, A. Venturi (in ms. opinions), and B. Berenson (in

Dedalo, vol. XI, 1931, pp. 1287 f.; *Italian Pictures . . . Florentine School*, vol. I, 1963, p. 86) attribute K63 to Giovanni del Biondo. R. Offner (in *Mitteilungen des Kunsthistorischen Instituts in Florenz*, vol. VII, 1956, p. 189) assigns it to Giovanni del Biondo's workshop. (3) Suggested by Berenson in *Dedalo, loc. cit.* in note 2, above.

FLORENTINE SCHOOL
Late XIV Century

K 1121 : Figure 88

MADONNA AND CHILD ENTHRONED WITH ST. JOHN THE BAPTIST AND ST. JOHN THE EVANGELIST. Los Angeles, Calif., Los Angeles County Museum of Art (L.2100.39-551), since 1938.[1] Wood. 33⅞ × 31½ in. (86·1 × 80 cm.). Inscribed on the Baptist's scroll: ECCE AGNUS DEI ECCE (from John 1 : 29); on the Child's scroll: EGO SUM LUX (from John 8 : 12); on the base of the throne: S. MARIA MATER DEI ORA PRO NOBIS (from the Hail Mary). Very good condition; moldings original.

Formerly attributed to Giovanni del Biondo,[2] K1121 has lately been more plausibly grouped with panels and miniatures believed to have been painted by Silvestro de' Gherarducci, a monk in the Camaldolese Monastery of Santa Maria degli Angeli, Florence, from 1352 to 1399.[3] Fine decorative detail, so profuse in K1121, which may date in the 1380's, is more characteristic of him than of Giovanni del Biondo.

Provenance: Contini Bonacossi, Florence. Kress acquisition, 1937 – exhibited, after entering the Los Angeles Museum of Art: Art Gallery, Vancouver, B.C., Nov. 17–Dec. 13, 1953, no. 3, as Giovanni del Biondo.

References: (1) Catalogue by P. Wescher, 1954, p. 12, no. 5, as Giovanni del Biondo. (2) G. Fiocco, A. Venturi (in ms. opinions), and B. Berenson (*Italian Pictures . . . Florentine School*, vol. I, 1963, p. 86) attribute K1121 to Giovanni del Biondo; R. Longhi, F. M. Perkins, and W. E. Suida (in ms. opinions) attribute it to a Florentine artist related to Giovanni del Biondo. (3) This attribution is proposed by M. Levi D'Ancona in *Rivista d'Arte*, vol. XXXII, 1957, pp. 21 f.

MASTER OF THE ORCAGNESQUE MISERICORDIA

Florentine School. Active late fourteenth century. The designation for this anonymous artist has been suggested by his association with the Orcagnesque *Madonna della Misericordia* in the Accademia, Florence. He appears to have been

influenced primarily by Jacopo di Cione and to have harked back to painters of the early fourteenth century.

K M-2 : Figure 89

K M-3 : Figure 90

CRUCIFIX. New York, Metropolitan Museum of Art (27.231), since 1927.[1] Wood. 18 × 13¼ in. (45·7 × 33·7 cm.). Slightly damaged.

The general form of this cross and the composition of the Crucified go back to the Giottesque, Arena Chapel *Crucifix*. Closer in a number of details is Pacino di Buonaguida's *Crucifix* in the Accademia Colombaria, Florence, which, like K M–2, M–3, shows the rare combination of the living Christ (with eyes open) on one side of the cross, and dead (with eyes closed) on the other side.[2] No exact parallel can be offered for the terminal figures on K M–2, M–3 : the four Evangelists on the side with the living Christ; the Virgin, John the Evangelist, St. Francis, and St. Anthony of Padua (?) on the other side. Critics agree in assigning the *Crucifix* to the fourteenth-century Florentine School, but within this framework various opinions have been offered.[3] The date may be about 1390.

Provenance: Contini Bonacossi, Rome. Kress acquisition, 1927.

References: (1) Catalogue by H. B. Wehle, 1940, pp. 14 f., as unknown Florentine painter, second half of fourteenth century. (2) The two faces of the cross had been split apart before the painting was acquired by the Foundation; they are still (1964) exhibited separately. (3) In ms. opinions R. Longhi places K M–2, M–3 close to Maso and Giottino (*c.* 1340/50); W. E. Suida suggests Maso (*c.* 1330/40); A. Venturi attributes the *Crucifix* to a follower of Giotto; F. M. Perkins, to an anonymous Florentine (after 1350); and G. Fiocco, the same (but *c.* 1300). J. M. Lansing (in *Metropolitan Museum Bulletin*, vol. XXIII, 1928, pp. 91 f.) calls it Florentine, fourteenth century; R. Offner (*Corpus of Florentine Painting*, sec. III, vol. VI, 1956, pp. 166 f.) assigns it to the Master of the Orcagnesque Misericordia; and B. Berenson (*Italian Pictures . . . Florentine School*, vol. I, 1963, p. 216), to an unidentified Florentine.

GIUSTO DE'MENABUOI

Also called Giusto da Padova. Florentine School. Active from 1363; died by 1391. Along with Giovanni da Milano, he may have been trained under Taddeo Gaddi or under Stefano Fiorentino. His youthful work was done in Lombardy; but he later settled and worked at Padua, where his style was influenced by Altichiero and Avanzo.

K179 : Figure 92

ST. PAUL AND ST. AUGUSTINE

K231A, B : Figures 93–94

ST. CATHERINE OF ALEXANDRIA AND ST. JOHN THE
BAPTIST

K1122A, B : Figures 95–96

ST. THOMAS AQUINAS AND ST. ANTHONY ABBOT

Athens, Ga., University of Georgia, Study Collection (R-5, R-4, and R-3), since 1961.[1] Wood. K179, $22\frac{3}{4} \times 13\frac{3}{8}$ in. ($57\cdot8 \times 34$ cm.); K231A, B, each, $22\frac{3}{8} \times 6\frac{1}{4}$ in. ($56\cdot9 \times 15\cdot9$ cm.); K1122A, $22\frac{1}{2} \times 6\frac{1}{2}$ in. ($57\cdot2 \times 16\cdot5$ cm.); K1122B, $22\frac{7}{16} \times 6\frac{1}{2}$ in. ($57 \times 16\cdot5$ cm.). Inscribed on the halos are only partly legible names of the saints. All panels considerably damaged and restored.

These have been recognized as parts of a dismembered polyptych of which the middle panel, the *Madonna* (in the Schiff Collection, formerly Pisa and then Montignoso di Massa),[2] bears an inscription stating that Giusto painted the altarpiece, Suor Isotta Terzaghi commissioned it, and the date was 1363. It is thus Giusto's earliest known documented work and belongs to his Lombard period. The panels here catalogued, augmented by two lost figures of saints, were originally placed at the sides of the *Madonna*, and the altarpiece was crowned by saints in half-length panels and *tondi*.[3]

Provenance: Contini Bonacossi, Florence. Kress acquisition, 1931 (K179), 1932 (K231A, B), 1937 (K1122A, B) – exhibited: 'Italian Paintings Lent by Mr. Samuel H. Kress,' Atlanta, Ga., Oct. 1932, through Salt Lake City, Sept. 1933, p. 29 of catalogue (K179 only), as Giusto de'Menabuoi; National Gallery of Art, Washington, D.C. (192), 1941–52 (K179 only);[4] 'Arte Lombarda dai Visconti agli Sforza,' Milan, April–June, 1958, nos. 36–40 of catalogue, as Giusto de' Menabuoi.

References: (1) Catalogue by L. C. Walker, Jr., as Giusto de' Menabuoi. (2) The Schiff panel is reproduced by S. Bettini, *Giusto de'Menabuoi*, 1944, fig. 9. (3) R. Longhi (in *Pinacoteca*, 1928, p. 138; and in *Arte Veneta*, vol. I, 1947, pp. 79 f.) associates the Kress panels and other extant panels with the Schiff *Madonna*. B. Berenson, G. Fiocco, R. van Marle, F. M. Perkins, W. E. Suida, and A. Venturi (in ms. opinions) attribute the panels to Giusto. (4) *Preliminary Catalogue*, 1941, p. 88, as Giusto de'Menabuoi.

GIOVANNI DA MILANO

Lombard-Florentine School. Mentioned 1346–69. He was trained by Giottesque artists in Lombardy; but he worked

in Florence and was influenced by the artists there also. The most talented Lombard artist of his time, he marks a transition to the International Style as it became fully manifest in Masolino and Lorenzo Monaco.

K199 : Figure 97

ST. ANTHONY ABBOT. Williamstown, Mass., Williams College Museum of Art, Study Collection (60.12), since 1960. Wood. $28\frac{1}{4} \times 13\frac{3}{4}$ in. ($71\cdot8 \times 35$ cm.). Good condition.

That the figure of the saint has been cut down from a full-length is indicated by comparison with a panel formerly in the Bordeaux Museum of a full-length St. Francis, which once must have belonged to the same polyptych as K199.[1] The date is probably about 1365, the period of Giovanni's Rinuccini frescoes in Santa Croce, Florence, and the panel of the *Pietà* (dated 1365) in the Galleria Antica e Moderna, Florence.

Provenance: Bianco Sale, Turin, 1889, as Francesco Traini.[2] Vienna Collection, Rome. Contini Bonacossi, Florence. Kress acquisition, 1932 – exhibited: National Gallery of Art, Washington, D.C. (197), 1941–52;[3] 'Arte Lombarda dai Visconti agli Sforza,' Milan, Apr.–June 1958, no. 62 of catalogue, as Giovanni da Milano.

References: (1) The St. Francis (long attributed to Sassetta) is reproduced in *Critica d'Arte*, July–Dec. 1940, fig. 6 (opposite p. 151) by R. Longhi, who (p. 181 n. 6) associates it with K199 and attributes both panels to Giovanni da Milano (see also M. Laclotte's catalogue of the exhibition 'De Giotto à Bellini,' Paris, 1956, no. 11, pl. IV). G. Fiocco, R. van Marle, F. M. Perkins, W. E. Suida, A. Venturi (in ms. opinions), and B. Berenson (*Italian Pictures ... Florentine School*, vol. I, 1963, p. 90) attribute K199 to Giovanni da Milano. (2) According to S. Reinach, *Répertoire des peintures*, vol. II, 1907, p. 583. (3) *Preliminary Catalogue*, 1941, p. 83, as Giovanni da Milano.

AGNOLO GADDI

Florentine School. Active from 1369; died 1396. One of the artist sons of Taddeo Gaddi, Agnolo studied under his father and also under Giovanni da Milano. He worked in Rome, Florence, and Prato, frescoes in the Prato Cathedral being definitely documented. Among the assistants who helped in the execution of his work there has been an attempt to identify Gherardo Starnina. But since this identification remains theoretical, the so-called Starnina paintings are here treated as representing a phase of Agnolo Gaddi and his school.

K 364 : Figures 98–99

THE CORONATION OF THE VIRGIN. Washington, D.C., National Gallery of Art (314), since 1941.[1] Wood. 64× 31⅛ in. (162·6×79·4 cm.). Generally good condition except for a few losses of paint, especially in the angel's face at vertical split of panel (middle angel on the right); this face is restored; cleaned 1955.

Blond, harmonious coloring and Gothic flow of line are characteristic of this early work, probably painted around 1370, and the solemn, Giottesque faces have not yet been modified by the somewhat mannered expression some-times attributed to Agnolo's pupil Starnina.[2]

Provenance: William Keith Rous, Norfolk, England (sold, Christie's, London, June 29, 1934, no. 58, as Orcagna; bought by Bellesi). Contini Bonacossi, Florence. Kress acquisition, 1935 – exhibited: 'Masterpieces of Art,' New York World's Fair, 1939, no. 128 of catalogue, as Agnolo Gaddi; 'Arts of the Middle Ages,' Museum of Fine Arts, Boston, Mass., Feb. 17–Mar. 24, 1940, no. 59 of catalogue, as Agnolo Gaddi.

References: (1) *Preliminary Catalogue*, 1941, p. 71, as Agnolo Gaddi. (2) The painting has been attributed to Agnolo Gaddi by G. Fiocco, R. Longhi, R. van Marle, F. M. Perkins, W. E. Suida, A. Venturi (in ms. opinions), C. L. Ragghianti (in *Critica d'Arte*, Aug. 1937, p. 188), H. D. Gronau (in *Proporzioni*, vol. III, 1950, p. 42), and B. Berenson (*Italian Pictures . . . Florentine School*, vol. I, 1963, p. 69). M. Bos-kovits (in ms. opinion) attributes it to the Pseudo-Compagno di Agnolo Gaddi characterized by R. Salvini in *Bollettino d'Arte*, vol. XXIX, 1935, pp. 291 ff.

Follower of AGNOLO GADDI

K 563 : Figure 100

MADONNA AND CHILD ADORED BY TWO ANGELS. Tucson, Ariz., University of Arizona (61.106), since 1951.[1] Wood. 27⅞×18¾ in. (70·8×47·6 cm.). Good condition except upper termination shortened and changed from shouldered pointed arch.

The composition of this Madonna of Humility adored by angels is known in a number of versions.[2] It shows the stylistic characteristics that have generally been explained as indicating the hand of a follower sometimes designated as 'Compagno di Agnolo,' or as Gherardo Starnina,[3] working near the end of the fourteenth century.

Provenance: Achillito Chiesa, Milan. Contini Bonacossi, Florence. Kress acquisition, 1939.

References: (1) Catalogue by W. E. Suida, 1951, no. 4, and 1957, no. 2, as Agnolo Gaddi. (2) Among others, versions are in the Cathedral, Perugia; the Stedelijk Museum, Amsterdam; and the Bargello, Florence. (3) In ms. opinions K 563 is attributed to an artist close to Agnolo Gaddi by F. M. Perkins; to Compagno d' Agnolo by R. Longhi; and to Starnina by G. Fiocco, W. E. Suida, and A. Venturi; it is attributed to Agnolo Gaddi by B. Berenson (*Italian Pictures . . . Florentine School*, vol. I, 1963, p. 69).

GIOVANNI DI BARTOLOMMEO CRISTIANI

Florentine School. Active 1367–98, chiefly in Florence and Pistoia. His style was formed under the influence of Orcagna and of Taddeo and Agnolo Gaddi.

Follower of
GIOVANNI DI BARTOLOMMEO CRISTIANI

K 108 : Figure 102

MADONNA AND CHILD WITH SAINTS AND ANGELS. Berea, Ky., Berea College, Study Collection (140.8), since 1961.[1] Wood. 26⅝×18 11/16 in. (67·6×47·5 cm.). Fair condition; probably cut down.

Among the paintings with which Cristiani's oeuvre has been reconstructed, the signed *Madonna and Child with Six Angels* in the Museo Civico, Pistoia, offers an interesting stylistic parallel to K 108.[2] Sts. Julian and Anthony Abbot in K 108, as well as the Virgin, are Cristiani types, but the execution is less delicate than is to be expected from Cristiani himself;[3] that it may be by Lorenzo di Niccolò has been plausibly suggested.[4] The date is probably near the end of the four-teenth century.

Provenance: Contini Bonacossi, Rome. Kress acquisition, 1930 – exhibited: 'Italian Paintings Lent by Mr. Samuel H. Kress,' Atlanta, Ga., Oct. 23–Nov. 22, 1932, p. 12 of catalogue, as Giovanni del Biondo; 'Golden Gate Inter-national Exposition,' San Francisco, 1940, no. 108 of catalogue, as Giovanni di Bartolommeo Cristiani; National Gallery of Art, Washington, D.C. (852), 1945–52, as Giovanni di Bartolommeo Cristiani.

References: (1) Catalogue, 1961, p. 6, as Giovanni di Bartolommeo Cristiani. (2) The Pistoia panel is reproduced by B. Berenson, fig. 335 of *op. cit.* in note 3, below. (3) In

ms. opinions, K108 is attributed to Giovanni di Bartolommeo Cristiani by G. Fiocco, R. Longhi (with reservations), R. van Marle, W. E. Suida, and A. Venturi; to a Florentine close to Cristiani by F. M. Perkins. It is attributed to Cristiani by B. Berenson (*Italian Pictures . . . Florentine School*, vol. 1, 1963, p. 50. (4) This suggestion has been offered by F. Zeri (verbally).

MASTER OF THE STRAUS MADONNA

Florentine School. Active late fourteenth and early fifteenth century. So called from a half-length *Madonna* formerly in the Percy S. Straus Collection (now in the Museum of Fine Arts, Houston), this master is identical with the one sometimes called the Master of the Innocenti (from his *Coronation* in the Gallery of the Innocenti, Florence) and Master of the Accademia Annunciation (from a painting in the Accademia, Florence).[1] He was a follower of Agnolo Gaddi, with whose style he sought to combine the calligraphic elegance of Lorenzo Monaco, arriving at an effect comparable to that of the Master of the Bambino Vispo.

K1546 : Figure 103

THE ADORATION OF THE MAGI. Seattle, Wash., Seattle Art Museum (It 37/M394S1.1), since 1952.[2] Wood. 13½ × 10⅝ in. (34·5 × 27 cm.). Fair condition except for small losses of paint; cleaned 1950.

A pendant, representing the *Nativity*, was with this in the Di Larderel Collection[3] and is now the property of Dr. Bagnarelli, Milan.[4] The facial types and mild expressions and the drawing and poses of hands find remarkably close parallels in the Straus *Madonna* and some of the other paintings attributed to this master.[5] A sympathetic relationship to Sienese art is also obvious.[6] The date may be about 1390.

Provenance: Conte Di Larderel, Livorno. Contini Bonacossi, Florence. Kress acquisition, 1948.

References: (1) R. Offner (in *Burlington Magazine*, vol. LXIII, 1933, pp. 169 f., n. 14) devised the pseudonym for this master, analyzed his style, and compiled a catalogue of his work. (2) Catalogue by W. E. Suida, 1952, no. 6, and 1954, p. 24, as Master of the Straus Madonna. (3) *Ibid.* (4) Information kindly given by F. Zeri. (5) K1546 is attributed to the Master of the Straus Madonna by R. Offner (in ms. opinion). It is discussed among this master's paintings by L. Bellosi (in *Paragone*, no. 187, 1965, pp. 38 f.), who reproduces its pendant as his fig. 36. (6) Cf., e.g., Andrea Vanni's *Adoration of the Magi* (K233, Fig. 156) for parallels with the hills and the giraffes.

MASTER OF THE ST. VERDIANA PANEL

Florentine School. Active *c.* 1390–1415. This anonymous follower of Agnolo Gaddi is now known in a number of paintings, of which K1054 (Fig. 105) has provided his pseudonym by its representation of St. Verdiana,[1] whose veneration was localized in her native Castelfiorentino.

K261 : Figure 104

MADONNA AND CHILD WITH SAINTS. Birmingham, Ala., Birmingham Museum of Art (61.96), since 1952.[2] Wood. 38 × 21 in. (96·5 × 53·4 cm.). Good condition.

This was formerly attributed to Agnolo Gaddi, but the identity of the style with that of the work of about 1390 attributed to Agnolo's follower the St. Verdiana Master is now well defended.[3] Among the very similar compositions which are apparently by the same master are a panel in the Museo Stibbert, Florence, of which even the predella is almost identical, a panel in the Christian Museum, Esztergom, and the middle panel of a triptych in the Museo di Palazzo Venezia, Rome.[4] In K261 the saints below the celestial Madonna of Humility are Catherine of Alexandria, Peter, James Major, Lucy, Anthony Abbot, and Paul.

Provenance: Giulio Sterbini, Rome (said to have come from the Vatican). Contini Bonacossi, Florence. Kress acquisition, 1933 – exhibited: National Gallery of Art, Washington, D.C. (239), 1941–51.[5]

References: (1) W. E. Suida (Birmingham catalogue, 1952, p. 23; 1959, pp. 20 f.) first suggested this designation and attributed K261 to the master. Suida's conclusions are followed by F. Zeri in *Studies in the History of Art Dedicated to William E. Suida*, 1959, pp. 35 ff. (2) See catalogues cited in note 1, above. (3) See note 1, above. But in ms. opinions G. Fiocco, R. Longhi, R. van Marle, W. E. Suida, and A. Venturi have attributed K261 to Agnolo Gaddi; F. M. Perkins and O. Sirén, tentatively, to him. B. Berenson (*Italian Pictures . . . Florentine School*, vol. 1, 1963, p. 66) attributes it to him in part. (4) Longhi is quoted (in Santangelo's catalogue of the Museo di Palazzo Venezia, 1948, p. 36) as attributing K261 to the same late fourteenth-century Florentine, close to Agnolo Gaddi, who painted the triptych in the Palazzo Venezia. (5) *Preliminary Catalogue*, 1941, pp. 70 f., as Agnolo Gaddi.

MASTER OF THE
ST. VERDIANA PANEL

K 1054 : Figure 105

MADONNA AND CHILD WITH SAINTS. Atlanta, Ga., Atlanta Art Association Galleries (58.49), since 1958.[1] Wood. 31¾×21⅜ in. (80·7×54·3 cm.). Excellent condition; cleaned 1957.

Sts. Nicholas, Catherine of Alexandria, Anthony Abbot, Julian, and Dorothy are familiar figures, but St. Verdiana, with the two snakes, is so rarely represented as to have furnished in this picture the name by which the painter is known. The Madonna of Humility here and in other compositions by the same master appears as a celestial vision in a mandorla of cherubim and seraphim. The date of K 1054 is probably about 1390.

Provenance: Contini Bonacossi, Florence. Kress acquisition, 1936 – exhibited: National Gallery of Art, Washington, D.C. (844), 1945–54, as Florentine School, fourteenth century.

Reference: (**1**) Catalogue by W. E. Suida, 1958, p. 14, as St. Verdiana Master. F. Zeri (in *Studies in the History of Art Dedicated to William E. Suida*, 1959, pp. 35 ff.) accepts Suida's characterization of the master and his attributions. In ms. opinions B. Berenson attributes the painting to an artist close to Mariotto di Nardo; A. Venturi gives it to Agnolo Gaddi; and G. Fiocco, R. Longhi, and F. M. Perkins, to the circle of Agnolo Gaddi.

CENNI DI FRANCESCO

Cenni di Francesco di Ser Cenni. Florentine School. Active first quarter of fifteenth century in Volterra. He was a follower and imitator of Agnolo Gaddi and shows parallels also with Giovanni del Biondo and Niccolò di Pietro Gerini.

K 268 : Figure 101

MADONNA AND CHILD. Lawrence, Kans., University of Kansas, Study Collection (60.46), since 1960.[1] Wood. 28½×21¾ in. (72·4×55·3 cm.). Perfect condition except for having been cut off at top.

Comparison with his frescoes in Volterra dated 1410 suggests that Cenni probably painted K 268 about the same time.[2] As he followed – almost copied – Agnolo Gaddi in those frescoes, so K 268 is inspired by Madonna panels by Agnolo. The frontal Virgin, the pose of her hands and of the Child almost duplicate a composition attributed to Agnolo.[3] But in K 268 Agnolo's facial expressions are greatly exaggerated

and the execution is cruder. In compensation, the brocade designs of dress and hanging, again inspired by Agnolo, are pleasingly rich and colorful. K 268 was probably once the middle panel of an altarpiece. It has been suggested[4] that other panels in the same altarpiece may have been the half-length figures of St. James and the Magdalen attributed to Antonio Veneziano in the Vatican Pinacoteca,[5] a *St. Agnes* in the Musée des Beaux-Arts of Nantes,[6] and three predella scenes of the life of the Magdalen attributed to Giovanni da Milano in the Vatican Pinacoteca.[7] Much the closest of these panels, stylistically, to K 268 is the *St. Agnes*, at Nantes.

Provenance: Conte Sturani, Bologna. Contini Bonacossi, Florence. Kress acquisition, 1933 – exhibited: National Gallery of Art, Washington, D.C. (245), 1941–52.[8]

References: (**1**) Catalogue by R. L. Manning (in *Register of the Museum of Art*, vol. II, no. 4, 1960, p. 14), as Cenni di Francesco. (**2**) K 268 is attributed (in ms. opinions) to Cenni by B. Berenson, G. Fiocco, R. Longhi, R. van Marle, W. E. Suida, and A. Venturi; to a close follower of Niccolò di Pietro Gerini by F. M. Perkins. (**3**) In the Richter Archives at the National Gallery of Art is a photograph of this painting, filed under Agnolo Gaddi, without record of its location, but with a notice that it is attributed by R. van Marle, vol. V, to Agnolo Gaddi. It is presumably the one van Marle cites among paintings by Agnolo (*Italian Schools of Painting*, vol. III, 1924, p. 556 n. 1) as an early half-length *Madonna* in a 'private collection' (Rome ?). On p. 600 of the same volume is reproduced a *Madonna* by Spinello Aretino in the Gallery at Città di Castello which may indicate another source of influence upon K 268 and show that the latter is an adaptation from a full-length *Enthroned Madonna*. (**4**) F. Zeri, in *Bollettino d'Arte*, vol. XLVIII, 1963, p. 255. (**5**) Nos. 16 and 19. (**6**) No. 195, attributed to the school of Taddeo Gaddi and incorrectly called John the Baptist. It was shown in the exhibition 'De Giotto à Bellini,' Orangerie, Paris, 1956, no. 4, as Cenni di Francesco. (**7**) Nos. 182, 183, and 184. (**8**) *Preliminary Catalogue*, 1941, p. 38, as Cenni di Francesco.

NICCOLÒ DI PIETRO GERINI

Florentine School. Active from 1368; died 1415. Niccolò early collaborated with Jacopo di Cione but was influenced especially by Taddeo Gaddi, Orcagna, and Nardo di Cione. He later collaborated with his son, Lorenzo di Niccolò, and with Spinello Aretino. Through his many pupils, Niccolò helped prolong the Giottesque tradition to the time of Masaccio.

K 1004 : Figure 106

MADONNA AND CHILD. Colorado Springs, Colo., Colorado Springs Fine Arts Center (61-1), since 1961.

Wood. 31¼×18 in. (79·4×45·7 cm.). Flesh tones slightly abraded; panel has been cut out of frame.

This type of three-quarter-length *Madonna* derives from such a prototype as Nardo di Cione's beautiful example in the National Gallery of Art (K478, Fig. 75) but probably dates some twenty or thirty years later, about 1380/90, in the late period of Niccolò di Pietro Gerini,[1] to which the stylistically similar full-length *Enthroned Madonna* in the Museum of Fine Arts, Boston, belongs.

Provenance: Contini Bonacossi, Florence. Kress acquisition, 1936 – exhibited: National Gallery of Art, Washington, D.C. (432), 1941–52.[2]

References: (1) G. Fiocco, R. Longhi, F. M. Perkins, W. E. Suida, A. Venturi (in ms. opinions), and B. Berenson (*Italian Pictures . . . Florentine School*, vol. I, 1963, p. 159) attribute K1004 to Niccolò di Pietro Gerini. (2) *Preliminary Catalogue*, 1941, pp. 143 f., as Niccolò di Pietro Gerini.

NICCOLÒ DI PIETRO GERINI

K17 : Figure 109

THE FOUR CROWNED MARTYRS BEFORE DIOCLETIAN. Denver, Colo., Denver Art Museum (E-IT-18-XV-927), since 1954.[1] Wood. 24½×17¾ in. (62·2×45·1 cm.). Good condition.

Usually attributed to Niccolò di Pietro Gerini,[2] about 1390, K17 probably comes from a large altarpiece, in which it was almost certainly associated with a panel now in the Johnson Collection, Philadelphia, likely also with a panel from the Loeser Collection, Florence,[3] and possibly with K1719 (Fig. 113). K17 represents four brothers, the masons Claudius, Nicostratus, Sempronianus, and Castor before the Emperor Diocletian, whose order to build a pagan temple they refuse to obey. The Johnson panel shows the scourging of the four brothers. The subject of the Loeser panel, a ruler and six other men kneeling in worshipful attitude round a column, has not been identified.[4]

Provenance: Contini Bonacossi, Rome. Kress acquisition, 1928 – exhibited: National Gallery of Art, Washington, D.C. (127), 1941–51, as Niccolò di Pietro Gerini.[5]

References: (1) Catalogue by W. E. Suida, 1954, pp. 14 f., as Niccolò di Pietro Gerini. (2) G. Fiocco, F. M. Perkins (in ms. opinions), and B. Berenson (*Italian Pictures . . . Florentine School*, vol. I, 1963, p. 159) attribute K17 to Niccolò di Pietro Gerini; R. Longhi and A. Venturi (in ms. opinions) attribute it to Spinello Aretino. (3) Sold, Sotheby's, London, Dec. 9, 1959, no. 32, as Niccolò di Pietro Gerini; bought by Marshall Spink. (4) The height of this painting,

21¼ in., and the fact that the top of the column is missing indicate that the panel has been cut down. The subject may well have been Diocletian and his subjects worshiping a pagan image which is now missing from the top of the column. (5) *Preliminary Catalogue*, 1941, p. 143, as Niccolò di Pietro Gerini.

NICCOLÒ DI PIETRO GERINI

K1719 : Figure 113

LEGEND OF THE FOUR CROWNED MARTYRS. Birmingham, Ala., Birmingham Museum of Art (61.119), since 1952.[1] Wood. 16×18 in. (40·6×45·7 cm.), apparently cropped at left side. Good condition except for a few abrasions; cleaned slightly 1951.

Obviously by the same artist as K17 (Fig. 109), K1719[2] may even come from the same altarpiece, painted about 1390; but, because of the discrepancy in measurements, it could scarcely have been a companion predella panel. The subject may be Diocletian, with his two counselors, directing one of the attempts on the lives of the Four Crowned Martyrs: they were locked in leaden boxes and cast into the river.

Provenance: Contini Bonacossi, Florence. Kress acquisition, 1950.

References: (1) Catalogue by W. E. Suida, 1952, pp. 24 f., and 1959, pp. 22 f., as Niccolò di Pietro Gerini. (2) R. Longhi (in ms. opinion) has attributed K1719 to Niccolò di Pietro Gerini, last decade of fourteenth century; B. Berenson (*Italian Pictures . . . Florentine School*, vol. I, 1963, p. 158) lists it as by this artist.

Follower of
NICCOLÒ DI PIETRO GERINI

K1119 : Figure 107

MADONNA AND CHILD. Ponce, Puerto Rico, Museo de Arte de Ponce, Study Collection (62.0256), since 1962.[1] Wood. 22¼×15⅛ in. (56·5×38·4 cm.). Excellent condition; panel has been cut out of frame and shortened at top.

The figures in K1119 are so closely paralleled in a *Madonna and Child with Angels* in the Louvre[2] as to suggest that both panels are by the same follower of Niccolò di Pietro Gerini. Probable identity of authorship with a triptych of the *Madonna and Child with Saints*, dated 1370, in San Pietro, Perticaia, near Florence, has suggested the designation

Master of the Perticaia Triptych for the anonymous painter of K1119,[3] with a date around 1370/80.

Provenance: Contini Bonacossi, Florence. Kress acquisition, 1937.

References: (**1**) Catalogue by J. S. Held, 1962, no. 3, as Master of the Perticaia Triptych. (**2**) The Louvre painting is reproduced by R. van Marle, *Italian Schools of Painting*, vol. III, 1924, p. 629, fig. 355. (**3**) K1119 has been attributed to Bartolommeo Cristiani by B. Berenson (*Italian Pictures . . . Florentine School*, vol. I, 1963, p. 51); to the Master of the Perticaia Triptych by G. Fiocco, R. Longhi, F. M. Perkins, W. E. Suida, and A. Venturi (in ms. opinions).

Follower of
NICCOLÒ DI PIETRO GERINI

K1160 : Figure 111

THE MOURNING MADONNA. Claremont, Calif., Pomona College, Study Collection (61.1.2), since 1961. Wood. $19\frac{1}{4} \times 19\frac{5}{8}$ in. (48·9 × 49·9 cm.). Some slight abrasions.

This would seem to have been painted in the last quarter of the fourteenth century by an artist close to Niccolò di Pietro Gerini.[1] Niccolò's *Mourning Madonna* on the left terminal of a *Crucifix* dated 1380 in Santa Croce, Florence, explains the probable use of K1160, as well as the source of its style. Another striking parallel is offered by the Madonna in the *Pietà* by Niccolò in the Johnson Collection, Philadelphia.

Provenance: Contini Bonacossi, Florence. Kress acquisition, 1938 – exhibited: National Gallery of Art, Washington, D.C. (845), 1945–52, as Florentine, fourteenth century.

Reference: (**1**) In ms. opinions, K1160 is related to Niccolò di Pietro Gerini by G. Fiocco, F. M. Perkins, and W. E. Suida; to Lorenzo di Niccolò by A. Venturi; and to Giovanni del Biondo by R. Longhi. It is listed as unidentified Florentine, between 1350 and 1420, by B. Berenson (*Italian Pictures . . . Florentine School*, vol. I, 1963, p. 214).

LORENZO DI NICCOLÒ

Florentine School. Active 1392–1411. He was the son and pupil of Niccolò di Pietro Gerini and collaborated with him and with Spinello Aretino.

K333 : Figure 117

MADONNA AND CHILD WITH SAINTS AND ANGELS. Birmingham, Ala., Birmingham Museum of Art (61.98),

since 1959.[1] Wood. $27\frac{1}{8} \times 17\frac{1}{2}$ in. (69 × 44·4 cm.). Good condition except for some restoration in gold background; cleaned 1959.

Attributed also to Mariotto di Nardo,[2] who may have been a pupil of Lorenzo di Niccolò, K333 seems closest in style to Lorenzo's work of the first years of the fifteenth century. The face of the Virgin is remarkably paralleled in the panel of St. Lucy from the Terenzano altarpiece (Settignano), which is signed and dated 1402. The influence of Lorenzo Monaco is seen in the fluttering mantle of the Child and the flowing robes of Sts. Francis and Anthony Abbot. The saints standing behind these two are the Magdalen, with her ointment box, and Dorothy, carrying flowers in the folds of her mantle.

Provenance: Contini Bonacossi, Florence. Kress acquisition, 1935 – exhibited: National Gallery of Art, Washington, D.C. (294), 1941–52.[3]

References: (**1**) Catalogue by W. E. Suida, 1959, p. 26, as Lorenzo di Niccolò. (**2**) K333 is attributed to Mariotto di Nardo by B. Berenson (*Italian Pictures . . . Florentine School*, vol. I, 1963, p. 129); to Lorenzo di Niccolò by G. Fiocco, R. Longhi, R. van Marle, F. M. Perkins tentatively, and A. Venturi (in ms. opinions). (**3**) *Preliminary Catalogue*, 1941, p. 125, as Mariotto di Nardo.

LORENZO DI NICCOLÒ

K1093 : Figure 110

THE CRUCIFIXION WITH THE VIRGIN AND SAINTS. Raleigh, N.C., North Carolina Museum of Art (GL.60.17.10), since 1960.[1] Wood. $13 \times 9\frac{7}{8}$ in. (33 × 25·1 cm.). Very good condition.

Painted probably between 1400 and 1410, at a time when the artist was collaborating with Spinello Aretino and Mariotto di Nardo,[2] K1093 is very likely a predella panel from an altarpiece which featured the bishop saint Nicholas.

Here the bishop is shown at the foot of the cross, along with the Virgin, John the Baptist, and John the Evangelist. He is the chief figure in another panel also which may have belonged to the same predella. That panel, which is in the Vatican Pinacoteca and, though wider, is approximately the height of K1093, with corresponding decorative design in border and halos, shows St. Nicholas saving three knights from execution. More definitely from the same altarpiece as K1093 are two other panels in the Vatican Pinacoteca. They have the same measurements and decorative details as K1093 and represent the *Annunciation* and the *Nativity*. All three of the Vatican panels have been attributed both to Lorenzo di Niccolò and to Mariotto di Nardo.[3]

Provenance: Contini Bonacossi, Florence. Kress acquisition, 1937 – exhibited: National Gallery of Art, Washington, D.C. (461), 1941–52.[4]

References: (1) Catalogue by F. R. Shapley, 1960, p. 38, as Lorenzo di Niccolò. (2) In ms. opinions K1093 is attributed to Lorenzo di Niccolò by G. Fiocco, F. M. Perkins, W. E. Suida, and A. Venturi; to Mariotto di Nardo by R. Longhi. B. Berenson (*Italian Pictures . . . Florentine School*, vol. 1, 1963, p. 123) attributes it to Lorenzo di Niccolò, possibly collaborating with Spinello. (3) The three panels are nos. 97, 101, and 102 in the Vatican Pinacoteca. (4) *Preliminary Catalogue*, 1941, p. 114, as Lorenzo di Niccolò.

Attributed to
LORENZO DI NICCOLÒ

K1016 : Figure 108

THE MARTYRDOM OF ST. STEPHEN. Little Rock, Ark., Arkansas Arts Center[1] (1.39), since 1938. Wood. $10\frac{3}{8} \times 19\frac{7}{8}$ in. (26·4×50·5 cm.). Good condition.

In figure types and in the details of landscape and architecture this predella panel is similar to the St. Nicholas predella panel by Lorenzo di Niccolò in the Vatican;[2] but the more hasty, less precise execution of K1016 makes its attribution to the same master uncertain.[3] It probably dates from about 1400.

Provenance: Contini Bonacossi, Florence. Kress acquisition, 1936.

References: (1) Formerly the Fine Arts Club of Arkansas. (2) See note to K1093 (p. 44, above). (3) In ms. opinions, K1016 is attributed to Lorenzo di Niccolò by G. Fiocco, R. Longhi, R. van Marle, W. E. Suida, and A. Venturi; to an artist close to Lorenzo di Niccolò by F. M. Perkins. It is attributed tentatively to Cenni di Francesco di Ser Cenni by B. Berenson (*Italian Pictures . . . Florentine School*, vol. 1, 1963, p. 47).

SPINELLO ARETINO

Spinello di Luca Spinelli, called Spinello Aretino. Florentine School. Born *c.* 1346; died 1410/11. Although he came from Arezzo, his style was developed under Orcagnesque influence in Florence. He was active there and also in Pisa and Siena.

K174 : Figure 112

FOUR APOSTLES. Allentown, Pa., Allentown Art Museum, Study Collection (60.11.KBS), since 1960. Wood. $28 \times$ $21\frac{1}{8}$ in. (71·1×53·7 cm.). Losses of paint throughout; vertical split through middle.

This fragment apparently comes from a large composition of the *Pentecost*, originally including thirteen figures, probably full-length – the Virgin and the twelve apostles. The tongues of fire on the heads in K174, signifying the descent of the Holy Ghost upon the apostles, identify the subject. In style the painting is so close to Spinello Aretino's *Dormition of the Virgin*, dated 1385, in the Siena Pinacoteca that K174 may be assigned to about the same date.[1] Since the above was written K174 has been reasonably identified as a fragment from the otherwise lost altarpiece of the *Descent of the Holy Spirit* which Vasari says Spinello painted for the high altar of the Church of Santi Apostoli, Florence.[2]

Provenance: Probably Santi Apostoli, Florence (removed by mid-eighteenth century[3]). Kerr-Lawson, Settignano (near Florence). Contini Bonacossi, Florence. Kress acquisition, 1931.

References: (1) G. Fiocco, R. Longhi, R. van Marle, F. M. Perkins, W. E. Suida, A. Venturi (in ms. opinions), and B. Berenson (*Italian Pictures . . . Florentine School*, vol. 1, 1963, p. 202) have attributed K174 to Spinello Aretino. (2) A. Gonzalez-Palacios (in *Paragone*, no. 187, 1965, pp. 49 f.), who dates the altarpiece in the 1390's. For the Vasari passage see Milanesi ed., vol. I, 1878, pp. 679 f. (3) Gonzalez-Palacios, *loc. cit.* in note 2, above.

Studio of SPINELLO ARETINO

K256 : Figure 116

MADONNA AND CHILD WITH SAINTS AND ANGELS. Lewisburg, Pa., Bucknell University, Study Collection (BL-K2), since 1961.[1] Wood. $37\frac{1}{8} \times 22\frac{1}{4}$ in. (94·3×56·5 cm.). Abrasions and small losses of paint throughout.

This may well have been designed by Spinello, for composition and figure types follow his style closely; only the execution suggests the work of assistants.[2] Recognizable among the saints are, at the left, Helena and John the Baptist and, at the right, Anthony Abbot. The date may be about 1390.

Provenance: Giulio Sterbini, Rome (said to have come from the Vatican). Contini Bonacossi, Florence. Kress acquisition, 1933 – exhibited: National Gallery of Art, Washington, D.C. (236), 1941–52.[3]

References: (1) Catalogue by B. Gummo, 1961, p. 8, as Spinello Aretino. (2) In ms. opinions G. Fiocco, R. Longhi,

R. van Marle, F. M. Perkins, O. Sirén, W. E. Suida, and A. Venturi have attributed K256 to Spinello Aretino; B. Berenson (*Italian Pictures . . . Florentine School*, vol. I, 1963, p. 205) attributes it to his studio. (3) *Preliminary Catalogue*, 1941, p. 190, as Spinello Aretino.

ANTONIO VENEZIANO

Tuscan School, although his name would indicate Venetian derivation. Mentioned 1369–88, in Siena, Florence, and Pisa. He worked in all three cities and felt the influence of their painters. The chief touchstone for his style has been the frescoes which he painted between 1384 and 1387 in the Campo Santo, Pisa. Destroyed during World War II, these frescoes must now be studied in reproduction.

K 429 : Figure 114

ST. PAUL. San Francisco, Calif., M. H. De Young Memorial Museum (61-44-4), since 1955.[1] Wood. $42\frac{1}{4} \times 17\frac{3}{8}$ in. (107·3×44·2 cm.). Very good condition; cleaned 1954.

Similarity with the artist's mature style in the Campo Santo frescoes, Pisa, indicates a date of about 1385 for K429. Comparison should also be made with the half lengths of *St. Peter* and *St. Paul*, formerly in the Loeser Collection, Florence, and with the *St. James Major*, University Gallery, Göttingen.[2] Like some other paintings now believed to be by Antonio, K429 has sometimes been attributed to Spinello Aretino.[3]

Provenance: Contini Bonacossi, Florence. Kress acquisition, 1936 – exhibited: National Gallery of Art, Washington, D.C. (348), 1941–51.[4]

References: (1) Catalogue by W. E. Suida, 1955, p. 34, as Antonio Veneziano. (2) These paintings are reproduced by R. Offner, *Studies in Florentine Painting*, 1927, figs. 8, 9, 10, following p. 82. (3) In ms. opinions K429 has been tentatively assigned to the early period of Spinello Aretino by B. Berenson; to Antonio Veneziano by G. Fiocco, R. Longhi, R. van Marle, F. M. Perkins, and A. Venturi. M. Meiss has suggested (verbally) that it is probably by Lorenzo di Niccolò Gerini. (4) *Preliminary Catalogue*, 1941, p. 9, as Antonio Veneziano.

MARIOTTO DI NARDO

Florentine School. Active from 1394; died probably 1424. Much of his work adheres to the fourteenth-century tradition, especially in the manner of Niccolò di Pietro Gerini, with close relationship also to Spinello Aretino. His later style was somewhat influenced by Lorenzo Monaco.

K93 : Figure 118

THE CRUCIFIXION. Amherst, Mass., Amherst College, Study Collection (1961–79), since 1961.[1] Wood. $27\frac{3}{4} \times 16\frac{3}{8}$ in. (70·5×41·6 cm.). Good condition except for much abraded background; cleaned 1952.

Resemblance of the figure types to those of Mariotto's well-known triptych at Villamagna is evidence in favor of attributing K93 to him, although the style of both pictures is so close to that of Spinello Aretino as to explain some critic's attribution of K93 to Spinello.[2] The date is probably about 1400.

Provenance: Contini Bonacossi, Rome. Kress acquisition, 1930 – exhibited: National Gallery of Art, Washington, D.C. (158), 1941–51;[3] Honolulu Academy of Arts, Honolulu, Hawaii, 1952–60.[4]

References: (1) Catalogue, 1961, p. 6, as Mariotto di Nardo. (2) K93 has been attributed to Mariotto di Nardo by G. Fiocco, F. M. Perkins (in ms. opinions), W. E. Suida (see note 4, below), and B. Berenson (*Italian Pictures . . . Florentine School*, vol. I, 1963, p. 129); and to Spinello Aretino by R. Longhi, R. van Marle, and A. Venturi (in ms. opinions). (3) *Preliminary Catalogue*, 1941, pp. 124 f., as Mariotto di Nardo. (4) Catalogue by W. E. Suida, 1952, p. 14, as Mariotto di Nardo.

LORENZO DI BICCI

Florentine School, mentioned from 1370; died 1427. He collaborated with Agnolo Gaddi and Spinello Aretino and was strongly influenced by Niccolò di Pietro Gerini.

K445 : Figure 115

THE CRUCIFIXION. Allentown, Pa., Allentown Art Museum, Study Collection (60.22.KBS), since 1960. Wood. Diameter $16\frac{7}{8}$ in. (44·9 cm.). An illegible inscription extends diagonally from both sides of Christ's body. Fragment; good condition.

While closely related to Niccolò di Pietro Gerini and Orcagna's followers,[1] K445 almost duplicates the Christ and some of the angels in the *Crucifixion* in the Museum of the Collegiata at Empoli,[2] which is documented as painted by Lorenzo di Bicci in 1399. *Tondi* were a common feature in the crowning sections of Lorenzo's altarpieces; K445 may have been so used originally.

Provenance: Contini Bonacossi, Florence. Kress acquisition, 1936.

References: (**1**) In ms. opinions K445 is connected with the circle of Niccolò di Pietro Gerini by R. Longhi and F. M. Perkins; and with the Florentine School by G. Fiocco, W. E. Suida, and A. Venturi. B. Berenson (*Italian Pictures . . . Florentine School*, vol. I, 1963, p. 103) lists it as from the studio of Jacopo di Cione. (**2**) Reproduced in *Rivista d'Arte*, vol. XXVI, 1950, p. 203, fig. 3.

BICCI DI LORENZO

Florentine School. Born 1373; died 1452. The son of Lorenzo di Bicci and the father of Neri di Bicci, he appears in his early work as a follower of Agnolo Gaddi. Later he was influenced by Gentile da Fabriano's Florentine sojourn of the 1420's, and soon after 1440 he collaborated with Domenico Veneziano.

K1228 : Figure 120

THE NATIVITY. Tempe, Ariz., Arizona State University, Study Collection (101), since 1962. Wood. $6\frac{7}{8} \times 19\frac{3}{4}$ in. (17·5×50·2 cm.). Good condition.

The strong reminders of Gentile da Fabriano, especially the picturesque details of the shepherds and flock on the right, suggest a date of about 1420/30 for K1228. Like a number of other known panels by Bicci,[1] it comes from an altarpiece predella. Very close to it in composition and style is Bicci's predella panel of the same scenes – hill city with stream at left, Nativity in the middle, and shepherds at right – in the Fogg Museum, Cambridge, Massachusetts.

Provenance: Cav. Enrico Marinucci, Rome. Contini Bonacossi, Florence. Kress acquisition, 1939 – exhibited: Traveling Exhibition, University of Arizona, Tucson, Ariz., Apr.–Sept. 1960.

Reference: (**1**) W. E. Suida (in *Apollo*, vol. XX, 1934, pp. 119 f.), G. Fiocco, R. Longhi, F. M. Perkins, and A. Venturi (in ms. opinions) attribute K1228 to Bicci di Lorenzo.

Follower of BICCI DI LORENZO

K1190 : Figure 119

MADONNA AND CHILD. Nashville, Tenn., George Peabody College for Teachers, Study Collection (A-61-10-3), since 1961.[1] Wood. $27\frac{5}{8} \times 20\frac{1}{2}$ in. (70·2×52·1 cm.). Good condition.

In the early style of Bicci di Lorenzo,[2] K1190 has been considered one of his first productions; but it may well be by a follower. It was painted under the influence of Agnolo Gaddi or Giovanni del Biondo, probably soon after 1400. The *Trinity* and *Annunciation*, normally enclosed in separate compartments, are here shown in the gold field above the *Madonna of Humility*. In the predella are a *Holy Martyr*, the *Angel at the Tomb*, and *Christ and Mary in the Garden*.

Provenance: Private Collection, Milan. Contini Bonacossi, Florence. Kress acquisition, 1939 – exhibited: National Gallery of Art, Washington, D.C. (846), 1945–52, as Florentine School, *c.* 1400.

References: (**1**) Peabody Acquisitions report, 1961, p. 8, as Florentine School, *c.* 1400. (**2**) In ms. opinions, K1190 is attributed to Bicci di Lorenzo by G. Fiocco, R. Longhi, W. E. Suida tentatively, and A. Venturi, and to the late fourteenth-century Florentine School by F. M. Perkins. B. Berenson (*Italian Pictures . . . Florentine School*, vol. I, 1963, p. 215) lists it as unidentified Florentine, between 1350 and 1420, close to Bicci di Lorenzo.

SIENESE SCHOOL
XIV CENTURY

SIMONE MARTINI

Sienese School. Born *c.* 1284; died 1344. He was a pupil of Memmo di Filippuccio, the father of his brother-in-law and collaborator, Lippo Memmi. With his great frescoed *Maestà*, of 1315, Simone abandoned the Byzantine aloofness and simplicity of Duccio, dressed his holy figures in elegant brocades and jewels, and gave them the courtly movement and poses of the International Style. He was active in many cities, from Naples to Avignon and his influence dominated Sienese painting from the death of Duccio to the fifteenth century.

K405 : Figure 121

THE ANGEL OF THE ANNUNCIATION. Washington, D.C., National Gallery of Art (327), since 1941.[1] Wood. 12⅛×8½ in. (31×22 cm.). Abraded throughout, especially in flesh tones and mantle; cleaned 1955 of old restorations, which had covered worn surface.

In the 'Mostra d'Arte Antica' in Siena (1904) the beautiful little painting of the *Virgin Annunciate*, then in the Stroganoff Collection, and now in the Hermitage Museum, was made known and was immediately classified in the oeuvre of Simone Martini.[2] It was not until thirty years later that its pendant was recognized in K405. Neither panel was in good condition. Before its recent cleaning the *Angel* was disfigured by so much repainting that the attribution to Simone, though generally accepted,[3] was doubted by some critics.[4] If an alternate were to be suggested, it might be that most appealing of Simone's devoted younger contemporaries, Barna da Siena.[5] The style is, in any case, very close to that of Simone's *Annunciation*, of 1333, in the Uffizi, Florence.

Provenance: Earl of Harewood, London. Lionello Venturi, New York. Kress acquisition, 1936.

References: (**1**) *Preliminary Catalogue*, 1941, pp. 186 f., as Simone Martini. (**2**) F. M. Perkins, in *Rassegna d'Arte*, vol. IV, 1904, p. 146. (**3**) G. Fiocco, R. Longhi, W. E. Suida, A. Venturi, and L. Venturi (in ms. opinions) attributed the painting to Simone and recognized it as a pendant to the Leningrad *Virgin Annunciate.*(**4**) B. Berenson (in ms. opinion) rejected the Simone attribution but offered no alternative; G. M. Richter (in *Burlington Magazine*, vol. LXXVIII, 1941, p. 177) suggested a close follower of Simone, perhaps his brother Donato. G. Paccagnini (*Simone Martini*, 1957, p. 168) and C. Volpe (in *Paragone*, no. 63, 1955, p. 52) suggest the circle of Simone. (**5**) Pertinent stylistic parallels are Barna's frescoed *Annunciation* in San Gimignano, his *Madonna* at Asciano, and *Christ Carrying the Cross* in the Frick Collection, New York.

SIMONE MARTINI and Assistants

K1350 : Figure 122
ST. THADDEUS

K1351 : Figure 123
ST. SIMON

K1352 : Figure 124
ST. JAMES MAJOR

K1353 : Figure 125
ST. MATTHEW

Washington, D.C., National Gallery of Art (820, 821, 822, 823), since 1945. Wood. Each, 12⅛×9 in. (31×23 cm.). Inscribed: · S̄C̄S · MATHEVS ·, SANTVS SYMON, · SĀTVS · YACOBVS ·, · SANTVS · TADEVS · All in good condition.

These four panels, together with those of the other apostles – four in the Metropolitan Museum, New York; one in the Lehman Collection, New York; one from the Stoclet Collection, Brussels (sold, Sotheby's, London, June 30, 1965, no. 17); and two now unknown – must once have been associated as part of a large altarpiece. They were probably painted about 1320, the date of Simone Martini's large altarpiece from the Church of Santa Caterina, Pisa, now in the Museo Nazionale, Pisa, which offers parallels in its half-length figures of apostles. Simone may be credited with the compositions of the panels divided between Washington, New York, and Brussels; but most of the execution – except, possibly, in the case of St. Matthew – seems to have been left to assistants.[1]

Provenance: Johann Anton Ramboux, Cologne (from first half of nineteenth century). Wallraf-Richartz-Museum, Cologne (1867–shortly after 1920).[2] Philip Lehman, New York (catalogue by R. Lehman, 1928, nos. XIX, XX, XXII, XXIII, as Simone Martini). Kress acquisition, 1943.

References: (1) B. Berenson (*Central Italian Painters of the Renaissance*, 1907, p. 148), Crowe and Cavalcaselle (*A History of Painting in Italy*, Douglas ed., vol. III, 1908, p. 76), and L. Venturi, *Italian Paintings in America*, vol. I, 1933, nos. 76, 77) attribute all ten panels to Lippo Memmi. Berenson (*Italian Pictures of the Renaissance*, 1932, p. 534; Italian ed., 1936, p. 459), lists the St. Matthew as in part by Simone, and all the other panels as by his studio. F. M. Perkins (in Thieme-Becker, *Allgemeines Lexikon*, vol. XXXI, 1937, p. 67) lists the paintings in Washington among Simone's works but as largely executed by assistants. G. Coor (in *Wallraf-Richartz-Jahrbuch*, vol. XVIII, 1956, pp. 116 f.) cites all ten panels as based on compositions by Simone but executed by assistants. (2) For data on the Ramboux and Wallraf-Richartz-Museum provenance see the article by Coor cited in note 1, above.

LIPPO MEMMI

Sienese School. Active 1317–47. He was the son of the painter Memmo di Filippuccio and the brother-in-law, follower, and assistant of Simone Martini. He did not go with Simone to Avignon, but a painting found there signed with Memmi's name and dated 1347 may indicate his presence at this time.

K511 : Figure 126

ST. JOHN THE BAPTIST. Washington, D.C., National Gallery of Art (402), since 1941.[1] Wood. 37¼×18 in. (95×46 cm.). Inscribed on the saint's scroll: ECCE AGNUS DEI · ECCE Q[ui] . . . (from John I : 29). Good condition except for abrasion throughout and a few losses of paint.

Sold as by Taddeo di Bartolo in 1932,[2] K511 was soon recognized as having a close connection with Simone Martini, a number of critics attributing it to that master himself.[3] However, there have been dissenting opinions, and lately the tendency to attribute the work to Lippo Memmi has gained ground.[4] This has come about partly through a study of the painting as associated originally with a number of other extant panels, attributed to Memmi and his circle. An extensive reconstruction of the original setting[5] suggests that the panel belonged to a large polyptych, probably the one described by Vasari on the high altar of San Paolo a Ripa d'Arno: 'it included Our Lady, St. Peter, St. Paul, St. John the Baptist, and other saints; and on it Lippo inscribed his name.'[6] Following closely the style and

arrangement of Simone's still-extant polyptych of about 1320 which is now in the Museo Nazionale, Pisa, Memmi's altarpiece probably displayed from left to right: *St. Louis of Toulouse* (Pinacoteca, Siena), *St. Paul* (Metropolitan Museum, New York), *St. John the Baptist* (K511), the *Madonna and Child* (Staatliche Museen, Berlin-Dahlem; a strip below the *Madonna*, where the signature would have been, is now missing[7]), *St. John the Evangelist* (Yale University Art Gallery, New Haven, Conn.), *St. Peter* (Louvre, Paris), and *St. Francis* (Pinacoteca, Siena), all these probably by Memmi or Memmi and assistant, while above them may have been smaller panels, of which the three now known (two *Holy Hermits*, Lindenau Museum, Altenburg; *Christ Blessing*, Douai Museum) are attributed to an assistant, the Master of the Glorification of St. Thomas.[8] The date of K511 and of the whole altarpiece is probably about 1325.

Provenance: Conte Oriola (from second half of nineteenth century; sold, Amsterdam, Apr. 13, 1932, no. 3 of catalogue, as Taddeo di Bartolo). Jacques Goudstikker, Amsterdam – exhibited: 'Italian Art in Dutch Collections,' Stedelijk Museum, Amsterdam, July 1–Oct. 1, 1934, no. 222 of catalogue, as Simone Martini. Duveen's, New York (*Duveen Pictures in Public Collections of America*, 1941, no. 13, as Simone Martini). Kress acquisition, 1938.

References: (1) *Preliminary Catalogue*, 1941, p. 187, as Simone Martini. (2) See *Provenance*, above. (3) B. Berenson, G. Fiocco, R. Longhi, A. Venturi (in ms. opinions), R. van Marle (*Le Scuole della pittura italiana*, vol. II, 1934, p. 110, and in *Bollettino d'Arte*, vol. XXVIII, 1935, p. 297), and W. E. Suida (in *Pantheon*, vol. XXVI, 1940, p. 274) have attributed the painting to Simone Martini. F. M. Perkins (in ms. opinion) thought it by a gifted pupil or close follower of Simone, and R. L. Douglas (cited in *Duveen Pictures in Public Collections of America*, 1941, no. 13) thought it probably by Lippo Memmi. K. Steinweg (in *Mitteilungen des Kunsthistorischen Instituts in Florenz*, vol. VII, 1956, p. 167) referred to it as Simonesque. (4) F. Zeri (in ms. opinion) definitely rejects Simone and suggests Memmi, as does G. Coor (in *Pantheon*, vol. XIX, 1961, pp. 126 ff.). (5) Coor, *loc. cit.* in note 4, above. (6) G. Vasari, *Le Vite*, Milanesi ed., vol. I, 1878, pp. 554 f. (7) Coor, p. 134 n. 16 of *op. cit.* in note 4, above. (8) *Ibid.* The Altenburg panels are attributed tentatively to the studio of Barna da Siena by R. Oertel, *Frühe italienische Malerei in Altenburg*, 1961, pp. 75 f.

LIPPO MEMMI

K1343 : Figure 127

MADONNA AND CHILD WITH SAINTS. Kansas City, Mo., William Rockhill Nelson Gallery of Art (61–62), since 1952.[1] Wood. 13¾×10¼ in. (35×26 cm.). The

inscription on the scroll held by the Child is now illegible. Fair condition; partially cleaned 1952.

This is recognized as one of Lippo Memmi's most tender and sensitive representations of the *Madonna and Child*.[2] These characteristics, as well as the more austere conception of the half-length saints – an unidentified bishop and John the Baptist – and also the profuse, but delicate, gold tooling, point to an early date, *c.* 1325, when Lippo was closest to Simone Martini. Reproductions hitherto published show an exceedingly poor restoration of the Virgin's left hand and the Child's lower drapery. This has been removed and only necessary repair work done.

Provenance: Henri Simon, Bordeaux. Wildenstein's, New York (*Italian Paintings*, 1947, list in Introduction). Kress acquisition, 1942 – exhibited: National Gallery of Art, Washington, D.C. (812), 1945–52; after entering the William Rockhill Nelson Gallery of Art: 'Art Treasures for America,' National Gallery of Art, Washington, D.C., Dec. 10, 1961–Feb. 4, 1962, no. 67, as Lippo Memmi.

References: (**1**) Catalogue by W. E. Suida, 1952, p. 8, as Lippo Memmi. (**2**) In a ms. opinion B. Berenson has called the picture a masterpiece of the artist, an opinion in which Suida (see note 1, above) concurs. D. C. Shorr (*The Christ Child in Devotional Images*, 1954, pp. 122, 125), treating the painting as by Lippo, calls attention to the unusual motive of the Baptist pointing at the Child from the roundel above.

BARNA DA SIENA

Sienese School. Active from *c.* 1330 to *c.* 1350 or later. Barna was perhaps the most significant of the continuers of the style of Simone Martini, appreciating the profundity of that master and combining it with some of the impetuosity and intimate feeling of the Lorenzetti.

Attributed to BARNA DA SIENA

K459 : Figure 128

MADONNA AND CHILD. Portland, Ore., Portland Art Museum (61.35), since 1952.[1] Wood. 28⅜ × 16½ in. (72·1 × 41·9 cm.). Flesh tones abraded; Madonna's blue mantle much darkened.

Artists in the Simone tradition as early as Lippo Memmi and as late as Bartolo di Fredi and Paolo di Giovanni Fei have been suggested in connection with K459.[2] The most likely among those proposed would seem to be Barna, whose frescoes at San Gimignano, as well as the panel paintings attributed to him, offer stylistic parallels. The date would presumably be about 1350.

Provenance: Contini Bonacossi, Florence. Kress acquisition, 1936 – exhibited: National Gallery of Art, Washington, D.C. (362), 1941–52.[3]

References: (**1**) Catalogue by W. E. Suida, 1952, p. 42, as Lippo Memmi. (**2**) In ms. opinions R. van Marle has attributed the painting to Donato Martini; G. Fiocco and A. Venturi, to Lippo Memmi; F. M. Perkins, to an anonymous contemporary of Lippo; R. Longhi, to Paolo di Giovanni Fei; B. Berenson, to the very early period of Bartolo di Fredi. Suida (see note 1, above) calls attention to a relationship with the Lorenzetti and Barna. C. Volpe (in *Arte Antica e Moderna*, 1960, p. 155) includes the painting in the oeuvre of Barna. (**3**) *Preliminary Catalogue*, 1941, p. 134, as Lippo Memmi.

GIOVANNI DI NICOLA DA PISA

Sienese School. Mentioned definitely in 1358 and 1360, he may be the Giovanni da Pisa who is recorded also in 1326 as a pupil of Lippo Memmi in Siena. In any case he was strongly influenced by Lippo Memmi and Simone Martini, whose Oriental flavor is emphasized in the nearly Mongolian features of Giovanni's Madonnas.

K4 : Figure 129

MADONNA AND CHILD WITH ANGELS. Williamstown, Mass., Williams College Museum of Art, Study Collection (60.13), since 1960. Wood. 30¼ × 18½ in. (76·8 × 47 cm.). Excellent condition except for abrasion of Virgin's mantle; cleaned 1960.

This is the type of *Madonna of Humility* believed to have been invented by Simone Martini.[1] The composition exists in many extant versions. Among those which vary from K4 principally in showing the figures turned in the opposite direction is one in the Cà d'Oro, Venice, which may be, like K4, by Giovanni di Nicola.[2] K4 has also been attributed to Barna da Siena, who undoubtedly influenced Giovanni di Nicola.[3] It probably dates about 1360, since it carries Giovanni's mannerism further than his other known work.

Provenance: Niccolini, Florence. Contini Bonacossi, Rome. Kress acquisition, 1927 – exhibited: National Gallery of Art, Washington, D.C. (116), 1941–52.[4]

References: (**1**) M. Meiss, *Painting in Florence and Siena*, 1951, p. 133. (**2**) *Ibid.*, p. 136 n. 14. (**3**) K4 has been attributed to Barna by R. Longhi, R. van Marle, and A. Venturi (in ms. opinions), and to Giovanni di Nicola by B. Berenson, G. Fiocco, F. M. Perkins, W. E. Suida (in ms. opinions), Meiss (*op. cit.*, p. 136 n. 14), D. C. Shorr (*The Christ Child in Devotional Images*, 1954, p. 76), and E. Carli (*Pittura pisana*

del trecento, vol. II, 1961, p. 42). (4) *Preliminary Catalogue*, 1941, pp. 83 f., as Giovanni di Nicola.

AMBROGIO LORENZETTI

Sienese School. Active from 1319; died probably 1348. Perhaps younger than his brother, Pietro Lorenzetti, Ambrogio showed a stronger premonition than he of the Renaissance taste for simplicity and naturalism, a taste fostered by occasional association with the immediate followers of Giotto in Florence.

Attributed to AMBROGIO LORENZETTI

K1354 : Figure 135

MADONNA AND CHILD. El Paso, Tex., El Paso Museum of Art (1961-6/4), since 1961.[1] Wood. 20¾×13⅞ in. (52·7× 35·2 cm.). Much damaged throughout; cleaned 1955.

From its first publication, in 1920, until recently, K1354 has been cited as one of the rare genuine examples in America of the work of Ambrogio Lorenzetti,[2] with a date of about 1335/40. The poor preservation of the picture may be responsible for the present doubt regarding it. The attempted attribution to a Lorenzetti follower designated as the 'Pompana Master' is unconvincing.[3] The compact, monumental composition and the affectionate gestures of Mother and Child are, in any case, typical of Ambrogio. The frame is original, contemporary with the painting.[4]

Provenance: Philip Lehman, New York (acquired 1912, as Lippo Memmi, from a picture restorer in Florence; catalogue by R. Lehman, 1928, no. 29, as Ambrogio Lorenzetti) – exhibited: 'Collection of Mediaeval and Renaissance Paintings,' Fogg Art Museum, Cambridge, Mass., 1927, p. 102 of catalogue, as Ambrogio Lorenzetti. Kress acquisition, 1943 – exhibited: National Gallery of Art, Washington, D.C. (805), 1945-57, as Ambrogio Lorenzetti.

References: (1) Catalogue by F. R. Shapley, 1961, no. 4, as close follower of Ambrogio Lorenzetti. (2) Attributed to Ambrogio by F. M. Perkins (in *Art in America*, vol. VIII, 1920, pp. 207, 209 f.), R. van Marle (*Italian Schools of Painting*, vol. II, 1924, p. 413), G. Sinibaldi (in Thieme-Becker, *Allgemeines Lexikon*, vol. XXIII, 1929, p. 386; *I Lorenzetti*, 1933, p. 200), C. H. Weigelt (*Die Sienesische Malerei des vierzehnten Jahrhunderts*, 1930, p. 97 n. 94, and p. 114), A. Péter (in *Rivista d'Arte*, vol. XIII, 1931, p. 24), G. H. Edgell (*A History of Sienese Painting*, 1932, p. 131), B. Berenson (*Italian Pictures of the Renaissance*, 1932, p. 291;

Italian ed., 1936, p. 250), L. Venturi (*Italian Paintings in America*, vol. I, 1933, no. 83), and E. Carli (*La Pittura senese*, 1955, pp. 132 ff.). (3) G. Rowley (*Ambrogio Lorenzetti*, vol. I, 1958, pp. 44 ff.) rejects the inclusion of the painting in Ambrogio's oeuvre and attributes it to the Pompana Master. R. Offner (in *Gazette des Beaux-Arts*, vol. LVI, 1960, pp. 235 f.) notes that this attribution is unconvincing and leaves the painter anonymous. (4) According to M. Modestini.

PIETRO LORENZETTI

Sienese School. Active possibly 1306–late 1340's; died probably 1348. Pietro Lorenzetti developed under the influence of Duccio and Simone Martini. While retaining the grandeur and intensity of their style, he marks a decided advance in the treatment of space and perspective, a field in which his brother, Ambrogio, pushes forward still further.

Attributed to PIETRO LORENZETTI

K277 : Figure 130

MADONNA AND CHILD WITH SAINTS. Seattle, Wash., Seattle Art Museum (It 37/L8873.1), since 1952.[1] Wood. Middle panel, 27½×15 in. (69·9×38·1 cm.); side panels, each, 23½×12½ in. (59·7×31·8 cm.). Abrasions and small losses of paint throughout; much restored; frame original except for pinnacles; cleaned 1952-53.

In spite of its poor preservation, the picture retains, especially in the Child, such characteristics of Pietro Lorenzetti that critics have usually attributed the work to the master himself.[2] The date is probably not far from that of the Arezzo altarpiece, of 1320, with which there are fairly close parallels, while at the same time Sts. Peter and Paul, in the side panels, are still very reminiscent of Duccio. In the pinnacles are the Magdalen (?), Christ, and the Archangel Michael.

Provenance: Achillito Chiesa, Milan (sold, American Art Association, New York, Apr. 16, 1926, no. 48 of catalogue, as Pietro Lorenzetti; bought by Canessa). Private Collection, Rome (1930). Contini Bonacossi, Florence. Kress acquisition, 1934 – exhibited: National Gallery of Art, Washington, D.C. (250), 1941-51.[3]

References: (1) Catalogue by W. E. Suida, 1952, pp. 11 f., and 1954, p. 16, as Pietro Lorenzetti. (2) Attributed by E. Cecchi (*Pietro Lorenzetti*, 1930, pp. 7 ff.), B. Berenson, G. Fiocco, R. Longhi, R. van Marle, and A. Venturi (in ms. opinions) to Pietro Lorenzetti; by F. M. Perkins (in ms. opinion) to an immediate follower of Pietro; listed by E. T. DeWald (*Pietro Lorenzetti*, 1930, p. 38) as attributed to

Pietro. (3) *Preliminary Catalogue*, 1941, p. 111, as Pietro Lorenzetti.

Attributed to PIETRO LORENZETTI

K447 : Figure 131

ST. CLARE. Athens, Ga., University of Georgia, Study Collection (R-1), since 1961. Wood. Including molding, 24⅜ × 11¹³⁄₁₆ in. (61·9 × 30 cm.). Very much worn throughout.

Both Pietro Lorenzetti and the Master of the Ovile Madonna have been credited with this panel.[1] Its unsatisfactory state of preservation makes a definite attribution impossible, yet it still offers a strong reflection of Pietro's style, especially in the phase which inspired his follower or associate known as the Master of the Ovile Madonna ('Ugolino Lorenzetti'), about 1335.

Provenance: Achillito Chiesa, Milan. Contini Bonacossi, Florence (by 1933). Kress acquisition, 1936 – exhibited: National Gallery of Art, Washington, D.C. (360), 1941–54.[2]

References: (1) Attributed by A. Péter (in *La Diana*, vol. VIII, 1933, p. 176), G. Fiocco, R. Longhi, W. E. Suida, and A. Venturi (in ms. opinions) to Pietro Lorenzetti; by F. M. Perkins (in ms. opinion), tentatively, to a pupil of Pietro Lorenzetti; by B. Berenson (in ms. opinion) to 'Ugolino Lorenzetti.' (2) *Preliminary Catalogue*, 1941, p. 111, as Pietro Lorenzetti.

Follower of PIETRO LORENZETTI

K27 : Figure 141

THE CRUCIFIXION. Tulsa, Okla., Philbrook Art Center (3344), since 1953.[1] Wood. 19⅜ × 7⅞ in. (49·2 × 20 cm.). Lacunae in gold background; slightly abraded throughout.

The style of Pietro Lorenzetti's following in the mid-fourteenth century has been easily recognized in K27,[2] a plausible suggestion placing it in the group of paintings that may be attributed to the follower who is known, from a painting in the Dijon Museum, as the Master of the Dijon Triptych.[3] At the foot of the cross are Mary, St. John, and the Magdalen; in the pinnacle above is an Evangelist reading.

Provenance: Achillito Chiesa, Milan. Contini Bonacossi, Rome. Kress acquisition, 1927 – exhibited: 'Italian Paintings Lent by Mr. Samuel H. Kress,' Oct. 1932, Atlanta, Ga., through June 1935, Charlotte, N.C., p. 2 of catalogue, as Pietro Lorenzetti; National Gallery of Art, Washington, D.C. (134), 1941–52.[4]

References: (1) Catalogue by W. E. Suida, 1953, p. 10, as close follower of Pietro Lorenzetti. (2) Attributed by R. Longhi (in ms. opinion) to Pietro Lorenzetti; by B. Berenson, G. Fiocco, F. M. Perkins, and A. Venturi (in ms. opinions) to a follower of Pietro. (3) Suida (see note 1, above) makes this suggestion. E. T. DeWald (*Pietro Lorenzetti*, 1930, pp. 29 ff.) tentatively reconstructs the oeuvre of the Master of the Dijon Triptych. His figs. 80 and 86 are especially pertinent for comparison with K27. (4) *Preliminary Catalogue*, 1941, p. 112, as follower of Pietro Lorenzetti.

Follower of PIETRO LORENZETTI

K157 : Figure 133

MADONNA AND CHILD. Waco, Tex., Baylor University, Study Collection (550A), since 1961.[1] Wood. 48⁵⁄₁₆ × 22⁷⁄₁₆ in. (122·2 × 57 cm.). Losses of paint throughout.

This has usually been attributed to the following of the Lorenzetti.[2] There are also strong reminiscences of the Simone Martini and Lippo Memmi tradition, especially in the delicate gold tooling and in the type of Child. K157 probably dates from the second half of the fourteenth century.

Provenance: Contini Bonacossi, Florence. Kress acquisition, 1931 – exhibited: 'Italian Paintings Lent by Mr. Samuel H. Kress,' Oct. 1932, Atlanta, Ga., through June 1935, Charlotte, N.C., p. 3 of catalogue, as school of the Lorenzetti.

References: (1) Catalogue, 1961, no. 1, as follower of Pietro Lorenzetti. (2) Attributed, in ms. opinions, by B. Berenson, G. Fiocco, R. Longhi, R. van Marle, F. M. Perkins, and A. Venturi to the school of the Lorenzetti, and by D. C. Shorr (*The Christ Child in Devotional Images*, 1954, pp. 52 f., 55) to a follower of the Lorenzetti. G. H. Edgell (verbally) has attributed K157 to Lippo Vanni, and W. E. Suida (in ms. opinion) has given it to 'Ugolino Lorenzetti.'

Follower of PIETRO LORENZETTI

K265 : Figure 136

MADONNA AND CHILD ENTHRONED WITH ANGELS. Allentown, Pa., Allentown Art Museum (61.37.KG), since 1960.[1] Wood. 41 × 25⁵⁄₁₆ in. (104·2 × 64·3 cm.). Much abraded throughout; cleaned 1960.

The high-backed throne, of the type invented by Duccio, here seems to be based more immediately on Pietro Lorenzetti's *Madonna with Saints and Angels* in the Cathedral at

Cortona. The pose of the Child, reaching for the hem of His mother's mantle, is derived from Pietro's altarpiece in the Pieve, Arezzo. But the expressions, especially of the angels, are more lighthearted, less solemn than in Pietro; the modeling is less firm; and the color scheme is more delicate and luminous.[2] The date may be about 1360/70.

Provenance: Sir Augustus O'Kane, Dublin. Contini Bonacossi, Florence. Kress acquisition, 1933.

References: (1) Catalogue by F. R. Shapley, 1960, p. 42, as pupil of Pietro Lorenzetti. (2) The painting is attributed to a pupil of Pietro Lorenzetti by F. M. Perkins (in *La Diana*, vol. VIII, 1933, pp. 116 f.); to the Sienese School, *c.* 1350/60, in the ms. opinions of G. Fiocco, W. E. Suida, A. Venturi, and R. Longhi (Longhi suggests a follower of Pietro Lorenzetti who shows Umbrian influence in his color scheme).

Follower of PIETRO LORENZETTI

K 1224A : Figure 137
ST. ANTHONY ABBOT

K 1224B : Figure 138
ST. ANDREW

Bridgeport, Conn., Museum of Art, Science and Industry, Study Collection, since 1962. Wood. A, $12\frac{7}{8} \times 8\frac{1}{8}$ in. (32·6 × 20·7 cm.); B, $12\frac{3}{4} \times 8\frac{1}{4}$ in. (32·4 × 21 cm.). Good condition.

These two panels, from some dismembered polyptych, are clearly related to the work of Pietro Lorenzetti, to whom they have been attributed by some critics.[1] They probably date from the second half of the fourteenth century.

Provenance: Private Collection, Città di Castello. Contini Bonacossi, Florence. Kress acquisition, 1939.

Reference: (1) Attributed, in ms. opinions, to Pietro Lorenzetti by G. Fiocco and A. Venturi; to a contemporary of Pietro Lorenzetti, by W. E. Suida; and to the Sienese School, by R. Longhi and F. M. Perkins.

Follower of PIETRO LORENZETTI
(Possibly Tegliacci)

K 1237 : Figure 134

ST. JOHN THE BAPTIST. Hartford, Conn., Trinity College, Study Collection, since 1961.[1] Wood. $42\frac{3}{4} \times 17$ in. (108·6 ×

43·2 cm.). Inscribed on scroll: ECCE AGNUS DEI ECCE QUI TOLLIS PECCATA MUNDI MISERĒ NOBIS (Behold the Lamb of God; Thou Who takest away the sins of the world, have mercy upon us) – partly from John 1 : 29. Extensively abraded.

This panel, from a dismembered altarpiece,[2] has been attributed to Pietro Lorenzetti and more recently to Tegliacci.[3] Its close similarity to the Baptist in an altarpiece in the Siena Pinacoteca signed by Tegliacci and Luca di Tommè makes an attribution to one or the other of these artists reasonable, and although critics have given Luca credit for the Baptist in the signed altarpiece, the more intensely expressive character of K 1237 may be evidence of Tegliacci's hand and may indicate a date preceding 1362, when the altarpiece was dated. The Evangelist (probably St. John) in the pinnacle of K 1237 is shown winged, a rare iconographical feature.

Provenance: Private Collection, Siena. Contini Bonacossi, Florence. Kress acquisition, 1939.

References: (1) J. C. E. Taylor, in *Cesare Barbieri Courier*, vol. IV, no. 1, 1961, p. 18, as Pietro Lorenzetti or a follower. (2) W. E. Suida (in ms. opinion) states that other parts of the same polyptych are in the Siena Pinacoteca. He may refer to the four half-length saints, Pinacoteca nos. 62 and 64, attributed there to Pietro Lorenzetti; another pair of saints in this series is in the Rabinowitz Collection at Yale University. (3) G. Fiocco, R. Longhi, W. E. Suida, and A. Venturi (in ms. opinions) have attributed K 1237 to Pietro Lorenzetti; F. M. Perkins (in ms. opinion) finds it strongly influenced by Pietro. F. Zeri (in *Paragone*, no. 105, 1958, p. 10) assigns it to the early oeuvre of Tegliacci.

MASTER OF THE OVILE MADONNA ('UGOLINO LORENZETTI')

Sienese School. Active *c.* 1320–*c.* 1360. The name 'Ugolino Lorenzetti' was coined within the last half century[1] to designate an anonymous artist whose style derives from Ugolino da Siena and, especially in its later phase, from Pietro Lorenzetti. Some critics, believing two artists to be involved, connect the earlier phase with 'Ugolino Lorenzetti' and the later with the Master of the Ovile Madonna, so called from the *Madonna* in the Church of San Pietro Ovile, Siena. The stronger evidence seems to favor the association of the whole oeuvre with one artist, whether he be referred to as the Master of the Ovile Madonna or 'Ugolino Lorenzetti.' That this master may be identical with Bartolommeo Bulgarini, known from documents of 1345 to 1378, is a plausible suggestion,[2] which, however, awaits proof and general acceptance.

K 1302 : Figure 145

ST. CATHERINE OF ALEXANDRIA. Washington, D.C., National Gallery of Art (521), since 1941.[3] Wood. 29× 16½ in. (74×42 cm.). Inscribed on morse: S. KATERINA. Good condition except for abrasions throughout.

The original association of K 1302 with four other panels to form an altarpiece is witnessed by a description of the altarpiece, in 1706, in the chapel of the Monastery of San Cerbone, Lucca.[4] Two of the other four panels, the *Madonna and Child* and *St. John the Evangelist*, are now in the Pinacoteca at Lucca, where they were formerly attributed to the Lucchese artist Deodato Orlandi and later to 'Ugolino Lorenzetti';[5] and two, *St. Bartholomew* and the *Magdalen*, are now in the Capitoline Picture Gallery, Rome, where, in 1950, they were attributed to Pietro Lorenzetti or a follower.[6] In spite of the document of 1706, it is only in recent years that the original association of all five panels has been recognized.[7] Even though most critics have noted that all are Sienese work, there has been disagreement as to attribution, some giving all to Pietro Lorenzetti, some giving all to 'Ugolino Lorenzetti' or the Ovile Master.[8] The more thorough studies made of the Lorenzetti and their circle in recent years point persuasively to the Master of the Ovile Madonna ('Ugolino Lorenzetti') as author of all five panels, which would then belong toward the middle of his career, about 1335. K 1302 shows obvious similarities to Pietro Lorenzetti and is not unworthy of him in quality; but the modeling is more generalized, with more emphasis on grace than strength; the vague, musing expression contrasts with Pietro's usual dramatic intensity, and facial details, hair, fingers, and accessories are typical of the Ovile Master.

Provenance: Monastery of San Cerbone, near Lucca. Giulio Sterbini, Rome (1905).[9] Julius Böhler's, Munich (*c.* 1930). Ringling, Munich. Godefroy Brauer, Nice. Duveen's, New York (*Duveen Pictures in Public Collections of America,* 1941, no. 14, as Pietro Lorenzetti). Kress acquisition, 1940.

References: (1) B. Berenson (in *Art in America,* vol. V, 1917, pp. 259 ff.) was the first to use the designation 'Ugolino Lorenzetti' and (although in part anticipated by F. M. Perkins, in *Rassegna d'Arte,* vol. XIII, 1913, p. 9) to characterize his style. (2) M. Meiss (in *Rivista d'Arte,* vol. XVIII, 1936, pp. 113 ff.) proposes the identification. (3) *Preliminary Catalogue,* 1941, p. 111, as Pietro Lorenzetti. (4) P. da Brandeglio, *La Vita di S. Cerbone,* 1706, pp. 221 f. (cited by Meiss – see note 7, below). (5) See I. Belli, *Guida di Lucca,* 1953, pp. 123 f. (6) See S. Bocconi, *Collezioni capitoline,* 1950, p. 348. (7) M. Meiss (in *Art Bulletin,* vol. XIII, 1931, pp. 380 ff.), attributing all five panels to 'Ugolino Lorenzetti,' quotes the description of 1706. (8) K 1302 has been given to Pietro Lorenzetti by A. Venturi (see note 9, below, and *Storia dell'arte italiana,* vol. V, 1907, p. 696 n. 1), E. Jacobsen (*Sienesische Meister . . . ,* 1907, p. 41 n. 1), R. van

Marle (*Italian Schools of Painting,* 1924, vol. II, pp. 326 f.; but in Italian ed., vol. II, 1934, p. 160, to 'Ugolino Lorenzetti'), E. Cecchi (*Pietro Lorenzetti,* 1930, p. 7), and G. H. Edgell (*A History of Sienese Painting,* 1932, p. 114). It has been given to an anonymous follower of Segna di Buonaventura by E. T. DeWald (in *Art Studies,* vol. VII, 1929, p. 160 n. 2); to the Ovile Master by A. Péter (in *Rivista d'Arte,* vol. XIII, 1931, pp. 28 ff.); and to 'Ugolino Lorenzetti' by Meiss (see note 7, above), B. Berenson (in ms. opinion), and F. Zeri (in ms. opinion). (9) A. Venturi (in *L'Arte,* vol. VIII, 1905, p. 427; *La Galleria Sterbini,* 1906, pp. 33 ff., as Pietro Lorenzetti).

MASTER OF THE OVILE MADONNA ('UGOLINO LORENZETTI')

K 106 : Figure 139

ST. MARY MAGDALENE. Columbia, S.C., Columbia Museum of Art (54-402/3), since 1954.[1] Wood. 41× 17⅜ in. (104·2×44·2 cm.). Bottom of panel cut off; very good condition; cleaned 1953.

The attribution, whether under the designation of 'Ugolino Lorenzetti' or of the Ovile Master, has been fully accepted.[2] K 106 probably dates in the second half of the artist's career, about 1350. It bears much similarity, in figure type, composition, and treatment of drapery, to the Magdalen from the San Cerbone altarpiece;[3] but its later date is evidenced by its greater emphasis on three-dimensional modeling. The panel has been shortened; the figure must have been fulllength originally, as in the four panels of saints by the same master in the Museum at Pisa; however, differences in proportions and decorative details make its derivation from the same polyptych unlikely.[4]

Provenance: Stefano Bardini, Florence. Contini Bonacossi, Rome. Kress acquisition, 1930 – exhibited: 'Italian Paintings Lent by Mr. Samuel H. Kress,' Oct. 1932, Atlanta, Ga., through June 1935, Charlotte, N.C., p. 4 of catalogue, as Maestro d'Ovile; National Gallery of Art, Washington, D.C. (164), 1941–52.[5]

References: (1) Catalogue by W. E. Suida, 1954, p. 13, and by A. Contini Bonacossi, 1962, pp. 15 f., as Master of the Ovile Madonna. (2) K 106 has been attributed to the Master of the Ovile Madonna (or 'Ugolino Lorenzetti') by G. Fiocco, R. Longhi, R. van Marle, F. M. Perkins, A. Venturi (in ms. opinions), and B. Berenson (*Pitture italiane del rinascimento,* 1936, p. 253). (3) For a discussion of the San Cerbone altarpiece see K 1302 (p. 54, above). The Magdalen from that altarpiece is reproduced by M. Meiss, in *Art Bulletin,* vol. XIII, 1931, fig. 5, opposite p. 379. Compare also the *Madonna* which passed some years ago from Durlacher's to the Maitland Griggs Collection, New York

(reproduced by E. T. DeWald in *Art Studies*, vol. I, 1923, fig. 33, opposite p. 52). (**4**) Contini Bonacossi (*loc. cit.* in note I, above) suggests derivation from the same polyptych. (**5**) *Preliminary Catalogue*, 1941, p. 113, as 'Ugolino Lorenzetti.'

MASTER OF THE OVILE MADONNA ('UGOLINO LORENZETTI')

K 1045 : Figure 142

THE CRUCIFIXION. New York, N.Y., Samuel H. Kress Foundation, since 1960. Wood. $19\frac{3}{4} \times 8\frac{5}{8}$ in. ($50 \cdot 2 \times 22$ cm.). Inscribed on shield at right: S . P . Q . R (the Senate and People of Rome). Very good condition; moldings and frame original.

The style of K 1045 places it convincingly with the later work of this master, about 1350.[1] The panel was likely designed as the right wing of a diptych, the left wing probably showing the Madonna and Child and, in the pinnacle, an Angel Annunciate corresponding to the half-figure of the Virgin Annunciate in the pinnacle of K 1045.

Provenance: William Young Ottley, London. Henry Wagner, London (sold, Christie's, Apr. 17, 1936, no. 12, as Jacopo del Casentino; bought by Fenouil). Giuseppe Bellesi, London. Kress acquisition, 1936 – exhibited: National Gallery of Art, Washington, D.C. (441), 1941–51;[2] Honolulu Academy of Arts, Honolulu, Hawaii, 1952–60.[3]

References: (**1**) K 1045 has been attributed, in ms. opinions, by B. Berenson, R. Longhi, R. Offner, and W. E. Suida to 'Ugolino Lorenzetti,' or the Ovile Master. The composition of Christ and the flanking angels is closely repeated in a polyptych in the Siena Accademia which M. Meiss (in *Art Bulletin*, vol. XIII, 1931, fig. 24, opposite p. 393) attributes to the shop of 'Ugolino Lorenzetti.' (**2**) *Preliminary Catalogue*, 1941, p. 113, as 'Ugolino Lorenzetti.' (**3**) Catalogue by W. E. Suida, 1952, p. 10, as Sienese painter called the Master of S. Pietro Ovile or 'Ugolino Lorenzetti.'

Studio of the
MASTER OF THE OVILE MADONNA ('UGOLINO LORENZETTI')

K 1364 : Figure 140

MADONNA AND CHILD. Tucson, Ariz., University of Arizona (61.111), since 1951.[1] Wood. $12\frac{1}{4} \times 8\frac{1}{4}$ in. ($31 \cdot 1 \times 21$ cm.). Very good condition.

The assumption that this type of composition, known as the *Madonna of Humility*, was invented in Sienese art in a lost

painting by Simone Martini is cited under K 4 (p. 50, above), a *Madonna* by Giovanni di Nicola. Dating probably about 1350, K 1364 is then one of the early derivations from Simone's model. The profuse ornament in tooled gold is characteristic of Simone; but the lively pose of the Child and His thick body and arms are unlike the presumed prototype. They, as well as the features of the Virgin, have led to the association of K 1364 with the Master of the Ovile Madonna.[2] Its classification as studio work seems safer because of its weak, summary drawing. Presumably it was originally part of a diptych, of which the right wing is now lost.

Provenance: Dr. Padelletti, Montalcino. Philip Lehman, New York (catalogue by R. Lehman, 1928, no. 30, as 'Ugolino Lorenzetti'). Kress acquisition, 1943 – exhibited: National Gallery of Art, Washington, D.C. (806), 1945–51, as 'Ugolino Lorenzetti.'

References: (**1**) Catalogue by W. E. Suida, 1951, no. 3, as Sienese Master of *c.* 1340; 1957, no. 1, as Master of the Ovile Madonna. (**2**) F. M. Perkins (in *Art in America*, vol. VIII, 1920, pp. 283, 287) was the first to attribute K 1364 to the Master of the Ovile Madonna, whom he then called the Master of the Fogg Museum Nativity. R. van Marle (*Italian Schools of Painting*, vol. II, 1924, p. 121), B. Berenson (*Italian Pictures of the Renaissance*, 1932, p. 295; Italian ed., 1936, p. 253), and M. Meiss (*Painting in Florence and Siena*, 1951, p. 134 n. 7 – here tentatively identifying the artist as Bartolommeo Bulgarini) attribute K 1364 to the Master of the Ovile Madonna or 'Ugolino Lorenzetti,' as does D. C. Shorr (*The Christ Child in Devotional Images*, 1954, p. 104). Among the paintings of the *Madonna and Child* attributed to the Master of the Ovile Madonna, especially close parallels to K 1364 are offered by three published by M. Meiss in *Art Bulletin*, vol. XIII, 1931, as (a) from the San Cerbone altarpiece, in the Pinacoteca, Lucca (*ibid.*, fig. 1, p. 377), (b) in Mrs. Daniel Guggenheim's Collection, Port Washington, L.I., N.Y. (*ibid.*, fig. 26, p. 395), and (c) in Dr. Lanz's Collection, Amsterdam (*ibid.*, fig. 27, p. 395).

GUIDOCCIO PALMERUCCI

Umbrian School. Mentioned 1315–49, in documents which rate him as the leading artist of his time in Gubbio. No extant paintings are signed by him or definitely documented as his work, but a group of frescoes and panel paintings are reasonably attributed to him. They show the influence of the Lorenzetti as interpreted by a pleasing, provincial painter.

K M–5 : Figure 132

MADONNA AND CHILD. Cambridge, Mass., Fogg Art Museum, Study Collection (1962.158), since 1962. Wood. $50\frac{1}{2} \times 25\frac{3}{8}$ in. ($128 \cdot 3 \times 64 \cdot 5$ cm.). Very poor condition, due

largely to unsuccessful transfer to another panel at un-known date.

The strong influence of the Lorenzetti may indicate a date in the 1330's for KM-5, which was attributed to Palmerucci about forty years ago along with two similar *Madonnas*.[1] In composition and large size it is especially close to a *Madonna* formerly in the Lanz Collection, Amsterdam. But for the types of the heads a closer parallel, perhaps, is the *Madonna and Child* in a *tondo*, one of the polyptych fragments by the artist in the Pinacoteca at Gubbio.[2]

Provenance: Contini Bonacossi, Rome (1926–27). Kress acquisition, 1927 – exhibited: Metropolitan Museum of Art, New York (27.250.2), 1927–61.[3]

References: (1) R. van Marle (in *Belvedere*, no. 59, Nov. 1927, pp. 140 f.), B. Berenson (*Italian Pictures of the Renaissance*, 1932, p. 413; Italian ed., 1936, p. 355), and G. Fiocco, R. Longhi, F. M. Perkins, and A. Venturi (in ms. opinions) have attributed KM-5 to Palmerucci. (2) The Gubbio *tondo* is reproduced by R. van Marle, *Italian Schools of Painting*, vol. V, 1925, p. 89, fig. 56. (3) *Bulletin of the Metropolitan Museum of Art*, vol. XXIII, 1928, p. 91; *Catalogue of Paintings*, 1932, p. 269, and *Catalogue of Italian, Spanish, and Byzantine Paintings*, 1940, p. 82 (by H. B. Wehle), as Palmerucci.

GUIDOCCIO PALMERUCCI

K1742 : Figure 144

MADONNA AND CHILD BETWEEN TWO ANGELS, ADORED BY DONORS. Lawrence, Kans., Museum of Art, University of Kansas, Study Collection (60.43), since 1960.[1] Wood. $7\frac{3}{8} \times 8\frac{7}{8}$ in. (18·8×22·6 cm.). Fragment; good condition except for a few losses of paint; cleaned 1949.

In the Pinacoteca at Gubbio, among the fragments of a polyptych attributed to Palmerucci is a small panel of the *Annunciation* which shows the Virgin seated on just such a throne, with curved sawed-off sides, as is seen in K1742.[2] The latter painting seems more suave, more mature in style than the polyptych fragments and is perhaps to be dated in the 1340's.

Provenance: Comte de Bermudez, Toulouse, France. Contini Bonacossi, Florence. Kress acquisition, 1950 – exhibited: Birmingham Museum of Art, Birmingham, Ala., 1952–59.[3]

References: (1) Catalogue by R. L. Manning (in *Register of the Museum of Art*, vol. II, no. 4, 1960, p. 8), as Palmerucci. (2) R. Longhi (in ms. opinion) attributes K1742 to Palmerucci. See also note 3, below. (3) Catalogue by W. E. Suida, 1952, p. 13, and 1959, p. 9, as Palmerucci.

SIENESE SCHOOL
Mid-XIV Century

K1074 : Figure 143

SEVEN SAINTS. Winter Park, Fla., Morse Gallery of Art, Rollins College (38-2-P), since 1938. Wood. Each lower panel, $7 \times 4\frac{1}{2}$ in. (17·8×11·4 cm.); upper panels, left and right, each, 7×5 in. (17·8×12·7 cm.); upper panel, middle, $7\frac{3}{4} \times 5$ in. (19·7×12·7 cm.). Fair condition.

Previously classified as Tuscan, Sienese, and Riminese,[1] the panels seem to fit most satisfactorily into the Sienese School, of the mid-fourteenth century. The four apostles in the rectangular panels (only St. Bartholomew, with his knife, is definitely identified) and St. Francis and the saint at the right in the triangular panels may well have been painted by a follower of Naddo Ceccarelli,[2] who was, in turn, a follower of Simone Martini and Lippo Memmi. As was noted years ago, the larger figure in the middle pinnacle is not by the same hand as the others; it seems to be by a follower of 'Ugolino Lorenzetti,'[3] and it probably comes from a different altarpiece. The framing of the panels is new; their original arrangement is unknown.

Provenance: Contini Bonacossi, Florence. Kress acquisition, 1931.

References: (1) In ms. opinions R. Longhi has classified K1074 as Tuscan; W. E. Suida, as Riminese; and G. Fiocco, R. van Marle, F. M. Perkins, and A. Venturi, as Sienese. (2) Compare Ceccarelli's polyptych no. 115 in the Pinacoteca, Siena. (3) This was noted by R. Longhi (in ms. opinion).

SIENESE SCHOOL
c. 1370

K2142 : Figure 146

MADONNA AND CHILD, THE CRUCIFIXION, AND SAINTS. Raleigh, N.C., North Carolina Museum of Art (GL.60.17.6), since 1960.[1] Wood. Middle panel, including molding, $15\frac{1}{4} \times 10\frac{1}{8}$ in. (38·8×25·7 cm.); left wing, $15 \times 5\frac{1}{4}$ in. (38·1×13·4 cm.); right wing, $15 \times 4\frac{7}{8}$ in. (38·1× 12·4 cm.). Inscribed, at bottom of middle panel: SCA . CATELINA SCA . AGNES (St. Catherine; St. Agnes). Fair condition except for much abrasion in Child's face; Franciscan saint kneeling under Crucifix is fifteenth-century work.

That the painter of K2142 derives appreciably from Pietro Lorenzetti is most evident in the facial type of the Madonna. Further study may identify the painter as Francesco di

Vannuccio (active 1361–88), who signed the small reliquary-like panel of the *Crucifixion*, dated 1370, in the Berlin Museum. Striking parallels may be traced also in Francesco's *Crucifixion* in the Johnson Collection of the Philadelphia Museum, where the unusual detail of the Virgin's folded hands in the middle panel of K2142 is repeated in the St. John. Like the few paintings which have been attributed to this master, K2142 is small, is profusely decorated with stamped patterns in the halos and borders of the gold-leaf background, and exhibits an attempt to express strong emotion in pose and facial expression. The saints in the left wing are Anthony Abbot and John the Baptist.

Provenance: Comtesse De Missiessi, Bordeaux, France. International Financing Co., S.A., Panama City. Kress acquisition, 1957.

Reference: (1) Catalogue by F. R. Shapley, 1960, p. 28, as Sienese, *c.* 1370, circle of Pietro Lorenzetti.

LIPPO VANNI

Sienese School. Active 1341–75. Lippo Vanni was a follower of Simone Martini, Lippo Memmi, and of the Lorenzetti. Documents show that he was often active as miniature painter, and his known work in this medium has a charming freedom of execution. Reconstruction of his oeuvre is of fairly recent date, a triptych signed and dated 1358 (Monastery of Santi Domenico e Sisto, Rome) serving as touchstone for his panel paintings.

K1355 A,B,C : Figures 147–149

MADONNA AND CHILD WITH DONORS AND ST. DOMINIC AND ST. ELIZABETH OF HUNGARY. Coral Gables, Fla., Joe and Emily Lowe Art Gallery, University of Miami (61.24A, B and C), since 1961.[1] Wood. Middle panel, 49×31¼ in. (124·5×79·4 cm.); side panels, each, 38¾×20¼ in. (98·5×51·5 cm.). Inscribed on the Virgin's halo: VIRGINIS INTACTE . . . (Virgin untouched . . .); on St. Dominic's halo: BEATUS DOMINICUS . . . (the Blessed Dominic . . .); on St. Elizabeth's halo: SCA ELISABETTA FILIA REG (St. Elizabeth, daughter of a king). Fair condition.

The similarity of this altarpiece, in composition and in figure types, to the signed and dated (1358) triptych in Santi Domenico e Sisto, Rome, supports the attribution to Lippo Vanni. This has been accorded general approval over the last fifty years.[2] A more fascinating problem is that of the identification of the donors, who kneel at the feet of the Madonna. The French fleurs-de-lis on the dress of one of these, together with the presence of St. Elizabeth of Hungary in the adjacent side panel, would seem to indicate a connec-

tion with the Anjou dynasty in Hungary. Ludwig I, the Great (1326–82), and his wife, Queen Elizabeth, have been proposed.[3] This King of Hungary was a prince of the French House of Anjou and was active in Italian political affairs.[4] There has also been an attempt to identify the donors as King Ludwig's mother, Queen Elizabeth of Hungary, and his brother Andreas, who married Giovanna of Naples.[5] The triptych would then presumably date from the year of the Queen's visit to Italy, 1343, in Lippo Vanni's early period.

Provenance: Torrini, Siena. Dormer Fawcus, Quinto al Mare, near Genoa. Philip Lehman, New York (catalogue by R. Lehman, 1928, no. XXXII, as Lippo Vanni). Kress acquisition, 1943 – exhibited: National Gallery of Art, Washington, D.C. (828, 829, 830), 1946–52, as Lippo Vanni; William Rockhill Nelson Gallery of Art, Kansas City, Mo., 1952–60,[6] as Lippo Vanni.

References: (1) Catalogue by F. R. Shapley, 1961, p. 20, as Lippo Vanni. (2) B. Berenson (in *Gazette des Beaux-Arts*, vol. IX, 1924, p. 280; *Studies in Medieval Painting*, 1930, pp. 57 f.; *Italian Pictures of the Renaissance*, 1932, p. 588; Italian ed., 1936, p. 506) includes the triptych among Lippo Vanni's paintings and gives credit to De Nicola for first recognizing it as his work. R. van Marle (*Italian Schools of Painting*, vol. II, 1924, pp. 324 ff.) calls it the work of a transition artist between Duccio and Pietro Lorenzetti which accords closely with the latter's earliest style. L. Venturi (*Italian Paintings in America*, vol. I, 1933, no. 99), and G. H. Edgell (*A History of Sienese Painting*, 1932, p. 153) find the attribution to Lippo Vanni reasonable. (3) A. M. Frankfurter, in *Art News*, 1946, p. 38. (4) In a letter dated in 1947 from the Director of the Musée Hongrois, Budapest, reference is made to certain knowledge of a connection between Lippo Vanni and Ludwig the Great; this reference has not been clarified. (5) W. E. Suida, in *Gazette des Beaux-Arts*, vol. XXXIII, 1948, pp. 201 ff. (6) Catalogue by W. E. Suida, 1952, p. 12, as Lippo Vanni.

ANDREA VANNI

Sienese School. Born possibly 1332; died *c.* 1414. The first definite notice of Andrea Vanni mentions his sharing a studio with Bartolo di Fredi in 1353. He was a follower of Simone Martini and seems at times especially close to Lippo Memmi and Barna da Siena.

K233 : Figure 156

THE ADORATION OF THE MAGI. New Orleans, La., Isaac Delgado Museum of Art (61.61), since 1953.[1] Wood. 16×30½ in. (40·6×77·5 cm.). Good condition except for a few abrasions.

That K233, probably from the predella of a large altarpiece, is the work of Andrea Vanni has not been doubted.[2] Parallels with the signed triptych in the Corcoran Gallery, Washington, D.C., have been noted; but while the latter is believed to date from Andrea's Neapolitan period, the late 1370's or early '80's,[3] the more Simonesque figure and facial types and gold tooling in K233 point to an earlier date, perhaps in the 1360's.[4]

Provenance:[5] Mr. Blayds (early nineteenth century). J. Fuller Russell – exhibited: 'Art Treasures,' Manchester, England, 1857, no. 35, as Bartolo di Fredi; Royal Academy, London, 1878, no. 202, as Bartolo di Fredi. Russell sale, Apr. 18, 1885, no. 103 (bought by Carrington). Hugh B. Carrington (sold, Dec. 18, 1931, no. 87, as Bartolo di Fredi, bought by Vitale Bloch). Contini Bonacossi, Florence. Kress acquisition, 1932 – exhibited: National Gallery of Art, Washington, D.C. (222), 1941–52.[6]

References: (1) Catalogue by W. E. Suida, 1953, p. 10, as Andrea di Vanni. (2) B. Berenson, G. Fiocco, R. Longhi, R. van Marle, F. M. Perkins, A. Venturi (in ms. opinions) attribute the painting to Andrea Vanni. (3) See R. van Marle (*Italian Schools of Painting*, vol. II, 1924, p. 444, figs. 290 f., for reproductions of the Corcoran triptych and discussion of its dating. (4) Longhi (in ms. opinion) dates K233 *c.* 1360. (5) E. K. Waterhouse has kindly supplied most of the provenance data. (6) *Preliminary Catalogue*, 1941, p. 208, as Andrea Vanni.

ANDREA VANNI

K1234 : Figure 154

THE MOURNING MADONNA. Madison, Wis., University of Wisconsin, Study Collection (61.4.10), since 1961.[1] Wood. 21⅜×10¼ in. (54·3×26 cm.). Extensively restored throughout; background repainted.

Although cruder in execution than Andrea Vanni's representative work, K1234 – evidently once part of a large *Crucifixion* – finds a sufficiently close parallel in the *Crucifixion* triptych generally accepted as by Vanni in the Accademia, Siena. The latter is believed to date 1396; perhaps this is a decade or more later than K1234, in which sorrow is more poignantly expressed.[2]

Provenance: Palmieri-Nuti, Siena. Aldo Noseda, Milan. Contini Bonacossi, Florence (1939). Kress acquisition, 1939 – exhibited: National Gallery of Art, Washington, D.C. (872), 1945–52, as Andrea Vanni.

References: (1) Catalogue, 1961, as Andrea Vanni. (2) G. Fiocco, R. Longhi, F. M. Perkins, W. E. Suida, and A. Venturi (in ms. opinions) have attributed K1234 to Andrea

Vanni. A good parallel is offered by Andrea Vanni's *St. Francis* in the Lindenau Museum, Altenburg (reproduced in *Bollettino d'Arte*, vol. XLVI, 1961, p. 222, fig. 9).

ANDREA VANNI

K1007 : Figure 155

ST. CLARE. Claremont, Calif., Pomona College, Study Collection (61.1.3), since 1961. Wood. 56⅜×19¼ in. (143·2× 48·9 cm.). Drapery and vase much damaged and restored; gold background completely false.

If by Andrea Vanni himself, as opinion has urged,[1] K1007 must date late in his career, toward 1400, when his figures had become comparatively rigid and stereotyped. The motive of the composition may be the saint's blessing of the loaves.

Provenance: Spina, Rome. Contini Bonacossi, Florence. Kress acquisition, 1936 – exhibited: National Gallery of Art, Washington, D.C. (434), 1941–52.[2]

References: (1) G. Fiocco, R. Longhi, F. M. Perkins, W. E. Suida, A. Venturi (in ms. opinions), and R. van Marle (*Le Scuole della pittura italiana*, vol. II, 1934, p. 482 n. 2 – at this time for sale in Florence and referred to as a *Holy Nun*) give the painting to Andrea Vanni, as does B. Berenson (in ms. opinion) tentatively. (2) *Preliminary Catalogue*, 1941, p. 208, as Andrea Vanni.

NICCOLÒ DI SER SOZZO TEGLIACCI

Sienese School. First mentioned 1348; died 1363. Two signed works have served as touchstones for a considerable representation of this master as both miniaturist and panel painter. He was strongly influenced by Simone Martini and Pietro Lorenzetti, emulating the former especially in his abundant use of gold ornament and light color harmonies, which distinguish his work from that of his more somber collaborator, Luca di Tommè.

K1085 : Figure 150

MADONNA AND CHILD WITH ANGELS. Tucson, Ariz., University of Arizona (61.149), since 1961. Wood. 48½× 27½ in. (123×70 cm.). Much restored and heavily varnished.

The painting has been cut down from a full-length *Enthroned Madonna* such as that shown on the middle panel of the polyptych in the Accademia, Siena, which Tegliacci

and Luca di Tommè signed as collaborators and dated 1362. Luca is now believed to have had no share in the middle panel, with which K1085 shows such striking resemblance as to establish its place in Tegliacci's work of about 1360.[1] While the delicate patterns of gold brocade recall Simone Martini, the facial types clearly derive from Pietro Lorenzetti. K1085 has been cited for an iconographical detail, the pomegranate, rare at this early date in a *Madonna and Child*; especially rare is the inclusion of the twig with the fruit.[2]

Provenance: Baron Arthur de Schickler, Martinvast, France. Comtesse Hubert de Pourtalès, Paris. Duveen's, New York (*Duveen Pictures in Public Collections of America*, 1941, no. 23, as Luca di Tommè) – exhibited: Wadsworth Atheneum, Hartford, Conn., 1932, no. 13; 'Sixteenth Loan Exhibition of Old Masters,' Detroit Institute of Arts, Detroit, Mich., no. 46 of catalogue, 1933, as Bartolo di Fredi. Kress acquisition, 1937 – exhibited: National Gallery of Art, Washington, D.C. (453), 1941–51;[3] William Rockhill Nelson Gallery of Art, Kansas City, Mo., 1952–60.[4]

References: (**1**) B. Berenson, F. M. Perkins (in ms. opinions), and L. Venturi (*Italian Paintings in America*, vol. I, 1933, no. 103), attribute the painting to Luca di Tommè; D. C. Shorr (*The Christ Child in Devotional Images*, 1954, pp. 184 f.) attributes it to a follower of Luca di Tommè; A. Venturi (in ms. opinion), to Vitale da Bologna; M. Meiss (*Painting in Florence and Siena*, 1951, p. 169; in *Art Bulletin*, vol. XLV, 1963, p. 47) and F. Zeri (in *Paragone*, no. 105, 1958, pp. 9, 11) give it to Tegliacci. (**2**) U. Schlegel, in *Mitteilungen des Kunsthistorischen Instituts in Florenz*, vol. XI, 1964, p. 68 n. 19, accepting Shorr's attribution to a follower of Luca di Tommè. (**3**) *Preliminary Catalogue*, 1941, p. 117, as Luca di Tommè. (**4**) Catalogue by W. E. Suida, 1952, p. 10, as Tegliacci.

LUCA DI TOMMÈ

Sienese School. Active 1356–89. There are signed and dated pictures from only 1362 to 1370. His earlier, more awkward style seems to have depended on Pietro Lorenzetti and his later, more graceful style, partly on Simone Martini. He collaborated in at least one altarpiece (dated 1362) with Niccolò di Ser Sozzo Tegliacci,[1] but his coloring is heavier and his mood more solemn than that of the earlier master.

K34 : Figure 157

THE CRUCIFIXION. San Francisco, Calif., M. H. De Young Memorial Museum (61.44.3), since 1955.[2] Wood. 16⅛×23½ in. (41×59.7 cm.). Inscribed on a shield at right: SP[qr] (the Senate and People of Rome). Excellent condition except for slight damage in gold background; cleaned 1954.

Originally the middle panel, most likely, of an altarpiece predella, K34 is characteristic in every detail of Luca di Tommè.[3] Its approximate date is determined by its very close relationship stylistically and in figure types to one of the artist's most important paintings, the *Crucifixion* in the Museo Civico, Pisa, signed, and dated 1366. A panel with the *Adoration of the Magi* in the Robert von Hirsch Collection, Basel, has been recognized as coming from the same predella as K34.[4]

Provenance: Achillito Chiesa, Milan. Contini Bonacossi, Rome. Kress acquisition, 1927 – exhibited: 'Italian Paintings Lent by Mr. Samuel H. Kress,' Oct. 1932, Atlanta, Ga., through June 1935, Charlotte, N.C., p. 5 of catalogue, as Luca di Tommè; National Gallery of Art, Washington, D.C. (136), 1941–51.[5]

References: (**1**) See the commentary on Tegliacci's *Madonna*, K1085 (p. 58, above). (**2**) Catalogue by W. E. Suida, 1955, p. 32, as Luca di Tommè. (**3**) Attributed to Luca di Tommè by G. Fiocco, R. Longhi, F. M. Perkins, A. Venturi (in ms. opinions), B. Berenson (in *Dedalo*, 1930, pp. 274 f.; in *International Studio*, Nov. 1930, p. 27; *Pitture italiane del rinascimento*, 1936, p. 269). (**4**) M. Meiss, in *Art Bulletin*, vol. XLV, 1963, p. 48. He believes the panels to be by Luca di Tommè. (**5**) *Preliminary Catalogue*, 1941, p. 117, as Luca di Tommè.

LUCA DI TOMMÈ

K1741 : Figure 151

CHRIST BLESSING. Raleigh, N.C., North Carolina Museum of Art (GL.60.17.5), since 1960.[1] Wood. 22⅞×13¼ in. (58.1×33.7 cm.). Inscribed on open book: EGO SVM VIA · VERITAS · ET VITA · QVI · CREDIT · IN ME · (conflation of parts of John 14 : 6 and 11 : 25). Good condition except for a few abrasions; cleaned 1949.

A blending of the characteristics of Pietro Lorenzetti with those of Simone Martini and also the smoky chiaroscuro in the face of Christ relate K1741 to Luca di Tommè's polyptych of St. Anne (in the Pinacoteca, Siena), which is signed and dated 1367. Such a panel as K1741 must originally have occupied the crowning pinnacle of that altarpiece in place of the St. Andrew, which Cavalcaselle[2] (inadvertently calling the saint Bartholomew) long ago noted as a substitution by another artist for a figure of Christ Blessing. K1741 would have been more appropriate in size than the much smaller panel of St. Andrew. But the careful measurements kindly transmitted by Professor E. Carli indicate that unless the framework has been altered the middle pinnacle is slightly too small to have accommodated K1741.[3]

Provenance: A convent in Siena. Contini Bonacossi, Florence. Kress acquisition, 1950 – exhibited: National Gallery of Art, Washington, D.C., 1951;[4] University of Arizona, Tucson, Ariz., 1951–57.[5]

References: (1) Catalogue by F. R. Shapley, 1960, p. 26, as Luca di Tommè. (2) Crowe and Cavalcaselle, *A History of Painting in Italy*, R. L. Douglas, ed., vol. III, 1908, p. 87, for discussion of the St. Anne altarpiece. (3) Professor E. Carli concurs, however, in the attribution of K1741 to Luca di Tommè. B. Berenson and R. Longhi (in ms. opinions) attribute it to Luca di Tommè, as does W. E. Suida in the catalogues cited in notes 4 and 5, below. (4) *Paintings and Sculpture from the Kress Collection*, 1951, p. 273 (catalogue by W. E. Suida), as Luca di Tommè. (5) Catalogue by W. E. Suida, 1951, no. 1, as Luca di Tommè.

LUCA DI TOMMÈ

KM-4 : Figure 152

MADONNA AND CHILD. Ponce, Puerto Rico, Museo de Arte de Ponce, Study Collection (64.0270), since 1964. Wood. $58\frac{1}{2} \times 24\frac{1}{2}$ in. (148.6×62.2 cm.). Inscribed on the Child's scroll: EGO · SVM · LVX · MVNDI (from John 8 : 12). Extensively abraded, especially Virgin's mantle; decoration of frame not original; cleaned 1963.

The attribution of KM-4 to Luca di Tommè is never doubted.[1] The painting falls perfectly into the style of his later work, when the influence of the more forceful Pietro Lorenzetti was modified by the suave grace of Simone Martini. KM-4 was probably painted about 1370, the date inscribed on the Rieti altarpiece. It is very close in shape and composition to the middle panel of the Rieti polyptych[2] and must originally have had a similar setting.

Provenance: Contini Bonacossi, Rome. Kress acquisition, 1927 – exhibited: Metropolitan Museum of Art, New York, 1928–61 (28.179).[3]

References: (1) R. van Marle (*Italian Schools of Painting*, vol. V, 1925, p. 462), G. Fiocco, R. Longhi, F. M. Perkins, W. E. Suida, A. Venturi (in ms. opinions), H. B. Wehle (in *Bulletin of the Metropolitan Museum of Art*, vol. XXIV, 1929, pp. 9 f.), and B. Berenson (in *Dedalo*, vol. XI, 1930, p. 273; in *International Studio*, Nov. 1930, p. 27; *Italian Pictures of the Renaissance*, 1932, p. 313, and Italian ed., 1936, p. 269) attribute KM-4 to Luca di Tommè. (2) Reproduced by van Marle, *op. cit.*, vol. II, 1924, p. 470, fig. 306. (3) Catalogue by H. B. Wehle, 1940, pp. 80 f., as Luca di Tommè.

LUCA DI TOMMÈ

K69 : Figure 153

MADONNA AND CHILD WITH ST. NICHOLAS AND ST. PAUL. Los Angeles, Calif., Los Angeles County Museum of Art (A.2531.31-1), since 1931.[1] Wood. $52\frac{1}{4} \times 45\frac{1}{8}$ in. (132·7×114·6 cm.). Inscribed on the scroll held by the Christ Child: EGO · SVM · LVX · MVNDI (from John 8 : 12); and beneath the saints, their names: S. NICOLAVS and S. PAVLV[s]. Fair condition.

The place of honor given St. Paul suggests that K69 may be the painting referred to in a Sienese document as an altarpiece in honor of St. Paul and the Sienese victory over the mercenary company of the Cappellucci, a painting which was executed by Luca di Tommè in 1373 by order of the general council of Siena.[2] This late date would be suitable for K69, since the modeling of the figures seems somewhat less firm than we find it in Luca's paintings of the 1360's, more nearly comparable to the style of the altarpiece in the Pinacoteca at Rieti, which is signed by Luca and dated 1370. Further, the composition of the *Madonna and Child* in the Rieti example is repeated in K69 with only slight variations.

Provenance: Charles Fairfax Murray, London. Contini Bonacossi, Rome. Kress acquisition, 1930 – exhibited, after entering the Los Angeles County Museum of Art: Scripps College, Claremont, Calif., Nov. 1952–Jan. 1953; Municipal Art Center, Long Beach, Calif., Jan.–Feb. 1956.

References: (1) Catalogue by P. Wescher, 1954, no. 4, p. 11, as Luca di Tommè. See also *California Arts and Architecture*, June 1931, p. 8; *Antiquarian*, June 1931, p. 39; and *International Studio*, July 1931, p. 49. (2) The possible connection of K69 with the document of 1373 is suggested by Wescher (see catalogue cited in note 1, above). F. M. Perkins (in *Art in America*, vol. VIII, 1920, p. 292 n. 12; and in Thieme-Becker, *Allgemeines Lexikon*, vol. XXIII, p. 427) lists K69 as by Luca di Tommè. R. Longhi (in ms. opinion), attributing the painting to Luca, suggests a date of about 1375. G. Fiocco, W. E. Suida, and A. Venturi (in ms. opinions) also attribute K69 to Luca di Tommè.

Studio of LUCA DI TOMMÈ

K373 : Figure 158

THE CONVERSION OF ST. PAUL. Seattle, Wash., Seattle Art Museum (It 37/Sp465.1), since 1952.[1] Wood. $12\frac{3}{8} \times 15\frac{1}{4}$ in. (31·4×38·7 cm.). Inscribed diagonally across center, from Christ to St. Paul: SAVLE · SAVLE · CVR · ME · PESEQERIS · [*sic*] · (from Acts 9 : 4); on the shields: SPQR (the Senate and People of Rome). Generally good condition except for a few abrasions.

That K373 has been connected with such various artists as Spinello Aretino, Luca di Tommè, and Lippo Vanni, gives some indication of the interchange of influences among the early Tuscan schools.[2] Apparently from the same predella as K373 are two panels in the Siena Pinacoteca which for more than a century have usually been attributed to Spinello Aretino or his school but more recently to an associate of Luca di Tommè. They represent *St. Paul Preaching* and *St. Paul Led to His Martyrdom*.[3] A fourth panel, representing the *Beheading of St. Paul*, is in the Christian Museum of Esztergom, Hungary (no. 55.156). Its subject marks it as the last in the series, while K373 would have been the first.[4] The date may be about 1380/90.

Provenance: Contini Bonacossi, Florence. Kress acquisition, 1935 – exhibited: National Gallery of Art, Washington, D.C. (319), 1941–51.[5]

References: (1) Catalogue by W. E. Suida, 1952, p. 12, and 1954, p. 26, as close follower of Spinello Aretino. (2) In ms. opinions, R. Longhi and A. Venturi incline toward Lorenzo di Bicci as painter of K373; G. Fiocco, toward Giovanni dal Ponte; R. van Marle and F. M. Perkins class it close to Spinello Aretino; B. Berenson suggests Lippo Vanni; M. Meiss (*Painting in Florence and Siena*, 1951, p. 34 n. 84; also in *Art Bulletin*, vol. XLV, 1963, p. 47 n. 7) suggests an associate of Luca di Tommè; see also note 3, below. (3) C. Brandi (*La Regia Pinacoteca di Siena*, 1933, pp. 365 f., nos. 117 f.) attributes the two paintings in Siena tentatively to Spinello Aretino; but E. Carli (in his 1961 guide to the Siena Pinacoteca) assigns them to an associate of Luca di Tommè. Better reproductions of the two Siena panels appear in G. Kaftal, *Iconography of the Saints in Tuscan Painting*, 1952, figs. 883 f. (4) M. Boskovits, who has kindly sent a photograph of the Esztergom panel, writes that he accepts the attribution of the series to an associate of Luca di Tommè and that he plans to devote an article to the panels soon, along with others attributable to the same associate of Luca di Tommè. (5) *Preliminary Catalogue*, 1941, pp. 208 f., as Lippo Vanni.

PAOLO DI GIOVANNI FEI

Sienese School. Mentioned from 1369; died 1411. Fei was so strongly influenced by Bartolo di Fredi that it is sometimes difficult to distinguish between the paintings of the two artists. The influence of Simone Martini is important in Fei's most attractive paintings.

K1547 : Figure 160

THE ASSUMPTION OF THE VIRGIN. Washington, D.C., National Gallery of Art (1623), since 1951.[1] Wood. $26\frac{1}{4} \times$ 15 in. (66·7×38·1 cm.). Very good condition; cleaned 1949.

The superior technique and the serious facial expressions, recalling Simone Martini, have ranked this brightly colored painting high in the artist's oeuvre.[2] It probably dates from about 1385.[3] For Fei's emulation of Bartolo di Fredi compare K1547 with Bartolo's *Assumption* in the Musée Ile-de-France, St.-Jean-Cap-Ferrat.[4]

Provenance: Marchese Chigi-Zondadari, Siena – exhibited: 'Quattrocento Pitture Inedite,' Venice, 1947, no. 23, pl.12, as Paolo di Giovanni Fei. Contini Bonacossi, Florence. Kress acquisition, 1948.

References: (1) *Paintings and Sculpture from the Kress Collection*, 1951, p. 40 (catalogue by W. E. Suida), as Fei. (2) R. L. Douglas (in Crowe and Cavalcaselle, *A History of Painting in Italy*, vol. III, 1908, p. 131 n. 3) lists K1547 as noteworthy for its beauty among Fei's paintings. R. Longhi (in ms. opinion) and F. M. Perkins (in *Rassegna d'Arte*, vol. I, 1914, p. 99) consider it one of Fei's finest productions. B. Berenson (*Italian Pictures of the Renaissance*, 1932, p. 184; Italian ed., 1936, p. 159) lists it as by Fei. (3) R. van Marle (*Italian Schools of Painting*, vol. II, 1924, pp. 529, 531) seems to agree with such a dating; he cites the panel for its charm and technical fineness. M. Mallory (in *Art Bulletin*, vol. XLVI, 1964, p. 530) dates it after 1400. (4) Reproduced by M. Meiss, in *Scritti di storia dell'arte in onore di Mario Salmi*, vol. II, 1962, p. 77.

PAOLO DI GIOVANNI FEI

K38 : Figure 162

CHRIST ON THE ROAD TO CALVARY. Memphis, Tenn., Brooks Memorial Art Gallery (61.188), since 1960. Canvas on wood.[1] $10\frac{1}{2} \times 8\frac{3}{8}$ in. (26·7×21·3 cm.). Good condition except for extensive abrasion; cleaned 1957.

So reminiscent of Simone Martini's Louvre painting of the same subject that it was at one time attributed to that master, K38 has more recently been recognized as characteristic of Fei.[2] It probably dates from about the same time (c. 1385) as K1547, *The Assumption of the Virgin* (Fig. 160), which it resembles in figure types, fineness of execution, and lobular termination.

Provenance: Giulio Sterbini, Rome.[3] Contini Bonacossi, Rome. Kress acquisition, 1927 – exhibited: National Gallery of Art, Washington, D.C. (137), 1941–52.[4]

References: (1) A. Venturi (*La Galleria Sterbini in Roma*, 1906, pp. 26 ff., no. 4, as Simone Martini) says that, according to an inscription on the back, the painting was transferred from wood to canvas in 1714 by Domenico Michelini. (2) R. van Marle (*Le Scuole della pittura italiana*, vol. II, 1934, p. 257 n. 1), disagreeing with Venturi's 1906 attribution to Simone

Martini, suggests the Bolognese School. But later (in ms. opinions) van Marle and Venturi, as well as B. Berenson, G. Fiocco, R. Longhi, F. M. Perkins, and W. E. Suida, attribute the painting to Fei. (3) See note 1, above. (4) *Preliminary Catalogue*, 1941, p. 63, as Fei.

PAOLO DI GIOVANNI FEI

K2045 : Figure 159

THE PRESENTATION OF THE VIRGIN. Washington, D.C., National Gallery of Art (1361), since 1956.[1] Transferred from wood to masonite. $57\frac{7}{8}$ (center) $\times 55\frac{1}{4}$ in. ($147\cdot1 \times 140\cdot4$ cm.). Fair condition except for abrasion throughout and some losses of paint.

Formerly considered to be a late work by Bartolo di Fredi, K2045 is now convincingly classified among the paintings by Fei,[2] dating, perhaps, about 1400. Several documents from the end of the fourteenth century and later in the Siena archives have recently been cited as indicating the probability that in 1398 Fei was engaged in painting K2045 as the middle panel of an altarpiece for the Chapel of St. Peter in the Cathedral of Siena, an altarpiece in which K2045 was flanked by figures of Sts. Peter and Paul, while figures of lesser importance also were included, possibly in predella and frame.[3] In composition, as well as in figure types, K2045 is very close to Fei's masterpiece, *The Birth of the Virgin*, in the Pinacoteca, Siena. The pairs of large-size figures at right and left in both paintings could easily be confused with figures by Bartolo di Fredi. But the bevy of young girls at upper right in K2045 are of the same appealing type as Fei's *Madonna of Humility* in the Cathedral, Siena. The group of kneeling figure and two small children, perhaps the donor and family, are modeled on Taddeo Gaddi's fresco of the *Presentation* in the Baroncelli Chapel in Santa Croce, Florence, or on his drawing in the Louvre, Paris.[4] Anna and Joachim, in the left foreground of K2045, also follow Gaddi; but in K2045 the Virgin is already in the sanctuary with the High Priest and his attendant, although she still looks back at her parents, as she does from a lower step in Gaddi's composition. The architecture of the temple may be based on Ambrogio Lorenzetti's *Presentation of Christ in the Temple*, in the Uffizi, Florence.

Provenance: Probably Chapel of St. Peter, Siena Cathedral. H. M. Clark, London – exhibited: 'The *Daily Telegraph* Exhibition of Antiques and Works of Art,' Olympia, London, July 19–Aug. 1, 1928 (p. 162 of catalogue, as Bartolo di Fredi). Edward Hutton, London. Wildenstein's, New York. Kress acquisition, 1954.

References: (1) *Paintings and Sculpture from the Kress Collection*, 1956, pp. 28 f. (catalogue by W. E. Suida and F. R. Shapley),

as Bartolo di Fredi. (2) B. Berenson (in ms. opinion) has attributed the painting to Bartolo di Fredi. M. Meiss (*Painting in Florence and Siena*, 1951, p. 28 n. 58), E. Carli (in ms. opinion), and M. Mallory (in *Art Bulletin*, vol. XLVI, 1964, pp. 529 ff., mistakenly stating that it was at this time labeled Bartolo di Fredi in the National Gallery), give it to Fei. (3) Mallory, *loc. cit.* in note 2, above. (4) See Meiss, *loc. cit.* in note 2, above, and his fig. 32.

PAOLO DI GIOVANNI FEI

K187 : Figure 161

MADONNA AND CHILD WITH TWO ANGELS, ST. FRANCIS AND ST. LOUIS OF TOULOUSE. Atlanta, Ga., Atlanta Art Association Galleries (58.42), since 1958.[1] Wood. $70\frac{1}{8} \times 50\frac{5}{8}$ in. ($178\cdot2 \times 128\cdot6$ cm.). Inscribed on the Child's scroll: EGO SVM LVX MV[ndi] (from John 8 : 12); and on the base of the throne: MCCCXXXIII. Some losses of paint in Madonna's face, in some of robes, and in floor; cleaned 1957.

The inscribed date is old;[2] but the style of the painting points to about 1400;[3] stylistic parallels are offered by some of the figures in the *Presentation of the Virgin* (K2045; Fig. 159).

Provenance: Paolo Paolini, Rome. Contini Bonacossi, Florence. Kress acquisition, 1931 – exhibited: National Gallery of Art, Washington, D.C. (193), 1941–52.[4]

References: (1) Catalogue by W. E. Suida, 1958, p. 12, as Fei. (2) According to the restorer M. Modestini. There are also illegible remnants of an older inscription here and on the left edge of the pedestal on which the saints kneel. (3) E. Cecchi (in *Vita Artistica*, vol. II, 1927, pp. 70 f.) attributes K187 to Fei's late period, while R. Longhi (in ms. opinion) fits it into his oeuvre of about 1380. R. van Marle (*Le Scuole della pittura italiana*, vol. II, 1934, p. 587 n. 1) includes K187 in a list of Fei's paintings and describes the composition as surmounted by the *Trinity*. Whether van Marle was in error as to this last detail we do not know. B. Berenson, G. Fiocco, F. M. Perkins, and A. Venturi (in ms. opinions) also give K187 to Fei. (4) *Preliminary Catalogue*, 1941, pp. 63 f., as Fei.

TADDEO DI BARTOLO

Sienese School. Born *c.* 1362; died 1422. His style was formed under the immediate influence of Bartolo di Fredi. His own influence was, in turn, strongly felt for decades, not only in Siena, but also in other regions where he worked.

K 1292 : Figure 163

THE CORONATION OF THE VIRGIN. Tucson, Ariz., University of Arizona (61.96), since 1957.[1] Wood. $38\frac{3}{4} \times 25\frac{3}{8}$ in. (98·4×64·5 cm.). Christ and the Virgin well preserved; some losses of paint elsewhere, especially in the seraphim.

As frequently in Taddeo's panels, the red wings and heads of seraphim silhouetted against a gold background are used to enhance the decorative effect. An example is offered by K 310 (Fig. 171), which is sufficiently comparable in other respects also to suggest a similar dating, toward 1405, for K 1292.[2]

Provenance: Larcade, St.-Germain, France. Private Collection, Florence. Canessa's, New York (sold Jan. 25, 1924, no. 167, as Taddeo di Bartolo; bought in). Contini Bonacossi, Florence. Kress acquisition, 1939 – exhibited: National Gallery of Art, Washington, D.C. (513), 1941–52.[3]

References: (1) Catalogue by W. E. Suida, 1957, no. 5, as Taddeo di Bartolo. (2) F. M. Perkins (in Thieme-Becker, *Allgemeines Lexikon*, vol. XXXII, 1938, p. 396), B. Berenson (*Italian Painters of the Renaissance*, 1952, pl. 269), G. Fiocco, R. Longhi, and A. Venturi (in ms. opinions) cite K 1292 among Taddeo's paintings. (3) *Preliminary Catalogue*, 1941, pp. 192 f., as Taddeo di Bartolo.

TADDEO DI BARTOLO

K 310 : Figure 171

MADONNA AND CHILD. San Francisco, Calif., M. H. De Young Memorial Museum (61-44-6), since 1955.[1] Wood. $40\frac{3}{4} \times 24\frac{1}{2}$ in. (103·5×62·3 cm.). Flesh tones slightly abraded; a few losses of paint.

Closely related in composition and style to several other extant paintings by the artist, among them one in the Pinacoteca, Perugia, which is signed, and dated 1403, K 310, like the example in Perugia, may have been originally a full-length *Madonna*, the middle panel of a polyptych. Its high rank in Taddeo di Bartolo's oeuvre has been noted repeatedly.[2]

Provenance: Max Bondi, Rome. Paris market (before 1924). Durlacher's, New York (1926). Contini Bonacossi, Florence. Kress acquisition, 1935 – exhibited: National Gallery of Art, Washington, D.C. (273), 1941–52.[3]

References: (1) Catalogue by W. E. Suida, 1955, pp. 38 f., as Taddeo di Bartolo. (2) R. van Marle (*Italian Schools of Painting*, vol. II, 1924, p. 554; in *La Diana*, vol. VI, 1931, p. 171) considers K 310 the finest in a group of *Madonnas* by Taddeo.

I. Vavasour Elder (in *La Balzana*, vol. I, 1927, pp. III ff.), F. M. Perkins (in Thieme-Becker, *Allgemeines Lexikon*, vol. XXXII, 1938, p. 396), D. G. Carter (in *Bulletin des Musées Royaux des Beaux-Arts*, Brussels, 1954, no. 1, p. 4) and, in ms. opinions, B. Berenson, G. Fiocco, R. Longhi, and A. Venturi have noted K 310 as Taddeo di Bartolo. (3) *Preliminary Catalogue*, 1941, p. 192, as Taddeo di Bartolo.

TADDEO DI BARTOLO

K 1179 : Figure 164

MADONNA AND CHILD. Tulsa, Okla., Philbrook Art Center (3364), since 1953.[1] Wood. $39\frac{1}{2} \times 26\frac{3}{4}$ in. (100·3× 68 cm.). Good condition except for abrasion of angels in background; strips have been cut from top and bottom of panel; cleaned 1953.

The pose of the Child finds a close prototype in Taddeo's altarpiece of 1403 in the Perugia Pinacoteca and in his altarpiece of 1400 in the Compagnia di Santa Caterina della Notte, Siena; but the figure types and the style of modeling point to a later date, about 1410, and to the possibility that K 1179 may have been associated originally in the same altarpiece as K 551–K 554 (Figs. 165–168). The total effect would have been similar to that of the triptych recently attributed to Priamo della Quercia in the Blumenthal Collection at the Metropolitan Museum, New York,[2] where the middle panel duplicates K 1179 in pose of Mother and Child and gives an idea of the original lower termination of K 1179.

Provenance: Private Collection, Siena. Contini Bonacossi, Florence. Kress acquisition, 1939.

References: (1) Catalogue by W. E. Suida, 1953, pp. 14 f., as Taddeo di Bartolo, to whom G. Fiocco, R. Longhi, F. M. Perkins, and A. Venturi (in ms. opinions) have attributed the painting. (2) M. Meiss, in *Burlington Magazine*, vol. CVI, 1964, p. 407, fig. 18.

TADDEO DI BARTOLO

K 551 : Figure 165
ST. JAMES MAJOR

K 552 : Figure 166
ST. JOHN THE BAPTIST

Memphis, Tenn., Brooks Memorial Art Gallery (61.195 and 61.196, respectively), since 1958.[1] Wood. K 551, $58\frac{7}{8} \times 17\frac{1}{8}$ in. (149·6×43·5 cm.); K 552, $58\frac{1}{2} \times 17\frac{1}{4}$ in. (148·6×

43·8 cm.). Flesh tones in good condition; mantles very much abraded; some losses of paint; cleaned 1957.

For the commentary, etc., see K 553 and K 554, below.

TADDEO DI BARTOLO

K 553 : Figure 167
ST. CATHERINE OF ALEXANDRIA

K 554 : Figure 168
A BISHOP SAINT BLESSING

New Orleans, La., Isaac Delgado Museum of Art (61.64 and 61.63, respectively), since 1953.[2] Wood. K 553, $59\frac{1}{8} \times 17\frac{1}{2}$ in. (150·2×44·5 cm.); K 554, $58\frac{7}{8} \times 17\frac{1}{8}$ in. (149·6×43·5 cm.). Fair condition except for abrasion throughout and some losses of paint.

These four panels come from a dismembered altarpiece, obviously of large size. The middle panel was probably a *Madonna and Child*, possibly K 1179 (Fig. 164), which is very similar to the four saints in figure style and in halo decoration. The bishop saint (probably Geminianus)[3] and John the Baptist would have been at the left; and Sts. James Major and Catherine, at the right. The style points to Taddeo's late period, about 1410.[4] Parts of the original frame remain attached to the panels.

Provenance: Dan Fellows Platt, Englewood, N.J. (as early as 1908; sold by estate trustee to the following). Kress acquisition, 1939.

References: (**1**) Catalogue by W. E. Suida, 1958, p. 10, as Taddeo di Bartolo. (**2**) Catalogue by W. E. Suida, 1953, p. 14, as Taddeo di Bartolo. (**3**) Cf. the St. Geminianus in K 104 (Fig. 169), by Taddeo. (**4**) F. M. Perkins (in *Rassegna d'Arte Senese*, 1908, pp. 8 f.; in Thieme-Becker, *Allgemeines Lexikon*, vol. XXXII, 1938, p. 396) places the panels fairly late in Taddeo's career. R. van Marle (*Italian Schools of Painting*, vol. II, 1924, p. 556) agrees; and B. Berenson (*Italian Pictures of the Renaissance*, 1932, p. 551; Italian ed., 1936, p. 474) lists the panels as by Taddeo.

TADDEO DI BARTOLO

K 104 : Figure 169

ST. GEMINIANUS. Notre Dame, Ind., University of Notre Dame, Study Collection (61.47.2), since 1961.[1] Wood. $26\frac{1}{4} \times 17\frac{3}{8}$ in. (66·7×44·2 cm.). Good condition.

The identification of the subject of K 104 is based on the similarity to the bishop saint Geminianus painted by Taddeo di Bartolo in the middle panel of a large altarpiece in the museum at San Gimignano and again as a half-length figure in the side panel of another polyptych in the same museum. K 104 also probably comes from a polyptych and may well have been commissioned in San Gimignano, of which the saint was a patron. The panel has been shortened, probably from a full-length figure, and it may be dated late in the artist's career, about 1410.[2]

Provenance: Contini Bonacossi, Rome. Kress acquisition, 1930 – exhibited: 'Italian Paintings Lent by Mr. Samuel H. Kress,' Oct. 1932, Atlanta, Ga., through June 1935, Charlotte, N.C., p. 6 of catalogue, as Martino di Bartolommeo, in the manner of Taddeo di Bartolo; National Gallery of Art, Washington, D.C. (163), 1941–52.[3]

References: (**1**) Catalogue, 1962, p. unnumbered, as Taddeo di Bartolo. (**2**) F. M. Perkins (in Thieme-Becker, *Allgemeines Lexikon*, vol. XXXII, 1938, p. 396) lists the painting as by Taddeo, as do B. Berenson, R. van Marle, and A. Venturi (in ms. opinions). G. Fiocco, R. Longhi, and W. E. Suida (in ms. opinions) have attributed it to Martino di Bartolommeo. (**3**) *Preliminary Catalogue*, 1941, p. 192, as Taddeo di Bartolo.

Follower of TADDEO DI BARTOLO

K 1075 : Figure 170

ST. DONATUS. San Antonio, Tex., Witte Memorial Museum (38.17.69), since 1937. Wood. $23\frac{3}{4} \times 11\frac{3}{4}$ in. (60·3×29·9 cm.). Inscribed on bishop's dalmatic: SCS. DONATVS. Good condition.

Although some critics have dated K 1075 as early as the middle of the fourteenth century, its dependence on the decorative style of such an artist as Taddeo di Bartolo would seem to place it near 1400.[1] A possible relationship to the following of Jacopo del Casentino, in the Florentine School, may be noted also: compare the *St. Prosper* (K 1138, Fig. 58) by a follower of Jacopo, and the Turkish floral design (as in K 1075) on the robe of the *Madonna* by Jacopo himself in Santo Stefano, Pozzolatico.[2] Finally, reminiscences of the style of the fourteenth-century Paduan Guariento are to be noted.

Provenance: Contini Bonacossi, Florence. Kress acquisition, 1935.

References: (**1**) In ms. opinions R. van Marle and W. E. Suida date K 1075 about the middle of the fourteenth century, in the Sienese School; F. M. Perkins, about the middle or second half of the century; R. Longhi, about

1350/60, between Ugolino da Siena and Luca di Tommè; G. Fiocco places it in the second half of the century; and A. Venturi, close to Taddeo di Bartolo. (2) Reproduced by R. Offner, *Corpus of Florentine Painting*, sec. III, vol. II, pt. II, 1930, pl. LVI.

MARTINO DI BARTOLOMMEO

Sienese School. Active from 1384 (or possibly 1376); died 1434/35. His best work was done after about 1405, when, following a sojourn in Pisa, he returned to Siena and the influence of Taddeo di Bartolo.

K110 : Figure 179

THE CRUCIFIXION. El Paso, Tex., El Paso Museum of Art (1961–6/6), since 1961.[1] Wood. 9¼ × 20¾ in. (23·5 × 52·7 cm.). Good condition; cleaned 1960.

K110 apparently was once the middle section of a predella from which four other panels, now in the Philadelphia Museum, are known.[2] All five panels were together in the Volpi sale of 1927, when they were catalogued as by Spinello Aretino.[3] The present attribution to Bartolommeo seems now to be unanimously accepted,[4] while the recent identification of the subjects of K110's companion panels as four scenes from the life of St. Barnabas[5] has led to the suggestion[6] that the predella may originally have belonged to an altarpiece by Martino di Bartolommeo, no. 160 in the Siena Pinacoteca, in which St. Barnabas is one of the four saints flanking the central panel of the Madonna. The date is probably about 1410.

Provenance: Elia Volpi (sold, American Art Galleries, New York, Mar. 31–Apr. 2, 1927, no. 366 of catalogue, where all five panels are reproduced, as Spinello Aretino). Contini Bonacossi, Rome. Kress acquisition, 1930 – exhibited: National Gallery of Art, Washington, D.C. (165), 1941–52;[7] Finch College, New York, 1959, as Martino di Bartolommeo.

References: (1) Catalogue by F. R. Shapley, 1961, no. 6, as Martino di Bartolommeo. (2) Philadelphia Museum, '45–25 – 120 a–d. (3) See first entry under *Provenance*, above. (4) B. Berenson (in *Dedalo*, vol. XI, 1930, p. 283), M. Weinberger (*The George Grey Barnard Collection*, 1941, p. 30, no. 120), G. Kaftal (*Iconography of the Saints in Tuscan Art*, 1952, cols. 129–134), G. Coor in *Philadelphia Museum of Art Bulletin*, Winter, 1961, pp. 56 ff.), G. Fiocco, R. Longhi, R. van Marle, F. M. Perkins, W. E. Suida, and A. Venturi (in ms. opinions) agree to the attribution. (5) The Barnabas scenes are identified by Kaftal (*loc. cit.* in note 4, above). (6) See Coor (*loc. cit.* in note 4, above). (7) *Preliminary Catalogue*, 1941, pp. 125 f., as Martino di Bartolommeo.

GUALTIERI DI GIOVANNI

Sienese School. Active *c.* 1406–*c.* 1445. Although probably born in Pisa, he may have been a pupil of Taddeo di Bartolo. He is known to have worked in the Siena Cathedral, where the remains of frescoes of the life of the Madonna are attributed to him.

Attributed to
GUALTIERI DI GIOVANNI

K114 : Figure 172

MADONNA AND CHILD. Notre Dame, Ind., University of Notre Dame, Study Collection (61.47.3), since 1961.[1] Wood. 34¾ × 22 in. (88·3 × 55·9 cm.). Good condition.

Among the paintings with which Berenson has attempted to reconstruct an oeuvre for this artist, K114 is cited as outstanding, with stylistic analogies to such artists as Jacopo Bellini and Jacobello del Fiore.[2] The attribution can be only tentative as long as no certain painting is known by which to distinguish Gualtieri's style from that of others in the group with whom he worked. Whether or not he be Gualtieri, the artist who painted a preserved passage of a mother and child in the frescoes of about 1410 in the Chapel of the Virgin, Siena Cathedral, is convincingly credited with K114, so close are the similarities between the two paintings.[3] The more stylized arrangement of the drapery folds may indicate a later date, about 1420/30 for K114.

Provenance: Paolo Paolini, Rome. Private Collections, Vienna and Venice. Knoedler's, London. Contini Bonacossi, Rome. Kress acquisition, 1930 – exhibited: National Gallery of Art, Washington, D.C. (168), 1941–52.[4]

References: (1) Catalogue, 1962, p. unnumbered, as Gualtieri di Giovanni da Pisa. (2) B. Berenson (in *International Studio*, Dec., 1930, pp. 67 ff., and in *Dedalo*, vol. XI, 1930, pp. 329 ff.). In ms. opinions K114 is attributed to Paolo di Giovanni Fei by G. Fiocco, R. Longhi, W. E. Suida, and A. Venturi; and to an anonymous Sienese master of the late fourteenth century by R. van Marle and F. M. Perkins. (3) The fresco is reproduced by Berenson in *Dedalo, loc. cit.* (4) *Preliminary Catalogue*, 1941, p. 93, as Gualtieri di Giovanni.

ANDREA DI BARTOLO

Sienese School. Died 1428. He is mentioned first in 1389, when he was collaborating with his father, Bartolo di Fredi.

His later work shows the influence of Taddeo di Bartolo so strongly that it is in some cases as difficult to distinguish his paintings from Taddeo's as it is in others to distinguish between Andrea's and his father's.

K86 : Figure 175
JOACHIM AND THE BEGGARS

K85 : Figure 176
THE NATIVITY OF THE VIRGIN

K84 : Figure 177
THE PRESENTATION OF THE VIRGIN

Washington, D.C., National Gallery of Art (154, 153, and 152), since 1941.[1] Wood. Each, 17½×12½ in. (44×32 cm.). Small losses of paint throughout; gold background new.

A date fairly early in the artist's career, about 1400, is probably correct for these paintings, since they are very close in style to the work of Andrea's father.[2] The panels probably come from some large complex, such as altarpiece wings like those from Bartolo di Fredi's Montalcino polyptych, of 1388; a reliquary cabinet also has been proposed as source.[3] The compositions suggest comparison in a number of details with both earlier and contemporary work. *The Nativity of the Virgin* is thought to be derived from the Lorenzetti's lost fresco on the façade of the Ospedale, Siena,[4] which was followed also in Bartolo di Fredi's horizontally composed fresco in Sant'Agostino, San Gimignano. *The Presentation of the Virgin* harks back to Taddeo Gaddi's well-known drawing and Santa Croce fresco and to Fei's more nearly contemporary version, as shown in K2045 (Fig. 159). A fourth panel in the series with K84–86 is in the Christian Museum at Esztergom, Hungary. Its subject is *Joachim Leaving the City*.[5] This last panel also has had its gold background renewed.

Provenance: Contessa Giustiniani, Genoa. Contini Bonacossi, Rome. Kress acquisition, 1930.

References: (**1**) *Preliminary Catalogue*, 1941, p. 3, as Andrea di Bartolo. (**2**) B. Berenson, R. Longhi (in ms. opinions), and C. Brandi (*Quattrocentisti senesi*, 1949, p. 243, suggesting possible collaboration of a follower of Fei) attribute K84–86 to Andrea di Bartolo; G. Fiocco, R. van Marle, F. M. Perkins tentatively, O. Sirén, and A. Venturi (in ms. opinions) give them to Bartolo di Fredi. (**3**) Brandi, *op. cit.* in note 2, above. (**4**) *Ibid.* (**5**) This painting (no. 55.148 in the Esztergom Museum), listed by R. van Marle (*Italian Schools of Painting*, vol. II, 1924, p. 581 n. 1), is published and reproduced as companion to K84–86, and like them given to

Andrea di Bartolo, by M. Mojzer, in *Pantheon*, vol. XXII, 1964, pp. 1 f., fig. 4.

ANDREA DI BARTOLO
K1014 : Figure 178

THE CRUCIFIXION, WITH THE VIRGIN, ST. JOHN, AND ST. MARY MAGDALENE. Nashville, Tenn., George Peabody College for Teachers, Study Collection (A-61-10-2), since 1961.[1] Wood. 16 9/16×15 5/16 in. (42·1×38·9 cm.). Inscribed at top of cross: I.N.R.I. (Jesus of Nazareth, King of the Jews). Much abraded throughout, especially the face of Christ.

The shape of the composition is good evidence that K1014 originally formed the central pinnacle of an altarpiece, where the *Crucifixion* was a frequent subject. Here not only is the *Crucifixion* shown; it is also symbolized by the scene in the apex, a pelican giving her life blood to feed her young. Although the name of Lippo Vanni has been connected with K1014, the closest parallels seem to be offered by Andrea di Bartolo,[2] whose *Crucifixion* in the pinnacle of no. 1095 in the Berlin Museum follows the same composition. Other parallels are the pinnacle of no. 58 in the Lindenau Museum in Altenburg and the *Crucifixion* on the back of K23 (Fig. 174). The date of K1014 is probably early, about 1400.

Provenance: Contini Bonacossi, Florence. Kress acquisition, 1936 – exhibited: National Gallery of Art, Washington, D.C. (870), 1951–52, as Sienese, fourteenth century.

References: (**1**) *Acquisitions, 1961, The Arts*, George Peabody College for Teachers, pp. 6 ff., as Sienese, fourteenth century. (**2**) In ms. opinions G. Fiocco, W. E. Suida, and A. Venturi have attributed K1014 to Lippo Vanni; F. M. Perkins, to an anonymous Sienese; R. van Marle, to a follower of Bernardo Daddi; B. Berenson, with reservations, to Luca di Tommè; and G. Coor, to Andrea di Bartolo.

ANDREA DI BARTOLO
K23 : Figures 173–174

MADONNA AND CHILD; THE CRUCIFIXION. Washington, D.C., National Gallery of Art (131), since 1941.[1] Wood. 11¼×7 in. (29×18 cm.). Excellent condition.

The *Crucifixion*, now on the reverse, is painted on a separate panel, which has been shortened at top and bottom. It may be a little later than the *Madonna*, although the decorative ornament of halos and borders is similar. Attributions of

the *Madonna* have varied from Simone Martini and Lippo Memmi to Andrea di Bartolo,[2] the last being the most likely,[3] with a date of about 1415. The composition of the Mother and Child, which follows the Madonna of Humility formula, is repeated in a number of known versions, all probably based on a lost painting by Simone Martini.[4] The closest to Simone's presumed prototype is no. 1072 in the Berlin Museum, which may be by Lippo Memmi.

Provenance: Contini Bonacossi, Rome. Kress acquisition, 1927.

References: (1) *Preliminary Catalogue*, 1941, pp. 134 f., as Lippo Memmi (?). (2) In ms. opinions A. Venturi has attributed the painting to Simone Martini; R. van Marle, tentatively to Donato Martini; R. Longhi, to Lippo Memmi, and B. Berenson, G. Fiocco, F. M. Perkins, and W. E. Suida, to Andrea di Bartolo. M. Meiss (in *Art Bulletin*, vol. XVIII, 1936, p. 437 n. 8; and *Painting in Florence and Siena*, 1951, p. 134) follows the attribution to Andrea di Bartolo. G. M. Richter (in *Burlington Magazine*, vol. LXXVIII, 1941, p. 177) suggests early Andrea Vanni, working in Memmi's studio. (3) An interesting comparison is offered by Andrea di Bartolo's *Coronation of the Virgin* in the Brera, where the facial type is closely similar and the principal figures are borne up by just such a cherub as appears here beneath the half-length figure of Christ in the apex. For the two angels flanking the Madonna, compare the version of K23 signed by Andrea di Bartolo which is now lost but is reproduced by Berenson in *International Studio*, Nov. 1930, p. 30, fig. 5. (4) For a discussion of the derivation see M. Meiss, *Painting in Florence and Siena*, 1951, pp. 132 ff.

Studio of ANDREA DI BARTOLO

K1176 : Figure 180
ST. BARTHOLOMEW AND ST. PAUL

K1177 : Figure 181
ST. JOHN THE EVANGELIST AND ST. PETER

Lincoln, Nebr., University of Nebraska, Study Collection (U-359-K and U-360-K), since 1962. Wood. K1176, $14\frac{11}{16} \times 15\frac{5}{8}$ in. (37·3×39·7 cm.); K1177, $14\frac{5}{8} \times 16\frac{1}{16}$ in. (37·2×40·8 cm.). Good condition except for abrasions in gold background and face of St. Peter.

Perhaps originally full length and serving as flanking figures at the right of a lost middle panel (*Madonna and Child*?), these figures, although weaker in modeling and at least a decade later, recall the saints by Andrea di Bartolo on an altarpiece dated 1413 in the Church of the Osservanza, Siena. K1176 and K1177 have been attributed to Andrea di Bartolo and also to Taddeo di Bartolo.[1] Martino di Bartolommeo, a contemporary who was influenced by these two artists, might also be considered in connection with the two panels.

Provenance: Private Collection, Siena. Contini Bonacossi, Florence. Kress acquisition, 1939.

Reference: (1) In ms. opinions, B. Berenson, R. Longhi, F. M. Perkins, W. E. Suida, and A. Venturi have attributed the paintings to Andrea di Bartolo, and G. Fiocco has attributed them to Taddeo di Bartolo.

RIMINESE, BOLOGNESE, PISAN, LUCCHESE, UMBRIAN, VENETIAN, LOMBARD, FERRARESE, AND PADUAN SCHOOLS
XIV AND XV CENTURIES

MASTER OF THE LIFE OF ST. JOHN THE BAPTIST

School of Rimini. Active second quarter of fourteenth century. The designation for this anonymous painter derives from his series of paintings of the life of the Baptist discussed below. Formerly conflated with Baronzio, he, like Baronzio, was strongly influenced by Cavallini and Giotto, but was less delicate, more rugged in style than Baronzio, using stronger contrasts of light and shade in modeling his forms.

K 1312 : Figure 182

MADONNA AND CHILD WITH ANGELS. Washington, D.C., National Gallery of Art (711), since 1945. Wood. 39⅝×18⅞ in. (100·6×48 cm.). Inscribed on the Virgin's halo: AVE MARIA GRAT[ia] PLENA DN̄S (from Luke 1 : 28). Fair condition, but obscured by old varnish.

For the commentary, etc., see K 1435, below.

Provenance: Prince Léon Ouroussoff, Russian ambassador at Vienna and Paris. Otto H. Kahn, New York – exhibited: 'Early Italian Painting,' Duveen Galleries, New York, 1924, no. 9 of catalogue by W. R. Valentiner, 1924, and 1926, no. 33, as Baronzio; 'Arts of the Middle Ages,' Museum of Fine Arts, Boston, Mass., March 1940, no. 57 of catalogue by G. Swarzenski, as Baronzio. Duveen's, New York. Kress acquisition, 1942.

MASTER OF THE LIFE OF ST. JOHN THE BAPTIST

K 1435 : Figure 183

SCENES FROM THE LIFE OF ST. JOHN THE BAPTIST. Washington, D.C., National Gallery of Art (1147), since 1951.[1] Wood. 19¼×16 in. (48·9×40·6 cm.). Fair condition except for abrasions throughout and small losses of paint; cleaned 1950.

Representing the birth, naming, and circumcision of John the Baptist, K 1435 was probably the second in the series of panels which presumably at one time were arranged in two vertical rows flanking the large panel of the *Madonna and Child,* K 1312 (Fig. 182). The first scene would have been the *Angel Appearing to Zacharias* (English Private Collection in 1916[2]). Other panels which have been referred to the series are: *The Young St. John Led by an Angel into the Wilderness* (Vatican Gallery, Rome), *St. John Preaching* (former Loeser Collection, Florence),[3] *St. John Meets Two Pharisees* (K 460, Fig. 185 – apparently to be connected with Matthew 3 : 7–12), the *Baptism of Christ* (K 264, Fig. 184), *St. John in Prison* (English private collection in 1916[4]), *Herod's Feast and the Beheading of John the Baptist* (Philip Lehman Collection, New York), *St. John in Limbo* (former Sterbini Collection, Rome).[5] The figure types, the rich colors, and the stamped designs on halos, borders, and backgrounds of all the panels support the assumption, indicated above, that they were once associated in a single polyptych with K 1312 as the center panel,[6] resulting in an effect comparable to that of the polyptych signed by Baronzio in the Urbino Pinacoteca.[7] A closer parallel for K 1312 itself is the *Madonna* in the center of Baronzio's polyptych in San Francesco, Mercatello. The drapery of the Virgin, striated with gold, harks back to Byzantine practice, while the solemn, strongly modeled faces recall Giotto. The grasshopper, represented with amazing anatomical accuracy, is an unusual but appropriate attribute to be found in the hand of the Christ Child since it is a symbol of 'converted paganism.'[8] This large panel, as well as the smaller scenes belonging with it, has only recently been recognized as the work of a master distinct from Baronzio.[9] The date is probably about 1340.

Provenance: Harold I. Pratt, New York – exhibited: 'Loan Exhibition of Italian Primitives,' Kleinberger Galleries, New York, Nov. 1917, p. 181 of catalogue by Sirén and Brockwell, as Baronzio.[10] Wildenstein's, New York – exhibited: 'Italian Paintings,' Wildenstein's, New York, 1947, no. 37 of catalogue, as Baronzio. Kress acquisition, 1947.

References: (1) *Paintings and Sculpture from the Kress Collection,* 1951, p. 36 (catalogue by W. E. Suida), as Master of the Life of St. John the Baptist. (2) Reproduced by O. Sirén (in *Burlington Magazine,* vol. XXIX, 1916, pp. 320 f.). The

Angel Appearing to Zacharias and the *St. John in Prison* (the latter not reproduced) were both at this time, according to Sirén, in an English private collection, perhaps the collection of G. E. Street, who was listed as their owner when they were exhibited in the Royal Academy, London (nos. 231 and 234), in 1880 (see Graves, *A Century of Loan Exhibitions*, vol. III, 1914, p. 1400). (3) Suida (catalogue cited in note 1, above) seems to have known this painting. (4) See note 2, above. (5) This panel is cited by A. Venturi (*La Galleria Sterbini in Roma*, 1906, p. 53) as a fragment, then in the Sterbini Collection, Rome, along with the fragmentary panel *St. John Meets Two Pharisees* and the intact *Baptism of Christ*. (6) The earlier proposal that the center panel may have been the *Enthroned St. John* at Christ Church, Oxford, has been rejected (see Salmi, *loc. cit.* in note 9, below). (7) The Urbino polyptych is reproduced by R. van Marle, *Italian Schools of Painting*, vol. IV, 1924, p. 311, fig. 158. (8) For the symbolism of the grasshopper, as used here see H. Friedmann, in *Gazette des Beaux-Arts*, vol. XXXV, 1949, pp. 345 ff. (9) The work (in some cases references are only to certain panels in the series) is attributed to a Romagnol master by R. Offner (in *The Arts*, 1924, p. 245) and D. C. Shorr (*The Christ Child in Devotional Images*, 1954, p. 122); to Baronzio by O. Sirén (*loc. cit.* in note 2, above), L. Venturi (*Italian Pictures in America*, vol. I, 1933, nos. 113, 116), B. Berenson (*Italian Pictures of the Renaissance*, 1932, p. 44; Italian ed., 1936, p. 37; Berenson, in ms. opinion, later attributes the series to the Master of the Life of St. John the Baptist), G. Fiocco, F. M. Perkins, and A. Venturi (in ms. opinions); to the Master of the Life of St. John the Baptist by C. Brandi (in catalogue, *Mostra della pittura riminese del trecento*, 1935, p. XXIII; in *Critica d'Arte*, June 1936, p. 236), A. Corbara, R. Longhi, R. van Marle (in ms. opinions); to an anonymous Riminese artist by M. Salmi (in *Rivista del R. Istituto d'Archeologia e Storia dell'Arte*, vol. V, 1935, pp. 112 ff.; *Rivista d'Arte*, vol. XVII, 1935, p. 326), R. van Marle (in *Rimini*, 1935, p. 13), E. Sandberg-Vavalà (in *Burlington Magazine*, vol. LXXXIX, 1947, pp. 31 f.), and P. Toesca (*Il Trecento*, 1951, p. 730). K264 and K1312 were formerly exhibited at the National Gallery of Art as Baronzio. (10) Reference in the Kleinberger catalogue and elsewhere to an earlier provenance, the G. E. (or A. E.) Street Collection, is probably an error, based on a misunderstanding of the entries in the Royal Academy exhibition of 1880 (see note 2, above).

MASTER OF THE LIFE OF ST. JOHN THE BAPTIST

K460 : Figure 185

ST. JOHN MEETS TWO PHARISEES. Seattle, Wash., Seattle Art Museum (It37/M394L1.1), since 1952.[1] Wood, transferred to masonite (1950). 11⅛×7¼ in. (28·3×18·4

cm.). Fragment; worn throughout; cleaned 1950. The panel has been cut down at top and left side.

For the commentary, etc., see K1435, above.

Provenance: Giulio Sterbini, Rome (catalogue by A. Venturi, 1906, p. 53, as Jacopo di Paolo da Bologna). Sangiorgi's, Rome. Contini Bonacossi, Florence. Kress acquisition, 1936 – exhibited: National Gallery of Art, Washington, D.C., 1951–52.[2]

References: (1) Catalogue by W. E. Suida, 1952, no. 2, and 1954, p. 14, as Master of the Life of St. John the Baptist. (2) *Paintings and Sculpture from the Kress Collection*, 1951, p. 38 (catalogue by W. E. Suida), as Master of the Life of St. John the Baptist.

MASTER OF THE LIFE OF ST. JOHN THE BAPTIST

K264 : Figure 184

THE BAPTISM OF CHRIST. Washington, D.C., National Gallery of Art (242), since 1941.[1] Wood. 19¼×16 in. (48·9×40·6 cm.). Good condition.

For the commentary, etc., see K1435, above.

Provenance: Vatican Gallery, Rome.[2] Giulio Sterbini, Rome (catalogue by A. Venturi, 1906, pp. 48 ff., as Jacopo di Paolo da Bologna). Pasini, Rome. Contini Bonacossi, Florence. Kress acquisition, 1933 – exhibited: 'Italian Paintings Lent by Mr. Samuel H. Kress,' Los Angeles, Calif., Feb. 28–Apr. 15, 1934; San Diego, Calif., Apr. 25–May 27, 1934, p. 32 of catalogue, as Baronzio.

References: (1) *Preliminary Catalogue*, 1941, p. 13, as Baronzio. (2) In a ms. opinion concerning this painting, B. Berenson states that up until about 1870, previous to its inclusion in the Sterbini Collection, it was in the Vatican Gallery.

RIMINESE SCHOOL, Late XIV Century

K29 : Figure 186

THE CRUCIFIXION. Allentown, Pa., Allentown Art Museum, Study Collection (60.02.KBS), since 1960. Wood. 10¼×11¾ in. (26×29·9 cm.). Abrasions and small losses of paint throughout.

The crowded, rectangular composition, the allover design of the background, and the attenuated figures are characteristic of the Riminese style in the following of the fourteenth-century master Baronzio.[1] There are suggestions

also, in the intense facial expressions, of the Bolognese Jacopino di Francesco. The provincial character of the work – awkward poses and exaggerated features – date K29 as a *retardataire* production, near the end of the century. It is likely a fragment of a large panel which was a wing of a triptych or diptych with scenes from the Passion of Christ.[2]

Provenance: Contini Bonacossi, Rome. Kress acquisition, 1927 – exhibited: 'Italian Paintings Lent by Mr. Samuel H. Kress,' Oct. 1932, Atlanta, Ga., through Sept. 1933, Salt Lake City, Utah, p. 28 of catalogue, as Baronzio; 'Golden Gate International Exposition,' San Francisco, Calif., 1940, no. 102 of catalogue, as Baronzio.

References: (**1**) K29 has been attributed, in ms. opinions, to Baronzio by G. Fiocco, R. Longhi, and W. E. Suida; to an artist close to Baronzio by B. Berenson, F. M. Perkins, and A. Venturi; to the School of Rimini by R. van Marle. (**2**) Compare the diptych in the Pinacoteca, Bologna, reproduced in the catalogue of the 'Mostra della Pittura Riminese del Trecento,' Rimini, June 20–Sept. 30, 1935, p. 141.

MASTER OF THE BLESSED CLARE

Riminese School. Active mid-fourteenth century. The few paintings now attributed to this master show the strong influence of Giotto and of the Sienese School – especially of Pietro Lorenzetti.

K 1084 : Figure 187

THE ADORATION OF THE MAGI. Coral Gables, Fla., Joe and Emily Lowe Art Gallery, University of Miami (61.18), since 1961.[1] Wood. $22\frac{3}{4} \times 23\frac{3}{8}$ in. (57·8 × 59·4 cm.). Extensive damage in flesh tones and gold background; mantle of Virgin unusually well preserved; cleaned 1960.

Sold as by Segna di Buonaventura in 1918[2] and more recently attributed to Baronzio,[3] K1084 has come to occupy a prominent place in the literature on Riminese painting.[4] The most fruitful study of the panel[5] proves that it was originally a wing of a triptych, of which the other wing, representing the *Vision of the Blessed Clare,* was recently sold[6] from the collection of Lady Ashburnham, and the middle panel, representing the *Crucifixion,* is now lost. An account of the triptych was published, while it was still intact, in a mid-eighteenth-century treatise on the Blessed Clare of Rimini (1262–1328).[7] The triptych was then in the Monastero degli Angeli, Rimini, where the Blessed Clare had served as superioress, and it was described as duplicating almost exactly the composition of another triptych[8] which was then in the same monastery and is now recognized, intact, in the Musée Fesch, Ajaccio. The latter appears from reproductions to be the weaker, less monumental of the

two, and is perhaps the slightly earlier one. The second, dismembered triptych, to which K1084 belongs, probably dates about 1340. Along with a *Crucifixion* in Strasbourg and a *Crucifix* in the Ducal Palace, Urbino,[9] K1084 is now attributed to a Riminese master for whom its companion panel, the *Vision of the Blessed Clare,* suggests the coined name 'Master of the Blessed Clare.' Most remarkable in K1084 is the delicate coloring and the delightfully naïve arrangement of the rows of figures, one above the other, in the rocky landscape, with the unusual detail of Sts. Joseph and Stephen (in his deacon's robe) kneeling at the bottom. A *Nativity* ascribed to Jacopino di Francesco (K1170, Fig. 188)[10] ingeniously combines iconographical details from K1084 and its counterpart at Ajaccio.

Provenance: Monastero degli Angeli, Rimini (until *c.* 1810, when the monastery was suppressed). G. A. Hoskins (until 1864). Hoskins family (sold, Christie's, London, Nov. 15, 1918, lot 112, as Segna di Buonaventura). R. Langton Douglas, London. Otto H. Kahn, New York. Duveen's, New York (*Duveen Pictures in Public Collections of America,* 1941, no. 19, as Baronzio). Kress acquisition, 1937 – exhibited: 'Masterpieces of Art,' New York World's Fair, 1939, no. 5 of catalogue, as Baronzio; 'Arts of the Middle Ages,' Museum of Fine Arts, Boston, Feb. 17–Mar. 24, 1940, no. 58 of catalogue, as Baronzio; National Gallery of Art, Washington, D.C. (452), 1941–56;[11] after entering the Joe and Emily Lowe Art Gallery: 'Art Treasures for America,' National Gallery of Art, Washington, D.C., Dec. 10, 1961 – Feb. 4, 1962, no. 61A, as Master of the Blessed Clare.

References: (**1**) Catalogue by F. R. Shapley, 1961, p. 18, as Master of the Blessed Clare. (**2**) See *Provenance,* above. (**3**) B. Berenson (*Italian Pictures of the Renaissance,* 1932, p. 44; Italian ed., 1936, p. 37), R. van Marle (in W. R. Valentiner's *Unknown Masterpieces . . . ,* vol. I, 1930, pl. I), H. Tietze (*Meisterwerke europäischer Malerei in Amerika,* 1935, p. 325), G. Swarzenski (in *Magazine of Art,* vol. 33, 1940, p. 159), and G. Fiocco, W. E. Suida, and A. Venturi (in ms. opinions) attribute K1084 to Baronzio. (**4**) L. Venturi (*Italian Paintings in America,* vol. I, 1933, no. 115, attributing K1084 to Baronzio) associates it in style with a Riminese *Crucifixion* in Strasbourg, which he dates *c.* 1348, and with the *Adoration* in the Parry Collection, Gloucester. M. Salmi (in *Bollettino d'Arte,* 1932, p. 260) finds Bolognese affinity in the work and attributes it to an anonymous master close to Francesco da Rimini, a classification accepted by A. Medea (in *Rivista d'Arte,* 1940, p. 6). C. Brandi (*Mostra della pittura riminese del trecento,* 1935, fig. 144, although it was not included in the exhibition) merely labels the painting fourteenth-century Riminese. P. Toesca (*Il Trecento,* 1951, p. 730 n. 257) thinks it may come from the circle of Pietro da Rimini. D. C. Shorr (*The Christ Child in Devotional Images,* 1954, p. 109 n. 3) refers to it as Romagnol. (**5**) F. Zeri, in *Burlington Magazine,* 1950, pp. 247 ff., figs. 1–5. (**6**) Sotheby's, London, June 24, 1953, lot 14. (**7**) G. Garampi, *Memorie . . .*

della B. Chiara di Rimini, 1755, pp. 436, 439. (8) Reproduced in Zeri, *op. cit.*, figs. 3–5. (9) These two paintings are reproduced by R. van Marle, *Italian Schools of Painting*, vol. IV, 1924, figs. 177 f. (10) Similarity between K 1084 and K 1170 was kindly called to my attention by Miss Mary Davis. (11) *Preliminary Catalogue*, 1941, pp. 13 f., as Baronzio.

JACOPINO DI FRANCESCO

Bolognese School, active *c.* 1360–83. His full name was probably Jacopino di Francesco de' Bavosi;[1] but his oeuvre has formerly been identified under the name of Jacopo da Bologna, Jacopo Avanzo, or Pseudo Jacopo Avanzo. He may well have been taught by Vitale da Bologna, but he also traveled and came under the strong influence of Riminese artists.

K 1170 : Figure 188

THE NATIVITY AND THE ADORATION OF THE MAGI

K 1166 : Figure 189

ST. MARY MAGDALENE WASHING CHRIST'S FEET

K 1168 : Figure 192

A MIRACLE OF ST. JOHN THE EVANGELIST

K 1169 : Figure 190

ST. CATHERINE OF ALEXANDRIA FREED
FROM THE WHEEL

K 1167 : Figure 191

THE BEHEADING OF ST. CATHERINE OF ALEXANDRIA

Raleigh, N.C., North Carolina Museum of Art (GL.60. 17.11, 12, 13, 14, 15, respectively), since 1960.[2] Wood. K 1166, $20\frac{7}{8} \times 22\frac{5}{8}$ in. ($53 \times 57 \cdot 5$ cm.); K 1167, $24\frac{3}{8} \times 26\frac{5}{8}$ in. ($61 \cdot 9 \times 67 \cdot 7$ cm.); K 1168, $20\frac{7}{8} \times 22\frac{3}{4}$ in. ($53 \times 57 \cdot 8$ cm.); K 1169, $24\frac{3}{8} \times 31\frac{1}{2}$ in. ($61 \cdot 9 \times 80$ cm.); K 1170, $20\frac{3}{4} \times 31\frac{5}{8}$ in. ($52 \cdot 7 \times 80 \cdot 3$ cm.). Badly damaged throughout, K 1169 less than the others; background of K 1168 almost completely regilded; all panels cleaned 1960.

K 1170, K 1166 and K 1168 were probably originally associated together in the predella of an altarpiece, dating about 1360, in Jacopino's Riminese phase.[3] The other two panels, slightly larger and more vehement in style, may have come from a second altarpiece.[4] It has been suggested also that the five panels may have come originally from the same altarpiece as Jacopino's panel of similar dimensions representing the *Coronation*, in the Pinacoteca at Bologna.[5] The composition of the *Nativity* ingeniously combines iconographical details from two Riminese representations of the *Nativity* which were both once in the Monastero degli Angeli, Rimini. One of these is now in the Musée Fesch,

Ajaccio. The other is K 1084 (Fig. 187), attributed to the Master of the Blessed Clare. It is quite possible that Jacopino saw these paintings (of *c.* 1340) on a visit to Rimini.

Provenance: Gozzadini, Bologna. Dan Fellows Platt, Englewood, N.J. – exhibited: 'Loan Exhibition of Italian Primitives,' Kleinberger Galleries, New York, Nov. 1917 (only K 1167, which was no. 74 of the catalogue, as Jacopo degli Avanzi). Sold by Platt estate trustee to the following. Kress acquisition, 1939 – exhibited: Roosevelt House, Hunter College, New York, 1944; National Gallery of Art, Washington, D.C., 1946–51 (only K 1167), as Pseudo Avanzo; 1951–52 (only K 1169 and K 1170), as Jacopino di Francesco; 'Mostra della Pittura Bolognese del '300,' Pinacoteca, Bologna, 1950, nos. 44–47 (only K 1167 was not included), as Jacopino di Francesco.

References: (1) L. Frati (in *L'Arte*, vol. XVII, 1914, pp. 393 ff.) discusses the identity of Jacopino di Francesco de' Bavosi. A further study of his identity is made by P. G. Giustini (in *L'Arte*, vol. LIX, 1960, pp. 265 ff.). (2) Catalogue by F. R. Shapley, 1960, pp. 40 ff., as Jacopino di Francesco. (3) All five panels were published by F. M. Perkins (in *Rassegna d'Arte*, vol. XI, 1911, p. 145) as five parts of a predella by Jacopo d'Avanzi; R. van Marle (*Italian Schools of Painting*, vol. IV, 1924, pp. 421 f.) seems to accept Perkins' suggestion. (4) This is suggested by W. E. Suida (in *Critica d'Arte*, May 1950, pp. 57 f.). (5) Pinacoteca, no. 744. R. Longhi (in *Paragone*, no. 5, 1950, pp. 13 f.) makes this suggestion and is followed by F. Arcangeli (in *Proporzioni*, vol. II, 1948, p. 68; see fig. 68 for a reproduction of the *Coronation*). E. Sandberg-Vavalà (in *Art in America*, vol. XX, 1931, p. 20) had suggested that the *Coronation* was probably a little earlier than the Kress panels.

DALMASIO

Bolognese School. Active 1350–70. The name 'Dalmasio,' although it cannot now be definitely connected with any known paintings, has been adopted for a group which show the characteristics appropriate to the Dalmasio who, as is inferred from documents, developed in Bologna, about 1350, under Vitale da Bologna and lived in Pistoia, about 1360–70, in contact with followers of Giotto.

K 1206 : Figure 196

THE FLAGELLATION. Seattle, Wash., Seattle Art Museum (It 37/B 63852.1), since 1952.[1] Wood. $22\frac{5}{8} \times 14\frac{1}{2}$ in. ($57 \cdot 5 \times 36 \cdot 8$ cm.). Small losses of paint along horizontal cracks; panel has been cut down; lobed shape at top not original.

The combination here of well-balanced composition and vigorous movement is especially close to the style of Vitale.

That K1206 is by the same artist as a larger panel of the *Crucifixion* in the Pinacoteca, Bologna, and probably originally from the same altarpiece, has been noted.[2] Even the horizontal craquelure of the gold background is uniform in the two panels. The date of the work is presumably about 1360.

Provenance: Achillito Chiesa, Milan. Contini Bonacossi, Florence. Kress acquisition, 1939 – exhibited: 'Mostra della Pittura Bolognese del '300,' Pinacoteca Nazionale, Bologna, May–July, 1950, p. 29 of catalogue by R. Longhi, as Dalmasio (?).

References: (**1**) Catalogue by W. E. Suida, 1952, pp. 31 f., and 1954, p. 22, as Bolognese painter, probably 'Dalmasio.' (**2**) Suida (in *Critica d'Arte*, May 1950, p. 57) publishes K1206 as by a follower of Vitale. R. Longhi (in *Paragone*, no. 5, 1950, pp. 11 f.) publishes it as Dalmasio, and in an earlier ms. opinion he notes that it must be by the same Bolognese artist and come from the same altarpiece as the *Crucifixion* in the Bologna Pinacoteca, no. 160 (reproduced on pl. 1 of Enrico Mauceri's *La Regia pinacoteca di Bologna*, 1935, as Jacopo da Bologna).

SIMONE DEI CROCIFISSI

Bolognese School. Mentioned 1355–99. Simone di Filippo, called dei Crocifissi from his many paintings of the *Crucifixion*, was probably a pupil of Vitale da Bologna. A considerable number of his many paintings are signed and so form a basis for further attributions. In his best work he has sometimes been confused with Vitale, but he eventually followed the general Bolognese trecento tendency toward mediocrity.[1]

K1201 : Figure 195

MADONNA AND CHILD WITH SAINTS. Athens, Ga., University of Georgia, Study Collection (R-2), since 1961.[2] Wood. Middle panel, including molding, 15⅜×6⅜ in. (39·1×16·2 cm.); side panels, each, 14¾×3⅛ in. (37·5×8 cm.). Excellent condition; frame and moldings original.

Probably datable about 1370/80, this triptych, though less attractive than his best paintings, is not yet so decadent as much of Simone's work.[3] It may once have been inscribed, on the base of the throne, with the artist's usual signature. The young saint kneeling at the feet of the Virgin in the middle panel has not been identified. On the side panels are Sts. Peter and Paul above St. John the Baptist praying and St. Jerome removing a thorn from the lion's paw. In the pinnacles are the Angel and Virgin of the *Annunciation* and, in the middle, Christ of the *Pietà*.

Provenance: Conte Avogli-Trotti, Paris. Contini Bonacossi, Florence. Kress acquisition, 1939 – exhibited: National Gallery of Art, Washington, D.C. (531), 1941–52;[4] Traveling Exhibition, University of Arizona, Tucson, Ariz., Apr.–Sept. 1960.

References: (**1**) For a thorough study of Simone's style see E. Sandberg-Vavalà, in *Rivista d'Arte*, vol. XI, 1929, pp. 449 ff., and vol. XII, 1930, pp. 20 ff. (**2**) Catalogue, 1962, p. unnumbered, as Simone dei Crocifissi. (**3**) B. Berenson, G. Fiocco, R. Longhi, F. M. Perkins, W. E. Suida, and A. Venturi (in ms. opinions) attribute K1201 to Simone dei Crocifissi. D. C. Shorr (*The Christ Child in Devotional Images*, 1954, pp. 107, 109) accepts this attribution. (**4**) *Preliminary Catalogue*, 1941, p. 186, as Simone dei Crocifissi.

JACOPO DI PAOLO

Bolognese School. Mentioned 1390–1426. He is believed to have descended from a painter family at Reggio. His easily recognized figures, with grimacing faces and flat folds of drapery, suggestive of intarsia, characterize him as the 'most vulgar'[1] Bolognese painter of the end of the fourteenth century. Jacopo di Paolo demonstrates the ultimate conclusion of a tendency prevalent among Bolognese painters of the fourteenth century: without adequate technical preparation, they strove for realism at any cost and too often produced mere caricature.

K1209 : Figure 197

THE CRUCIFIXION. Nashville, Tenn., George Peabody College for Teachers, Study Collection (A-61-10-1), since 1961.[2] Wood. 21×11¾ in. (53·3×29·9 cm.). Gold background abraded.

Comparison with the two paintings signed by Jacopo di Paolo in the Pinacoteca at Bologna, a *Coronation* and a *Crucifixion*, confirms the attribution of K1209 to this painter.[3] It probably dates about 1400, earlier perhaps than the Bologna *Crucifixion*.[4]

Provenance: Achillito Chiesa, Milan. Contini Bonacossi, Florence. Kress acquisition, 1939 – exhibited: National Gallery of Art, Washington, D.C. (854), 1951–52, as Jacopo di Paolo.

References: (**1**) So characterized by R. van Marle, *Italian Schools of Painting*, vol. IV, 1924, p. 463. (**2**) *Acquisitions, 1961*, The Arts, George Peabody College for Teachers, pp. 6 f., as Jacopo di Paolo. (**3**) In ms. opinions B. Berenson, G. Fiocco, R. Longhi, F. M. Perkins, W. E. Suida, and A. Venturi attribute K1209 to Jacopo di Paolo. (**4**) W. Arslan (in *Rivista del R. Istituto d'Archeologia e Storia dell'Arte*, vol. III, 1932, pp. 219 f., fig. 5) dates the Bologna *Crucifixion*, which he thinks was painted with studio assistance, late in the artist's career.

MICHELE DI MATTEO

Bolognese School. Active 1416–48. Best known for his large signed polyptych in the Venice Accademia, he is clearly a follower of Gentile da Fabriano.

K 1195 : Figures 193–194

MATER DOLOROSA AND ST. JOHN THE EVANGELIST. Columbia, Mo., University of Missouri, Study Collection (61.81), since 1961. Wood. Left panel, 9¾×6⅝ in. (24·8× 16·8 cm.); right panel, 9¾×6¾ in. (24·8×17·2 cm.). Good condition.

These panels probably come from an altarpiece where they flanked a *Crucifix* or a half-length *Christ in the Tomb*. They are typical examples of Michele's emulation of Gentile da Fabriano's elegant style, with its profusion of decorative detail and flowing, voluminous drapery.[1] The pseudo-Arabic border designs are like those on the Virgin's robe in Michele's Venice altarpiece. The faces, too, with their sharply pointed noses, are paralleled there and even more closely, perhaps, in the *Coronation of the Virgin* in the Massari Collection, Ferrara,[2] which is inscribed with Michele's name. K 1195 probably dates about 1440.

Provenance: De Clemente, Florence. Cav. Enrico Marinucci, Rome. Contini Bonacossi, Florence. Kress acquisition, 1939.

References: (1) B. Berenson, G. Fiocco, R. Longhi, F. M. Perkins, W. E. Suida, and A. Venturi (in ms. opinions) have attributed K 1195 to Michele di Matteo. (2) Reproduced in R. van Marle, *Italian Schools of Painting*, vol. VII, 1926, fig. 145.

CECCO DI PIETRO

Pisan School. Active from *c.* 1370; died by 1402. He was known to have worked in the Campo Santo at Pisa, where he was influenced by the frescoes of Traini. He was also influenced by Francesco da Volterra and Giovanni di Nicola da Pisa. Of the Sienese artists Luca di Tommè affected him most.

K 102 : Figure 198

ST. JEROME IN HIS STUDY. Raleigh, N.C., North Carolina Museum of Art (GL.60.17.16), since 1960.[1] Wood. 35⅛× 20⅛ in. (89·2×51·1 cm.). Good condition.

Attempts have been made to associate K 102 with the schools of Venice, Florence, Bologna, and Pisa. Such masters as Guariento and Orcagna have been suggested and such lesser painters as Simone dei Crocifissi and Jacopo di Paolo da Bologna.[2] The most recent attribution, to the Pisan Cecco di Pietro,[3] is also the most acceptable. The date is probably early in this artist's career, about 1370, when he would have been most influenced by Traini's Campo Santo frescoes; there the apostles in the *Last Judgment* offer the closest stylistic models for the severely chiseled head in K 102.

Provenance: Ravasco, Milan. Paolo Paolini, Rome (sold, American Art Galleries, New York, Dec. 10–11, 1924, no. 34, as Guariento). Contini Bonacossi, Rome. Kress acquisition, 1930 – exhibited: National Gallery of Art, Washington, D.C. (162), 1941–52;[4] Staten Island Institute of Arts and Sciences, Dec. 1955, as Jacopo di Paolo da Bologna.[5]

References: (1) Catalogue by F. R. Shapley, 1960, p. 44, as Jacopo di Paolo da Bologna. (2) In ms. opinions K 102 has been attributed to the North Italian School by B. Berenson and F. M. Perkins; to Simone dei Crocifissi by G. Fiocco, R. Longhi, and A. Venturi; tentatively to Guariento by R. van Marle; and tentatively to Orcagna by L. Coletti. W. E. Suida (in *Critica d'Arte*, vol. IX, May 1950, p. 58) attributes it to Jacopo di Paolo da Bologna. (3) E. Carli (*Pittura pisana del trecento*, vol. II, 1961, p. 92) attributes the panel to the early period of Cecco di Pietro. (4) *Preliminary Catalogue*, 1941, pp. 200 f., as Tommaso da Modena. (5) *The New Bulletin*, vol. V, 1955, pp. 25 f.

CECCO DI PIETRO

K 1174 : Figure 201

MADONNA AND CHILD. Portland, Ore., Portland Art Museum (61.44), since 1952.[1] Wood. 48¾×21 in. (123·8× 53·3 cm.). Inscribed on the Virgin's halo: GRATIA PLENA DOMINUS (from Luke I : 28); and on the base of the frame, the artist's signature and the date: CECCHUS PETRI DE PISI ME PISIT A. D. MCCCLXXXVI. Good condition.

Kneeling at the feet of the Madonna are two donors, one of them wearing the cruciform badge of the Knights of St. John of Jerusalem (Knights of Malta). K 1174 was originally the center of a polyptych. Four of the side panels, representing saints, are preserved (*Peter* and *Bartholomew* in the Museum at Nantes; *John the Baptist* and *Nicholas* in the Museum at Rennes) and two others, described in 1864 as a *St. Christopher* and a *Saint Carrying a Purse*, were probably in the same group of side panels.[2] The composition of K 1174, even to the arrangement of the donors, is closely modeled on Francesco da Volterra's signed *Madonna* in the Estense Gallery, Modena;[3] the types of Virgin and Child are most closely related to those of Cecco di Pietro's *Madonna*, signed and dated 1372 (or 1379), in the Royal Museum at Copenhagen.[4]

Provenance: Conte Ferroni, Florence. Contini Bonacossi, Florence. Kress acquisition, 1939.

References: (1) Catalogue by W. E. Suida, 1952, p. 52, as Cecco di Pietro. (2) The connection with K1174 of the side panels was first recognized by F. Zeri and communicated to E. Carli (*Pittura pisana del trecento*, vol. II, 1961, p. 89, figs. 162 f.), who accepts the attribution recorded in the signature, as do B. Berenson, G. Fiocco, R. Longhi, F. M. Perkins, and A. Venturi (in ms. opinions). (3) Carli, *op. cit.*, p. 93, figs. 98 f. (4) *Ibid.*, fig. 160; see also H. Olsen, *Italian Paintings and Sculpture in Denmark*, 1961, p. 51.

TURINO DI VANNI

Giovanni Turino di Vanni. Pisan School. Born *c.* 1349; died 1438. Documents record his activity from 1390 to 1415, and extant paintings rank him at the top of his profession at the time in Pisa, when, admittedly, standards were not high. Although probably taught in Pisa he was influenced by Barnaba da Modena and Taddeo di Bartolo.

Attributed to TURINO DI VANNI

K177 : Figure 199
ST. LUCY AND ST. AGNES

K176 : Figure 200
A BISHOP SAINT AND ST. FRANCIS

Birmingham, Ala., Birmingham Museum of Art (on permanent loan from the Birmingham Public Library), since 1952.[1] Wood. Each, $52\frac{3}{4} \times 19\frac{1}{4}$ in. (134×48·9 cm.). Fair condition; cleaned 1956.

These two panels, painted about 1400, in the style of Turino di Vanni,[2] must have formed the wings of a triptych.

Provenance: Contini Bonacossi, Florence. Kress acquisition, 1931 – exhibited: Birmingham Public Library, Birmingham, Ala., 1933–52.

References: (1) Catalogue by W. E. Suida, 1952, p. 19, and 1959, p. 16, as Turino di Vanni. (2) In ms. opinions, K176 and K177 are attributed to Turino di Vanni by G. Fiocco, R. Longhi, R. van Marle, and A. Venturi; to an early fifteenth-century Florentine-Pisan painter by F. M. Perkins.

ANGELO PUCCINELLI

Lucchese School. Active 1350–99. He was influenced by Giottesque painters and by Simone Martini and other artists of Siena, where a document proves he was working in 1379.

K153 : Figure 202

TOBIT BLESSING HIS SON. Tulsa, Okla., Philbrook Art Center (3347), since 1953.[1] Wood. $14\frac{7}{8} \times 17\frac{1}{8}$ in. (37·8×43·5 cm.). Good condition except for abrasion at bottom edge.

Contrary to the Apocryphal Book of Tobit's account of Tobias about to leave home with the Archangel Raphael, the latter is here shown winged and richly dressed.[2] The style of the figures resembles that of Puccinelli's work of the end of his career, in the 1390's.[3] K153 probably comes from the predella of an altarpiece.

Provenance: Conte Giuseppe Galli, Piacenza. Contini Bonacossi, Florence. Kress acquisition, 1931 – exhibited: National Gallery of Art, Washington, D.C. (180), 1941–52.[4]

References: (1) Catalogue by W. E. Suida, 1953, pp. 12 f., as Angelo di Puccinelli. (2) This feature of K153 is cited by F. Lugt (in *Gazette des Beaux-Arts*, vol. XXV, 1944, p. 325). (3) In ms. opinions, K153 is attributed to Puccinelli by B. Berenson tentatively, G. Fiocco, R. Longhi, R. van Marle, F. M. Perkins tentatively, and A. Venturi. (4) *Preliminary Catalogue*, 1941, p. 162, as Angelo Puccinelli.

BATTISTA DA VICENZA

School of Vicenza. Active late fourteenth century and early fifteenth. His style, known from two altarpieces of 1404 and 1408 and from frescoes of about the same date, shows him a follower of Lorenzo Veneziano and of the Veronese Altichieri.[1]

Attributed to BATTISTA DA VICENZA

K1779 : Figure 203

CHRIST ON THE CROSS BETWEEN THE VIRGIN AND ST. JOHN. New Orleans, La., Isaac Delgado Museum of Art (61.65), since 1953.[2] Wood. $14\frac{3}{4} \times 14\frac{3}{4}$ in. (37·5×37·5 cm.). Good condition except for a few losses of paint; cleaned 1950.

The figure and drapery types and the tragic expression of faces and gestures find plausible parallels in the work of Battista da Vicenza. K1779 may have been placed originally at the top of a polyptych, as in the case of the *Crucifixion* panel by this artist in San Giorgio, Velo d'Astico. The date also would be similar, around 1400/10.[3]

Provenance: Contini Bonacossi, Florence. Kress acquisition, 1950.

References: (**1**) See A. Moschetti in *Rassegna d'Arte*, vol. v, 1918, pp. 30 ff. (**2**) Catalogue by W. E. Suida, 1953, p. 16, as Battista da Vicenza. (**3**) The attribution to Battista da Vicenza and the dating are R. Longhi's (in ms. opinion).

ALLEGRETTO NUZI

School of Fabriano. Active from 1345; died 1373. In Florence by 1346, he came under the influence of Maso and Daddi. A number of the paintings which he was formerly believed to have painted around the middle of the century are now given to the Master of the Fabriano Altarpiece, whom he emulated for a time.

K 1226 : Figure 205

CHRIST BLESSING. Brunswick, Me., Walker Art Museum, Bowdoin College, Study Collection (1961.100.4), since 1961.[1] Wood. Diameter, 7⅜ in. (18·7 cm.). Good condition.

The facial type, the three-dimensional modeling of the figure, and the calm dignity of the gesture and expression relate K 1226 to the following of Giotto.[2] Its attribution to Nuzi, about 1360, seems reasonable,[3] while its shape and small size suggest use in a frame, perhaps to decorate the central pinnacle of an altarpiece.

Provenance: Cav. Enrico Marinucci, Rome. Contini Bonacossi, Florence. Kress acquisition, 1939 – exhibited: National Gallery of Art, Washington, D.C. (864), 1945–52, as Nuzi.

References: (**1**) *Walker Art Museum Bulletin*, vol. I, 1961, pp. 4–5, 8, as Nuzi. (**2**) W. E. Suida (in *Apollo*, vol. xx, 1934, p. 119) attributes K 1226 to the school of Giotto. (**3**) In ms. opinions, B. Berenson, G. Fiocco, R. Longhi, F. M. Perkins, W. E. Suida, and A. Venturi attribute K 1226 to Nuzi.

ALLEGRETTO NUZI

K 1197 : Figure 204

THE CRUCIFIXION. Birmingham, Ala., Birmingham Museum of Art (61.113), since 1952.[1] Wood. 10⅝×7⅝ in. (27×19·4 cm.). Abrasions and small losses of paint throughout; some larger lacunae.

The most striking parallel to K 1197 is the *Crucifixion* which forms the right wing of a small diptych in the Berlin Museum[2] signed by Nuzi. K 1197 is finished with less care and precision – possibly indicating studio assistance in the execution – but figure types and composition are closely

similar to those in the Berlin panel. The date may be around 1365.

Provenance: Cav. Enrico Marinucci, Rome (as late as 1934). Contini Bonacossi, Florence. Kress acquisition, 1939.

References: (**1**) Catalogue by W. E. Suida, 1952, pp. 16 f., and 1959, pp. 13 f., as Nuzi. (**2**) Suida called attention to this parallel (with no. 1078 in the Berlin Museum) in his publication of K 1197 in *Apollo*, vol. xx, 1934, p. 120. In ms. opinions, B. Berenson, G. Fiocco, R. Longhi, F. M. Perkins, and A. Venturi approve the attribution of K 1197 to Nuzi.

ALLEGRETTO NUZI

K 205A : Figure 207

ST. JOHN RESUSCITATING DRUSIANA. Portland, Ore., Portland Art Museum (61.32), since 1952.[1] Wood. 13½× 14½ in. (34·3×36·8 cm.). Good condition.

For the commentary, etc., see K 205B–D, below.

Reference: (**1**) Catalogue by W. E. Suida, 1952, pp. 20 f., as Nuzi.

ALLEGRETTO NUZI

K 205B : Figure 209
ST. JOHN AND THE PHILOSOPHER CRATO

K 205C : Figure 208
ST. JOHN CONVERTING ATTICUS AND EUGENIUS

K 205D : Figure 210
ST. JOHN AND THE POISONED CUP

Raleigh, N.C., North Carolina Museum of Art (GL.60.17. 18, 19, and 20), since 1960.[1] Wood. K 205B, 14×16¼ in. (35·5×41·3 cm.); K 205C, 13¾×15 in. (34·9×38·1 cm.); K 205D, 13⅞×15 3/16 in. (35·7×38·6 cm.). All panels in good condition.

The scenes in these four panels follow stories from the life of St. John the Evangelist as told by Jacobus de Voragine in *The Golden Legend*. In the first scene St. John raises his devoted friend Drusiana from the dead. In the second he restores crushed jewels to their original condition so that they may be sold for charity. In the third he confirms the faith of two followers by changing the pebbles and reeds of the seashore into riches. And in the fourth he drinks unharmed from the poisoned cup which had proved fatal to the two criminals whose bodies lie on the ground.

These four panels were originally associated with three in the collection of Mrs. Murray Crane, New York.[2] An eighth, now lost, would have completed the series. A satisfactory reconstruction of the altarpiece from which the panels come shows K205A and K205B, both of which are arched, above K205C and K205D on the left side of the altarpiece, while on the right, along with one empty space, are the three panels belonging to Mrs. Crane (two of which are arched), and in the middle is a tall panel of the *Crucifixion*, now in the Art Institute, Chicago.[3] Figures of saints and cherubim in the spandrels of the arched panels were divided into halves by the dismemberment of the altarpiece and so when fitted together again serve to indicate the sequence of the panels. The date is probably about 1370. The figure types in the Evangelist scenes are closely similar to those in Nuzi's Macerata triptych, dated 1369.

Provenance: Baron Fassini, Rome. Contini Bonacossi, Florence. Kress acquisition, 1932 – exhibited: 'Italian Paintings Lent by Mr. Samuel H. Kress,' Oct.1932, Atlanta, Ga., through June 1935, Charlotte, N.C., pp. 28 f. of catalogue, as Nuzi; National Gallery of Art, Washington, D.C. (201–204), 1941–52.[4]

References: (1) Catalogue by F. R. Shapley, 1960, pp. 48 ff., as Nuzi. (2) First noted by L. Venturi (*Italian Paintings in America*, vol. I, 1933, no. 111). In ms. opinions, G. Fiocco, R. Longhi, R. van Marle, W. E. Suida, and A. Venturi attribute K205A–D to Nuzi, while F. M. Perkins gives them to Nuzi and assistant, and B. Berenson (*Pitture italiane del rinascimento*, 1936, p. 344) lists them as by Nuzi in great part. (3) The reconstruction is made by F. Zeri (in *Bollettino d'Arte*, vol. XXXIV, 1949, pp. 21 ff., fig. 5). (4) *Preliminary Catalogue*, 1941, pp. 144 ff., as Nuzi.

GENTILE DA FABRIANO

Umbrian School. Born *c.* 1360/70; died 1427. Since the first notice is from 1408, Gentile's training can only be surmised from his style, which suggests the influence of goldsmiths, enamelers, and miniaturists. Somewhere, in his early years, he was strongly influenced by the Lombard-Burgundian International Style. Active in Venice, Brescia, Florence, Siena, Rome, and elsewhere, he influenced and was influenced by the art of these regions.

K535 : Figure 213

MADONNA AND CHILD WITH TWO ANGELS. Tulsa, Okla., Philbrook Art Center (3358), since 1953.[1] Wood. $23\frac{1}{8} \times 16\frac{7}{8}$ in. (58·7×42·9 cm.). Inscribed on the Virgin's halo: AVE MARIA GRACIA PLENA (from Luke 1 : 28). Very much abraded, especially the angels and the flesh tones; cleaned 1953.

If by the master himself, as seems plausible in spite of the poor preservation, K535 was probably painted about 1410, earlier than any of his known dated pictures. The alternative suggestion gives the work to a close follower.[2] An interesting parallel for the throne is seen in Gentile's *Madonna and Child* in the Pinacoteca at Perugia, where a mass of foliage rises above the Gothic back of the seat.

Provenance: Contini Bonacossi, Florence. Kress acquisition, 1938 – exhibited: National Gallery of Art, Washington, D.C. (420), 1941–52.[3]

References: (1) Catalogue by W. E. Suida, 1953, p. 20, as Gentile da Fabriano. (2) In ms. opinions, G. Fiocco, L. Grassi, R. Longhi, F. M. Perkins, and A. Venturi attribute K535 to Gentile, and B. Berenson notes that it is close to Gentile, perhaps by a Veronese follower. F. Zeri (in letter of Sept. 20, 1948) attributes K535 to Gentile and suggests that it may be the painting which Cavalcaselle saw in Casa Persicini, Belluno ('Virgin and Child between two angels, an injured piece with embossed ornament, of the school of Gentile da Fabriano') and which T. Borenius (in his 1912 ed. of Crowe and Cavalcaselle, *A History of Painting in North Italy*, vol. II, p. 116 n. 4) notes is no longer traceable. A. Gherardini (in *L'Arte*, vol. LVII, 1958, p. 8) cites K535 as an example of the strongly Venetian phase of Gentile's style. (3) *Preliminary Catalogue*, 1941, pp. 75 f., as Gentile da Fabriano.

GENTILE DA FABRIANO

K472 : Figure 212

MADONNA AND CHILD. Washington, D.C., National Gallery of Art (366), since 1941.[1] Wood. $37\frac{3}{4} \times 22\frac{1}{4}$ in. (95·9×56·5 cm.). Inscribed, on the Virgin's collar: MATER (Mother); on the lower border of her dress: AVE MARIA GRATIA PLENA DOM[inus] TECVM BEN[edicta] (from Luke 1 : 28). Her halo is inscribed with a garbled copy of Arabic words which have been tentatively identified as: *al-malik* (the king) *al-sulṭān*[2] (the sultan) *al-ʿādil* (the just) *al-ʿālim* (the wise).[3] Good condition except for some abrasions on the Madonna's mantle, which is very much overpainted; needs cleaning.

The rich decoration of the dresses and halos and especially the four angels minutely engraved on the gold background point to a familiarity with the goldsmith's craft, while the delicately shaded, polished effect of the faces and hands of the Virgin and Child is worthy of a master enameler. With His right hand the Child seems to call attention to the word MATER, as if to emphasize the important role of His mother. The butterfly, which He holds on a string in His left hand, is a symbol of the Resurrection, as the caterpillar and chrysalis stages of this insect are symbols of Life and Death.

In a closely similar painting by Gentile in a French private collection the Child holds a bird on a string.[4] K472, which is unanimously accepted as one of the important productions of Gentile,[5] probably dates from about the time he went to Florence, in 1422 or shortly before.[6] There is much restoration on the Virgin's dress and in the textile thrown over the seat, but the heads, especially that of the Virgin, and also the hands are remarkably well preserved.

Provenance: Alexander Barker, London (sold Christie's, London, June 6, 1874, no. 45 of catalogue, as Gentile da Fabriano). E. J. Sartoris, Paris – exhibited: Royal Academy, London, 1876, no. 195, as Gentile da Fabriano. Madame E. J. Sartoris, Paris – exhibited: Musée des Arts Décoratifs, Paris, 1911, as Gentile da Fabriano. Henry Goldman, New York (catalogue by W. R. Valentiner, 1922, no. 2, as Gentile da Fabriano) – exhibited: 'Fiftieth Anniversary Exhibition,' Metropolitan Museum of Art, New York, 1920. Wildenstein's, New York. Duveen's, New York (*Duveen Pictures in Public Collections of America*, 1941, no. 26, as Gentile da Fabriano). Kress acquisition, 1937.

References: (1) *Preliminary Catalogue*, 1941, p. 75, as Gentile da Fabriano. (2) Al-sulṭān is inscribed mirrorwise. (3) This interpretation of the inscription has been suggested by Richard Ettinghausen, who explains that the four words reflect a typical royal inscription on a Mamlūk object made of bronze, brass, or glass, or possibly on a textile. Dr. Ettinghausen points out that a correct copy of a related Mamlūk inscription is on a drawing by Pisanello in the Louvre (no. M.I. 1062r), as analyzed by M. S. Reich (in *Bulletin de l'Institut d'Égypte*, vol. XXII, 1939–40, pp. 123 ff.). (4) This *Madonna and Child with St.Lawrence and St.Julian* is published by C. Sterling in *Paragone*, no. 101, 1958, pp. 26 ff., figs. 1 ff. (5) The bibliography of K472 includes the following: A. Colasanti, in *Bollettino d'Arte*, vol. V, 1911, pp. 33 ff.; Crowe and Cavalcaselle, *A History of Painting in Italy*, ed. Borenius, vol. V, 1914, p. 209 n. 7; R. van Marle, *Italian Schools of Painting*, vol. VIII, 1927, pp. 18 f.; L. Venturi, *Italian Paintings in America*, vol. I, 1933, no. 132; B. Berenson, *Italian Pictures of the Renaissance*, 1932, p. 221 (Italian ed., 1936, p. 190). (6) Calling K472 the 'sister' of the very similar Madonna fragment in the Berenson Collection, Florence, L. Grassi (in *Paragone*, no. 15, 1951, pp. 29 f.) dates both paintings in Gentile's Florentine period, 1422–25.

GENTILE DA FABRIANO

K486 : Figure 211

A MIRACLE OF ST. NICHOLAS. Washington, D.C., National Gallery of Art (379), since 1941.[1] Wood. 14¼ × 14 in. (36×35 cm.). Good condition; yellow varnish and unnecessary restorations; needs cleaning.

When K486 became known, in the 1930's, it was finally possible to complete the reconstruction of the altarpiece which Gentile da Fabriano painted at the order of the Quaratesi family for the high altar of San Niccolò Oltrarno, Florence.[2] The polyptych had been dismembered by about 1835, at which time only the wings (now in the Uffizi, Florence), with full-length figures of Sts. Mary Magdalene, Nicholas, John the Baptist, and George, remained in the church. The middle panel (now in the Queen's Collection, London), with the Madonna and Child, and four of the predella panels (now in the Vatican Pinacoteca), with scenes from the legend of St. Nicholas, had disappeared. The fifth predella panel, K486, although at this time (*c.* 1835) known to belong to the Puccini family, Pistoia, had disappeared by 1878.[3] At present the only part of the altarpiece still missing is the original frame, which, presumably, bore the inscription, last verified in 1762: OPUS GENTILIS DE FABRIANO MCCCCXXV MENSE MAII.[4]

Vasari described the altarpiece briefly in 1568 and praised the small panels especially: 'The predella of this painting, filled with stories of the life of St. Nicholas, in small figures, could not be more beautiful nor better executed than it is.'[5] K486 is better preserved than its four companion panels. It is also particularly interesting for its composition, which shows the sick and crippled being cured by touching the tomb of St. Nicholas, while a robed man, perhaps the sacristan, half visible at the top of the steps to the right of the apse, watches the people at the tomb. This novel inclusion of a witness to what is taking place has suggested comparison with Jan van Eyck's Arnolfini portrait.[6] The original sequence of the five predella panels, with K486 at the extreme right, can be inferred from Gentile's repetition of the five predella compositions as part of the decoration of the apse of the church where the miracle is taking place. This repetition of the predella scenes, as if reflected in a mirror, is another evidence of Gentile's inventiveness, anticipating by nine years van Eyck's use of a convex mirror in the Arnolfini portrait.[7] The other paintings and mosaics with which Gentile decorates his setting for the miracle are earlier in style, for example a Byzantine composition of *Christ between the Virgin and St. Nicholas*, in the apse, and a thirteenth-century *Crucifixion*, on the wall behind the sacristan. Perhaps the recent restorations of the late-eleventh-century basilica of St. Nicholas at Bari may produce some evidence as to Gentile's knowledge of the actual appearance of the crypt, whither the saint's remains had been transported in the eleventh century.[8] Ambrogio Lorenzetti's *Mass of St. Nicholas* (Uffizi, Florence) has a setting similar to Gentile's *Miracle*, and a panel by Andrea di Giusto, recently exhibited in Birmingham, England,[9] seems to be a simplification of Gentile's treatment of the scene.

Provenance: San Niccolò Oltrarno, Florence. Cav. Tommaso Puccini, Pistoia. Niccolò Puccini (nephew of the preceding), Pistoia (*c.* 1835). Contini Bonacossi, Florence. Kress acquisition, 1937.

References: (**1**) *Preliminary Catalogue,* 1941, p. 75, as Gentile da Fabriano. (**2**) R. Longhi (in ms. opinion, 1937) first recognized k486 as part of the Quaratesi predella. It was so published by Longhi (in *Critica d'Arte,* July–Dec. 1940, pp. 190 f.) and by W. E. Suida (in *Art Quarterly,* Autumn, 1940, pp. 351 f.) and so recognized (in ms. opinions) by B. Berenson, G. Fiocco, F. M. Perkins, and A. Venturi. L. Grassi (in *Paragone,* no. 15, 1951, pp. 23 ff.) discusses the style of the whole altarpiece. (**3**) All this information is gleaned from the notes, some of them reprinted from earlier editions, in Milanesi's edition (1878) of Vasari (*Le Vite,* vol. III, p. 7). All five predella panels were still missing as late as 1905 (see H. P. Horne, in *Burlington Magazine,* vol. VI, 1905, p. 424). (**4**) This inscription is recorded by G. Richa (*Notizie istoriche delle chiese fiorentine,* vol. X, 1762, p. 35; see L. Grassi, in *Paragone,* no. 15, 1951, p. 23 n. 1). (**5**) Vasari, *Le Vite,* 1568, Milanesi ed., vol. III, 1878, p. 7. (**6**) See Longhi, *Critica d'Arte,* in note 2, above. (**7**) *Ibid.* (**8**) For a discussion of the architecture of the church see É. Bertaux (*L'Art dans l'italie méridionale,* vol. I, 1904, pp. 335 ff.); for a drawing of the crypt see H. Saladin (in *Gazette des Beaux-Arts,* vol. XXX, 1884, p. 509). (**9**) Reproduced in *Dedalo,* vol. XII, 1932, p. 522, the Andrea di Giusto panel was exhibited in 'Works of Art Belonging to the Friends of the Art Gallery,' 1962, no. 68, Birmingham, England, and was sold Nov. 29, 1963, no. 74, at Christie's from the property of Mrs. R. L. Edwards; bought by L. Koetser. C. Brandi (*Giovanni di Paolo,* 1947, p. 84 n. 68) suggests that also the scene of pilgrims at the tomb of St. Stephen in Giovanni di Paolo's predella in the Church of Santo Stefano alla Lizza, Siena, of *c.* 1450, was inspired by k486.

Follower of GENTILE DA FABRIANO

K1777 : Figure 214

THE ANNUNCIATION TO THE SHEPHERDS. Denver, Colo., Denver Art Museum (E-GE-18-XV-950), since 1954.[1] Wood. 21⅜ × 16¾ in. (54·3 × 42·6 cm.). Good condition except for a few abrasions.

Through comparison with the remarkable panel in the Poldi Pezzoli Museum, Milan, of *St. Benedict the Hermit,*[2] k1777 has recently been attributed to the Bohemian painter Master Wenceslaus.[3] However, the attribution of the Poldi Pezzoli panel is far from being established[4] and, moreover, the two panels differ considerably in quality. k1777, which may be a fragment of a *Nativity,* is evidently the work of a fifteenth-century provincial painter, likely a North Italian, possibly a Bohemian, influenced by the International Style, of which Gentile da Fabriano was a purveyor.

Provenance: Contini Bonacossi, Florence. Kress acquisition,

1950 – exhibited: National Gallery of Art, Washington, D.C., 1951–52, as school of Gentile da Fabriano.

References: (**1**) Catalogue by W. E. Suida, 1954, pp. 60 f., as Master Wenceslaus. (**2**) No. 591 in the Poldi Pezzoli (see the 1955 catalogue by F. Russoli, pp. 227 ff., with a summary of the discussions regarding the painting's various attributions and a decision to classify it for the present as Venetian, *c.* 1415). Longhi (in ms. opinion) attributes both k1777 and the Poldi Pezzoli painting to the young Pisanello. (**3**) See note 1, above. (**4**) Summaries published by Suida (catalogue cited in note 1, above) and Russoli (catalogue cited in note 2, above).

VERONESE SCHOOL, Early XV Century

K135 : Figure 215
THE ANNUNCIATION AND THE NATIVITY

K136 : Figure 216
LEGEND OF A SAINT

New York, N.Y., Mrs. Rush H. Kress. Wood. Each, 9 × 6⅝ in. (22·9 × 16·9 cm.). Inscribed on scroll at bottom of K135: E[cce] UIRGO IN UTERO . . . (beginning of Matthew I : 23); on scroll at bottom of K136: DEPONAT DN̄S OM̄S . . . (inscription unclear).

Especially in the scene of the *Annunciation* there is something of the International Style of Gentile da Fabriano. The two paintings may be Veronese, of the beginning of the fifteenth century, although a related contemporary panel, the *Adoration of the Magi,* no. 30 in the Accademia, Venice, has been attributed not only to the Veronese School, but also to the Bolognese, to the Ferrarese, and to the Venetian. The subject of k136 has not been identified, nor have the two figures and the inscription at the bottom of this panel. At the bottom of k135 it would seem to be Joseph, at the right, to whom the prophet, at the left, is proclaiming the virgin birth of Christ.

Provenance: Dr. Oldenberg. Böhler's, Munich (1924). Kress acquisition, 1924.

PIETRO DI DOMENICO DA MONTEPULCIANO

School of the Marches. Active early fifteenth century. Identical with the Pietro who signed an altarpiece dated 1422 in the Pinacoteca at Recanati (and therefore known as Pietro da Recanati), he was born near Siena but worked in the Marches, following the local style as it was modified

by the influence of Gentile da Fabriano and of fourteenth-century Venetian art.

K 59 : Figure 218

THE CORONATION OF THE VIRGIN. Washington, D.C., Howard University, Study Collection (61.148.P), since 1961.[1] Wood. 32⅝×21 in. (82·9×53·3 cm.). Good condition.

The attribution is based on stylistic affinity with the *Madonna and Angels* in the Metropolitan Museum, New York, which is signed by the artist and dated 1420, a date which is approximately correct for K 59 also.[2] The style of the work recalls such artists as Lorenzo Veneziano. Even the choice of subject is significant: the *Coronation of the Virgin* early became a favorite theme in Venetian painting.

Provenance: Contini Bonacossi, Rome. Kress acquisition, 1929 – exhibited: National Gallery of Art, Washington, D.C. (145), 1941–52.[3]

References: (1) Catalogue, 1961, no. 1, as Pietro di Domenico da Montepulciano. (2) K 59 has been attributed to Pietro di Domenico by R. Longhi (in *Vita Artistica*, vol. II, 1927, pp. 18 ff.), L. Serra (*L'Arte nelle Marche*, 1934, p. 381), B. Berenson, G. Fiocco, R. van Marle, F. M. Perkins, O. Sirén, W. E. Suida, and A. Venturi (in ms. opinions). (3) *Preliminary Catalogue*, 1941, p. 157, as Pietro di Domenico da Montepulciano.

MASTER OF STAFFOLO

School of the Marches. Active, in the neighborhood of Fabriano, c. 1420–c. 1450. His recently proposed designation[1] was suggested by the location of his large polyptych in San Francesco at Staffolo. He was a follower of Gentile da Fabriano and of Pietro di Domenico da Montepulciano, copying some of the latter's paintings. His work has been variously attributed, some of it to a so-called Master of the Culla.

K 1162 : Figure 217

MADONNA AND CHILD WITH ST. LUCY AND ST. ELIGIUS. Claremont, Calif., Pomona College, Study Collection (61.1.5), since 1961. Wood. 53⅛×37¼ in. (135×94·6 cm.). Inscribed with the saints' names at bottom: SANCTA LUCIA SANCTA MARIA SANCTUS ALOI. Much baraded and heavily restored.

Formerly attributed to the 'Master of the Culla,'[2] K 1162 now takes its place among the paintings assigned to the Master of Staffolo and probably belongs late in his career, toward 1450.[3] Close stylistic parallels are offered by a

polyptych in the Parish Church at Albacina[4] and a triptych in the Gallery at Fabriano featuring the Virgin adoring the Child, Who lies in a cradle.[5]

Provenance: Dan Fellows Platt, Englewood, N.J. (sold by estate trustee to the following). Kress acquisition, 1939 – exhibited: National Gallery of Art, Washington, D.C. (860), 1945–52, as School of the Marches.

References: (1) First suggested by A. Santangelo (*Museo di Palazzo Venezia*, 1947, p. 32). F. Zeri (in *Proporzioni*, vol. II, 1948, pp. 166 f. n. 2) lists the recognized oeuvre of this minor master. (2) So attributed (in ms. opinion) by B. Berenson. (3) F. Zeri (in letter of Sept. 20, 1948) offers this attribution and dating. (4) Reproduced by R. van Marle, *Italian Schools of Painting*, vol. VIII, 1927, fig. 169. (5) Reproduced, *ibid.*, fig. 185.

MICHELE GIAMBONO

Michele di Taddeo Bono, called Giambono. Venetian School. Active c. 1420–62. He was probably influenced by Jacobello del Fiore and even more by Gentile da Fabriano. His work is typical of the more flowery, light-hearted phase of the International Style.

K 178 : Figure 221

ST. PETER. Washington, D.C., National Gallery of Art (191), since 1941.[1] Wood. 33¾×13¾ in. (86×35 cm.). Good condition.

Since K 178 became known to modern scholars, other panels have successively come to be associated with it, nearly completing the reconstruction of an altarpiece. Proposed for the main panel of the altarpiece is Giambono's *Archangel Michael* in the Berenson Collection, Florence, which would have been flanked by four full-length figures: *John the Baptist* (Bardini Museum, Florence), a *Bishop Saint* (Museo Civico, Padua), a *Pope* (Museo Civico, Padua), and *St. Peter* (K 178). Above these four full-length figures would have been four half-lengths: a *Bishop* (Gardner Museum, Boston), *St. Mark* (National Gallery, London), *St. Stephen* (Gilbert Collection, Bellagio), and a *Bishop* (Museo Civico, Padua).[2] The reconstruction leaves unaccounted for the panel (probably a *Madonna* or a *Pietà*) above the archangel and, of course, an elaborate Gothic frame for the whole altarpiece. Also no satisfactory suggestion has been made regarding the original location of the altarpiece. The date is probably about 1440.

Provenance: Probably Marchese Galeazzo Dondi dall'Orologio, Padua.[3] Stefano Bardini, Florence. Contini Bonacossi, Florence. Kress acquisition, 1931 – exhibited: 'Italian Paintings Lent by Mr. Samuel H. Kress,' Oct. 1932,

Atlanta, Ga., through June 1935, Charlotte, N.C., p. 39 of catalogue, as Giambono; 'Exhibition of Venetian Paintings,' California Palace of the Legion of Honor, San Francisco, June 25–July 24, 1938, no. 28 of catalogue, as Giambono; 'Special Exhibition of Venetian Paintings from the Samuel H. Kress Collection,' Seattle, Wash., Aug. 1–25, 1938; Portland, Oregon, Sept. 1–26, 1938; Montgomery, Ala., Oct. 1–31, 1938; 'Four Centuries of Venetian Painting,' Toledo Museum of Art, Toledo, Ohio, Mar. 1940, no. 24 of catalogue, as Giambono.

References: (1) *Preliminary Catalogue,* 1941, p. 77, as Giambono. (2) G. Fiocco, R. van Marle, F. M. Perkins, W. E. Suida, and A. Venturi (in ms. opinions) and B. Berenson (*Italian Pictures . . . Venetian School,* vol. 1, 1957, p. 83) recognize K178 as by Giambono. R. Longhi (*Viatico per cinque secoli di pittura veneziana,* 1946, p. 50) suggests a reconstruction of the lower tier of the altarpiece which is the same as that proposed by E. Sandberg-Vavalà (in *Journal of the Warburg and Courtauld Institutes,* vol. X, 1947, pp. 22 ff.), who adds the four smaller panels at the top. This reconstruction is accepted by M. Davies (*National Gallery Catalogues: The Earlier Italian Schools,* 1961, pp. 225 f.). (3) In this collection Crowe and Cavalcaselle (*A History of Painting in North Italy,* vol. I, 1871, p. 296 n.) describe a *St. Peter* answering the description of K178 (see Davies, *loc. cit.* in note 2, above). T. Borenius (in the 1912 ed. of Crowe and Cavalcaselle, *A History of Painting in North Italy,* vol. II, p. 3 n. 4) says this picture, which once belonged to Marchese Dondi dall'Orologio, could no longer be traced.

Follower of MICHELE GIAMBONO

K123 : Figure 219

MADONNA AND CHILD. Tucson, Ariz., University of Arizona, Study Collection (62.151), since 1962. Wood. 18⅛×13 in. (46×33 cm.). Inscribed indistinctly on the Virgin's halo: AVE MARIA GRATIA PLENA DOMINVS TECVM (from Luke 1 : 28). Much restored, especially in flesh tones.

Although less elegant than its prototype, this painting, which dates about 1450, derives from such a panel by Giambono as the half-length *Madonna* in the Museo Civico, Venice.[1] Not only the composition of that painting is echoed here, but also the treatment of the background, with an allover decorative pattern. At the same time K123 harks back remarkably clearly to Giambono's predecessors, Gentile da Fabriano and Jacopo Bellini.

Provenance: Contini Bonacossi, Rome. Kress acquisition, 1930 – exhibited: 'Religion in Painting,' Arkansas Arts Center, Little Rock, Ark., Dec. 7, 1963–Jan. 30, 1964, no. 24, as unknown Venetian.

Reference: (1) In ms. opinions, B. Berenson, G. Fiocco, F. M. Perkins, W. E. Suida and A. Venturi attribute K123 to a follower of Giambono; R. Longhi recognizes a relationship to Giambono and calls it Venetian, *c.* 1440/50.

LOMBARD SCHOOL, XV Century

K22 : Figure 220

MADONNA AND CHILD WITH SAINTS AND DONOR. Raleigh, N.C., North Carolina Museum of Art (GL.60.17.21), since 1960.[1] Wood. 13⅜×9½ in. (34×24·1 cm.). Inscribed below: SPECTABILIS AC STRENUUS VIR MATTHAEUS DE ATTENDOLIS BOLOGNINUS, TICINENSIS ARCIS PRAEFECTUS CREATUS SANCTI ANGELI COMES A FRANCISCO SFORTIA MEDIOLANI DUCE ANNO MCCCCLII, COMMENDANTIBUS, SANCTIS JOHANNE EUANGELISTE, ET ANTONIO ABBATE, AB DEIPARA CLIENTELAM RECIPITUR (see translation, below). Fair condition; extensively abraded, especially face of donor; cleaned 1960.

Dating originally from the first half of the fifteenth century, K22 was altered after 1452, the date mentioned in the inscription. Changes were made in the donor's portrait and the coat of arms; and the inscription, which is on an applied strip of paper and seems to have been printed with movable type, was added. The original painting is in the International Style, but while similarity to the style of Jacquemart de Hesdin is obvious, there is hardly sufficient support for classification of the work as Franco-Flemish.[2] It could have been painted by such a Lombard artist as Michelino da Besozzo and is not far from the style of Cristoforo de'Moretti. Old photographs show the features of an old man painted over the head of the donor whom we now see, and X-ray shows that he once wore a scalloped cloak. The original coat of arms, partly visible in the X-ray, has not been identified; the present one, a lion rampant carrying a branch, is that of the Sforzas, thus agreeing with the inscription, which states that 'the outstanding and capable gentleman, Matteo de'Attendoli, of Bologna, commander of the Ticinian fortress, made Count of Sant'Angelo by Francesco Sforza, Duke of Milan, in 1452, is received by the Mother of God into her patronage, his sponsors being Sts. John the Evangelist and Anthony Abbot.' This Matteo de'Attendoli of Bologna, popularly known as Il Bolognino, was a member of the family Attendoli (Sforza) by adoption. The adoption, as well as the gift of the Castle of Sant'Angelo, near Lodi, was a token of Francesco Sforza's gratitude to Il Bolognino for having yielded to him the fortress of Pavia when that city found itself, in 1447, in the necessity of choosing between Venice and Milan.[3]

Provenance: Julius Böhler's, Munich (as early as 1909).

Conte Avogli-Trotti, Paris. Contini Bonacossi, Rome. Kress acquisition, 1928 – exhibited: National Gallery of Art, Washington, D.C. (130), 1941–56;[4] 'Arte Lombarda dai Visconti agli Sforza,' Palazzo Reale, Milan, Apr.–June 1958, no. 196, as Lombard, early fifteenth century; 'The International Style,' Walters Art Gallery, Baltimore, Md., Oct. 23–Dec. 2, 1962, pp. 16 f. of catalogue, as Lombard, early fifteenth century.

References: (**1**) Catalogue by F. R. Shapley, 1960, p. 52, as Lombard, fifteenth century. (**2**) E. Panofsky (*Early Netherlandish Painting,* vol. I, 1953, p. 392 n. I) classifies K22 as Franco-Flemish. W. E. Suida (in *Monatshefte für Kunstwissenschaft,* vol. II, 1909, pp. 473 and 495) and P. Toesca (*La Pittura e la miniatura nella Lombardia,* 1912, pp. 556 f.) call it Lombard, as do B. Berenson, G. Fiocco, R. Longhi, F. M. Perkins, and A. Venturi (in ms. opinions). (**3**) F. R. Shapley, in *Art Quarterly,* vol. VIII, 1945, pp. 34 and 37. (**4**) *Preliminary Catalogue,* 1941, pp. 109 f., as Lombard, fifteenth century.

BELBELLO DA PAVIA

Lombard School. Active *c.* 1430–after 1462. His work was highly prized by the Gonzaga of Mantua, with whom documents from 1448 to 1462 connect him. He is believed to have been active in Venice for several years after 1462. One of the most notable North Italian miniaturists of his time, he is stylistically related to Lorenzo Monaco and is believed to have influenced Taddeo Crivelli, Girolamo da Cremona, Tura, and the Paduan circle of Squarcione.

K616 : Figure 206

THE VIRGIN ADORING THE CHILD. New York, N.Y., Mrs. Rush H. Kress. Illumination on vellum. $6\frac{5}{8} \times 6\frac{1}{2}$ in. (16·8×16·5 cm.); full page, $22\frac{1}{4} \times 15\frac{7}{8}$ in. (56·5×40·3 cm.). Very good condition.

Formerly attributed to Sano di Pietro,[1] K616 is a typical Lombard illumination, conforming in detail to the style of Belbello da Pavia. The foliate design of the letter V in which the Virgin and Child are enclosed is like that in the initial letters of antiphonary pages by Belbello in the Cini Collection, Venice,[2] as are the elegantly stylized drapery folds and the figure types (even the parting of the Virgin's lips to give a glimpse of the teeth is characteristic of Belbello's types). K616 is the initial letter of an antiphonary page, of which it still forms an integral part. The date is probably about 1440/50.

Provenance: Swiss private collection (sold, Müller-Mensing, Amsterdam, Nov. 22, 1929, no. 84, as Sano). P. Graupe, Berlin (sold, May 12 [1930?], no. 10). Kress acquisition, date unknown.

References: (**1**) K616 is published by P. Misciattelli (in *La Diana,* vol. V, 1930, p. 31), as Sano di Pietro. (**2**) Reproduced by P. Toesca, *Monumenti e studi per la storia della miniatura italiana,* 1930, pls. 86 f. Cf. also the *Annunciation* page from an antiphonary, attributed to Belbello, in the Rosenwald Collection (B-14,851) at the National Gallery of Art, Washington, D.C.

COSIMO TURA

Known also as Cosmè. Ferrarese School. Born *c.* 1430; died 1495. The style of this first important painter of Ferrara seems to have been inspired chiefly by the Squarcionesques of Padua, especially the young Mantegna, and by Piero della Francesca, Donatello, Castagno, and Rogier van der Weyden, all of whom left important work which Tura must have seen in Ferrara, Venice, or Padua. But Tura is more unrealistic, more mannered, more medieval in spirit than any of these; and his eccentric style is echoed in the whole school of fifteenth-century Ferrarese painting. He had become court painter by 1452 and through the best years of the Este regime he was highly respected and much in demand, not only for paintings but for decoration of furnishings of all kinds.

K1373 : Figure 225

MADONNA AND CHILD IN A GARDEN. Washington, D.C., National Gallery of Art (827), since 1945. Wood. $20\frac{3}{4} \times 14\frac{5}{8}$ in. (53×37 cm.). Fair condition except for abrasion throughout and some losses of paint, especially in the Madonna's mantle; stucco decoration at top is original but regilded.

Perhaps Tura's earliest known painting, K1373 seems to be contemporary with Ferrarese illuminations of about 1455.[1] The figures of the Angel and Virgin Annunciate in the upper part of the panel may give an idea of Tura's own miniatures with which documents credit him.[2] The M-shaped gilded scroll enclosing these figures is to be thought of as part of the picture's original frame, most of which has been lost.[3] The scroll is in relief and is probably characteristic of the designs which Tura is recorded as having used to decorate chests. The Ferrarese custom was to mold such relief ornaments from fragrant moss paste.[4] The finny projections on the scroll relate it to Tura's dolphin decorations on the throne of the allegorical figure in the National Gallery, London. Used to enclose the *Annunciation* and converging upon the Virgin and Child, the scroll may be a reference to the Tree of Jesse.[5] The composition of the Virgin with clasped hands adoring the sleeping Child was common at the time, especially in the oeuvre of Bartolomeo Vivarini; but Tura, suspending the Child, as in a swing, between the Virgin's knees, has produced an original, eccentric variation.

Provenance: Harold I. Pratt, New York – exhibited: 'Loan Exhibition of Italian Primitives,' Kleinberger Galleries, New York, Nov. 1917, no. 78 of catalogue by O. Sirén and M. W. Brockwell, as Tura; 'Italian Paintings of the Renaissance,' The Century Association, New York, Mar. 2–24, 1935, no. 16 of catalogue, as Tura; 'Italian paintings and Drawings,' Fogg Art Museum, Cambridge, Mass., Mar. 24–Apr. 15, 1939, no. 40, as Tura; 'Masterpieces of Art,' New York World's Fair, May–Oct. 1939, no. 389 of catalogue, as Tura. Wildenstein's, New York (*Italian Paintings,* 1947, list in Introduction). Kress acquisition, 1943.

References: (**1**) A. Venturi (in *L'Arte,* vol. XXVIII, 1925, p. 94; *North Italian Painting of the Quattrocento,* 1931, p. 40; and elsewhere) and E. Ruhmer (*Tura,* 1958, p. 173) date K1373 late, about 1470. But L. Venturi (*Italian Paintings in America,* vol. II, 1933, no. 344), R. Longhi (*Officina ferrarese,* 1934, pp. 34 f., 160; and later ed.), S. Ortolani (*Cosmè Tura, Francesco del Cossa, Ercole de' Roberti,* 1941, pp. 20 ff.), and M. Salmi (*Cosmè Tura,* 1957, pp. 10 f.) assign K1373 to Tura's earliest period. As for the attribution to Tura, it is accepted by all scholars in the field, including B. Berenson (*Italian Pictures of the Renaissance,* 1932, p. 581; Italian ed., 1936, p. 500). (**2**) From the circle of Tura, if not by Tura himself is the miniature on vellum of the *Stigmatization of St. Francis,* in the Rosenwald Collection, National Gallery of Art, Washington, D.C. The scene is enclosed in a scroll design related to that in K1373. (**3**) Ruhmer, *loc. cit.,* in note 1, above. (**4**) A. Venturi, *Storia dell'arte italiana,* vol. VII, pt. III, 1914, p. 506. (**5**) Ortolani, *loc. cit.* in note 1, above.

triptych, flanking a middle panel of the *Madonna and Child,* were decorated with small figures of saints.[5]

Provenance: Cook Collection, Richmond, as early as 1888 (catalogue by T. Borenius, vol. I, 1913, no. 117, as Tura; abridged catalogue by M. W. Brockwell, 1932, no. 117, as Tura) – exhibited: 'Works of the School of Ferrara-Bologna,' Burlington Fine Arts Club, London, 1894, no. 5 of catalogue, as Tura. Paul Drey's, New York. Kress acquisition, 1947.

References: (**1**) *Paintings and Sculpture from the Kress Collection,* 1951, p. 74 (catalogue by W. E. Suida), as Tura. (**2**) F. Harck (in *Jahrbuch der Königlich Preussischen Kunstsammlungen,* vol. IX, 1888, p. 37, no. 47, as Tura. They are included in the pertinent reference books: Thieme-Becker, Berenson's lists, etc. (**3**) A. Venturi (*Storia dell'arte italiana,* vol. VII, pt. III, 1914, p. 538), followed tentatively by U. Ojetti (in catalogue of the 'Exhibition of Italian Art,' Royal Academy, London, 1930, under no. 214, the right wing of the Roverella altarpiece) and others, connects them in this manner with the Roverella polyptych, where they would have involved, however, a repetition of St. Maurelius. (**4**) R. Longhi, *Officina ferrarese,* 1934, p. 39. (**5**) Harck (see note 2, above) and G. Gruyer (*L'Art ferrarais,* vol. II, 1897, p. 80) suggest a diptych. S. Ortolani (*Cosmè Tura, Francesco del Cossa, Ercole de' Roberti,* 1941, pp. 70 f.), M. Salmi (*Cosmè Tura,* 1957, p. 43), and E. Ruhmer (*Tura,* 1958, p. 178) find a triptych like Duke Ercole's a plausible source of the four panels and Ruhmer labels them, tentatively, as from that very triptych.

COSIMO TURA

K1429 : Figures 226–229

THE ANNUNCIATION WITH ST. FRANCIS AND ST. MAURELIUS. Washington, D.C., National Gallery of Art (1089), since 1951.[1] Wood. Each, 12×4⅝ in. (30·5×11·8 cm.). Very good condition, as far as can be seen through the discolored varnish.

Since they were first published, in 1888, these four panels have been unanimously accepted as the work of Tura.[2] Critics are in agreement also regarding their date, around 1475. But suggestions as to their original use have varied. That they may have been used, one above another, to decorate the pilaster of an altarpiece is a proposal[3] that has been rejected because their perspective shows they were intended to be placed on a single plane.[4] They could have been used in a predella of a large altarpiece or more likely they were parts of a small diptych or triptych, such as the portable altarpiece which Tura is recorded as having painted in 1475 for Duke Ercole I d'Este. The wings of that

Attributed to COSIMO TURA

K1082 : Figure 230

PORTRAIT OF A MAN. Washington, D.C., National Gallery of Art (450), since 1941.[1] Wood. 14×10 in. (35·5× 25·4 cm.). Good condition except much too heavily varnished.

Ever since it was first published, in 1930,[2] K1082 has posed a problem over which critics have sharply disagreed. The picture has been defended as typical of Tura's maturity, about 1475/85;[3] as an unmistakable work by Zoppo;[4] as a characteristic example of Cossa;[5] and it has been tentatively attributed to the young Lorenzo Costa.[6]

Provenance: Matthiesen Gallery, Berlin (sold to the following). Duveen's, New York (*Duveen Pictures in Public Collections of America,* 1941, no. 62, as Tura) – exhibited: 'Esposizione della Pittura Ferrarese del Rinascimento,' Ferrara, May–Oct. 1933, no. 62 of catalogue, as Tura. Kress acquisition, 1937.

References: (**1**) *Preliminary Catalogue*, 1941, p. 201, as Tura. (**2**) A. Venturi, in *L'Arte*, vol. XXXIII, 1930, pp. 283 f. (**3**) A. Venturi (see note 2, above). B. Berenson (in ms. opinion), and E. Ruhmer (*Tura*, 1958, pp. 21, 56, tentatively) ascribe K1082 to Tura; S. Ortolani (*Cosmè Tura, Francesco del Cossa, Ercole de' Roberti*, 1941, pp. 64 ff.) concludes that it is more probably an unsuccessful work by Tura than an excellent example of Zoppo. (**4**) R. Longhi (*Officina ferrarese*, 1934, p. 40), C. L. Ragghianti (in *Critica d'Arte*, Feb. 1936, p. 139, comparing the portrait to a drawing in the Uffizi, Florence, which he attributes to Zoppo), and (in ms. opinions) G. Fiocco, F. M. Perkins, W. E. Suida, and F. Zeri believe K1082 to be by Zoppo. (**5**) G. M. Richter (in *Burlington Magazine*, vol. LXXVIII, 1941, p. 178) attributes it to Cossa. (**6**) M. Salmi (*Cosmè Tura*, 1957, p. 55) finds more probable an attribution to the young Lorenzo Costa, whose *St. Sebastian* in the Dresden Gallery he thinks it resembles. L. Serra (in *Bollettino d'Arte*, vol. XXVI, 1933, p. 580), reviewing the Ferrarese exhibition of 1933, not only rejects the attribution to Tura but expresses some doubt regarding the authenticity of the painting.

BALDASSARE D'ESTE

Ferrarese School. Known also as Baldassare da Reggio, from his birthplace in Emilia. Active second half of fifteenth century. He was a half-brother of Borso d'Este, under whom he shared with Tura the honors of court painter. Although he features frequently and prominently in documents of the time, which praise, especially, the 'living likeness' of his portraiture, little of his work is now definitely identified.

Attributed to BALDASSARE D'ESTE

K1245 : Figure 231

FRANCESCO II GONZAGA, FOURTH MARQUIS OF MANTUA. Washington, D.C., National Gallery of Art (542), since 1941. Wood. $10\frac{1}{2} \times 8\frac{3}{8}$ in. (26·7×21·3 cm.). Inscribed at top: FRANC MAR M IIII (Francesco, Fourth Marquis of Mantua). Good condition.

This was painted about 1476–78, according to the age of the sitter. That he is correctly identified in the inscription is indicated by a comparison of the features with his portraits on medals and in Mantegna's fresco in the Camera degli Sposi at Mantua. The inscription dates some years later than the execution of the portrait since Francesco Gonzaga, born in 1466, became Marquis of Mantua only at the age of eighteen, in 1484, and the boy here shown can be scarcely more than ten or twelve years old. There is no question as to the high quality of the painting, with its firm modeling,

individual characterization of features, and rich blue background. But opinion has varied as to its authorship, usually ascribed to Ercole Roberti.[1] The attribution to Baldassare d'Este is based chiefly on comparison of the painting with the only signed portrait by Baldassare, the profile of 'Tito Strozzi,' now in the Cini Collection, Venice, and with the portrait of Borso d'Este attributed to Baldassare in the Castello Sforzesco, Milan.[2]

Provenance: J. Quincy Shaw, Boston. Schoenemann's, New York. Kress acquisition, 1940.

References: (**1**) Formerly exhibited as Ercole Roberti at the National Gallery of Art. G. M. Richter, W. E. Suida, and L. Venturi (in ms. opinions) have attributed it to Ercole Roberti. G. Bargellesi (*Notizie di opere d'arte ferrarese*, 1955, pp. 38 f.) proposes the little-known Antonio da Crevalcore. (**2**) C. L. Ragghianti (in *Critica d'Arte*, May 1949, p. 82) and M. Calvesi (in *Bollettino d'Arte*, vol. XLIII, 1958, p. 156 n. 18) suggest an attribution to Baldassare d'Este, which is defended by F. R. Shapley (in *Studies in the History of Art Dedicated to William E. Suida*, 1959, pp. 124 ff., where comparative material is reproduced). B. Berenson, who once suggested Cossa, agreed (in ms. opinion) in 1959 to the Baldassare attribution, as did A. Scharf and F. Wittgens (verbally). M. Salmi (*Ercole de' Roberti*, 1960, p. 49) rejects the attribution to Ercole and to Antonio da Crevalcore without suggesting another.

FRANCESCO DEL COSSA

Ferrarese School. Born *c.* 1435; died *c.* 1477. He may have developed under Tura; both were influenced by the Squarcione circle at Padua, especially Mantegna, and by Piero della Francesca. The earliest important paintings recorded as by Cossa are his frescoes, of about 1470, in the Schifanoia Palace, Ferrara.

K416 : Figure 222
ST. FLORIAN

K417 : Figure 223
ST. LUCY

Washington, D.C., National Gallery of Art (338 and 339), since 1941.[1] Wood. $31\frac{1}{4} \times 21\frac{5}{8}$ in. (79×55 cm.) and $31\frac{1}{4} \times 22$ in. (79×56 cm.), respectively. Very good condition except for a few abrasions in K416 and a few losses of paint in K417.

Unanimously accepted as by Cossa,[2] these are generally believed to have come from a large altarpiece which Cossa painted soon after 1470 for the Griffoni Chapel in San

Petronio, Bologna. In the early eighteenth century the altarpiece seems to have been removed to the house of the Aldrovandi family, Bologna, who had come into possession of the Griffoni Chapel. K416 and K417 were first noted in modern times in the Spiridon Collection, whither they had come from the Beni Collection.[3] A painting of the full-length, nearly life-size *St. Vincent Ferrer*, now in the National Gallery, London, is believed to have been the central panel of the Griffoni altarpiece, with flanking full-length figures of *St. Peter* and *St. John the Baptist*, now in the Brera, Milan. A predella panel in the Vatican Pinacoteca, with scenes from the life of St. Vincent Ferrer, has found acceptance into the complex, the most complete reconstruction of which shows K416 and K417 above the full-length figures of *St. Peter* and *St. John the Baptist*, with the *tondo* of the *Crucifixion* (K1361, Fig. 224) above the middle panel, of *St. Vincent Ferrer*, while *tondi* representing the *Annunciation* (Cagnola Collection, Milan) and diminutive panels of saints (in various collections) may have decorated the framing pilasters.[4] Not only does the style of K416 and K417 agree with that of the panels in London and Milan but the choice of one of the saints, Florian, seems especially appropriate, since the altarpiece was painted for a Griffoni whose Christian name was Florian.[5]

Provenance: Conte U. Beni, Gubbio (as early as 1858; K416, called 'St. Martin by Zoppo'; sold, Apr.–May 1882, nos. 4 and 5).[6] Joseph Spiridon, Paris (sold, Cassirer & Helbing's, Berlin, May 31, 1929, nos. 12 and 13 of catalogue by O. Fischel, as Cossa). Duveen's, New York (*Duveen Pictures in Public Collections of America*, 1941, nos. 65 f., as Cossa) – exhibited: 'Italian Renaissance Art,' Wadsworth Atheneum, Hartford, Conn., 1932, nos. 17 and 18; 'Italian Paintings of the XIV to XVI Century,' Detroit Institute of Arts, Detroit, Mich., Mar. 8–30, 1933, no. 78 of catalogue, as Cossa; 'Exposition de l'Art Italien,' Petit Palais, Paris, 1935, nos. 121 and 122, as Cossa. Kress acquisition, 1936.

References: (1) *Preliminary Catalogue*, 1941, pp. 45 f., as Cossa. (2) They were ascribed to Zoppo when in the Beni Collection (see *Provenance*, above); but they have been ascribed to Cossa by A. Venturi (in *L'Arte*, vol. IX, 1906, pp. 139 f.; *Storia dell'arte italiana*, vol. VII, pt. III, 1914, p. 596; and in later publications), B. Berenson (*North Italian Painters of the Renaissance*, 1907, p. 202), M. H. Bernath (in Thieme-Becker, *Allgemeines Lexikon*, vol. VII, 1912, p. 509), T. Borenius (in Crowe and Cavalcaselle, vol. II, 1912, p. 234 f. n. 1), L. Dussler (in *Pantheon*, vol. III, 1929, pp. 160 ff.), L. Venturi (*Italian Paintings in America*, vol. II, 1933, nos. 349 and 350), R. Longhi (*Officina ferrarese*, 1934, p. 50, and later editions), L. Serra (in *Bollettino d'Arte*, vol. XXIX, 1935, pp. 42 f.), S. Ortolani (*Cosmè Tura, Francesco del Cossa, Ercole de'Roberti*, 1941, p. 131), B. Nicolson (*The Painters of Ferrara*, 1950, p. 13), A. Neppi (*Francesco del Cossa*, 1958, pp. 24 ff.), E. Ruhmer (*Francesco del Cossa*, 1959, p. 85), and M. Davies (*National Gallery Catalogues: The Earlier Italian*

Schools, 1961, pp. 150 ff.), among others, and in ms. opinions by G. Fiocco, F. M. Perkins, and W. E. Suida. (3) See *Provenance*, above. (4) This is the reconstruction proposed by R. Longhi (*Ampliamenti nell'officina ferrarese*, 1940, fig. 10). Neppi, Ruhmer, and Davies (see references cited in note 2, above) raise some objections to this reconstruction. Neppi, citing a ms. communication from G. Bargellesi, notes the lack of architectural background in K416 and K417. Davies finds these two panels extra large for the positions indicated, and K1361 (Fig. 224) too small; Ruhmer sees also stylistic discrepancy. But Longhi's proposal remains a probable solution of the matter. (5) This figure (K416) is called Liberale in much of the earlier literature. That it is St. Florian is proven by the identity of costume and attributes with the figure inscribed s. FLORIANVS in a painting by Vecchietta in the Pienza Museum. (6) Davies, *op. cit.* (in note 2, above), p. 152 n. 16.

FRANCESCO DEL COSSA

K1361 : Figure 224

THE CRUCIFIXION. Washington, D.C., National Gallery of Art (793), since 1945. Wood. Diameter, 25⅛ in. (64 cm.). Very good condition.

It is not surprising that the bold modeling of Christ's body and the grief-stricken expressions of the Virgin and St. John have led some critics to attribute K1361 to Castagno.[1] But these characteristics are compatible with Cossa's style; the drapery is typical for him, and the miniature bridge is a motive frequently found in Ferrarese painting.[2] The attribution to Cossa is now generally accepted, as is the probable derivation of the panel from the upper part of the altarpiece painted by Cossa in the early 1470's for the Griffoni Chapel in San Petronio, Bologna.[3]

Provenance: Costabili, Ferrara. Philip Lehman, New York (no. LXXX of 1928 catalogue by R. Lehman, as Cossa). Kress acquisition, 1943.

References: (1) W. von Bode (in ms. opinion) and G. Fiocco (*L'Arte di Andrea Mantegna*, 1927, pp. 78, 83 f.) have ascribed K1361 to Castagno; but Fiocco later (*ibid.*, 1959 ed., p. 99) accepts the attribution to Cossa. B. Berenson (*Italian Pictures of the Renaissance*, 1932, p. 137; Italian ed., 1936, p. 119) gives it to Castagno; however, he later probably accepted the attribution to Cossa, since he omitted the painting from *Italian Pictures . . . Florentine School*, 1963. It has been given unreservedly to Cossa by F. M. Perkins (in *L'Arte*, vol. XVII, 1914, pp. 222 f.), J. Breck (in *Art in America*, vol. II, 1914, pp. 314 ff.), A. Venturi (*North Italian Painting of the Quattrocento*, 1931, p. 43), M. Salmi (*Paolo Uccello, Andrea del Castagno, Domenico Veneziano*, n.d., p. 136), R. Longhi, S.

Ortolani, B. Nicolson, A. Neppi, M. Davies (references cited in catalogue note to K416 and K417, above), C. Volpe (in *Arte Antica e Moderna*, 1958, no. 1, p. 27), and E. Ruhmer (*Francesco del Cossa*, 1959, p. 77). (2) B. Nicolson (*The Painters of Ferrara*, 1950, p. 16) notes that this 'toy bridge' was borrowed from K1361 by the anonymous Ferrarese miniature painter of the *Madonna on the Bridge* in the National Gallery at Edinburgh. (3) The connection of K1361 with the Griffoni altarpiece and the vicissitudes of that altarpiece are discussed in the catalogue note to K416 and K417 (pp. 83 f., above).

Attributed to FRANCESCO DEL COSSA

K241 : Figure 235

MADONNA AND CHILD WITH ANGELS. Washington, D.C., National Gallery of Art (226), since 1941.[1] Wood. $21\frac{1}{8} \times 14\frac{1}{4}$ in. (53·5 × 36·2 cm.). Good condition.

In an early publication of this panel it is associated with the School of Padua.[2] The question of its authorship continues to attract a variety of suggestions.[3] But the attribution to Cossa is generally accepted.[4] Reasonably close parallels for figure types and for the strange formations in the landscape may be found in Cossa's frescoes of the Schifanoia Palace, Ferrara. In composition there seems to be a direct relationship between K241 and the *Madonna and Angels* in the glass window of 1467, in San Giovanni in Monte, Bologna, which Cossa is believed to have designed.[5] This is one of the reasons for suggesting a date of about 1465 for K241, several years earlier than Cossa's frescoes in the Schifanoia Palace. A significant obstacle to the attribution of K241 to Cossa is the fact that the figures are here less consistently stylized than is expected in his paintings (compare K416 and K417, Figs. 222 and 223). Moreover, a *Madonna and Child with an Angel* at Ledreborg, Denmark, apparently by the same artist as K241, does not fall convincingly into the oeuvre of Cossa.[6]

Provenance: Leo Nardus, Suresnes, France.[7] Marczell von Nemes, Munich. Contini Bonacossi, Florence. Kress acquisition, 1932.

References: (1) *Preliminary Catalogue*, 1941, p. 45, as Cossa. (2) S. Reinach (*Répertoire de peintures*, vol. III, 1910, p. 462) labels K241 as having been attributed to Mantegna. (3) A. Neppi (*Francesco del Cossa*, 1958, p. 11) hesitates to accept the attribution to Cossa, suggesting some relationship to Domenico Veneziano. R. Longhi (see reference in note 4, below) attributes the painting to Cossa, but sees in it echoes of Florentine masters, of Uccello, e.g., and of Giovanni di Francesco. F. Zeri (verbally) has suggested Francesco de'Maineri, and M. Meiss (verbally), a Ferrarese follower

of Piero della Francesca. (4) A. Venturi (in *Pantheon*, vol. V, 1930, pp. 249 f.), the first to publish K241 as by Cossa, has been followed by R. Longhi (*Officina ferrarese*, 1934, p. 46; and later editions), B. Berenson (*Pitture italiane del rinascimento*, 1936, p. 134), W. Arslan (in *Zeitschrift für Kunstgeschichte*, vol. V, 1936, p. 178), S. Ortolani (*Cosmè Tura, Francesco del Cossa, Ercole de'Roberti*, 1941, pl. 69), B. Nicolson (*The Painters of Ferrara*, 1950, p. 12), E. Ruhmer (in *Zeitschrift für Kunstgeschichte*, vol. XX, 1957, p. 91, and *Francesco del Cossa*, 1959, p. 67), and (in ms. opinions) G. Fiocco, R. van Marle, F. M. Perkins, O. Sirén, and W. E. Suida. (5) Reproduced by C. Volpe (in *Arte Antica e Moderna*, 1958, no. 1, p. 24, pl. 13a), who calls attention to the relationship between K241 and the window. (6) This painting, in the collection of Count Holstein-Ledreborg, is reproduced by H. Olsen (*Italian Paintings and Sculpture in Denmark*, 1961, pl. XII, b), who notes that, although it was published in 1945 as Sienese, it is no doubt by the same master as K241; he therefore catalogues it as Cossa. (7) S. Reinach (*loc. cit.*, in note 2, above) gives this location.

Follower of FRANCESCO DEL COSSA

K334 : Figure 234

ST. JUSTINA AND DONOR. Madison, Wis., University of Wisconsin, Study Collection (64.4.5), since 1961.[1] Canvas. $16\frac{1}{2} \times 12\frac{1}{2}$ in. (41·9 × 35·8 cm.). Landscape in good condition; otherwise abraded throughout, especially in donor's face and the saint; cleaned 1956.

Although the recent tendency has been to attribute this panel to the Paduan Bernardo Parentino,[2] its more frequent classification is in the Ferrarese School, which allows also for its Paduan elements. Zoppo has been proposed[3] and, more plausibly, Cossa.[4] Protagonists of Cossa parallel the donor in K334 with the donor in the *Pietà* in the Jacquemart-André Museum, Paris, which has been attributed to Parentino, however, as well as to Cossa. The date of K334 is possibly in the 1470's.

Provenance: Contini Bonacossi, Florence. Kress acquisition, 1935.

References: (1) *Catalogue*, 1961, as Parentino (tentatively). (2) G. Fiocco (in ms. opinion). See also note 1, above. (3) By B. Berenson (in ms. opinion). (4) R. Longhi (*Officina ferrarese*, 1934, p. 45; 1956 ed., pp. 29 f.) considers K334 one of Cossa's earliest paintings. S. Ortolani (*Cosmè Tura, Francesco del Cossa, Ercole de'Roberti*, 1941, p. 125), and C. Volpe (in *Arte Antica e Moderna*, 1958, no. 1, p. 37 n. 22) have followed this attribution, as have R. van Marle, F. M. Perkins, W. E. Suida, and A. Venturi (in ms. opinions).

FERRARESE SCHOOL, Late XV Century

K387 : Figure 236

MADONNA AND CHILD. Lewisburg, Pa., Bucknell University, Study Collection (BL-K10), since 1961.[1] Wood. 19¼×15⅞ in. (48·9×40·2 cm.). Inscribed on scroll in Virgin's hand: DEVS IN ADIVTORIVM [mevm intende] (from Psalms 70 : 1). Much abraded, especially in background and seraphim; cleaned 1960.

Recent cleaning of this damaged panel, while revealing greater beauty in some details, such as the Child's drapery, has shown the Virgin's head to be less Cossa's type than it seemed when the painting was attributed to that master.[2] Other attributions have pointed toward Scaletti and Maineri.[3] Perhaps the little-known Antonio Aleotti d'Argenta also should be considered as a candidate. In his polyptych of 1494 in Argenta there are comparable cherubs, and the musical angels there are closely related to the Christ Child in K387.

Provenance: Contini Bonacossi, Florence. Kress acquisition, 1935 – exhibited: National Gallery of Art, Washington, D.C. (322), 1941–46.[4]

References: (1) Catalogue by B. Gummo, 1961, p. 26, as Cossa. (2) R. Longhi (*Officina ferrarese*, 1934, p. 56) finds the head (before cleaning) so typical of Cossa that a head from the Schifanoia frescoes could be convincingly substituted for it (Longhi's pl. 67). This substitution, however, serves to accentuate the difference in the style of the rest of the painting. Longhi dates the picture late in Cossa's career, and is followed by R. van Marle, F. M. Perkins tentatively, W. E. Suida, and A. Venturi, while G. Fiocco calls it Cossesque (in ms. opinions). (3) B. Berenson (in ms. opinion) attributes K387 to Scaletti, and S. Ortolani (*Cosmè Tura, Francesco del Cossa, Ercole de'Roberti*, 1941, p. 134) finds it unlike Cossa and very near the taste of Maineri. A. Neppi (*Francesco del Cossa*, 1958, p. 33) also objects to the Cossa attribution and tentatively suggests the orbit of Domenico Panetti. (4) *Preliminary Catalogue*, 1941, p. 182, as Scaletti.

ERCOLE ROBERTI

Ercole d'Antonio de'Roberti. Ferrarese School. Born early 1450's; died 1496. He was probably a pupil of Cossa, with whom he may have worked on the frescoes in the Schifanoia Palace, Ferrara. About 1473 he seems to have followed Cossa to Bologna, but the first document in which he is mentioned locates him in Ferrara, in 1479, where, after 1486, he was working at the court of the Este. With Tura and Cossa, who were some twenty years his senior, Ercole was one of the three greatest artists of Ferrara.

K408 : Figure 232

GIOVANNI II BENTIVOGLIO

K409 : Figure 233

GINEVRA BENTIVOGLIO

Washington, D.C., National Gallery of Art (330 and 331), since 1941.[1] Wood. K408, 21⅛×15 in. (54×38 cm.); K409, 21⅛×15¼ in. (54×39 cm.). Good condition except for a few abrasions; heavily varnished; need cleaning.

Giovanni Bentivoglio (1443–1508), tyrant of Bologna, and his wife, Ginevra, are shown as if facing each other, with the drapery drawn back from the window between them to disclose a narrow view of Bologna. The two portraits must originally have formed a diptych inspired by Piero della Francesca's diptych (now in the Uffizi, Florence) of the Duke and Duchess of Urbino, Ginevra's brother-in-law and sister. That K408 and K409 are worthy of that inspiration is recognized by their being called 'the noblest portraits of the Ferrarese school.'[2] Although Ercole Roberti is now generally believed to have painted the two portraits, about 1480, an attribution to Cossa has been strongly supported.[3]

Provenance: Louis Charles Timbal, Paris (acquired in Italy[4]). Gustave Dreyfus, Paris (as early as 1887). Duveen's, New York (*Duveen Pictures in Public Collections of America*, 1941, nos. 63, 64, as Cossa). Kress acquisition, 1936 – exhibited: Wadsworth Atheneum, Hartford, Conn., 1934; 'Italian Renaissance Portraits,' Knoedler's, New York, Mar. 18–Apr. 6, 1940, nos. 8 and 9 of catalogue, as Ercole Roberti.

References: (1) *Preliminary Catalogue*, 1941, p. 172, as Ercole Roberti. (2) M. Salmi, *Ercole Roberti*, 1960, p. 19. (3) By W. von Bode (in *Jahrbuch der Königlich Preussischen Kunstsammlungen*, vol. VIII, 1887, p. 126), who says Harck had already proposed the attribution to Cossa. His opinion was followed by G. Gruyer (*L'Art ferrarais*, vol. II, 1897, p. 120), S. Reinach (*Tableaux inédits . . .*, 1906, pp. 30 ff. – he states the cases for the attributions that had been proposed; he favors Cossa, but does not come to a definite conclusion), J. Guiffrey (in *Les Arts*, no. 73, 1908, pp. 8 ff.), M. H. Bernath (in Thieme-Becker, *Allgemeines Lexikon*, vol. VII, 1912, p. 509), and L. Venturi (*Italian Paintings in America*, vol. II, 1933, nos. 352, 353). A. Venturi, who had earlier (*Storia dell'arte italiana*, vol. VII, pt. III, 1914, pp. 653 ff.) attributed the portraits to a follower of Cossa, later (in ms. opinion) gave them to Cossa himself, as did G. M. Richter (in *Burlington Magazine*, vol. LXXVIII, 1941, p. 178). H. Cook (in *Gazette des Beaux-Arts*, vol. XXV, 1901, p. 382) suggested Bianchi-Ferrari, and later (in *Burlington Magazine*, vol. XXVII, 1915, p. 104) Baldassare d'Este. A. Neppi (*Francesco del Cossa*, 1958, p. 41) suggests the youthful Costa. B. Berenson (*North*

Italian Painters of the Renaissance, 1907, p. 218) suggested Maineri or Bianchi, but later (in ms. opinion) attributed the work to Ercole Roberti, as have G. Fiocco, F. M. Perkins, W. E. Suida (in ms. opinions), R. Longhi (*Officina ferrarese*, 1934, pp. 74 f.; 1956, p. 46), W. Arslan (in *Zeitschrift für Kunstgeschichte*, vol. v, 1936, p. 180), S. Ortolani (*Cosmè Tura, Francesco del Cossa, Ercole de' Roberti*, 1941, p. 158), C. Volpe (in *Arte Antica e Moderna*, 1958, no. 1, p. 28), and M. Salmi (*Ercole de' Roberti*, 1960, pp. 19 f.), while E. Ruhmer (*Francesco del Cossa*, 1959, p. 93) suggests a collaboration of Cossa and Roberti, which he defines further (in *Pantheon*, vol. XXII, 1964, p. 79) as work begun by Cossa and finished by Roberti or executed entirely by Roberti after lost models by Cossa. (4) According to Reinach, *loc. cit.* in note 3, above.

MARCO ZOPPO

Marco di Ruggero, called Lo Zoppo. Paduan School. Born 1433–died *c.* 1478. Because of his sculpturesque forms and mannered poses Zoppo has sometimes been classified also as Ferrarese. He was born in Cento, was active partly in Bologna, and signed himself as Bolognese. Most important, he was trained under Squarcione in Padua, where he was influenced by Giovanni Bellini and Mantegna.

K2033 : Figure 237

MADONNA AND CHILD. Washington, D.C., National Gallery of Art (1414), since 1956.[1] Wood. 16×11¾ in. (40·6×29·9 cm.). Signed on the multicolored marble parapet: MARCO ZOPPO DA BOLOGNA OPVS. The coat of arms affixed to the parapet shows a silver pale on an azure field. Very good condition; panel very thin and warped; original frame attached to panel; cleaned 1954.

Painted about 1470, in a manner related to that of Zoppo's Berlin altarpiece, dated 1471, this is the most attractive of the artist's known *Madonnas*.[2] It has been tentatively identified with the panel described in 1678 by Malvasia[3] as a very exquisite painting then in the Foschi Collection, Bologna, which had been attributed to Dürer until the inscription 'MARCO ZOPPO DA BOLOGNIA [*sic*] OPVS' was found on it. In the Le Monnier edition of Vasari (1849)[4] the Malvasia reference is connected with a painting then at a picture dealer's in the Palazzo Zampieri at Bologna with the same signature as that on K2033, except for the preposition, written DI instead of DA. But Malvasia's quotation of the inscription on the Foschi painting corresponds exactly to the inscription which has come to light on Zoppo's *Madonna and Child* in the Lindenau Museum, Altenburg.[5] What may be a first thought for the composition of K2033 is seen in the *Madonna and Child* in the top center of a sheet of drawings by Zoppo in the Munich Print Room.[6]

Provenance: Cook Collection, Richmond, Surrey (as early as 1893; catalogue by T. Borenius, vol. I, 1913, p. 154, no. 129, as Zoppo) – exhibited: 'Works of the School of Ferrara-Bologna,' Burlington Fine Arts Club, London, 1894, no. 4 of catalogue, as Zoppo. Rosenberg & Stiebel, New York. Kress acquisition, 1954.

References: (**1**) *Paintings and Sculpture from the Kress Collection*, 1956, p. 206 (catalogue by W. E. Suida and F. R. Shapley), as Zoppo. (**2**) Among those who have discussed K2033, all recognizing its importance, are: I. Lermolieff (*Kunstkritische Studien . . . : Die Galerie zu Berlin*, 1893, p. 62), F. Harck (in *Repertorium für Kunstwissenschaft*, vol. XVII, 1894, p. 318), B. Berenson (*North Italian Painters of the Renaissance*, 1907, p. 304; other publications by the same author), E. G. Gardner (*The Painters of the School of Ferrara*, 1911, pp. 61 f.), Crowe and Cavalcaselle (*A History of Painting in North Italy*, vol. II, 1912, pp. 51 n. 1, and 53 f. n. 1; and earlier editions), and A. Venturi (*Storia dell' arte italiana*, vol. VII, pt. III, 1914, pp. 29 f.). (**3**) C. C. Malvasia, *Felsina pittrice*, vol. I, 1678, p. 34. (**4**) Vasari, *Le Vite*, Le Monnier ed., 1849 (quoted in Milanesi ed., vol. III, 1878, p. 406 n. 1). (**5**) See R. Oertel, *Frühe italienische Malerei in Altenburg*, 1961, pp. 196 f. (**6**) Munich 2802 verso; reproduced by L. Armstrong (in *Pantheon*, vol. XXI, 1963, p. 307, fig. 9), who dates the sheet of drawings about 1471.

MARCO ZOPPO

K489 : Figure 238

ST. PETER. Washington, D.C., National Gallery of Art (382), since 1941.[1] Wood. 19¼×12 in. (48·9×30·5 cm.). Fair condition except for abrasion throughout and a few losses of paint.

This undoubtedly comes from the upper tier of a polyptych. Three other panels, of approximately the same size as K489, have been recognized as members of the same series: a *Bishop Saint*, in the National Gallery, London (turned, like St. Peter, to the right); *St. Paul*, in the Ashmolean Museum, Oxford; and *St. Jerome*, in the Walters Art Gallery, Baltimore (both of the latter turned to the left).[2] The middle panel which the two pairs of saints originally flanked may have been the three-quarter-length *Christ in the Tomb* formerly in the Vieweg-Braunschweig Collection.[3] This panel, like those in Oxford and Baltimore, has a rounded top and Christ's halo is closely similar to the halos in all the other panels. It has been suggested that the panels belonged to the now-lost altarpiece which was reported in the sixteenth century to have been painted in 1468 for Santa Giustina, Venice.[4] The style agrees with that of Zoppo's altarpiece in Berlin dated 1471. The St. Paul in that painting offers an especially close parallel to figures in the present series.[5]

Provenance: Henry Harris, London (acquired in London, no later than 1921).[6] Contini Bonacossi, Florence. Kress acquisition, 1937.

References: (1) *Preliminary Catalogue*, 1941, p. 218, as Zoppo. (2) T. Borenius (in *Burlington Magazine*, vol. XXXVIII, 1921, pp. 9 f.) first associated K489 with the Oxford and London panels. (3) Sold, Rud. Lepke's, Berlin, Mar. 18, 1930, no. 29 of catalogue by F. Winkler, as Zoppo. The size of this panel is 77·5×58 cm. (4) Borenius (p. 10 of *op. cit.* in note 2, above) and R. Longhi (*Ampliamenti nell' officina ferrarese*, 1940, p. 14) make this suggestion, referring to Sansovino's report and praise of the altarpiece (*Venetia*, 1581; 1663 ed., p. 42). (5) Others who have attributed K489 to Zoppo are B. Berenson (*Italian Pictures of the Renaissance*, 1932, p. 608; Italian ed., 1936, p. 523), G. Fiocco, F. M. Perkins, W. E. Suida, and A. Venturi (in ms. opinions). (6) Borenius, p. 9 of *op. cit.* in note 2, above.

FLORENTINE SCHOOL
XV CENTURY

LORENZO MONACO

Piero di Giovanni, called Lorenzo Monaco (he took his vows and the name of Lorenzo at the Camaldolese Monastery of Santa Maria degli Angeli, Florence, in 1391). Florentine School. Born *c.* 1370; died 1422/24. He came from Siena to Florence, where he was influenced by Agnolo Gaddi, became the most important painter at the beginning of the fifteenth century, and influenced the stylistic formation of Masolino and Fra Angelico. Panel paintings, frescoes, and illuminations, characterized by the flowing line of the International Style, make up his very considerable oeuvre.

K 1293 : Figure 239

MADONNA AND CHILD. Washington, D.C., National Gallery of Art (514), since 1941.[1] Wood. 46×21¾ in. (117×55 cm.). Inscribed on the Child's scroll: EGO S[vm lv]x M[vndi] (from John 8 : 12); and at the bottom of the panel, a line which is mostly lost except for the ending: ANO MCCCCXIII. Good condition except for abrasions in flesh tones; cleaned 1955.

The substitution of a cushion for the usual throne characterizes this as the *Madonna of Humility*. Otherwise the composition is very similar to that of the *Enthroned Madonna* in the center of a polyptych in the Uffizi, Florence; other parallels by Lorenzo might be cited. The date, 1413, places K 1293 in the same year as his great polyptych of the *Coronation* in the Uffizi.[2] That K 1293 may witness the influence of Ghiberti on Lorenzo Monaco has been alleged;[3] but it would seem more likely that the influence flowed in the opposite direction.

Provenance: Masson, Amiens. Contini Bonacossi, Florence. Kress acquisition, 1939.

References: (1) *Preliminary Catalogue*, 1941, p. 113, as Lorenzo Monaco. (2) M. Meiss (in *Burlington Magazine*, vol. C, 1958, p. 195 n. 18, figs. 5–8) suggests the possibility that K 1293 may have been the middle section of a polyptych, with panels of Old Testament figures at the sides. O. Sirén (*Lorenzo Monaco*, 1905, pp. 88 f. and in *Rassegna d'Arte*, vol. IX, 1909, p. 36) was the first to publish K 1293. It is also cited in Lorenzo Monaco's oeuvre by R. van Marle (*Italian Schools of Painting*, vol. IX, 1927, p. 162), by W. E. Suida (in Thieme-Becker, *Allgemeines Lexikon*, vol. XXIII, 1929, p. 392), G. Fiocco, R. Longhi, F. M. Perkins, and A. Venturi (in ms. opinions), and by B. Berenson (*Italian Pictures . . . Florentine School*, vol. I, 1963, p. 121). M. Eisenberg (verbally) finds K 1293 somewhat attenuated in type and otherwise scarcely worthy of Lorenzo; he attributes it to a follower. (3) G. Pudelko (in *Burlington Magazine*, vol. LXXIV, 1939, pp. 76 f.) suggests the influence of Ghiberti in K 1293.

Studio of LORENZO MONACO

K 1047 : Figure 244

ST. ROMUALD. Tulsa, Okla., Philbrook Art Center (3360), since 1953.[1] Wood. 11⅝×10⅝ in. (29·5×27 cm.). Fair condition; cleaned 1953.

Shape, size, decorative motives, and treatment of the figure identify this as pendant to the *St. Benedict* at the left-hand end of a predella panel in the Copenhagen Royal Museum.[2] In the Copenhagen painting the *St. Benedict* is followed at the right by a horizontal section representing the *Annunciation*, and then by a much narrower section with a kneeling nun, facing right. Beyond the nun there must have followed (possibly after a now-lost section) another horizontal section now in the Vatican Pinacoteca.[3] It represents the *Nativity* and is the same size and shape as the one featuring the *Annunciation* (in both horizontal sections triangular spaces are reserved at the corners for scroll decoration). Finally, came the right-hand termination, K 1047, bringing the full width of the predella to 74 inches or more. The date may be about 1420.

The featuring of St. Romuald (founder of the Camaldolese order, a branch of the Benedictine) and of St. Benedict (founder of the Benedictine order) would suggest that the predella comes from an altarpiece connected with the Camaldolese order, to which Lorenzo Monaco belonged and for which he and his followers frequently carried out commissions.

Provenance: Giuseppe Bellesi, London. Kress acquisition,

1936 – exhibited: National Gallery of Art, Washington, D.C. (857), 1945–52, as follower of Lorenzo Monaco.

References: (**1**) Catalogue by W. E. Suida, 1953, p. 18, as Lorenzo Monaco and assistants. (**2**) Catalogue of the Statens Museum for Kunst, 1922, no. 6, as style of Lorenzo Monaco; H. Olsen, *Italian Paintings and Sculpture in Denmark*, 1961, pp. 59 f., as Florentine School, early fifteenth century. Crowe and Cavalcaselle (*A History of Painting in Italy*, R. L. Douglas ed., vol. II, 1903, p. 302 n. 1) give the Copenhagen painting to Lorenzo Monaco. O. Sirén (*Lorenzo Monaco*, 1905, p. 191) gives it to a pupil of Lorenzo. (**3**) *Guida della Pinacoteca Vaticana*, 1933, no. 194 (82), as Lorenzo Monaco. Reproduced by R. van Marle (*Italian Schools of Painting*, vol. IX, 1927, p. 187) as school of Lorenzo Monaco. G. Pudelko (in *Art Bulletin*, vol. XVII, 1935, p. 84) associates the Vatican panel with the one in Copenhagen (K1047 was unknown to him). He attributes them to 'Pseudo-Ambrogio Baldese' and suggests they may have served as predella for that artist's altarpiece in San Pietro a Cedda, Poggibonsi. B. Berenson (*Italian Pictures . . . Florentine School*, vol. I, 1963, pp. 117, 121, and earlier editions) attributes the predella sections to the studio of Lorenzo Monaco.

Follower of LORENZO MONACO

K1654 : Figure 240

THE CRUCIFIXION. Seattle, Wash., Seattle Art Museum (It 37/L8876.1), since 1952.[1] Wood. Including frame, 49½×23½ in. (125·7×59·7 cm.). Inscribed on base of original frame: AVE MARIA GRATIA PL[ena] (from Luke 1 : 28) MCCCCVIII. Good condition.

Crucifixions by Lorenzo Monaco in which the Virgin and St. John the Evangelist appear show these two figures seated at the sides of the cross, as, for example, in the panels in Yale University, New Haven, and the former Loeser Collection, Florence. Not the different composition, however, but the different expression and the mannered poses of the Virgin and St. John suggest that a contemporary follower rather than the master himself may have been responsible for K1654.[2]

Provenance: Charles Butler, London – exhibited: Royal Academy, London, 1885, no. 229, as Cennino Cennini; New Gallery, London, 1894, no. 40, as Cennino Cennini. Wildenstein's, New York. Kress acquisition, 1949.

References: (**1**) Catalogue by W. E. Suida, 1952, p. 14, and 1954, p. 28, as Lorenzo Monaco. (**2**) K1654 is attributed to the studio of Lorenzo Monaco by B. Berenson (*Italian Pictures . . . Florentine School*, vol. I, 1963, p. 121) and to a follower by M. Eisenberg (verbally).

Follower of LORENZO MONACO

K260 : Figure 241

MADONNA AND CHILD WITH ST. CLEMENT AND ST. JULIAN. Allentown, Pa., Allentown Art Museum, Study Collection (60.16.KBS), since 1960. Wood. 20¾×14⅜ in. (52·7×36·5 cm.). Madonna very much abraded.

Attributions to Andrea di Giusto and to the Master of the Bambino Vispo have been suggested for this painting.[1] In spite of its badly worn condition its dependence on the style of Lorenzo Monaco is still very evident. The date may be about 1425.

Provenance: Contini Bonacossi, Florence. Kress acquisition, 1933.

Reference: (**1**) Attributed tentatively to Andrea di Giusto by B. Berenson (in *Dedalo*, vol. XII, 1932, p. 518); but later to the Maestro del Bambino Vispo by Berenson (*Italian Pictures . . . Florentine School*, vol. I, 1963, p. 138) and by G. Fiocco, R. Longhi, W. E. Suida, and A. Venturi (in ms. opinions); to an artist close to that master, by F. M. Perkins (in ms. opinion); and to Lorenzo Monaco's workshop by R. van Marle (in ms. opinion).

MASTER OF THE BAMBINO VISPO

Florentine School. Active early fifteenth century. The name, meaning 'Master of the Lively Child,' was coined[1] to express this anonymous artist's treatment of the Christ Child in a number of paintings assigned to him. His style is closely related to that of Lorenzo Monaco. There is evidence that he worked not only in Florence but also in Spain: one of his paintings, which dates 1415, comes from Majorca, and there is a Spanish flavor in his style.

K525 : Figure 242

ST. NICHOLAS OF BARI. El Paso, Tex., El Paso Museum of Art (1961–6/10), since 1961.[2] Wood. 25×12 in. (63·5× 30·5 cm.). Fair condition except for abrasion throughout and some losses of paint.

This panel was formerly attributed to Rossello di Jacopo Franchi.[3] But the slight swaying of the body of the bishop saint and the agitated folds of his robes have more recently been recognized as typical of the Master of the Bambino Vispo,[4] recalling, as do the translucent colors, the paintings of Lorenzo Monaco. K525, which comes from some unidentified polyptych, where it was possibly associated with a panel of *St. Anthony Abbot* now in Rotterdam,[5] was probably painted in Florence about the same time as the similar

panels from an altarpiece attributed to the Master of the Bambino Vispo which was ordered by the Corsini family in 1422 for the Cathedral in Florence.[6] Especially pertinent for comparison with K525 is the side panel (of the Cathedral altarpiece) now in the Nationalmuseum, Stockholm.

Provenance: Contini Bonacossi, Florence. Kress acquisition, 1938 – exhibited: William Rockhill Nelson Gallery of Art, Kansas City, Mo., 1952–60.[7]

References: (1) O. Sirén, in *L'Arte*, vol. VII, 1904, pp. 349 ff. (2) Catalogue by F. R. Shapley, 1961, no. 10, as Master of the Bambino Vispo. (3) B. Berenson, G. Fiocco, F. M. Perkins, and A. Venturi (in ms. opinions). (4) R. Longhi, in *Critica d'Arte*, July–Dec. 1940, p. 184; also given to the Master of the Bambino Vispo by Berenson (*Italian Pictures . . . Florentine School*, vol. I, 1963, p. 139, suggesting that K525 may have been a companion to the panel of *St. Anthony Abbot* in Rotterdam, no. 2649). (5) See Berenson (*loc. cit.*, in note 4, above). (6) Reproduced by Berenson, pl. 476 of *op. cit.* in note 4, above. See also W. and E. Paatz, *Die Kirchen von Florenz*, vol. III, 1953, pp. 406 f. (7) Catalogue by W. E. Suida, 1952, p. 28, as Rossello di Jacopo Franchi. But Suida's handwritten note on a copy of the catalogue indicates that he later agreed with Longhi's attribution to the Master of the Bambino Vispo.

MASTER OF THE BAMBINO VISPO

K1135 : Figure 245

THE ADORATION OF THE MAGI. Kansas City, Mo., William Rockhill Nelson Gallery of Art (61-60), since 1952.[1] Wood. 13×31⅜ in. (33×79·7 cm.). Very good condition except for a few abrasions at bottom right; cleaned 1952.

Formerly attributed by some critics to Giovanni dal Ponte, this panel is now accepted as by the closely related Master of the Bambino Vispo.[2] It probably dates between 1420 and 1430 and comes from the predella of some dismembered altarpiece, as does the same master's similar panel in the Douai Museum (believed to derive from the Corsini altarpiece which was painted for the Cathedral in Florence in 1422 or a little later).[3]

Provenance: F. Kleinberger's, Paris. Jules S. Bache, New York (1927). Walter P. Pearson (1928). Levy's, New York. Kress acquisition, 1938 – exhibited: National Gallery of Art (483), 1941-51.[4]

References: (1) Catalogue by W. E. Suida, 1952, p. 26, as Master of the Bambino Vispo. (2) K1135 has been attributed to Giovanni dal Ponte by R. L. Douglas, G. Fiocco, C. Gamba, and was placed close to this artist by F. M. Perkins

(in ms. opinions). B. Berenson (in *Dedalo*, vol. XII, 1932, p. 184; *Italian Pictures . . . Florentine School*, vol. I, 1963, p. 140), G. Pudelko (in *Art in America*, vol. XXVI, 1938, p. 54 n. 21), and R. Longhi (in ms. opinion) have attributed it to the Master of the Bambino Vispo. (3) Reproduced by B. Berenson, *Italian Pictures . . . Florentine School*, vol. I, 1963, pl. 477. See also R. Oertel, in Heydenreich Festschrift: *Studien zur Toskanischen Kunst*, 1964, p. 208 n. 18, fig. 7. (4) *Preliminary Catalogue*, 1941, p. 128, as Master of the Bambino Vispo.

FLORENTINE SCHOOL
Early XV Century

K1072 : Figure 243

MADONNA AND CHILD. Montgomery, Ala., Huntingdon College (1), since 1936. Wood. 22½×13½ in. (57·3×34·5 cm.).

Usually associated with the circle of Parri Spinelli (1387–1453),[1] son of Spinello Aretino, this picture also recalls the Master of the Bambino Vispo. The elongated figures and the languid attitude of the Virgin suggest Parri; the playful Child and the influence of Lorenzo Monaco suggest the Master of the Bambino Vispo.

Provenance: Frascione, Naples. Contini Bonacossi, Rome. Kress acquisition, 1929.

Reference: (1) In ms. opinions K1072 is attributed to Parri Spinelli by A. Venturi; to an artist close to Parri and his father, Spinello Aretino, by R. Longhi; to a painter connected with Spinello Aretino by G. Fiocco and W. E. Suida; to a Tuscan painter by R. van Marle; and to the school of Agnolo Gaddi by F. M. Perkins. B. Berenson (*Italian Pictures . . . Florentine School*, vol. I, 1963, p. 215) lists it as unidentified Florentine follower of Orcagna.

GIOVANNI DAL PONTE

Giovanni di Marco, called Giovanni dal Ponte, from the location of his studio, near Santo Stefano a Ponte, Florence. Florentine School. Born *c.* 1385; died 1437 (?). His consistent, somewhat *retardataire* style has been recognized in a large number of paintings, although only a few are documented or signed and these date in his last years, after 1430. He may have been a pupil of Spinello Aretino but was influenced chiefly by Lorenzo Monaco and Fra Angelico. His nearest of kin among the minor Gothic painters of his class is the Master of the Bambino Vispo.

K 300 : Figures 246–248

MADONNA AND CHILD WITH SAINTS. Columbia, S.C., Columbia Museum of Art (54-402/4), since 1954.[1] Wood. Middle panel, $36\frac{1}{2} \times 23$ in. ($92 \cdot 7 \times 58 \cdot 4$ cm.); sides, each, $28 \times 13\frac{7}{8}$ in. ($71 \cdot 1 \times 35 \cdot 2$ cm.). Inscribed on book held by Christ in middle pinnacle: AΩ (the Beginning and the End). Very good condition except for a few abrasions.

Probably painted in the artist's late period, the 1430's, this triptych is especially admired for the St. Michael, weighing souls in the left panel, and the St. George, in the right panel.[2] The mannered, but very spirited, composition of the St. George may be based on a drawing described by Vasari: 'In my book of old and modern drawings is a watercolor drawing by Giovanni in which there is a St. George on horseback killing the dragon. . . .'[3] The saints flanking the Virgin, although they lack clearly identifying symbols, are dressed as deacons and are probably intended as Sts. Lawrence and Stephen. The Virgin wears finger rings and earrings, details rare in paintings of the time but found in other examples by this artist.[4]

Provenance: Pio Fabbri, Rome (as early as 1906) – exhibited: 'Mostra Retrospettiva,' Castel Sant'Angelo, Rome, 1912. Contini Bonacossi, Florence. Kress acquisition, 1934 – exhibited: 'California Pacific International Exhibition,' Palace of Fine Arts, San Diego, Calif., Feb. 12–Sept. 9, 1936, no. 439 of catalogue, as Giovanni dal Ponte; National Gallery of Art, Washington, D.C. (265), 1941–51;[5] after entering the Columbia Museum of Art: 'Art Treasures for America,' National Gallery of Art, Washington, D.C., Dec. 10, 1961–Feb. 4, 1962, no. 38, as Giovanni dal Ponte.

References: (1) Catalogue by W. E. Suida, 1954, pp. 14 f., and by A. Contini Bonacossi, 1962, pp. 32 f., as Giovanni dal Ponte. (2) K 300 was first published by C. Gamba (in *Rivista d'Arte*, vol. IV, 1906, p. 164) as Giovanni dal Ponte, with special praise for the St. Michael. It is listed as his work by A. Venturi (*Storia dell'arte italiana*, vol. VII, pt. 1, 1911, p. 27). G. Bernardini (in *Rassegna d'Arte*, vol. XII, 1912, p. 97) is the only critic who doubts the attribution to Giovanni. R. van Marle (*Italian Schools of Painting*, vol. IX, 1927, p. 85) places K 300 late in Giovanni's career. E. Sandberg-Vavalà (in *Burlington Magazine*, vol. LXXXVIII, 1946, p. 191 n. 2) refers to it as by Giovanni. G. Fiocco, R. Longhi, R. van Marle, F. M. Perkins, A. Venturi (in ms. opinions), and B. Berenson (*Italian Pictures . . . Florentine School*, vol. I, 1963, p. 90) attribute it to Giovanni, differing only as to the dating. (3) Vasari, *Le Vite*, Milanesi ed., vol. I, 1878, p. 634 (in his life of Giovanni dal Ponte). (4) Vavalà, *loc. cit.* in note 2, above. (5) *Preliminary Catalogue*, 1941, p. 86, as Giovanni dal Ponte.

GIOVANNI DAL PONTE

K 1556 : Figure 249

MADONNA AND CHILD WITH ANGELS. San Francisco, Calif., M. H. De Young Memorial Museum (61-44-5), since 1955.[1] Wood. $46\frac{3}{4} \times 26\frac{3}{4}$ in. ($118 \cdot 7 \times 68$ cm.). Very good condition except for some losses of paint in Madonna's mantle; cleaned 1952.

How characteristic this is of Giovanni dal Ponte may be seen by comparing it with the similar panel, considered his masterpiece, in the Fitzwilliam Museum, Cambridge. Like the latter, K 1556 dates from the artist's late period, after 1430, and even if less sensitively executed than the Fitzwilliam example, it bears eloquent testimony to the Gothic charm of this 'Master of the Classic Profiles.'[2] K 1556 must once have formed the middle panel of such a triptych as K 300 (Figs. 246–248), by Giovanni.

Provenance: Contini Bonacossi, Florence. Kress acquisition, 1948.

References: (1) Catalogue by W. E. Suida, 1955, p. 36, as Giovanni dal Ponte. (2) This epithet was suggested by E. Sandberg-Vavalà (in *Burlington Magazine*, vol. LXXXVIII, 1946, pp. 191 ff., where, as pl. IIA, the Fitzwilliam panel is reproduced). K 1556 has not yet come to the attention of many critics; but R. Longhi (in ms. opinion), L. Berti (in *Commentari*, vol. XII, 1961, p. 87 n. 4), and B. Berenson (*Italian Pictures . . . Florentine School*, vol. I, 1963, p. 92) have referred to it as by Giovanni dal Ponte, placing it late in his career.

FRANCESCO D'ANTONIO

Francesco d'Antonio di Bartolommeo, wrongly called 'Banchi.'[1] Florentine School. Born 1394; last mentioned 1433. Dominated until about 1420 by Lorenzo Monaco, his style was modified by the influence of Gentile da Fabriano, Masolino, Masaccio, and Domenico Veneziano. He would also seem to have come in contact with Alvaro Pirez of Evora in Pisa.

K 543 : Figure 250

MADONNA AND CHILD. Denver, Colo., Denver Art Museum (E-IT-18-XV-928), since 1954.[2] Wood. $44\frac{3}{8} \times 21\frac{1}{4}$ in. ($112 \cdot 7 \times 54$ cm.). Abraded throughout and some losses of paint.

Two panels with pairs of saints in the Museum at Pisa have been recognized as having once flanked K 543 to form a triptych.[3] Since one of the saints is a Dominican and since the side panels came from the Church of San Domenico,

Pisa, the triptych was probably painted for that church. Comparison with signed and dated paintings by the artist places K 543 about 1420.

Provenance: Probably Church of San Domenico, Pisa. Probably Giuseppe Toscanelli, Pisa (nineteenth century).[4] Private Collection, Munich. Emile Weinberger, Vienna (bought from Julius Böhler's, Munich, 1904) – exhibited: 'Renaissanceausstellung,' Vienna, 1924, no. 107 of catalogue, as Parri Spinelli. Weinberger sale, C. J. Wawra's, Vienna, Oct. 22–24, 1929, no. 453 of catalogue by L. Baldass, as Francesco d'Antonio. Contini Bonacossi, Florence. Kress acquisition, 1938 – exhibited: National Gallery of Art (427), 1941–51.[5]

References: (1) For biographical data and stylistic analysis see M. Salmi (in *Rivista d'Arte*, vol. XI, 1929, pp. 1 ff.), G. Gronau (in *ibid.*, vol. XIV, 1932, pp. 382 ff.), and R. Longhi (in *Critica d'Arte*, July–Dec. 1940, pp. 186 f.). (2) Catalogue by W. E. Suida, 1954, p. 16, as Francesco d'Antonio. (3) The association of K 543 with the Pisa panels was first recognized by F. Zeri (in *Bollettino d'Arte*, vol. XXXIV, 1949, pp. 22 ff.). K 543 was first published by O. Sirén (*Lorenzo Monaco*, 1905, p. 174) as Parri Spinelli. Later Sirén (in *Burlington Magazine*, vol. XLIX, 1926, pp. 123 ff.) and also T. von Frimmel (in *Blätter für Gemäldekunde*, Sept. 1926, p. 124) recognized that it was by the painter who worked in the Church of Figline (now identified as Francesco d'Antonio). Longhi (*op. cit.*), Zeri (*op. cit.*) and B. Berenson (*Italian Pictures . . . Florentine School*, vol. I, 1963, p. 62), as well as (in ms. opinions) G. Fiocco, F. M. Perkins tentatively, W. E. Suida, and A. Venturi, have attributed K 543 to Francesco d'Antonio. (4) See Zeri, *op. cit.*, pp. 25 f. If K 543 is the painting to which it seems to correspond in the Toscanelli Collection, then the strip at the bottom which shows in old reproductions (cf. *Burlington Magazine*, cited in note 3, above) was presumably once inscribed with the artist's signature (see Salmi, p. 20 n. 1 of *loc. cit.* in note 1, above). (5) *Preliminary Catalogue*, 1941, pp. 11 f., as Francesco d'Antonio Banchi.

FRANCESCO D'ANTONIO

K 1015A : Figure 251
ST. JOHN THE BAPTIST

K 1015B : Figure 252
ST. ANTHONY ABBOT

Tucson, Ariz., St. Philip's in the Hills (School), Study Collection, since 1962. Wood. 1015A: 16¾×9½ in. (42·5×24·1 cm.). 1015B: 16¾×9¾ in. (42·5×23·8 cm.). Visible on St. John's scroll, two letters of the legend: [ecc]E. A[gnus dei] (from John 1 : 29). Fair condition.

No doubt from an altarpiece of about 1420, these panels are close in style to K 543 (Fig. 250), by Francesco d'Antonio. St. John is most closely paralleled in the artist's *Tabernacle of Piazza Santa Maria Nuova*, Florence.[1]

Provenance: Contini Bonacossi, Florence. Kress acquisition, 1936.

Reference: (1) The tabernacle is reproduced by M. Salmi (in *Rivista d'Arte*, vol. XI, 1929, p. 13). K 1015A and B are attributed to Francesco d'Antonio by R. Longhi (in *Critica d'Arte*, July–Dec. 1940, p. 186), B. Berenson (*Italian Pictures . . . Florentine School*, vol. I, 1963, p. 64), and (in ms. opinions, in which the erroneous designation *Banchi* is used in the name – thus, Francesco d'Antonio Banchi) by G. Fiocco, R. van Marle, F. M. Perkins tentatively, W. E. Suida, and A. Venturi.

FRANCESCO D'ANTONIO

K 1046 : Figure 253

THE ANNUNCIATION, THE CRUCIFIXION, AND SAINTS. Montgomery, Ala., Montgomery Museum of Fine Arts, since 1937. Wood. 27⅞×17½ in. (70·8×44·5 cm.). Inscribed on a strip beneath the *Crucifixion*: HOPVS [*sic*] FECIT FIERI MAESTRO ANTONIO DE GVARGVAGLI DA LVCHA MEDICO (Master Antonio de Guarguagli of Lucca, physician, had this work done). Good condition.

This has been attributed both to Francesco d'Antonio, about 1425/30,[1] and to a follower of Sassetta.[2] Flanking the crucified Christ in the middle register are, from left to right: Sts. Agatha and Catherine of Alexandria, the Virgin, Mary Magdalene, John the Evangelist, Francis, and Lawrence. In the bottom register are Sts. Michael, Leonard, Cosmas and Damian, Christopher, James Major, Anthony Abbot, Julian, and George.

Provenance: Col. C. J. Fergusson-Buchanan, Auchentorlie, Bowling, Dumbartonshire, Scotland. Giuseppe Bellesi, London. Kress acquisition, 1936.

References: (1) R. Longhi (in *Critica d'Arte*, July–Dec. 1940, p. 187) and B. Berenson (*Italian Pictures . . . Florentine School*, vol. I, 1963, p. 63) attribute K 1046 to Francesco d'Antonio, the former dating it between 1425 and 1430. (2) Ms. opinion of R. van Marle.

MASOLINO

Tommaso di Cristofano di Fino, called Masolino. Florentine School. Born 1383/84; active to 1432.[1] He was influenced by

Lorenzo Monaco and also by Ghiberti, of whom he was possibly an asssistant. He worked in Florence, Castiglione d'Olona, Empoli, Todi, Rome, and in Hungary.

K414 : Figure 254
THE ARCHANGEL GABRIEL

K415 : Figure 255
THE VIRGIN ANNUNCIATE

Washington, D.C., National Gallery of Art (336 and 337), since 1941.[2] Wood. Each, 30×22⅝ in. (76×57·5 cm.). The open book on the Virgin's lap is inscribed with the passage *Ecce Virgo*. . . . (from Isaiah 7 : 14–15). Fragments; Archangel and Virgin abraded throughout; heavily varnished; need cleaning.

The figure types and the style of painting place these two panels in the same period of Masolino's career as the Goldman *Annunciation* (also in the National Gallery of Art), probably between 1420 and 1430, as early as the Munich *Madonna*, which all three paintings resemble.[3] It is customary to assume that K414 and K415 were originally side panels of a triptych or polyptych. The attempt to associate them with the *Miracle of the Snow* and the *Assumption* in Naples has not been successful.[4] No consideration seems to have been given to the possibility that K414 and K415 may have been parts of a single panel of the *Annunciation*, larger in scale and less elaborate in detail, perhaps, but otherwise comparable to the Goldman panel. If this is their origin, considerable sections of the original panel have been lost, notably from the upper part of K414 and the lower part of K415 – probably also a vertical strip from the middle, the area between the two figures.

Provenance: Count von Ingenheim, Munich (until *c.* 1930). Duveen's, New York (*Duveen Pictures in Public Collections of America*, 1941, nos. 29, 30, as Masolino) – exhibited: 'L'Art Italien,' Petit Palais, Paris, May–July, 1935, nos. 303 f., as Masolino. Kress acquisition, 1936.

References: (1) For recent evidence regarding Masolino's uncertain death date see U. Procacci, in *Rivista d'Arte*, vol. XXVIII, 1953, pp. 42 f. n. 59. (2) *Preliminary Catalogue*, 1941, pp. 127 f., as Masolino. (3) R. Longhi (in *Critica d'Arte*, July–Dec. 1940, pp. 181 f.) thinks K414 and K415 slightly earlier than the Goldman *Annunciation*, but would date them about 1430. L. Berti (in *Commentari*, vol. XII, 1961, p. 96 n.) dates them no later than 1425 and relates them to the Munich *Madonna*. B. Berenson (in ms. opinion, 1929; cf. *Italian Pictures . . . Florentine School*, vol. I, 1963, p. 137) seems to have been the first to call attention to them, recognizing them as by Masolino. They have since been published, always as Masolino, by W. R. Valentiner (in *Pantheon*, vol. VIII, 1931, pp. 413 ff.), L. Venturi (*Italian Paintings in America*, vol. II, 1933, nos. 186 f.), M. Salmi (*Masaccio*, 1948, p. 111), etc. (4) Valentiner (*loc. cit.* in note 3, above) suggested this connection; it is disproven by M. Davies (*National Gallery Catalogues: Earlier Italian Schools*, 1961, p. 355).

FRA ANGELICO

Guido di Pietro, called Angelico. Florentine School. Active from 1417; died 1455. It is not known who his teacher was, but he seems to have been principally influenced by Ghiberti, Lorenzo Monaco, Masolino, and Masaccio. He lived for years in the Dominican friary near Fiesole, of which he became the prior, although he was much more extensively employed by the Dominican friary of San Marco, Florence. Except for a short sojourn in 1447 in Orvieto, he was busy more than half a decade in Rome from 1445.

K1387 : Figures 258, 262

THE HEALING OF PALLADIA BY ST. COSMAS AND ST. DAMIAN. Washington, D.C., National Gallery of Art (790), since 1945. Wood. 14⅜×18⅜ in. (36·5×46·3 cm.). Abraded throughout; some faces very thin, very much overcleaned.

The existence of such a panel of this size and subject by Fra Angelico was anticipated as early as 1904,[1] but K1387 was not known by specialists in the field until 1924.[2] Its attribution to Fra Angelico has been almost unanimously accepted,[3] as is its association with the altarpiece which he painted for the high altar of San Marco, Florence, probably between 1438 and 1443.[4] The main panel of the altarpiece, much abraded, is now in the Museum of San Marco, Florence. Among the saints who surround the Madonna and Child in that panel, Cosmas and Damian are given the most prominent positions, kneeling in the foreground, before the Virgin. It is these saints whose legend, especially their martyrdom, is recounted in eight small panels which, together with a *Pietà*, are now believed to have been in the predella. Since the combined widths of the nine panels considerably exceeds the width of the main panel, their original arrangement has posed a problem.[5] The most plausible solution thus far presented assumes that the main panel was flanked by pilasters,[6] with the predella carried across their front and side faces.[7] The arrangement of the predella panels would then have been, presumably: on the outer side of the left-hand pilaster, the *Healing of Justinian*, Museum of San Marco, Florence; on the front of this pilaster, the *Healing of Palladia* (K1387); under the main panel: the *Saints before Lycias*, Alte Pinakothek, Munich; *Lycias Possessed by Devils and the Saints Thrown into the Sea*, Alte Pinakothek, Munich; the *Pietà*, Alte Pinakothek, Munich; the *Saints Saved from Fire*, National Gallery of Ireland, Dublin; the *Saints Crucified*, Alte Pinakothek, Munich; on the front of the right-hand

pilaster, the *Saints Beheaded*, Louvre, Paris; on the outer side of this pilaster, the *Burial of the Saints*, Museum of San Marco, Florence.[8] Simulated colonnettes, of which traces of the gilding are still visible on most, if not all, of the panels, originally separated the compositions one from another.[9] In contrast with the main panel of the altarpiece, K1387 is in a fair state of preservation. It confirms Vasari's comment that the predella of the San Marco altarpiece 'is so well painted that one could not hope to see anything executed more carefully or with more delicate and better conceived figures.'[10] Probably because of the headdress, the person being healed in the scene at the left in K1387 has been called Palladia's husband,[11] but this kind of headdress is commonly worn by women in similar scenes.[12] The subject here clearly illustrates the *Golden Legend* account of the healing of Palladia by Cosmas and Damian and of her insistence that the reluctant Damian accept her grateful offering.

Provenance: High altar of the Church of San Marco, Florence (until 1679).[13] Passageway of the Sacristy of San Marco, Florence (as early as 1758).[14] Possibly Accademia, Florence (c. 1800).[15] Comte de Pourtalès-Gorgier, Paris (catalogue by J. J. Dubois, pt. I, 1841; sold Hôtel Pourtalès-Gorgier, Paris, March 27, 1865, no. 86, as Masaccio; bought by de Zincourt [?].[16] Julius Böhler's, Munich. Albert Keller, New York (cited here as early as 1924) – exhibited: 'Italian Art,' Royal Academy, London, Jan. 1–Mar. 8, 1930.[17] 'Educational Loan Exhibition,' Phillips Memorial Gallery, Washington, D.C., 1941, no. 10, as Fra Angelico. Duveen's, New York (1944). Kress acquisition, 1944.

References: (**1**) T. de Wyzewa (in *Revue de l'Art*, vol. XVI, 1904, pp. 339 f.) deduced from the *Golden Legend's* account of the story of Cosmas and Damian that the Palladia episode must have been included in the predella of the San Marco altarpiece (see below). (**2**) F. Schottmüller (*Fra Angelico*, 1924, no. 145) seems to have been the first modern critic to publish K1387, bringing it, at the same time, into connection with the San Marco altarpiece. She notes that a label on the back of the panel states that it came from the Convent of San Marco. This label, still preserved and now attached to the cradling, is inscribed, 'No. 510 [or 512]; Estratti del Convento di S. Marco di Firenze.' T. Bodkin (*loc. cit.* in note 3, below) refers to the label on this painting and quotes the similar label on the Louvre panel. (**3**) Among the critics who treat K1387 as characteristic of Fra Angelico are F. Schottmüller (*loc. cit.* in note 2, above), A. Venturi (*Studi dal vero*, 1927, pp. 12 ff.), T. Bodkin (in *Burlington Magazine*, vol. LVIII, 1931, pp. 193 f.), B. Berenson (*Italian Pictures of the Renaissance*, 1932, p. 22, and later editions), L. Venturi (*Italian Paintings in America*, vol. II, 1933, no. 161), and J. Pope-Hennessy (*Fra Angelico*, 1952, pp. 13 ff., 174 ff.). R. van Marle (*Italian Schools of Painting*, vol X, 1928,. p. 96) seems to be alone in doubting the attribution to Fra Angelico, although P. Muratoff (*Fra Angelico*, 1930, p. 43) is not clear as to whether he denies this panel, along with

other parts of the predella, to Angelico. (**4**) These dates are deduced from documents citing the removal of an older altarpiece from the high altar and its substitution; the execution was probably finished at least by 1443, when the church was consecrated. (**5**) To get around the difficulty of too great width in the predella, T. Bodkin (*loc. cit.* in note 3, above) and L. Ragghianti Collobi (in *Critica d'Arte*, Mar. 1950, pp. 468 ff.) omit some of the panels, among them K1387, from the San Marco predella. But R. L. Douglas (in *Art Quarterly*, vol. VIII, 1945, pp. 290 ff.) emphasizes that such omission is untenable. J. Pope-Hennessy (pp. 172 f. of *op. cit.* in note 3, above) suggests the addition of a tenth, as yet unidentified, panel to the predella and an arrangement in two tiers of five panels each. (**6**) Pope-Hennessy (p. 176 and fig. XI of *op. cit.* in note 3, above) cites figures of saints which he believes may have decorated the pilasters. (**7**) This arrangement, with four of the panels accommodated on the pilasters was proposed by M. Salmi (in *Catalogo della Mostra delle Opere di Fra Angelico*, Rome–Florence, 1955, 3rd ed., pp. 72 f.). (**8**) M.-L. David-Danel (*Iconographie des saints médecins Côme et Damien*, 1958, pp. 90 ff.) suggests some change in the consecutive order of the scenes. (**9**) Only the slightest traces of gilding are now visible at the right and left edges of K1387. (**10**) Vasari, *Le Vite*, Milanesi ed., vol. II, 1878, p. 509. (**11**) G. Kaftal, *Iconography of the Saints in Tuscan Art*, 1952, col. 292. (**12**) E.g., St. Anna wears such a headdress in the *Birth of the Virgin* by Fra Angelico in the Prado, Madrid; and it is worn by the new mother on Masaccio's *Birth Salver* in the Berlin Museum. (**13**) W. and E. Paatz, *Die Kirchen von Florenz*, vol. III, 1952, p. 44. (**14**) G. Richa (*Notizie istoriche delle chiese fiorentine . . .*, vol. VII, 1758, p. 143) cites the altarpiece as hanging in the passageway of the Sacristy of San Marco. (**15**) See P. L. V. Marchese (*Memorie dei più insigni pittori . . .*, vol. I, 1845, p. 283) and Bodkin (pp. 193 f. of *op. cit.* in note 3, above. (**16**) In the sale catalogue, which describes K1387 in detail, it is stated that the picture was formerly at the Certosa near Florence. (**17**) Listed as Fra Angelico (in *Art News*, Dec. 28, 1929, p. 4) among the paintings sent to the exhibition; but it is not included in the catalogue.

FRA ANGELICO AND FRA FILIPPO LIPPI

K1425 : Frontispiece, Figures 259–261

THE ADORATION OF THE MAGI. Washington, D.C., National Gallery of Art (1085), since 1951.[1] Wood. Diameter 54 in. (137·4 cm.). Generally good condition; horizontal split across panel; a few losses of paint.

The question of the attribution of K1425 assumes special significance because of the pictorial innovations involved.

The picture presumably set the fashion for representing the Adoration in a *tondo*. There are conventional details, to be sure: the oversized birds are undoubtedly here for their symbolical significance, the peacock, e.g., signifying immortality; and the medieval tapestrylike treatment of the flowered sward in the foreground, like that in Angelico's large *Deposition*, San Marco, Florence, may be a reference to Paradise. But there is much also that is abreast of contemporary progress and even prophetic of the future. If K1425 was painted about 1445, as is generally believed,[2] the horses seen in foreshortened rear view are contemporary with, and more naturalistic than, the horses in Uccello's famous battlepieces. The nude youths[3] climbing over the ruins are noteworthy contemporaries of Castagno's anatomical studies and could have been an inspiration to the later essays of Pollaiuolo in this field. As for genre painting, which Bruegel the Elder mastered more than a century later, it is already here in abundance, in the stable scene and in the gaping beggars and ragamuffins.

Most critics have believed that Filippo Lippi was wholly responsible for K1425, only employing some studio assistance.[4] Many of the figures, notably the shepherd entering the scene from the right foreground and the kneeling Magi and their retinue are typical of Filippo. But other figures, for example the Virgin and Child and some of the female spectators in the right middle ground, seem to belong to Fra Angelico in type and execution. This is especially convincing in the case of the Virgin and Child. As to the figures in the right middle ground, compare them (especially the one to whom two nude children are clinging) with the Donna Palladia standing in the doorway in K1387 (Fig. 258), by Angelico. It seems reasonable that Fra Angelico may have painted these figures, at least, and may have designed the *tondo* in the period just preceding the revelations of his naturalistic phase in the frescoes of the Chapel of Nicholas V. Much of the execution, then, would have been left to Filippo after Angelico was called to Rome no later than 1447. Pentimenti, most clearly visible in the group of kneeling figures in the left foreground, reveal earlier poses of some of the faces and figures.

Provenance: Possibly Medici family, Florence (inventory of 1492).[5] Guicciardini Palace, Florence (inventory of 1807, attributed to Botticelli; sold July 1810).[6] Apparently bought by Dubois, Florence.[7] William Coningham, London (sold, Christie's, London, July 9, 1849, no. 34, as Filippo Lippi).[8] Alexander Barker, London (1854; sold, Christie's, London, June 6, 1874, no. 42, as Filippino Lippi; bought for the following).[9] Cook Collection, Richmond, Surrey (catalogue by T. Borenius, vol. I, 1913, no. 16, as Filippo Lippi[10]) – exhibited: 'Old Masters,' Royal Academy, London, 1875, no. 184, as Filippo Lippi; 'National Loan Exhibition,' Grafton Gallery, 1910, no. 68, as Filippo Lippi; 'Florentine Painting before 1500,' Burlington Fine Arts Club, London, 1919, no. 26 of 1920 catalogue, as Filippo Lippi; 'Italian Art, 1200–1900,' Royal Academy, London, 1930, no. 93 of

catalogue, as Filippo Lippi. Paul Drey's, New York. Kress acquisition, 1947.

References: (**1**) *Paintings and Sculpture from the Kress Collection*, 1951, p. 42 (catalogue by W. E. Suida), as Fra Angelico and Filippo Lippi. (**2**) Only R. Oertel (*Fra Filippo Lippi*, 1942, p. 70) dates K1425 a decade later, because of its 'romantic style.' (**3**) See C. Eisler (in *Essays in Honor of Erwin Panofsky*, 1961, pp. 87 f.) for a possible connection of these nudes with the concept of the 'athlete of virtue.' (**4**) K1425 was attributed to Botticelli in the Guicciardini inventory (see *Provenance*, above), to Gozzoli by Waagen (*Treasures of Art in Great Britain*, vol. II, 1854, p. 125). Among others, the following critics have attributed K1425 to Filippo: Crowe and Cavalcaselle (*New History of Painting*, vol. II, 1864, p. 350), A. Venturi (*Storia dell'arte italiana*, vol. VII, pt. I, 1911, p. 361), R. van Marle (*Italian Schools of Painting*, vol. X, 1928, p. 402), B. Berenson (*Italian Pictures of the Renaissance*, 1932, p. 288), P. Toesca (in *Enciclopedia italiana*, vol. XXI, 1934, p. 238, citing assistance of a close follower of Fra Angelico), G. Pudelko (in *Rivista d'Arte*, vol. XVIII, 1936, pp. 68 ff., with some assistance), M. Pittaluga (*Filippo Lippi*, 1949, pp. 76 ff. and 211 ff., citing assistance of Pesellino), J. Pope-Hennessy (*Fra Angelico*, 1952, p. 204, as 'substantially' by Filippo), and R. Salvini (in *Scritti di storia dell'arte in onore di Mario Salmi*, 1962, pp. 299, 304, implicitly). In *Bollettino d'Arte* (vol. XXVI, 1932, pp. 1 ff.) B. Berenson (followed by C. L. Ragghianti in *Critica d'Arte*, Feb. 1936, p. 115 n. 2; May 1949, p. 81) defended the theory that K1425 was designed and partly painted by Fra Angelico, with some assistance of a pupil, and then finished by Filippo Lippi (see also *Pitture italiane del rinascimento*, 1936, p. 20), although more recently (in ms. opinion) he inclined to attribute it to Filippo under the strong influence of Fra Angelico, an influence which almost all critics have emphasized. In the posthumous edition (1963) of his lists (*Italian Pictures . . . Florentine School*, vol. I, pp. 16, 114) Berenson's attribution given in the 1936 edition is repeated. (**5**) In the copy of the 1492 Medici inventory, as published by E. Müntz (*Les Collections des Médicis au XVe siècle*, 1888, p. 60), is the following entry among the paintings in the large chamber of Lorenzo: '*Uno tondo grande cholla chornicie atorno messe d'oro dipintovi la nostra Donna e el nostro Signore e e' Magi che vanno a offerire, di mano di fra giovanni, f. 100.*' (**6**) Regarding this inventory see M. Davies, *National Gallery Catalogues: Earlier Italian Schools*, 1961, p. 102 n. 6, where the Botticelli *tondo* of the *Adoration* now in the National Gallery, London, is shown to have been together with K1425 in the Guicciardini Collection. (**7**) According to a handwritten note in the 1810 Guicciardini sale catalogue; and K1425 is presumed to be one of the items in H. Delaroche's catalogue of the Dubois Collection (1813). For more information about this catalogue, of which no copy is at present available, see Davies, *loc. cit.* in note 6, above. (**8**) K1425 was still with the London Botticelli at this time. See Davies, n. 7 of *loc. cit.* above. (**9**) K1425 is apparently identical with one described

by Waagen (*Treasures of Art in Great Britain*, vol. II, 1854, p. 125) and ascribed to Gozzoli. It appeared in the 1874 sale of Barker's Collection together with the Berlin *tondo* of the *Adoration of the Magi* now generally attributed to Domenico Veneziano. (10) The provenance is here confused in some details with the provenance of the Botticelli *tondo* now in London.

Attributed to FRA ANGELICO

K289 : Figure 256

THE MEETING OF ST. FRANCIS AND ST. DOMINIC. San Francisco, Calif., M. H. De Young Memorial Museum (61-44-7), since 1955.[1] Wood. $10\frac{1}{4} \times 10\frac{1}{2}$ in. (26×26·7 cm.). Fair condition except for face of second monk from right; cleaned 1954.

This subject was treated by Fra Angelico in his early period in the predella of an altarpiece painted for Cortona. Again it appears in a predella panel now in Berlin, attributed to the master or his studio in his late period. The concern for spatial effect in K289, which must have come from a third predella, may indicate that K289 also is to be dated late, after 1445, when Fra Angelico was working in Rome. It has usually been attributed to the master himself.[2]

Provenance: Alexis-François Artaud de Montor, Paris (probably as early as 1808; catalogue by Artaud de Montor, 1843, no. 129, as Baldovinetti; sold, Hôtel des Ventes Mobilières, Paris, Jan. 17-18, 1851, no. 129, as Baldovinetti). Georges Chalandon, Paris. R. L. Douglas, London (cited here 1924). Mrs. Walter Burns, London. Contini Bonacossi, Florence. Kress acquisition, 1934 – exhibited: National Gallery of Art, Washington, D.C. (256), 1941-50;[3] 'Mostra del Beato Angelico,' Vatican, Rome, Apr.-May, 1955, and Museo di San Marco, Florence, May–Sept., 1955, no. 41, as Fra Angelico.

References: (1) Catalogue by W. E. Suida, 1955, p. 12, as Fra Angelico. (2) K289 has been attributed to Fra Angelico by B. Berenson (*Florentine Painters of the Renaissance*, 1909, p. 107; later, in ms. opinion, Berenson gives the painting to Angelico with reservations, and in the 1963 edition of his lists its entry under Fra Angelico is followed by *r*, indicating that he believed it to be ruined, restored, or repainted), F. Schottmüller (*Fra Angelico*, 1924, no. 178, with a notice that her attribution is based on Berenson's authority), T. Borenius, G. Fiocco, R. Longhi, F. M. Perkins, A. Venturi, and R. van Marle (in ms. opinions). Van Marle had earlier (*Italian Schools of Painting*, vol. X, 1928, p. 120) cited K289 (but without comment) on the basis of the reproduction in Schottmüller. M. Meiss (verbally) gives K289 to a follower of Fra Angelico; M. Modestini expresses (verbally) a strong

belief that it is by Fra Angelico and an assistant. (3) *Preliminary Catalogue*, 1941, p. 6, as Fra Angelico.

Attributed to FRA ANGELICO

K477 : Figure 257

THE ENTOMBMENT. Washington, D.C., National Gallery of Art (371), since 1941.[1] Wood. $35 \times 21\frac{5}{8}$ in. (89×55 cm.). Very much worn; large zones in sky and landscape repainted.

This may be the painting listed as by Fra Angelico in the Medici inventory of 1492, 'A painting of the dead Christ with many saints, who are carrying him to the tomb.'[2] The distant landscape recalls that of the great *Deposition* in the Museum of San Marco, Florence, and the devout seriousness of the figures reflects Angelico's mood. But the awkward gestures of some of the figures and what at least now seems poor execution have led to recent denial of K477 to Angelico.[3] The most satisfactory figures, the two Marys in the foreground – especially the one at the right – have suggested the participation of Filippo Lippi in the work, perhaps in such combination with Fra Angelico, about 1445, as is proposed in the case of the *Adoration of the Magi*, K1425 (pp. 95 f., above).[4]

Provenance: Possibly Medici family, Florence (inventory of 1492).[5] Stefano Bardini, Florence. Luigi Grassi, Florence. Duveen's, New York (*Duveen Pictures in Public Collections of America*, 1941, no. 40, as Fra Angelico). Henry Goldman, New York – exhibited: 'Early Italian Paintings,' Duveen Galleries, New York, Apr.–May 1924, no. 4 of catalogue of 1926 by W. R. Valentiner, as Fra Angelico. Kress acquisition, 1937.

References: (1) *Preliminary Catalogue*, 1941, p. 6, as Fra Angelico. (2) E. Müntz, *Les Collections des Médicis au XVe siècle*, 1888, p. 64. The identification of K477 with the Medici entry was first suggested by F. Schottmüller (*Fra Angelico*, 1924, no. 180). (3) K477 has been attributed to Fra Angelico by F. Schottmüller (*loc. cit.* in note 2, above), A. Venturi (in ms. opinion), L. Venturi (*Italian Paintings in America*, vol. II, 1933, no. 182), and B. Berenson (*Italian Pictures of the Renaissance*, 1932, p. 22; Italian ed., 1936, p. 19); but later (in ms. opinion, 1955) Berenson gave it to a close follower of Fra Angelico, while in the posthumous edition (*Italian Pictures . . . Florentine School*, vol. I, 1963, p. 16) it is listed under Fra Angelico with a question mark. In ms. opinions, G. Fiocco, R. Longhi, F. M. Perkins, and W. E. Suida have suggested it was begun by Fra Angelico and finished by an unidentified artist (possibly Jacopo del Sellaio, according to Longhi). C. L. Ragghianti (*loc. cit.* in note 4, below) identifies the artist who finished it as Filippo Lippi.

R. Offner (in *The Arts*, vol. v, 1924, p. 245) says K477 is not by Fra Angelico. R. van Marle (*Italian Schools of Painting*, vol. x, 1928, p. 143 n. 3) questions the attribution to Angelico, and J. Pope-Hennessy (*Fra Angelico*, 1952, p. 204) rejects it. (4) This suggestion is made by C. L. Ragghianti (in *Critica d'Arte*, May 1949, p. 81). (5) See note 2, above.

APOLLONIO DI GIOVANNI

Florentine School. Active mid-fifteenth century. Known formerly as the Master of the Jarves Cassoni, the Master of the Virgil Codex, and the Dido Master, this painter has recently been plausibly identified as the documented master who, in partnership with Marco del Buono, operated a workshop in Florence for the decoration, chiefly, of cassoni, or marriage chests.[1] The decoration was based on the International Style as practiced by Gentile da Fabriano. Variation in the work attributed to Apollonio is explained by his employment of a number of artists in his shop.

K251 : Figure 267

THE JOURNEY OF THE QUEEN OF SHEBA. Birmingham, Ala., Birmingham Museum of Art (61.95), since 1961. Wood. $17 \times 69\frac{1}{4}$ in. ($43 \cdot 2 \times 175 \cdot 9$ cm.). Good condition except for abrasions.

The story of the Queen of Sheba was popular in the decoration of marriage chests, especially in the studio from which this panel comes.[2] *The Meeting of the Queen of Sheba with Solomon* is depicted on one of the Apollonio panels in the Jarves Collection, Yale University, New Haven; and on one in the Museum of Fine Arts, Boston, is a version of the *Journey of the Queen*. K251 is treated as a continuous narrative: in the background at the left the Queen kneels praying before the bridge made from the tree of Good and Evil; in the center, surrounded by ladies and courtiers, she is drawn forward on her chariot; and at the right her retinue proceeds into the background. The date of the painting is probably about 1450.

Provenance: Contini Bonacossi, Florence. Kress acquisition, 1933 – exhibited: National Gallery of Art, Washington, D.C. (233), 1941–51;[3] William Rockhill Nelson Gallery of Art, Kansas City, Mo., 1952–60.[4]

References: (1) E. H. Gombrich, in *Journal of the Warburg and Courtauld Institutes*, vol. XVIII, 1955, pp. 16 ff. (2) K251 has been associated with the Jarves cassoni and related panels by G. Fiocco, R. Longhi, R. van Marle, F. M. Perkins, A. Venturi (in ms. opinions), and B. Berenson (*Italian Pictures . . . Florentine School*, vol. i, 1963, p. 18). (3) *Preliminary Catalogue*, 1941, pp. 129 f., as Master of the Jarves

Cassoni. (4) Catalogue by W. E. Suida, 1952, p. 34, as Virgil Master.

APOLLONIO DI GIOVANNI

K491 : Figures 265, 263

THE TRIUMPH OF CHASTITY. Raleigh, N.C., North Carolina Museum of Art (GL.60.17.23), since 1960.[1] Wood. $23 \times 23\frac{1}{4}$ in. ($58 \cdot 4 \times 59 \cdot 1$ cm.). Fair condition except for abrasion throughout, especially in background, and a few losses of paint.

Painted probably about 1450,[2] as decoration for a marriage salver, the scene is inspired by the *Triumphs* of Petrarch. Chastity, in a gold mandorla and bearing the palm of victory, is carried on a triumphal car drawn by unicorns, symbol of chastity. Cupid, with hands bound, kneels at her feet. An ermine, symbol of purity, is emblazoned on a banner at the head of the procession; a dog, symbol of fidelity, drinks from a fountain; and a rabbit, symbol of fertility, runs toward the procession. On the back of the panel are three coats of arms, which are probably of later date,[3] and a scene of nude children playing with mandrake roots, symbol of fertility.

Provenance: Contini Bonacossi, Florence. Kress acquisition, 1937 – exhibited: National Gallery of Art, Washington, D.C. (384), 1941–56.[4]

References: (1) Catalogue by F. R. Shapley, 1960, p. 56, as Master of the Jarves Cassoni. (2) G. Fiocco, R. Longhi, F. M. Perkins, W. E. Suida, A. Venturi (in ms. opinions), and B. Berenson (*Italian Pictures . . . Florentine School*, vol. i, 1963, p. 18) attribute K491 to Apollonio di Giovanni (under his various designations). (3) R. Mather (in a letter of Apr. 21, 1947) says the shields are modern, that their colors do not make sense, and that there should be only two shields (for parents) or four (for grandparents). (4) *Preliminary Catalogue*, 1941, p. 130, as Master of the Jarves Cassoni.

ANDREA DI GIUSTO

Andrea di Giusto Manzini. Florentine School. Active from 1422; died 1455. He was an eclectic, chiefly influenced by Lorenzo Monaco, also by Fra Angelico. He worked with Bicci di Lorenzo, and, in 1426, with Masaccio on the predella of the altarpiece which Masaccio painted for the Church of the Carmine, Pisa.

K234 : Figure 264

THE ASSUMPTION OF THE VIRGIN WITH ST. JEROME AND ST. FRANCIS. Tulsa, Okla., Philbrook Art Center

(3351), since 1953.[1] Wood. 21⅜×21⅜ in. (54·3×54·3 cm.). Faces considerably abraded and restored.

There is general agreement as to the attribution, but less as to the date, which is probably in the early 1420's.[2] The coat of arms is that of a member of the Gaddi family, probably of Agnolo di Zanobi Gaddi, whose patron saint was Jerome, here given a place of honor. The single coat of arms would indicate that the painting antedates Agnolo's marriage, which took place in 1424/25.[3] A painting of *St. Jerome* attributed to Masaccio or Masolino, about 1425, formerly in the collection of Frank J. Mather, Jr., Princeton, N.J., bears the coats of arms of both Agnolo and his bride.[4]

Provenance: Partini, Rome. Contini Bonacossi, Florence. Kress acquisition, 1932 – exhibited: National Gallery of Art, Washington, D.C. (223), 1941–52.[5]

References: (1) Catalogue by W. E. Suida, 1953, p. 28, as attributed to Andrea di Giusto. (2) K234 has been attributed to Andrea di Giusto by B. Berenson (*Italian Pictures . . . Florentine School*, vol. I, 1963, p. 7), G. Fiocco, R. Longhi, R. van Marle, F. M. Perkins tentatively, A. Venturi (in ms. opinions), and M. Salmi (in *Commentari*, vol. I, 1950, p. 147). Salmi recognizes the coat of arms as probably belonging to Agnolo di Zanobi Gaddi, but dates the picture *c.* 1445. (3) The data regarding the coat of arms is from a written communication from R. Mather, 1947. (4) F. J. Mather, Jr., in *Art Bulletin*, vol. XXVI, 1944, p. 186. (5) *Preliminary Catalogue*, 1941, p. 4, as Andrea di Giusto.

ANDREA DI GIUSTO

K420 : Figure 266

THE NATIVITY. Allentown, Pa., Allentown Art Museum Study Collection (60.21.KBS), since 1960. Wood. 5⅛× 15⅝ in. (13×39·7 cm.). Good condition except for a few abrasions.

In spite of its small size and rather summary treatment, the serious conception of the figures and the lyric charm of the landscape render this painting worthy of its attribution,[1] with a date of about 1435. As a predella panel it would have been suitable for such an altar picture as Andrea's *Enthroned Madonna and Child with Two Angels* (in the manner of Lorenzo Monaco) in the Accademia, Florence.

Provenance: Contini Bonacossi, Florence. Kress acquisition, 1936.

Reference: (1) K420 has been attributed to Andrea di Giusto by G. Fiocco, R. Longhi, R. van Marle, F. M. Perkins, W.

E. Suida, A. Venturi (in ms. opinions), and B. Berenson (*Italian Pictures . . . Florentine School*, vol. I, 1963, p. 5).

FLORENTINE SCHOOL
Mid-XV Century

K103 : Figure 268

THE STORY OF HELEN OF TROY (?). Allentown, Pa., Allentown Art Museum, Study Collection (60.09.KBS), since 1960. Wood. 16¼×54¼ in. (41·3×137·8 cm.). Abraded throughout.

Evidently from a cassone, this panel has been not unreasonably attributed to Andrea di Giusto;[1] for the lively manner suggests comparison with the St. Stephen frescoes in the Prato Cathedral which are attributed to Andrea and an assistant. An alternative subject (instead of the *Story of Helen of Troy*) for K103 is the sack of Rome by the Vandals in 455, when the Emperor Maximus was murdered and the Empress Eudoxia and her two daughters were carried off by the Vandal King Gaiseric.

Provenance: Contini Bonacossi, Florence. Kress acquisition, 1931.

Reference: (1) K103 has been attributed to Andrea di Giusto by G. Fiocco, R. Longhi, R. van Marle, and W. E. Suida (in ms. opinions); to an anonymous Florentine by F. M. Perkins, A. Venturi (in ms. opinions), and B. Berenson (*Italian Pictures . . . Florentine School*, vol. I, 1963, p. 217).

MASTER OF THE GRIGGS CRUCIFIXION

Florentine School. Active first half of fifteenth century. He is related in style to Arcangelo di Cola and Rossello di Jacopo Franchi, each of whom has tentatively been given credit for some of the paintings now attributed to the Master of the Griggs Crucifixion.[1] He also shows the influence of Lorenzo Monaco, Fra Angelico, and Masolino.

K170 : Figure 270

SCENE IN A COURT OF LOVE. Madison, Wis., University of Wisconsin, Study Collection (61.4.3), since 1961.[2] Wood. 14¹³⁄₁₆×48¼ in. (37·6×122·6 cm.). Abraded throughout.

Formerly attributed to Rossello di Jacopo, K170 is now convincingly given to the Master of the Griggs Crucifixion, with a date of about 1440.[3] The subject is presumed to have been taken from, or at least suggested by, Boccaccio's *Decameron*: a party of young dilettanti whiling away their

time in the country with competitive storytelling. It is a lady who accepts the victor's laurel crown, as it is a woman who triumphs in the story of Judith shown on the panel presumed to have been a pendant to K170 when they were together in the Artaud de Montor Collection.[4] A courtly scene of closely related style is in the Berlin Museum.[5]

Provenance: Visconti, Milan. Alexis-François Artaud de Montor, Paris (first half of nineteenth century). Art Market, Paris (*c.* 1925). Contini Bonacossi, Florence. Kress acquisition, 1931 – exhibited: 'Italian Paintings Lent by Mr. Samuel H. Kress,' Oct. 1932, Atlanta, Ga., through June 1935, Charlotte, N.C., p. 13 of catalogue, as Rossello di Jacopo Franchi; National Gallery of Art, Washington, D.C. (188), 1941–52.[6]

References: (**1**) One of the first critics to study the group of paintings was B. Berenson (in *Dedalo*, vol. X, 1929, pp. 133 ff.; vol. XII, 1932, pp. 173 ff.; *Italian Pictures of the Renaissance*, 1932, pp. 493 f., and later editions, including *Italian Pictures . . . Florentine School*, vol. I, 1963, p. 193), who gave much of the work to Rossello di Jacopo. In the course of more specialized study, R. Offner (in *Burlington Magazine*, vol. LXIII, 1933, pp. 170 ff.) has given some of these paintings to an anonymous painter whom he calls, from a picture given by Maitland F. Griggs to the Metropolitan Museum, New York, the Master of the Griggs Crucifixion. R. Longhi (in *Critica d'Arte*, July–Dec. 1940, p. 185 n. 22) makes some additions, including K170, to Offner's catalogue of the Griggs Master's oeuvre. (**2**) Catalogue by D. Loshak, 1961, p. unnumbered, as Rossello di Jacopo Franchi. (**3**) See Longhi, *loc. cit.* in note 1, above, and Pudelko, *loc. cit.* in note 5, below. Berenson (*loc. cit.* in note 1, above) had given K170 to Rossello; he was followed by G. Fiocco, R. van Marle, W. E. Suida, and A. Venturi (in ms. opinions); see also note 4, below. (**4**) P. Schubring, *Cassoni*, 1923, nos. 428, 429, pl. C. Schubring, followed by T. Borenius (in the Paul Schubring-Festschrift, 1929, pp. 1 f.), ascribed K170 tentatively to the Sienese School. Borenius says that Artaud de Montor had ascribed it to Dello. (**5**) Schubring, no. 427, pl. C, of *op. cit.* in note 4, above (Staatliche Museen, no. 1467). G. Pudelko (in *Art in America*, vol. XXVI, 1938, p. 63 n. 31) says this painting and K170 belonged together; he gives them both to the Griggs Master. (**6**) *Preliminary Catalogue*, 1941, p. 175, as Rossello di Jacopo Franchi.

Circle of the MASTER OF THE GRIGGS CRUCIFIXION

K275 : Figure 269

SCENES FROM A LEGEND. Brunswick, Me., Walker Art Museum, Bowdoin College, Study Collection (1961.100.1),

since 1961.[1] Wood. $11\frac{3}{8} \times 49\frac{3}{4}$ in. ($28·9 \times 126·3$ cm.). Much abraded, damaged, and restored.

Relationship to Arcangelo di Cola and to Rossello di Jacopo has been recognized in this cassone panel.[2] It probably dates about 1430 and it retains what appears to be its original frame. Help in interpreting the lively scenes is offered by versions on other known cassone panels, notably one in the Honolulu Museum, which is very similar to K275 and probably comes from the same studio. The theme is the detection and judgment of breach of chastity among the huntress band of Diana and her following. At the right the offense of Callisto is discovered; in the center Diana is wafted down to the sleeping Endymion; at the left witnesses testify and judgment is pronounced.

Provenance: Louis-Philippe Bern, Paris. Contini Bonacossi, Florence. Kress acquisition, 1933 – exhibited: National Gallery of Art, Washington, D.C. (248), 1941–52.[3]

References: (**1**) Catalogue, 1961, p. 8, as Florentine, first half of fifteenth century. (**2**) In ms. opinions K275 has been classified as Florentine, first half of the fifteenth century, by G. Fiocco (who notes a close relationship to Arcangelo di Cola), R. Longhi (who points to the following of Lorenzo Monaco and Spinello), R. van Marle, F. M. Perkins, W. E. Suida, and A. Venturi. B. Berenson (*Italian Pictures . . . Florentine School*, vol. I, 1963, p. 217) lists K275 as Florentine, close to Rossello di Jacopo. (**3**) *Preliminary Catalogue*, 1941, pp. 64 f., as Florentine, fifteenth century.

MASTER OF THE BUCKINGHAM PALACE MADONNA

Florentine School. Active mid-fifteenth century. Identified by some critics as Domenico di Michelino,[1] by others as Zanobi Strozzi,[2] this artist is, in any case, appropriately designated by reference to his masterpiece, the *Buckingham Palace Madonna*.[3] He was probably a pupil of Fra Angelico, with whom he may have collaborated, and he was influenced also by Pesellino and Domenico Veneziano.

K1720 : Figure 274

THE MADONNA OF HUMILITY. Tucson, Ariz., University of Arizona (61.119), since 1951.[4] Wood. $27\frac{1}{4} \times 18\frac{3}{8}$ in. ($69·2 \times 46·7$ cm.). Inscribed on scroll held by Christ Child: EGO SVM [lvx mvndi] (from John 8 : 12). Fair condition except for abrasion throughout; cleaned 1948.

This painting is so closely similar to several other *Madonnas* of the mid-fifteenth century – not only the one at Buckingham Palace, but also, for example, one in the Crespi

Collection, Milan,[5] one in an altarpiece now at the Musée de Chartres,[6] and one formerly in the Achillito Chiesa Collection, Milan[7] – as to assign them all to the same master, however he may be called.[8] Most of these examples show the Madonna seated low, on a cushion, and all show her holding a stalk of lilies in her right hand.

Provenance: Colonel Barclay, Bury Hill, Dorking, Surrey. Contini Bonacossi, Florence. Kress acquisition, 1950 – exhibited: National Gallery of Art, Washington, D.C., 1951.[9]

References: (**1**) Among others, R. van Marle (*Italian Schools of Painting*, vol. X, 1928, pp. 188 ff.) and B. Berenson (*Italian Pictures . . . Florentine School*, vol. I, 1963, pp. 60 f., and earlier editions and elsewhere). (**2**) M. Salmi (in *Commentari*, vol. I, 1950, p. 151) and L. Ragghianti Collobi (in *Critica d'Arte*, May 1950, p. 19). (**3**) The pseudonym was suggested by R. Longhi (in ms. opinion) and adopted by the compilers of the catalogue of the exhibition 'De Giotto à Bellini,' Musée de l'Orangerie, Paris, May–July, 1956, p. 68. (**4**) Catalogue by W. E. Suida, 1951, no. 9, and 1957, no. 8, as Master of the Buckingham Palace Madonna.(**5**) Reproduced by Berenson, vol. II, pl. 630 of *op. cit.* in note 1, above. (**6**) Reproduced, *ibid.*, pl. 632. (**7**) Reproduced by Ragghianti Collobi, fig. 15 of *op. cit.* in note 2, above. (**8**) See notes 1–3, above. K1720 is attributed to Domenico di Michelino by Berenson (*loc. cit.* in note 1, above); to the Master of the Buckingham Palace Madonna by R. Longhi (in ms. opinion). (**9**) *Paintings and Sculpture from the Kress Collection*, 1951, p. 273 (catalogue by W. E. Suida), as Master of the Buckingham Palace Madonna.

DOMENICO DI MICHELINO

Domenico di Francesco, called di Michelino. Florentine School. Born 1417; died 1491. He was apprenticed to a cassone painter called Michelino and was afterwards, probably, in the studio of Fra Angelico. His only extant documented work is the Dante in the Cathedral at Florence, which he painted in 1465–66. Generally accepted reconstructions of his oeuvre[1] omit some of the more attractive paintings in Angelico's style, while adding to his later production Filippesque paintings sometimes attributed to Giusto d'Andrea.[2]

K159 : Figure 271
ST. JEROME

K158 : Figure 272
ST. FRANCIS

Dallas, Tex., Dallas Museum of Fine Arts (1933.2; 1933.1), since 1933. Wood. K159, 54×23¼ in. (137·1×59·1 cm.); K158, 53¾×22⅜ in. (136·5×56·8 cm.).

These two panels come from the sides of a polyptych, other parts of which may eventually be identified by matching details of the cherubs in the spandrels of K158 and K159. As a consequence of the division of opinion mentioned above, K158 and K159 have been attributed by some critics to Domenico di Michelino, by others to Giusto d'Andrea.[3] They probably date about 1460.

Provenance: Federico Pedulli, Florence. Contini Bonacossi, Florence. Kress acquisition, 1931.

References: (**1**) A. M. Ciaranfi (in *Dedalo*, vol. VI, 1926, pp. 522 ff.), R. Offner (in *Burlington Magazine*, vol. LXIII, 1933, pp. 174 ff.), and L. Ragghianti Collobi (in *Critica d'Arte*, Jan. 1950, pp. 363 ff.). (**2**) B. Berenson (in *Dedalo*, vol. XII, 1932, pp. 700 ff.; *Italian Pictures . . . Florentine School*, vol. I, 1963, pp. 60 f., 92 f.) maintains the less widely accepted division between the work of Domenico di Michelino and Giusto d'Andrea. (**3**) They have been attributed to Giusto d'Andrea by Berenson (in *Dedalo*, loc. cit.; *Italian Pictures . . . Florentine School*, vol. I, 1963, p. 92), G. Fiocco, R. van Marle, and A. Venturi (in ms. opinions); to Domenico di Michelino by R. Offner (in *Burlington Magazine*, vol. LXIII, 1933, p. 174 n. 27), L. Ragghianti Collobi (in *Critica d'Arte*, Jan. 1950, p. 369 and n. 20), R. Longhi, and W. E. Suida (in ms. opinions).

PAOLO UCCELLO

Paolo di Dono, called Uccello. Florentine School. Born c. 1397; died 1475. As a boy he was helper to Ghiberti on the bronze doors of the Florentine Baptistery, but by 1415 he was enrolled in a guild as painter. He was chiefly active in this profession in Florence although he executed some mosaics in Venice. An outstanding leader of the 'scientific school,' his consuming interest was in linear perspective.

Attributed to PAOLO UCCELLO

K518 : Figure 273

MADONNA AND CHILD. Raleigh, N.C., North Carolina Museum of Art (GL.60.17.24), since 1960.[1] Wood. 22¼× 15⅝ in. (56·5×39·7 cm.). Fair condition except for abrasion throughout, especially in flesh tones and gold background; cleaned 1960.

The types of faces and figures, their preoccupied expressions, and the mannered fastidiousness of their gestures place K518 in a group of works of about 1440/50 much discussed in relation to Uccello. Most similar to K518 are a half-length *Madonna* in the Berlin Museum and one in a private collection in Florence.[2] These two may well be by the same

hand as K 518. That the hand is Uccello's has been vigorously defended by some critics, denied by others. Undisputed paintings by Uccello offer sufficiently close parallels to place these three paintings within his circle and to suggest that they may be by him.[3]

Provenance: Achillito Chiesa, Milan. Contini Bonacossi, Florence. Kress acquisition, 1938 – exhibited: National Gallery of Art, Washington, D.C. (409), 1941 – 52;[4] 'Mostra di Quattro Maestri del Primo Rinascimento,' Palazzo Strozzi, Florence, Apr. 22–July 12, 1954, no. 24, as attributed to Uccello.

References: (**1**) Catalogue by F. R. Shapley, 1960, p. 58, as circle of Paolo Uccello. (**2**) These are reproduced by L. Berti, in *Pantheon*, vol. XIX, 1961, pp. 229 and 306. Here are reproduced somewhat less similar *Madonnas* in other private collections and the better-known but still less similar *Madonna* in the National Gallery of Ireland. (**3**) K 518 was attributed to Uccello some thirty years ago by R. Longhi, W. E. Suida, and A. Venturi (in ms. opinions); to a master close to Uccello by G. Fiocco and F. M. Perkins (in ms. opinions); tentatively to a Paduan follower of Uccello by B. Berenson (in ms. opinion); and listed as 'attributed to Uccello' by E. Sindona (*Paolo Uccello*, 1957, p. 63). In *Pantheon*, vol. XXVI, 1940, p. 274, Suida again favored an attribution to Uccello. More recently J. Pope-Hennessy (*Paolo Uccello*, 1950, p. 164) has given K 518 and the closely similar Berlin painting to a follower of Uccello whom he designates, from the *Adoration* in Karlsruhe, as the Karlsruhe Master, active 1440–60. Although Pope-Hennessy's characterization of this master and of a 'Prato Master' is well defended, the recent tendency, among Italian critics at least, is to conflate these masters with Uccello himself. L. Berti (in *Pantheon*, vol. XIX, 1961, pp. 298 ff.) rejects the divisions and attributes K 518 unreservedly to Uccello, dating it *c.* 1443. (**4**) *Preliminary Catalogue*, 1941, p. 203, tentatively as Uccello.

Follower of PAOLO UCCELLO

K 320 : Figure 275

MADONNA AND CHILD WITH ST. FRANCIS. Allentown, Pa., Allentown Art Museum (60.18.KB), since 1960.[1] Wood. 23½ × 17¾ in. (59·7 × 45·1 cm.). Abraded throughout, especially in flesh tones; cleaned 1960.

Like K 518 (Fig. 273) this panel, painted around 1440/50, falls within a group of paintings closely related to Uccello if not, as some critics believe, by Uccello himself.[2] The angels suggest comparison with a drawing sometimes attributed to Uccello in the Uffizi (no. 2778c), Florence, although they lack its consistently forceful design. Some details are strikingly paralleled in paintings by Niccolò da Foligno, especially his altarpiece of 1457 in the Municipio, Deruta.

Provenance: Contini Bonacossi, Florence. Kress acquisition, 1935 – exhibited: National Gallery of Art, Washington, D.C., 1951–52.[3]

References: (**1**) Catalogue by F. R. Shapley, 1960, p. 48, as Florentine School, *c.* 1440. (**2**) In ms. opinions K 320 has been given with some question to Uccello by R. Longhi and W. E. Suida; placed close to Uccello by G. Fiocco and R. van Marle; attributed to an unknown master by F. M. Perkins and A. Venturi; and thought not to be Florentine but possibly Spanish or Romagnol by B. Berenson. I am informed that Berenson more recently suggested Scaletti as possible painter of the picture. E. Sindona (*Paolo Uccello*, 1957, p. 63) lists it as 'attributed to Uccello.' J. Pope-Hennessy (*Paolo Uccello*, 1950, p. 167) gives it to the Karlsruhe Master (see K 518, note 3); M. Salmi (in *Commentari*, vol. I, 1950, p. 26) gives it to the Master of the Quarata Predella; while L. Berti (in *Pantheon*, vol. XIX, 1961, pp. 298 ff.), conflating these two masters with Uccello and following C. L. Ragghianti (*Miscellanea Minore di Critica d'Arte*, 1946, p. 75), attributes K 320 to Uccello himself. (**3**) *Paintings and Sculpture from the Kress Collection*, 1951, p. 44 (catalogue by W. E. Suida), as Florentine, *c.* 1440, possibly Uccello.

Follower of PAOLO UCCELLO

K 490 : Figures 276–277

EPISODES FROM THE MYTH OF THESEUS. Seattle, Wash., Seattle Art Museum (It 37/Uc22.1), since 1952.[1] Wood. 16⅛ × 61½ in. (41 × 156·2 cm.). Very good condition for a cassone panel except for a few losses of paint.

Such paintings by Uccello as his battle subjects and the Ashmolean Museum's panel of the *Chase* seem to have been the inspiration for a number of cassone panels of about 1460, among them K 490. It is possible that K 490 may have been executed in Uccello's studio. Some critics see in it the participation of the master himself and also of his pupil or follower known as the Anghiari Master.[2] Identification of the subject with the Theseus myth seems plausible: thus at the left would be Theseus received by King Aegeus; at the right, the battle of Theseus' troops against the Amazons.[3]

Provenance: Mameli, Rome. Contini Bonacossi, Florence. Kress acquisition, 1937 – exhibited: National Gallery of Art, Washington, D.C. (383), 1941–51.[4]

References: (**1**) Catalogue by W. E. Suida, 1952, no. 10, and 1954, p. 30, as follower of Uccello with assistance of the Anghiari Master. (**2**) In ms. opinions B. Berenson attributes K 490 to a follower of Uccello; F. M. Perkins thinks it may have been painted in Uccello's studio; G. Fiocco and A. Venturi give it to Uccello and assistants; and R. Longhi

considers it chiefly by assistants, one of whom may have been the Anghiari Master. Landscape and architectural background are especially close to the Anghiari Master's treatment in a cassone in the National Gallery, Dublin (reproduced by P. Schubring, *Cassoni*, 1923, pl. XVIII). (3) The interpretation of the subject was suggested by W. E. Suida (see note 1, above). (4) *Preliminary Catalogue*, 1941, p. 203, as *A Battle Scene*, tentatively ascribed to Uccello.

DOMENICO VENEZIANO

Florentine School. Active 1438–61. Of Venetian origin and training, under the influence, probably, of Gentile da Fabriano and Pisanello, Domenico was likely active in Venice before going to Perugia in 1438. He is believed to have been employed again in Venice in 1442. But he was active chiefly in Florence, where he was influenced by Masaccio, Masolino, and Uccello, among others. He is especially important for his conquests in aerial perspective and treatment of light, accomplishments in which Piero della Francesca, possibly his pupil and at one time his collaborator, surpassed and probably influenced him. Domenico is remarkable also for his unusual combinations of blond colors and his anticipation of Leonardo in drapery treatment.

K410 : Figure 278

MADONNA AND CHILD. Washington, D.C., National Gallery of Art (332), since 1941.[1] Wood. 32½ × 22¼ in. (82·6 × 56·5 cm.). Good condition except for slight over-cleaning.

Similarity of this to the Madonna in the altarpiece from Santa Lucia dei Magnoli, Florence, now in the Uffizi, is sufficient proof that K410 is correctly attributed to Domenico Veneziano.[2] It is probably to be dated earlier, soon after the artist's presumptive collaboration in the San Tarasio frescoes, Venice (1442), since the Child would seem to have been inspired by Castagno's wreath-bearing *putti* there.[3] For the whole group of the Madonna and Child, relationship to Michelozzo's marble relief in the Bargello, Florence, has been cited.[4] Although less plainly than in K1723 (Fig. 323, by a Florentine artist of the second half of the fifteenth century), the outlines of K410 show traces of having been transferred to the panel from a pricked cartoon.[5]

Provenance: Edgeworth family, Edgeworthstown, Longford, Ireland (sold by Professor Francis Y. Edgeworth). Julius Böhler's, Munich – exhibited: 'Italian Art,' Royal Academy, Burlington House, London, 1930, no. 115, as Domenico Veneziano. Duveen's, New York (*Duveen Pictures in Public Collections of America*, 1941, no. 42, as Domenico Veneziano) – exhibited: 'L'Art Italien,' Petit Palais, Paris, 1935, no. 141, as Domenico Veneziano. Kress acquisition, 1936.

References: (1) *Preliminary Catalogue*, 1941, p. 58, as Domenico Veneziano. (2) K410 has been published as Domenico Veneziano by, among others, W. G. Constable (in *Gazette des Beaux-Arts*, vol. III, 1930, p. 287), C. Gamba (in *Dedalo*, vol. XI, 1931, p. 583), L. Venturi (*Italian Paintings in America*, vol. II, 1933, no. 199), G. Pudelko (in *Mitteilungen des Kunsthistorischen Instituts in Florenz*, vol. IV, 1934, pp. 165 f., where it is suggested that the rose hedge derives from Pesellino), M. Salmi (*Paolo Uccello, Andrea del Castagno, Domenico Veneziano*, n.d. [1935?], pp. 193 f.), A. Busuioceanu (in *L'Arte*, vol. XL, 1937, p. 9), R. Kennedy (*Alesso Baldovinetti*, 1938, pp. 5 ff.), K. Clark (*Piero della Francesca*, 1951, p. 3), and B. Berenson (*Italian Pictures . . . Florentine School*, vol. I, 1963, p. 62). (3) F. Zeri (*Due dipinti, la filologia e un nome*, 1961, p. 45) dates K410 later, toward 1450. (4) Pudelko, *loc. cit.*, in note 2, above. (5) Cf. the enlarged detail of the Christ Child's eye reproduced by L. Tintori and M. Meiss, *The Painting of The Life of St. Francis in Assisi*, 1962, fig. 6.

DOMENICO VENEZIANO

K278 : Figure 279

ST. FRANCIS RECEIVING THE STIGMATA. Washington, D.C., National Gallery of Art (251), since 1941.[1] Wood. 10⅞ × 12 in. (26·7 × 30·5 cm.).[2] Good condition except for a few losses of paint.

For the commentary, etc., see K1331, below.

Provenance: Santa Lucia dei Magnoli, Florence. Julius Böhler's, Munich. Contini Bonacossi, Florence – exhibited: 'Italian Art,' Royal Academy, London, 1930, no. 128, as Domenico Veneziano. Kress acquisition, 1933 – exhibited: 'Italian Paintings of the Renaissance,' Century Association, New York, Mar. 2–24, 1935, no. 5, as Domenico Veneziano; 'The Great Lakes Exposition,' Cleveland Museum of Art, Cleveland, Ohio, June 25–Oct. 4, 1937, no. 149 of catalogue, as Domenico Veneziano.

References: (1) *Preliminary Catalogue*, 1941, pp. 57 f., as Domenico Veneziano. (2) Modern framing strips are now attached to top and bottom of the panel. The original painted frame is found only along the right side; it is missing from the top, bottom, and left side (cf. K1331, below, which has its painted frame intact and is slightly larger than K278).

DOMENICO VENEZIANO

K1331 : Figure 280

ST. JOHN IN THE DESERT. Washington, D.C., National Gallery of Art (715), since 1946. Wood. 11⅛ × 12¾ in.

(28·3 × 32·4 cm.). Good condition except for some restoration in sky at left.

This and K278 (Fig. 279) are two of the five panels originally in the predella of the altarpiece which Domenico Veneziano painted, about 1445, for the Church of Santa Lucia dei Magnoli, Florence. The main panel, representing the *Enthroned Madonna and Child with Sts. Francis, John the Baptist, Zenobius, and Lucy,* is now in the Uffizi Gallery, Florence. The sequence of the predella scenes no doubt corresponded to that of the figures in the main panel; thus, they would have been arranged, from left to right, as follows *St. Francis Receiving the Stigmata* (K278), *St. John in the Desert* (K1331), *The Annunciation* (Fitzwilliam Museum, Cambridge), *A Miracle of St. Zenobius* (Fitzwilliam Museum, Cambridge), *The Martyrdom of St. Lucy* (Berlin Museum). K278 has been cut down slightly so that the panel is now smaller than K1331. Separated from the main part of the altarpiece and scattered probably early in the nineteenth century,[1] the five predella panels reappeared one or two at a time, each immediately being recognized as the work of Domenico Veneziano, typical of his clear organization of space in landscape or architectural view and of his pearly light effects.[2] A drawing by Domenico in the Uffizi, Florence, has been cited as closely paralleling St. Francis' head in K278.[3] K1331 is of special interest iconographically, since it is the only known representation of St. John discarding his worldly dress and donning the haircloth, symbol of his spiritual dedication. The scene is apparently based on the fourteenth-century *Vita di San Giovanni Battista,* of which two or three more literal illustrations are known, showing St. John with two angels, one of them bringing him the haircloth.[4] Most pertinent for comparison with K1331 is an almost effaced fresco of about 1435 (therefore about ten years earlier than K1331), in the Baptistry of Castiglione d'Olona.[5] Here a frontal, nude young Baptist, closely similar to the figure in K1331, has placed his folded dress on the ground, while two angels stand nearby, one of them carrying the haircloth garment. A very similar, though more lithe and slender, figure of the nude Baptist is seen in a drawing by Pollaiuolo at Bayonne.[6] Was the nude figure in K1331 based directly on Classical sculpture or was it inspired by such a painting as the *Holy Hermit* in the Poldi Pezzoli Museum, Milan, usually attributed to Pisanello or to Gentile da Fabriano?[7]

Provenance: Santa Lucia dei Magnoli, Florence. Bernard Berenson, Settignano. Carl Hamilton, New York – exhibited: 'Italian Art,' Royal Academy, Burlington House, London, 1930, no. 132, as Domenico Veneziano; 'Italian Paintings of the Renaissance,' Century Association, New York, Mar. 2–24, 1935, no. 6, as Domenico Veneziano. Kress acquisition, 1942.

References: (1) L. Lanzi (*Storia pittorica dell'Italia,* originally published 1792/6; English ed., vol. I, 1828, p. 82) mentions the altarpiece as still in the church, ascribes it to Castagno, but does not say whether the predella was with it. The Fitzwilliam Museum panels were acquired in Florence, perhaps as early as 1815 (see C. Winter, *Fitzwilliam Museum,* 1958, nos. 35, 36). The Berlin panel was acquired by the Kaiser Friedrich Museum in 1841/42. See W. and E. Paatz, *Die Kirchen von Florenz,* vol. II, 1941, pp. 612, 617 n. 46, 618 n. 51. (2) When (in a ms. opinion of 1921) G. Gronau tentatively connected K278 with the Santa Lucia dei Magnoli altarpiece, the only other of the predella panels recognized as such was the one in Berlin. R. Longhi (in *L'Arte,* vol. XXVIII, 1925, pp. 31 ff.) confirmed Gronau's proposal. A. Venturi (in *L'Arte,* vol. XXVIII, 1925, p. 28 ff.; *Studi dal vero,* 1927, pp. 18 ff.) added the *Annunciation,* Fitzwilliam Museum. W. Bode (in *Berliner Museen,* vol. XLVI, 1925, p. 23) discussed the subject matter of the predella; and B. Berenson (in *Dedalo,* vol. V, 1925, p. 642 n. 6; *Three Essays in Method,* 1927, p. 25 n. 1) announced the discovery of the remainder of the five panels. K278 and K1331 are further discussed by, among others, R. van Marle (*Italian Schools of Painting,* vol. X, 1928, pp. 314 ff.), R. Fry (in *Burlington Magazine,* vol. LVI, 1930, pp. 83 ff.), C. Gamba (in *Dedalo,* vol. XI, 1931, pp. 575 ff.), G. Pudelko (in *Mitteilungen des Kunsthistorischen Instituts in Florenz,* vol. IV, 1934, pp. 154 ff.), and M. Salmi (*Paolo Uccello, Andrea del Castagno, Domenico Veneziano,* French ed. n.d. [1935?], pp. 102 f.; in *Bollettino d'Arte,* vol. XLIII, 1958, p. 128). (3) Uffizi no. 1108E, cited and reproduced by B. Degenhart, in *Festschrift Friedrich Winkler,* 1959, p. 102, fig. 7. (4) M. R. Lavin, in *Art Bulletin,* vol. XLIII, 1961, pp. 319 ff. (5) Reproduced, *ibid.,* fig. 7, opposite p. 319. H. Wohl (in a paper read before the College Art Association in Washington, D.C., Jan 28, 1958) seems to have been the first to interpret the fresco and note its relationship to K1331. (6) Reproduced by A. Venturi, *Studi dal vero,* 1927, fig. 22. (7) Cf. B. Degenhart, in *Festschrift Friedrich Winkler,* 1959, pp. 104 ff., fig. 12.

GIOVANNI DI FRANCESCO

Florentine School. Formerly called the Master of the Carrand Triptych, from the well-known painting in the Museo Nazionale, Florence. He was active in the mid-fifteenth century, under the influence of Uccello, Castagno, and Domenico Veneziano, among others.

K1128 : Figure 283

THE NATIVITY. Berea, Ky., Berea College, Study Collection (140.15), since 1961.[1] Wood. 19¾ × 12½ in. (50·2 × 31·7 cm.). Fair condition; abraded throughout, especially the Madonna's face; cleaned 1954.

Similarity of the Virgin and Joseph to the two figures in the *Coronation* which serves as pinnacle to the middle panel

of the Carrand triptych supports the attribution of K1128 to Giovanni di Francesco,[2] with a date in the mid-century. The Christ Child finds parallels in paintings attributed to Uccello and his immediate followers.

Provenance: Contini Bonacossi, Florence. Kress acquisition, 1937.

References: (1) Catalogue, 1961, p. 12, as Giovanni di Francesco. (2) K1128 has been attributed (in ms. opinions) to Giovanni di Francesco by G. Fiocco, R. Longhi, F. M. Perkins, W. E. Suida, and A. Venturi. B. Berenson (in ms. opinion) saw the hand of Giovanni di Francesco in only the Joseph. He probably knew the painting only before it was cleaned; an old photograph shows that the Virgin had been much altered by repainting.

PAOLO SCHIAVO

Paolo di Stefano Badaloni, called Schiavo. Florentine School. Born 1397; died 1478. Schiavo may have been a pupil of Masolino, with whom he later collaborated. He was influenced also by Masaccio, Uccello, Domenico Veneziano, and Castagno.

K216 : Figure 281

THE FLAGELLATION. Ponce, Puerto Rico, Museo de Arte de Ponce, Study Collection (64.0271), since 1964. Wood. 13 × 10½ in. (33 × 26·7 cm.). Very much worn.

For the commentary, etc., see K1188, below.

Provenance: Achillito Chiesa, Milan. Contini Bonacossi, Florence. Kress acquisition, 1932 – exhibited: 'Italian Paintings Lent by Mr. Samuel H. Kress,' Oct. 1932, Atlanta, Ga., through June 1935, Charlotte, N.C., p. 16 of catalogue, as Schiavo; National Gallery of Art, Washington, D.C. (214), 1941–46.[1]

Reference: (1) Preliminary Catalogue, 1941, p. 182, as Schiavo.

PAOLO SCHIAVO

K1188 : Figure 282

THE CRUCIFIXION. Athens, Ga., University of Georgia, Study Collection (R-6), since 1961.[1] Wood. 14⅛ × 11⅜ in. (35·9 × 28·9 cm.). Inscribed on shield at right: SPQR (the Senate and People of Rome). Very much worn.

These two panels probably came originally from the predella of the same altarpiece. Close relationship of the style to Masolino has always been recognized and there is general agreement in attributing the execution to Schiavo.[2] The date is probably about 1430/40.

Provenance: M. Gentner, Florence. Contini Bonacossi, Florence. Kress acquisition, 1939.

References: (1) Catalogue, 1962, p. unnumbered, as Schiavo. (2) K216 was first published by B. Berenson (in *Dedalo*, vol. XII, 1932, pp. 514, 516 ff.), who favored an attribution to Schiavo. Berenson later (*Italian Pictures . . . Florentine School*, vol. I, 1963, pp. 165 f.) lists both panels tentatively as Schiavo. G. Pudelko (in Thieme-Becker, *Allgemeines Lexikon*, vol. XXX, 1936, p. 47) gives K216 to Schiavo. R. van Marle (*Italian Schools of Painting*, vol. XI, 1929, p. 103) sees in it the influence of Piero della Francesca. Both K216 and K1188 are given to Schiavo by R. Longhi (in *Critica d'Arte*, July–Dec. 1940, p. 188), G. Fiocco, W. E. Suida, and A. Venturi (in ms. opinions). F. M. Perkins (in ms. opinions) gives K1188 to Schiavo and K216 to an anonymous Florentine.

MASTER OF FUCECCHIO

Tuscan School. Active mid-fifteenth century. This artist, sometimes confused with Francesco d'Antonio, is designated from the location of some of his work at Fucecchio, a small town west of Florence. He is also sometimes called the Master of the Adimari from the interpretation of a scene painted by him on a cassone now in the Accademia, Florence. He probably developed in the ambient of Vecchietta and Paolo Schiavo and seems to have collaborated with the latter.[1]

K1145A, B : Figures 284–285

THE ANNUNCIATION (K1145A *The Angel Annunciate*; K1145B *The Virgin Annunciate*). Seattle, Wash., Seattle Art Museum (It 37/M394Fl.1), since 1954.[2] Wood. K1145A, 18 × 7 in. (45·7 × 17·8 cm.); K1145B, 18 × 7½ in. (45·7 × 19 cm.). Inscribed on angel's scroll: AVE MARIA GRA [tia] plena] (from Luke 1 : 28). Good condition except for slight abrasions; frame not original.

The blond tonality of K1145A and B,[3] may indicate the influence of Domenico Veneziano or of such a painting as the Goldman *Annunciation* by Masolino,[4] painted about 1430, which may well have been also the model for the architectural background of K1145B. The date of K1145A and B may be about 1440.

Provenance: Mrs. Ralph W. Curtis, Villa Sylvia, Beaulieu (Alp. Mar.), France. Contini Bonacossi, Florence. Kress

acquisition, 1938 – exhibited: Roosevelt House, Hunter College, New York, December 1944.

References: (**1**) A study of the artist's development and activity is made by R. Longhi (in *Critica d'Arte*, July–Dec., 1940, p. 187), who calls him the Master of the Adimari. (**2**) Catalogue by W. E. Suida, 1954, p. 32, as Master of Fucecchio. (**3**) R. Longhi (*loc. cit.* in note 1, above) and F. M. Perkins (in ms. opinion) have attributed K1145A and B to the Master of Fucecchio (Master of the Adimari). B. Berenson (*Italian Pictures of the Renaissance*, 1932, p. 39; Ital. ed., 1936, p. 34), G. Fiocco and A. Venturi (in ms. opinions) attributed them to Francesco d'Antonio Banchi. Berenson later (*Italian Pictures . . . Florentine School*, vol. 1, 1963, p. 64) attributes them to Francesco d'Antonio, distinguishing him from Banchi. (**4**) Now in the National Gallery of Art, Washington, D.C., no. 16.

MASTER OF FUCECCHIO

K1108A : Figure 287
St. Anthony Abbot Tempted by Gold

K1108B : Figure 288
St. Bernardine of Siena Preaching

Birmingham, Ala., Birmingham Museum of Art (61.107 and 61.108), since 1952.[1] Wood. Each, 10½×10 in. (26·7× 25·4 cm.). Inscribed on the plaque held by St. Bernardine: YHS (the monogram of Jesus). K1108A, very good condition; K1108B, slight damages throughout.

For the unusual scene of St. Anthony Abbot's temptation by gold, as he journeys in search of St. Paul, the artist had a prototype in the very similar composition by Fra Angelico now in the Straus Collection of the Museum of Fine Arts, Houston, Texas. Since St. Bernardine is shown with a halo, the panels, which probably come from the predella of an altarpiece, would have been painted, one might conclude, after his death (1444) and probably after he was canonized (1450). But Bernardine is an exception to the rule: he was not infrequently shown with a halo not only before his canonization, but also before his death.[2]

Provenance: Contini Bonacossi, Florence. Kress acquisition, 1937.

References: (**1**) Catalogue by W. E. Suida, 1952, pp. 31 ff., and 1954, p. 40, as the Master of Fucecchio. (**2**) C. Brandi (in *Burlington Magazine*, vol. LXXXIX, 1947, p. 196; see also G. Kaftal, *Iconography of the Saints in Tuscan Painting*, 1952, cols. 197 f., for this iconographical detail. As to the attribution of K1108A and B, R. Longhi (in *Critica d'Arte*, July–Dec. 1940, p. 187), B. Berenson, G. Fiocco, and A. Venturi (in

ms. opinions) agree in attributing them to the Master of Fucecchio; but Berenson later (*Italian Pictures . . . Florentine School*, vol. 1, 1963, p. 62) lists them as Francesco d'Antonio.

MASTER OF FUCECCHIO

K1148 : Figure 286

Madonna and Child with St. Stephen and St. Lawrence. Lewisburg, Pa., Bucknell University, Study Collection (BL-K11), since 1961.[1] Wood. 15¼×12¼ in. (38·7×31·1 cm.). Very good condition.

Although the figures seem more solidly constructed than in other paintings attributed to the Master of Fucecchio, the attribution to him of K1148 is convincing.[2] The date may be late in his career, perhaps about 1460. The style shows especially strong influence of Domenico Veneziano, of such a painting, for example, as the *Madonna and Child* in the National Gallery (K410, Fig. 278), which may have dictated the pose of the Child in K1148.

Provenance: Contini Bonacossi, Florence. Kress acquisition, 1938.

References: (**1**) Catalogue by B. Gummo, 1961, pp. 10 f., as Master of Fucecchio. (**2**) B. Berenson, G. Fiocco, R. Longhi, F. M. Perkins, W. E. Suida, and A. Venturi (in ms. opinions) agree that the most plausible attribution of K1148 is to the Master of Fucecchio; Berenson (*Italian Pictures . . . Florentine School*, vol. 1, 1963, p. 63) lists it as by Francesco d'Antonio.

FRA FILIPPO LIPPI

Florentine School. Born probably *c.* 1406; died 1469. He was a novitiate at the Carmine for some time before he took the Carmelite vows in 1421, and since he was first mentioned as painter ten years later, while he was still at the Carmine, it is no wonder that his style was formed on that of Masaccio. Later he was influenced by the more delicate style of Fra Angelico. He was active in Florence, Prato, Padua, Arezzo, and Spoleto. He is credited with the earliest extensive adaptation of portraiture to religious personages, thus rendering his paintings more mundane than Fra Angelico's, even if they are often no less lovely.

K510 : Figure 289

Madonna and Child. Washington, D.C., National Gallery of Art (401), since 1941.[1] Wood. 31⅜×20¼ in. (80×51 cm.). Good condition except for a few losses of paint.

Following a suggestion made a century ago,[2] it has been customary to connect this painting with Vasari's description of Fra Filippo's painting in the hall of the Council of Eight, Florence: 'a tempera painting in a half *tondo* of Our Lady with the Child in her arms.'[3] Such a connection is not plausible, for neither is the shape of K510 a half *tondo* nor is the Virgin carrying the Child. Among the various dates proposed for K510, the period between 1440 and 1445 seems most likely.[4] The tender, melancholy expression of the Virgin, prophetic of Botticelli,[5] has been cited as evidence that Filippo did not follow in K510 his usual practice of painting the Virgin as a portrait of his model.[6]

Provenance: Edward Solly, London (sold 1821, to the following). Kaiser Friedrich Museum, Berlin (no. 58, until late 1930's). Duveen's, New York (*Duveen Pictures in Public Collections of America,* 1941, no. 44, as Filippo Lippi). Kress acquisition, 1938.

References: (1) *Preliminary Catalogue,* 1941, p. 108, as Filippo Lippi. (2) Crowe and Cavalcaselle, *A New History of Painting in Italy,* vol. II, 1864, p. 349. (3) *Le Vite,* Milanesi ed., vol. II, 1878, p. 625: 'in un mezzo tondo dipinto a tempera, una Nostra Donna col Figliuolo in braccio.' (4) The dating varies between *c.* 1437 (R. van Marle, *Italian Schools of Painting,* vol. X, 1928, pp. 419 f.; B. Berenson, *Pitture italiane del rinascimento,* 1936, p. 247 – his designation of the painting as early is abandoned in *Italian Pictures . . . Florentine School,* vol. I, 1963, p. 114) and 1445 (H. Mendelsohn, *Fra Filippo Lippi,* 1909, pp. 107 f.; G. Pudelko, in *Rivista d'Arte,* vol. XVIII, 1936, p. 68; R. Oertel, *Fra Filippo Lippi,* 1942, p. 75; M. Pittaluga, *Filippo Lippi,* 1949, pp. 214 f.). (5) As noted by Pittaluga (*loc. cit.* in note 4, above). She had at one time (in *L'Arte,* vol. XLIV, 1941, pp. 74 ff.) tentatively attributed K510 to Botticelli himself, dating it, consequently, much too late. (6) See C. de Tolnay (in *Gazette des Beaux-Arts,* vol. XXXIX, 1952, p. 263), who discusses Fra Filippo's use of portraiture in religious pictures.

FRA FILIPPO LIPPI

K1241 : Figure 299

THE ANNUNCIATION. Washington, D.C., National Gallery of Art (536), since 1941.[1] Wood. $40\frac{1}{2} \times 64$ in. (103×163 cm.). Extensively damaged throughout, especially in face of angel; top of panel missing.

This is reasonably identified as one of Filippo's paintings for the Palazzo Vecchio, Florence, referred to in the mid-sixteenth century by Vasari: 'An *Annunciation,* on wood, over a door, and in the same palace a St. Bernard, over another door.'[2] Payment for the latter panel is dated 1447.[3] K1241 probably dates from soon after 1440. The St. Ber-

nard panel is believed to be the *St. Bernard's Vision of the Virgin* now in the National Gallery, London,[4] which is reasonably similar in shape to K1241. Removal of old repaint between the first publication of K1241, in 1926,[5] and its reproduction in 1934[6] made some changes in the appearance of the painting, notably through the disappearance of the lock, and the keys hanging from it, on the chest (or bench) at the right.

Provenance: Probably Palazzo della Signoria, Florence. Achillito Chiesa, Milan. Percy S. Straus, New York (as early as 1932). Bachstitz', The Hague (1934). Duveen's, New York (as early as 1937; *Duveen Pictures in Public Collections of America,* 1941, no. 47, as Filippo Lippi). Kress acquisition, 1940.

References: (1) *Preliminary Catalogue,* 1941, pp. 108 f., as Filippo Lippi. (2) Vasari, *Le Vite,* Milanesi ed., vol. II, 1878, p. 617. (3) *Ibid.,* p. 617 n. 3. See F. Baldinucci, *Notizie,* vol. I, 1845, pp. 508 f. Only the *Annunciation* is mentioned by the Anonimo Magliabechiano (ed. C. Frey, 1892, p. 97). (4) M. Davies, *National Gallery Catalogues: Earlier Italian Schools,* 1961, pp. 291 ff., no. 248. (5) O. H. Giglioli (in *Dedalo,* vol. VI, 1926, pp. 553 ff.), who attributes K1241 to Filippo and identifies it as the *Annunciation* painted for the Palazzo Vecchio. Others who have published K1241 as by Filippo are G. Gronau (in Thieme-Becker, *Allgemeines Lexikon,* vol. XXIII, 1929, p. 273), B. Berenson (in *Bollettino d'Arte,* vol. XXVI, 1937, p. 52; *Italian Pictures . . . Florentine School,* 1963, p. 114, and 1932 ed., p. 288), G. Pudelko (in *Rivista d'Arte,* vol. XVIII, 1936, p. 58), and M. Pittaluga (*Filippo Lippi,* 1949, pp. 215 f.). R. Oertel (*Fra Filippo Lippi,* 1942, p. 67) thinks the execution may be by an assistant of Filippo's, perhaps Neri di Bicci. (6) Reproduction advertisement of Bachstitz Gallery, in *Burlington Magazine,* vol. LXV, 1934, Dec. Advertisement Supplement, p. XVI.

FRA FILIPPO LIPPI

K1342 : Figures 290, 292

ST. BENEDICT ORDERS ST. MAURUS TO THE RESCUE OF ST. PLACIDUS. Washington, D.C., National Gallery of Art (804), since 1945. Wood. $16\frac{3}{8} \times 28$ in. ($41\cdot6 \times 71\cdot1$ cm.). Fair condition; cleaned 1955.

From the time this painting was first noted, at the beginning of this century, it has been recognized as characteristic of Fra Filippo, with a date of about 1445.[1] It has recently been tentatively associated with a panel of the same size, the *Annunciation,* which comes from the Griggs Collection and is now in the Metropolitan Museum, New York.[2] These two panels, undoubtedly from a predella, may be the only remnants now known of an altarpiece with scenes from the legend of Sts. Benedict and Bernard which Vasari reports as

begun in 1443 for one of the altars in the Church of the Murate, Florence.[3] K1342 and its pendant would have been appropriate also in a predella for the altarpiece of the *Coronation* now in the Vatican Pinacoteca, which Filippo painted for the Chapel of St. Bernard at Monte Oliveto, Arezzo. Sts. Benedict and Bernard figure conspicuously in the Vatican *Coronation* as the patrons who present the donors. This altarpiece also is generally believed to date about 1445. No predella is associated with it at present. It is significant to note that there is a prototype of the composition of K1342 in the predella of Lorenzo Monaco's *Coronation* in the Uffizi, Florence. As the *Nativity* and the *Adoration of the Magi* are placed in the middle of Lorenzo Monaco's predella, between the Benedictine scenes, so the Metropolitan's *Annunciation* would presumably have been placed in the middle of Fra Angelico's predella of Benedictine scenes. The subject of K1342, taken from the *Golden Legend*, is the miraculous rescue of the young monk Placidus from drowning: at the left, Benedict, informed of Placidus' peril in a vision, enjoins Maurus to carry out the rescue, which is shown at the right.

Provenance: Enrico Cernuschi. Édouard Aynard, Lyons (sold, Georges Petit, Paris, Dec. 1, 1913, no. 52 of catalogue, as Filippo Lippi). Mme. Douine, Château de la Boissière, S. et O., France. Wildenstein's, New York (*Italian Paintings*, 1947, list in Introduction). Kress acquisition, 1942.

References: (**1**) B. Berenson (*Florentine Painters of the Renaissance*, 1912, p. 151, and earlier ed.; *Italian Pictures . . . Florentine School*, vol. 1, 1963, p. 114; *Dedalo*, vol. XII, 1932, p. 539), R. Oertel (*Fra Filippo Lippi*, 1942, pp. 66, no. 51, and 68, under nos. 64–66), and M. Pittaluga (*Filippo Lippi*, 1949, p. 194) are among those who have published K1342 as by Filippo. Only R. van Marle (*Italian Schools of Painting*, vol. X, 1928, p. 459 n. 2) seems to have any reservations about the attribution. (**2**) F. Zeri (in *Catalogue of Italian Paintings in the Metropolitan Museum of Art*, New York, 1963, unpublished, no. 43.98.2) tentatively associates the *Annunciation* with K1342 – even the craquelure is the same in the two panels. Zeri classifies the *Annunciation* as 'idea of Filippo Lippi, execution in large part by Pesellino.' Berenson (1963 *op. cit.* in note 1, above) attributes the *Annunciation* to an unidentified Florentine between Filippo and Pesellino. (**3**) Suggested for K1342 by, among others, Oertel (*loc. cit.* in note 1, above). Vasari's passage: *Le Vite*, Milanesi ed., vol. II, 1878, p. 617.

FRA FILIPPO LIPPI and Assistant

K497 : Figure 291

THE NATIVITY. Washington, D.C., National Gallery of Art (390), since 1941.[1] Wood. 9½×22¾ in. (24×58 cm.).

Good condition except for a few losses of paint; needs cleaning.

Obviously this comes from the same predella and the same atelier as a panel in the Ashmolean Museum, Oxford, representing the *Meeting of Joachim and Anna*.[2] The painter has been variously identified as Filippo Lippi, as a Prato pupil of Filippo's, and as Pesellino.[3] The *Annunciation* now in Munich is the altarpiece with which the two predella panels are most plausibly associated and the date is probably about 1445.

Provenance: Comtesse de Lezze, Nice. Contini Bonacossi, Florence. Kress acquisition, 1937.

References: (**1**) *Preliminary Catalogue*, 1941, p. 108, as Filippo Lippi. (**2**) The Ashmolean panel (*Catalogue of Paintings*, n.d. [1952?], no. 246, as Filippo) measures only 20×48 cm.; but it has been cut down. (**3**) B. Berenson (*Italian Pictures . . . Florentine School*, vol. 1, 1963, p. 113, and earlier editions) attributes the Oxford panel to Filippo. On p. 114 of the 1963 edition he attributes K497 to Filippo in part. G. Fiocco, R. Longhi, F. M. Perkins, W. E. Suida, and A. Venturi (in ms. opinions) give it to Filippo. M. Pittaluga (*Filippo Lippi*, 1949, p. 216) seems to favor an attribution to Filippo. Referring only to the Oxford panel, H. Mendelsohn (*Fra Filippo Lippi*, 1909, pp. 197 f.) gives this to Pesellino, G. Pudelko (in *Rivista d'Arte*, vol. XVIII, 1936, p. 57 n.) gives it to the 'Scolaro di Prato,' and R. Oertel (*Fra Filippo Lippi*, 1942, p. 65) gives it to Filippo, in his 'abstract' style, 'romantic' period, c. 1450; K497 was apparently unknown to these critics.

Follower of FRA FILIPPO LIPPI

K1325 : Figure 304

MADONNA AND CHILD ENTHRONED. New Orleans, La., Isaac Delgado Museum of Art (61.66), since 1953.[1] Wood. 32⅜×16⅞ in. (82·3×42·9 cm.). Fair condition.

In supporting an attribution of this painting to Filippo Lippi, some critics have dated it late in his career because it relates to his trend away from Masaccio and toward Fra Angelico, others have dated it early because of its timid, tentative character.[2] Only the attribution of the painting to a follower of Filippo, it would seem, can satisfactorily account for the combination of late influence and early inexperience.[3] It would be dated, then, about the middle of the fifteenth century.

Provenance: Edmond Foulc, Paris (no. 2 of catalogue by H. Leman, 1927, as Filippo Lippi) – exhibited: Philadelphia Museum of Art, 1930. Ernst Rosenfeld, New York (1930).

Wildenstein's, Paris (*Italian Paintings*, 1947, list in Introduction). Duveen's, New York. Kress acquisition, 1942 – exhibited: National Gallery of Art, Washington, D.C. (719), 1945–51, as Filippo Lippi.

References: (1) Catalogue by W. E. Suida, 1953, p. 18, as pupil of Filippo. (2) B. Berenson (in *Bollettino d'Arte*, vol. XXVI, 1932, pp. 16 ff.) dated K1325 late in Filippo's career. More recently he seems to have qualified his attribution, for in *Italian Pictures . . . Florentine School*, vol. I, 1963, p. 113, K1325 is listed as *in part* by Filippo. M. Salmi (in *Liburni Civitas*, vol. V–VI, 1938, p. 235 n. 46) and M. Pittaluga (*Filippo Lippi*, 1949, pp. 213 f.) follow Berenson's earlier opinion. L. Venturi (in *L'Arte*, vol. XXXV, 1932, pp. 407 f.; *Italian Paintings in America*, vol. II, 1933, no. 205) believes K1325 to be the earliest known work by Filippo. (3) G. Pudelko (in *Rivista d'Arte*, vol. XVIII, 1936, p. 56 n.) lists it as a work of Filippo's studio.

See also FRA ANGELICO AND FRA FILIPPO LIPPI (p. 95, above).

FRA DIAMANTE

Florentine School. Born *c.* 1430; last mentioned 1498. He was a pupil and assistant of Fra Filippo Lippi, and attempts to distinguish his paintings from those of other followers of Filippo are usually only tentative.

K441 A,B,C,D : Figures 293–296

FOUR SAINTS. Honolulu, Hawaii, Honolulu Academy of Arts (2983.1, 2984.1, 2985.1, and 2986.1), since 1952.[1] Wood. Each, 19⅛×5¼ in. (48·6×13·4 cm.). Fair condition except slightly worn.

For the commentary, etc., see K503 A,B, below.

Reference: (1) Catalogue by W. E. Suida, 1952, p. 18, as Filippo Lippi and assistants.

FRA DIAMANTE

K503 A,B : Figures 297–298

TWO SAINTS. Athens, Ga., University of Georgia, Study Collection (R-8), since 1962.[1] Wood. Each, 19⅛×5⅛ in. (48·6×13 cm.). Abraded throughout, especially face of saint at right, and some losses of paint.

These come from a series of eighteen panels of equal size and sufficient stylistic similarity to indicate that all were painted in the same studio and for the same polyptych. The set was broken up only about forty years ago. Two of the panels are now in the Lehman Collection, New York; two in the Worcester Art Museum; four in the Courtauld Institute, London; and four cannot at present be located. Early assigned to Filippino Lippi,[2] the series has usually been attributed to Filippo Lippi or to his studio, while present opinion favors an attribution to Fra Diamante.[3] How the panels were originally used is uncertain, possibly in two rows of nine each, one row above the other, on an altarpiece; they were not on the back of Pesellino's altarpiece of the *Trinity*, as was formerly suggested; for that place is now known to have been occupied by the *Madonna della Misericordia* lately in the Kaiser Friedrich Museum, Berlin (destroyed in the Second World War).[4] Very few of the eighteen saints have definite attributes; the arrow in K441C probably indicates Sebastian and the open book in K441A may refer to John the Evangelist. The series probably dates from about 1470.

Provenance: Sir John Leslie, London (said to have been bought in Florence in the middle of nineteenth century) – exhibited: Royal Academy, 1885, nos. 252, 256 (including all the figures), as Filippino Lippi and as coming from the Carmine, Florence. Leslie sale, Christie's, London, July 9, 1926, no. 129 (including all the figures), as Filippino Lippi; bought by W. Buckley. Contini Bonacossi, Florence. Kress acquisition: K441 A,B,C,D, 1936; K503 A,B, 1937 – exhibited: National Gallery of Art, Washington, D.C. (354, 355, 398), 1941–51;[5] Traveling Exhibition (K503A, B only), University of Arizona, Tucson, Ariz., Apr.–Sept. 1960.

References: (1) Catalogue by L. Dodd, 1962, p. unnumbered, as Fra Diamante. (2) See *Provenance*, above. (3) The panels were attributed to Filippo by R. van Marle (*Italian Schools of Painting*, vol. X, 1928, p. 578) and R. L. Douglas (in *Burlington Magazine*, vol. LX, 1932, p. 287, some of the figures by Filippo, some by his studio); to Filippo and assistants by G. Fiocco, R. Longhi, F. M. Perkins, and A. Venturi (in ms. opinions); to the studio of Filippo by G. Pudelko (in *Rivista d'Arte*, vol. XVIII, 1936, p. 56 n.) and B. Berenson (*Pitture italiane del rinascimento*, 1936, p. 248). In *Italian Pictures . . . Florentine School*, vol. I, 1963, pp. 58 f., Berenson's attribution is changed to Fra Diamante, while M. Pittaluga (in *Rivista d'Arte*, vol. XXIII, 1941, pp. 31 f.; *Filippo Lippi*, 1949, pp. 207, 211, 215, figs. 170 f., where all eighteen panels are reproduced) attributes some of them to Fra Diamante, others to assistants. (4) P. Bacci, in *Le Arti*, vol. III, 1941, pp. 432 ff., documents XXIII f. (5) *Preliminary Catalogue*, 1941, p. 55, as Fra Diamante.

PESELLINO

Francesco di Stefano, called Pesellino. Florentine School. Born *c.* 1422; died 1457. He was probably trained under

Filippo Lippi and was subject to the direct influence of Fra Angelico also. The touchstone for his attributed oeuvre is his one documented work, the altarpiece of the *Trinity* now in the National Gallery, London. Even this was finished, after Pesellino's death, by Filippo Lippi.

K230 : Figure 300

THE CRUCIFIXION WITH ST. JEROME AND ST. FRANCIS. Washington, D.C., National Gallery of Art (220), since 1941.[1] Wood. 24½ × 19 in. (62 × 48 cm.). Inscribed on a scroll at the top of the cross: INRI (Jesus of Nazareth, King of the Jews). Some abrasions.

This type of Christ is found again in the London *Trinity*, which shows more emphasis, however, on muscular development. K230 must date considerably earlier in Pesellino's career, probably about 1440/45,[2] in the stylistic period of the artist's predella panels in the Uffizi, Florence, and the *Crucifixion* in the Museum at Esztergom. The sun and moon in the sky refer to the Biblical account of nature's upheaval at the time of the Crucifixion; the skull locates the event at Golgotha; the pelican feeding her young on her life's blood symbolizes Christ's sacrifice; and the penitent St. Jerome and the stigmatized St. Francis refer to repentance and salvation.

Provenance: Duchessa Melzi d'Eril, Milan. Contini Bonacossi, Florence. Kress acquisition, 1932 – exhibited: 'Exposition de l'Art Italien,' Petit Palais, Paris, 1935, no. 358, as Pesellino.

References: (1) *Preliminary Catalogue*, 1941, pp. 152 f., as Pesellino. (2) G. Fiocco, R. Longhi, R. van Marle, C. Norris, F. M. Perkins, O. Sirèn, W. E. Suida, A. Venturi (in ms. opinions), L. Ragghianti Collobi (in *Critica d'Arte*, May 1950, p. 17), and B. Berenson (*Italian Pictures . . . Florentine School*, vol. I, 1963, p. 168) attribute K230 to Pesellino and favor a date of *c.* 1440/45.

PESELLINO

K485 : Figure 301

MADONNA AND CHILD. Denver, Colo., Denver Art Museum (E-IT-18-XV-930), since 1954.[1] Wood. 22½ × 14 in. (57·2 × 35·5 cm.). Fair condition.

This was formerly attributed to Filippo Lippi and may well have been inspired by his *Madonna and Child* (K510, Fig. 289) now at the National Gallery of Art. The type of Virgin, however, and the emphasis upon solemnity rather than grace, are more closely paralleled in the work of

Pesellino, about 1455.[2] X-ray shows that the turn of the Child's head was changed during the process of painting. The placing of His hand, farther to the left, as it appears in older reproductions,[3] was apparently due to repaint, which has been removed.

Provenance: Edward Hutton, London. Julius Böhler's, Munich. Steinmeyer, Paris (1937). Contini Bonacossi, Florence. Kress acquisition, 1937 – exhibited: National Gallery of Art, Washington, D.C. (378), 1941–52.[4]

References: (1) Catalogue by W. E. Suida, 1954, p. 20, as Pesellino. (2) K485 was attributed (in ms. opinions) to Filippo by G. Fiocco, F. M. Perkins, W. E. Suida, and A. Venturi. Suida later (see note 1, above) gave it to Pesellino, following B. Berenson and R. Longhi (in ms. opinions; see also Berenson, *Italian Pictures . . . Florentine School*, vol. I, 1963, p. 167). (3) When in possession of Böhler. (4) *Preliminary Catalogue*, 1941, p. 153, as Pesellino.

PESELLINO and Studio

K540 : Figure 302
THE SEVEN LIBERAL ARTS

K541 : Figure 303
THE SEVEN VIRTUES

Birmingham, Ala., Birmingham Museum of Art (61.101 and 61.102), since 1952 and 1960, respectively.[1] Wood. K540, 17⅜ × 58¹⁵⁄₁₆ in. (44·1 × 149·7 cm.); K541, 17¼ × 58⅝ in. (43.8 × 148·9 cm.). Slight remains of original inscriptions on the lower step in each panel; inscriptions at the tops of the panels, identifying the Arts and Virtues, are more recent additions. Fair condition except very much abraded and heavily restored.

These two panels have been attributed to Pesellino himself, entirely or in part to his studio, and to a specific artist related to Pesellino, such as Domenico di Michelino.[2] Reasonably close parallels for some of the figures may be found in Pesellino's oeuvre: in his panel of *Triumphs*, for example, in the Isabella Gardner Museum, Boston, and in the former Holford *Madonna and Saints* now in the Metropolitan Museum, New York. K540 and K541 may well have been painted in Pesellino's studio about 1460, the master himself having a considerable share in the execution of K541. The scheme of the compositions – the Arts and Virtues personified in female figures, each accompanied by a famous exponent of the art or virtue designated by her attributes – follows a tradition reaching back to the early Middle Ages.[3] An outstanding fourteenth-century example is to be seen in Andrea da Firenze's fresco in the Spanish Chapel, Santa Maria Novella, Florence; probably about

contemporary with K540 and K541 are two similar panels, attributed to the school of Pollaiuolo, formerly in the Spiridon Collection, Paris.[4]

At the right in K540 is the Trivium: Logic, with Aristotle below her; Rhetoric, with Cicero; and Grammar, with Priscian. At the left is the Quadrivium: Arithmetic, with Pythagoras; Geometry, with Euclid; Music, with Tubalcain; and Astrology (Astronomy), with Ptolemy. In the center of K541 are the theological virtues: Faith, with St. Peter; Charity, with St. John the Evangelist; and Hope, with St. James Major. At the sides are the four cardinal virtues: Prudence, with Solon; Justice, with Solomon; Fortitude, with Samson; and Temperance, with Scipio Africanus.[5]

Provenance: Giuseppe Toscanelli, Pisa (middle of nineteenth century; sold, Sambon's, Florence, Apr. 9–23, 1883, no. 61, as Castagno). Ludwig Wittgenstein, Vienna. Contini Bonacossi, Florence. Kress acquisition, 1938 – exhibited: National Gallery of Art, Washington, D.C. (424, 425), 1941–46;[6] William Rockhill Nelson Gallery of Art, Kansas City, Mo. (K541 only), 1952–60.[7]

References: (1) K540: catalogue by W. E. Suida, 1952, p. 29, and 1959, pp. 36 f., as Pesellino and Domenico di Michelino. K541: see Kansas City catalogue, note 7, below. (2) J. Schlosser (in *Jahrbuch der Kunsthistorischen Sammlungen*, vol. XVII, 1896, p. 34) called K540 and K541 Florentine, early sixteenth century; W. Weisbach (in *Gazette des Beaux-Arts*, vol. XX, 1898, p. 158; *Francesco Pesellino*, n.d. [1901 ?], pp. 90 ff., where he also traces the iconography through earlier centuries) attributes them to Pesellino; S. Reinach (*Répertoire de peintures*, vol. III, 1910, p. 751) gives them to Castagno; A. Venturi (*Storia dell'arte italiana*, vol. VII, pt. I, 1911, p. 396) rejects the attribution to Pesellino and later (in ms. opinion) gives them to Domenico di Michelino; P. Schubring (*Cassoni*, 1923, pp. 281 f.) says they are in the manner of Pesellino; R. van Marle (*Italian Schools of Painting*, vol. X, 1928, p. 504 n. 1) thinks them Florentine, a generation later than Pesellino. In ms. opinions G. Fiocco gives them to Domenico di Michelino; R. Longhi, to Domenico di Michelino, based on Pesellino; F. M. Perkins, to Pesellino bottega. B. Berenson (*Italian Pictures . . . Florentine School*, vol. I, 1963, p. 167) lists them as from the studio of Pesellino. (3) Weisbach, *Francesco Pesellino*, loc. cit. in note 2, above. (4) Reproduced by Schubring, pl. LXXXI of *op. cit.* in note 2, above; and by R. van Marle (*Iconographie de l'art profane*, 1932, fig. 47), who makes an extensive study of medieval and Renaissance personifications of the Virtues. (5) The unusual type of halo in K541 appears again in a fifteenth-century Florentine personification of music in a private collection (reproduced as fig. 50 of the catalogue by St. John Gore of the exhibition 'The Art of Painting in Florence and Siena from 1250 to 1500,' Wildenstein's, New York, Feb. 24–Apr. 10, 1965). (6) *Preliminary Catalogue*, 1941, pp. 56 f., as Domenico di Michelino. (7) Catalogue by W. E. Suida, 1952, p. 30, as Pesellino.

Follower of PESELLINO

K528 : Figure 306

MADONNA AND CHILD WITH ANGELS. Berea, Ky., Berea College, Study Collection (140.11) since 1961.[1] Wood. $27\frac{7}{8} \times 18\frac{3}{8}$ in. (70·8 × 46·7 cm.). Good condition except for a few losses of paint.

It has been customary in recent years to connect this and similar compositions of the *Madonna and Angels* (notably one in the Fogg Art Museum, Cambridge, Mass.,[2] and one in the Berenson Collection, Settignano[3]) with the Virgil Master (or his shop), who is now identified as Apollonio di Giovanni.[4] Such an attribution may be correct; but since the known work of Apollonio's shop was the decoration of cassoni, it seems safer to classify the larger-figured, more monumental *Madonna* panels in the following of Pesellino, under the strong influence of Filippo Lippi.[5] The date of K528 is probably about 1450.

Provenance: Giuseppe Toscanelli, Pisa (sold, Sambon's, Florence, Apr. 9–23, 1883, pl. 27). Gustave Dreyfus, Paris (acquired c. 1908; sold by his heirs, 1930, to the following). Duveen's, New York. Godfrey Locker-Lampson, London (catalogue by R. L. Douglas, 1937?, no. 18, as the Virgil Master). Contini Bonacossi, Florence. Kress acquisition, 1938 – exhibited: National Gallery of Art, Washington, D.C. (413), 1941–51.[6]

References: (1) Catalogue, 1961, p. 10, as Virgil Master. (2) Reproduced by B. Berenson, in *Dedalo*, vol. XII, 1932, p. 680. (3) *Ibid.*, p. 681. (4) See the biographical entry for Apollonio di Giovanni on p. 98 of this catalogue. R. Offner (*Italian Primitives at Yale University*, 1927, p. 28) seems to have been the first to connect the *Madonnas* (he apparently did not know K528) with the Virgil Master, attributing them to his shop. Offner's opinion is followed by M. Salmi (in *Rivista d'Arte*, vol. XI, 1929, p. 272, and in *Commentari*, vol. V, 1954, p. 72). G. Fiocco, R. Longhi, F. M. Perkins, W. E. Suida, and A. Venturi (in ms. opinions) attribute the *Madonnas* to the Virgil Master. They are given tentatively to the school of Giovanni Boccati in the Fogg Museum's 1927 catalogue of *Mediaeval and Renaissance Paintings*, pp. 154 f. (5) B. Berenson (pp. 679 ff. of *op. cit.* in note 2, above; *Italian Pictures . . . Florentine School*, vol. I, 1963, p. 167) attributes the group to the studio of Pesellino. (6) *Preliminary Catalogue*, 1941, p. 130, as Master of the Jarves Cassoni.

Follower of PESELLINO

K1187 : Figure 307

ST. JOHN THE BAPTIST. Bloomington, Ind., Indiana University, Study Collection (L62.158), since 1962. Wood.

$14\frac{1}{4} \times 10\frac{1}{4}$ in. (36·2×26 cm.). Inscribed on the saint's scroll: ECCE ANGN[vs dei] (from John 1 : 29). Good condition except for damages in background.

Painted probably about 1460, this panel has been tentatively associated with Domenico di Michelino, with Domenico Veneziano, with Giusto d'Andrea, and with Paolo Schiavo.[1] Perhaps such paintings as Pesellino's *Crucifixion*, K230 (Fig. 300), and Castagno's *Resurrection* in the Frick Collection, New York, are enough to explain the stylistic derivation of the unknown painter of K1187.

Provenance: Gentner, Florence. Contini Bonacossi, Florence. Kress acquisition, 1939 – exhibited: National Gallery of Art, Washington, D.C. (526), 1941–52.[2]

References: (**1**) K1187 has been attributed, in ms. opinions, to Domenico di Michelino by G. Fiocco, R. Longhi, F. M. Perkins tentatively, W. E. Suida, and A. Venturi. F. Zeri (in ms. opinion) gives it to a follower of Pesellino such as Giusto d'Andrea, and B. Berenson (*Italian Pictures . . . Florentine School*, vol. I, 1963, p. 217) lists it as by an unidentified Florentine close to Paolo Schiavo. (**2**) *Preliminary Catalogue*, 1941, p. 58, as possibly by Domenico Veneziano.

NERI DI BICCI

Florentine School. Born 1419; died *c.* 1491. A pupil and close follower of his father, Bicci di Lorenzo, he was influenced by Fra Filippo Lippi, Fra Angelico, and Domenico Veneziano. He kept a diary from 1453 to 1475 recording his work and that of his pupils.

K254 : Figure 309

FIVE SAINTS. Oberlin, Ohio, Allen Memorial Art Museum, Oberlin College, Study Collection (61.78), since 1961.[1] Wood. $48\frac{5}{8} \times 32\frac{1}{4}$ in. (123·5×81·9 cm.). Inscribed on St. John's scroll: ECCE . AGNVS . DEI . QVI . (from John 1 : 29). Good condition except for vertical split right of center, with some loss of pigment; cleaned 1961.

From the testament of the Florentine merchant Jacopo Villani, drawn up in 1454, supplemented by seventeenth-century descriptions and a seventeenth-century drawing, it has been possible to determine that K254 was originally the left wing of a triptych in the Chapel of St. James (also called the Chapel of the Crucifixion) in the Church of Santissima Annunziata, Florence, that the middle panel was a *Madonna and Child*, now lost, and that the right wing was a panel of five saints now in the Accademia, Florence, to which it is known to have come from Santissima Annunziata. The testament of 1454[2] does not mention the

triptych; but, in dictating the religious rites to be celebrated in the Chapel of St. James, which was then the Villani family chapel, it does mention the names of the testator's wife, Margaret, and six sons and these are all represented by their patron saints in the two side panels. Given the place of honor in K254, where he would have stood at the right of the Virgin, is the patron of the testator, St. James Major (lower row, right). The others in K254 are St. Margaret (lower row, left), patron of the testator's wife, and Sts. John the Baptist (lower row, middle), Bernard (upper row, left), and Matthew (upper row, right), patrons of three of the testator's sons. The seventeenth-century descriptions[3] mention the subject of the middle panel of the triptych as the *Madonna and Child* and say that there were five saints in each side panel. The seventeenth-century drawing[4] shows such a triptych in place in the apse of the chapel, its wings corresponding in shape and proportions to K254 and the companion panel in the Accademia, Florence.[5] The triptych was probably painted about 1445, shortly after the chapel was acquired by the Villani. Its attribution to Neri di Bicci seems satisfactory, although Paolo Schiavo, Ventura di Moro, and a Florentine between Schiavo and Neri di Bicci have been suggested also.[6]

Provenance: Church of Santissima Annunziata, Florence. Vatican, Rome (?), until *c.* 1870. Giulio Sterbini, Rome. Newman, Florence. Contini Bonacossi, Florence. Kress acquisition, 1933 – exhibited: 'Italian Paintings Lent by Mr. Samuel H. Kress,' Sept. 1933, Seattle, Wash., through June 1935, Charlotte, N.C. (p. 14 of catalogue, as Neri di Bicci); National Gallery of Art, Washington, D.C. (235), 1941–52.[7]

References: (**1**) Catalogue by W. Stechow (in *Allen Memorial Art Museum Bulletin*, vol. XIX, 1961, pp. 9 f.), as Neri di Bicci; see correction in *ibid.*, vol. XIX, 1962, p. 102. (**2**) Published by W. Cohn (in *Rivista d'Arte*, vol. XXXI, 1956, pp. 61 ff.), who attributes the paintings to Neri di Bicci. (**3**) Published by Cohn (*op. cit.* in note 2, above) and E. Casalini (in *Studi storici sull'Ordine dei Servi di Maria*, vol. XII, 1962, pp. 57 ff.). (**4**) Reproduced by Casalini, pl. I of *op. cit.* in note 3, above. (**5**) The drawing shows, further, that the triptych extended the full width of the niche, which, according to Casalini (p. 69 of *op. cit.*) measures 290 cm. across, a measurement into which K254 would fit suitably as the wing of a triptych. (**6**) U. Procacci (*The Gallery of the Accademia of Florence*, 1951, p. 35) attributes the companion panel to a Florentine between Schiavo and Neri di Bicci and says it has been attributed to Schiavo by Dami. K254 has been attributed (in ms. opinions) to Schiavo by R. van Marle; to an anonymous Florentine by F. M. Perkins; and to Neri di Bicci by G. Fiocco, R. Longhi, W. E. Suida, and A. Venturi. B. Berenson (*Italian Pictures . . Florentine School*, vol. I, 1963, p. 156) also attributes it to Neri di Bicci. A. Parronchi (*Studi su la dolce prospettiva*, 1964, footnote on pp. 131 ff.), following Casalini (*op. cit.* in note 3, above) in

part, suggests that the triptych may have been transferred in 1449 from the high altar of Santissima Annunziata, in which case its painter would be Ventura di Moro, who worked with Rossello di Jacopo Franchi on some Bigallo frescoes in 1445–46 but seems to be unknown at present in definitely documented extant work. (7) *Preliminary Catalogue*, 1941, pp. 140 f., as Neri di Bicci.

NERI DI BICCI

K 1003 : Figure 310

THE MARTYRDOM OF ST. APOLLONIA. Claremont, Calif., Pomona College, Study Collection (61.1.6), since 1961. Wood. 8⅜×20⅝ in. (21·3×52·4 cm.). Very good condition.

A companion to K 1003 is probably the *Martyrdom of a Holy Bishop* formerly in the Nemes Collection, Munich,[1] where it was attributed to the school of Pesellino. The fact that the Nemes panel is 10¼ inches high and that the capitals of the columns are missing in K 1003 indicates that the latter panel has been trimmed at the top. The date is probably about 1460 and the attribution to Neri di Bicci has not been challenged.[2] K 1003 would have been appropriate as a predella panel for Neri's *Annunciation* in the Museum at Pescia, where St. Apollonia is in the left wing; but the figure in the right wing is St. Luke, not a bishop saint. The subject of K 1003 is the torture of St. Apollonia before her death by fire or sword.

Provenance: Contini Bonacossi, Florence. Kress acquisition, 1936 – exhibited: National Gallery of Art, Washington, D.C. (431), 1941–52.[3]

References: (1) Catalogue of sale, June 16, 1931, no. 19, reproduced. (2) K 1003 has been attributed to Neri di Bicci by B. Berenson (*Italian Pictures . . . Florentine School*, vol. I, 1963, p. 153), G. Fiocco, R. Longhi, R. van Marle, F. M. Perkins, W. E. Suida, and A. Venturi (in ms. opinions). (3) *Preliminary Catalogue*, 1941, p. 141, as Neri di Bicci.

NERI DI BICCI

K 1143 : Figure 305

ST. BARTHOLOMEW AND ST. JAMES MAJOR. Lawrence, Kans., University of Kansas, Study Collection (60.47), since 1960.[1] Wood. 48½×30¼ in. (123·2×76·9 cm.). Very good condition.

The pose of the figures, turned to the left, indicates that K 1143 was once in the right wing of a polyptych. The corresponding left panel, with St. Anthony Abbot and a bishop saint (Augustine?) is in the Nantes Museum; a pinnacle with the Annunciate Angel is said to belong to it,[2] indicating that K 1143 was once terminated by a corresponding pinnacle, depicting the Virgin Annunciate. The style agrees with that of Neri di Bicci's oeuvre between 1460 and 1470,[3] with the *Crucifixion* of 1463, for example, in the Church of San Francesco, Fiesole.

Provenance: Contini Bonacossi, Florence. Kress acquisition, 1938.

References: (1) Catalogue by R. L. Manning (in *Register of the Museum of Art*, vol. II, no. 4, 1960, p. 16), as Neri di Bicci. (2) B. Berenson, *Italian Pictures . . . Florentine School*, vol. I, 1963, p. 156. (3) K 1143 has been attributed to Neri di Bicci by B. Berenson (p. 155 of *op. cit.* in note 2, above), G. Fiocco, R. Longhi, F. M. Perkins, W. E. Suida, and A. Venturi (in ms. opinions).

NERI DI BICCI

K 1728 : Figure 308

ST. ANTHONY ABBOT. Denver, Colo., Denver Art Museum (E-IT-18-XV-935), since 1954.[1] Wood. 58× 28¼ in. (147·3×71·8 cm.). Inscribed on the open book: LASCIATE . IVITII . LE VIRTV . PIGLATE [*sic*] . VOSTRO ADVOCATO SO SE QVVESTO FATE. (Forsake vices; embrace virtue; I am your advocate if you do this.) Fragment; about three inches on right side are new; fair condition; partially cleaned 1952.

Probably once the middle panel of an altarpiece, K 1728 has been dated about 1460/70 in Neri di Bicci's career and may be even as late as 1480/90.[2] St. Anthony's symbol, the pig, at his feet, the crablike creatures at right and left, and the golden siren-shaped arms of the elaborate throne are examples, along with St. Margaret's dragon in K 254 (Fig. 309), of the artist's skill in painting both real and fantastic animals. The sirens may allude to St. Anthony's temptation by women and gold.

Provenance: Contini Bonacossi, Florence. Kress acquisition, 1950.

References: (1) Catalogue by W. E. Suida, 1954, p. 28, as Neri di Bicci. (2) R. Longhi (in ms. opinion) has attributed K 1728 to Neri di Bicci, dating it between 1460 and 1470; Suida (*loc. cit.* in note 1, above) dates it after 1480.

ALESSO BALDOVINETTI

Florentine School. Born probably 1425; died 1499. There
is some evidence that he was out of Florence from 1433 to
1446; but it was in Florence that his style developed, chiefly
under the influence of Domenico Veneziano, Fra Angelico,
and Castagno. He was not only a painter; mosaics, windows,
and designs for intarsia claimed much of his time.

Style of ALESSO BALDOVINETTI

K 1334 : Figure 311

THE ANNUNCIATION. Notre Dame, Ind., University of
Notre Dame, Study Collection (62.17.1), since 1962.[1]
Wood. $14\frac{1}{4}\times11\frac{5}{8}$ in. (36·2×29·5 cm.). Considerably
damaged; restored in manner of Baldovinetti.

The poor preservation has left insufficient evidence on
which to base a definite attribution. A small, unclear repro-
duction[2] made when K 1334 was owned in Rome more than
fifty years ago shows an inscription (illegible in the re-
production) in the friezes on the wall and in a vertical strip
along the left side of the painting; further, it shows differ-
ences in the shapes of the flower pots and tree tops above the
wall. The picture had been restored to its present state when
it appeared in America and was published as an early
Baldovinetti, possibly from his now-lost Sant'Ansano
altarpiece of 1450.[3] The architectural setting recalls that of
about the same time in Piero della Francesca's frescoed
Annunciation in San Francesco, Arezzo.

Provenance: Madame Mihalyffy (née Hartmann), Budapest
(said to have been brought by a Hartmann ancestor from
Italy in the mid-nineteenth century). Chev. Prof. Mariano
Rocchi, Rome (c. 1909).[4] Wildenstein's, New York (1940–
42; Italian Paintings, 1947, list in Introduction). Kress
acquisition, 1942 – exhibited: National Gallery of Art,
Washington, D.C. (792), 1945–51, as Baldovinetti.

References:(1) Catalogue, 1962, p. unnumbered, as attributed
to Baldovinetti. (2) Collection of Objects of Art and Antiquities
of Chev. Prof. Mariano Rocchi, Rome, Via Nazionale, 243,
Rome, p. 85. This pamphlet is undated but the reference to
K 1334 is in a section of the pamphlet which is a translation
of an article by G. Stiavelli in Ars et Labor, 15 Feb., 1909,
Milan. (3) R. W. Kennedy, in Art in America, vol. XXVIII,
1940, pp. 139 ff. Mrs. Kennedy's suggestion of the connec-
tion with the Sant'Ansano altarpiece is based chiefly on the
belief that K 1334 has been cut along the top, bottom, and
left side, but is intact on the right side; X-ray indicates an
equally ragged edge on the right. B. Berenson (Italian
Pictures . . . Florentine School, vol. I, 1963, p. 22) also attributes
K 1334 to Baldovinetti; C. L. Ragghianti (in Critica d'Arte,

May 1949, p. 81), noting its problematical preservation,
sees a similarity to Giovanni di Francesco and says it is in
any case by the hand that painted the Coronation, no. 2,
in the Städel Institut, Frankfort. Stiavelli (loc. cit. in note 2,
above) assigned it to the early period of Pintoricchio.
(4) According to the pamphlet cited in note 2, above.
Inquiry as to what happened to Rocchi's collection after
1909 has brought no results. Did K 1334 perhaps go from
Rocchi to the Mihalyffy Collection (instead of vice versa) in
spite of the 'family tradition' that it had been in the latter
half a century?

PIER FRANCESCO FIORENTINO

Florentine School. Active 1474–97. The large oeuvre
attributed to him shows him influenced especially by
Gozzoli, Neri di Bicci, Castagno, and Baldovinetti.

K 402 : Figure 312

MADONNA AND CHILD. Washington, D.C., National
Gallery of Art (325; not currently exhibited), since 1941.[1]
Transferred from wood to canvas. $29\frac{1}{2}\times21\frac{1}{2}$ in. (75×54·5
cm.). Poor condition; faked as Baldovinetti by unknown re-
storer; cleaned 1954.

Once repainted in the style of Baldovinetti,[2] K 402 is now,
after cleaning, attributable in spite of its ruined state to
Pier Francesco Fiorentino, near the end of the fifteenth
century. His mannered figure types, fastidious poses of
hands, and profuse use of finger rings are all in evidence
here. In a painting in Zagreb attributed to him[3] and another,
from the same Florentine circle, formerly in the Sackville
Gallery, London, are found details which could largely
make up the figure composition of K 402. An even closer
parallel to K 402 in toto is offered by the version in the
Thorvaldsen Museum, Copenhagen.[4]

Provenance: Arnaldo Corsi, Florence. Duveen's, New York.
William Salomon, New York (before 1923). Duveen's,
New York (Duveen Pictures in Public Collections of America,
1941, no. 58, as Baldovinetti). Clarence H. Mackay, Roslyn,
N.Y. (catalogue by W. R. Valentiner, 1926, no. 2, as
Baldovinetti) – exhibited: 'Italian Art,' Smith College,
Northampton, Mass., 1925. Duveen's, New York. Kress
acquisition, 1936.

References: (1) Preliminary Catalogue, 1941, pp. 10 f., as
Baldovinetti. (2) Before it was cleaned, K 402 was attributed
to Baldovinetti by R. Offner (in The Arts, vol. V, 1924,
p. 249), W. R. Valentiner (see Provenance, above, and
elsewhere), R. van Marle (Italian Schools of Painting, vol. XI,
1929, pp. 278 f.), B. Berenson (Italian Pictures of the Renais-
sance, 1932, p. 37; Italian ed., 1936, p. 32; omitted from the

1963 ed.), L. Venturi (*Italian Paintings in America*, vol. II, 1933, no. 233), R. W. Kennedy (*Alesso Baldovinetti*, 1938, pp. 92 ff.; and in *Art in America*, vol. XXVIII, 1940, p. 147), G. Fiocco, F. M. Perkins, W. E. Suida, and A. Venturi (in ms. opinions). (3) Tentatively attributed by B. Berenson (*Italian Pictures . . . Florentine School*, vol. I, 1963, p. 170) to Pier Francesco Fiorentino, the Zagreb picture is reproduced by R. W. Kennedy (*op. cit.*, fig. 89), who placed it and also the Sackville painting in the circle of Baldovinetti. (4) Reproduced by H. Olsen (*Italian Paintings and Sculpture in Denmark*, 1961, pl. XIIa), who attributes it to the Florentine School, late fifteenth century, 'a somewhat varied copy of A. Baldovinetti's painting in the Kress Collection, National Gallery, Washington.'

PSEUDO PIER FRANCESCO FIORENTINO

Florentine School. Active second half of fifteenth century. Under this designation are grouped a number of paintings which derive from Filippo Lippi and Pesellino, repeating and combining compositions invented by those masters. It is probable that while the group of derivations come from a single bottega, they are divisible among several painters. The favorite subject is the half-length *Madonna and Child*, similar to K510 (Fig. 289), by Filippo, and to K485 (Fig. 301), by Pesellino.

K321 : Figure 313

MADONNA AND CHILD. Tulsa, Okla., Philbrook Art Center (3354), since 1953.[1] Wood. 23⅛×16⅛ in. (58·7× 41 cm.). Excellent condition; cleaned 1953.

The model for the two figures may well have been the *Madonna and Child* in the Gardner Museum, Boston, attributed to Pesellino. The only considerable change in the composition is the substitution of a rose hedge for the shell-niche background so characteristic of Pesellino. There are further background variations in the many other versions of the composition, with the figure group remaining nearly the same.[2] K321 is perhaps the most pleasing of the known variations[3] and may date about 1480.

Provenance: Contini Bonacossi, Florence. Kress acquisition, 1935 – exhibited: National Gallery of Art, Washington, D.C. (285), 1941-52.[4]

References: (1) Catalogue by W. E. Suida, 1953, p. 48, as Pier Francesco Fiorentino. (2) A list of some of the versions is given by R. van Marle, *Italian Schools of Painting*, vol. XIII, 1931, pp. 440 ff. (3) In ms. opinions, K321 has been attributed to Pier Francesco Fiorentino by G. Fiocco, R. van Marle, and A. Venturi; and to a follower of Pesellino by R. Longhi

and F. M. Perkins. B. Berenson (in ms. opinion and *Italian Pictures . . . Florentine School*, vol. I, 1963, p. 174) attributes it to Pseudo Pier Francesco Fiorentino. (4) *Preliminary Catalogue*, 1941, p. 154, as Pseudo Pier Francesco Fiorentino.

PSEUDO PIER FRANCESCO FIORENTINO

K57 : Figure 314

MADONNA AND CHILD. New York, Samuel H. Kress Foundation, since 1954. Wood. 22¼×13¼ in. (56·5× 33·7 cm.). Very good condition.

Except that the Virgin is here reduced to three-quarter length, the group of Mother and Child is taken from the *Nativity* in the Riccardi Chapel, Florence, which is, in turn, a copy by Pseudo Pier Francesco of Filippo Lippi's *Nativity* now in Berlin. Other paintings by Filippo offer models for the little St. John. K57, which may date about 1480, has been attributed to Pier Francesco as well as to Pseudo Pier Francesco,[1] under whom it is safely classified, especially if the designation is taken to cover more than one follower of Filippo and Pesellino. Numerous variants of K57 are known; perhaps the most closely similar is one in the Walters Art Gallery, Baltimore.

Provenance: Contini Bonacossi, Rome. Kress acquisition, 1929 – exhibited: M. H. De Young Memorial Museum, San Francisco, Calif., 1930–54, as Pier Francesco Fiorentino.

Reference: (1) K57 has been attributed to Pier Francesco Fiorentino by G. Fiocco, R. Longhi, and A. Venturi (in ms. opinions); to Pseudo Pier Francesco Fiorentino by F. M. Perkins, W. E. Suida (in ms. opinions), and B. Berenson (*Italian Pictures . . . Florentine School*, vol. I, 1963, p. 173).

BENOZZO GOZZOLI

Benozzo di Lese, called Gozzoli. Florentine School. Born 1420; died 1497. He had already trained as a painter, probably under Fra Angelico, when he contracted to work with Ghiberti for three years on the doors of the Florentine Baptistery. At the end of this period he assisted Fra Angelico in Rome and Orvieto. He was active also in Florence, San Gimignano, Montefalco, and Pisa.

K482 : Figure 315

ST. URSULA WITH ANGELS AND DONOR. Washington, D.C., National Gallery of Art (376), since 1941.[1] Wood.

$18\frac{1}{2} \times 11\frac{1}{4}$ in. $(47 \times 29$ cm.). Inscribed on the halos: SANCTA . VREVLA . VIRGO, ANGELVS, and ANGELVS (the E in VREVLA has been changed from s); below the nun the unclear inscription seems to read: Suora . Ginevera. Good condition except a few losses of paint.

This scheme of composition, two angels holding up an embroidered or brocaded textile behind the principal figure, was repeated by Benozzo at times throughout his career. Of well-known examples the one most like K482 is the fresco in Santa Maria in Aracoeli, Rome, of St. Anthony with two donors kneeling at his feet, a painting of about 1455, the period to which K482 may be assigned.[2] The rough script at the bottom of the picture seems to have been added as an afterthought to identify the nun, presumably the donor.

Provenance: Dukes of Saxe-Meiningen, Castle of Meiningen, Thuringia, Germany. Duveen's, New York (*Duveen Pictures in Public Collections of America*, 1941, no. 49, as Gozzoli). Kress acquisition, 1937.

References: (**1**) *Preliminary Catalogue*, 1941, pp. 90 f., as Benozzo Gozzoli. (**2**) K482 has been attributed to Benozzo by B. Berenson (*Florentine Painters of the Renaissance*, 1907, p. 106, and later editions; *Italian Pictures . . . Florentine School*, vol. I, 1963, p. 97), R. van Marle (*Italian Schools of Painting*, vol. XI, 1929, p. 216), L. Venturi (*Italian Paintings in America*, vol. II, 1933, no. 216), G. Fiocco, R. Longhi, F. M. Perkins, W. E. Suida, and A. Venturi (in ms. opinions).

BENOZZO GOZZOLI

K1648 : Figure 317

THE DANCE OF SALOME. Washington, D.C., National Gallery of Art (1086), since 1951.[1] Wood. $9\frac{3}{8} \times 13\frac{1}{2}$ in. $(23 \cdot 8 \times 34 \cdot 3$ cm.). Good condition; old restorations discolored.

One of the most interesting of fifteenth-century painters' contracts now known concerns an altarpiece commissioned of Gozzoli in 1461 by the Confraternity of the Purification of the Virgin for their meeting place above the Church of San Marco, Florence.[2] The contract not only binds the artist to carry out the work himself and to follow a certain program of subject matter; it specifies the quality of the pigments to be used (the finest ultramarine blue, for example), the amount and periods of the payments, and the time of delivery of the completed work (by November 1462). The main panel of the altarpiece corresponding to this contract has been easily recognized as the *Virgin and Child Enthroned with Saints and Angels* in the National Gallery, London. Of the predella, which the contract specifically required to be painted entirely by Gozzoli himself, four panels have for some time been known; K1648,

which came to light only a few years ago, was almost immediately recognized as completing the series.[3] The *Purification of the Virgin* in the Johnson Collection of the Philadelphia Museum, was the middle section of the predella.[4] The other panels were arranged, as we know from the contract, in the order corresponding to the placing, in the main panel, of the saints whose lives these four panels illustrate: at the extreme left, *A Miracle of St. Zenobius*, Berlin Museum; next, K1648, with the John the Baptist scenes; then, beyond the *Purification of the Virgin*, the *Death of Simon Magus*, Buckingham Palace, London; and, at the extreme right, *A Miracle of St. Dominic*, now in the Brera, Milan. The altarpiece, now presumably known in all its parts except for the 'beautiful frame, all done in gold,'[5] was still intact when listed in an inventory of 1518 after the confraternity had moved to a new building in the Via San Gallo, and presumably it was still whole when last recorded there, in 1757. Then, in 1775, came the suppression of the confraternity and, probably at the same time, the dispersion of the various panels of the altarpiece. K1648 has been cited as the best preserved picture by Gozzoli and the 'most enchanting thing of its kind ever done in Florence.'[6] The plausible suggestion has been made[7] that the interior, with its coffered ceiling, pilastered walls and high, grated window – all drawn with careful attention to perspective – may have been inspired by the interior of Michelozzo's Riccardi Palace Chapel, in which Gozzoli had in 1461 just finished painting his famous *Journey of the Magi*.

Provenance: Confraternity of the Purification of the Virgin, Florence. Conte Vittorio Cini, Venice. Wildenstein's, New York (1949). Kress acquisition, 1949.

References: (**1**) *Paintings and Sculpture from the Kress Collection*, 1951, p. 50 (catalogue by W. E. Suida), as Benozzo Gozzoli. (**2**) The contract is published by C. Ricci in *Rivista d'Arte*, vol. II, 1904, pp. 9 ff., and in English translation by F. R. Shapley in *Gazette des Beaux-Arts*, vol. XXXIX, 1952, pp. 87 f. (**3**) Shapley, pp. 77 ff. of *op. cit.* in note 2, above. (**4**) This subject was not mentioned in the contract. Its inclusion and the omission of scenes from the lives of two of the saints represented in the main panel are discussed by Shapley, *ibid.* (**5**) It was probably somewhere on the frame that the composition with the monogram of the confraternity, described in the contract, was placed. (**6**) B. Berenson (in ms. opinion and *Italian Pictures . . . Florentine School*, vol. I, 1963, p. 97). (**7**) A. M. Frankfurter (in *Art News Annual*, 1952, pp. 90 f.).

Follower of BENOZZO GOZZOLI

K250 : Figure 316

MADONNA AND CHILD WITH ANGELS. Honolulu, Hawaii, Honolulu Academy of Arts (2978.1), since 1952.[1]

Wood. $31\frac{1}{2} \times 19\frac{1}{4}$ in. (80×48.9 cm.). Inscribed in Virgin's halo: MATER OMNIVM (Mother of all). Good condition.

There is a possibility that the painter of K250 was an Umbrian, such as Caporali, inspired by Gozzoli;[2] or he may have been a Florentine whom Umbrian influence reached through Gozzoli after the latter's sojourn in Umbria in the 1450's. K250, which dates from the second half of the century, shows a knowledge of Gozzoli's altarpiece of 1461 in the National Gallery, London, but it deviates further from that model than does the Gozzoli school piece, likewise in London, which is in large part a direct copy.[3] The theory that both these derivations were painted by the same artist is not altogether convincing.[4]

Provenance: Lady Florence Brown, Surrey, England. Contini Bonacossi, Florence. Kress acquisition, 1933 – exhibited: National Gallery of Art, Washington, D.C. (232), 1941–49.[5]

References: (1) Catalogue by W. E. Suida, 1952, p. 22, as Florentine painter, pupil of Benozzo Gozzoli. (2) K250 has been attributed to a Florentine close to Benozzo by G. Fiocco, R. Longhi, C. Norris, F. M. Perkins, O. Sirén, and W. E. Suida (in ms. opinions, usually noting Umbrian influence). (3) National Gallery, London, no. 2863, copying National Gallery, London, no. 283. (4) The identity of authorship was suggested by Longhi (in ms. opinion) and the suggestion approved by Suida (see note 1, above). (5) *Preliminary Catalogue*, 1941, p. 64, as Florentine School, fifteenth century.

'ALUNNO DI BENOZZO'

Florentine School. Active late fifteenth century. The designation,[1] which means pupil of Benozzo, indicates that he was chiefly influenced by Benozzo Gozzoli, whom he may have assisted in the 1480's. Later he was influenced also by Umbrian and Sienese artists. He is identical with the so-called Esiguo Master;[2] but the recent attempt to identify him, on the basis of one signed painting, as Amadeo da Pistoia is not convincing.[3]

K372 : Figure 318

PROCESSIONAL CROSS. Columbia, Mo., University of Missouri, Study Collection (61.73), since 1961. Wood. $20\frac{3}{4} \times 16\frac{3}{8}$ in. (52.7×41.6 cm.). Inscribed on God the Father's open book: A Ω (the beginning and the end); and at the top of the cross: INRI (Jesus of Nazareth, King of the Jews). Good condition.

Similar to a drawing in the Uffizi, Florence,[4] attributed to this artist, K372 probably dates from about 1480/90, when

Benozzo's influence on Alunno was subject to a Byzantinizing tendency, more evident in the painting than in the drawing.[5] In the quatrefoils are God the Father at the top, the Virgin and St. John the Evangelist at the sides, and St. Catherine of Siena, exhibiting the stigmata, at the bottom. Below God the Father is a symbol of Christ's sacrifice, the pelican giving her blood to feed her young.

Provenance: Graf Louis Paar (sold, Rome, Mar. 20–28, 1889, no. 355, as Gozzoli). Contini Bonacossi, Florence. Kress acquisition, 1935 – exhibited: National Gallery of Art, Washington, D.C. (318), 1941–52.[6]

References: (1) B. Berenson (in *Bollettino d'Arte*, vol. XXV, 1932, pp. 293 ff.; *Dedalo*, vol. XII, 1932, pp. 837 ff.) coined the name Alunno di Benozzo, characterized the artist's style, and identified paintings and drawings by him. (2) R. Longhi (in *Vita Artistica*, vol. II, 1927, pp. 68 ff.) applied this designation to the anonymous artist whom Berenson calls Alunno di Benozzo. (3) See W. E. Suida in his catalogue of the Kress Collection in the Denver Art Museum, 1954, p. 34. The signed picture is reproduced by B. Berenson, *Italian Pictures . . . Florentine School*, vol. II, 1963, fig. 909. In this, his only autograph painting, Amadeo's poses, especially of the hands, are more mannered than Alunno's; his drapery treatment is softer; his landscape background is of a more northern character, less like Gozzoli's Arno Valley views. G. Coor (in *Record of the Art Museum, Princeton University*, vol. XX, 1961, no. 1, p. 20) discusses the identification of Alunno di Benozzo with Amadeo da Pistoia on the basis of the signed painting and finds the identification unconvincing. (4) Uffizi no. 1866c, recto; reproduced by Berenson, fig. 2 of the *Bollettino* citation in note 1, above. (5) In ms. opinions K372 has been attributed to the Esiguo Master by G. Fiocco, R. Longhi, F. M. Perkins, A. Venturi, and W. E. Suida, who later (see note 3, above) identifies the artist as Amadeo da Pistoia. B. Berenson (vol. I, p. 3 of *op. cit.* in note 3, above) attributes it to Alunno di Benozzo. (6) *Preliminary Catalogue*, 1941, pp. 2 f., as Alunno di Benozzo.

'ALUNNO DI BENOZZO'

K1024 : Figure 320

THE DEPOSITION OF CHRIST. Tulsa, Okla., Philbrook Art Center (3359), since 1953.[1] Wood. $20\frac{1}{2} \times 15\frac{1}{2}$ in. (52.1×39.4 cm.). Fair condition except for damage in legs of Christ and surrounding area; cleaned 1953.

Along with another version, which is in the collection of Mrs. C. H. Coster, Florence,[2] K1024 follows very closely a drawing in the Uffizi, Florence,[3] by the same artist. The version in the Coster Collection, tighter and more Byzantinized, is probably earlier than K1024, which must date as late as 1500.[4]

Provenance: Contini Bonacossi, Florence. Kress acquisition, 1936.

References: (**1**) Catalogue by W. E. Suida, 1953, p. 54, as Amadeo da Pistoia. (**2**) Reproduced by B. Berenson, *Italian Pictures . . . Florentine School*, vol. II, 1963, pl. 908. (**3**) Uffizi no. 1866C, verso; reproduced by B. Berenson (*Drawings of the Florentine Painters*, vol. III, 1938, fig. 53; in vol. II, p. 261, Berenson comments on the remarkable agreement of the drawing with the two painted versions, and in *Bollettino d'Arte*, vol. XXV, 1932, pp. 293 f., he notes the relationship of the drawing to Alunno's *Deposition* in the Vatican Pinacoteca no. 264). (**4**) K1024 has been attributed (in ms. opinions) to the Esiguo Master by G. Fiocco, R. Longhi, R. van Marle, F. M. Perkins, W. E. Suida (but see note 1, above), and A. Venturi. It is given to Alunno di Benozzo by B. Berenson (*Italian Pictures . . . Florentine School*, vol. I, 1963, p. 3; see also note 3, above).

'ALUNNO DI BENOZZO'

K1025 : Figure 319

HOLY TRINITY ADORED BY ST. FRANCIS AND A BISHOP. Denver, Colo., Denver Art Museum (E-IT-18-XV-938), since 1954.[1] Wood. 21 × 14½ in. (53·3 × 36·8 cm.). Good condition.

While the influence of Gozzoli is still dominant here and the Christ, as on the *Processional Cross* (K372, Fig. 318), recalls Alunno's drawings in the Uffizi, Florence,[2] the figure of St. Francis seems to be modeled on Perugino. It is similar, although in reverse, to Alunno's Berlin pen-and-bistre copy of Perugino's St. Bernard in the Santa Maria dei Pazzi fresco.[3] K1025 probably dates about 1500.[4]

Provenance: Contini Bonacossi, Florence. Kress acquisition, 1936 – exhibited: National Gallery of Art, Washington, D.C. (835), 1946–53, as Alunno di Benozzo.

References: (**1**) Catalogue by W. E. Suida, 1954, p. 34, as Amadeo da Pistoia. (**2**) See note 4 under K372, above. (**3**) Alunno's drawing in Berlin, no. 4199, is reproduced by B. Berenson, *Drawings of the Florentine Painters*, vol. III, 1938, fig. 61. (**4**) K1025 has been attributed (in ms. opinions) to the Esiguo Master by G. Fiocco, R. Longhi, F. M. Perkins, W. E. Suida (but see note 1, above), and A. Venturi. It is given to Alunno di Benozzo by R. van Marle (*Italian Schools of Painting*, vol. XVI, 1937, p. 208) and B. Berenson (*Italian Pictures . . . Florentine School*, vol. I, 1963, p. 3). As typical of the iconography of the Trinity at the turn of the century, it is compared by H. S. Francis (in *Bulletin of the Cleveland Museum of Art*, vol. XLVIII, 1961, p. 58) with other examples of the subject.

ANDREA DEL VERROCCHIO

Andrea di Michele di Francesco Cione, called Verrocchio, presumably from a teacher, Giuliano Verrocchi. Florentine School. Born *c.* 1435; died 1488. He was probably a pupil of Donatello and was trained also as goldsmith and painter. Leonardo and Lorenzo di Credi were early associated with him, probably both as pupils and as assistants. His importance as sculptor and painter is still patent in spite of the scarcity of extant examples of his work, especially in painting.

Style of ANDREA DEL VERROCCHIO

K1282 : Figure 322

MADONNA AND CHILD. Washington, D.C., National Gallery of Art (502), since 1941.[1] Wood. 30¾ × 21¼ in. (78 × 54 cm.). Very much abraded throughout; cleaned 1954–55.

Except for the almost complete omission of a far-reaching landscape background, the composition duplicates that of the *Madonna* attributed to Verrocchio in the Berlin Museum. This relationship has been explained by classifying K1282 as a replica of the Berlin picture.[2] Definite conclusion as to attribution is precluded by the poor condition of K1282.

Provenance: Baron Arthur de Schickler, Martinvast, Normandy (as early as 1896; as late as 1912). Comtesse Hubert de Pourtalès, Paris. Duveen's, New York (*Duveen Pictures in Public Collections of America*, 1941, no. 71, as Verrocchio). Clarence H. Mackay, Roslyn, N.Y. (catalogue by W. R. Valentiner, 1926, no. 3, as Verrocchio) – exhibited: 'Early Italian Paintings,' Duveen Galleries, New York, Apr.–May 1924, no. 11 of catalogue of 1926 by W. R. Valentiner, as Verrocchio. Duveen's, New York. Kress acquisition, 1939.

References: (**1**) *Preliminary Catalogue*, 1941, p. 213, as Verrocchio. (**2**) When he first listed K1282 (*Florentine Painters of the Renaissance*, 1896, p. 187; 1912, p. 187), B. Berenson qualified the attribution to Verrocchio with the statement that the painting had been 'designed and superintended by Verrocchio.' His posthumous list (*Italian Pictures . . . Florentine School*, vol. I, 1963, p. 212) still includes it under Verrocchio, but with the comment: 'restored; later replica of the Berlin 104A.' Except in the catalogues cited under *Provenance* K1282 has been merely mentioned in the literature, usually without objection to the Verrocchio attribution. Only C. L. Ragghianti (in *Critica d'Arte*, May 1949, pp. 81 f.), judging apparently from photographs, attributes the painting to the young Botticelli; and G. Passavant (*Andrea del Verrocchio als Maler*, 1959, pp. 97 f.) treats it as a contemporary copy of the Berlin *Madonna*.

Follower of
ANDREA DEL VERROCCHIO

K 1722 : Figure 324

MADONNA ADORING THE CHILD. Birmingham, Ala., Birmingham Museum of Art (61.120), since 1952.[1] Wood. 34×19½ in. (86·4×49·5 cm.). Inscribed on the hem of the Virgin's robe: parts of ECCE ANCILLA DOMINI (from Luke 1 : 38), GLORIA IN EXCELSIS DEO (from Luke 2 : 14), and more fragmentary parts of other legends. Very much abraded, especially in flesh tones.

This type of composition is found earlier in Fra Angelico, Fra Filippo Lippi, Luca della Robbia, and Baldovinetti. An especially close parallel to K 1722 is seen in a panel of about 1470 in the Ruskin Museum, Sheffield, Yorks, attributed to Verrocchio and assistants.[2] K 1722 is less close to Verrocchio and may date a decade or more later.[3]

Provenance: Principe Corsini, Florence. Contini Bonacossi, Florence. Kress acquisition, 1950.

References: (1) Catalogue by W. E. Suida, 1952, p. 36, and 1959, p. 44, as Florentine painter, c. 1470. (2) B. Berenson, in *Bollettino d'Arte*, vol. XXVII, 1933, p. 204, fig. 7; *Italian Pictures . . . Florentine School*, vol. I, 1963, p. 212. (3) R. Longhi (in ms. opinion) attributes K 1722 to the painter of the Sheffield *Adoration*, and believes him to be the early Botticelli, c. 1466. Berenson (*Italian Pictures . . . Florentine School*, vol. I, 1963, p. 210) attributes K 1722 to 'Utili,' i.e. Biago d'Antonio da Firenze, which would date it in the last quarter of the century.

FLORENTINE SCHOOL, Second Half
of XV Century

K 1723 : Figure 323

MADONNA AND CHILD. Memphis, Tenn., Brooks Memorial Art Gallery (61.206), since 1958.[1] Wood. 31⅞× 26¼ in. (81×66·7 cm.). Fragment; extended at both sides; many losses of paint; partially cleaned 1951.

The influence of Florentine masters from Filippo Lippi and the Carrand Master to Verrocchio and Botticelli is evident in K 1723. It was at one time attributed to so early a painter as Masaccio[2] and at another, to Filippo Lippi.[3] Recent attempts to connect it with Francesco Botticini are more plausible.[4] Black dots outlining such details as fingers, veil, and hair are still visible, showing that the design was transferred to the panel from a pricked cartoon.

Provenance: William Graham, London – exhibited: Royal

Academy, London, 1884, no. 238, as Masaccio. Graham sale, Christie's, London, Apr. 9, 1886, no. 326, as Masaccio; bought by Agnew. Hon. J. F. Cheetham, Dunkinfield Lodge, Bournemouth (sold, Christie's, London, June 15, 1923, no. 82, as Masaccio; bought by the following). Frank T. Sabin's, London (catalogued 1932, as Filippo Lippi and with the implausible suggestion that it may be the painting which Vasari, *Le Vite*, Milanesi ed., vol. II, 1878, p. 625, says Filippo painted for Lodovico Capponi; A. C. Cooper photograph no. 49466 shows K 1723 when in the possession of Sabin, before the additions at the sides were painted). Contini Bonacossi, Florence. Kress acquisition, 1950.

References: (1) Catalogue by W. E. Suida, 1958, p. 26, as Florentine Master, c. 1475, probably Francesco Botticini. (2) See *Provenance*, above. (3) See *Provenance*, above. (4) R. Longhi (in ms. opinion, 1950) has described K 1723 as 'probably an early work by Francesco Botticini.' See also note 1, above. B. Berenson (*Italian Pictures . . . Florentine School*, vol. I, 1963, p. 221) lists it as by an unidentified Florentine.

FLORENTINE SCHOOL, c. 1475

K 369 : Figure 328

MADONNA AND CHILD WITH AN ANGEL. Ponce, Puerto Rico, Museo de Arte de Ponce, Study Collection (64.0269), since 1964. Wood. 27¼×19⅜ in. (69·2×49·2 cm.). Good condition; heavily varnished; needs cleaning.

Although generally attributed to Biagio d'Antonio da Firenze, K 369[1] exhibits such independent figure types as to recommend cataloguing it for the present as anonymous. Its one-time attribution to Pollaiuolo and a variant's attribution to Verrocchio[2] point up prominent stylistic tendencies. An attribution to either Biagio d'Antonio or the Master of San Miniato cannot be far wrong.

Provenance: Lord Battersea, London (late nineteenth century) – exhibited: New Gallery, London, 1893–94, no. 93, as Antonio Pollaiuolo. Contini Bonacossi, Florence. Kress acquisition, 1935.

References: (1) K 369 was attributed to Pollaiuolo by S. Reinach (*Répertoire de peintures*, vol. I, 1905, p. 161); to the Master of San Miniato by G. de Francovich (in *Bollettino d'Arte*, vol. VI, 1927, p. 530) and R. van Marle (*Italian Schools of Painting*, vol. XVI, 1937, p. 202); to a follower of Verrocchio by G. Fiocco and F. M. Perkins (in ms. opinions); to a Florentine related to Pollaiuolo by W. E. Suida (in ms. opinion); and to Biagio d'Antonio by B. Berenson (*Italian Pictures . . . Florentine School*, vol. I, 1963, p. 211, using the designation 'Utili'), R. Longhi, R. van Marle, and A.

Venturi (in ms. opinions). (2) A photograph of this variant is in the Richter Archives, National Gallery of Art (labeled as attributed to Verrocchio but filed as follower of Botticini), with the indication in Italian that it was in the market (no date, no record of whereabouts).

FLORENTINE SCHOOL, *c.* 1475

K 54 : Figure 321

MADONNA AND CHILD. Allentown, Pa., Allentown Art Museum, Study Collection (60.05.KBS), since 1960. Wood. $27\frac{3}{4} \times 17\frac{1}{2}$ in. (70·5×44·5 cm.). Vertical split right of center; *c.* 2 inches of pigment missing across bottom; abrasions and losses of paint throughout; cleaned 1960.

Recognition of the strong influence of both Verrocchio and Pollaiuolo in K 54 has thrown doubt on its attribution to Cosimo Rosselli.[1] Like K 369 (Florentine School, *c.* 1475; Fig. 328), where the Child, especially, is paralleled, K 54 should perhaps be considered in connection with the Master of San Miniato.

Provenance: Contini Bonacossi, Rome. Kress acquisition, 1929 – exhibited: 'Italian Paintings Lent by Mr. Samuel H. Kress,' Oct. 1932, Atlanta, Ga., through June 1935, Charlotte, N.C., p. 17 of catalogue, as Cosimo Rosselli.

Reference: (1) K 54 has been attributed to Cosimo Rosselli by G. Fiocco, R. Longhi, R. van Marle, W. E. Suida, and A. Venturi (in ms. opinions); to the school of Verrocchio by F. M. Perkins (in ms. opinion); and to an unidentified Florentine between Pollaiuolo and Verrocchio by B. Berenson (*Italian Pictures . . . Florentine School*, vol. 1, 1963, p. 217).

COSIMO ROSSELLI

Florentine School. Born 1439; died 1507. A pupil of Neri di Bicci, Rosselli was influenced also by Gozzoli, Baldovinetti, and Verrocchio. Although lacking in originality, his good craftsmanship won him commissions for altarpieces, and in the early 1480's he painted frescoes in the Sistine Chapel of the Vatican, along with Botticelli, Ghirlandaio, and Perugino. He was the master of Piero di Cosimo, who adopted his name.

K 1002 : Figure 325

THE ADORATION OF THE CHILD WITH ST. JOSEPH, ST. JOHN THE BAPTIST, AND ST. JEROME. Columbia, S.C., Columbia Museum of Art (54-402/8), since 1954.[1] Wood. $20\frac{3}{4} \times 13\frac{3}{4}$ in. (52·7×34·9 cm.). Very poor condition; much restored; cleaned 1953.

The large halos, drawn without foreshortening, suggest an early date, about the time of the *Annunciation* in the Louvre, Paris, dated 1473, in which the Virgin corresponds in type to K 1002.[2] The composition was a favorite in Rosselli's following and appears in a number of variants.[3]

Provenance: Contini Bonacossi, Florence. Kress acquisition, 1936 – exhibited: National Gallery of Art, Washington, D.C. (430), 1941–51.[4]

References: (1) Catalogue by W. E. Suida, 1954, p. 23, and by A. Contini Bonacossi, 1962, p. 81, as Cosimo Rosselli. (2) K 1002 is attributed to Rosselli by B. Berenson (*Italian Pictures . . . Florentine School*, vol. 1, 1963, p. 189), G. Fiocco, R. Longhi, R. van Marle, F. M. Perkins, and A. Venturi (in ms. opinions). (3) E.g., in the Johnson Collection, Philadelphia Museum. (4) *Preliminary Catalogue*, 1941, pp. 174 f., as Cosimo Rosselli.

COSIMO ROSSELLI

K 515 : Figure 330

MADONNA ADORING THE CHILD. Tulsa, Okla., Philbrook Art Center (3357), since 1953.[1] Wood. $20\frac{5}{8} \times 14$ in. (52·4×35·6 cm.). Inscribed along the Virgin's left side, as if issuing from her lips: [ec] CE CONPLETA . QVE . DICTA . SṼT . MICHI . (Behold those things have come to pass which were foretold to me). Very good condition except for a few restorations; cleaned 1953.

The landscape background, as not uncommonly in Rosselli, suggests an Umbrian connection; but the stylistic conformity of K 515 to Rosselli's late works, such as the *Madonna and Saints* of 1492 in the Accademia, Florence, is patent.[2]

Provenance: Victor de Cock, Paris. Frederick Lewisohn, New York. Duveen's, New York (*Duveen Pictures in Public Collections of America*, 1941, no. 99, as Cosimo Rosselli). Kress acquisition, 1938 – exhibited: National Gallery of Art, Washington, D.C. (406), 1941–52.[3]

References: (1) Catalogue by W. E. Suida, 1953, p. 26, as Cosimo Rosselli. (2) K 515 has been attributed to Cosimo Rosselli by B. Berenson (*Italian Pictures . . . Florentine School*, vol. 1, 1963, p. 191), G. Fiocco, R. Longhi, and A. Venturi (in ms. opinions); and to an Umbro-Florentine artist, or possibly Rosselli in an Umbrian phase, by F. M. Perkins (in ms. opinion). (3) *Preliminary Catalogue*, 1941, p. 174, as Cosimo Rosselli.

COSIMO ROSSELLI

K1734 : Figure 326

CHRIST ON THE CROSS. Notre Dame, Ind., University of Notre Dame, Study Collection (61.47.13), since 1961.[1] Wood. 80⅜×41¾ in. (204·2×106 cm.). Good condition except for a few abrasions.

In the painted Crucifix, which had a long tradition in Italy, the cross and the figure of the Crucified were rarely completely cut out along their contours. Lorenzo Monaco's practice of cutting them out is recalled by K1734, in which the facial type is typical of Cosimo Rosselli and the heavy body, modeled in detail, indicates a late date, about 1500.[2]

Provenance: Arthur Acton, Florence (*c.* 1930). Contini Bonacossi, Florence. Kress acquisition, 1950.

References: (1) Catalogue, 1961, p. unnumbered, as Cosimo Rosselli. (2) K1734 has been attributed to Rosselli by B. Berenson (*Italian Pictures . . . Florentine School*, vol. I, 1963, p. 191), R. Longhi, and W. E. Suida (in ms. opinions); to the Master of the Göttingen *Crucifixion* (reproduced by R. van Marle, *Italian Schools of Painting*, vol. XIII, 1931, p. 292, as Lorenzo di Credi) by B. Degenhart (in *Münchener Jahrbuch der Bildenden Kunst*, vol. IX, 1931–32, pp. 111, 116), who tentatively identifies this master as Gianjacopo di Castrocaro.

Studio of COSIMO ROSSELLI

K1073 : Figure 329

MADONNA AND CHILD ENTHRONED. Winter Park, Fla., Morse Gallery of Art, Rollins College (37-1-P), since 1937. Wood. 40×22 in. (101·6×55·9 cm.).

The Virgin follows closely Cosimo Rosselli's characteristic type of female figure, as exhibited, for example, in St. Lucy, the chief figure in an early altarpiece by Rosselli in the Uffizi, Florence. Whether or not K1073 was painted by Rosselli himself, to whom it has been attributed,[1] it too is probably early, about 1470/75. But the summary, lax drawing and modeling suggest at least the participation of an assistant or follower. The Child was evidently inspired by the same model as the Child in a painting by an unidentified Florentine, K1723 (Fig. 323), in which, however, the Virgin is quite different from the one in K1073.

Provenance: Contini Bonacossi, Florence. Kress acquisition, 1931.

Reference: (1) K1073 has been attributed to Cosimo Rosselli by B. Berenson (*Italian Pictures . . . Florentine School*, vol. I,

1963, p. 192), G. Fiocco, R. Longhi, R. van Marle, F. M. Perkins, W. E. Suida, and A. Venturi (in ms. opinions).

BOTTICELLI

Alessandro di Mariano Filipepi, called Botticelli. Florentine School. Born 1444/45; died 1510. Probably a pupil of Filippo Lippi, he was influenced also by Pollaiuolo, Verrocchio, and Castagno. He was active chiefly in Florence but he painted some of the frescoes in the Sistine Chapel in the Vatican in 1481–82. At the end of his life he was strongly influenced by the religious teaching of Savonarola.

K1644 : Figure 335

GIULIANO DE'MEDICI. Washington, D.C., National Gallery of Art (1135), since 1956.[1] Wood. 29¾×20⅝ in. (75·6×52·6 cm.). Very good condition; has never been cradled; cleaned 1950.

Two other versions of this portrait, one in the Accademia Carrara, Bergamo, one in the Berlin Museum, have long been known and have competed for first place in critics' opinions. A version showing the profile to left, in the Crespi Collection, Milan (formerly in the Otto Kahn Collection, New York) has figured in the literature on the portrait. K1644 was first published in 1942, with the proposal that it is the archetype of the series, that it was painted from life, probably on the occasion of the famous giostra of 1475, and that the other versions are posthumous replicas.[2] If it is a life portrait it must have been painted shortly before 1478, when Giuliano died, at the age of twenty-five, a victim of the Pazzi conspiracy, which attempted the assassination of both Giuliano and his elder brother, Lorenzo the Magnificent. Several peculiarities of the painting have been interpreted as evidence that it is posthumous: the lowered eyelids, suggesting the artist's use of a death mask as model; the open 'door,' a Classical funerary symbol; the turtledove, cited in Classical and Renaissance literature as the loyal mourner. But none of this evidence is conclusive. Giuliano is shown with lowered eyelids in the Uffizi Adoration of the Magi, usually believed to have been painted no later than 1477. The open window (rather than door) valve may possibly be merely a device to give more variety to the architectural moldings in the background. And the turtledove – does it refer to the mourning of the Medici family and friends at the death of Giuliano (1478) or to the mourning of Giuliano at the death of his beloved Simonetta (1476)?[3] In any case, some of the repetitions of Giuliano's portrait were undoubtedly commissioned for political reasons, to foster the idea that the young prince was a martyr.[4]

Provenance: Conte Vittorio Cini, Venice. Wildenstein's, New York (1949). Kress acquisition, 1949.

References: (**1**) *Paintings and Sculpture from the Kress Collection*, 1956, pp. 36 ff. (catalogue by W. E. Suida and F. R. Shapley), as Botticelli. (**2**) This is the theory proposed by S. Bettini (*Botticelli*, 1942, pp. 25 ff.). R. Salvini (*Tutta la pittura del Botticelli*, 1958, pp. 47 f.), noting that the Crespi version shows the eyes slightly more open, believes it to be Botticelli's original from life and thinks K1644 as well as the Bergamo and Berlin versions are posthumous replicas. The Crespi painting has been accepted as the original life portrait by some other critics also, whose opinions were, however, published before K1644 became known. Salvini (*loc. cit.*) believes K1644 to be partly autograph. B. Berenson (*Italian Pictures . . . Florentine School*, vol. I, 1963, p. 39) lists it as by Botticelli. K. W. Forster (in *Pantheon*, vol. XXII, 1964, p. 378) refers to it as from the studio of Botticelli. (**3**) According to legend, a widowed turtledove remains faithful to its lost mate and will never again perch on a green branch, but only, as in K1644, on a dead one. Its presence in this picture is discussed by H. Friedmann (in *Studies in the History of Art Dedicated to William E. Suida*, 1959, pp. 116 ff.), who reasons that since the turtledove is specifically a symbol of conjugal fidelity and a symbol of the loyal mourner himself, its presence here labels the subject of the picture as a mourner for his beloved, not as a person being mourned. (**4**) A now-lost version which belonged to Paolo Giovio (engraving in the *Elogia* printed in 1575) shows a dagger thrust into the breast. But to harmonize with this posthumous interpretation the pose of the head, so erect and proud in the other versions, is in the engraving drooping and lifeless, and the eyeball is rolled back so that vision would be obstructed by the eyelid.

BOTTICELLI

K1432 : Figure 333

THE VIRGIN ADORING THE CHILD. Washington, D.C., National Gallery of Art (1087), since 1951.[1] Wood. Diameter, 23¾ in. (59·6 cm.). Good condition, but needs cleaning.

In the thirty-five years since K1432 first came to the attention of modern critics, its attribution to Botticelli has been accepted.[2] Proposed datings are about 1480 and about 1490, depending partly on whether the painting to which K1432 is most closely related stylistically, Botticelli's *Madonna of the Book* in the Poldi Pezzoli, Milan, is dated early or late in the decade. Two instances of Botticelli's subtle symbolism have been cited in K1432: the arch at the bottom of the picture opens into a cave, or abyss, symbolizing death or sin, over which Christ triumphs;[3] the duck, realistically depicted on the water at the right, probably symbolizes reverence, adoration.[4] Both K1432 and K2155 (Fig. 332) are related to Botticelli's drawing of the *Nativity* in the Uffizi, Florence (no. 209E).[5]

Provenance: M. Paravey, Conseiller d'État, Paris (sold, Hôtel Drouot, Paris, Apr. 13, 1878, no. 97, as Filippo Lippi). Mme. Raynaud (daughter of the former), Paris (anonymous sale, Hôtel Drouot, Paris, Dec. 16, 1929, no. 44, as Filippo Lippi; bought by the following). Wildenstein's, New York – exhibited: 'Italian Paintings of the XIV to XVI Century,' Detroit Institute of Arts, Mar. 8–30, 1933, no. 24, as Botticelli; 'A Century of Progress,' Art Institute of Chicago, June 1–Nov. 1, 1933, no. 109, as Botticelli; 'Five Centuries of European Painting,' Los Angeles County Museum, Nov. 25–Dec. 31, 1933, no. 3, as Botticelli; 'Italian Paintings of the Renaissance,' Century Association, New York, Mar. 2–24, 1935, no. 2, as Botticelli; 'Masterpieces of Art,' New York World's Fair, May–Oct., 1939, no. 21, as Botticelli; 'Masterpieces of Art from European and American Collections,' Detroit Institute of Arts, 1941, no. 4, as Botticelli; 'Italian Paintings,' Wildenstein's, New York, 1947, no. 16 of catalogue, as Botticelli. Kress acquisition, 1947.

References: (**1**) *Paintings and Sculpture from the Kress Collection*, 1951, p. 52 (catalogue by W. E. Suida), as Botticelli. (**2**) K1432 has been attributed to Botticelli by A. L. Mayer (in *Pantheon*, vol. VI, 1930, pp. 393 f., dating it *c.* 1490), R. van Marle (*Italian Schools of Painting*, vol. XII, 1931, p. 171, also dating it *c.* 1490), W. R. Valentiner (in *Pantheon*, vol. XII, 1933, p. 238), L. Venturi (*Italian Paintings in America*, vol. II, 1933, no. 246, dating it *c.* 1481), J. Mesnil (*Botticelli*, 1938, p. 225), R. Salvini (*Tutta la pittura del Botticelli*, 1958, p. 50, dating it *c.* 1491), and B. Berenson (*Italian Pictures . . . Florentine School*, vol. I, 1963, p. 38). (**3**) C. de Tolnay, in *Revue des Arts*, vol. VI, 1956, p. 163. (**4**) H. Friedmann, in *Studies in the History of Art Dedicated to William E. Suida*, 1959, pp. 120 ff. (**5**) Reproduced by Berenson, *Drawings of the Florentine Painters*, vol. III, 1938, fig. 193.

BOTTICELLI and Assistants

K2155 : Figure 332

THE ADORATION OF THE CHILD. Raleigh, N.C., North Carolina Museum of Art (GL.60.17.26), since 1960.[1] Wood. Diameter 49½ in. (125·7 cm.). Abraded throughout; Madonna's mantle repainted; many losses of paint; cleaned shortly before it was acquired by the Kress Foundation.

Recent cleaning has revealed a closer relationship of K2155 to Botticelli than was formerly recognized.[2] It can now be attributed to the master himself, probably about 1490, with studio assistance. Among the several versions of the composition, K2155 is unique in including the cavalcade of the Magi in the background, where the spirited movement of horses and riders recalls distant figures in Botticelli's *St. Sebastian* in the Berlin Museum.

Provenance: John Francis Austen, Capel Manor, Hors-monden, Kent – exhibited: 'Early Italian Art,' New Gallery, London, 1893–94, no. 130, as Botticelli. Austen sale, Christie's, London, Mar. 18, 1921, no. 77, as Botticelli; but apparently bought in by the Austen estate's trustees, who sold it at Christie's, July 10, 1931, no. 45, as Botticelli, to Smith. Earl of Crawford and Balcarres, London. International Financing Co., S.A., Panama. Kress acquisition, 1956 – exhibited, after entering the North Carolina Museum of Art: 'Art Treasures for America,' National Gallery of Art, Washington, D.C., Dec. 10, 1961–Feb. 4, 1962, no. 11, as Botticelli.

References: (1) Catalogue by F. R. Shapley, 1960, p. 62, as Botticelli. (2) W. von Bode (*Botticelli*, 1926, pp. 127, 149) thought K2155 wrongly ascribed to Botticelli; R. van Marle (*Italian Schools of Painting*, vol. XII, 1931, p. 269) attributed it to Botticelli's school; R. L. Douglas (*Piero di Cosimo*, 1946, p. 50) gives it to a follower of Botticelli; B. Berenson (*Italian Pictures . . . Florentine School*, vol. I, 1963, p. 38) attributes it to his studio. Note the similarity of the foreground figures to those in Botticelli's drawing of the *Nativity*, Uffizi no. 209E, reproduced by Berenson in *Drawings of the Florentine Painters*, vol. III, 1938, fig. 193.

Attributed to BOTTICELLI

K1311 : Figure 337

MADONNA AND CHILD WITH ANGELS. Washington, D.C., National Gallery of Art (714), since 1946. Wood. 35 × 23⅝ in. (89 × 60 cm.). Good condition except for some losses of paint, especially in robes and background; cleaned 1955.

The composition derives from Fra Filippo Lippi's *Madonna* with the Child upheld by angels in the Uffizi, Florence. K1311 is one of several variants, of which the one in the Ospedale degli Innocenti, Florence, is the simplest in detail and perhaps the earliest. Like the other variants, K1311 is sometimes attributed to the young Botticelli, about 1465/70, and sometimes to Filippo Lippi.[1] A striking similarity to the presumed self-portrait in the Uffizi *Adoration of the Magi* has been cited as evidence that the angel facing left in K1311 may be a self-portrait of the youthful Botticelli.[2]

Provenance: Charles Sedelmeyer, Paris (*One Hundred Masterpieces of Painting*, 1914, no. 63, as Filippo Lippi). Duveen's, New York – exhibited: Cincinnati Art Museum, 1925; 'Old Masters,' Detroit Institute of Arts, Mar. 22–Apr. 4, 1926, no. 6, as Botticelli. Mrs. Nicholas F. Brady, Manhasset, L.I., N.Y. William J. Babington Macaulay (married Mrs. Brady, 1937). Duveen's, New York. Kress acquisition, 1942.

References: (1) K1311 has been attributed to the youthful Botticelli by B. Berenson (*Italian Pictures of the Renaissance*,

1932, p. 104; Italian ed., 1936, p. 90; *Italian Pictures . . . Florentine School*, vol. I, 1963, p. 38). C. Gamba (*Botticelli*, 1936, p. 94), S. Bettini (*Botticelli*, 1942, p. 6). R. Salvini (*Tutta la pittura del Botticelli*, 1958, p. 67), who had not seen the painting, treats it among the works attributed to Botticelli, with a tendency to favor the attribution (see also in *Scritti di storia dell'arte in onore di Mario Salmi*, vol. II, 1962, p. 300). The attribution to Botticelli is rejected by J. Mesnil (*Botticelli*, 1938, p. 194 n. 10), without substitution of another. See *Provenance* for attribution to Filippo Lippi. (2) This suggestion was made by Prof. Mario Modestini, who cleaned K1311 a few years ago and believes that it is by Botticelli.

Attributed to BOTTICELLI

K1410 : Figure 331

THE NATIVITY. Columbia, S.C., Columbia Museum of Art (54-402/10), since 1954.[1] Fresco transferred to canvas primed and cradled. 63½ × 54 in. (161·3 × 137·2 cm.). Fair condition; but heavily restored.

The composition is familiar in fifteenth-century Florentine art. Most of its features are seen, for example, in the terracotta relief (K288) of about 1470 attributed to Verrocchio in the National Gallery of Art, Washington, D.C., and especially close parallels for the pair of shepherds and the wooden shelter are found as early as 1450 in a predella panel of Gozzoli's *Madonna della Cintola* in the Vatican Pinacoteca. K1410 shows characteristics of Botticelli's early style, about 1475, and most critics have attributed it to the master himself.[2] Well-known drawings by Botticelli[3] are related to the groups of the Holy Family and the three singing angels (the latter group much restored in the fresco).

Provenance: Sir William Neville Abdy, Newdigate, Dorking, England – exhibited: 'Exposition de Tableaux . . . au profit de l'Oeuvre des Orphelins . . .,' Louvre, Paris, 1885, no. 312, as Filippino Lippi; Museum of Fine Arts, Budapest, 1909–11. Abdy sale, Christie's, London, May 5, 1911, no. 86, as Botticelli; bought by Prideaux. Marczell von Nemes, Budapest, 1912 – exhibited: State Museum, Düsseldorf, 1912, no. 3, as Botticelli. Nemes sale, Galerie Manzi, Paris, June 17, 1913, no. 4, as Botticelli (bought by the following). M. Broux-Gilbert, Paris. Charles Sedelmeyer, Paris (catalogue of 12th Series, 1913, p. 62, no. 39, as Botticelli). Staatliche Museen, Berlin (from c. 1935; sold, Julius Böhler's, Munich, June 1–2, 1937, no. 654, pl. 48 of catalogue, where the fresco is shown before restoration). Duveen's, New York. Kress acquisition, 1946 – exhibited: National Gallery of Art, Washington, D.C. (879), 1946–53, as Botticelli.

References: (1) Catalogue by W. E. Suida, 1954, pp. 26 ff., and by A. Contini Bonacossi, 1962, pp. 66 ff., as Botticelli,

c. 1475. (**2**) B. Berenson and L. Venturi (in ms. opinions) attribute K1410 to Botticelli; but Berenson later (*Italian Pictures . . . Florentine School*, vol. I, 1963, p. 33) gives it to his studio. G. von Terey (*Katalog . . . Nemes*, 1912, no. 3), A. L. Mayer (in *Westermann Monatshefte*, vol. CXIII, 1912, p. 540), G. Biermann (in *Der Cicerone*, vol. V, 1913, p. 374), G. Mourey (tentatively, in *Les Arts*, June 1913, p. 2), F. de Miomandre (in *L'Art et les Artistes*, vol. XVI, 1913, p. 251), É. Dacier (in *Revue de l'Art Ancien et Moderne*, vol. XXXIII, 1913, p. 458), and S. Reinach (*Répertoire de peintures*, vol. IV, 1918, p. 76) attribute it to Botticelli. R. van Marle (*Italian Schools of Painting*, vol. XII, 1931, p. 272) lists it as by the school of Botticelli. (**3**) Reproduced by B. Berenson, *The Drawings of the Florentine Painters*, vol. III, 1938, figs. 192 f.

Attributed to BOTTICELLI

K 591 (formerly K 8917) : Figure 327

CHRIST ON THE CROSS. Portland, Ore., Portland Art Museum (61.54), since 1952.[1] Wood. $21\frac{7}{8} \times 15\frac{3}{4}$ in. (55.5×40 cm.). Very much worn; heavily restored; cleaned 1952.

Although its condition precludes a definite attribution, K591 is close in composition and style to the Christ in the *Mystic Crucifixion* generally ascribed to Botticelli in the Fogg Museum, Cambridge, with which it shares also the pronounced pathos inspired by Savonarola. For these reasons it has been attributed to Botticelli, about 1500.[2] Having been cut out around the contours of the figure and cross,[3] a practice seldom followed in Florentine art outside the circle of Lorenzo Monaco, K591 was probably used as a processional cross; hence the paint is worn from much handling.

Provenance: Contini Bonacossi, Florence. Kress acquisition, 1936 – exhibited: National Gallery of Art, Washington, D.C. (112), 1941–52.[4]

References: (**1**) Catalogue by W. E. Suida, 1952, p. 34, as Botticelli. (**2**) K591 has been attributed to Botticelli by G. Fiocco, R. Longhi, R. van Marle, F. M. Perkins, A. Venturi (in ms. opinions), and B. Berenson (*Italian Pictures . . . Florentine School*, vol. I, 1963, p. 38). (**3**) Cf. K1734 by Cosimo Rosselli (Fig. 326). (**4**) *Preliminary Catalogue*, 1941, p. 29, as Botticelli.

Follower of BOTTICELLI

K 1240 : Figure 336

MADONNA AND CHILD. El Paso, Tex., El Paso Museum of Art (1961-6/11), since 1961.[1] Wood (probably rect-

angular originally). Mean diameter $33\frac{1}{4}$ in. (84.5 cm.). Good condition except for slight abrasions.

This type of Madonna, with the faces of Mother and Child pressed together in an impulsive gesture of affection and apprehension, was developed by Botticelli in his late period, probably between 1500 and 1510, when he had come under the influence of Savonarola and was looking back to the mystically religious sculptures of Donatello. There are a number of variants of the composition and it is often difficult, as in the case of K1240, to determine whether they are close enough to the master to have been executed in his studio.[2]

Provenance: Comte de Sarty, Paris. Baron de Vandeuvre, Paris – exhibited: 'Exposition des Alsaciens-Lorrains,' Palais de la Présidence du Corps Legislatifs, Paris, 1874, no. 671, as Botticelli. Duveen's, New York (*Duveen Pictures in Public Collections of America*, 1941, no. 105, as Botticelli) – exhibited: 'Old Masters,' Detroit Institute of Arts, Mar. 22– Apr. 4, 1926, no. 7, as Botticelli; 'Old and Modern Masters,' Detroit Institute of Arts, Oct. 1927, no. 8, as Botticelli; 'Primitives,' Knoedler Galleries, New York, Feb. 16–Mar. 2, 1929, no. 6, as Botticelli. 'Italian Paintings from the XIV to XVI Century,' Detroit Institute of Arts, Detroit, Mich., Mar. 8–30, 1933, no. 23, as Botticelli. Kress acquisition, 1940 – exhibited: National Gallery of Art, Washington, D.C. (535), 1941–58.[3]

References: (**1**) Catalogue by F. R. Shapley, 1961, no. 11, as Botticelli. (**2**) K1240 has been attributed to Botticelli by A. Venturi (in *L'Arte*, vol. XXVII, 1924, pp. 194 f.; *Botticelli*, 1925, pp. 58 f.), C. Gamba (*Botticelli*, 1937, pp. 181 f.), J. Mesnil (*Botticelli*, 1938, p. 163), and B. Berenson (in ms. opinion), who later (1955) doubted the attribution, which appears as accepted, however, in the posthumous edition of his Florentine lists (vol. I, 1963, p. 34). K1240 is attributed to the school of Botticelli by R. van Marle (*Italian Schools of Painting*, vol. XII, 1931, p. 230) and R. Salvini (*Tutta la pittura del Botticelli*, 1958, p. 77), who plausibly suggests that it may be by the same hand as the *Madonna* formerly in the Trotti Collection, Paris, which Salvini reproduces in his pl. 151B. (**3**) *Preliminary Catalogue*, 1941, pp. 29 f., as Botticelli.

DOMENICO GHIRLANDAIO

Domenico Corradi Bigordi, called Ghirlandaio. Florentine School. Born 1449; died 1494. He was a pupil of Baldovinetti but probably studied first under Verrocchio. In his prolific production, especially in fresco, he employed assistants and his style attracted many followers. His activity, aside from the vast demands upon it in Florence, took him to San Gimignano, to Pisa, and to Rome.

K2076 : Figure 344

MADONNA AND CHILD. Washington, D.C., National Gallery of Art (1412), since 1956.[1] Transferred from wood to masonite. $28\frac{7}{8} \times 20$ in. (73.4×50.8 cm.). Very good condition except for background, which is partly regilded; transferred from wood to masonite and cleaned 1954.

Sold a few years ago as by Verrocchio, K2076 was at once cited as a typical example of Verrocchio's influence upon the young Ghirlandaio.[2] It may have been painted about 1470, as early as the fresco attributed to Ghirlandaio in Sant'Andrea, Brozzi, near Florence. The Virgin's headdress is an invention of Verrocchio's, the Child's sculpturesque ringlets recall that master; even the oval brooch on the Virgin's breast and the striped sashes probably come from Verrocchio's studio. But the facial types and the articulation of the fingers, which are without Verrocchio's tenseness, point in the direction Ghirlandaio was to follow in his long series of *Madonnas*. The gold background is the most difficult feature of K2076 to explain. Could it be a later addition, covering what was originally an architectural or landscape background? X-ray examination throws no specific light on the problem.

Provenance: Mrs. E. L. Scott (sold, Sotheby's, London, Apr. 22, 1953, no. 32, as Verrocchio; bought by the following). Hazlitt Gallery, London. Contini Bonacossi, Florence. Kress acquisition, 1954.

References: (**1**) *Paintings and Sculpture from the Kress Collection*, 1956, p. 88 (catalogue by W. E. Suida and F. R. Shapley), as Domenico Ghirlandaio. (**2**) B. Berenson (*Italian Pictures . . . Florentine School*, vol. I, 1963, p. 77; and in ms. opinion, which was based on his study of the young Ghirlandaio in *Bollettino d'Arte*, vol. XXVII, 1933, pp. 241 ff.) and F. Zeri (in *ibid.*, vol. XXXVIII, 1953, p. 139 n. 15) attribute K2076 to the young Ghirlandaio under the strong influence of Verrocchio.

DOMENICO GHIRLANDAIO

K1725 : Figure 334

LUCREZIA TORNABUONI. Washington, D.C., National Gallery of Art (1141), since 1951.[1] Wood. $21 \times 15\frac{3}{4}$ in. (53.3×40 cm.). Inscribed on back: . . . TORNABUONI. . . . Fair condition; face area looks very thin, but could have been painted thus.

Close stylistic relationship to Ghirlandaio's Vespucci fresco, of 1473, in Ognissanti, Florence, and to his Santa Fina frescoes, of 1475, in the Collegiata at San Gimignano,

supports the attribution of K1725 to Ghirlandaio, with a date in the 1470's.[2] The most striking parallel, perhaps, is with the portraits of the two attendants in the scene of the *Annunciation of Santa Fina's Death*. Just at the time that a study of Medici family features was leading toward the identification of Lucrezia Tornabuoni, mother of Lorenzo the Magnificent, in one of Ghirlandaio's frescoes in Santa Maria Novella, Florence (the woman immediately preceding the running servant in the *Birth of John the Baptist*),[3] K1725 first came to attention, portraying, apparently, the same woman and bearing on the back of the panel an inscription which was read by Procacci in 1950, when the picture was in Rome for restoration, as LU . . . TIA TORNA-BUONI MEDICI.[4] The sitter is older in the fresco, which was painted in 1486, four years after Lucrezia had died, at the age of 57.[5] She seems to be about 45 or 50 in K1725, which would agree with a date toward 1475. The death of her husband, Piero de' Medici (Il Gottoso), in 1469, would explain the mourning band on her veil.[6]

Provenance: William Graham, Burntshields, England (probably sold, Christie's, London, Apr. 8, 1886, no. 200, as D. Ghirlandaio). Sir Kenneth Muir MacKenzie, P.C., London. Frank T. Sabin's, London – exhibited: 'Gems of Painting,' Sabin Galleries, London, 1937; catalogued by A. Scharf as portrait of Nera Corsi, 1479, by Domenico Ghirlandaio. Mrs. Mark Hambourg, London. Contini Bonacossi, Florence. Kress acquisition, 1950.

References: (**1**) *Paintings and Sculpture from the Kress Collection*, 1951, p. 56 (catalogue by W. E. Suida), as Florentine School, *c.* 1475, possibly Domenico Ghirlandaio. (**2**) K1725 has been attributed to the young Ghirlandaio by A. Scharf (*loc. cit.* in *Provenance*, above), G. Pieraccini (in *Rivista d'Arte*, vol. XXVII, 1952, pp. 177 ff.), G. Marchini (in *Burlington Magazine*, vol. XCV, 1953, p. 320), and by B. Berenson and R. Longhi (in ms. opinions); but it is omitted from the post-humous 1963 edition of Berenson's Florentine lists and I am informed that it will be included as Ferrarese in the revised edition, now in preparation, of his North Italian lists. (**3**) G. Pieraccini, *loc. cit.* in note 2, above. (**4**) *Ibid.* However, even with the help of infra-red photography, only the word *Tornabuoni* is now definitely decipherable. As for the preceding and following words, it can only be said that infra-red photography does not prove Procacci's reading incorrect. (**5**) G. Marchini (*loc. cit.* in note 2, above) assumes that the fresco portrait was copied by one of Domenico's assistants from K1725. (**6**) A. Scharf (*loc. cit.* in *Provenance*, above) suggested an identification of the sitter in K1725 as Nera Corsi, wife of Francesco Sassetti, at an earlier age than she is shown in Ghirlandaio's portrait of her in the Santa Trinita fresco, Florence. He dates K1725 tentatively in 1479, explaining the mourning band on her veil by the death of her eldest son in that year.

Studio of DOMENICO GHIRLANDAIO

K1726 : Figure 338

THE CORONATION OF THE VIRGIN. Denver, Colo., Denver Art Museum (E-IT-18-XV-934), since 1954.[1] Wood. 42⅞×60½ in. (108·9×153·7 cm.). Fragment; bottom part missing; fair condition except for many losses of paint throughout; slightly cleaned 1951.

Fiorenzo di Lorenzo, Mainardi, and Domenico Ghirlandaio have each been credited with this painting,[2] and the suggestion has been made that it may be the *Coronation* which, according to documents, Ghirlandaio painted in 1478/79 for the large hall of the Opera del Duomo, Pisa.[3] The drawing and modeling of the figures in K1726 are more suggestive of his studio, around 1490, than of Ghirlandaio himself. The closest parallel, perhaps, is offered by the painting of the *Madonna in Glory with Six Saints* in the Museum at San Gimignano, which is attributed to Mainardi.[4] K1726 may have lost a few inches at the bottom: the two saints, John the Baptist and John the Evangelist, were probably originally full-length and the broad view over the valley may have extended to the foreground. On three sheets in the British Museum, London, are drawings which correspond to the figures of the Virgin, Christ, and the two musical angels at the left in K1726. Whether the drawings are based on the painting or the painting is based on them is uncertain. They were probably drawn by someone in the circle of Ghirlandaio.[5] The musical instruments played by the angels in the upper zone of K1726 have been identified as, from left to right: an Early Renaissance lute with eight strings, a frame drum, a pair of cymbals, and a *lira da braccio*.[6]

Provenance: In an anonymous sale at Christie's, London, Dec. 10, 1937, no. 96, as Fiorenzo di Lorenzo (bought by Bernard). Contini Bonacossi, Florence. Kress acquisition, 1950 – exhibited: National Gallery of Art, Washington, D.C., 1951.[7]

References: (1) Catalogue by W. E. Suida, 1954, p. 26, as Domenico Ghirlandaio. (2) For the attribution to Fiorenzo di Lorenzo, see *Provenance*, above. K1726 has been attributed to Mainardi by B. Berenson (*Italian Pictures . . . Florentine School*, vol. I, 1963, p. 126) and to Domenico Ghirlandaio by R. Longhi (in ms. opinion). Reasons for abandoning attributions to Mainardi are discussed by M. Davies, *National Gallery Catalogues: The Earlier Italian Schools*, 1961, p. 326. (3) Suida, *loc. cit.* in note 1, above. (4) Cf. also the Ghirlandaio studio *Madonna in Glory with Four Saints* in the Berlin Museum. Here the two principal saints are, again, the Baptist and John the Evangelist. (5) B. Berenson (*Drawings of the Florentine Painters*, vol. I, 1938, p. 71) attributes the drawings to Francesco Botticini, *c.* 1465; A. E. Popham and P. Pouncey (*Italian Drawings . . . British Museum*, 1950, nos. 28–30) attribute them to Raffaello Botticini; and W. E.

Suida (*loc. cit.* in note 1, above), relates them to Filippino Lippi or Raffaellino del Garbo. (6) The instruments were identified by E. Winternitz, of the Metropolitan Museum, New York (in letters of May 26 and 27, 1953). (7) *Paintings and Sculpture from the Kress Collection*, 1951, p. 58 (catalogue by W. E. Suida), as Domenico Ghirlandaio.

Studio of DOMENICO GHIRLANDAIO

K1147 : Figure 340

MADONNA AND CHILD. Hartford, Conn., Trinity College, Study Collection, since 1961.[1] Wood. Diameter, 14 in. (35·6 cm.). Extensively damaged.

That the style of K1147 places it in the milieu of Domenico Ghirlandaio has not been doubted. It has been tentatively assigned in part to Domenico himself and to his brother Davide.[2] Although it shows the tendency in Domenico's followers toward greater softness of modeling, more delicacy of feature and sweetness of expression, it is close enough to Domenico's style to have been painted in his studio, probably toward 1490. It is a fragment of a larger painting, in which the Child, similar to the one in Domenico's altarpiece in Sant'Andrea, Brozzi, near Florence, was probably shown, as there, making the sign of blessing.

Provenance: Contini Bonacossi, Florence. Kress acquisition, 1938.

References: (1) J. C. E. Taylor, in *Cesare Barbieri Courier*, vol. IV, 1961, p. 19, as Davide or Domenico Ghirlandaio or a follower. (2) K1147 has been attributed tentatively to the early Domenico Ghirlandaio by B. Berenson (*Italian Pictures . . . Florentine School*, vol. I, 1963, p. 75); to Davide Ghirlandaio by A. Venturi, and tentatively to Davide by G. Fiocco, R. Longhi, F. M. Perkins, and W. E. Suida (in ms. opinions).

Follower of
DOMENICO GHIRLANDAIO

K298 : Figure 341

MADONNA AND CHILD. Charlotte, N.C., Mint Museum of Art (36·1), since 1936. Wood. Diameter, 33⅝ in. (85·4 cm.).

Only the very mannered pose of the figures and treatment of drapery throw doubt on the former attribution of K298 to Granacci.[1] Among the followers of Ghirlandaio, both

Granacci and Bartolommeo di Giovanni offer fairly close stylistic parallels. The date is probably about 1500.

Provenance: Contini Bonacossi, Florence. Kress acquisition, 1934.

Reference: (1) K298 has been attributed to Granacci by G. Fiocco, R. Longhi, R. van Marle, A. Venturi (in ms. opinions), and B. Berenson (*Italian Pictures . . . Florentine School*, vol. I, 1963, p. 98).

Follower of
DOMENICO GHIRLANDAIO

K267 : Figure 339

MADONNA AND CHILD WITH ST. JOHN AND ANGELS
Birmingham, Ala., Birmingham Museum of Art (61.97) since 1952.[1] Wood. Diameter, 33½ in. (85·1 cm.). Good condition.

This has usually been attributed to Sebastiano Mainardi,[2] a pupil, and possibly assistant, of Ghirlandaio, with a date of about 1500. But there now seems to be insufficient evidence on which to base any attributions to Mainardi.[3] Many versions of K267 are known,[4] some corresponding closely to it in composition, some including fewer angels or none. One of the finest versions, in the Louvre, Paris, is virtually a duplicate of K267 in composition. The scene through the arcade at the right is recognized as a view of Venice.

Provenance: W. Hekking, Holland. P. A. B. Widener, Philadelphia (bought from Nardus, 1899; sold 1910, to Sulley; Widener ms. catalogue, vol. I, 1908, p. 158, attributed to Ghirlandaio and Mainardi). Contini Bonacossi, Florence. Kress acquisition, 1933 – exhibited: 'Italian Paintings Lent by Mr. Samuel H. Kress,' Sept. 1933, Seattle, Wash., through June 1935, Charlotte, N.C., p. 20 of catalogue, as Mainardi; National Gallery of Art, Washington, D.C. (244), 1941–51.[5]

References: (1) Catalogue by W. E. Suida, 1952, p. 43, and 1959, p. 59, as Mainardi. (2) K267 has been attributed to Mainardi by G. Fiocco, R. Longhi, R. van Marle, F. M. Perkins, A. Venturi (in ms. opinions), and B. Berenson (*Pitture italiane del rinascimento*, 1936, p. 287; *Italian Pictures . . . Florentine School*, vol. I, 1963, p. 126). (3) Reasons for abandoning attributions to Mainardi are discussed by M. Davies, *National Gallery Catalogues: The Earlier Italian Schools*, 1961, p. 326. (4) For a partial list of the versions see B. Berenson, *Italian Pictures . . . Florentine School*, vol. I, 1963, p. 127, under *Paris 1367*. (5) *Preliminary Catalogue,*

1941, pp. 120 f., as Mainardi; here the provenance data seems to be in error.

Follower of
DOMENICO GHIRLANDAIO

K487B : Figure 342
ST. MICHAEL

K487A : Figure 343
ST. DOMINIC

Portland, Ore., Portland Art Museum (61.56 and 61.57), since 1952.[1] Wood. K487A, 31⅝×16½ in. (80·3×41·9 cm.); K487B, 31⅞×15⅞ in. (81×40·3 cm.). Fair condition except for abrasion throughout (especially in the legs and flesh tones of K487B) and a few losses of paint.

Although these two panels, evidently from a dismembered altarpiece, have been attributed to Domenico Ghirlandaio himself,[2] the weaker, looser drawing and modeling seem to point to execution by a follower, around 1500. This follower worked from Domenico's designs, or he may have followed an immediate pupil's interpretation of the master's designs. The model for K487A seems to have been a panel of *St. Vincent Ferrer* in the Berlin Museum which comes from Ghirlandaio's altarpiece for Santa Maria Novella, Florence. The *St. Vincent* is believed to be one of the panels finished by pupils after Ghirlandaio's death and its execution is generally attributed to Granacci. K487A follows the composition of this panel faithfully except in the head and right hand of the saint. The model for K487B was the *St. Michael* in Domenico Ghirlandaio's altarpiece of about 1484 in the Uffizi, Florence, which furnished also the model for the frieze with the tops of cypresses and an orange tree above. But the trees are conventionalized in K487B and are entirely different in K487A. The lithe Pollaiuolesque pose of Michael has been lost, too, by the placing of his right foot flat on the ground.

Provenance: Mrs. Herbert Obergavering, England. Contini Bonacossi, Florence. Kress acquisition, 1937 – exhibited: National Gallery of Art, Washington, D.C. (381, 380), 1941–51;[3] after entering the Portland Art Museum: 'Art Treasures for America,' National Gallery of Art, Washington, D.C., Dec. 10, 1961–Feb. 4, 1962, nos. 34, 35, as Domenico Ghirlandaio.

References: (1) Catalogue by W. E. Suida, 1952, p. 32, as Domenico Ghirlandaio. (2) K487A and B have been attributed to Domenico Ghirlandaio by G. Fiocco, R. Longhi, F. M. Perkins, A. Venturi (in ms. opinions) and B. Berenson (*Italian Pictures . . . Florentine School*, vol. I, 1963,

Pietà attributed to Filippino in the Robert von Mendelssohn Collection, Berlin.

Provenance: Aldrovandi, Florence. Contini Bonacossi, Florence. Kress acquisition, 1935 – exhibited: National Gallery of Art, Washington, D.C. (298, 299), 1941–51.[5]

References: (1) Catalogue by F. R. Shapley, 1960, p. 64, as Filippino Lippi. (2) K342A and B have been attributed to Filippino by G. Fiocco, R. Longhi, R. van Marle, F. M. Perkins, W. E. Suida, A. Venturi (in ms. opinions), A. Scharf (*Filippino Lippi*, 1950, pp. 22, 54), L. Berti and U. Baldini (*Filippino Lippi*, 1957, p. 84), and B. Berenson (*Italian Pictures . . . Florentine School*, vol. I, 1963, p. 111). (3) Berti and Baldini, *loc. cit.* in note 2, above. (4) Scharf, *loc. cit.* in note 2, above. (5) *Preliminary Catalogue*, 1941, p. 106, as Filippino Lippi.

FILIPPINO LIPPI

K1727 : Figure 375

ST. JEROME IN HIS STUDY. El Paso, Tex., El Paso Museum of Art (1961-6/13), since 1961.[1] Wood. 19¼×14 in. (48·9× 35·5 cm.). Very good condition except for a few abrasions on the mantle; cleaned 1948.

The attribution to Filippino[2] at a date in the early 1490's is supported by stylistic similarity to the frescoes which Filippino finished in 1493 in the Caraffa Chapel, Santa Maria Sopra Minerva, Rome. A drawing (incorrectly inscribed as by Ghirlandaio) in the Cleveland Museum corresponds in most details to K1727 and may have served as cartoon for it. The parts of the drawing which are pricked for transfer correspond fairly closely to the painting; other parts correspond more closely to a contemporary engraving of the subject.[3] Both the drawing and K1727 have also been attributed to Raffaellino del Garbo.[4]

Provenance: Marchese Bernardo Patrizi (sold through Giuseppe Grassi, Rome, 1949/50). Contini Bonacossi, Florence. Kress acquisition, 1950 – exhibited: National Gallery of Art, Washington, D.C., 1951–54;[5] after entering the El Paso Museum of Art: 'Art Treasures for America,' National Gallery of Art, Washington, D.C., Dec. 10, 1961–Feb. 4, 1962, no. 53, as Filippino Lippi.

References: (1) Catalogue by F. R. Shapley, 1961, no. 13, as Filippino Lippi. (2) K1727 has been attributed to Filippino by R. Longhi (in ms. opinion), L. Berti and U. Baldini (*Filippino Lippi*, 1957, pp. 42, 87), and B. Berenson (*Italian Pictures . . . Florentine School*, vol. I, 1963, p. 108). (3) A. M. Hind, *Early Italian Engravings*, vol. I, pt. I, 1938, p. 217; vol. III, pl. 316. (4) A. Scharf (in letter of Nov. 2, 1951). See

Scharf's study of a comparable drawing by Raffaellino in *Jahrbuch der preussischen Kunstsammlungen*, vol. LIV, 1933, p. 151, fig. 2. (5) *Paintings and Sculpture from the Kress Collection*, 1951, p. 54 (catalogue by W. E. Suida), as Filippino Lippi.

FILIPPINO LIPPI and Assistants

K209 : Figure 372

ST. FRANCIS IN GLORY. Memphis, Tenn., Brooks Memorial Art Gallery (61.190), since 1958.[1] Wood. 70½× 58½ in. (179·1×148·6 cm.). Inscribed on St. Francis' scroll: VENITE FILII AVDITE ME TIMORĒ DN̄I DOCEBO VOS (Come, my sons, listen to me, I will teach you the fear of the Lord). Good condition except for some losses of paint in robes and sky; cleaned 1957–58.

What seems to be a first thought for the group of St. Francis and the two kneeling figures nearest him, St. Louis IX of France and St. Elizabeth of Hungary, is found in a drawing formerly in the Palazzo Corsini, now in the Print Cabinet, Villa Farnesina, Rome.[2] Here Francis is handing scrolls (evidently the rules of the order) to the kneeling saints. On the back of the drawing is a *St. Sebastian* which has been connected with the altarpiece of St. Sebastian, in the Palazzo Bianco, Genoa, dated 1503, the approximate date, therefore, of K209, in which the composition is extended to include, at the sides, the Blessed Lucchesius of Poggibonsi and his wife, the Blessed Bona, figures largely executed, probably, by an assistant.[3] Lucchesius and Bona were Franciscan Tertiaries, and are so dressed. Also Louis IX of France and Elizabeth of Hungary were Franciscan Tertiaries. It has been suggested[4] that K209 may have been one of the altarpieces mentioned by Vasari as painted by Filippino for the Church of San Salvatore, Florence.

Provenance: Stefano Bardini, Florence. Contini Bonacossi, Florence. Kress acquisition, 1932 – exhibited: National Gallery of Art, Washington, D.C. (208), 1941–52.[5]

References: (1) Catalogue by W. E. Suida, 1958, p. 24, as Filippino Lippi. (2) Reproduced by A. Scharf, *Filippino Lippi*, 1950, fig. 140. (3) K209 has been attributed to Filippino by G. Fiocco, R. van Marle, F. M. Perkins, and A. Venturi (in ms. opinions; see also note 1, above). R. Longhi (in ms. opinion) thinks it a late Filippino probably finished by an assistant. K. B. Neilson (*Filippino Lippi*, 1938, p. 216 n. 20) thinks it a copy of a lost original by Filippino. A. Scharf (*Filippino Lippi*, 1950, pp. 42 f., 58) believes it was left unfinished by Filippino and finished in his studio, perhaps by Raffaellino del Garbo. L. Berti and U. Baldini (*Filippino Lippi*, 1957, pp. 97 f.) also consider it a late Filippino finished by his followers. B. Berenson (*Italian Pictures . . . Florentine*

School, vol. I, 1963, p. 110) attributes it to Filippino in part. (**4**) See catalogue cited in note I, above. (**5**) *Preliminary Catalogue*, 1941, p. 107, as Filippino and assistants.

Attributed to FILIPPINO LIPPI

KX-7 : Figure 376

MONSIGNOR FRANCESCO DA CASTIGLIONE. New York, N.Y., Mrs. Rush H. Kress, since 1929. Paper on canvas. 10½×8½ in. (26·7×21·6 cm.). Inscribed at top: RITRATTO DEL MTO RDO PADRE MR FRANCO DA CASTIGLIONE CONFESSORO DELLA VENEDA MRE SOR DOMCA FONDATRICE DE MONRIO DELLA CROCE DI FIRENZE (Portrait of the Very Reverend Father Monsignor Francesco da Castiglione, confessor of the Venerable Mother Suor Domenica, founder of the Monastery of the Cross in Florence). Thinly painted; considerably abraded.

Cosimo Rosselli, Piero di Cosimo, and, less tentatively, Filippino Lippi have been proposed in attributions of this portrait.[1] The sitter is identified in the inscription, which may be considerably later than the painting, as the confessor of the Venerable Madre Suor Domenica (del Paradiso), founder of the Monastery of the Cross in Florence.[2] Padre Francesco, recorded elsewhere as an Aretine who served as canon of San Lorenzo, Florence, is highly praised by later writers.[3] He was not only Suor Domenica's confessor for thirty-six years; he collected details concerning her life, her visions, her foundation of the Monastery of the Cross (in 1511), and he served as spiritual father of her sisterhood. He was evidently already Suor Domenica's confessor before 1506, the year in which he vouched for her spiritual character to the Dominican fathers of Florence. KX-7 may therefore fall within the span of Filippino's lifetime. The style of the portrait is plausibly related to that of Filippino's frescoes in the Chapel of Filippo Strozzi in Santa Maria Novella, Florence, finished in 1502.

Provenance: Contini Bonacossi, Rome. Kress acquisition, 1929.

References: (**1**) KX-7 has been attributed in ms. opinions tentatively to Filippino Lippi by R. Longhi, R. van Marle, F. M. Perkins (the last suggesting the bare possibility that it may be a sixteenth-century copy of a Filippino), and A. Venturi; tentatively to Cosimo Rosselli by W. E. Suida; and tentatively to Piero di Cosimo by G. Fiocco. B. Berenson (*Italian Pictures . . . Florentine School*, vol. I, 1963, p. 110) lists it without question as by Filippino. (**2**) W. and E. Paatz (*Die Kirchen von Florenz*, vol. I, 1940, pp. 702 ff.) trace the founding and vicissitudes of the 'Monasterio della Croce' (Convento della Crocetta), Florence. (**3**) G. Richa (*Notizie istoriche delle chiese fiorentine*, pt. 2, 1755, pp. 263 ff.), writing chiefly of the visions and works of Suor Domenica, includes some information on Padre Francesco.

GHERARDO DEL FORA

Gherardo di Giovanni di Miniato, also called Gherardo del Fora. Florentine School. Born 1445/46; died 1497. He was a follower of Ghirlandaio and Filippino Lippi and was influenced by the *sfumato* of Leonardo, who mentions him favorably in one of his manuscripts. He was active as fresco painter and especially as miniaturist, chiefly in association with his brother Monte. The miniatures in only one extant manuscript are documented as painted by him alone.[1]

K1724 : Figure 366

ST. MARY OF EGYPT BETWEEN ST. PETER MARTYR AND ST. CATHERINE OF SEINA. Brunswick, Me., Walker Art Museum, Bowdoin College, Study Collection (1961. 100.11), since 1961.[2] Wood. 16¾×11¼ in. (42·5×28·6 cm.). Good condition; cleaned 1949.

The preoccupation with details and the combination of Ghirlandaiesque figure types and Leonardesque light and shade strongly support the attribution of K1724 to the miniaturist Gherardo del Fora.[3] The combination of scenes – here the *Noli Me Tangere* is shown in the background – is characteristic of the miniatures from the studio of Gherardo and his brother Monte. Some influence of Filippino Lippi also is seen here, especially in the St. Mary of Egypt. Crowns descending in rays of light upon the head of St. Peter Martyr seem to be unique to this picture. The date is probably near the end of the century.

Provenance: Tornabuoni, Florence. Contini Bonacossi, Florence. Kress acquisition, 1950.

References: (**1**) M. Levi D'Ancona, *Miniatura e miniatori a Firenze . . .*, 1962, pp. 127 ff., 306. See also G. S. Martini, *La bottega di un cartolaio fiorentino . . .*, 1956, for documents on Gherardo and other members of the family. (**2**) *Bulletin of the Walker Art Museum*, vol. I, no. 1, 1961, p. 8, as Gherardo del Fora. (**3**) K1724 is attributed (in ms. opinion) by R. Longhi to Gherardo del Fora.

MASTER OF THE STRATONICE CASSONI

Tuscan School. Active last quarter of fifteenth century. The story of Stratonice on two cassone panels in the Huntington Museum, San Marino, Calif., suggested the designation of this artist, whose style shows the influence of the Sienese

masters Francesco di Giorgio and Matteo di Giovanni, and of the Florentines Botticelli and Filippino Lippi.[1]

K 2067 : Figure 367

ENTHRONED MADONNA AND CHILD WITH SAINTS AND ANGELS. Birmingham, Ala., Birmingham Museum of Art (61.124), since 1959.[2] Wood. $56 \times 43\frac{1}{2}$ in. (142·2 × 110·5 cm.). Good condition except at joints of panel; cleaned 1955.

This has been treated as a key picture in the master's oeuvre.[3] Florentine influence dominates it, almost to the exclusion of Sienese; the reflection of the fully developed Filippino Lippi in the types and poses of the figures and in the elaborate decoration of the throne points to a date of about 1500. St. Agatha kneels at the right. The martyr saint at the left has not been definitely identified; the most tempting suggestion is that she is St. Ursula and that the altarpiece may have been painted for the Church of St. Agatha in the Via San Gallo, Florence.[4] The nuns of St. Ursula were incorporated with the cloister of St. Agatha in 1435.[5]

Provenance: John Watkins Brett, London (sold Christie's, London, Apr. 5–18, 1864, no. 820, as Filippino Lippi; bought by Colnaghi's). Francis Austen, London – exhibited: Royal Academy, London, 1877, no. 182, as Italian School. Mrs. Austen, London – exhibited: 'Early Italian Art,' New Gallery, London, 1893–94, no. 113, as Filippo Lippi. John Francis Austen, Capel Manor, Horsmonden, Kent (sold, Christie's, London, Mar. 18, 1921, no. 82, as Filippo Lippi, but apparently bought by the Austen estate's trustees, who sold it at Christie's, July 10, 1931, no. 64, as Filippo Lippi, to H. Howard). Contini Bonacossi, Florence. Kress acquisition, 1954.

References: (**1**) B. Berenson (in *Dedalo*, vol. XI, 1931, pp. 735 ff., and in *International Studio*, March 1931, p. 40) was the first to characterize the Stratonice Master and outline his oeuvre. (**2**) Catalogue by W. E. Suida, 1959, pp. 50 f., as Stratonice Master. (**3**) B. Berenson (*loc. cit.* in note 1, above) and R. van Marle (*Italian Schools of Painting*, vol. XVI, 1937, p. 512. (**4**) Suggested by C. del Bravo (in *Paragone*, no. 129, 1960, p. 35). F. Zeri (in *Burlington Magazine*, vol. XCIII, 1951, pp. 117 f.) attributes to the Stratonice Master an *Annunciation* in another church (San Giovannino dei Cavalieri) in the same street in Florence. (**5**) W. and E. Paatz, *Die Kirchen von Florenz*, vol. I, 1940, p. 15 n. 54.

DOMENICO DI BARTOLO

Sienese School. Active 1428–c. 1446. Probably an early sojourn in Florence inspired him through the example of Masaccio and the inquiring spirit of the early Renaissance. Whether he was influenced by Filippo Lippi or Filippo was influenced by him is a disputed matter. He seems to have been impressed by Domenico Veneziano and by Jacopo della Quercia, among others. His fresh, progressive work belongs to his early period; later he succumbed in a measure to Sienese conservatism.

K1388 : Figure 377

MADONNA AND CHILD ENTHRONED WITH ST. PETER AND ST. PAUL. Washington, D.C., National Gallery of Art (706), since 1945. Wood. $20\frac{3}{4} \times 12\frac{1}{4}$ in. (53×31 cm.). Very good condition.

At first assigned in modern criticism to Domenico di Bartolo,[1] K1388 was then attributed to the early period of Filippo Lippi.[2] Now, after years of recognition as one of the most significant keys to the stylistic development of about 1430, it is unanimously attributed to Domenico di Bartolo.[3] It probably dates a little earlier than the *Madonna with Angels*, of 1433, in the Pinacoteca, Siena, Domenico's masterpiece.

Provenance: Earl of Ashburnham, Ashburnham Place, Battle, Sussex. Duveen's, London and New York (as early as 1919) – exhibited: Bache Collection, New York, Apr. 27–May 27, 1943.[4] Kress acquisition, 1944.

References: (1) O. Sirén (in ms. opinion, 1919) and R. van Marle (*Italian Schools of Painting*, vol. IX, 1927, p. 544). (2) G. Pudelko (in *Art Bulletin*, vol. XVIII, 1936, pp. 107 f.) uses this as an example of the influence of Masaccio and Domenico Veneziano on the early Filippo. It is reported, however (by Ragghianti, *loc. cit.* in note 3, below), that Pudelko later withdrew the Filippo attribution in favor of Domenico di Bartolo. (3) Among those who follow the early attribution of K1388 to Domenico di Bartolo are C. L. Ragghianti (in *Critica d'Arte*, Aug.–Dec. 1938, pp. XXII f.), R. Longhi (in *Critica d'Arte*, July–Dec. 1940, p. 178), R. Oertel (*Fra Filippo Lippi*, 1942, p. 15), J. Pope-Hennessy (in *Burlington Magazine*, vol. LXXXIV, 1944, p. 119), E. Carli (*Capolavori dell'arte senese*, 1947, pp. 62 f.), and C. Brandi (*Quattrocentisti senesi*, 1949, pp. 107 ff., 262). B. Berenson (in ms. opinion) classified K1388 as Florentine, between Filippo Lippi and Domenico Veneziano, possibly

an early Pesellino; but it is not included in his *Italian Pictures . . . Florentine School*, 1963. (4) Further information about this exhibition has been unattainable.

SASSETTA

Stefano di Giovanni di Consolo da Cortona, called Sassetta. Sienese School. Active from 1423; died 1450. Influenced by Gentile da Fabriano, and also probably by French miniaturists and such Florentine painters as Masolino, Masaccio, and Fra Angelico, Sassetta nevertheless developed a thoroughly original style. A group of paintings, dating from the 1430's, formerly included in his oeuvre on the assumption that there was a 'Gothic interlude' in his development, are now generally attributed to a member of his studio, identified as the Osservanza Master, from a triptych in the Osservanza, Siena, or as the early Sano di Pietro.

K443 : Figure 383

MADONNA AND CHILD. Washington, D.C., National Gallery of Art (357), since 1941.[1] Wood. $19 \times 8\frac{3}{8}$ in. ($48\cdot3 \times 21\cdot3$ cm.). Very good condition except for darkening of the Madonna's blue mantle; cleaned 1955.

Almost unanimously accepted as by Sassetta,[2] K443 belongs to a series of *Madonnas*, of around 1435, one of which, the large *Madonna and Child Crowned by Two Angels*, in the Siena Pinacoteca, is signed. The poses of the Mother and Child in K443 are closely paralleled in a panel in the Cathedral at Grosseto. To prove Sassetta's authorship of K443 beyond a doubt it is enough to compare the Child here with the Child in the Grosseto panel and with the one in the altarpiece of the *Madonna of the Snow*, now in the Contini Bonacossi Collection, Florence. The figure in the pinnacle is possibly a conflation of the Saviour with God the Father, since He wears a cruciform nimbus, yet is borne up by cherubim, and from Him descends the dove of the Holy Ghost.

Provenance: Steinmeyer, Lucerne (c. 1929). Edward Hutton, London. Contini Bonacossi, Florence. Kress acquisition, 1936.

References: (1) *Preliminary Catalogue*, 1941, p. 180, as Sassetta. (2) K443 has been published as a typical example of Sassetta by R. van Marle (in *La Diana*, vol. IV, 1929, pp.

309 f.), with the suggestion that the type of Child indicates the influence of Giovanni di Paolo. B. Berenson (*Italian Pictures of the Renaissance*, 1932, p. 512; Italian ed., 1936, p. 440), J. Pope-Hennessy (*Sassetta*, 1939, pp. 68 f., denying the influence of Giovanni di Paolo). A. Graziani (in *Proporzioni*, vol. II, 1948, p. 80), E. Sandberg-Vavalà (*Sienese Studies*, 1953, p. 236), E. Carli (*Sassetta*, 1957, pp. 38, 40), G. Fiocco, R. Longhi, F. M. Perkins, W. E. Suida, and A. Venturi (in ms. opinions) attribute K443 to Sassetta. Only C. Brandi (*Quattrocentisti senesi*, 1949, p. 190 n. 32), while noting that K443 is in the taste of Sassetta, thinks it does not qualify as his work.

SASSETTA and Assistant

K1367 : Figure 378

ST. ANTHONY DISTRIBUTING HIS WEALTH TO THE POOR. Washington, D.C., National Gallery of Art (817), since 1945. Wood. 18⅝×13⅝ in. (47·5×34·5 cm.). Some losses of paint, especially in some of the faces which are heavily repainted.

For the commentary, etc., see K1568, below.

Provenance: Conte Augusto Caccialupi, Macerata (catalogue by F. Raffaelli, 1870, no. 5, as *St. Martin Distributing Alms*, 50×36 cm., by Masaccio or, 'more reasonably,' by Masolino, and as excellently preserved).[1] Dr. Robert Jenkins Nevin, Rome (1906). Dan Fellows Platt, Englewood, N.J. (by 1907) – exhibited: 'Masterpieces of Art,' New York World's Fair, May–Oct., 1939, no. 347, as by Sassetta. Sold by Platt estate trustee to the following. Kress acquisition, 1943.

Reference: (1) Mrs. E. Gardner has kindly called attention to a copy of the Caccialupi catalogue in the Hertziana Library, Rome, whence a quotation of the pertinent passage has been provided. For Perkins' reference to the Masolino attribution see note 2 under K1568, p. 142, below.

SASSETTA and Assistant

K1368 : Figure 379

ST. ANTHONY LEAVING HIS MONASTERY. Washington, D.C., National Gallery of Art (818), since 1945. Wood. 18½×13¾ in. (47×35 cm.). Fair condition except for some losses of paint.

For the commentary, etc., see K1568, below.

Provenance: Conte Augusto Caccialupi, Macerata (catalogue by F. Raffaelli, 1870, no. 6, as *St. Martin Presenting Himself in Monk's Habit to Abbot Hilary to be Received into His Monastery*, 50×36 cm., by Masaccio or, 'more reasonably,' by Masolino, and as excellently preserved).[1] Dr. Robert Jenkins Nevin, Rome (1906). Dan Fellows Platt, Englewood, N.J. (by 1907) – exhibited: 'Italian Primitives,' Kleinberger Galleries, Nov. 1917, no. 52 of catalogue by O. Sirén and M. W. Brockwell, as by Sassetta; 'Masterpieces of Art,' New York World's Fair, May–Oct., 1939, no. 347-A, as by Sassetta. Sold by Platt estate trustee to the following. Kress acquisition, 1943.

Reference: (1) See note 1 under K1367, above.

SASSETTA and Assistant

K513 : Figures 380–381

THE MEETING OF ST. ANTHONY AND ST. PAUL. Washington, D.C., National Gallery of Art (404), since 1941.[1] Wood. 18¾×13⅝ in. (47·5×34·5 cm.). Good condition except for a few losses of paint.

For the commentary, etc., see K1568, below.

Provenance: Granville Edward Harcourt Vernon,[2] Grove Hall, Nottinghamshire (sold, Christie's, London, June 17, 1864, no. 270, as '*Two Monks Embracing at the Foot of a Mountain*, by P. Laurenti, of Sienna'; bought by Anthony). Wentworth Blackett Beaumont, later First Lord Allendale (died 1907). Viscount Allendale, London – exhibited: Burlington Fine Arts Club, London, 1930–31, no. 19. Duveen's, New York (from 1937; *Duveen Pictures in Public Collections of America*, 1941, no. 33, as Sassetta). Kress acquisition, 1938.

References: (1) *Preliminary Catalogue*, 1941, pp. 180 f., as Sassetta. (2) E. K. Waterhouse (in *Burlington Magazine*, vol. LIX, 1931, p. 113 n. 7) reports that an old attribution on the frame ascribes the picture to 'Pietro Laurati,' and that an old label (now lost) on the back of the frame reads: 'Lady S. Vernon, June 10, 1802.' In a communication of Dec. 15, 1964, to the Kress Foundation, Prof. Waterhouse corrects the reading of the date 1802 to 1862 and explains that in 1862 Lady Selina Vernon (later, Lady Selina Hervey) was the widow of Granville Edward Harcourt Vernon (died 1861), who had been a collector of primitives.

SASSETTA and Assistant

K1568 : Figure 382

THE DEATH OF ST. ANTHONY. Washington, D.C., National Gallery of Art (1152), since 1951.[1] Wood. 14¾×15⅛ in. (36·5×38·4 cm.). A few losses of paint; years ago the

small windows at the top were painted to simulate stained glass and cast shadows were added under bier; originally neither this panel nor any of the others in this predella series had cast shadows; cleaned 1947.

In a series of eight panels depicting scenes from the legend of St. Anthony Abbot, K1568 was the last to come to light.[2] These panels are believed to have been arranged in an altarpiece in two vertical rows, flanking a full-length figure of the titular saint. At the left side, from top to bottom, the order would probably have been: *St. Anthony at Mass* (Berlin Museum), *St. Anthony Distributing His Wealth to the Poor* (K1367), *St. Anthony Leaving His Monastery* (K1368), *Temptation of St. Anthony* (Yale University, New Haven); at the right, from top to bottom: *St. Anthony Beaten by Devils* (Yale University), *St. Anthony and the Porringer* (Lehman Collection, New York), *Meeting of St. Anthony and St. Paul* (K513), *Death of St. Anthony* (K1568).[3] This arrangement would have placed K1568 and the other similarly-proportioned panel (the Yale *Temptation*, $14\frac{1}{2} \times 15\frac{3}{4}$ in.) at the bottom, with the six panels of a different proportion (each, *c.* $18\frac{1}{2} \times 13\frac{3}{4}$ in.) above them. The fact that only two of the panels (Figs. 379 and 380) have tooled borders – and these only at the tops – might, at first thought, seem to indicate that these two were intended to stand above the others.[4] But, on second thought, it will be noted that these two panels are the only ones in the series which have gold backgrounds and that their gold backgrounds are only at the tops of the panels. Their tooling therefore merely conforms to contemporary practice and is probably quite independent of their position in the complex; the other panels in the series were not gilded and so were not tooled.

As for the panel of the full-length saint presumed to have been flanked by the small scenes, it has been tentatively identified as that of *St. Anthony Abbot* in the Louvre, a half-length to be completed as a seated figure,[5] and also as that of the full-length, standing *St. Anthony Abbot*, in a private collection in Florence.[6]

The attribution of the eight small scenes has been much discussed in recent literature on Sassetta and his alter ego, variously designated as the Master of the Osservanza, the early Sano di Pietro, Luca di Vico, and also simply as an anonymous associate of Sassetta.[7] Some critics see more than one hand in the execution of the panels. It seems plausible that Sassetta may have been responsible for the design of the complex and also for the execution of at least parts of the finest panels in the series, for example, K513 and K1367. But that the share of each collaborator can be clearly distinguished on the evidence of macrophotographs of heads and such details as trees and pebbled ground[8] may be overly hopeful. A macrophotograph of the head of the young saint in the foreground of K1367, for example, is similar in effect to that of *St. Catherine of Alexandria* in the Siena Pinacoteca, attributed to the Master of the Osservanza; but it is similar also to a macrophotograph of an apostle in Sassetta's *Last Supper* in the same gallery. Differences in tree

and ground formation may be due to an artist's attempt to represent natural differences.

Perhaps the least satisfactory of the panels is K1568, in which the figure types are especially crude and staring. Yet the head of the monk kneeling at the bier is presented in a three-quarters-rear view that finds a parallel in such a splendid Sassetta as the Saracini-Chigi *Adoration*, and the monk's flowing robe is beautifully rendered. Moreover, incised lines still visible through the paint and more clearly in the X-ray trace beneath the plain striped walls a magnificent vaulted interior for this last scene in the legend of the saint. Restoration has been charged with having removed from beneath the bier a rectangular cast shadow inspired by that in Sassetta's Sansepolcro *Death of St. Francis* (National Gallery, London), thus pointing to a date of no earlier than about 1440 for the St. Anthony series.[9] A photograph of the picture when it was at Sestieri's does show a strong cast shadow of the kneeling monk and of the bier;[10] but the shadow, arranged very differently from Sassetta's, proved to be, like the same black paint in the windows, an earlier restorer's addition, which came away when the picture was cleaned in 1947, leaving the original pigment intact.[11] A dating of about 1440 seems suitable for the series in any case. Documents have given no clue to the original location of the altarpiece. Perhaps the coat of arms above the door in K1367 may eventually help identify the donor.[12]

The sources of the legend narrated in the series of little panels are presumably Cavalca's *Lives of the Holy Fathers* and Jacobus de Voragine's *Golden Legend*. In K1367, in pursuance of admonitions pronounced at mass, the rich young man distributes his money to the needy. In K1368, he leaves the monastery (presumably one he had founded) to go into the desert. In K513, after surmounting temptations, he goes in search of the most holy of all hermits, inquiring his way of a centaur and at the end of his journey falling into the arms of the venerable St. Paul. Finally, in K1568 his brethren administer his burial rites.

Provenance: Private Collection, Rome (until 1948). Sestieri's, Rome. Contini Bonacossi, Florence. Kress acquisition, 1948.

References: (**1**) *Paintings and Sculpture from the Kress Collection*, 1951, p. 46 (catalogue by W. E. Suida), as Master of the Osservanza Altarpiece. (**2**) K1367 and K1368 were first published, when in the Platt Collection, by F. M. Perkins (in *Rassegna d'Arte*, vol. VII, 1907, p. 45), who says (possibly referring to the 1870 Caccialupi catalogue cited in the entry for K1367, p. 141 above) that they 'had always been ascribed to Masolino' but are obviously by Sassetta; K513 first appears in the Vernon sale catalogue of 1864 (see *Provenance* for K513, above), while K1568, although J. Pope-Hennessy (*Sassetta*, 1939, p. 72) had suggested that such a picture belonged to the series, became known only shortly before it entered the Kress Collection (1948). M. Gengaro (in *La Diana*, vol. VIII, 1933, pp. 12 ff.) discusses several panels in

the series. (3) This arrangement, which has met with approval, was outlined in general by E. K. Waterhouse (in *Burlington Magazine*, vol. LIX, 1931, p. 113) and in detail by A. Graziani (in an article of 1942 published posthumously in *Proporzioni*, vol. II, 1948, pp. 83 f., fig. 96). (4) Noted by Waterhouse in *loc. cit.* in note 3, above. (5) Graziani, *loc. cit.* in note 3 above. (6) J. Pope-Hennessy (in *Burlington Magazine*, vol. XCVIII, 1956, p. 369). But F. Zeri (pp. 36 ff., fig. 1, of the same vol. of the *Burlington*) associates this full-length of St. Anthony, which in pose does indeed suggest a side panel, with Sassetta's earlier (c. 1425) Arte della Lana triptych. (7) R. Longhi (in *Critica d'Arte*, Apr.–June, 1940, pp. 188 f.) seems to have been the first to suggest that the St. Anthony series was, along with a group including the Osservanza triptych, the work of a more archaic although excellent artist, who parallels, but is not identical with, Sassetta. Graziani (*op. cit.* in note 3, above) develops this theory, calling the alter ego the Master of the Osservanza. E. Carli (*Sassetta*, 1957, pp. 104 ff.) and C. Volpe (in *Arte Antica e Moderna*, Jan.–Mar., 1958, pp. 84 ff.) accept Graziani's attribution of the St. Anthony series to the Master of the Osservanza. C. Brandi (*Quattrocentisti senesi*, 1949, pp. 79 ff.), following B. Berenson's identification (*Sassetta*, 1946, p. 52) of the Master of the Osservanza with the early Sano di Pietro, attributes the St. Anthony series to the latter. Although identifying the Master of the Osservanza as the early Sano di Pietro, Pope-Hennessy (in *Burlington Magazine*, vol. XCVIII, 1956, pp. 364 ff.) attributes the St. Anthony series to Sassetta and an assistant, possibly to be identified with Vico di Luca. B. Berenson (*op. cit.*, figs. 41, etc., and in earlier publications) attributes to Sassetta the members of the series which he reproduces. In ms. opinion he has attributed K1568 to the studio of Sassetta or Sano. Among others who have attributed panels in the series to Sassetta are R. van Marle (*Italian Schools of Painting*, vol. IX, 1927, p. 328) and L. Venturi (*Italian Paintings in America*, vol. I, 1933, no. 138). (8) C. Seymour (in *Journal of the Walters Art Gallery*, vol. XV–XVI, 1952–53, pp. 30 ff.), followed by Pope-Hennessy (in the *Burlington* article cited in note 7, above) and Carli (*op. cit.* in note 7, above).

(9) Both C. Brandi (*Quattrocentisti senesi*, 1949, p. 199 n. 60) and Pope-Hennessy, pp. 365 f. of the *Burlington* article cited in note 7, above). (10) This photograph is reproduced by G. Kaftal, *Iconography of the Saints in Tuscan Painting*, 1952, fig. 77. (11) As reported by the restorer, M. Modestini. The panel has been examined by X-ray, ultra-violet, and infra-red photography. (12) The shield is gold, with three stars on a horizontal azure band. Rufus Mather, studying this stemma, reported (in ms., 1947) that he could not identify it with any Italian family and that for various reasons he concluded it was a false addition. Examination establishes it, however, as an integral part of the original pigment.

Attributed to SASSETTA

K1285A : Figure 384

St. Apollonia

K1285B : Figure 385

St. Margaret

Washington, D.C., National Gallery of Art (506 and 505), since 1941.[1] Wood. K1285A, 11×4½ in. (27·9×10·4 cm.); K1285B, 11×3⅞ in. (27·9×9·8 cm.). Generally good condition; originally painted with glazes on silver foil over red bole; glazes now gone from drapery, leaving much abraded and oxidized foil, with red bole showing through; cleaned 1955.

Although these two panels are now framed with K443 (Fig. 383) to form a triptych, the different tooling of halos and borders shows that this association was not originally intended. All three panels probably date from the same period, about 1435, but the two saints are not so typical of Sassetta as the *Madonna and Child* and they have not met with such general attribution to the master himself. They cannot be too casually dismissed, for they recall delightful figures in the Chigi-Saracini (Siena) *Adoration of the Magi* and the Cortona altarpiece of the *Madonna*, both fully accepted in Sassetta's oeuvre. However, recent progress in the study of Pietro di Giovanni d'Ambrogio points ever more convincingly toward that sensitive master as the author of K1285A and B.[2] They are exceedingly close, even in tooled decorative details, to the *St. Ursula* and *St. Apollonia* in the Horne Museum, Florence, which were formerly attributed to Sassetta but now generally to Pietro di Giovanni.[3]

Provenance: R. Langton Douglas, London. Dan Fellows Platt, Englewood, N.J. (sold by estate trustee to the following). Kress acquisition, 1939.

References: (1) *Preliminary Catalogue*, 1941, p. 181, as Sassetta. (2) K1285A and B have been attributed to Sassetta by F. M. Perkins (in *Rassegna d'Arte*, vol. XIII, pp. 195 f.), B. Berenson (*Italian Pictures of the Renaissance*, 1932, p. 512; Italian ed., 1936, p. 440), and J. Pope-Hennessy (*Sassetta*, 1939, pp. 68 f.). E. Carli (*Sassetta*, 1957, note following p. 121) places them in the following of Sassetta, close to Pietro di Giovanni d'Ambrogio; although later (1961, verbally). when he looked at the panels again, he gave them to Sassetta. C. Volpe (in *Arte Antica e Moderna*, Jan.–Mar. 1958, p. 86, reviewing Carli's *Sassetta*) favors the attribution to Pietro di Giovanni, and later (in *Paragone*, no. 165, 1963, p. 37) definitely accepts it. (3) The Horne panels are reproduced by M. Gregori (in *Paragone*, no. 75, 1956, pl. 32), who (p. 49) attributes them to Pietro di Giovanni, as do Pope-Hennessy (p. 166 of *op. cit.* in note 2, above) and others.

Berenson (p. 440 of Italian edition of the lists cited in note 2, above) attributes the Horne panels to Sassetta.

Studio of SASSETTA

K425 : Figure 386

HEAD OF AN ANGEL. Lawrence, Kans., University of Kansas, Study Collection (60.44), since 1960.[1] Wood. Diameter, 8¾ in. (22·2 cm.). Fragment; good condition.

Thirty years ago, before the Osservanza altarpiece at Siena and a related group of paintings were dissociated from Sassetta's oeuvre, K425 was attributed to that master.[2] In more recent years it has been given to a close follower, who presumably worked in Sassetta's studio and is sometimes called the Master of the Osservanza and sometimes identified as the early Sano di Pietro.[3] That K425 belongs in the group of studio paintings is evident from the essential identity in the face, hair, and olive wreath with the heads of angels in the panel of the *Madonna Crowned by Angels* at the top of the *Nativity of the Virgin* polyptych in the Collegiata, Asciano, one of the key pictures in the group. Like the Asciano polyptych, K425 probably dates about 1440.

Provenance: Achillito Chiesa, Milan. Contini Bonacossi, Florence. Kress acquisition, 1936.

References: (**1**) Catalogue by R. L. Manning (in *Register of the Museum of Art*, vol. II, no. 4, 1960, p. 10), as studio of Sassetta. (**2**) K425 has been attributed to Sassetta by B. Berenson, G. Fiocco, R. Longhi, R. van Marle, F. M. Perkins, W. E. Suida, A. Venturi (in ms. opinions), and by J. Pope-Hennessy (*Sassetta*, 1939, p. 114). (**3**) A. Graziani (in *Proporzioni*, vol. II, 1948, p. 81) attributes K425 to the Master of the Osservanza. Attribution to the studio of Sassetta is accepted by M. L. Jones in vol. III, no. 2, 1964, pp. 3 ff., of the *Register* cited in note 1, above.

Follower of SASSETTA

K444 : Figure 412

MADONNA AND CHILD WITH SAINTS. Lawrence, Kans., University of Kansas, Study Collection (60.45), since 1960.[1] Wood. Overall, including molding, 19×16½ in. (48·2×41·9 cm.). Inscribed on Gabriel's scroll: AVE GRATIA (from Luke 1 : 28). Very good condition, even the gold background; frame regilded.

The resemblance of this triptych to the paintings signed by Pellegrino di Mariano (cf. K1120, Fig. 413) is scarcely

close enough to justify its attribution to that follower of Giovanni di Paolo.[2] Here the influence of Sassetta is strong. The *Madonna of Humility* in the middle panel is set against a pair of cherubim that give the semblance of a throne and hark back to a similar motif dear to Taddeo di Bartolo (cf. K310, Fig. 171). Above the Madonna is the Saviour and in the side panels are Sts. Catherine of Alexandria (?) and Peter, with the Angel and Virgin of the Annunciation in the pinnacles. The date may be about 1460/70.

Provenance: Achillito Chiesa, Milan. Contini Bonacossi, Florence. Kress acquisition, 1936 – exhibited: National Gallery of Art, Washington, D.C. (358), 1941–52.[3]

References: (**1**) Catalogue by R. L. Manning (in *Register of the Museum of Art*, vol. II, no. 4, 1960, p. 12), as Pellegrino di Mariano. (**2**) K444 has been attributed (in ms. opinions) to Pellegrino di Mariano by G. Fiocco, R. Longhi, W. E. Suida, and A. Venturi; to Pellegrino tentatively or the school of Sassetta by B. Berenson; to the school of Sassetta by F. M. Perkins. J. Pope-Hennessy (*Sassetta*, 1939, pp. 177 f.) attributes it to a follower of Sassetta who had worked in Sassetta's bottega and who in K444 shows some influence of Pellegrino di Mariano. (**3**) *Preliminary Catalogue*, 1941, pp. 149 f., as Pellegrino di Mariano.

SANO DI PIETRO

Ansano di Pietro di Mencio. Sienese School. Born 1406; died 1481. He was a pupil and follower of Sassetta and he collaborated on occasion with Vecchietta and with Giovanni di Paolo. His style in the last forty years of his life is well known from documented paintings and numerous others that are almost duplicates of documented ones; for his productivity in those years was remarkable, and equally remarkable was the uniformity of his style. His career becomes more interesting if we accept the attribution to him in an earlier period, c. 1430–40, of paintings formerly thought to belong to a Gothic phase of Sassetta and given by some critics to a so-called Master of the Osservanza.[1]

K88 : Figure 388

THE CRUCIFIXION. Washington, D.C., National Gallery of Art (156), since 1941.[2] Wood. 9¼×12⅞ in. (23·5× 33 cm.). Good condition.

Painted probably about 1445/50, K88 suggests comparison with the *Pietà* in the predella of Sano's polyptych in the Accademia, Siena, dated 1448.[3] Closer parallels for composition are the *Crucifixion* of almost identical size from the Sir Philip Burne-Jones Collection[4] and one in a missal of

about 1450, believed to have been illuminated by Sano, now in the Fitzwilliam Museum, Cambridge, England.[5]

Provenance: Contessa Giustiniani, Genoa. Contini Bonacossi, Rome. Kress acquisition, 1930.

References: (1) For a discussion of this problem see footnote 7 to K 1568 (Sassetta and assistant, p. 143, above). (2) *Preliminary Catalogue,* 1941, p. 178, as Sano di Pietro. (3) K 88 has been attributed (in ms. opinions) to Sano by B. Berenson, G. Fiocco, R. Longhi (dating it between 1440 and 1450), F. M. Perkins, W. E. Suida, and A. Venturi. (4) Sold, Sotheby's, London, Dec. 8, 1926, no. 55. (5) From the collection of Viscount Lee of Fareham. The missal was made for the Augustinian Friars Hermits of Siena. Reproduced in *Connoisseur,* vol. CXXXIV, 1955, p. 231.

SANO DI PIETRO

K 286 : Figure 391

MADONNA AND CHILD WITH SAINTS. Coral Gables, Fla., Joe and Emily Lowe Art Gallery, University of Miami (61.12), since 1961.[1] Wood. $21\frac{1}{4} \times 16\frac{5}{8}$ in. ($54 \times 42 \cdot 2$ cm.). Very good condition; cleaned 1961.

Painted probably about 1450, K 286 follows one of Sano's favorite types of composition,[2] still used in such late examples as K 492 and K 522 (Figs. 392 and 389), where angels are among the figures accompanying the Madonna. Here all are saints: John the Baptist, Peter Martyr, and an unidentified female saint at the left; Jerome, Francis of Assisi, and Anthony of Padua at the right.

Provenance: Howel Wills (1894). Charles Lock Eastlake, London – exhibited: Royal Academy, London, 1896, no. 145, as Sano; 'Pictures of the School of Siena,' Burlington Fine Arts Club, London, 1904, p. 62 of 1905 catalogue, as Sano. Eastlake sale, Christie's, London, Mar. 23, 1912, no. 142, as Sano (bought by Gooden & Fox, London). Frederick Anthony White (sold, Christie's, London, Apr. 20, 1934, no. 135, as Sano; bought by Giuseppe Bellesi, London). Contini Bonacossi, Florence. Kress acquisition, 1934 – exhibited: 'Golden Gate International Exposition,' San Francisco, Calif., 1940, no. 118 of catalogue, as Sano.

References: (1) Catalogue by F. R. Shapley, 1961, p. 22, as Sano di Pietro. (2) K 286 is attributed (in ms. opinions) to Sano by B. Berenson, G. Fiocco, R. Longhi (dating it before 1450), F. M. Perkins, W. E. Suida, and A. Venturi. It is also listed among Sano's works by E. Jacobsen (*Das Quattrocento in Siena,* 1908, p. 39), E. Gaillard (*Sano di Pietro,* 1923,

p. 202), and R. van Marle (*Italian Schools of Painting,* vol. IX, 1927, p. 528).

SANO DI PIETRO

K 1036 : Figure 387

MADONNA AND CHILD. New York, N.Y., Samuel H. Kress Foundation. Wood. $7\frac{1}{4} \times 5\frac{1}{4}$ in. ($18 \cdot 4 \times 13 \cdot 4$ cm.). Inscribed on the Child's scroll: EGO SVM (from John 8 : 12); on the Virgin's veil: ECCE · AN[ci]LLA · DOM[i]NI · FIAT · MICHI (from Luke 1 : 38). Very good condition.

The composition is familiar in Sano's oeuvre;[1] but while other examples show the Virgin's free hand lying across the Child's legs it is here raised gracefully to hold a rose. The earnest expression and delicate execution place K 1036 among Sano's more attractive productions and point to a date of about 1450.[2]

Provenance: Contini Bonacossi, Florence. Kress acquisition, 1936.

References: (1) K 1036 has been attributed to Sano by B. Berenson, G. Fiocco, R. Longhi, R. van Marle, F. M. Perkins, W. E. Suida, and A. Venturi (in ms. opinions). (2) Cf. the small panel reproduced by R. van Marle (*Italian Schools of Painting,* vol. IX, 1927, fig. 304) as an early Sano, in a private collection.

SANO DI PIETRO

K 522 : Figures 389–390

MADONNA AND CHILD WITH SAINTS AND ANGELS. El Paso, Tex., El Paso Museum of Art (1961-6/7), since 1961.[1] Wood. 25×18 in. ($63 \cdot 5 \times 45 \cdot 7$ cm.); with original molding, $31\frac{1}{4} \times 25\frac{1}{2}$ in. ($79 \cdot 4 \times 64 \cdot 8$ cm.); reverse: $29\frac{1}{4} \times 21\frac{7}{8}$ in. ($75 \times 55 \cdot 6$ cm.). Inscribed on the Virgin's halo: AVE GRATIA PLENA DO[minvs tecvm] (from Luke 1 : 28). On the back of the panel is the emblem of St. Bernardine surrounded by cherubim and seraphim. Excellent condition except for a few losses of paint; cleaned 1960.

The composition was repeated many times by Sano (compare, for example, K 492, Fig. 392), with slight variations in the pose and costume of the Child, the choice of the attendant saints (here John the Baptist and Bartholomew) and the shape of the panel top (here rounded, in slight concession to Renaissance style). The style is in keeping with signed paintings of Sano's later career, in the 1460's and '70's.[2] Painted both back and front, the panel probably

served as a processional standard, and the Bernardine emblem on the reverse recalls the fact that documents of 1467 and 1469 record payments to Sano by the Confraternity of San Bernardino for a standard, along with other work by him carried out for that organization.[3] The Child in K522 holds a goldfinch, symbol of Christ's Passion.

Provenance: Contini Bonacossi, Florence. Kress acquisition, 1938 – exhibited: Honolulu Academy of Arts, Honolulu, Hawaii, 1952–60.[4]

References: (**1**) Catalogue by F. R. Shapley, 1961, no. 7, as Sano di Pietro. (**2**) K522 has been attributed to Sano by B. Berenson, G. Fiocco, R. Longhi, and A. Venturi (in ms. opinions), and to Sano and assistant, by F. M. Perkins (in ms. opinion). (**3**) E. Gaillard, *Sano di Pietro*, 1923, p. 85. (**4**) Catalogue by W. E. Suida, 1952, p. 16, as Sano di Pietro.

SANO DI PIETRO

K311 : Figure 397

THE ADORATION OF THE CHILD. Amherst, Mass., Amherst College, Study Collection (1961–83), since 1961.[1] Wood. $33\frac{3}{4} \times 25\frac{1}{4}$ in. (85·7×64·2 cm.). Inscribed on the Virgin's halo: AVE GRATIA PLENA (from Luke 1 : 28); and on the Child's: [e]GO SVM (from John 8 : 12). Very good condition except for some restoration in gold background.

In Sano's vast oeuvre, with its numerous repetitions of traditional compositions, the unusual iconography of K311 comes as a refreshing change.[2] An angel holds up the Child for the Virgin to adore, while Sts. Bernard and Bernardine kneel at left and right and a bevy of angels hover above. It is a late work, close in style to the *Coronation* at Gualdo Tadino, of 1473. Like that painting, K311 is overflowing with ornament: brocaded robes, floral wreaths, gaily colored angel wings, tapestried background, and Turkish carpet. The design of the carpet, with a repeat medallion enclosing a pair of long-legged eagles confronting a formalized tree, is based on an Anatolian type[3] well known in Siena, for it appears a century earlier in a painting by Lippo Memmi in the Berlin Museum and in at least two other paintings by Sano, the *Marriage of the Virgin*, in the Vatican, and the *Assumption*, in the Jarves Collection at Yale. Sano has taken greater liberty with his model in K311 than in his other two paintings, combining free floral motifs with the conventional medallions, here rectangular instead of the usual octagonal shape.

Provenance: Viscount Lee of Fareham, London. Contini Bonacossi, Florence. Kress acquisition, 1935 – exhibited: National Gallery of Art, Washington, D.C. (274), 1941–52.[4]

References: (**1**) Catalogue by C. H. Morgan, 1961, p. 8 (where there are errors in the data concerning provenance and exhibitions), as Sano di Pietro. (**2**) K311 is attributed to Sano by B. Berenson, G. Fiocco, R. Longhi (dating it very late), R. van Marle, F. M. Perkins, W. E. Suida, and A. Venturi (in ms. opinions). (**3**) E. Kühnel, *Antique Rugs from the Near East*, trans. by C. G. Ellis, 1958, pp. 27 ff. (**4**) *Preliminary Catalogue*, 1941, pp. 178 f., as Sano di Pietro.

SANO DI PIETRO

K492 : Figure 392

MADONNA AND CHILD WITH SAINTS AND ANGELS. Washington, D.C., National Gallery of Art (385), since 1941.[1] Wood. $25\frac{1}{2} \times 17\frac{1}{4}$ in. (64·8×43·8 cm.). Inscribed on the Virgin's halo: AVE GRATIA PLENA DO[minvs tecvm] (from Luke 1 : 28). One of the best preserved paintings of the period; has never been cleaned or varnished.

The special attraction of this panel is in the pastel-like freshness of its colors, quite free of varnish. The composition is repeated with slight variation in many extant paintings by Sano.[2] In pose, dress, and expression K492 almost duplicates the *Madonna and Child* in his large altarpiece usually dated 1471 in the Accademia, Siena. K492 is probably of approximately the same date. St. Bernardine, at the right, finds a parallel there; St. Jerome, at the left, is elsewhere represented by Sano in this guise, his penance indicated by the rosary, as, for example, in the *Coronation* at Gualdo Tadino, of 1473.

Provenance: Larniano Chapel, near Siena. Conte Silvio Piccolomini, Siena. Contini Bonacossi, Florence. Kress acquisition, 1937.

References: (**1**) *Preliminary Catalogue*, 1941, p. 179, as Sano di Pietro. (**2**) B. Berenson, G. Fiocco, R. Longhi, F. M. Perkins, W. E. Suida, and A. Venturi (in ms. opinions) have attributed K492 to Sano.

SANO DI PIETRO

K101 : Figure 393
St. AUGUSTINE

K100 : Figure 394
St. BENEDICT

Birmingham, Ala., Birmingham Museum of Art (61.92 and 61.91), since 1952.[1] Wood. Each, 47×16 in. (119·4× 40·6 cm.). Good condition.

As is indicated by the Annunciation figures in the pinnacles, K101 comes from the left side of a polyptych and K100, from the right side. Comparison with figures in Sano's altarpiece at Badia a Isola suggests a date of about 1470.[2] As in the Badia a Isola altarpiece, St. Benedict here carries a scourge, symbolizing the discipline of his monastic rule.

Provenance: Ehrich Galleries, New York (sold, Anderson Galleries, New York, Nov. 12, 1924, no. 40, *Benedict*; no. 41, *Augustine*, as Sano). Anonymous sale (Christie's, London, Apr. 26, 1929, no. 30, as Sano, to the following). Giuseppe Bellesi, London. Contini Bonacossi, Rome. Kress acquisition, 1930 – exhibited: 'Italian Paintings Lent by Mr. Samuel H. Kress,' Oct. 1932, Atlanta, Ga., through June 1935, Charlotte, N.C., p. 7 of catalogue, as Sano; National Gallery of Art, Washington, D.C. (160, *Benedict*; 161, *Augustine*), 1941–51.[3]

References: (1) Catalogue by W. E. Suida, 1952, p. 27, and 1959, p. 33 (Acton Collection erroneously included in provenance), as Sano di Pietro. (2) K100 and K101 have been attributed (in ms. opinions) to Sano di Pietro by B. Berenson, T. Borenius, G. Fiocco, R. Longhi (dating them *c.* 1470), R. van Marle, F. M. Perkins, and A. Venturi. (3) *Preliminary Catalogue*, 1941, p. 178, as Sano di Pietro.

Follower of SANO DI PIETRO

K1155 : Figure 395
ST. DOMINIC

K1156 : Figure 396
ST. THOMAS AQUINAS

Tucson, Ariz., University of Arizona, Study Collection (62.153 and 62.154), since 1962. Wood. Each, $15\frac{7}{8} \times 6\frac{1}{4}$ in. (40·3 × 15·9 cm.). K1155, extensively abraded; K1156, good condition.

K1155 and K1156 probably come from the framing pilasters of a polyptych. Although in the style of Sano, to whom they have been attributed,[1] their weak modeling points more convincingly to a follower working around 1480.

Provenance: Contini Bonacossi, Florence. Kress acquisition, 1938 – exhibited, after acquisition by the University of Arizona: 'Religion in Painting,' Arkansas Arts Center, Little Rock, Ark., Dec. 7, 1963–Jan. 30, 1964, nos. 20 and 21, as Sano di Pietro.

Reference: (1) B. Berenson, G. Fiocco, R. Longhi, F. M. Perkins, W. E. Suida, and A. Venturi (in ms. opinions) have attributed K1155 and K1156 to Sano.

SIENESE SCHOOL, *c.* 1440

K1434 : Figures 398–400

THE ADORATION OF THE SHEPHERDS WITH ST. JOHN THE BAPTIST AND ST. BARTHOLOMEW. El Paso, Tex., El Paso Museum of Art (1961-6/5), since 1961.[1] Wood. Including molding, $24\frac{5}{8} \times 19\frac{13}{16}$ in. (62·6 × 50·3 cm.). Excellent condition.

Although it presents striking parallels with the Lorenzetti school *Nativity* in the Fogg Museum, Cambridge, Mass.,[2] K1434 dates much later, probably after 1440. It has been attributed to several of the well-known Sienese painters of the time, Sassetta, Giovanni di Paolo, and Sano di Pietro,[3] a diversity of attribution explained by the painting's ambiguity of style coupled with excellence of quality. The enchanting scene of the *Annunciation to the Shepherds* is especially close to Sano di Pietro's treatment of the subject in the Siena Pinacoteca.[4] In the pinnacle of the main panel of K1434 is the *Last Judgment*; at the tops of the side panels are the Angel and Virgin of the *Annunciation*, and on the backs of these panels are small medallion-shaped paintings of *Christ on the Cross* and the *Mourning Madonna*.

Provenance: Max Chabrière-Arlès, Lyons. Harold I. Pratt, New York – exhibited: 'Loan Exhibition of Italian Primitives,' Kleinberger Galleries, New York, Nov. 1917, no. 51 of catalogue by O. Sirén and M. W. Brockwell, as Sassetta; 'Masterpieces of Art,' World's Fair, New York, May–Oct. 1939, no. 350 of catalogue by G. H. McCall, as Sassetta. Wildenstein's, New York – exhibited: 'Italian Paintings,' 1947, no. 24 of catalogue, as Sano di Pietro. Kress acquisition, 1947 – exhibited: National Gallery of Art, Washington, D.C., 1951-56.[5]

References: (1) Catalogue by F. R. Shapley, 1961, no. 5, as Sienese, *c.* 1440. (2) J. Pope-Hennessy (*Sassetta*, 1939, p. 176). The Lorenzetti school piece is reproduced in *Collection of Mediaeval and Renaissance Paintings*, Fogg Art Museum, 1927, opp. p. 108. (3) O. Sirén (in *Art in America*, vol. v, 1917, p. 206) and R. van Marle (*Italian Schools of Painting*, vol. IX, 1927, p. 361 n. 1, tentatively) attribute K1434 to Sassetta. B. Berenson (*Italian Pictures of the Renaissance*, 1932, p. 247; Italian ed., 1936, p. 212) lists it, tentatively, as an early Giovanni di Paolo, and later (verbally) attributes it to Sano di Pietro. J. Pope-Hennessy (*Giovanni di Paolo*, 1938, pp. 159, 165 n. 23) gives it to an unknown pupil of Sassetta; a little later (*Sassetta*, 1939, p. 176) he connects it with a Sassetta follower whom he calls the Vatican Master; more recently (in *Burlington Magazine*, vol. XCVIII, 1956, p. 369) he puts it in the 'artist B' (perhaps, according to Pope-Hennessy, to be identified as Sassetta's obscure assistant of 1442, Vico di Luca) group of paintings which some critics attribute to a Sassetta alter ego, the Osservanza Master (see the commentary under Sassetta and

assistant, K1568, pp. 141 f., above). E. Carli (*Sassetta*, 1957, p. 122) attributes K1434 to a follower of Sassetta whom he calls the Master of Pienza from a small triptych there; F. Zeri (in *Burlington Magazine*, vol. CVII, 1965, p. 256) gives that triptych and K1434 to the same artist but identifies him as the Pseudo Pellegrino di Mariano. And C. Volpe (in *Arte Antica e Moderna*, Jan.–Mar., 1958, p. 86) inclines toward an attribution to Sano di Pietro, comparing K1434 effectively with the small *Assumption* (Siena Pinacoteca, no. 227) which Carli (*op. cit.*, pl. 143) gives to Sano. (**4**) Reproduced by L. Dami, in *Dedalo*, vol. IV, 1923, p. 288. (**5**) *Paintings and Sculpture from the Kress Collection*, 1951, p. 48 (catalogue by W. E. Suida), as Sienese School, *c.* 1440.

GIOVANNI DI PAOLO

Sienese School. Active from 1420; died, 1482. Probably a pupil of Taddeo di Bartolo, he was strongly influenced also by Gentile da Fabriano, who was painting in Siena in 1426, and by Sassetta. Giovanni di Paolo's fertile imagination was preoccupied with fantastic linear design and serious spiritual expression, which became progressively more exaggerated and lugubrious in the later years of his long, well-dated career. He developed a very personal, mannered style, invariably sincere, but ranging in quality from exquisite delicacy to startling crudity. His remarkable painting of landscape, inspired perhaps by Ambrogio Lorenzetti, was based on keen observation of nature and appreciation of her lyricism.

K412 : Figures 402, 404

THE ANNUNCIATION. Washington, D.C., National Gallery of Art (334), since 1941.[1] Wood. 15¾ × 18¼ in. (40 × 46 cm.). Good condition except for a few losses of paint; needs cleaning.

Among the five panels, now widely separated, which must have formed one of Giovanni di Paolo's most successful altarpiece predellas, K412 would have been first on the left. It would have been followed by the *Nativity*, now in the Vatican Gallery; then, in the middle of the predella, the *Crucifixion*, in the Berlin Museum; next, the *Adoration of the Magi* (its cave-stable echoing the setting of the *Nativity*), in the Cleveland Museum of Art; and, finally, the *Presentation in the Temple* (echoing the architectural setting of K412), in the Metropolitan Museum, New York. Critics agree in assigning the predella to Giovanni's best period, about 1445.[2] There are strong reminiscences of Ambrogio Lorenzetti, especially in the *Presentation*; of Gentile da Fabriano, notably in the *Nativity* and the *Adoration*; and of Fra Angelico, in the iconography of K412, with its combination of the *Expulsion* and the *Annunciation*, clearly referring to the

Fall of Man and the plan for his redemption.[3] Giovanni's preoccupation with dogma in this picture is further indicated by a subtle reference to the passage of time between the miraculous conception and the birth of Christ. This reference has been ingeniously explained[4] in the case of the nearly contemporary Merode altarpiece, which, like K412, is one of the very few examples in which Joseph appears in conjunction with the Annunciation.[5] Here, as in the Merode altarpiece, a door connects the scene of the Annunciation with a setting of springtime, season of the Annunciation (and Conception), while on the right, not connected with the Annunciation, but separated from it by a wall, is a winter scene, season of the Nativity, when Joseph is appropriately in evidence, warming himself at the fire; even smoke is shown issuing from the chimney.

Provenance: Sir William J. Farrer, London (1866), as Gentile da Fabriano. Sir J. Charles Robinson, London (*Memoranda on Fifty Pictures*, 1868, p. 2, no. 2; sold, Christie's, Apr. 19, 1902, no. 73, as Giovanni di Paolo). Charles Fairfax Murray, London. Robert H. and Evelyn Benson, London (catalogue by T. Borenius, 1914, no. 9, as Giovanni di Paolo) – exhibited: 'Sienese Exhibition,' Burlington Fine Arts Club, London, 1904, no. 30, as Giovanni di Paolo; 'Old Masters,' Royal Academy, Burlington House, London, 1910, no. 1, as Giovanni di Paolo. Duveen's, New York (from Benson Collection, 1927; *Duveen Pictures in Public Collections of America*, 1941, no. 37, as Giovanni di Paolo). Kress acquisition, 1936.

References: (**1**) *Preliminary Catalogue*, 1941, p. 84, as Giovanni di Paolo. (**2**) See, among others, Crowe and Cavalcaselle (*A History of Painting in Italy*, vol. III, 1866, p. 80 n. 6), R. Fry (in *Rassegna d'Arte*, vol. IV, 1904, p. 118), G. Frizzoni (in *L'Arte*, vol. VII, 1904, p. 268), R. van Marle (*Italian Schools of Painting*, vol. IX, 1927, p. 420), B. Berenson (*Pitture italiane del rinascimento*, 1936, p. 212), J. Pope-Hennessy (*Giovanni di Paolo*, 1938, p. 37), H. S. Francis (in *Art Quarterly*, vol. V, 1942, pp. 313 ff.; all five panels of the predella are here reproduced), and C. Brandi (*Giovanni di Paolo*, 1947, pp. 24 f.; *Quattrocentisti senesi*, 1949, p. 260). (**3**) See L. Baránszky-Jób (in *Marsyas*, vol. VIII, 1959, pp. 1 ff.) for a discussion of the iconography. (**4**) By C. de Tolnay, in *Gazette des Beaux-Arts*, vol. LIII, 1959, pp. 65 ff.; *ibid.*, vol. LV, 1960, pp. 177 f. (**5**) M. Schapiro, in *Art Bulletin*, vol. XXVII, 1945, pp. 182 ff.

GIOVANNI DI PAOLO

K432 : Figure 401

MADONNA AND CHILD WITH ST. JEROME AND ST. AUGUSTINE. Kansas City, Mo., William Rockhill Nelson Gallery of Art (61-58), since 1952.[1] Wood transferred to

composition board (novaply). 26¼×24 in. (66·7×61 cm.). Inscribed on base of throne: X\overline{AI} . PS . . .T . . .XXXXX; on St. John's scroll: E\overline{CE} AGNVS DEI (from John 1 : 29). Middle panel and St. Jerome in fair condition; St. Augustine's mantle worn; frame and background of Annunciation regilded in nineteenth century; entire painting cleaned and transferred 1957.

This triptych has been dated in the artist's early period, shortly before 1445.[2] If, however, the fragmentary, unclear inscription preserves the ending of 1450, this would be a reasonable date in view of the fact that St. Bernardine (died, 1444, but not canonized until 1450) is shown in a spandrel above with the same kind of halo as those given the accompanying Sts. Anthony Abbot, John the Baptist, and the Magdalen, and also the Angel and Virgin Annunciate.

Provenance: Tadini-Buoninsegni, Florence. Contini Bonacossi, Florence. Kress acquisition, 1936 – exhibited: National Gallery of Art, Washington, D.C. (351), 1941–52.[3]

References: (**1**) Catalogue by W. E. Suida, 1952, p. 14, as Giovanni di Paolo. (**2**) J. Pope-Hennessy, *Giovanni di Paolo*, 1938, p. 33. C. Brandi (in *Le Arti*, vol. III, 1941, p. 246 n. 38) traces the derivation of the throne and baldachin in Sienese painting. (**3**) *Preliminary Catalogue*, 1941, p. 85, as Giovanni di Paolo.

GIOVANNI DI PAOLO

K 500 : Figure 403

THE ASSUMPTION OF THE VIRGIN. El Paso, Tex., El Paso Museum of Art (1961-6/8), since 1961.[1] Wood. 7⅜×19 in. (18·8×48·3 cm.). Abraded throughout; a few losses of paint at bottom; cleaned 1960.

As early as 1862 (when it was attributed to Vecchietta[2]) and until the period between the two World Wars, K 500 was accompanied by an *Entombment of the Virgin*, once obviously its companion piece in a predella.[3] A *Crucifixion* (but not the one now in Utrecht[4]) or a *Man of Sorrows* was probably in the middle panel of the predella, while a full-length Virgin may have occupied the principal panel of the altarpiece from which K 500 comes.[5] The saints flanking the Assumption in K 500 are probably John the Evangelist and Ansanus. Dating of the panel in Giovanni's late period, about 1470, is most convincing.[6]

Provenance: Johann Anton Ramboux, Cologne (with the *Entombment*, nos. 127 and 128 of the catalogue of 1862, as Vecchietta). Wallraf-Richartz Museum, Cologne (both panels sold between World Wars; present whereabouts of the *Entombment* unknown).[7] A. S. Drey, Munich (the 1920's). P. Bottenwieser, Berlin. Durlacher's, New York.

Contini Bonacossi, Florence. Kress acquisition, 1937 – exhibited: National Gallery of Art, Washington, D.C. (393), 1941–54;[8] Finch College, New York, Dec. 18, 1959– Apr. 20, 1960.

References: (**1**) Catalogue by F. R. Shapley, 1961, no. 8, as Giovanni di Paolo. (**2**) See *Provenance*, above. (**3**) For the history of the panels see G. Coor, discussing the Ramboux Collection, in *Wallraf-Richartz-Jahrbuch*, vol. XXI, 1959, pp. 85 f. (**4**) The Utrecht *Crucifixion*, tentatively proposed by J. Pope-Hennessy (*Giovanni di Paolo*, 1938, pp. 75 f. and 107 n. 44) as the middle panel of the predella, is too early in date and also differs in size. (**5**) Coor, *loc. cit.* in note 3, above. (**6**) Pope-Hennessy (*loc. cit.* in note 4, above), following L. Dussler (in *Burlington Magazine*, vol. L, 1927, p. 36), dates K 500 in Giovanni's middle period. It is assigned to his late period, about 1470, by V. Romea (in *Rassegna d'Arte Senese*, vol. XVIII, 1925, pp. 72 f.), R. van Marle (*Italian Schools of Painting*, vol. IX, 1927, p. 446), C. Brandi (in *Le Arti*, vol. III, 1941, p. 333; *Giovanni di Paolo*, 1947, pp. 54 f., 88 n. 75), and Coor (*loc. cit.* in note 3, above). Also B. Berenson, G. Fiocco, R. Longhi, F. M. Perkins, W. E. Suida, and A. Venturi (in ms. opinions) have attributed K 500 to Giovanni di Paolo. (**7**) Coor, *loc. cit.* in note 3, above. (**8**) *Preliminary Catalogue*, 1941, p. 85, as Giovanni di Paolo.

GIOVANNI DI PAOLO

K 1094 : Figure 405

ST. LUKE THE EVANGELIST. Seattle, Wash., Seattle Art Museum (It 37/G4393.1), since 1952.[1] Wood. 22×13½ in. (55·9×34·3 cm.). Good condition except for slight damages.

Painted toward 1475, K 1094 is an example of the strong but rude work of the artist's late period.[2] The half-length *St. Luke*, with his symbol of the winged ox, has been recognized as coming from a series of the four Evangelists, which must have been, in spite of some difference in their measurements, pinnacle sections of a now-dismembered altarpiece. The *St. Mark* from the series is in the Siena Pinacoteca; *St. Matthew* is in the Budapest Gallery; and *St. John* (its present location unknown) was sold from the Wallraf-Richartz Museum, Cologne, in 1939, having been formerly, along with the *St. Luke* and *St. Matthew*, in the Ramboux Collection, Cologne.[3] Unconvincing attempts have been made to connect the Evangelist pinnacles with the San Galgano altarpiece or with the Staggia altarpiece, both of Giovanni's late period.[4] Also, unacceptable as middle pinnacle, because earlier in style, is the Siena Pinacoteca *Christ Blessing*.[5]

Provenance: Johann Anton Ramboux, Cologne (from first half of nineteenth century; catalogue, 1862, p. 23, as Vecchietta; sold 1867). Gnecco, Genoa. Contini Bonacossi,

Florence. Kress acquisition, 1937 – exhibited: National Gallery of Art, Washington, D.C. (462), 1941–51.[6]

References: (**1**) Catalogue by W. E. Suida, 1952, no. 9, and 1954, p. 34, as Giovanni di Paolo. (**2**) K1094 (or whichever of the series was known to the critic) has been attributed to Giovanni di Paolo by P. Schubring (in *Rassegna d'Arte*, vol. XII, 1912, p. 164), J. Pope-Hennessy (*Giovanni di Paolo*, 1938, p. 125), C. Brandi (*Giovanni di Paolo*, 1947, pp. 91 f.), G. Coor (in *Wallraf-Richartz-Jahrbuch*, vol. XXI, 1959, p. 86); and (in ms. opinions) by B. Berenson, G. Fiocco, R. Longhi, F. M. Perkins, and A. Venturi. Only R. van Marle (*Italian Schools of Painting*, vol. IX, 1927, p. 458; and elsewhere) has attributed the work to Giacomo del Pisano. (**3**) See Coor, *loc. cit.* in note 2, above. (**4**) The connection of K1094 and its companion panels with the San Galgano altarpiece, suggested by Pope-Hennessy (*loc. cit.* in note 2, above), is refuted, because of dissimilarity of ornamental details, by Brandi and Coor (*loc. cit.* in note 2, above). Coor notes also that, although the style of the panels might suggest that they come from the Staggia altarpiece of 1475, their finer execution makes also this connection doubtful. (**5**) The connection with this panel is suggested by Pope-Hennessy and refuted by Brandi and Coor (see citations in note 2, above). (**6**) *Preliminary Catalogue*, 1941, pp. 85 f., as Giovanni di Paolo.

Studio of GIOVANNI DI PAOLO

K440 : Figure 406

MADONNA AND CHILD WITH ANGELS. Tucson, Ariz., University of Arizona, Study Collection (62.152), since 1962. Wood. $21\frac{3}{8} \times 14\frac{3}{4}$ in. (54.3×37.5 cm.). Good condition.

The large-scale figures, their rough, careless execution, and the dependence upon Matteo di Giovanni instead of Gentile da Fabriano, associate K440 with Giovanni di Paolo's late period, about 1475. He may have painted it himself, as some critics have suggested;[1] but he is known to have employed a number of collaborators at the time, notably Giacomo del Pisano. X-ray indicates minor changes in the drawing of the Virgin's hands.

Provenance: Donati, Perugia. Contini Bonacossi, Florence. Kress acquisition, 1936 – exhibited, after entering the University of Arizona Study Collection: 'Religion in Painting,' Arkansas Arts Center, Little Rock, Ark., Dec. 7, 1963–Jan. 30, 1964, no. 19, as Giovanni di Paolo.

Reference: (**1**) G. Fiocco, R. Longhi, F. M. Perkins, W. E. Suida, A. Venturi (in ms. opinions), and J. Pope-Hennessy (*Giovanni di Paolo*, 1938, p. 119, with a dating of *c.* 1475 and

emphasis upon the influence of Matteo di Giovanni) attribute K440 to Giovanni di Paolo; B. Berenson (in ms. opinion) gives it to Giacomo del Pisano; C. Brandi (in *Le Arti*, vol. III, 1941, p. 338 n. 82) gives it to an unidentified follower of Giovanni di Paolo.

Studio of GIOVANNI DI PAOLO

K1053 : Figure 407

MADONNA AND CHILD WITH ANGELS. Madison, Wis., University of Wisconsin, Study Collection (61.4.8), since 1961.[1] Wood. $15 \times 10\frac{5}{8}$ in. (38.1×27 cm.). Much damaged and badly restored.

Painted probably toward 1475, when Giovanni's work had become so crude as to challenge distinction between his own part in it and that of his assistants, K1053 has been attributed both to Giovanni and to his close collaborator Giacomo del Pisano.[2] A reminder of Giovanni's lyric interpretations of nature is the delicate treatment of the rose hedge that fills the upper background.

Provenance: Amaro, Rome. Contini Bonacossi, Florence. Kress acquisition, 1936 – exhibited: National Gallery of Art, Washington, D.C. (848), 1951–52.[3]

References: (**1**) Catalogue by D. Loshak, 1961, p. unnumbered, as Giacomo del Pisano. (**2**) K1053 has been attributed to Giovanni di Paolo by G. Fiocco, R. Longhi, F. M. Perkins, W. E. Suida, A. Venturi (in ms. opinions), and J. Pope-Hennessy (*Giovanni di Paolo*, 1938, p. 140 n. 4); to Giacomo del Pisano, by B. Berenson (in ms. opinion). It should be noted that some critics tend to assign to Giacomo del Pisano a considerable share of the work which others include in the third (last) period of Giovanni di Paolo. (**3**) As Giacomo del Pisano.

Follower of GIOVANNI DI PAOLO

K1142 : Figure 408

MADONNA ADORING THE CHILD. Staten Island, N.Y., Institute of Arts and Sciences, Study Collection (61-17.3), since 1961. Wood. $23\frac{5}{8} \times 17\frac{5}{8}$ in. (60×44.8 cm.). Inscribed on the Child's scroll: EGO · SVM (from John 8 : 12). Very good condition.

This has been attributed to Giovanni himself,[1] in his late period, but may have been painted about 1480 by a follower, perhaps under Florentine influence, attempting to give greater refinement to his master's types.

Provenance: Contini Bonacossi, Florence. Kress acquisition, 1938.

Reference: (**1**) K1142 has been attributed to Giovanni di Paolo by G. Fiocco, R. Longhi, W. E. Suida, and A. Venturi (in ms. opinions); to an anonymous Sienese artist by F. M. Perkins (in ms. opinion); and to a follower of Pesellino by B. Berenson (in *Dedalo*, vol. XII, 1932, p. 682); it is omitted, however, from the 1963 edition of Berenson's Florentine lists, perhaps indicating an intention to include it under the Sienese School.

PELLEGRINO DI MARIANO

Pellegrino di Mariano Rossini. Sienese School. Active from 1449; died 1492. He was strongly influenced by Giovanni di Paolo and to less extent by Sassetta. He was active chiefly as a miniaturist.

K1120 : Figure 413

MADONNA AND CHILD WITH ST. JOHN THE BAPTIST AND ST. BERNARDINE OF SIENA. Memphis, Tenn., Brooks Memorial Art Gallery (61.198), since 1958.[1] Wood. 23×16½ in. (58·4×41·9 cm.). Inscribed on St. John's scroll: ECCE AGNUS DEI (from John 1 : 29); on St. Bernardine's plaque: YHS (the monogram of Jesus); and on the base of the picture frame, the artist's signature and the date: OPVS PELLEGRINVS . MARIANI . DE . SENIS . M . CCCC . L . XXXX. Slight damages; cleaned 1958; frame original.

Only two other known paintings are signed by this artist and only one of these, a *Madonna* in the South Kensington Museum, London, is dated (1448).[2] K1120 has thus been an important touchstone for his style,[3] especially since it is well preserved and is probably complete. Above the main panel, in which the Madonna and Child with a pomegranate are accompanied by Sts. John the Baptist and Bernardine, is an arched terminal in which the Virgin and John the Evangelist keep watch at the foot of the Crucifix. The painting may have been executed in connection with some celebration in honor of St. Bernardine, since it is dated in the year of his canonization.

Provenance: Giuseppe Toscanelli, Pisa (sold, Sambon's, Florence, Apr. 9–23, 1883, no. 116, as Pellegrino di Mariano). Charles Fairfax Murray, London (1914). Achillito Chiesa, Milan. Contini Bonacossi, Florence. Kress acquisition, 1937 – exhibited: National Gallery of Art, Washington, D.C. (479), 1941–52;[4] after entering the Brooks Memorial Art Gallery: 'Religion in Painting,' Arkansas Arts Center, Little Rock, Ark., Dec. 7, 1963–Jan. 30, 1964, no. 17, as Pellegrino di Mariano.

References: (**1**) Catalogue by W. E. Suida, 1958, p. 14, as Pellegrino di Mariano. (**2**) Reproduced by J. Pope-Hennessy, in *Burlington Magazine*, vol. LXXIV, 1939, p. 215. (**3**) K1120 was first described by Crowe and Cavalcaselle (*A History of Painting in Italy*, vol. III, 1866, p. 81, no. 1) when it had been for some years in the Toscanelli Collection; they read the date as MCCCCLXXXX. The letter in question is now fragmentary; but X-ray indicates an X rather than an L, and the compiler of the 1883 sale catalogue read it as X, as have subsequent critics. K1120 has been discussed by F. M. Perkins (in *Rassegna d'Arte Antica e Moderna*, vol. I, 1914, pp. 165 ff.), R. van Marle (*Italian Schools of Painting*, vol. IX, 1927, pp. 375 f.), B. Berenson (in *Dedalo*, vol. XI, 1931, pp. 632 f.), and J. Pope-Hennessy (*Giovanni di Paolo*, 1938, pp. 159 f.; *Sassetta*, 1939, pp. 172 f.; and in *Burlington Magazine*, vol. LXXIV, 1939, pp. 214 ff.). (**4**) *Preliminary Catalogue*, 1941, p. 150, as Pellegrino di Mariano.

LORENZO VECCHIETTA

Lorenzo di Pietro, called il Vecchietta. Sienese School. Born c. 1412; died 1480. He was a pupil of Sassetta, and possibly also of Masolino, and was influenced by Matteo di Giovanni and by Florentine painting and sculpture. He was active as painter, miniaturist, sculptor, and architect.

Attributed to
LORENZO VECCHIETTA

K269 : Figure 409

A JUDGMENT SCENE. Bridgeport, Conn., Museum of Art, Science and Industry, Study Collection, since 1961.[1] Wood. 17×18¼ in. (43·2×46·4 cm.). Much abraded.

Formerly attributed to Andrea di Giusto, K269 is now generally believed to be Sienese, and more likely by Vecchietta, about 1450, than by Domenico di Bartolo, with whom it has also been associated.[2] K269 probably comes from a cassone, in the decoration of which it was associated with a panel of approximately the same height, but wider, in the Johnson Collection, Philadelphia Museum, there labeled *Esther in the Temple*, by Andrea di Giusto.[3] K269 also probably represents an episode from the story of Esther, rather than one from the *Decameron*.[4] The scene may be the *Degradation of Haman*, who lies prostrate before the throne, as in a drawing of the subject by Aert de Gelder.[5]

Provenance: Vatican, Rome (?). Giulio Sterbini, Rome (catalogue by A. Venturi, 1906, no. 37A,[6] as Vecchietta). Contini Bonacossi, Florence. Kress acquisition, 1933 – exhibited: 'Italian Paintings Lent by Mr. Samuel H. Kress,'

Jan. 1934, San Francisco, Calif., through June 1935, Charlotte, N.C., p. 15 of catalogue, as Andrea di Giusto; National Gallery of Art, Washington, D.C. (246), 1941–53[7].

References: (**1**) Catalogue, n.d. [1962], p. unnumbered, as Andrea di Giusto. (**2**) K 269 has been attributed to Andrea di Giusto by B. Berenson (in *Dedalo*, vol. XII, 1932, pp. 518 ff.; *Pitture italiane del rinascimento*, 1936, p. 11; but this and also its Philadelphia pendant are omitted from the 1963 edition of Berenson's Florentine lists, to be transferred to the Sienese section, where, I am informed, it will be included as Taddeo di Bartolo), G. Fiocco, R. van Marle, W. E. Suida, and A. Venturi (in ms. opinions). C. L. Ragghianti (in *Critica d'Arte*, Aug.–Dec. 1938, p. XXIII) attributes it to Domenico di Bartolo. R. Longhi (in *Critica d'Arte*, July–Dec. 1940, p. 183 n. 18) favors an attribution to Vecchietta, as does F. Zeri (in ms. opinion). J. Pope-Hennessy (in *Burlington Magazine*, vol. LXXXIV, 1944, p. 139) thinks the painting is Florentine rather than Sienese. (**3**) The Johnson painting is reproduced by Berenson in *Dedalo, loc. cit.* in note 2, above. (**4**) A *Decameron* source is suggested in the catalogue referred to in note 7, below. (**5**) Reproduced by H. Tietze, *European Master Drawings*, 1947, no. 75. (**6**) Reported as in an English edition, not available to me. (**7**) *Preliminary Catalogue*, 1941, pp. 4 f., as Andrea di Giusto.

Follower of LORENZO VECCHIETTA

K 1235 : Figure 410

ST. BERNARDINE. Brunswick, Me., Walker Art Museum, Bowdoin College, Study Collection (1961.100.7), since 1961.[1] Wood. 15 × 7⅛ in. (38·1 × 18·1 cm.). Good condition except for restorations in gold background and on the original frame.

The appearance of St. Bernardine was firmly fixed in art from the time of his death (May 20, 1444) and canonization (1450) and he was frequently represented in the manner of K 1235 by artists in the circle of Sassetta, Sano di Pietro, and Vecchietta. It is difficult to say which of these three artists had the strongest stylistic influence upon K 1235,[2] which is probably to be dated in the second half of the fifteenth century.

Provenance: Venier, Venice. Contini Bonacossi, Florence. Kress acquisition, 1939.

References: (**1**) *The Walker Art Museum Bulletin*, vol. I, 1961, p. 8, as Vecchietta. (**2**) In ms. opinions K 1235 has been attributed to Vecchietta by G. Fiocco, W. E. Suida, and A. Venturi; tentatively to Pietro di Domenico by R. Longhi; and to Sassetta or possibly Pietro di Giovanni d' Ambrogio by B. Berenson.

ANDREA DI NICCOLÒ

Andrea di Niccolò di Giacomo. Sienese School. Active 1470–1510. Possibly a pupil of Vecchietta, Andrea di Niccolò collaborated with Giovanni di Paolo in 1470. Some of his later signed pictures show the influence of Matteo di Giovanni and Benvenuto di Giovanni, and even of Neroccio de' Landi.

Attributed to ANDREA DI NICCOLÒ

K 290 : Figure 411

PIETÀ. Memphis, Tenn., Brooks Memorial Art Gallery (61.192), since 1958.[1] Wood. 20⅛ × 16¼ in. (51·2 × 41·3 cm.). Fair condition except for some abrasions and a few losses of paint; cleaned 1957.

Sometimes attributed to Vecchietta himself, K 290 is undoubtedly close to him in style. It is perhaps most convincingly attributed to Andrea di Niccolò.[2] His signed and dated (1502) *Crucifixion* in the Siena Pinacoteca offers stylistic parallels to K 290, which probably dates about 1500. Saints who lived in various periods (Rosalie, with a flower; Ursula (?), with the banner of victory over death; Agnes, with a lamb; Margaret, with a small cross; Jerome, with a stone; and Francis, with the stigmata) are ranged as witnesses behind the participants in the scene at the foot of the cross: John the Evangelist, the Virgin, the dead Christ, and the Magdalen.

Provenance: Karl Neumann, Barmen-Elberfeld, Germany (1933). Contini Bonacossi, Florence. Kress acquisition, 1934 – exhibited: National Gallery of Art, Washington, D.C. (257), 1941–51.[3]

References: (**1**) Catalogue by W. E. Suida, 1958, p. 12, as Andrea di Niccolò. (**2**) K 290 has been attributed to Vecchietta by G. Fiocco, R. Longhi, R. van Marle, A. Venturi (in ms. opinions), and B. Berenson (*Pitture italiane del rinascimento*, 1936, p. 508); to a pupil of Vecchietta by F. M. Perkins (in ms. opinion); to the school of Vecchietta by G. Vigni (*Vecchietta*, 1937, p. 89); to Girolamo di Benvenuto by R. Offner (in ms. opinion); tentatively to Benvenuto di Giovanni by F. Zeri (in *Bollettino d'Arte*, vol. XLIX, 1964, p. 48); to Andrea di Niccolò by M. Meiss (in ms. opinion). (**3**) *Preliminary Catalogue*, 1941, p. 209, as Vecchietta.

FRANCESCO DI GIORGIO

Francesco Maurizio di Giorgio Martino. Sienese School. Born 1439; died 1501/02. He was probably trained under Vecchietta, who had a decisive influence on his style. First

recorded as painter and sculptor in 1464, he was especially in demand as architect and engineer. A six-or-seven-year partnership between him and Neroccio de'Landi was terminated in 1475, leaving Neroccio's style strongly marked by Francesco's eccentric genius. He was active not only in Siena, but also at the courts of Urbino and Naples and elsewhere in Italy.

K1564 : Figure 419

THE NATIVITY. Atlanta, Ga., Atlanta Art Association Galleries (61.25), since 1961. Wood. 9⅜×8¾ in. (23·8× 22·3 cm.). Fair condition except for abrasions throughout; cleaned 1951.

A miniature of the *Nativity* which must have been painted by Francesco di Giorgio about 1460 (in an antiphonal now in the Cathedral Museum at Chiusi)[1] is very close in composition and style to K1564, indicating a similarly early date for this small painting.[2] The composition was used again, but with more elaborate detail, in Francesco's *Nativity* (now in the Metropolitan Museum, New York) to which K1356 once belonged (see p. 154, below).

Provenance: Cook Collection, Richmond, Surrey (catalogue by T. Borenius, 1913, no. 7, as Francesco di Giorgio); – exhibited: 'Winter Exhibition,' Burlington Fine Arts Club, London, 1902, no. 12, as Francesco di Giorgio; 'Pictures of the School of Siena,' Burlington Fine Arts Club, London, 1904, no. 35 of catalogue of 1905, as Francesco di Giorgio. Contini Bonacossi, Florence. Kress acquisition, 1948 – exhibited: William Rockhill Nelson Gallery of Art, Kansas City, Mo., 1952–60.[3]

References: (1) Reproduced by A. S. Weller, *Francesco di Giorgio*, 1943, fig. 9. (2) K1564 has been attributed to Francesco di Giorgio by B. Berenson (*Central Italian Paintings of the Renaissance*, 1897; 1909, p. 170; *Italian Pictures of the Renaissance*, 1932, p. 203; Italian ed., 1936, p. 174), T. Borenius (in Crowe and Cavalcaselle, *A History of Italian Painting*, vol. v, 1914, p. 157 n.), A. McComb (in *Art Studies*, vol. II, 1924, p. 18), F. M. Perkins (in *La Diana*, vol. IV, 1929, p. 217), R. van Marle (*Italian Schools of Painting*, vol. XVI, 1937, p. 273, dating it after 1475), A. S. Weller (*Francesco di Giorgio*, 1943, pp. 62 f., dating it in the 1460's), J. Pope-Hennessy (*Sienese Quattrocento Painting*, 1947, pp. 20, 32, dating it c. 1465), and R. Longhi (in ms. opinion, dating it 1470/80). (3) Catalogue by W. E. Suida, 1952, p. 18, as Francesco di Giorgio.

FRANCESCO DI GIORGIO

K1370 : Figure 414

MADONNA AND CHILD WITH ANGELS. Coral Gables, Fla., Joe and Emily Lowe Art Gallery, University of Miami (61.25), since 1961.[1] Wood. 28⅞×18⅛ in. (73·4×46·1 cm.). Many small retouchings on the Madonna's face and hands; angels in better condition; cleaned 1960–61.

This has been well known ever since it was shown in the Sienese exhibition of 1904, where it was wrongly attributed to Neroccio, although it had before been correctly listed as by Francesco di Giorgio.[2] Early reproductions show the panel much repainted, thus accounting for some mistakes in attribution, which seem to have strayed even as far afield as to Fra Angelico. Cleaning has revealed the characteristics of Francesco's early style, of about 1470. The heads of the angels betray derivation from Vecchietta, transformed by Francesco into blond types that might have served as models for Marie Laurencin.

Provenance: Monastery of Sant'Eugenio, near Siena (property of the Sienese Griccioli family, mid-nineteenth century) – exhibited: 'Mostra dell'Antica Arte Senese,' Siena, Apr.–Aug., 1904, p. 314, no. 11 (132), of catalogue, under Sala XXIX, as by Neroccio. Dan Fellows Platt, Englewood, N.J. (as early as 1924; sold by estate trustee to the following). Kress acquisition, 1943 – exhibited: National Gallery of Art, Washington, D.C., 1945–52 (798), as Francesco di Giorgio; after entering the Joe and Emily Lowe Art Gallery: 'Art Treasures for America,' National Gallery of Art, Washington, D.C., Dec. 10, 1961–Feb. 4, 1962, no. 26, as Francesco di Giorgio.

References: (1) Catalogue by F. R. Shapley, 1961, p. 26, as Francesco di Giorgio. (2) B. Berenson (*Central Italian Painters*, 1897, 1909, p. 171) listed K1370 as Francesco di Giorgio, and added the qualifying phrase 'in great part' in his later lists (*Italian Pictures of the Renaissance*, 1932, p. 202; Italian ed., 1936, p. 174). K1370 is treated among the artist's paintings by E. G. Gardner (*Story of Siena . . .*, 1902, p. 301), F. M. Perkins (in *Burlington Magazine*, vol. v, 1904, p. 583; in *Rassegna d'Arte*, vol. IV, 1904, p. 151; ibid., vol. XI, 1911, p. 5; in *Rassegna d'Arte Antica e Moderna*, vol. I, 1914, pp. 102 ff.), A. McComb (in *Art Studies*, vol. II, 1924, p. 18), and L. Venturi (*Italian Paintings in America*, vol. II, 1933, no. 302). A. S. Weller (*Francesco di Giorgio*, 1943, pp. 84 f.), in a more detailed study of the painting, considers it typical of Francesco's early work, of about 1470, as does G. Coor (*Neroccio de' Landi*, 1961, p. 87 n. 305 and p. 117).

FRANCESCO DI GIORGIO

K1356 : Figure 416

GOD THE FATHER SURROUNDED BY ANGELS AND CHERUBIM. Washington, D.C., National Gallery of Art (799), since 1945. Wood. 14⅜×20⅜ in. (36·5×51·8 cm.). Fair condition.

This has long been recognized as a fragment from the upper part of such a composition as an approximately contemporary *Nativity* signed by Matteo di Giovanni, recently in the art market,[1] and a *Nativity* by Girolamo da Cremona in the Jarves Collection, at Yale University, New Haven. The lower part of the composition has now been identified in Francesco's *Nativity* in the Metropolitan Museum, New York.[2] The original picture, its arched top preserved as the upper part of K1356, was sawed in two, probably late in the last century. The horizontal division came immediately below the lowest angel's right knee. To repeat the top curve of K1356 on its lower edge, the panel was trimmed at lower left and right and a curved strip added at the bottom. X-ray reveals the upper edge of the Virgin's halo at the lower right in the original part of K1356, the roof of the Nativity hut at the left, and below the angels a swirl of light such as that below the cherubim-borne God the Father in Francesco's *Coronation of the Virgin* in the Siena Pinacoteca, dated 1471. K1356 was probably painted about the same time. Its exhibition of foreshortening is as remarkable as that in the heavenly host at the top of the *Coronation*, and for expression of exuberant, exultant movement it is ranked as Francesco's greatest achievement.[3] Some of the angels are repetitions – but more brilliantly painted – of figures in Francesco's book cover of 1467 in the Palazzo Piccolomini, Siena.

Provenance: Alphonse Kann, Paris (sold 1917, to the following). Duveen's, New York. Philip Lehman, New York (catalogue by R. Lehman, 1928, no. LII, as Francesco di Giorgio). Kress acquisition, 1943.

References: (1) Recently offered for sale by G. Cramer, The Hague; reproduced in *Burlington Magazine*, vol. XCIII, 1951, Dec. Supplement, pl. I. (2) F. Zeri (in *Bollettino d'Arte*, vol. XLIX, 1964, pp. 41 ff.). (3) K1356 was first published by F. M. Perkins (in *Rassegna d'Arte, Antica e Moderna*, vol. I, 1914, pp. 101 f.), as Francesco di Giorgio, to whom it has been attributed also by A. McComb (in *Art Studies*, vol. II, 1924, pp. 18 f.), G. H. Edgell (*Sienese Painting*, 1932, pp. 244 f.), B. Berenson (*Italian Pictures of the Renaissance*, 1932, p. 202; Italian ed., 1936, p. 174), L. Venturi (*Italian Paintings in America*, vol. II, 1933, no. 304), R. van Marle (*Italian Schools of Painting*, vol. XVI, 1937, p. 274), A. S. Weller (*Francesco di Giorgio*, 1943, pp. 60, 67 f.), and C. L. Ragghianti (in *Critica d'Arte*, May 1949, p. 81).

Studio of FRANCESCO DI GIORGIO

K530 : Figure 420

THE MEETING OF DIDO AND AENEAS. Portland, Ore., Portland Art Museum (61.36), since 1952.[1] Wood. 14¾ × 43⅜ in. (37·5 × 110·2 cm.). Fair condition except worn throughout; cleaned 1957.

Francesco di Giorgio's style is reflected so faithfully in the buildings and figure types that this cassone panel has been attributed to the master himself. The somewhat stiff drawing of the figures and their insecure stance make the attribution to his studio more plausible.[2] The date may be about 1480. The left half of the painting represents the first meeting between Dido and Aeneas at Carthage, as related in the first book of Virgil's *Aeneid*. At the right may be the disembarkation of Aeneas at Carthage.

Provenance: Contini Bonacossi, Florence. Kress acquisition, 1938 – exhibited: National Gallery of Art, Washington, D.C. (415), 1941–46.[3]

References: (1) Catalogue by W. E. Suida, 1952, p. 24, as Francesco di Giorgio. (2) K530 has been attributed to Francesco di Giorgio by B. Berenson, G. Fiocco, R. Longhi, F. M. Perkins, and A. Venturi (in ms. opinions). A. S. Weller (*Francesco di Giorgio*, 1943, pp. 127 n. 108, 311) and G. Coor (*Neroccio de' Landi*, 1961, p. 92 n. 325) attribute it to Francesco's studio. (3) *Preliminary Catalogue*, 1941, p. 67, as Francesco di Giorgio.

NEROCCIO DE'LANDI

Neroccio di Bartolomeo di Benedetto di Neroccio, a member of the Sienese noble family Landi del Poggio. Sienese School. Born 1447; died 1500. He was trained under Vecchietta, was an independent artist by 1468, and entered about this time into a partnership with Francesco di Giorgio, which lasted until 1475. He was active chiefly as painter, but occasionally as sculptor, and was employed mostly in Siena.

K439 : Figure 417
THE VISIT OF CLEOPATRA TO ANTONY

K438 : Figure 418
THE BATTLE OF ACTIUM

Raleigh, N.C., North Carolina Museum of Art (GL.60.17.29 and 30), since 1960.[1] Wood. K439, 14¼ × 44½ in. (36·2 × 113 cm.); K438, 14⅜ × 44⅛ in. (36·5 × 112·1 cm.). Abraded throughout; cleaned 1960.

Documents record several pairs of cassoni, or marriage chests, by Neroccio.[2] One of these is described as a 'pair of chests with stories worked in fine gold.' That pair was painted in 1476, but the description applies equally well to K438 and K439, which are probably the principal sides from a pair of earlier cassoni. Critics now agree in attributing these two panels to Neroccio, shortly after 1470, while he was associated with Francesco di Giorgio.[3] The former attribution of K439 to Francesco[4] may be explained in part by Neroccio's use of Francesco's architectural designs. The

two panels witness the interest, among Sienese art patrons of the time, in Classical subject matter. The scene in K439 follows the account in Plutarch's *Lives* of the arrival of Cleopatra's barge in the River Cydnus:

'She herself lay all alone under a canopy of cloth of gold, dressed as Venus in a picture, and beautiful young boys, like painted Cupids, stood on each side to fan her. Her maids were dressed like sea nymphs and graces, some steering at the rudder, some working at the ropes. The perfumes diffused themselves from the vessel to the shore, which was covered with multitudes, part following the galley up on either bank, part running out of the city to see the sight, while the word went through all the multitude that Venus was come to feast with Bacchus, for the common good of Asia.'[5]

K438 is a pageantlike version of the early phase of the famous battle in which Mark Antony was eventually defeated by Octavian (31 B.C.) in the Gulf of Arta, off the promontory of Actium.

Provenance: Earl of Northesk, Ethie Castle, Arbroath (sold, Christie's, London, July 13, 1928, no. 21, as *Story of Saint Ursula* by Matteo di Giovanni; bought by Hallyn). Edward Hutton, London. Contini Bonacossi, Florence. Kress acquisition, 1936 – exhibited: National Gallery of Art, Washington, D.C. (353, 352), 1941–56;[6] after entering the North Carolina Museum: 'Art Treasures for America,' National Gallery of Art, Washington, D.C., Dec. 10, 1961– Feb. 4, 1962, nos. 72, 71, as Neroccio de' Landi.

References: (**1**) Catalogue by F. R. Shapley, 1960, pp. 66 and 68, as Neroccio de' Landi. (**2**) G. Coor, *Neroccio de' Landi,* 1961, pp. 28 f., 141 f. (document VIII), 195. (**3**) K438 and 439 have been attributed to Neroccio de' Landi by B. Berenson (only K438), G. Fiocco, R. Longhi, F. M. Perkins, W. E. Suida, A. Venturi (in ms. opinions), A. S. Weller (*Francesco di Giorgio,* 1943, p. 311, mentioning only K439), J. Pope-Hennessy (*Sienese Quattrocento Painting,* 1947, pp. 21 f., mentioning only K439), E. Carli (*Sienese Painting,* 1956, p. 70), and G. Coor (*Neroccio de'Landi,* 1961, pp. 28 ff., 176, 195). (**4**) See note 7, below. (**5**) Quoted (from Plutarch's *Lives;* Antony, XXVI) by Pope-Hennessy, *loc. cit.* in note 3, above. (**6**) *Preliminary Catalogue,* 1941, pp. 67 and 142: K438, as Neroccio; K439, as Francesco di Giorgio.

NEROCCIO DE'LANDI

K411 : Figure 415

MADONNA AND CHILD WITH ST. JEROME AND ST. MARY MAGDALENE. New York, Metropolitan Museum of Art (61.43), since 1961.[1] Wood. $24\frac{1}{2} \times 17\frac{7}{8}$ in. (62.2×45.4 cm.). Excellent condition; heavily varnished; needs cleaning.

Close relationship to well-established paintings by Neroccio has assured unanimous attribution of K411 to this master,[2] with preference for a date in the early 1490's. The striking similarity of the head of the Magdalen to that in a papier mâché mirror frame in the Victoria and Albert Museum, London, attributed to the studio of Neroccio has suggested that the same model served for both heads.[3] The pose of the Child is undoubtedly derived from Vecchietta's Pienza altarpiece.[4]

Provenance: Dukes of Saxe-Meiningen, Castle of Meiningen, Thuringia, Germany (by 1897 to c. 1928; inventory, 1909). R. Langton Douglas, London. Duveen's, New York (c. 1932–36; *Duveen Pictures in Public Collections of America,* 1941, no. 120, as Neroccio de'Landi). Kress acquisition, 1936 – exhibited: National Gallery of Art, Washington, D.C. (333), 1941–60.[5]

References: (**1**) F. Zeri, *Catalogue of Italian Painting, Metropolitan Museum of Art,* 1963, unpublished. (**2**) K411 has been attributed to Neroccio by B. Berenson (*Central Italian Painters of the Renaissance,* 1897, p. 156, and later editions), P. Schubring (in Thieme-Becker, *Allgemeines Lexikon,* vol. XXII, 1928, p. 295), L. Venturi (*Italian Paintings in America,* vol. II, 1933, no. 307), R. van Marle (*Italian Schools of Painting,* vol. XVI, 1937, p. 302), G. Fiocco, R. Longhi, F. M. Perkins, W. E. Suida, A. Venturi (in ms. opinions), J. Pope-Hennessy (in *Burlington Magazine,* vol. LXXXIV, 1944, p. 144), C. Brandi (*Quattrocentisti senesi,* 1949, p. 271, dating it between 1480 and 1492), and G. Coor (*Neroccio de'Landi,* 1961, pp. 80 f., 85, 95 ff., 122, 190 f., dating it at the beginning of the 1490's). (**3**) Coor, *op. cit.,* p. 81. J. H. Stubblebine (in *Speculum,* vol. XXXVII, 1962, p. 429) tentatively identifies the model for the mirror frame as Neroccio's bride, Lucrezia Paltoni, whom he married in 1493. (**4**) Reproduced by Coor, fig. 100 of *op. cit.,* in note 2, above. (**5**) *Preliminary Catalogue,* 1941, p. 142, as Neroccio de'Landi.

NEROCCIO DE'LANDI

K1346 : Figure 421

MADONNA AND CHILD WITH ST. ANTHONY ABBOT AND ST. SIGISMUND. Washington, D.C., National Gallery of Art (813), since 1945. Wood. $62\frac{3}{8} \times 55\frac{7}{8}$ in. (158.5×142 cm.). Good condition but much obscured by old varnish; many darkened stains.

Unanimously attributed to Neroccio,[1] K1346 is convincingly dated c. 1495 by comparison with other of his large altarpieces. The unusual *contrapposto* pose of the Child derives from Vecchietta's altarpiece at Pienza.[2] St. Anthony Abbot, at the left, is easily recognized by his symbols; St. Sigismund, at the right, is less familiar in art;

but he appears in three of Neroccio's altarpieces of about this time.

Provenance: Cappella di San Bartolommeo, Rapolano (1865).[3] I. Magi, mayor of Rapolano (by 1902). Pievania delle Serre, Rapolano (by 1911). Private Collection, Rapolano (sold 1925 to the following). Comm. Elia Volpi, Florence. Arthur Sachs, New York – exhibited: Metropolitan Museum of Art, New York, Feb. 1931– Feb. 1934. Seligman's, New York. Kress acquisition, 1943.

References: (1) K1346 has been attributed to Neroccio by F. Brogi (*Inventario generale degli oggetti d'arte della provincia di Siena*, compiled, 1862–65, published 1897, p. 460), R. L. Douglas (*History of Siena*, 1902, p. 385 n. 1), B. Berenson (*Central Italian Painters of the Renaissance*, 1909, p. 207, and later editions of the lists), P. Rossi (in *Rassegna d'Arte Senese*, vol. v, 1909, p. 23 n.), J. Breck (in *L'Arte*, vol. xv, 1912, pp. 67 f.), L. Dami (in *Rassegna d'Arte*, vol. xiii, 1913, p. 161), T. Borenius (in Crowe and Cavalcaselle, *A History of Painting in Italy*, vol. v, 1914, p. 159 n.), G. H. Edgell (*Sienese Painting*, 1932, p. 248), L. Venturi (*Italian Paintings in America*, vol. ii, 1933, no. 310), R. van Marle (*Italian Schools of Painting*, vol. xvi, 1937, p. 308), J. Pope-Hennessy (in *Burlington Magazine*, vol. lxxv, 1939, p. 235; *ibid.*, vol. lxxxiv, 1944, p. 144; *Sienese Quattrocento Painting*, 1947, pp. 22, 33, as perhaps Neroccio's greatest work), and G. Coor (*Neroccio de'Landi*, 1961, pp. 9, 67 n. 221, 96 f., 99, 104, 122, 192, 195). (2) Reproduced by Coor, *op. cit.*, fig. 100. (3) Described in the *Inventario generale . . .* cited in note 1, above, as in this chapel.

Follower of NEROCCIO DE'LANDI

K1901 : Figure 422

MADONNA AND CHILD WITH SAINTS. Notre Dame, Ind., University of Notre Dame, Study Collection (62.17.2), since 1962.[1] Wood. $9\frac{1}{16} \times 9\frac{5}{16}$ in. (23×24·5 cm.). Abraded throughout; some losses of paint.

Suggestions of Neroccio de'Landi, especially in the Virgin's sharply inclined head, have led to the attribution of K1901 to that master,[2] but reminders of other Sienese artists, notably of Vecchietta, compete for attention. The date is probably about 1500. St. John the Baptist introduces the kneeling monk, presumably the donor, and the Magdalen, with ointment box, stands beyond.

Provenance: Bargagli-Petrucci, Siena. Knoedler's, New York (1952). Kress acquisition, 1952.

References: (1) Catalogue, 1962, p. unnumbered, as Neroccio de'Landi. (2) *Ibid.*

MATTEO DI GIOVANNI

Sienese School. Born *c.* 1430; died 1495. He was active chiefly in Siena and signed himself as Sienese. Early Umbrian influences upon his style were superseded by those of the Sienese painters Domenico di Bartolo and Vecchietta and of the Florentine Pollaiuolo. Extant paintings by Matteo are dated as early as 1460 and almost as late as 1490, a span of activity in which he was one of the most prominent painters in Siena.

K517 : Figure 423

MADONNA AND CHILD WITH SAINTS AND ANGELS. Washington, D.C., National Gallery of Art (408), since 1941.[1] Wood. $26 \times 17\frac{3}{8}$ in. (66×44 cm.). Inscribed on the Virgin's halo: AVE GRATIA PLENA DO[minvs tecvm] (from Luke 1 : 28). Very good condition except for a few losses of paint; heavily varnished; needs cleaning.

The full-length *Enthroned Madonna and Child with Angels* in the Siena Pinacoteca, which is signed and dated 1470, offers significant parallels to K517 in figure types and three-dimensional effect, suggesting about the same period for K517.[2] The male saint (Jerome?) and the singing angels recall Domenico di Bartolo, while the head of St. Catherine may indicate some contact with Francesco di Giorgio and Neroccio de'Landi.

Provenance: Earl of Ashburnham, Battle, Sussex. R. Langton Douglas, London. Duveen's, New York (*Duveen Pictures in Public Collections of America*, 1941, no. 94, as Matteo di Giovanni). Clarence H. Mackay, Roslyn, Long Island, N.Y. (catalogue by W. R. Valentiner, 1926, no. 5, as Matteo di Giovanni) – exhibited: Duveen Galleries, New York, Apr.–May, 1924, no. 30 of catalogue, 1926, by W. R. Valentiner, as Matteo di Giovanni. Duveen's, New York. Kress acquisition, 1938.

References: (1) *Preliminary Catalogue*, 1941, p. 131, as Matteo di Giovanni. (2) K517 has been attributed to Matteo di Giovanni by G. Fiocco, R. Longhi, F. M. Perkins, W. E. Suida, A. Venturi (in ms. opinions), B. Berenson (*Italian Pictures of the Renaissance*, 1932, p. 351; Italian ed., 1936, p. 302), M. Gengaro (in *La Diana*, vol. ix, 1934, p. 181), R. van Marle (*Italian Schools of Painting*, vol. xvi, 1937, pp. 358 f.), and C. Brandi (*Quattrocentisti senesi*, 1949, p. 210, dating it 1470).

MATTEO DI GIOVANNI

K1746 : Figure 425

MADONNA AND CHILD WITH ST. CATHERINE OF SIENA AND ST. SEBASTIAN. Columbia, S.C., Columbia Museum of Art (62-920), since 1962.[1] Wood. 25½ × 16¾ in. (64·8 × 42·6 cm.). Inscribed on the Virgin's halo: REGINA CELI LETARE (beginning of the *Regina Coeli*, an Easter antiphon); on the collar of her dress: AVE MARIA GR[atia] (from Luke 1 : 28). Good condition except for slight abrasion of the Madonna's face; cleaned 1949.

Among the many half-length *Madonnas* by Matteo, one of the closest to K1746 in composition and style is the *Madonna and Child with Sts. Jerome and Francis* in the Siena Pinacoteca, from Matteo's latest period. K1746 also probably dates toward 1490,[2] a few years later, perhaps than the triptych of the *Madonna and Saints* in San Domenico, Siena, which anticipates K1746 in the lively pose of the Child.

Provenance: Lucien Marchand, Geneva, Switzerland. Contini Bonacossi, Florence. Kress acquisition, 1950 – exhibited: William Rockhill Nelson Gallery of Art, Kansas City, Mo., 1952–60.[3]

References: (1) Catalogue by A. Contini Bonacossi, 1962, pp. 21 f., as Matteo di Giovanni. (2) R. Longhi (in ms. opinion) attributes K1746 to Matteo di Giovanni, dating it c. 1480. (3) Catalogue by W. E. Suida, 1952, p. 16, as Matteo di Giovanni.

MATTEO DI GIOVANNI

K1745A : Figure 424
THE MAGI BEFORE HEROD

K1745B : Figure 427
THE CRUCIFIXION

San Francisco, Calif., M. H. De Young Memorial Museum (61-44-8 and 61-44-9), since 1955.[1] Wood. K1745A, 11¾ × 27 in. (29·9 × 68·6 cm.); K1745B, 11¾ × 26¾ in. (29·9 × 68 cm.). Very good condition except for a few losses of paint in K1745A; cleaned 1948.

These panels are believed to have come from the predella of Matteo di Giovanni's *Massacre of the Innocents*, dated 1491, in the Church of Santa Maria dei Servi, Siena.[2] The *Crucifixion* would have been in the middle, the *Magi before Herod* at the left, and an unknown third panel, no doubt representing the *Adoration of the Magi*, at the right. The landscape in K1745B is like a continuation of that in the lunette of the Servi altarpiece. In the execution of both lunette and predella Matteo may well have had the cooperation of an assistant. K1745A shows Herod, surrounded by his chief priests and scribes, preparing to question the three Magi. In K1745B John the Evangelist stands behind the group of holy women, who support the swooning Virgin, and Longinus and the Centurion stand at the foot of the cross.

Provenance: Vittorio Forti, Rome. Contini Bonacossi, Florence. Kress acquisition, 1950 – exhibited: National Gallery of Art, Washington, D.C., 1951–52.[3]

References: (1) Catalogue by W. E. Suida, 1955, pp. 40, 42, as Matteo di Giovanni. (2) K1745A and B have been attributed to Matteo di Giovanni by R. Longhi (in ms. opinion, the first to connect the panels with the Servi altarpiece), B. Berenson (in ms. opinion), and J. Pope-Hennessy (in *Burlington Magazine*, vol. CII, 1960, p. 64). (3) *Paintings and Sculpture from the Kress Collection*, 1951, p. 274 (catalogue by W. E. Suida), as Matteo di Giovanni.

MATTEO DI GIOVANNI

K496 : Figure 426

JUDITH WITH THE HEAD OF HOLOFERNES. Bloomington, Ind., Indiana University, Study Collection (L62.163), since 1962. Wood. 22 × 18⅛ in. (55·9 × 46·1 cm.). Fragment; abraded throughout; sky much restored; landscape and balustrade modern additions; cleaned 1955.

The panel has been shortened and the painted balustrade added on a separate piece of wood. Presumably the figure of Judith was originally full length and was shown standing on a pedestal like that under the *Claudia Quinta* by Neroccio de'Landi, in the National Gallery of Art. Thus completed, the *Judith* was probably included in the series of *Virtuous Men and Women*, of which eight are now known:[1] *Alexander the Great* (Barber Institute, Birmingham, England), *Eunostos of Tanagra* (National Gallery of Art, Washington, D.C., catalogued as K1400 in vol. II of the present publication), *Tiberius Gracchus* (Budapest Gallery), an *Unidentified Woman* (Museo Poldi Pezzoli, Milan) – these four attributed to Signorelli and the Master of the Griselda Legend; *Scipio Africanus* (Bargello, Florence), by Francesco di Giorgio and the Master of the Griselda Legend; *Claudia Quinta* (National Gallery of Art, Washington, D.C. no. 12), by Neroccio de'Landi and the Master of the Griselda Legend; *Sulpicia* (Walters Art Gallery, Baltimore), by Pacchiarotto; and *Judith* (here catalogued, K496), by Matteo di Giovanni. Pacchiarotto's panel is probably the latest in the series, dating about 1500, while Matteo's (K496) is probably one of the earliest, since it cannot be later than 1495, the year of his death.[2] Moreover, the costume, hairdress, and mild expression are paralleled in Matteo's *Massacre of the Innocents*

of 1491. On the pedestals, which are preserved on most of the panels in the series, are crescents, probably indicating that the paintings were commissioned by a member of the Sienese Piccolomini family.[3] The panels probably decorated a long wall in the great hall of a palace or villa, the male figures alternating with the female, as in Castagno's Villa Legnaia series of famous men and women.[4] It has been suggested that the commission for the whole series was given to Signorelli, who gave part of the work to independent artists.[5]

Provenance: Seventh Duke of Newcastle (from whom, by inheritance, to the following). Earl of Lincoln, Clumber, Worksop, Nottinghamshire (sold, Christie's, London, June 4, 1937, no. 100, as Signorelli). Giuseppe Bellesi, London. Contini Bonacossi, Florence. Kress acquisition, 1937 – exhibited: National Gallery of Art, Washington, D.C. (389), 1941–57.[6]

References: (1) As this volume goes to press, R. Longhi (in *Paragone,* no. 175, 1964, pp. 5 ff., figs. 2a, 2b, and 4 ff.) suggests the addition of three more panels to the series: *Jugurtha* (Henry Harris sale, Sotheby's, London, Oct. 25, 1950, no. 194, as Fungai) and *Augustus* (private collection, Florence), both of which Longhi attributes to Girolamo di Benvenuto, and *Cleopatra* (title uncertain; private collection), which he attributes to Raphael. The compositions of the lower parts of these panels may throw some doubt on their inclusion in the series. (2) K496 has been attributed to Matteo di Giovanni by B. Berenson, G. Fiocco, F. M. Perkins, W. E. Suida, A. Venturi (in ms. opinions), and G. Coor (*Neroccio de'Landi,* 1961, pp. 94 f.); and to Neroccio de'Landi by R. Longhi (in ms. opinion). (3) For this frequently repeated assumption (first suggested by G. de Nicola, in *Burlington Magazine,* vol. XXXI, 1917, p. 228) Coor (*loc. cit.* in note 2, above) offers evidence in the similar crescents on the Testa Piccolomini monument. (4) Coor, *loc. cit.* (5) *Ibid.* (6) *Preliminary Catalogue,* 1941, pp. 131 f., as Matteo di Giovanni.

BENVENUTO DI GIOVANNI

Benvenuto di Giovanni di Meo del Guasta. Sienese School. Born 1436; died *c.* 1518. He was probably trained under Vecchietta, but the concise modeling and bright, translucent coloring, which characterize his finest work, surely indicate the strong influence of Girolamo da Cremona and of the Paduan School.

K545 : Figure 428

THE AGONY IN THE GARDEN. Washington, D.C., National Gallery of Art (429), since 1941.[1] Wood. 17×19 in. (43·2×48·3 cm.). Very much abraded; needs cleaning.

For the commentary, etc., see K1647A–D, below.

Provenance: Contini Bonacossi, Florence. Kress acquisition, 1938 – exhibited: 'Night Scenes,' Wadsworth Atheneum, Hartford, Conn., Feb. 15–Mar. 7, 1940, no. 9.

Reference: (1) *Preliminary Catalogue,* 1941, p. 24, as Benvenuto di Giovanni.

BENVENUTO DI GIOVANNI

K1647A : Figure 429
CHRIST CARRYING THE CROSS

K1647B : Figure 430
THE CRUCIFIXION

K1647C : Figure 431
CHRIST IN LIMBO

K1647D : Figure 432
THE RESURRECTION

Washington, D.C., National Gallery of Art (1131, 1132, 1133, and 1134, respectively), since 1951.[1] Wood. A and C, each, 17×19 in. (43·2×48·3 cm.); B, 16¾×21½ in. (42·6×54·6 cm.); D, 17×19¼ in. (43·2×48·9 cm.). Very good condition.

These five panels are now reunited to form what was probably a complete predella. Since the style dates it late in Benvenuto's career,[2] it is tempting to think that it may have been the predella to Benvenuto's altarpiece of the *Ascension,* dated 1491, in the Siena Pinacoteca, for which its total width would have been suitable. It may date, however, a little earlier, nearer the altarpiece of the *Madonna* (1483) in the Church of San Domenico, Siena. The series of panels has been attributed by some critics to Girolamo di Benvenuto,[3] whose style it is possible to confuse with that of his father, Benvenuto di Giovanni. A striking parallel may be noted between the group of holy women at the lower left in K1647B and the *Pietà* in the Berenson Collection, Settignano, accepted as by Benvenuto.[4]

Provenance of K1647A–D: Cook Collection, Richmond, Surrey (acquired 1875, through Sir J. C. Robinson; catalogue by T. Borenius, vol. I, 1913, no. 6, as Benvenuto di Giovanni) – exhibited: 'Pictures of the School of Siena,' Burlington Fine Arts Club, London, 1904, no. 54 of 1905 catalogue, as early Girolamo di Benvenuto, while working with his father. Wildenstein's, New York. Kress acquisition, 1949.

References: (**1**) *Paintings and Sculpture from the Kress Collection,* 1951, p. 62 (catalogue by W. E. Suida), as Benvenuto di Giovanni. (**2**) The series has been attributed to Benvenuto di Giovanni by E. Hutton (in Crowe and Cavalcaselle, *A New History of Painting in Italy,* vol. III, 1909, p. 118), B. Berenson (*Italian Pictures of the Renaissance,* 1932, p. 77; Italian ed., 1936, p. 66), R. Longhi (in ms. opinion, suggesting a date of *c.* 1483), and R. van Marle (*Italian Schools of Painting,* vol. XVI, 1937, pp. 416 f.). It was attributed earlier to Girolamo di Benvenuto by G. Frizzoni (in *L'Arte,* vol. VII, 1904, p. 269), R. E. Fry (in *Rassegna d'Arte,* vol. IV, 1904, p. 118), and T. Borenius (in Crowe and Cavalcaselle, *A History of Painting in Italy,* vol. V, 1914, p. 164 n. 1, tentatively, but see under *Provenance,* above). (**3**) See *Provenance* and note 2, above. (**4**) Reproduced by van Marle, p. 408 of *op. cit.* in note 2, above.

BENVENUTO DI GIOVANNI

K1833 : Figure 433

ST. JOHN GUALBERT AND THE CRUCIFIX. Raleigh, N.C., North Carolina Museum of Art (GL.60.17.31), since 1960.[1] Wood. 13¼×7¾ in. (33·7×19·7 cm.). Good condition except for some losses of paint in architecture parts; cleaned 1954.

Attributions of K1833 to Crivelli and Niccolò da Foligno have been rejected in favor of Benvenuto di Giovanni,[2] about 1485/90. K1833 finds close parallels for its agitated gestures and facial expressions in such examples of the artist's work as the *Assumption* in the Metropolitan Museum, New York, and as the passion scenes (K545, K1647A–D, Figs. 428–432). In K1833 John Gualbert, armed with dagger and sword, stands at the foot of the Crucifix with his brother's murderer, whose life he has just spared; the Crucifix bends forward and Christ speaks to Gualbert in approval of his clemency.

Provenance: Professor Richard von Kaufmann, Berlin (as early as 1902; sold, Cassirer's, Berlin, Dec. 4, 1917, no. 42, as *Scene from a Legend* by Carlo Crivelli). Heinrich Freiherr von Tucher, Vienna and Munich. Kress acquisition, 1950.

References: (**1**) Catalogue by F. R. Shapley, 1960, p. 70, as Benvenuto di Giovanni. (**2**) For the attribution to Crivelli see *Provenance,* above. K1833 has been attributed to Niccolò da Foligno by G. Frizzoni (in *L'Arte,* vol. V, 1902, pp. 293 ff.); to Benvenuto di Giovanni by F. M. Perkins (in *Rassegna d'Arte Senese,* vol. III, 1907, p. 76), B. Berenson (in *Dedalo,* vol. XI, 1931, pp. 643 f.) and R. van Marle (*Italian Schools of Painting,* vol. XVI, 1937, pp. 409, 420).

GUIDOCCIO COZZARELLI

Guidoccio di Giovanni di Marco Cozzarelli. Sienese School. Born 1450; died 1516/17. He was a pupil of Matteo di Giovanni, whose style he emulated so successfully that his paintings have in some cases been attributed to his master. Cozzarelli's most successful work was in manuscript illumination.

K1286 : Figure 435

SCENES FROM THE LIFE OF THE VIRGIN. Coral Gables, Fla., Joe and Emily Lowe Art Gallery, University of Miami (61.22), since 1961.[1] Wood. 26¾×21¼ in. (68×54 cm.). Good condition.

The stylized dolphin-and-vase border at the bottom is unusual in a panel painting but would be normal in a miniature of the period. Close parallels are offered in some of Cozzarelli's book illuminations, of 1480–81, now in the Piccolomini Library, Siena.[2] K1286 was probably painted about the same time. The fact that it is a fragment of a larger painting may also help explain some of the decorative elements: the pilaster and the corner of an entablature at the left may have been part of a now-missing Madonna's throne. The two scenes have been variously interpreted;[3] for Cozzarelli was inclined to be free and informal in matters of iconography. The palm branch carried by the angel in the scene at the right is generally used to indicate that the Virgin's death is being announced. However, Dante[4] describes Gabriel with a palm branch as he comes to announce to the Virgin that she is to be the mother of Christ, and the palm is found in rare paintings of this scene – one by Fra Angelico, for instance. This is likely the subject shown at the right in K1286; and the scene at the left is probably the *Departure of the Virgin and Joseph for Bethlehem,* not the *Flight into Egypt,* which would call for the inclusion of the Christ Child.

Provenance: Dr. Friedrich Lippmann, Berlin (sold, Rudolph Lepke's, Berlin, Nov. 26–27, 1912; catalogue by M. J. Friedländer, no. 35, as Domenico Cozzarelli; bought by Kleinberger's). R. L. Douglas, London (purchased, 1922) – exhibited: 'Antiques and Works of Art,' Olympia, London, July 19–Aug. 1, 1928, no. X-21, as Guidoccio Cozzarelli. London Market. Contini Bonacossi, Florence. Kress acquisition, 1939 – exhibited: National Gallery of Art, Washington, D.C. (507), 1941–57.[5]

References: (**1**) Catalogue by F. R. Shapley, 1961, p. 24, as Cozzarelli. (**2**) Some of these illuminations are reproduced by R. van Marle, *Italian Schools of Painting,* vol. XVI, 1937, figs. 208, 209. K1286 has been attributed to Cozzarelli by B. Berenson, G. Fiocco, R. Longhi, W. E. Suida, A. Venturi (in ms. opinions), T. Borenius (in Crowe and Cavalcaselle, *A History of Painting in Italy,* vol. V, 1914, p. 186), I. Vavasour

Elder (in *Rassegna d'Arte Senese, La Balzana*, vol. I, 1927, p. 116), R. van Marle (*op. cit.*, p. 378), J. Pope-Hennessy (*Sienese Quattrocento Painting*, 1947, pp. 18, 30), and E. Carli (*Sienese Painting*, 1956, p. 69). (3) Van Marle (*op. cit.*, p. 378) interprets the scenes as the *Announcement to the Virgin of Her Death* and the *Journey to Bethlehem*. Pope-Hennessy (*loc. cit.*) labels the scenes as the *Annunciation* and the *Flight into Egypt*. This is the interpretation offered also by Borenius (*loc. cit.*) and E. Carli (*loc. cit.*). (4) Dante, *Il Paradiso*, XXXII, 112–114. (5) *Preliminary Catalogue*, 1941, p. 48, as Cozzarelli.

GUIDOCCIO COZZARELLI

K1283 : Figure 438

MADONNA AND CHILD. Madison, Wis., University of Wisconsin, Study Collection (61.4.11), since 1961.[1] Wood. $18\frac{5}{8} \times 11\frac{1}{2}$ in. (47·3×29·2 cm.).

The strong influence of Matteo di Giovanni upon both Cozzarelli and Pacchiarotto accounts for the attribution of such paintings as K1283 to first one and then the other of these two pupils of Matteo.[2] Two of the closest parallels to K1283 are by Cozzarelli: one in the Palazzo Pubblico, Siena, dated 1484; the other in the Accademia there, signed and dated 1482. K1283 also must date in the early 1480's.

Provenance: Dan Fellows Platt, Englewood, N.J. (sold by estate trustee to the following). Kress acquisition, 1939 – exhibited: National Gallery of Art, Washington, D.C. (503), 1941–52.[3]

References: (1) Catalogue, n.d. (1961?), p. unnumbered, as Pacchiarotto. (2) K1283 has been attributed to Cozzarelli by B. Berenson (*Italian Pictures of the Renaissance*, 1932, p. 157; Italian ed., 1936, p. 136) and R. van Marle (*Italian Schools of Painting*, vol. XVI, 1937, p. 382). It is attributed to Pacchiarotto by F. M. Perkins (in *Rassegna d'Arte*, vol. XI, 1911, p. 5, noting that it had been attributed to Cozzarelli); see also note 1, above, and note 3, below. (3) *Preliminary Catalogue*, 1941, pp. 147 f., as Pacchiarotto.

GUIDOCCIO COZZARELLI

K168 : Figure 439

MADONNA AND CHILD WITH ANGELS. Amherst, Mass., Amherst College, Study Collection (1961–76), since 1961.[1] Wood. $22\frac{3}{4} \times 15\frac{7}{8}$ in. (57·8×40·3 cm.). Inscribed on the Virgin's halo: AVE · MARIA · GRATIA · PLE[na] (from Luke I : 28). Small losses of paint throughout; cleaned 1956.

The artist's close approximation to Matteo di Giovanni's style is indicated by the fact that K168 is assigned by some critics to Guidoccio, by others to Matteo.[2] The date, in either case, would probably be about 1485.

Provenance: Contini Bonacossi, Florence. Kress acquisition, 1931 – exhibited: 'Italian Paintings Lent by Mr. Samuel H. Kress,' Oct. 1932, Atlanta, Ga., through June, 1935, Charlotte, N.C., p. 8 of catalogue, as Matteo di Giovanni; National Gallery of Art, Washington, D.C. (187), 1941–52.[3]

References: (1) Catalogue by C. H. Morgan, 1961, p. 10, as Cozzarelli. (2) K168 has been attributed to Matteo di Giovanni (in ms. opinions) by G. Fiocco, R. Longhi, F. M. Perkins tentatively, W. E. Suida, and A. Venturi; also by R. van Marle (*Italian Schools of Painting*, vol. XVI, 1937, p. 332). It has been attributed to Cozzarelli by B. Berenson (*Pitture italiane del rinascimento*, 1936, p. 136). (3) *Preliminary Catalogue*, 1941, pp. 47 f., as Cozzarelli.

GUIDOCCIO COZZARELLI

K1173 : Figure 434

THE CRUCIFIXION. Tucson, Ariz., University of Arizona (61.109), since 1951.[1] Wood transferred to masonite (only the layer of pigment remains; the gesso had to be removed). $19\frac{3}{4} \times 12\frac{1}{8}$ in. (50·2×30·8 cm.). Good condition except for slight abrasions; cleaned 1952.

The style is closely similar to that of Cozzarelli's book cover representing the *Presentation of the Virgin*, Archivio di Stato, Palazzo Piccolomini, Siena. The date of that illumination, 1483/84, seems suitable for K1173.[2] The figures at the foot of the cross are the Virgin swooning between two holy women, the Magdalen and John the Evangelist standing, and, on horseback, Longinus and the Centurion.

Provenance: Possibly Mrs. Worthington, London (1904) – exhibited: 'Pictures of the School of Siena,' Burlington Fine Arts Club, London, 1904, no. 45 of 1905 catalogue,[3] as Cozzarelli. Private Collection, Siena. Contini Bonacossi, Florence. Kress acquisition, 1939 – exhibited: National Gallery of Art, Washington, D.C. (841), 1945–46, as Cozzarelli.

References: (1) Catalogue by W. E. Suida, 1951, no. 6, and 1957, no. 6, as Cozzarelli. (2) K1173 has been attributed to Cozzarelli by B. Berenson, G. Fiocco, R. Longhi, F. M. Perkins, and A. Venturi (in ms. opinions); also by R. van Marle (*Italian Schools of Painting*, vol. XVI, 1937, p. 386) if K1173 is identical with the painting formerly owned by Mrs. Worthington (see note 3, below). (3) In this catalogue (p. 67) the description of Mrs. Worthington's painting

agrees with that of K1173 except for the larger size (23½×15½ in.), which may possibly be explained by the inclusion of the frame in the measurement. No reproduction of no. 45 of the catalogue is available for comparison.

GUIDOCCIO COZZARELLI

K1743A : Figure 436

ST. SEBASTIAN, ST. URSULA, AND ST. CHRISTOPHER. Tulsa, Okla., Philbrook Art Center (3372), since 1953.[1] Wood. Without moldings: 11×5 in. (28×12·7 cm.); 12¼×5 in. (31·1×12·7 cm.); 11¼×5 in. (28·6×12·7 cm.). Good condition except for a few losses of paint.

For the commentary, etc., see Girolamo di Benvenuto, K1744B, below.

Reference: (1) Catalogue by W. E. Suida, 1953, p. 32, as Cozzarelli.

GUIDOCCIO COZZARELLI

K1743B : Figure 437

ST. ANTHONY ABBOT, ST. ROCH, ST. PETER, AND ST. ANTHONY OF PADUA. Columbia, S.C., Columbia Museum of Art (62-919), since 1962.[1] Wood. Without moldings, each, 10⅞×5 in. (27·7×12·7 cm.). Good condition except for a few losses of paint; partially cleaned 1961.

For the commentary, etc., see Girolamo di Benvenuto, K1744B, below.

Reference: (1) Catalogue by A. Contini Bonacossi, 1962, p. 19, as Cozzarelli.

GIROLAMO DI BENVENUTO

Girolamo di Benvenuto di Giovanni del Guasta. Sienese School. Born 1470; died 1524. The son and pupil of Benvenuto di Giovanni, whom he emulated in style and occasionally equaled in quality.

K1744A : Figures 441–443

ST. JEROME AND TWO OTHER SAINTS. Lewisburg, Pa., Bucknell University, Study Collection (BL-K5), since 1961.[1] Wood. Including moldings: *St. Jerome,* 15¾×7⁵⁄₁₆ in. (40×18·6 cm.); other two, each, 15⅝×7⁵⁄₁₆ in.

(39·7×18·6 cm.). Good condition except for a few abrasions.

For the commentary, etc., see K1744B, below.

Reference: (1) Catalogue by B. Gummo, 1961, p. 22, as Girolamo di Benvenuto.

GIROLAMO DI BENVENUTO

K1744B : Figures 444–446

ST. JOHN THE BAPTIST, ST. MARGARET, AND THE BLESSED AMBROGIO SANSEDONI. New Orleans, La., Isaac Delgado Museum of Art (61.69a, b, and c), since 1953.[1] Wood. Including moldings: *John the Baptist,* 15¾×7¼ in. (40×18·4 cm.); *Margaret,* 15⅝×7³⁄₁₆ in. (39·7×18·3 cm.); *Ambrogio,* 15¹¹⁄₁₆×7⁵⁄₁₆ in. (39·9×18·6 cm.). Good condition except for a few losses of paint.

The thirteen panels catalogued under Cozzarelli, K1743A and B (Figs. 436, 437), and under Girolamo di Benvenuto, K1744A and B, evidently come from a single polyptych, of about 1490. The slight dissimilarities among them (the Ursula panel is higher than the others, and the Christopher and Peter panels have extra decorations in the spandrels) suggest that the panels may have been divided between pilasters and predella of the altarpiece.[2] Two of the panels in K1744A may represent the Blessed Albert the Great, with open book, and St. Augustine.

Provenance: Principe Chigi Albani della Rovere, Rome. Contini Bonacossi, Florence. Kress acquisition, 1950 – exhibited (K1744B only), after entering the Isaac Delgado Museum of Art: 'Religion in Painting,' Arkansas Arts Center, Little Rock, Ark., Dec. 7, 1963–Jan. 30, 1964, no. 13, as Girolamo di Benvenuto.

References: (1) Catalogue by W. E. Suida, 1953, p. 24, as Girolamo di Benvenuto. (2) In ms. opinions, R. Longhi attributes K1743A, B to Cozzarelli and K1744A, B to Girolamo di Benvenuto and dates all of them *c.* 1490.

GIROLAMO DI BENVENUTO

K1287 : Figure 447

THE ADORATION OF THE CHILD WITH ST. JEROME. Tulsa, Okla., Philbrook Art Center (3369), since 1953.[1] Transferred from wood to masonite (1953). 25×17 in. (63·5×43·2 cm.). Good condition; very few losses of paint; cleaned 1953.

Formerly attributed to the Umbrian School, perhaps because of its Peruginesque landscape, K1287 is now recognized as characteristic of Girolamo di Benvenuto, about 1500.[2] His father, Benvenuto, had used essentially the same composition and there are at least three variants by Girolamo.[3]

Provenance: Said to have belonged to Richard Wilson, London. George Richmond, R.A., London – exhibited: Royal Academy, London, 1880, no. 222, as Umbrian School (George Richmond sale, Christie's, London, May 1, 1897, no. 35, as Umbrian School; bought by the following). John Richmond, London – exhibited: 'Pictures of the Umbrian School,' Burlington Fine Arts Club, London, 1910, no. 60 (with the catalogue notation that it is not Umbrian but is by Girolamo di Benvenuto). George L. Durlacher (sold, Christie's, London, July 8, 1938, no. 76 as Girolamo di Benvenuto). Contini Bonacossi, Florence. Kress acquisition, 1939 – exhibited: National Gallery of Art, Washington, D.C. (508), 1941-52.[4]

References: (**1**) Catalogue by W. E. Suida, 1953, p. 34, as Girolamo di Benvenuto. (**2**) K1287 has been attributed to Girolamo di Benvenuto by B. Berenson, G. Fiocco, R. Longhi, F. M. Perkins, W. E. Suida, and A. Venturi (in ms. opinions). For the attribution to the Umbrian School see *Provenance,* above. (**3**) One of Girolamo's versions is in the Gallery at Montepulciano (reproduced by R. van Marle, *Italian Schools of Painting,* vol. XVI, 1937, fig. 250). Another was in a sale at Christie's, London, May 24, 1963, no. 49; and a third (whereabouts unknown) was reproduced by B. Berenson in *Dedalo,* vol. XI, 1931, p. 646. (**4**) *Preliminary Catalogue,* 1941, p. 87, as Girolamo di Benvenuto.

GIROLAMO DI BENVENUTO

K222 : Figure 448

VENUS AND CUPID. Denver, Colo., Denver Art Museum (E-IT-18-XV-943), since 1954.[1] Wood. Polygonal, $20\frac{1}{2} \times$ 20 in. (51·1 × 50·8 cm.). Abraded throughout.

Although most critics formerly attributed this birth salver (*desco da parto*) to Matteo Balducci, it accords better with the style of Girolamo di Benvenuto, around 1500.[2] Parallels are offered by panels attributed to Girolamo that are of similar shape and are decorated, like K222, with mythological scenes: the *Judgment of Paris,* in the Louvre, for example, and *Hercules Choosing between Vice and Virtue,* in the Ca d'Oro, Venice. The coat of arms at the bottom of K222 has not been identified.[3]

Provenance: Conte della Gherardesca, Florence. Contini Bonacossi, Florence. Kress acquisition, 1932 – exhibited:

National Gallery of Art, Washington, D.C. (217), 1941-53.[4]

References: (**1**) Catalogue by W. E. Suida, 1954, p. 46, as Girolamo di Benvenuto. (**2**) Following P. Schubring (*Cassoni,* 1923, p. 344, pl. CXXI), R. Longhi, R. van Marle, W. E. Suida, and A. Venturi (in ms. opinions) attributed K222 to Balducci. Only F. M. Perkins and, tentatively, A. Burroughs at that time (*c.* 1932) attributed it to Girolamo di Benvenuto, to whom it was more recently attributed by W. E. Suida (see note 1, above). When it was in the Gherardesca Collection, K222 was, according to Schubring (*ibid.*; both front and back are here reproduced) decorated on the back with a standing cupid in a circular simulated frame. In a letter of Feb. 19, 1949, R. Mather writes of having seen back and front as two separate panels before K222 entered the Kress Collection. An X-ray made by A. Burroughs soon after it entered the Kress Collection shows a circle corresponding to the inner circle of the *tondo* frame but no further evidence of the *tondo* panel. Discussing the X-rays, Burroughs indicates that there was some kind of design at this time on the reverse of the panel: 'In spite of the design on the reverse of this panel,' he says, 'the paint is well recorded in good condition.' Whatever the design, it seems to have disappeared when the panel was treated for cradling in 1933; not even the circle shows in an X-ray made in the 1950's. The present whereabouts of the cupid *tondo* is unknown. A seated cupid in a landscape which is very similar to the view in K222 decorates a twelve-sided *desco da parto* of approximately the same size in the Chigi Saracini Collection, Siena. It is reproduced by A. R. de Cervin-Albrizzi in *Connaissance des Arts,* Dec. 1964, p. 146, where it is attributed to Balducci. (**3**) In Schubring's reproduction (see note 2, above) the coat of arms is indecipherable. Mather (see note 2, above) did not believe the arms as they now appear to be genuine. (**4**) *Preliminary Catalogue,* 1941, p. 11, as Matteo Balducci.

GIROLAMO DI BENVENUTO

K1078 : Figure 449

PORTRAIT OF A YOUNG WOMAN. Washington, D.C., National Gallery of Art (446), since 1941.[1] Wood. $23\frac{5}{8} \times$ $17\frac{7}{8}$ in. (60 × 45 cm.). Good condition except for minor restoration.

Although generally less interesting than other prominent Sienese painters of his time, Girolamo di Benvenuto seems to have had an unusual flair for portraiture. Aside from his portraits and the one by Neroccio de'Landi in the Widener Collection of the National Gallery of Art, the Sienese Quattrocento has very little to compare with Florentine production in this genre. Known at the beginning of the

nineteenth century as a *Portrait of Petrarch's Laura* by Simone Martini and engraved as such in 1812 by Raphael Morghen, K 1078 has long been recognized as characteristic of Girolamo di Benvenuto, dating about 1505.[2] The unknown sitter might easily be the younger sister of the lady who appears in the guise of St. Catherine of Alexandria in Girolamo's signed and dated (1508) altarpiece of the *Madonna with Saints and Angels* in the Siena Pinacoteca: coiffure, dress, features, and pose of hand on breast are similar. Conceivably it is her brother who appears in a recently published portrait attributed to Girolamo in the Kisters Collection, Kreuzlingen,[3] a panel corresponding in size and general composition to K 1078 and likewise with black background. It lacks the gold border decoration of K 1078 but has, like K 1078, the stripes of gold embroidery on the white linen puffs of the sleeves.

Provenance: Cav. Antonio Piccolomini Bellanti, Siena (1811). Signora Ciaccheri, daughter of the former, who sold it (1895) to the following. William Lockett Agnew, London – exhibited: 'Pictures of the Sienese School,' Burlington Fine Arts Club, London, 1904, no. 52, as Girolamo di Benvenuto. George M. Salting, London. Arthur Sanderson, Edinburgh (sold, Knight, Frank & Rutley's, London, June 14–16, 1911, no. 621, as *Petrarch's Laura* by Girolamo di Benvenuto). Robert H. and Evelyn Benson, London (catalogue by T. Borenius, 1914, no. 10, as Girolamo di Benvenuto; sold, 1927, to the following). Duveen's, New York (*Duveen Pictures in Public Collections of America*, 1941, no. 123, as Girolamo di Benvenuto). Kress acquisition, 1937 – exhibited: 'Italian Renaissance Portraits,' Knoedler's, New York, Mar. 18–Apr. 6, 1940, no. 13, as Girolamo di Benvenuto.

References: (**1**) *Preliminary Catalogue*, 1941, pp. 86 f., as Girolamo di Benvenuto. (**2**) K 1078 has been attributed to Girolamo di Benvenuto by G. Frizzoni (in *L'Arte*, vol. VII, 1904, pp. 269 f.), R. E. Fry (in *Rassegna d'Arte*, vol. IV, 1904, p. 118), T. Borenius (in Crowe and Cavalcaselle, *History of Painting in Italy*, vol. V, 1914, p. 165 n. 3), R. L. Douglas (in *Rassegna d'Arte Senese, La Balzana*, vol. I, 1927, pp. 103 f.), P. Misciattelli (in *La Diana*, vol. II, 1927, p. 228), L. Dussler (in *Pantheon*, vol. II, 1928, p. 379), R. C. Morrison (in *Art in America*, vol. XIX, 1931, p. 145), L. Venturi (*Italian Paintings in America*, vol. II, 1933, no. 301), R. van Marle (*Italian Schools of Painting*, vol. XVI, 1937, pp. 430 f.), B. Berenson, G. Fiocco, R. Longhi, F. M. Perkins, W. E. Suida (in ms.

opinions), C. Brandi (*Quattrocentisti senesi*, 1949, pp. 164, 273 f.), and E. Carli (*La Pittura senese*, 1955, p. 262). A. Venturi (in ms. opinion) attributed it to Benvenuto di Giovanni. (**3**) Reproduced by E. Buchner, in *Festschrift Friedrich Winkler*, 1959, p. 168.

GIROLAMO DI BENVENUTO

K 1295 : Figure 440

ST. CATHERINE OF SIENA EXORCISING A POSSESSED WOMAN. Denver, Colo., Denver Art Museum (E-IT-18-XV-942), since 1954.[1] Transferred from wood to masonite (1953). $12\frac{1}{4} \times 21\frac{7}{8}$ in. ($31 \cdot 1 \times 55 \cdot 6$ cm.). Fair condition except for some losses of paint; cleaned 1953.

Obviously a predella panel and companion to another depicting scenes from the legend of St. Catherine (Fogg Museum, Cambridge, Mass.), K 1295 is painted in Girolamo's more virile manner, of about 1505.[2] It has been plausibly suggested[3] that the predella in question may have belonged to the altarpiece of *St. Catherine Receiving the Stigmata*, in the Oratory of Santa Caterina, Siena, which was painted by Fungai, a pupil, like Girolamo, of Benvenuto di Giovanni. K 1295 and its companion panel present two specific instances of St. Catherine's power to cast out devils, instances which are described in the early accounts of her life.[4]

Provenance: Comte Roger de Blives, Paris (as early as 1914). Private Collection, Florence. Contini Bonacossi, Florence. Kress acquisition, 1939 – exhibited: National Gallery of Art, Washington, D.C. (544), 1941–52, as Girolamo di Benvenuto.

References: (**1**) Catalogue by W. E. Suida, 1954, p. 44, as Girolamo di Benvenuto. (**2**) K 1295 was first published by F. M. Perkins (in *Rassegna d'Arte Antica e Moderna*, vol. I, 1914, p. 168), when it was in the Blives Collection. He attributed it to Girolamo di Benvenuto, as have B. Berenson, G. Fiocco, R. Longhi, F. M. Perkins, and A. Venturi (in ms. opinions). (**3**) R. van Marle (*Italian Schools of Painting*, vol. XVI, 1937, pp. 424 f.), who was apparently acquainted with only the Fogg Museum panel, suggested the connection with Fungai's altarpiece. (**4**) See G. Kaftal, *Iconography of the Saints in Tuscan Painting*, 1952, cols. 241, 248.

ILLUSTRATIONS

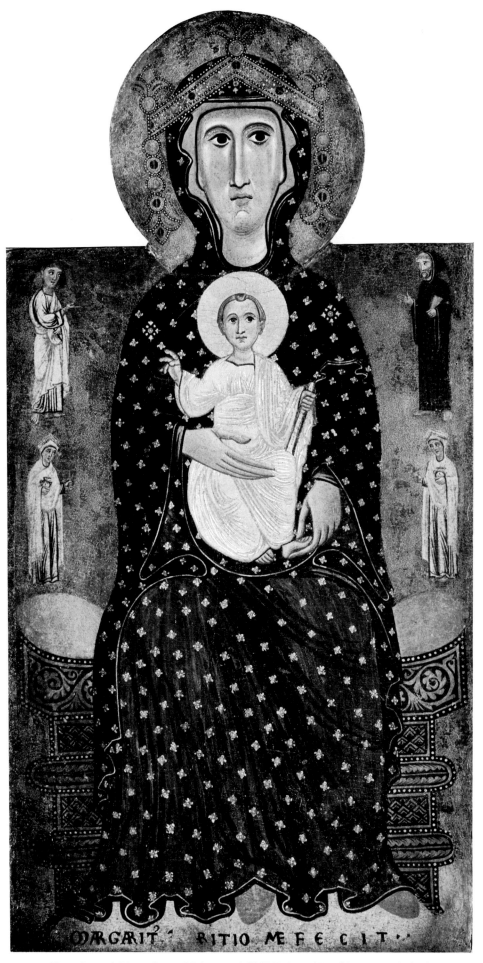

Fig. 1 (K 1347) Margaritone: *Madonna and Child Enthroned*. Washington, D.C. (p. 3)

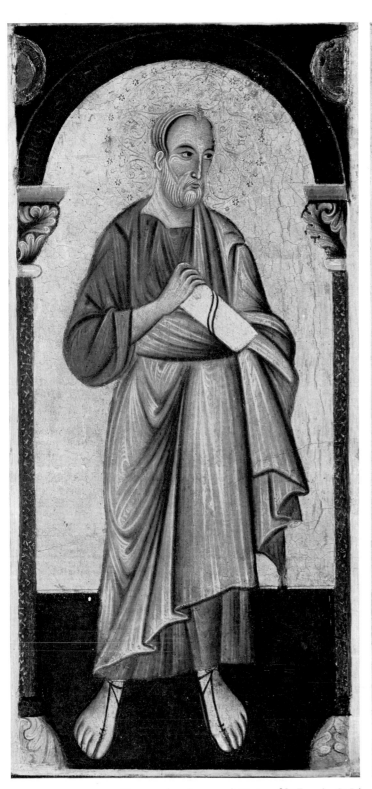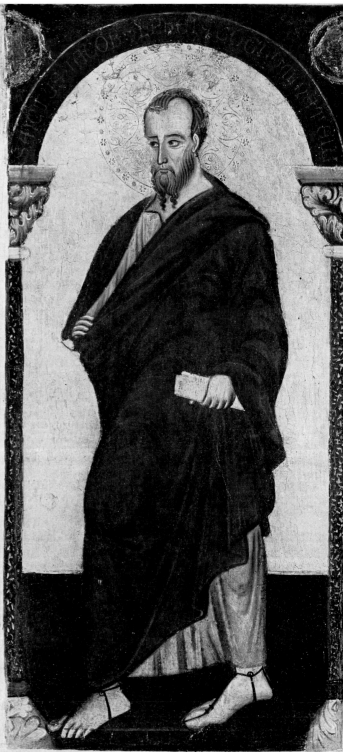

Figs. 2–3 (K 1360, K 1359) Master of St. Francis: *St. John the Evangelist; St. James Minor*. Washington, D.C. (p. 4)

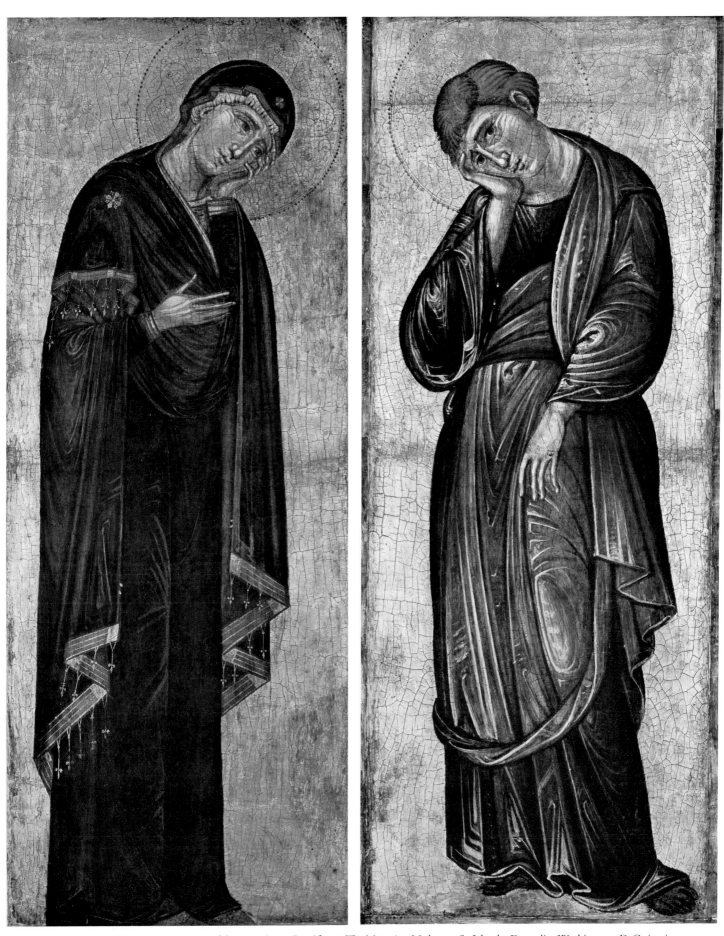

Figs. 4–5 (K 1357, K 1358) Master of the Franciscan Crucifixes: *The Mourning Madonna; St. John the Evangelist*. Washington, D.C. (p. 4)

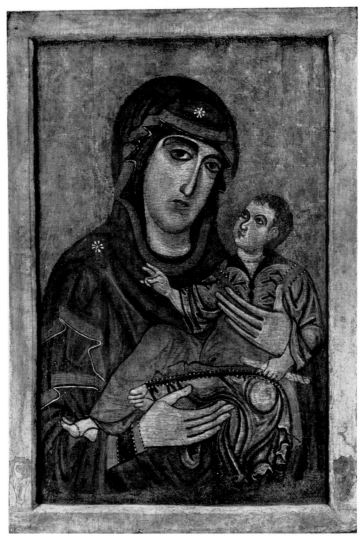

Fig. 6 (K 1715) Lucchese School, c. 1200: *Madonna and Child*. El Paso, Tex. (p. 3)

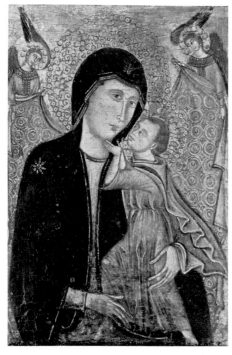

Fig. 7 (K 1716) Follower of Cimabue: *Madonna and Child with Two Angels*. Columbia, S.C. (p. 6)

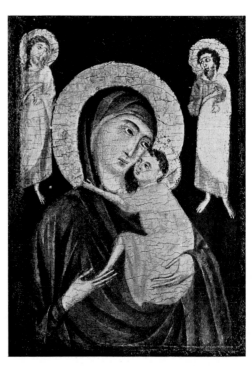

Fig. 8 (K 1189) Tuscan School, Late XIII Century: *Madonna and Child with Saints*. Birmingham, Ala. (p. 6)

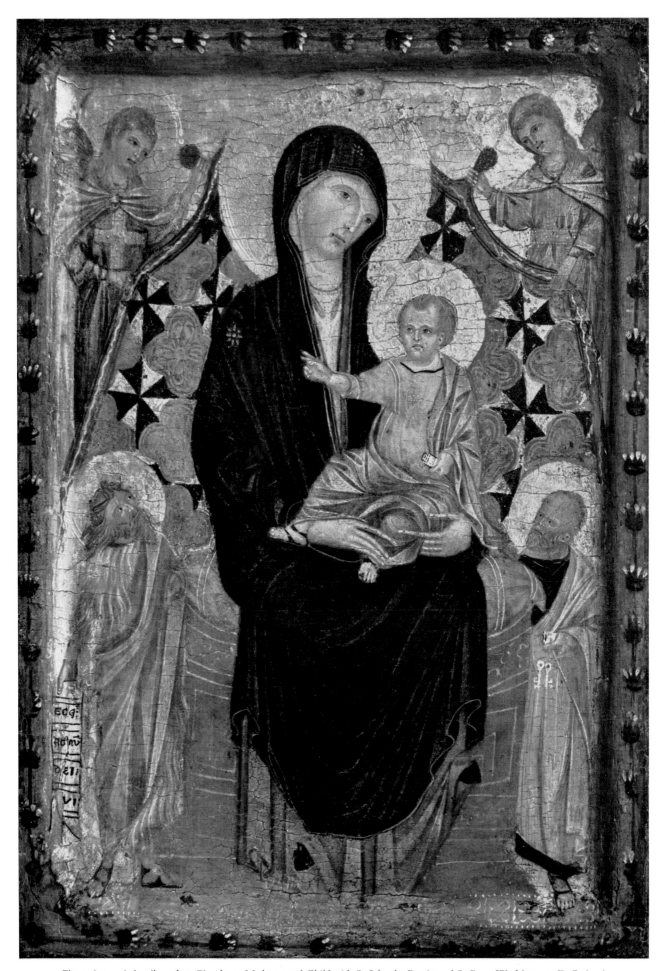

Fig. 9 (K 1549) Attributed to Cimabue: *Madonna and Child with St. John the Baptist and St. Peter*. Washington, D.C. (p. 5)

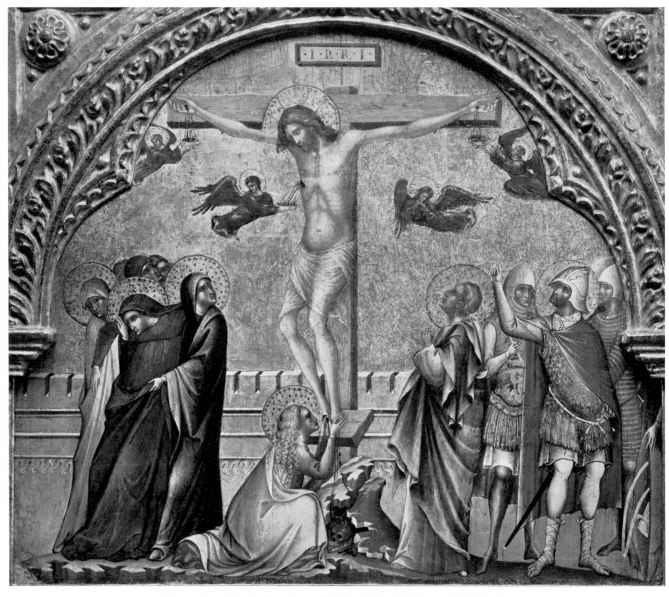

Fig. 10 (K285) Paolo Veneziano: *The Crucifixion*. Washington, D.C. (p. 8)

Fig. 11 (K361) Italian School, c. 1300: *The Last Supper*. New Orleans, La. (p. 6)

Fig. 12 (K324) Italian School, c. 1300: *The Capture of Christ in the Garden*. Portland, Ore. (p. 6)

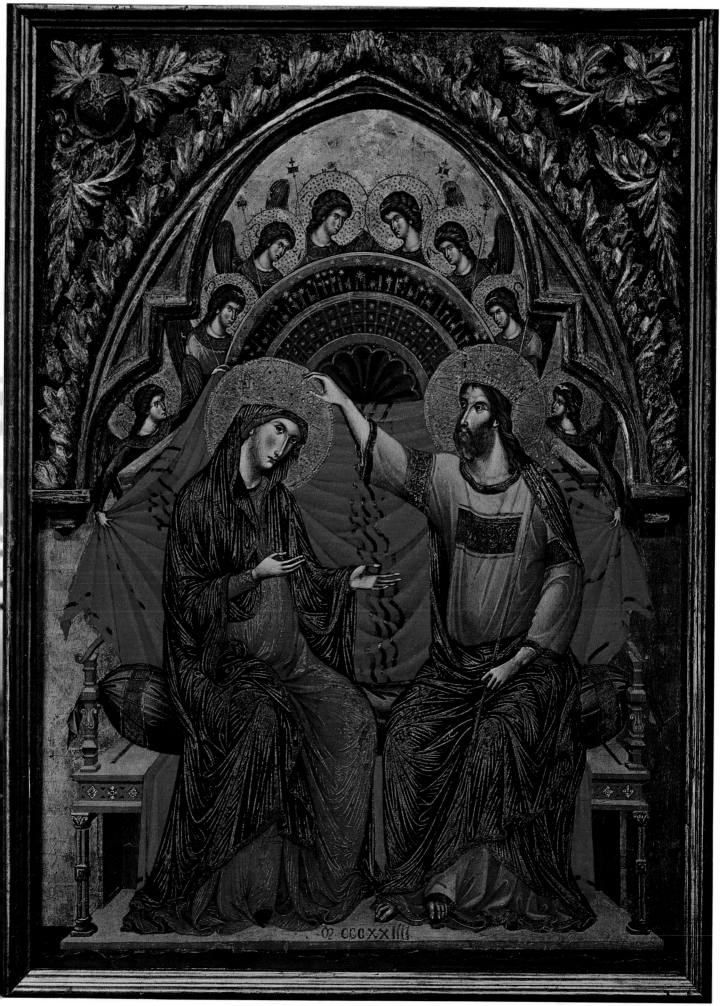

Fig. 13 (K 1895) Paolo Veneziano: *The Coronation of the Virgin*. Washington, D.C. (p. 7)

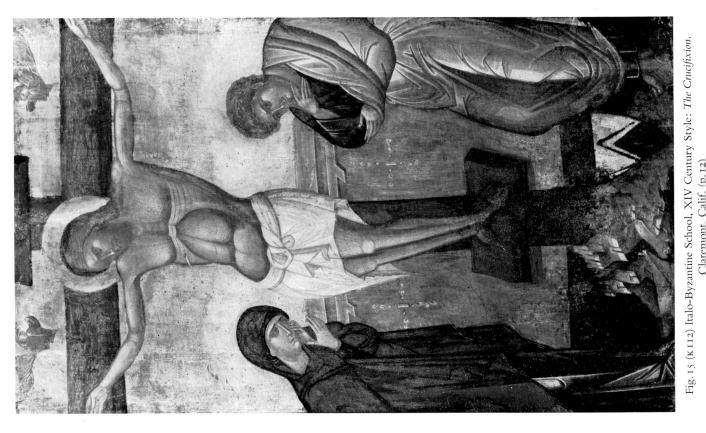

Fig. 15 (K112) Italo-Byzantine School, XIV Century Style: *The Crucifixion.* Claremont, Calif. (p. 12)

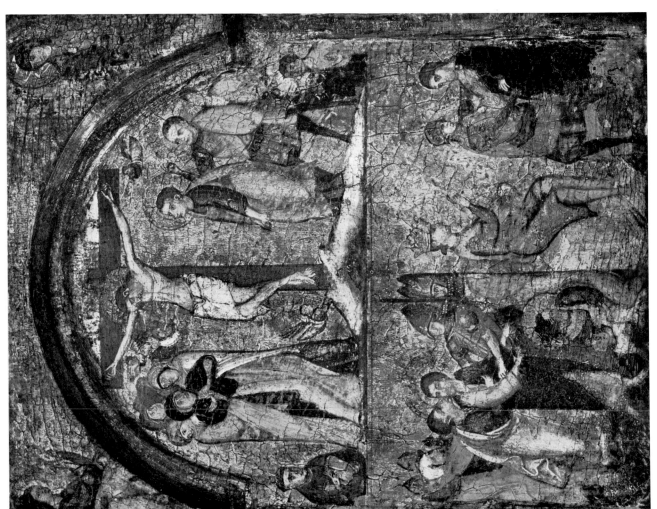

Fig. 14 (K431) Venetian School, c. 1300: *Scenes from the Passion of Christ.* Williamstown, Mass. (p. 7)

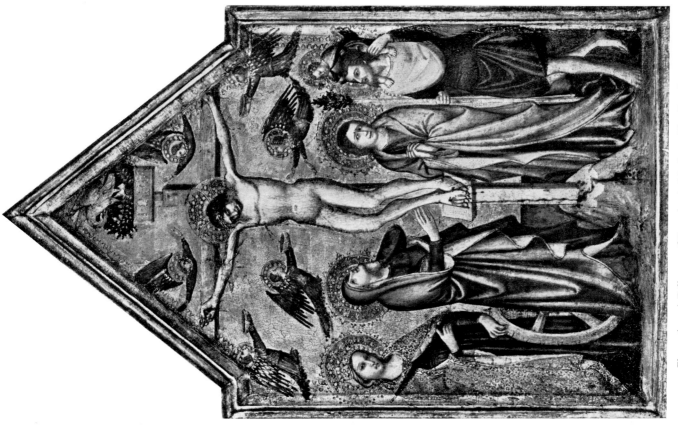

Fig. 17 (K 527) Follower of Barnaba da Modena: *The Crucifixion.*
Brunswick, Me. (p. 12)

Fig. 16 (K 65) Venetian School, Late XIV Century: *Madonna and Child, the Crucifixion, and Saints.*
Allentown, Pa. (p. 11)

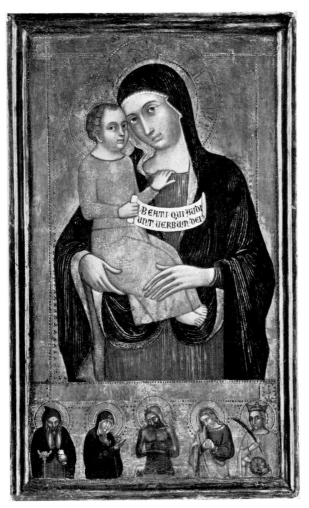

Fig. 18 (K 495) Follower of Barnaba da Modena: *Madonna and Child*. Claremont, Calif. (p. 12)

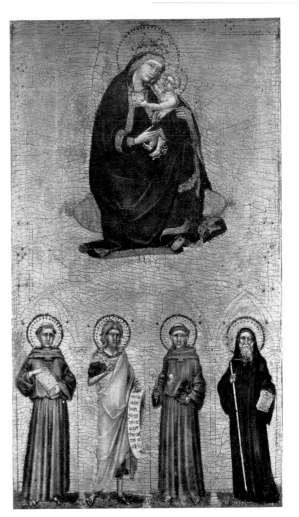

Fig. 19 (K 1091) Guariento: *Madonna and Child with Four Saints*. Raleigh, N.C. (p. 10)

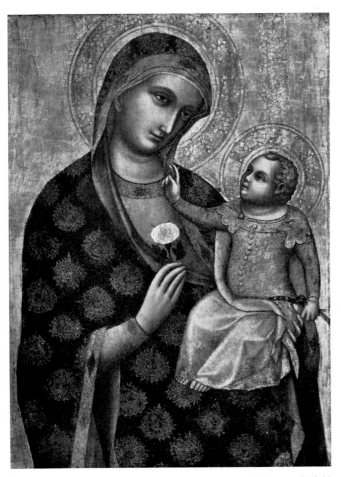

Fig. 20 (K 526) Attributed to Lorenzo Veneziano: *Madonna and Child*. Birmingham, Ala. (p. 9)

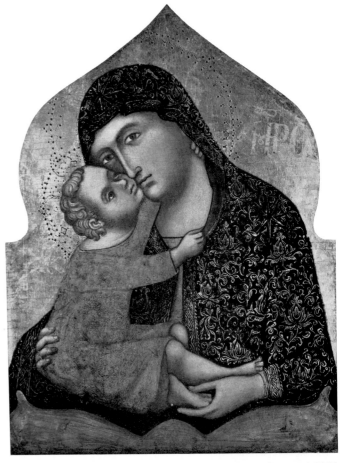

Fig. 21 (K 560) Venetian School, Late XIV Century: *Madonna and Child*. Allentown, Pa. (p. 11)

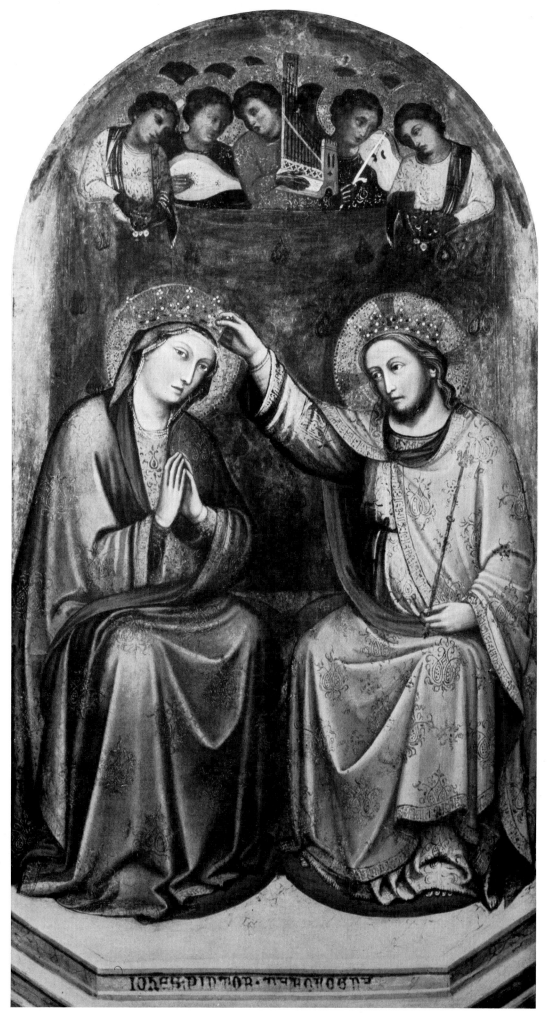

Fig. 22 (K 428) Giovanni da Bologna: *The Coronation of the Virgin*. Denver, Colo. (p. 10)

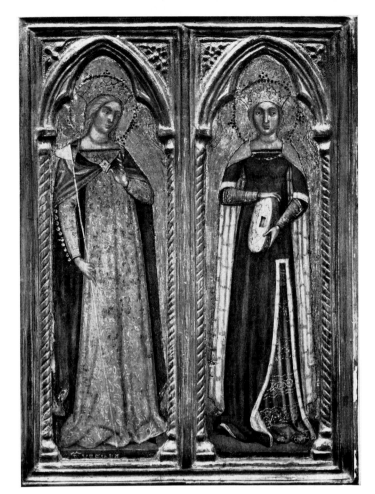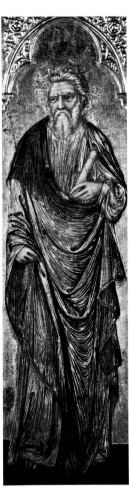

Fig. 23 (K 1225) Venetian School, Early XIV Century: *St. Ursula and St. Christina.* Bloomington, Ind. (p. 9)
Fig. 24 (K 568) Attributed to Lorenzo Veneziano: *St. Andrew.* Atlanta, Ga. (p. 9)

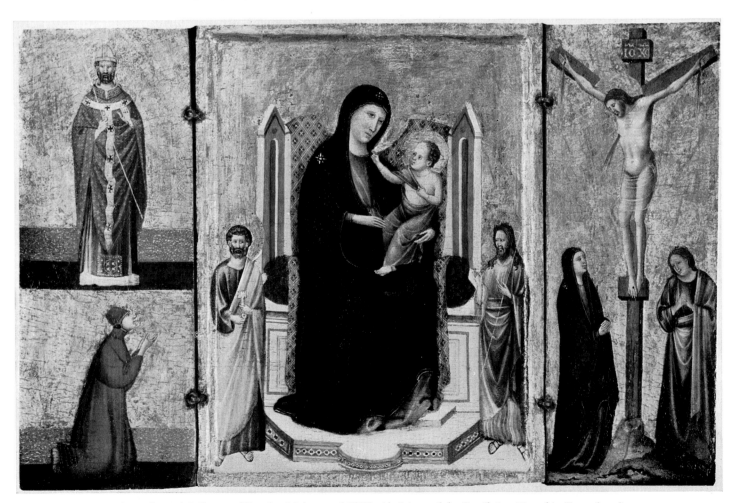

Fig. 25 (K 1289) Follower of Duccio: *Madonna and Child with Saints and the Crucifixion.* Memphis, Tenn. (p. 15)

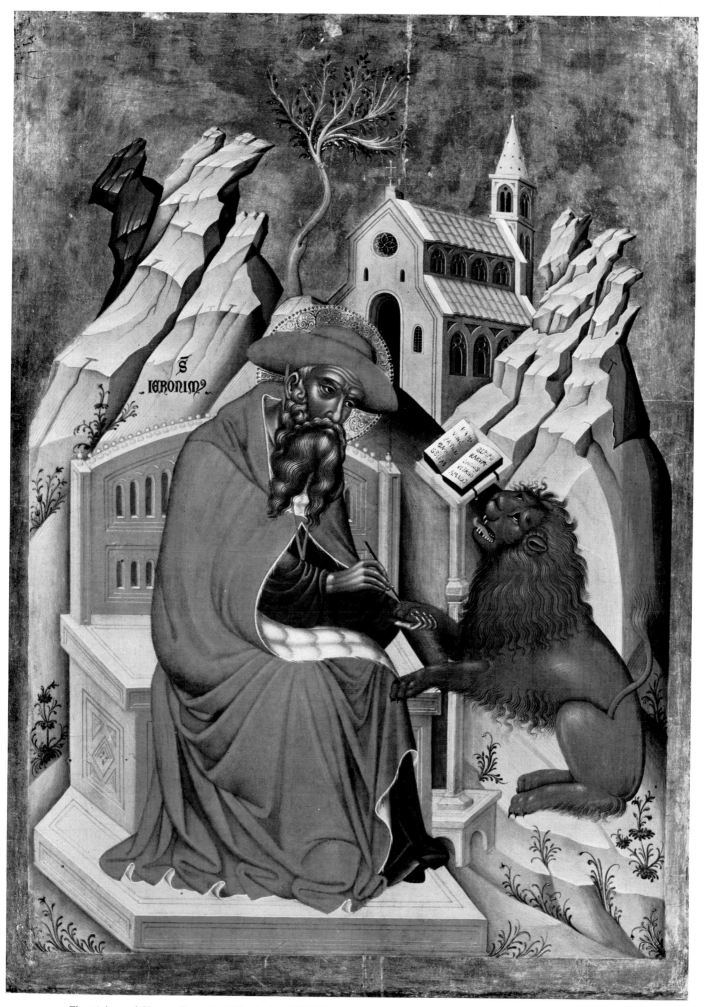

Fig. 26 (K 1109) Veneto-Byzantine School, Late XIV Century: *St. Jerome*. New York, Samuel H. Kress Foundation (p. 11)

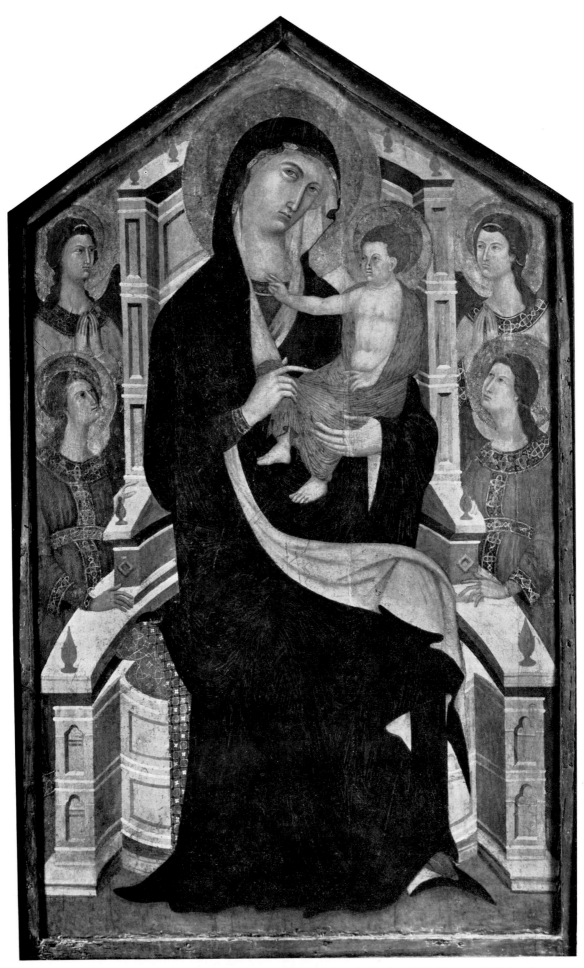

Fig. 27 (κ 2063) Follower of Duccio: *Madonna and Child Enthroned with Angels*. Washington, D.C. (p. 14)

Fig. 28 (K 283) Duccio: *The Calling of the Apostles Peter and Andrew*. Washington, D.C. (p. 14)

Fig. 29 (K 1747) Nicolò da Voltri: *Madonna and Child.*
El Paso, Tex. (p. 13)

Fig. 30 (K 1102) Follower of Segna di Buonaventura:
St. Margaret. Portland, Ore. (p. 17)

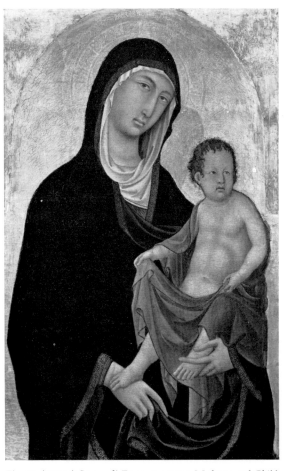

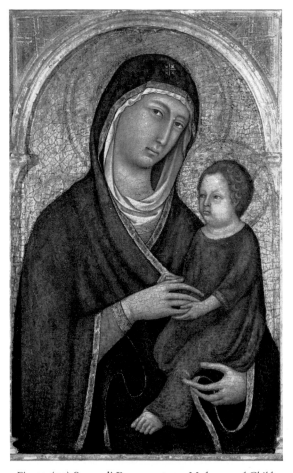

Fig. 31 (K 1349) Segna di Buonaventura: *Madonna and Child.*
Raleigh, N.C. (p. 16)

Fig. 32 (K 3) Segna di Buonaventura: *Madonna and Child.*
Honolulu, Hawaii (p. 16)

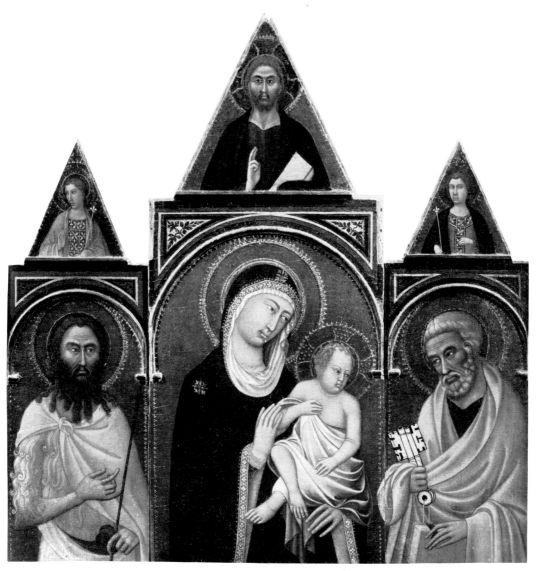

Fig. 33 (K 577) Follower of Duccio: *Madonna and Child with St. Peter and St. John the Baptist.* Ponce, Puerto Rico (p. 15)

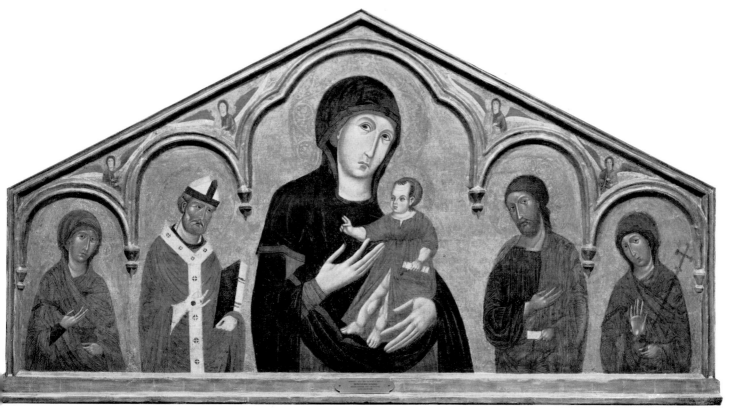

Fig. 34 (K 1930) Master of the Clarisse Panel: *Madonna and Child with Four Saints.* Memphis, Tenn. (p. 13)

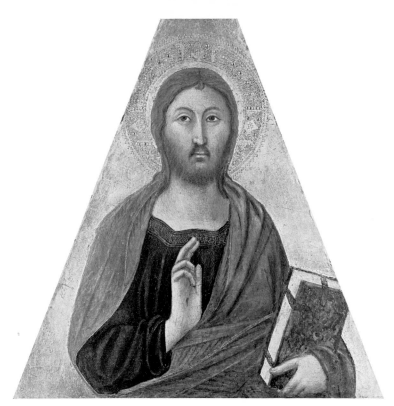

Fig. 35 (K219) Sienese School, Early XIV Century: *Christ Blessing*.
Raleigh, N.C. (p. 16)

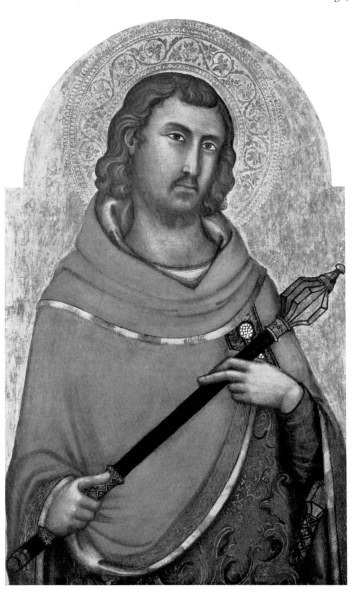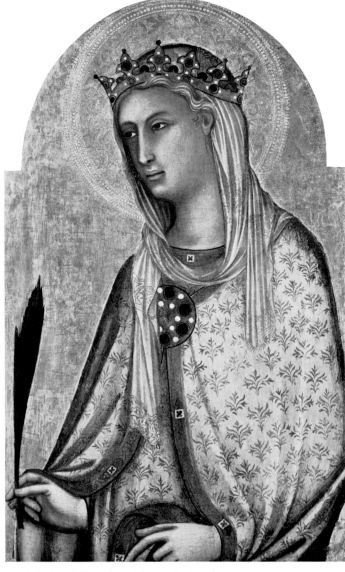

Figs. 36–37 (K40, K41) Niccolò di Segna: *St. Vitalis; St. Catherine of Alexandria*. Atlanta, Ga. (p. 17)

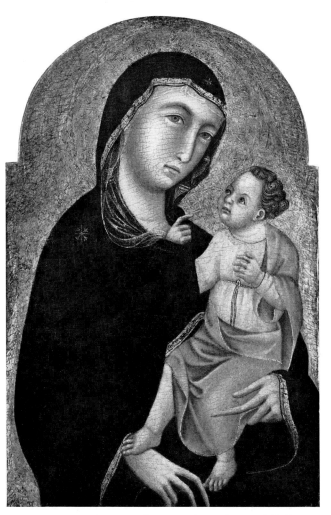

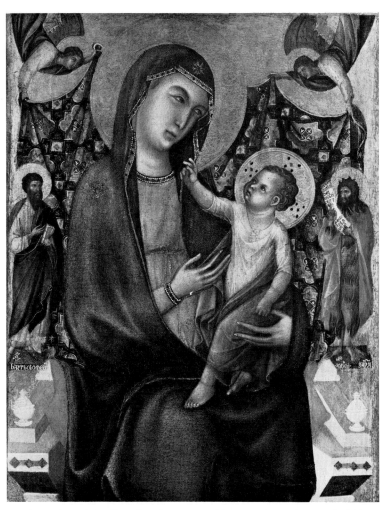

Fig. 38 (K 309) Master of San Torpè: *Madonna and Child.*
Seattle, Wash. (p. 18)

Fig. 39 (K 292) Attributed to the Master of San Torpè: *Madonna and Child
with St. Bartholomew and St. John the Baptist.* Raleigh, N.C. (p. 19)

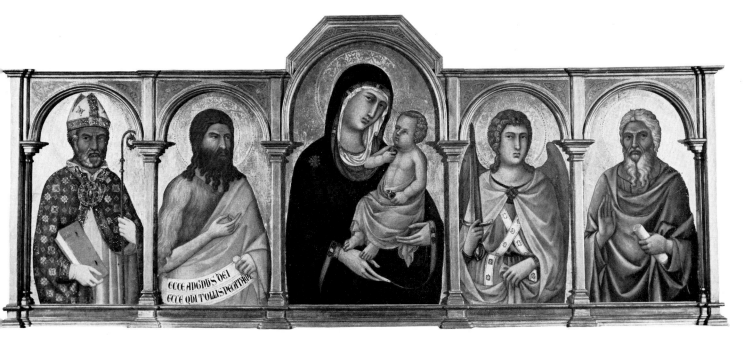

Fig. 40 (K 592) Master of the Goodhart Madonna: *Madonna and Child with Four Saints.* Birmingham, Ala. (p. 18)

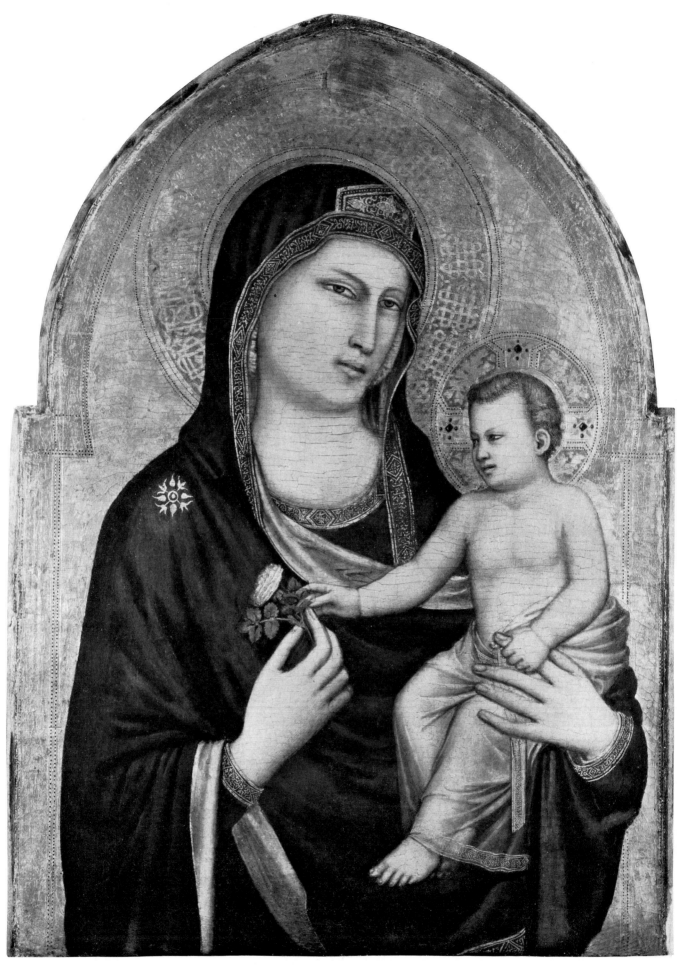

Fig. 41 (K473) Giotto: *Madonna and Child*. Washington, D.C. (p. 20)

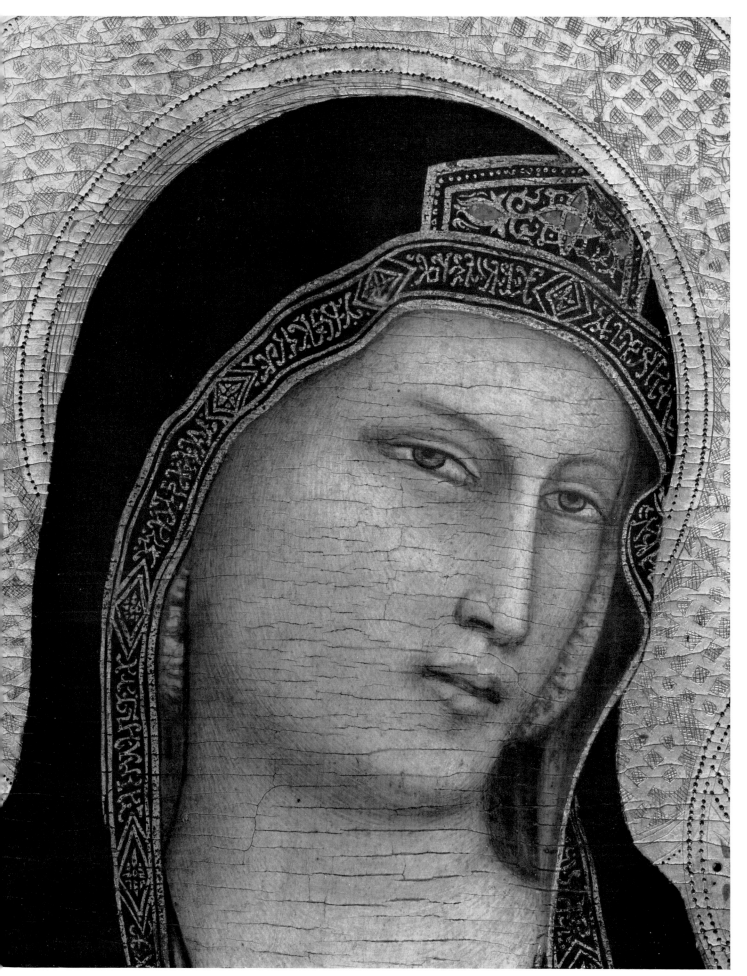

Fig. 42 Detail from Fig. 41

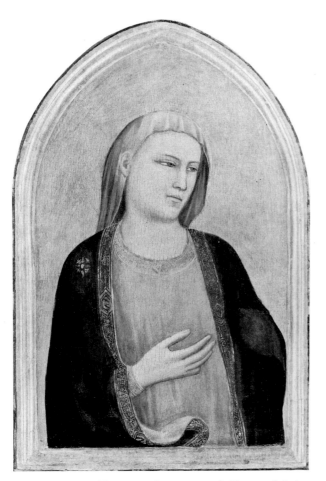
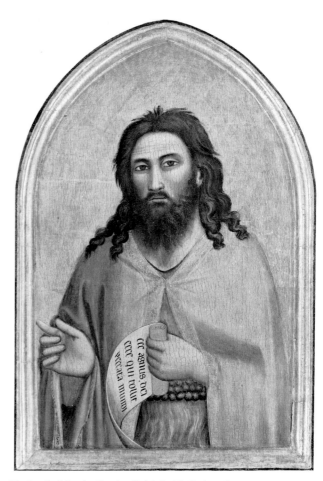

Figs. 43–44 (K 1442, K 1444) Giotto and Assistants: *The Virgin; St. John the Baptist*. Raleigh, N.C. (p. 21)

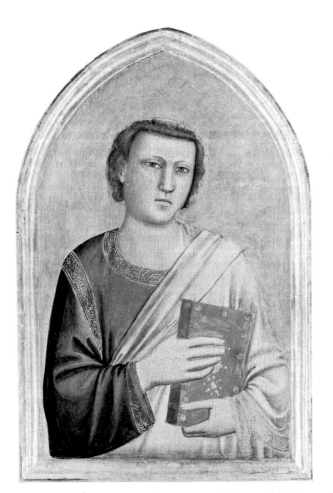
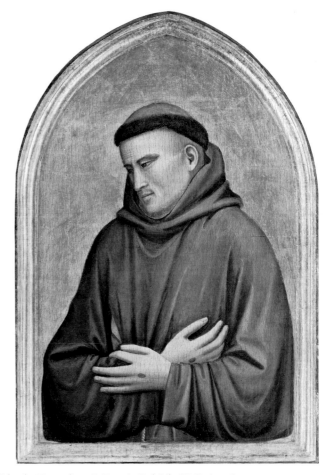

Figs. 45–46 (K 1441, K 1443) Giotto and Assistants: *St. John the Evangelist; St. Francis*. Raleigh, N.C. (p. 21)

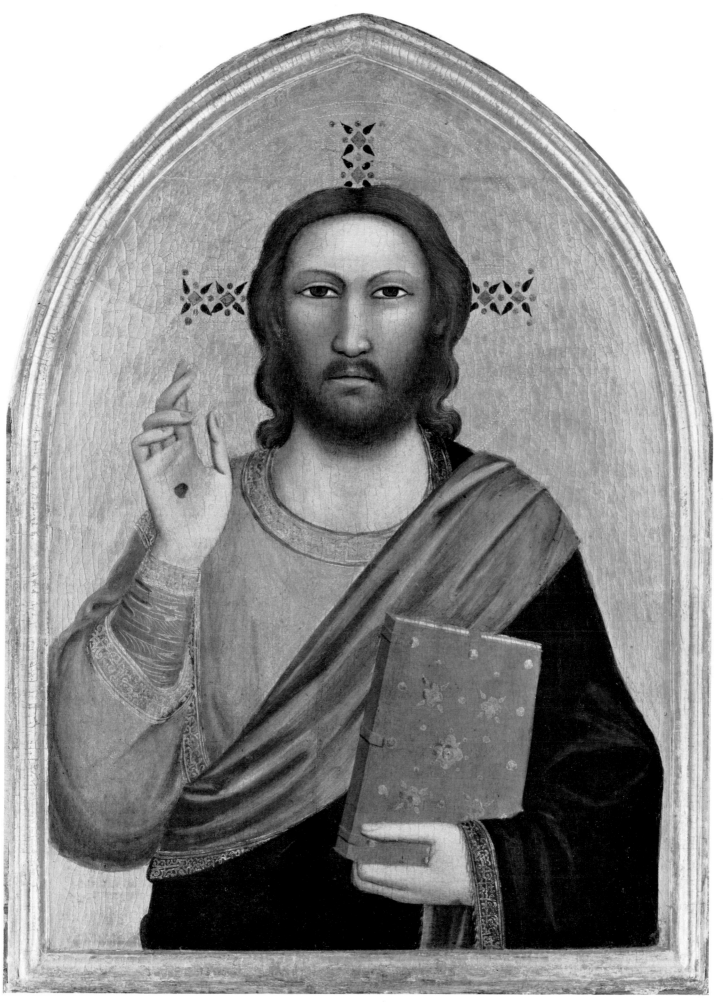

Fig. 47 (K 1424) Giotto and Assistants: *Christ Blessing*. Raleigh, N.C. (p. 21)

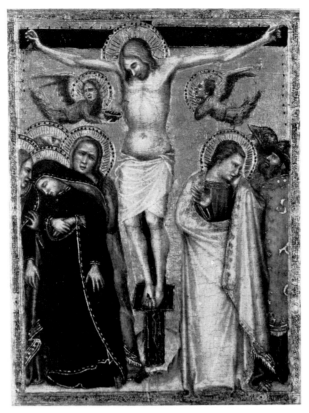

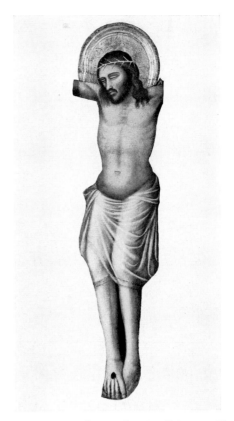

Fig. 48 (K 539) Follower of Giotto: *The Crucifixion.*
Raleigh, N.C. (p. 22)

Fig. 49 (K 1262) Follower of Pacino di Buonaguida:
Crucifix. Ponce, Puerto Rico (p. 23)

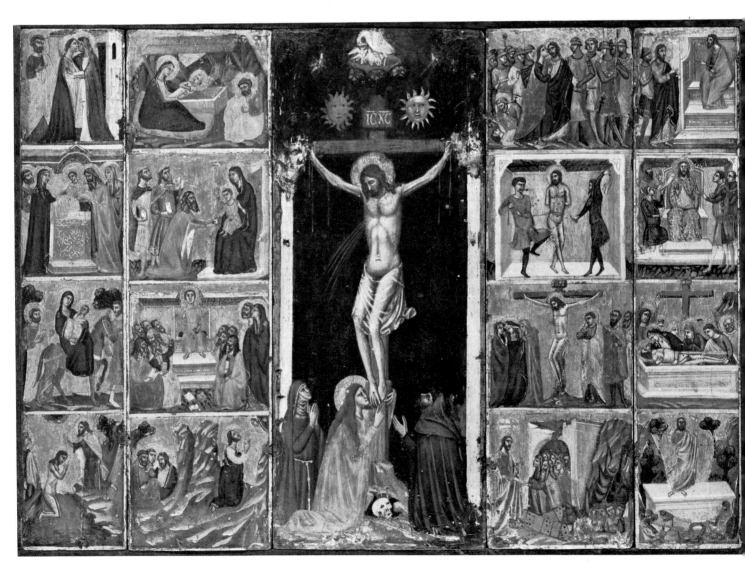

Fig. 50 (K 1717) Pacino di Buonaguida: *Custodial.* Tucson, Ariz. (p. 23)

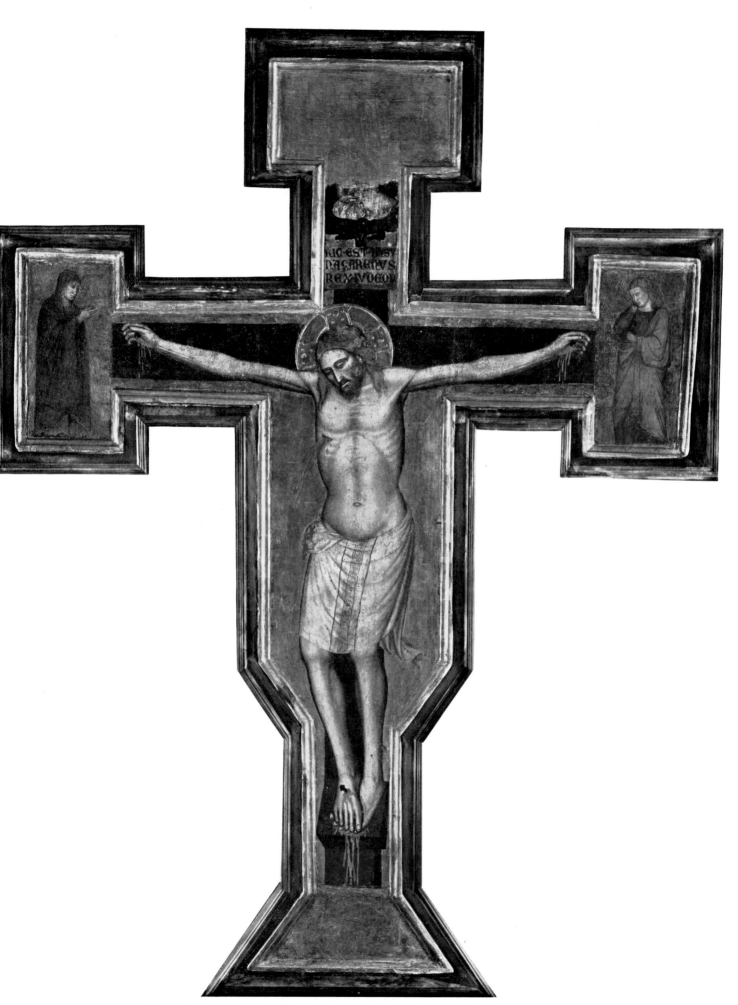

Fig. 51 (K 537) Follower of Giotto: *Crucifix*. Tucson, Ariz., St. Philip's in the Hills (p. 22)

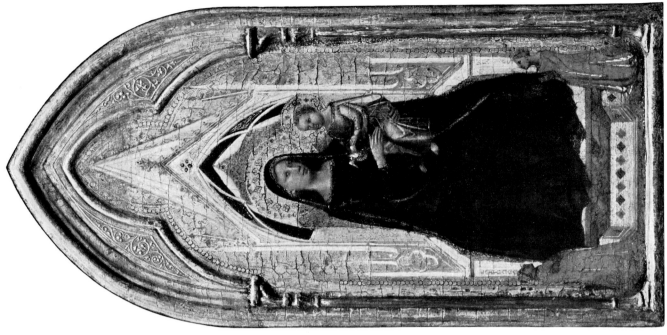

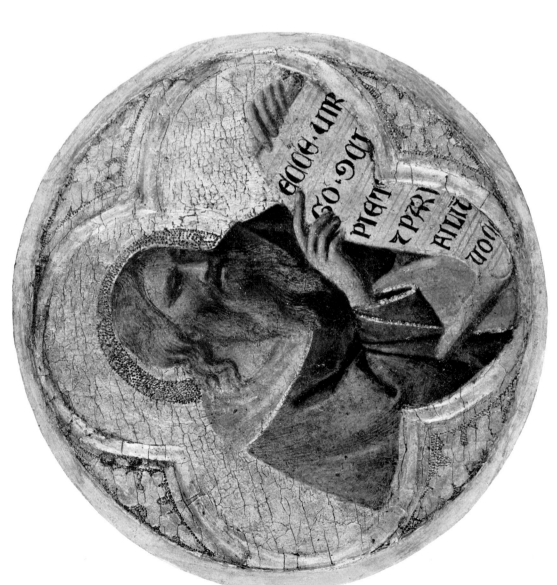

Fig. 52 (K 1372) Taddeo Gaddi: *Isaiah*. Williamstown, Mass. (p. 23)

Fig. 53 (K 1348) Follower of Taddeo Gaddi:
Madonna and Child Enthroned with Donors.
Bloomington, Ind. (p. 24)

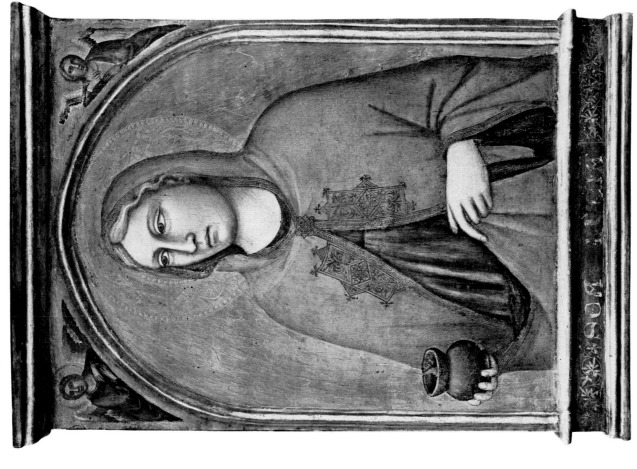

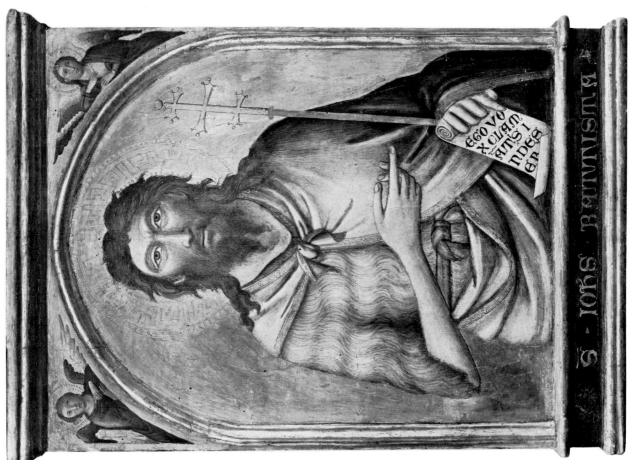

Figs. 54–55 (K 1296, K 1297) Jacopo del Casentino and Assistant: *St. John the Baptist*; *St. Lucy*. El Paso, Tex. (p. 24)

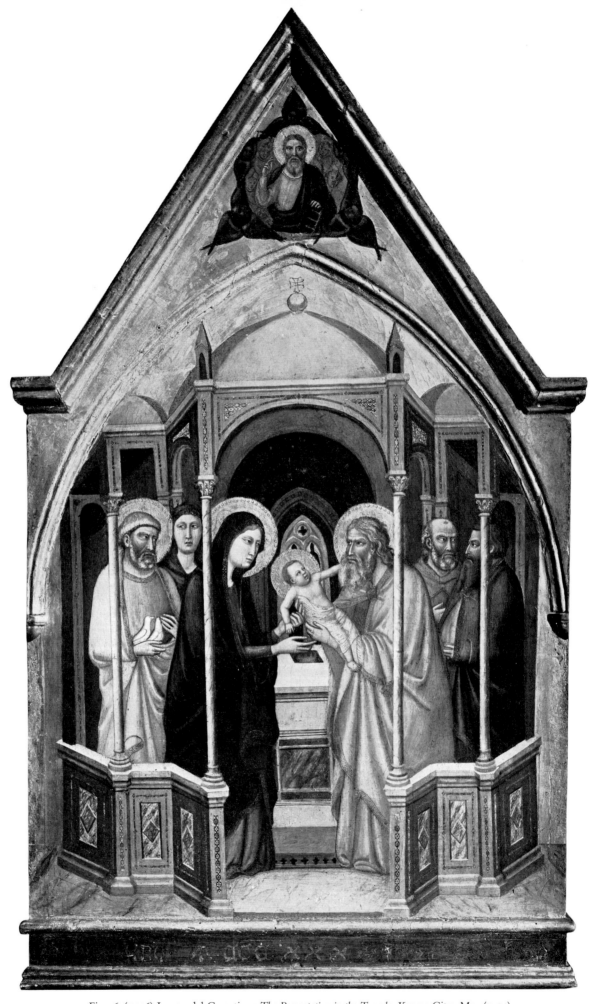

Fig. 56 (K 446) Jacopo del Casentino: *The Presentation in the Temple*. Kansas City, Mo. (p. 24)

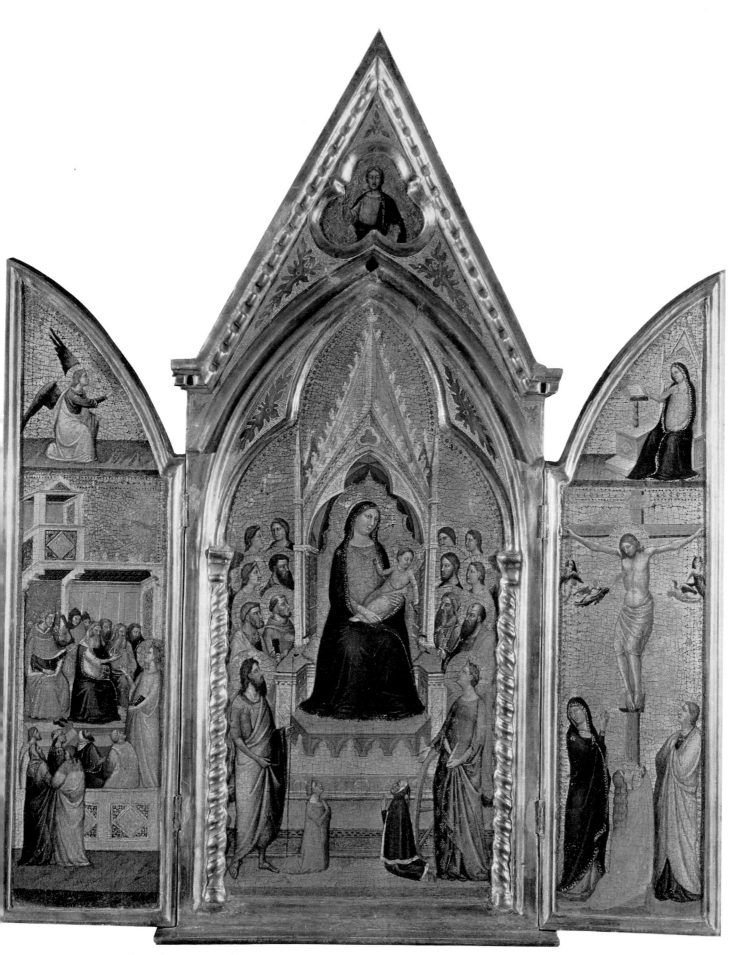

Fig. 57 (K 572) Jacopo del Casentino and Assistant: *Madonna and Child Enthroned*. Tucson, Ariz. (p. 25)

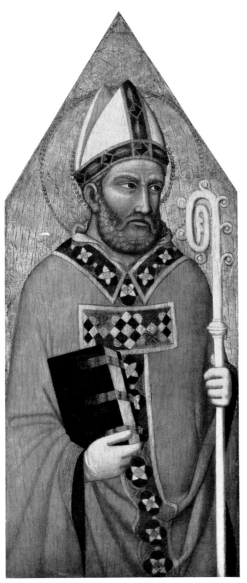

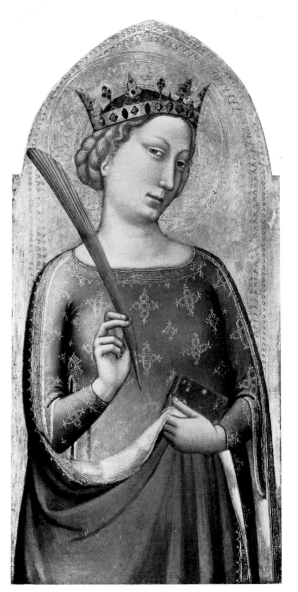

Fig. 58 (K 1138) Follower of Jacopo del Casentino: *St. Prosper*. Staten Island, N. Y. (p. 25)

Fig. 59 (K 198) Attributed to Bernardo Daddi: *A Crowned Virgin Martyr*. San Francisco, Calif. (p. 27)

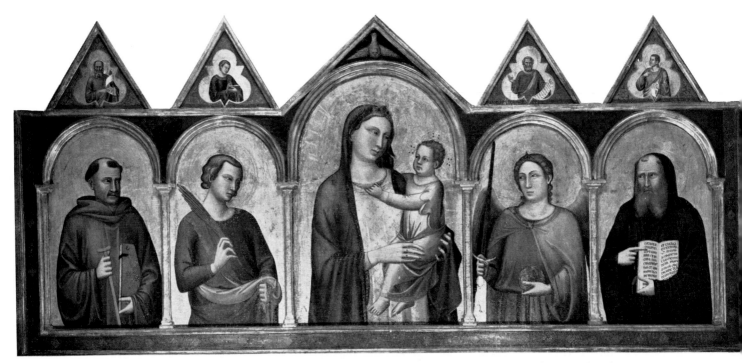

Fig. 60 (K 204) Follower of Bernardo Daddi: *Madonna and Child with Saints*. New Orleans, La. (p. 28)

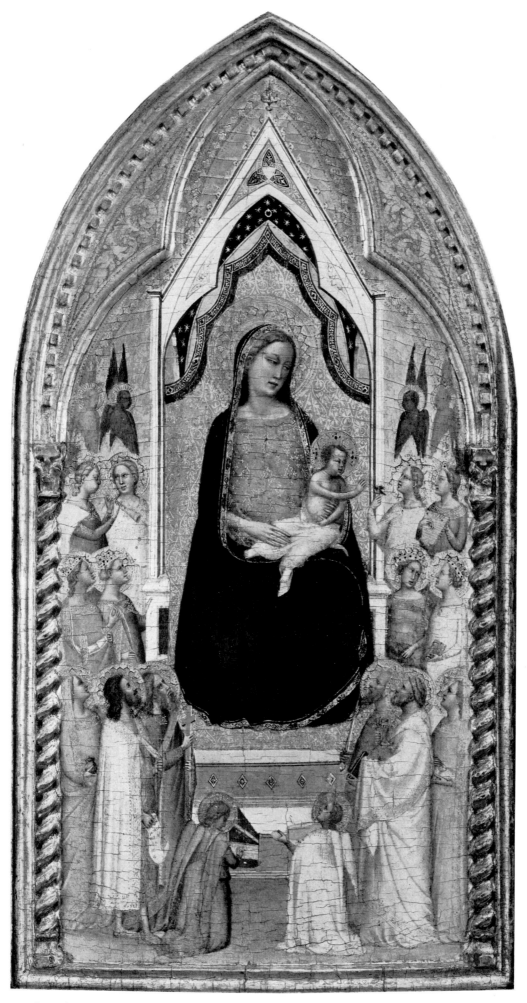

Fig. 61 (K 1718) Bernardo Daddi: *Madonna and Child with Saints and Angels*. Washington, D.C. (p. 26)

Fig. 63 (κ 1925) Follower of Bernardo Daddi: *The Aldobrandini Triptych.*
Portland, Ore. (p. 28)

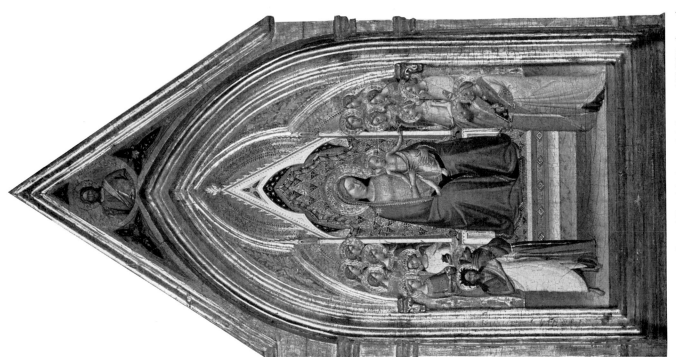

Fig. 62 (κ 1300) Bernardo Daddi and Assistant: *Madonna and Child Enthroned
with Saints and Angels.* Kansas City, Mo. (p. 26)

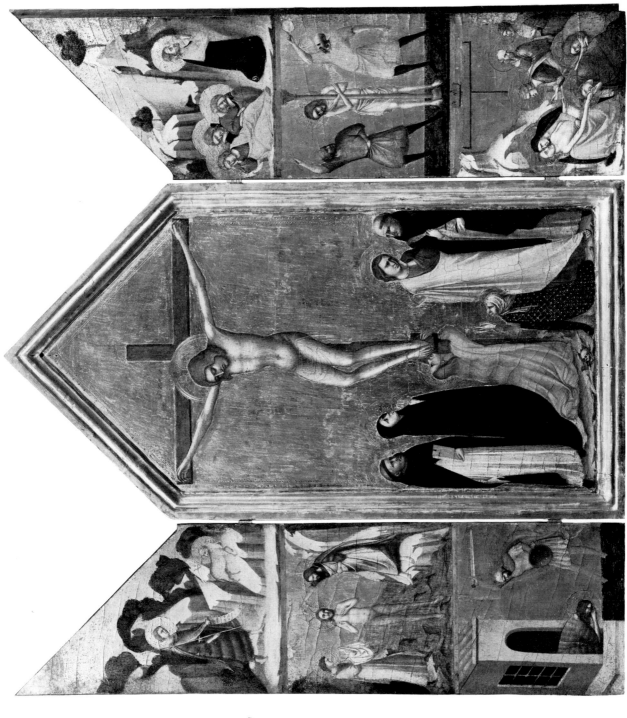

Fig. 65 (K 1430) Tuscan School, XIV Century: *The Crucifixion with Scenes from the Passion and the Life of St John the Baptist.* Memphis, Tenn. (p. 31)

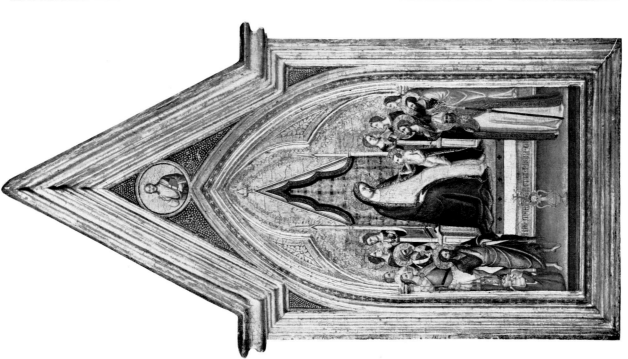

Fig. 64 (K 1089) Studio of Bernardo Daddi: *Madonna and Child Enthroned with Saints.* Columbia, S.C. (p. 27)

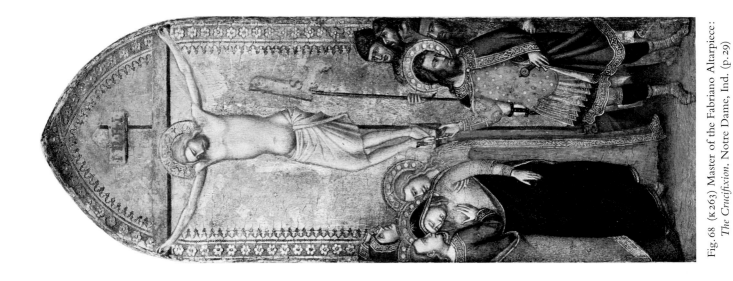

Fig. 68 (κ263) Master of the Fabriano Altarpiece:
The Crucifixion. Notre Dame, Ind. (p.29)

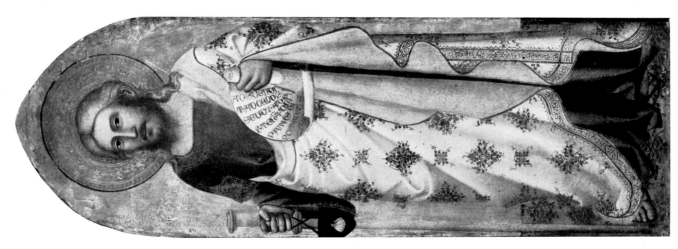

Fig. 67 (κ463) Follower of Bernardo Daddi:
St. James Major. Seattle, Wash. (p.29)

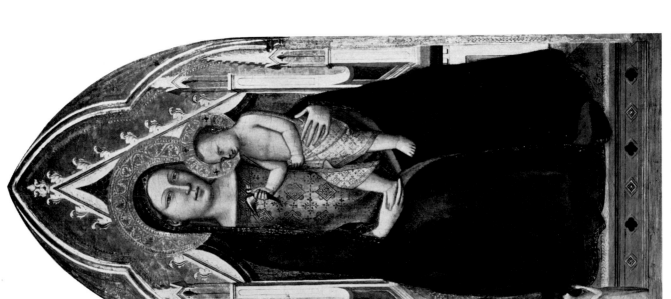

Fig. 66 (κ1290) Studio of Bernardo Daddi: *Madonna and Child
with Donor.* Seattle, Wash. (p.28)

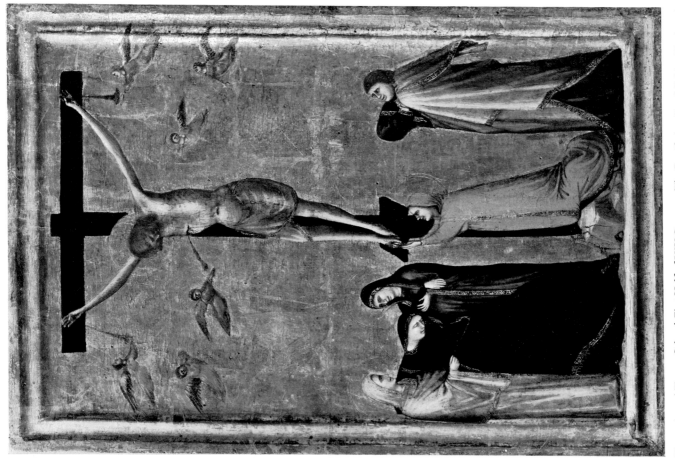

Fig. 69 (K 1369) Attributed to Bernardo Daddi: *The Crucifixion.* Washington, D.C. (p. 26)

Fig. 70 (K 201) Tuscan School, First Half of XIV Century: *The Crucifixion.* Coral Gables, Fla. (p. 30)

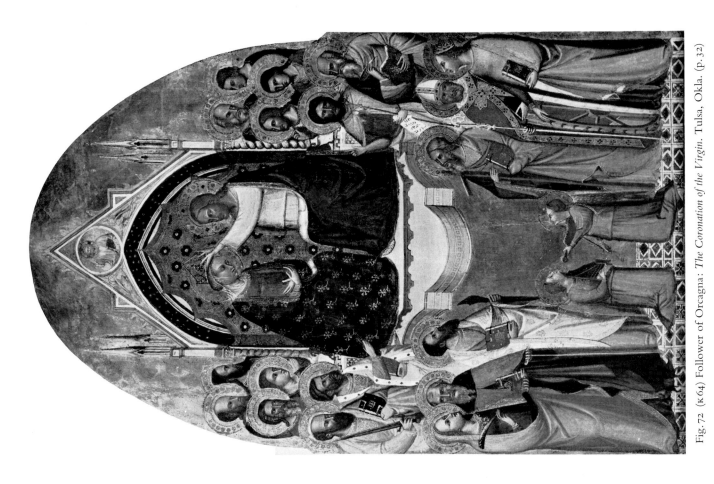

Fig. 72 (к64) Follower of Orcagna: *The Coronation of the Virgin*. Tulsa, Okla. (p. 32)

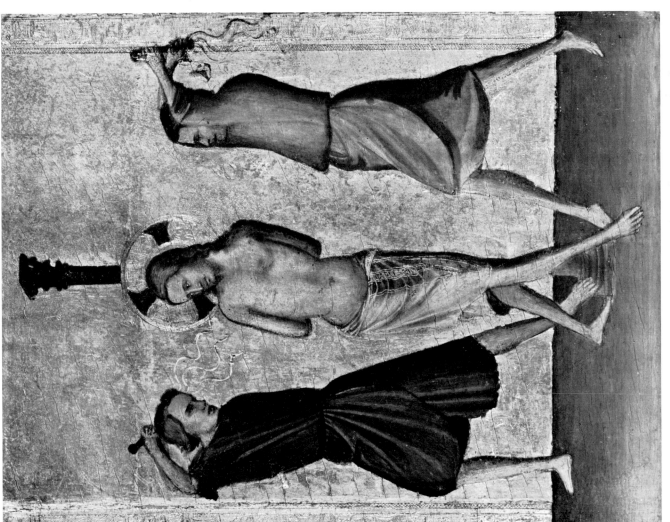

Fig. 71 (к197) Master of San Martino alla Palma: *The Flagellation*. Berea, Ky. (p. 30)

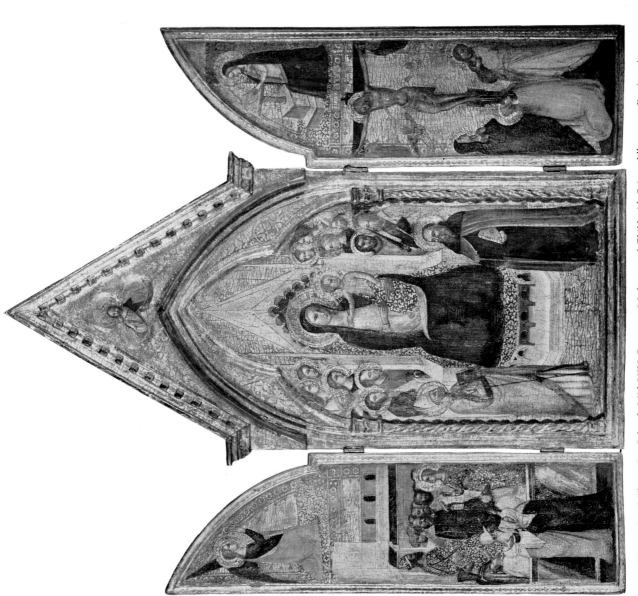

Fig. 73 (K33) Florentine School, Mid-XIV Century: *Madonna and Child with Saints*. Allentown, Pa. (p. 34)

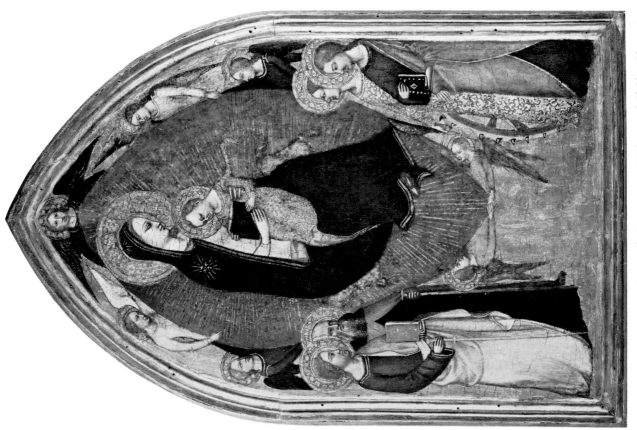

Fig. 74 (K44) Follower of Niccolò di Tommaso: *Madonna and Child in Glory*. Allentown, Pa. (p. 35)

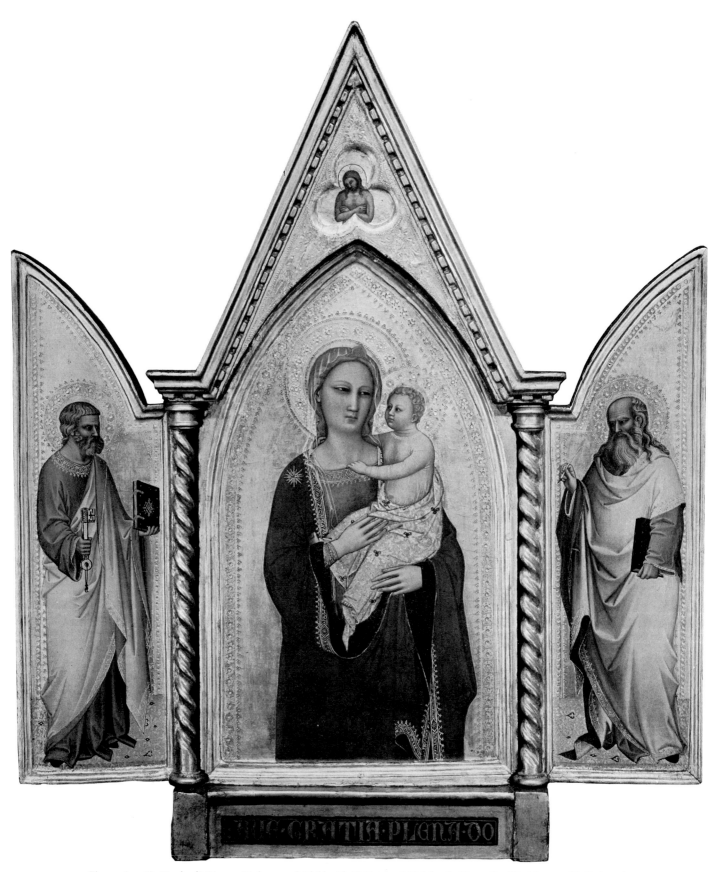

Fig. 75 (K478) Nardo di Cione: *Madonna and Child with St. Peter and St. John the Evangelist*. Washington, D.C. (p. 34)

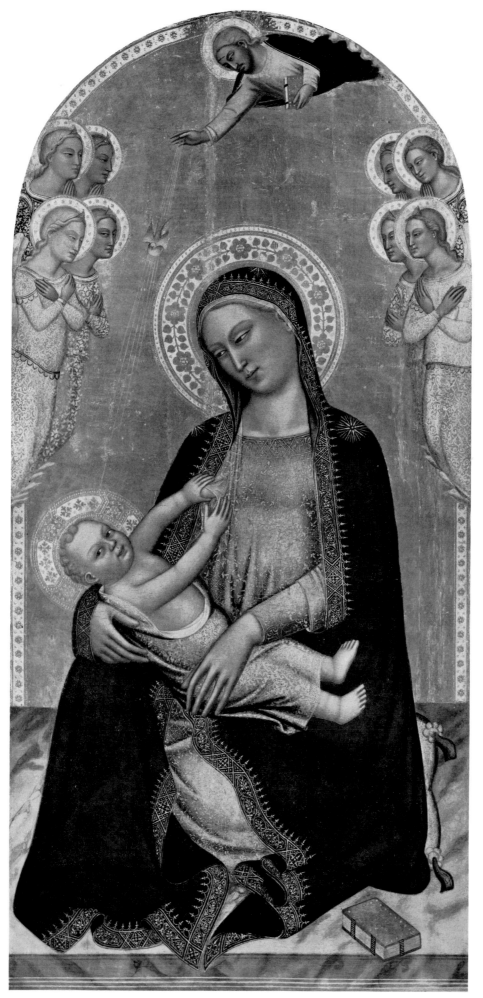

Fig. 76 (κ1363) Orcagna and Jacopo di Cione: *Madonna and Child with Angels.*
Washington, D.C. (p. 31)

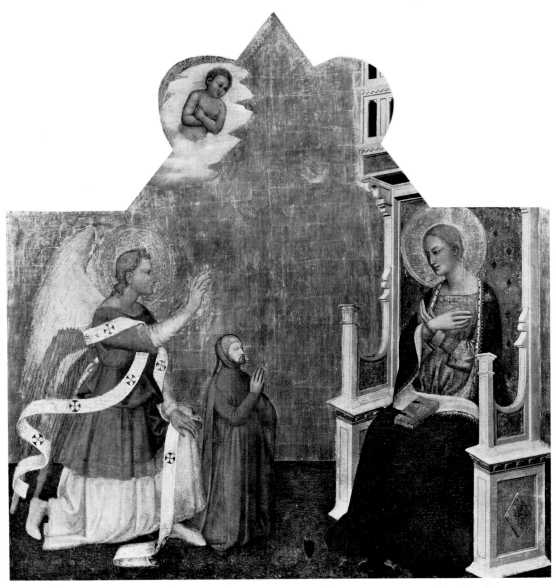

Fig. 77 (K 156) Studio of Orcagna: *The Annunciation with Donor*. Ponce, Puerto Rico (p. 32)

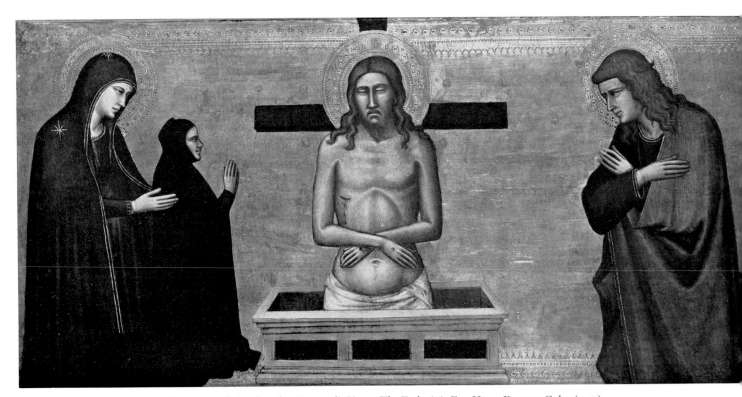

Fig. 78 (K 296) Attributed to Jacopo di Cione: *The Eucharistic Ecce Homo*. Denver, Colo. (p. 33)

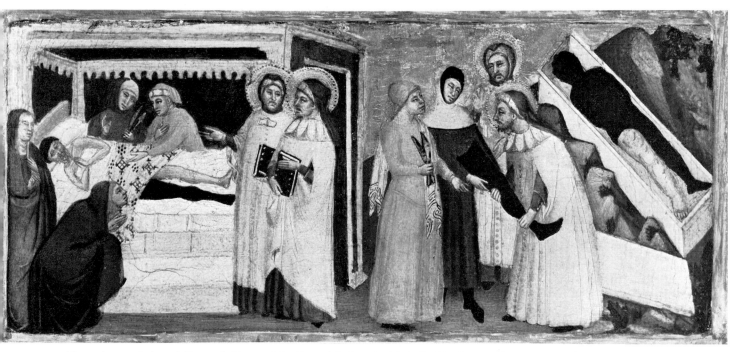

Fig. 79 (K1171, left predella panel) Master of the Rinuccini Chapel: *A Miracle of St. Cosmas and St. Damian*. Raleigh, N.C. (p. 35)

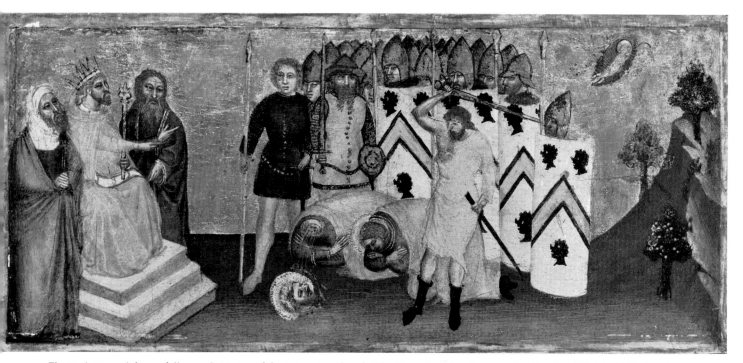

Fig. 80 (K1171, right predella panel) Master of the Rinuccini Chapel: *The Martyrdom of St. Cosmas and St. Damian*. Raleigh, N.C. (p. 35)

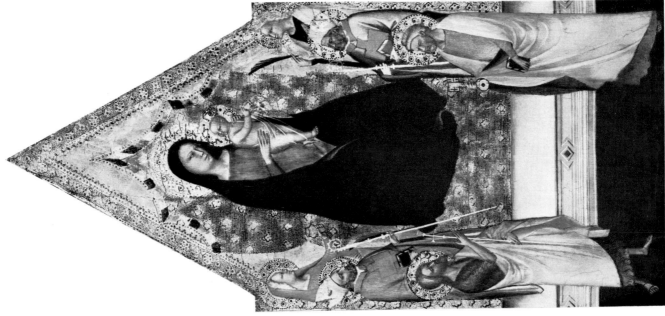

Fig. 82 (K74) Attributed to Jacopo di Cione: *Madonna and Child with Saints*. San Francisco, Calif. (p. 33)

Fig. 81 (K1171, main panel) Master of the Rinuccini Chapel: *St. Cosmas and St. Damian*. Raleigh, N.C. (p. 35)

Figs. 83–84 (K66, K67) Giovanni del Biondo: *Hebrew Prophets*. Ponce, Puerto Rico (p. 36)

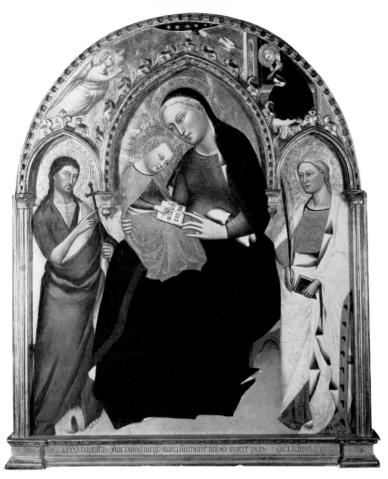

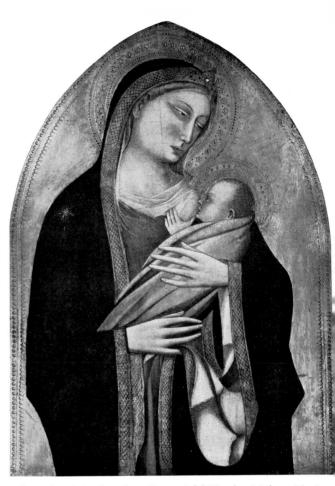

Fig. 85 (K259) Giovanni del Biondo: *Madonna and Child, St. John the Baptist, and St. Catherine.* Memphis, Tenn. (p. 37)

Fig. 86 (K63) Attributed to Giovanni del Biondo: *Madonna Nursing Her Child.* New Orleans, La. (p. 37)

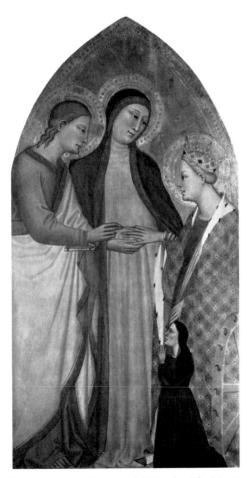

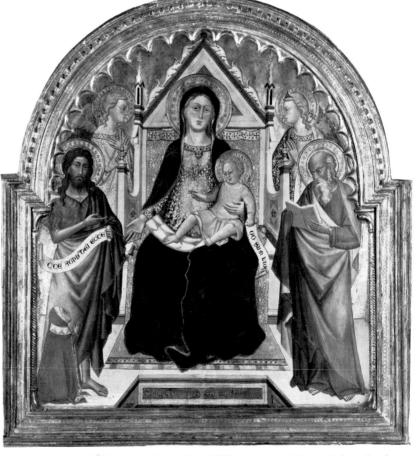

Fig. 87 (K1150) Giovanni del Biondo: *The Mystic Marriage of St. Catherine.* Allentown, Pa. (p. 37)

Fig. 88 (K1121) Florentine School, Late XIV Century: *Madonna Enthroned with St. John the Baptist and St. John the Evangelist.* Los Angeles, Calif. (p. 38)

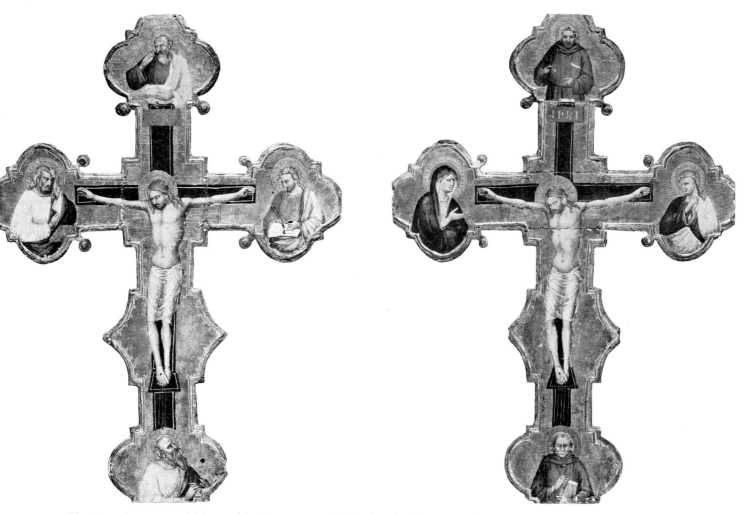

Figs. 89–90 (κ m-2, κ m-3) Master of the Orcagnesque Misericordia: *Crucifix*. New York, Metropolitan Museum of Art (p. 38)

Fig. 91 (κ 1161) Giovanni del Biondo: *The Annunciation*. Lewisburg, Pa. (p. 36)

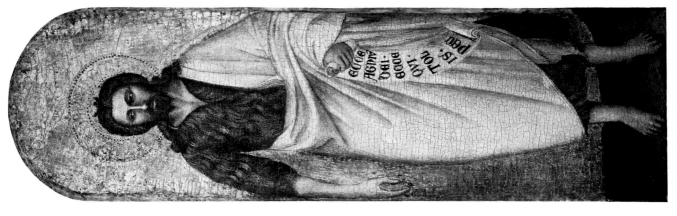

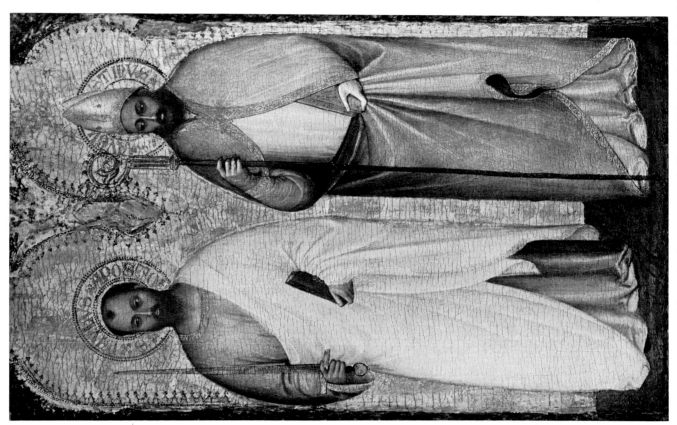

Figs. 92–94 (K 179, K 231 A, B) Giusto de' Menabuoi: *St. Paul and St. Augustine*; *St. Catherine of Alexandria*; *St. John the Baptist*. Athens, Ga. (p. 39)

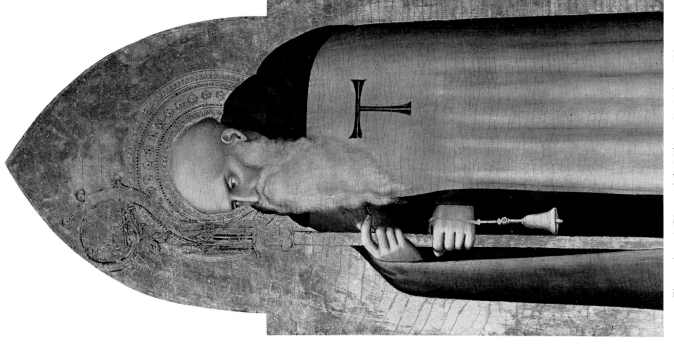

Fig. 97 (K 199) Giovanni da Milano: *St. Anthony Abbot.*
Williamstown, Mass. (p. 39)

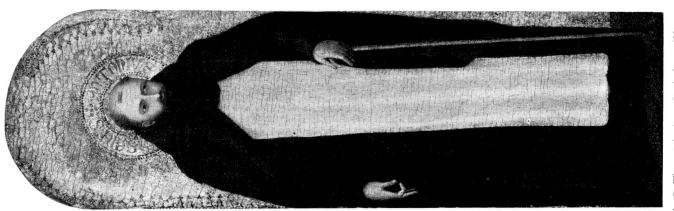

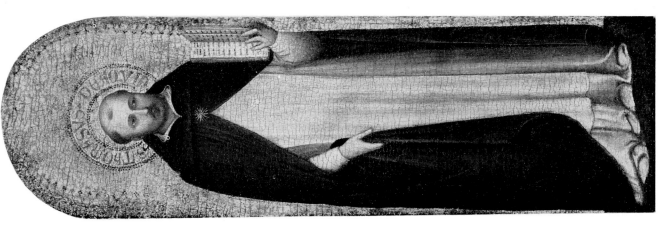

Figs. 95–96 (K 1122 A, B) Giusto de' Menabuoi: *St. Thomas Aquinas; St. Anthony Abbot.*
Athens, Ga. (p. 39)

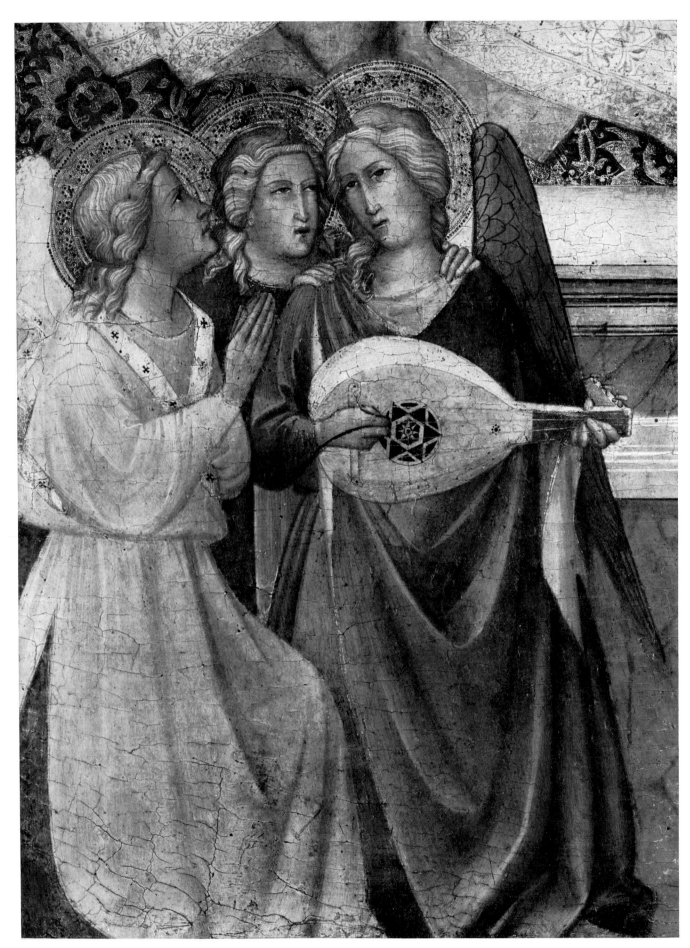

Fig. 98 Detail from Fig. 99

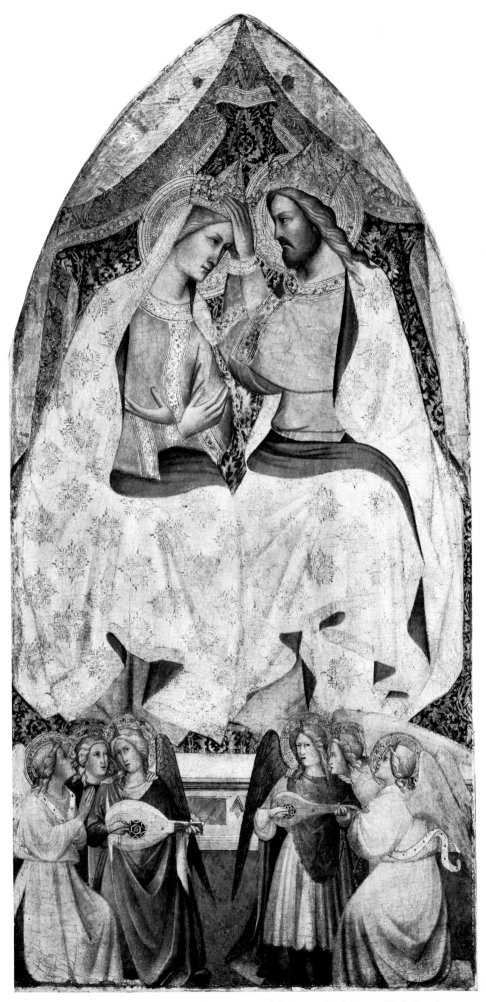

Fig. 99 (K 364) Agnolo Gaddi: *The Coronation of the Virgin*. Washington, D.C. (p. 40)

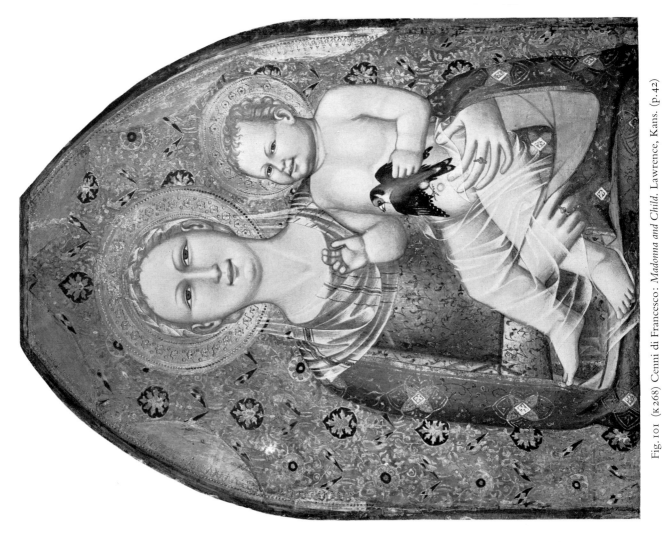

Fig. 101 (K 268) Cenni di Francesco: *Madonna and Child*. Lawrence, Kans. (p. 42)

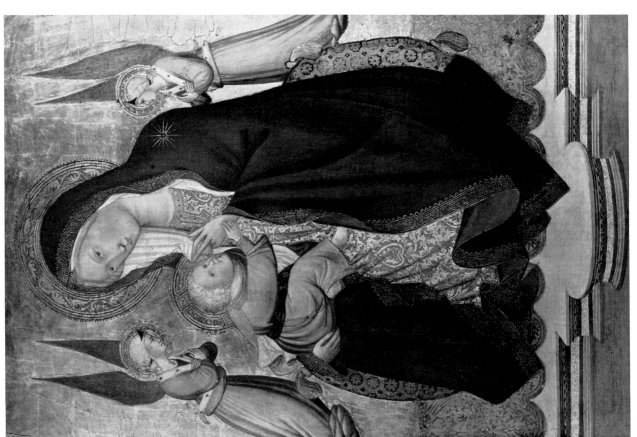

Fig. 100 (K 563) Follower of Agnolo Gaddi: *Madonna and Child Adored by Two Angels*. Tucson, Ariz. (p. 40)

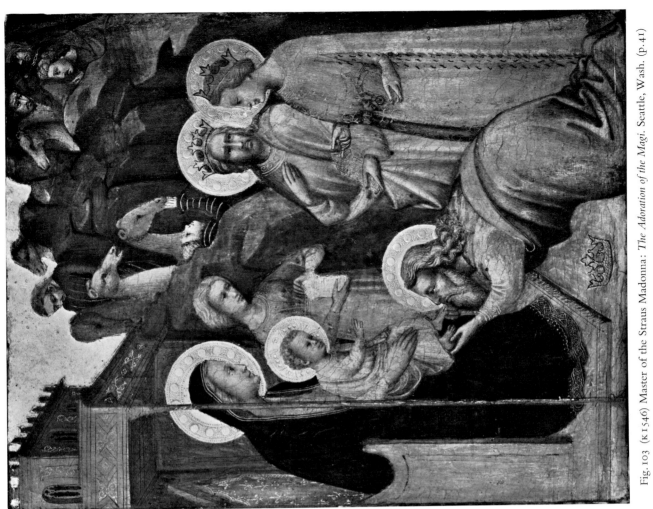

Fig. 103 (K1546) Master of the Straus Madonna: *The Adoration of the Magi*. Seattle, Wash. (p.41)

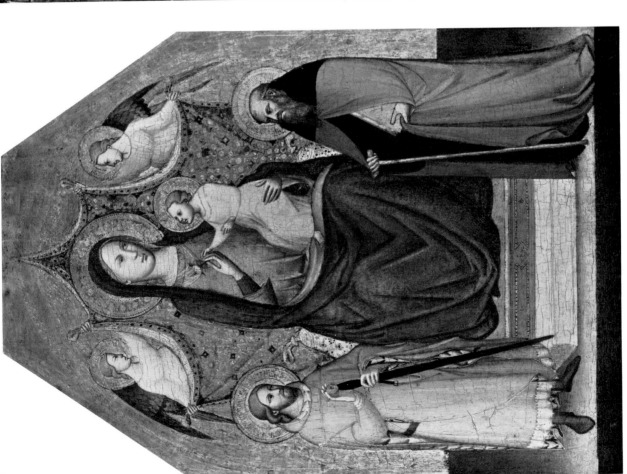

Fig. 102 (K108) Follower of Giovanni di Bartolommeo Cristiani: *Madonna and Child with Saints and Angels*. Berea, Ky. (p.40)

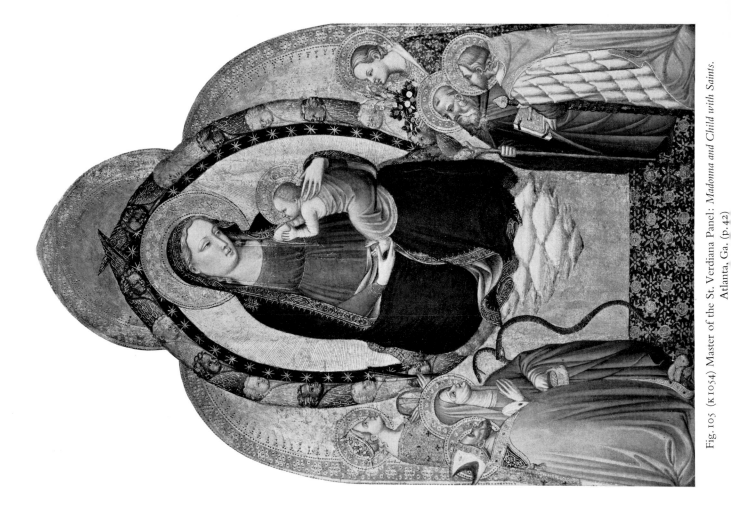

Fig. 105 (K 1054) Master of the St. Verdiana Panel: *Madonna and Child with Saints.*
Atlanta, Ga. (p. 42)

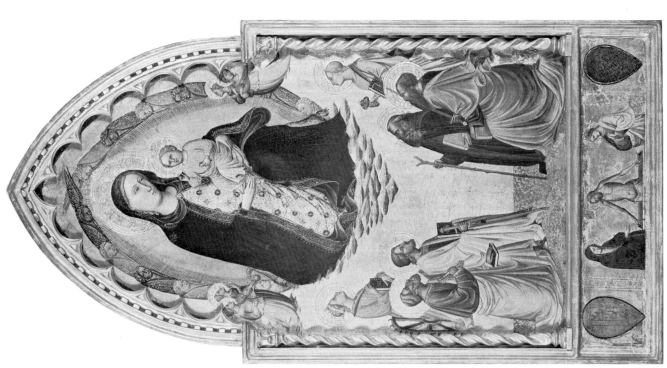

Fig. 104 (K 261) Master of the St. Verdiana Panel: *Madonna and Child
with Saints.* Birmingham, Ala. (p. 41)

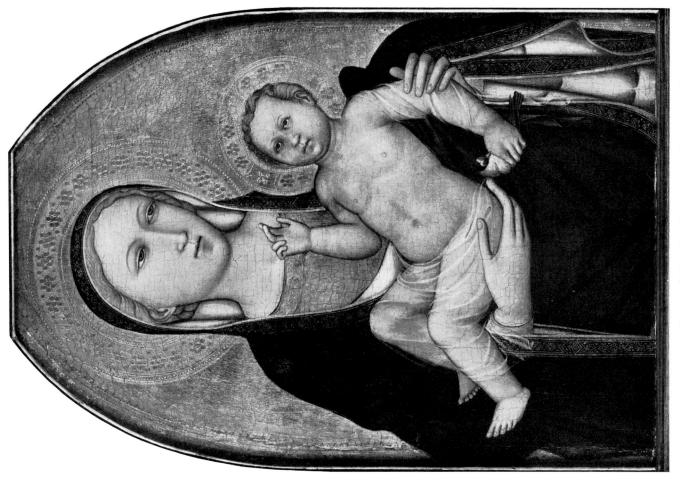

Fig. 107 (K 1119) Follower of Niccolò di Pietro Gerini: *Madonna and Child.*
Ponce, Puerto Rico (p. 43)

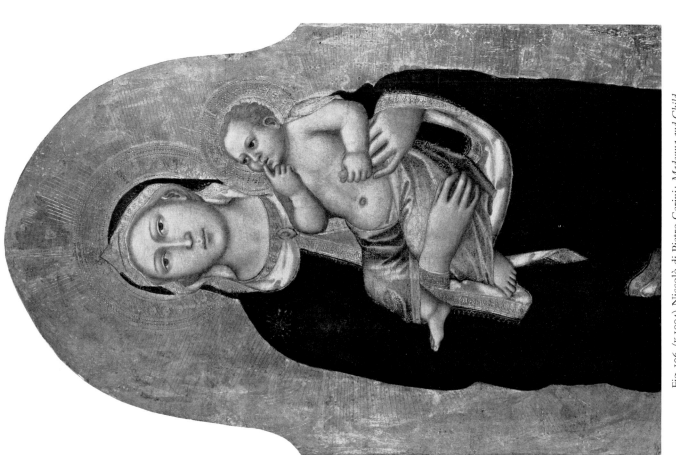

Fig. 106 (K 1004) Niccolò di Pietro Gerini: *Madonna and Child.*
Colorado Springs, Colo. (p. 42)

Fig. 108 (K 1016) Attributed to Lorenzo di Niccolò: *The Martyrdom of St. Stephen*. Little Rock, Ark. (p. 45)

Fig. 109 (K 17) Niccolò di Pietro Gerini: *The Four Crowned Martyrs before Diocletian*. Denver, Colo. (p. 43)

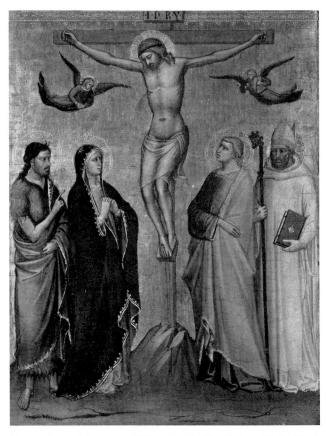

Fig. 110 (K 1093) Lorenzo di Niccolò: *The Crucifixion with the Virgin and Saints*. Raleigh, N.C. (p. 44)

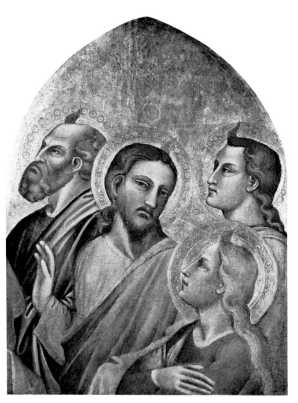

Fig. 111 (K1160) Follower of Niccolò di Pietro Gerini:
The Mourning Madonna. Claremont, Calif. (p. 44)

Fig. 112 (K174) Spinello Aretino: *Four Apostles.*
Allentown, Pa. (p. 45)

Fig. 113 (K1719) Niccolò di Pietro Gerini: *Legend of the Four Crowned Martyrs.* Birmingham, Ala. (p. 43)

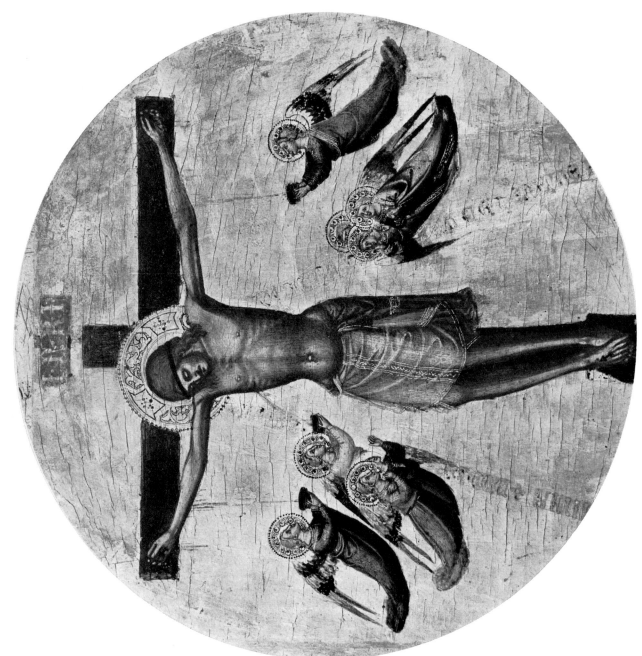

Fig. 115 (K445) Lorenzo di Bicci: *The Crucifixion.* Allentown, Pa. (p. 46)

Fig. 114 (K429) Antonio Veneziano: *St. Paul.*
San Francisco, Calif. (p. 46)

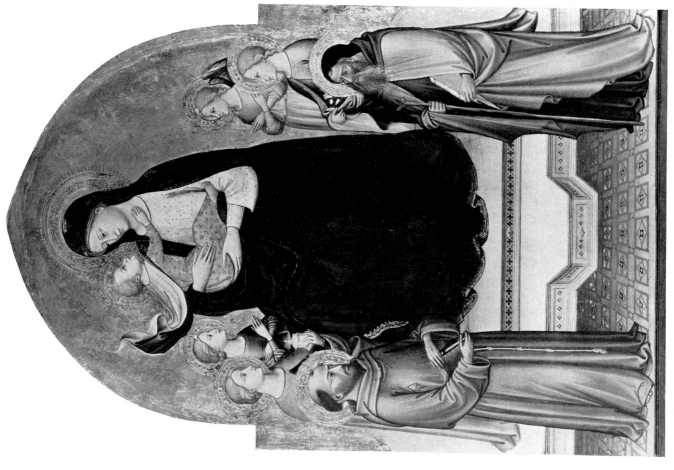

Fig. 117 (κ333) Lorenzo di Niccolò: *Madonna and Child with Saints and Angels.*
Birmingham, Ala. (p. 44)

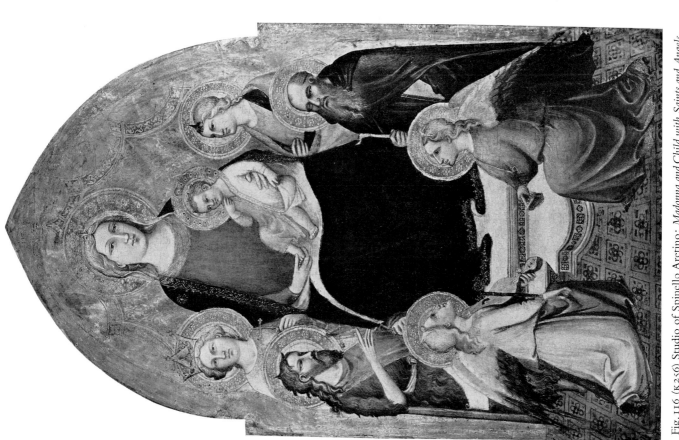

Fig. 116 (κ256) Studio of Spinello Aretino: *Madonna and Child with Saints and Angels.*
Lewisburg, Pa. (p. 45)

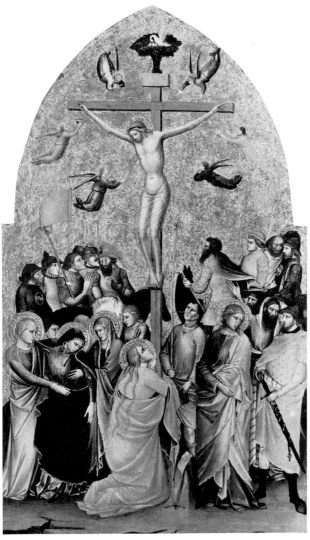

Fig. 118 (κ93) Mariotto di Nardo: *The Crucifixion.*
Amherst, Mass. (p. 46)

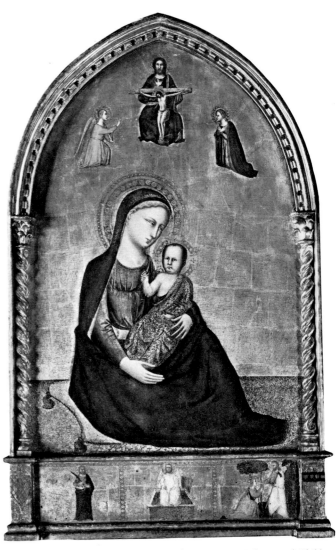

Fig. 119 (κ1190) Follower of Bicci di Lorenzo: *Madonna and Child.*
Nashville, Tenn. (p. 47)

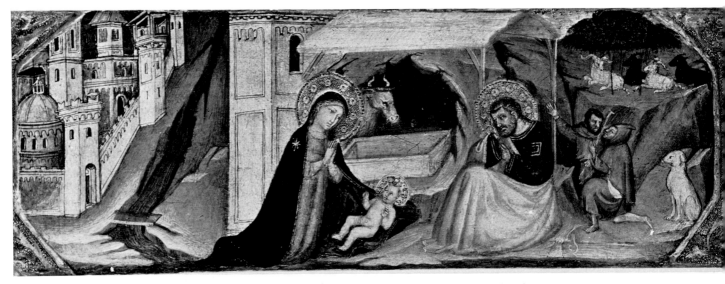

Fig. 120 (κ1228) Bicci di Lorenzo: *The Nativity.* Tempe, Ariz. (p. 47)

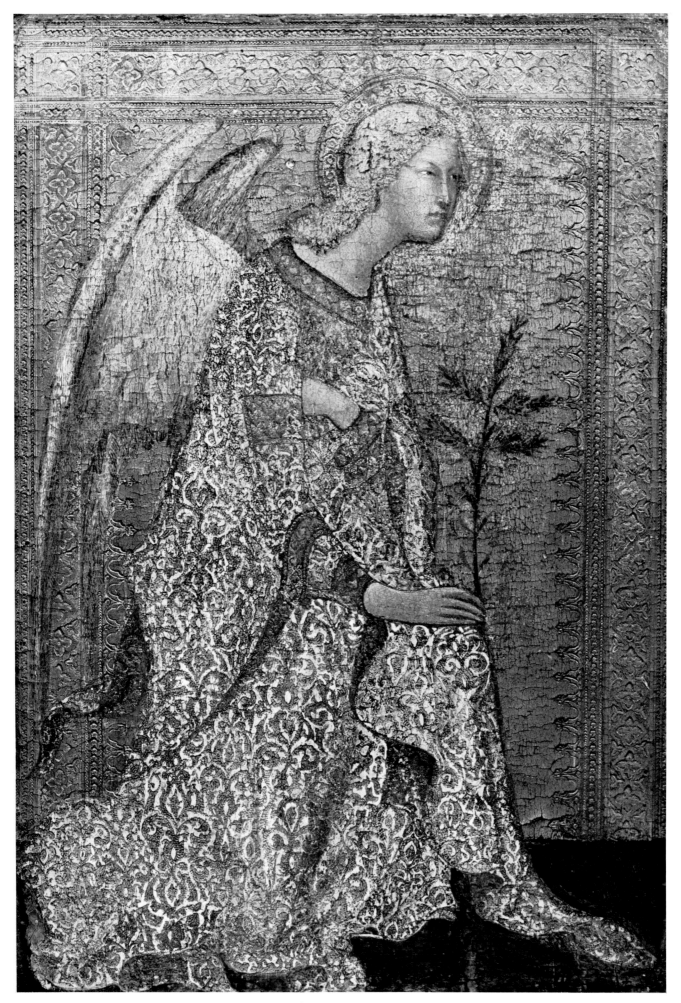

Fig. 121 (K405) Simone Martini: *The Angel of the Annunciation*. Washington, D.C. (p.48)

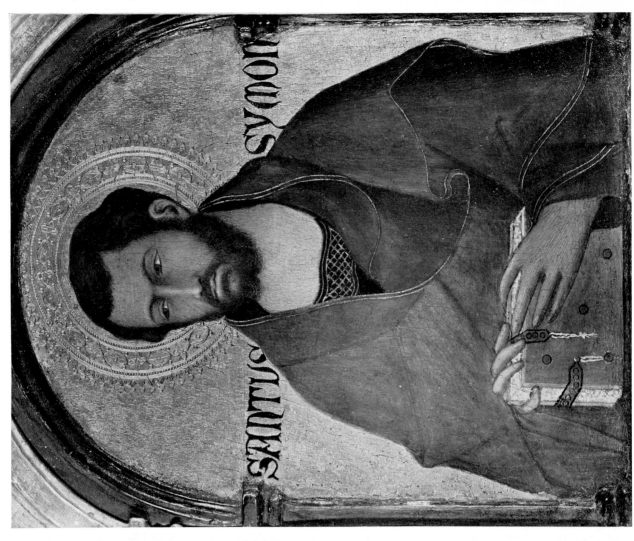

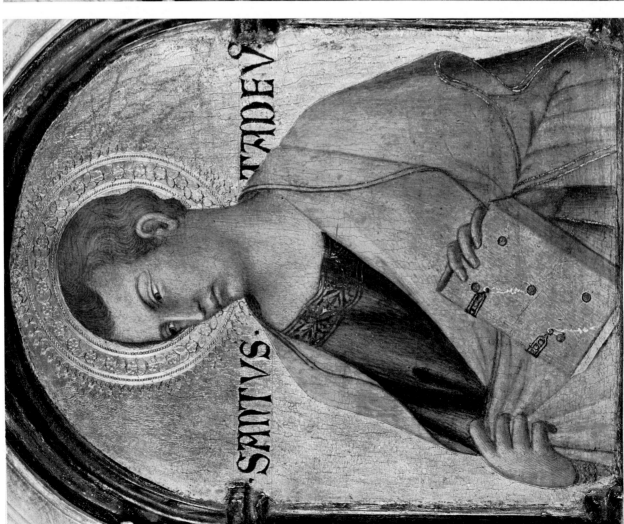

Figs. 122–123 (K1350, K1351) Simone Martini and Assistants: *St. Thaddeus; St. Simon*. Washington, D.C. (p.48)

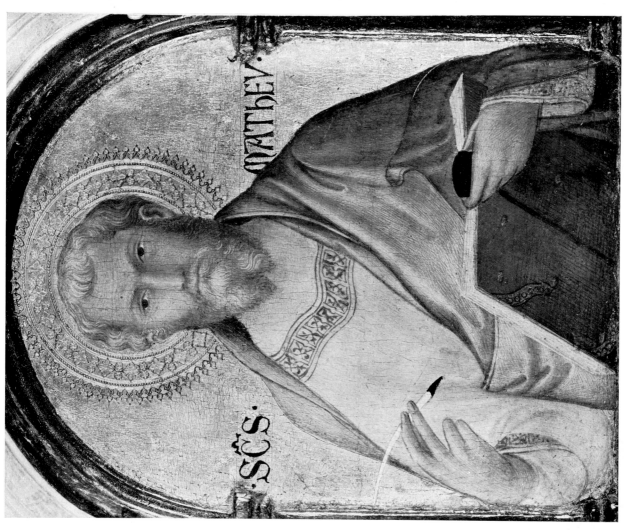

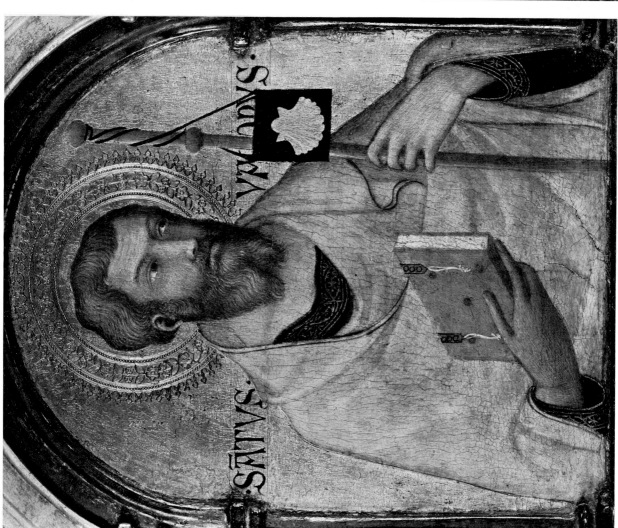

Figs. 124–125 (K1352, K1353) Simone Martini and Assistants: *St. James Major; St. Matthew.* Washington, D.C. (p.48)

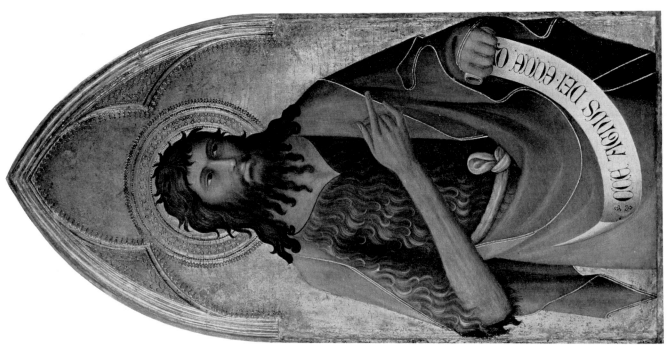

Fig. 127 (K1343) Lippo Memmi: *Madonna and Child with Saints*. Kansas City, Mo. (p. 49)

Fig. 126 (K511) Lippo Memmi: *St. John the Baptist*. Washington, D.C. (p. 49)

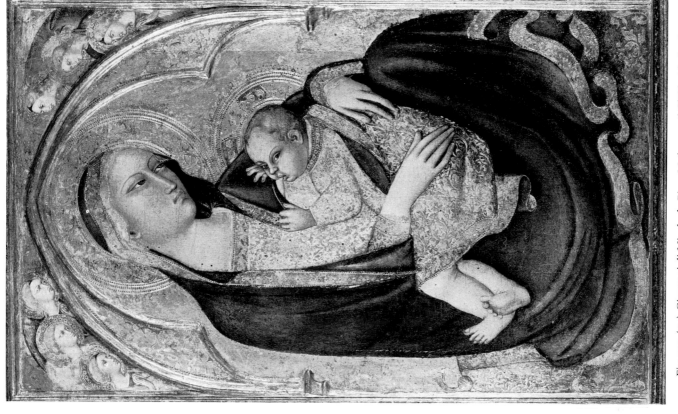

Fig. 129 (K4) Giovanni di Nicola da Pisa: *Madonna and Child with Angels.*
Williamstown, Mass. (p. 50)

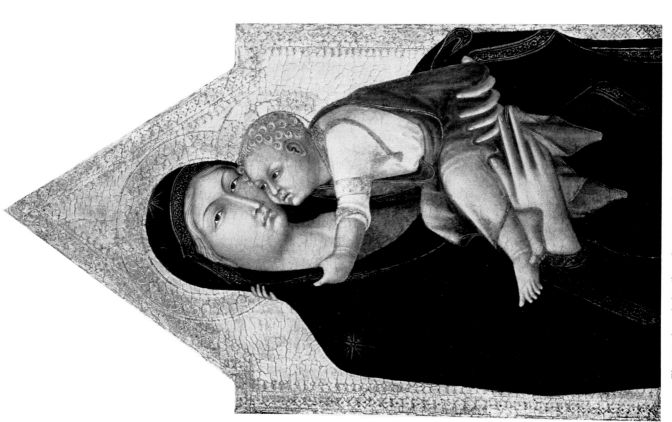

Fig. 128 (K459) Attributed to Barna da Siena: *Madonna and Child.*
Portland, Ore. (p. 50)

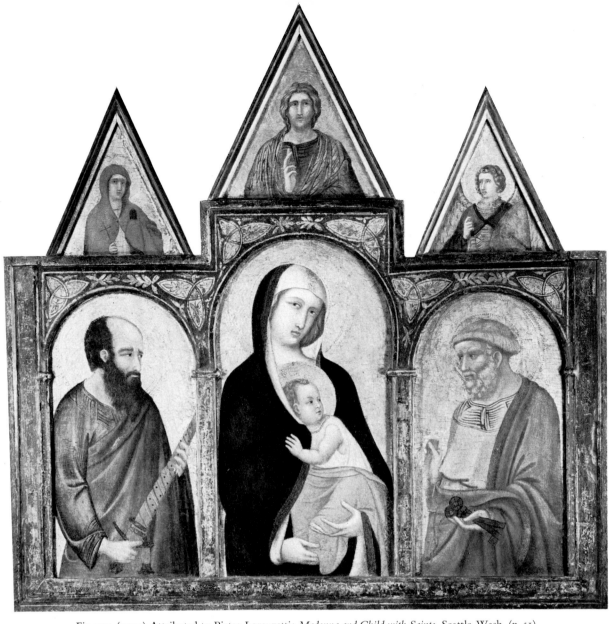

Fig. 130 (K 277) Attributed to Pietro Lorenzetti: *Madonna and Child with Saints*. Seattle, Wash. (p. 51)

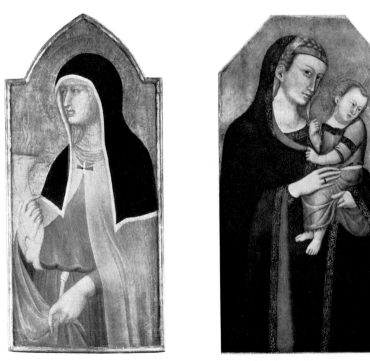

Fig. 131 (K 447) Attributed to Pietro Lorenzetti: *St. Clare*. Athens, Ga. (p. 52)
Fig. 132 (K M-5) Guidoccio Palmerucci: *Madonna and Child*. Cambridge, Mass. (p. 55)

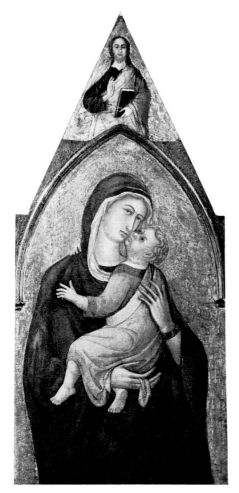
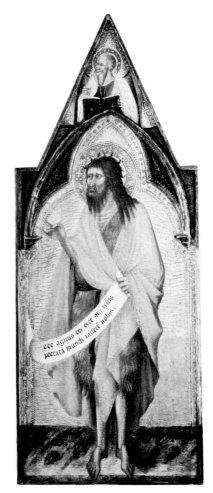

Fig. 133 (K 157) Follower of Pietro Lorenzetti: *Madonna and Child*. Waco, Tex. (p. 52)

Fig. 134 (K 1237) Follower of Pietro Lorenzetti (possibly Tegliacci): *St. John the Baptist*. Hartford, Conn. (p. 53)

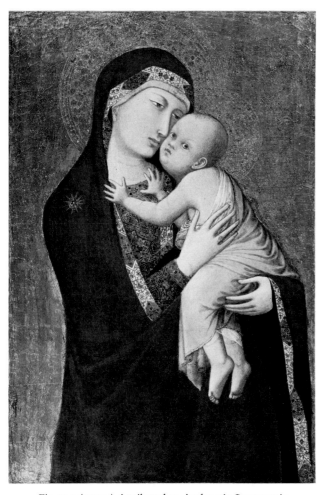
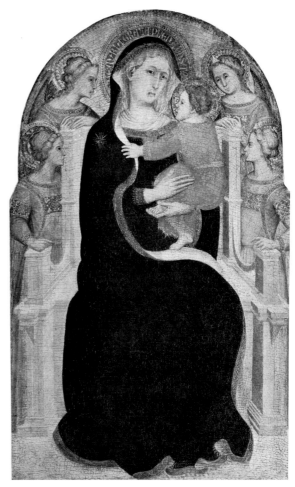

Fig. 135 (K 1354) Attributed to Ambrogio Lorenzetti: *Madonna and Child*. El Paso, Tex. (p. 51)

Fig. 136 (K 265) Follower of Pietro Lorenzetti: *Madonna and Child Enthroned with Angels*. Allentown, Pa. (p. 52)

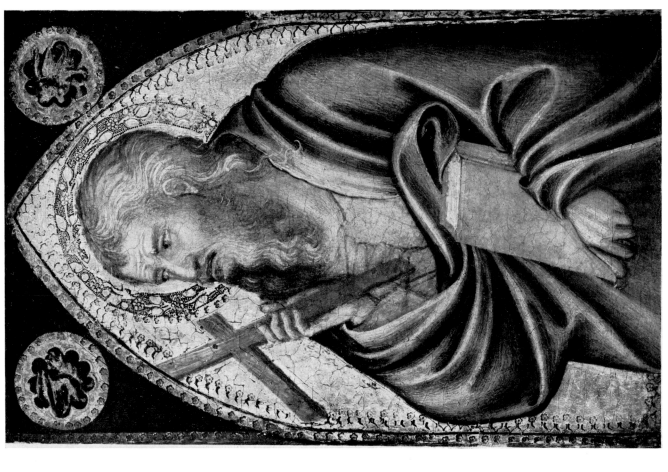

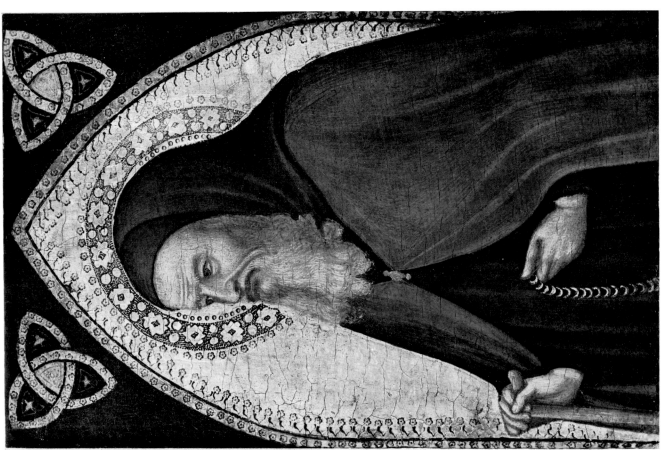

Figs. 137-138 (K1224 A, B) Follower of Pietro Lorenzetti: *St. Anthony Abbot; St. Andrew.* Bridgeport, Conn. (p. 53)

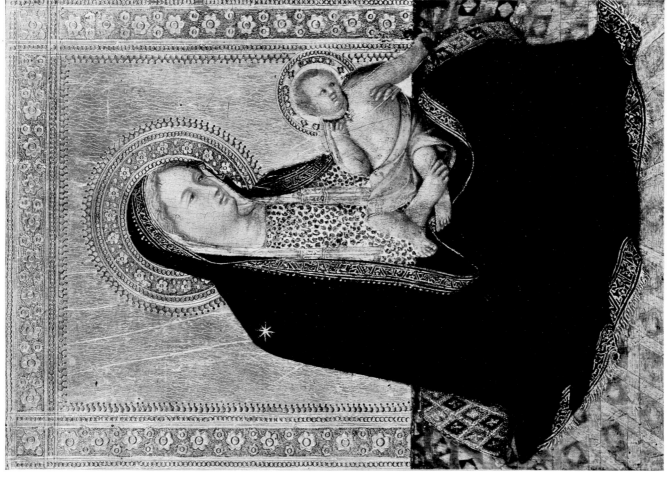

Fig. 140 (κ 1364) Studio of the Master of the Ovile Madonna ('Ugolino Lorenzetti'):
Madonna and Child. Tucson, Ariz. (p. 55)

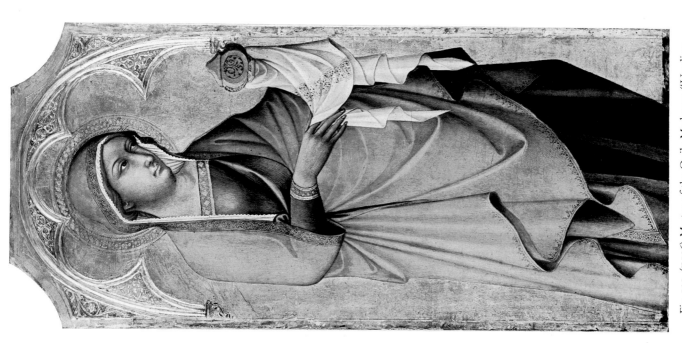

Fig. 139 (κ 106) Master of the Ovile Madonna ('Ugolino
Lorenzetti'): *St. Mary Magdalene.* Columbia, S.C. (p. 54)

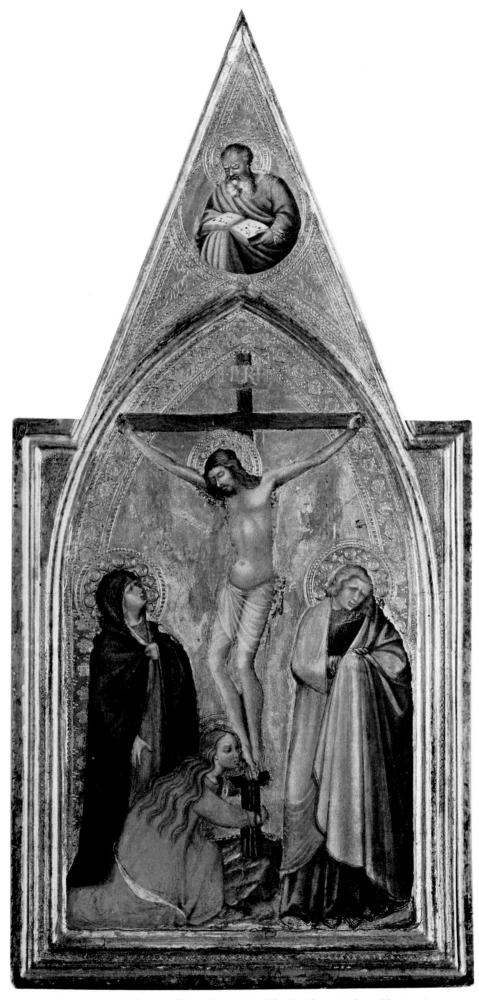

Fig. 141 (K27) Follower of Pietro Lorenzetti: *The Crucifixion*. Tulsa, Okla. (p. 52)

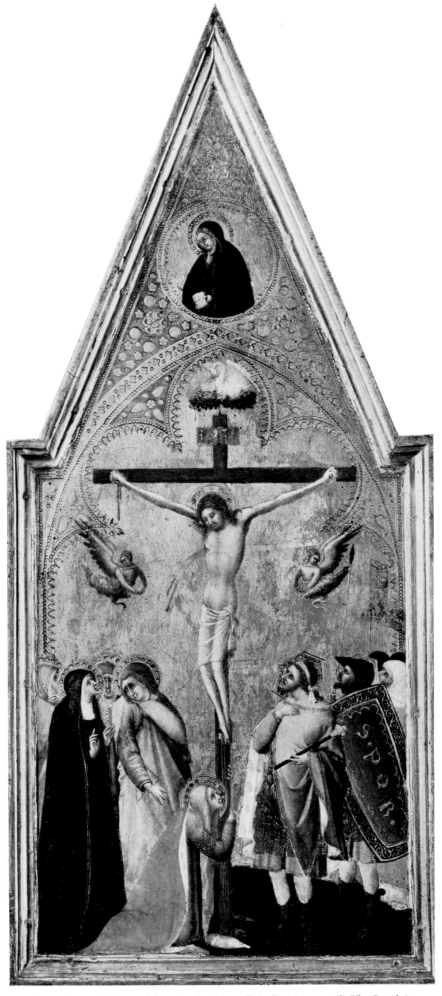

Fig. 142 (K 1045) Master of the Ovile Madonna ('Ugolino Lorenzetti'): *The Crucifixion*
New York, Samuel H. Kress Foundation (p. 55)

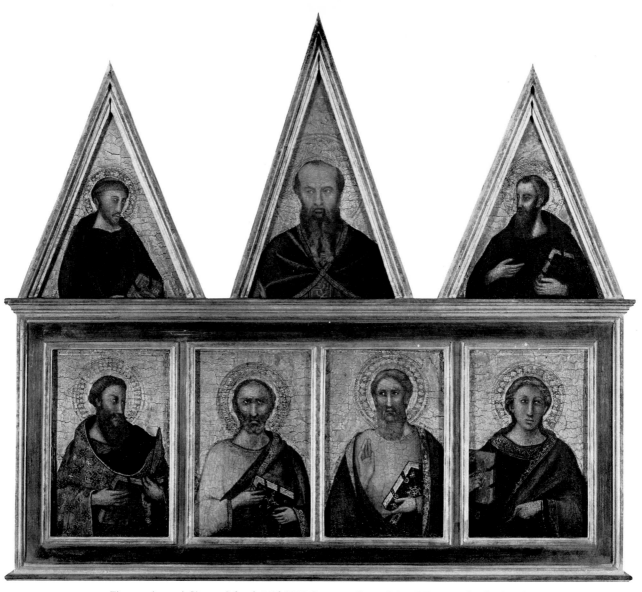

Fig. 143 (K 1074) Sienese School, Mid-XIV Century: *Seven Saints*. Winter Park, Fla. (p. 56)

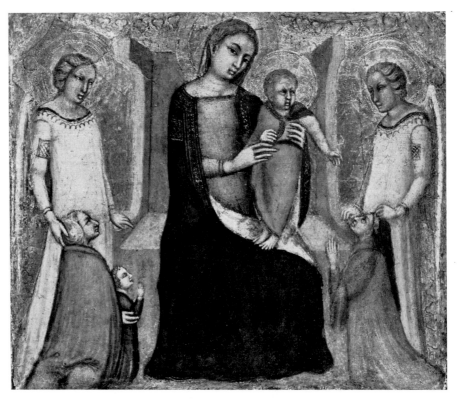

Fig. 144 (K 1742) Guidoccio Palmerucci: *Madonna and Child between Two Angels,
Adored by Donors*. Lawrence, Kans. (p. 56)

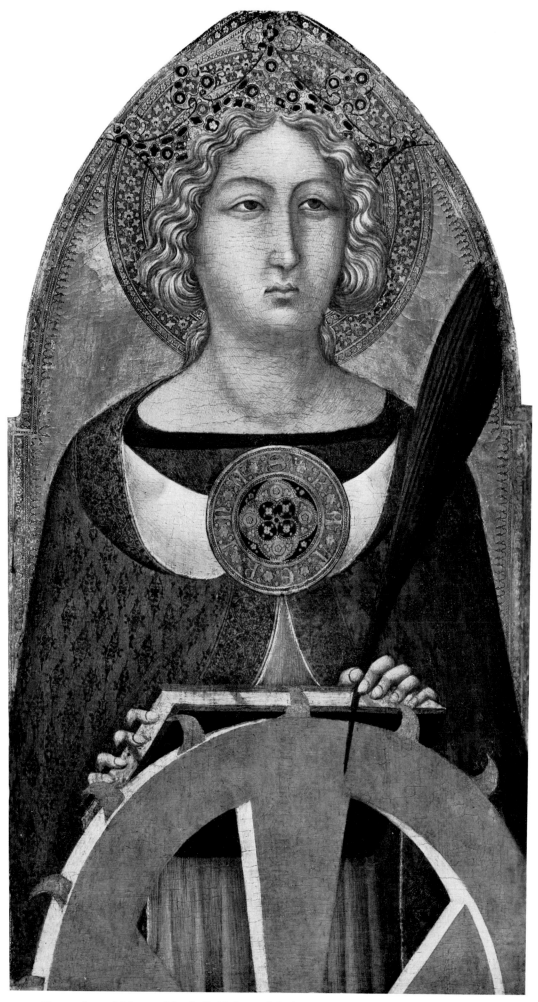

Fig. 145 (κ 1302) Master of the Ovile Madonna ('Ugolino Lorenzetti'): *St. Catherine of Alexandria.*
Washington, D.C. (p. 54)

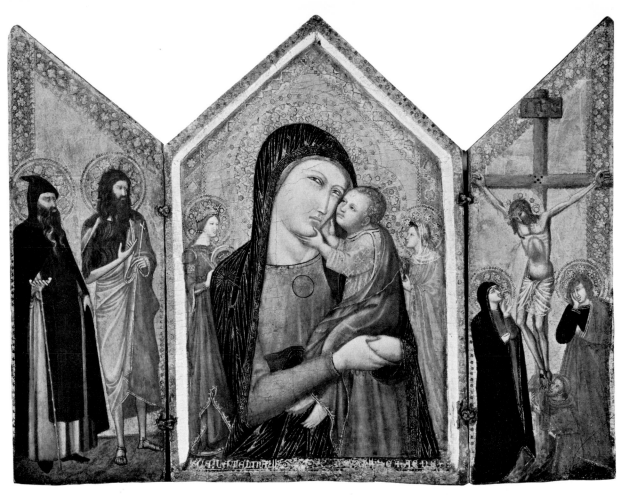

Fig. 146 (K 2142) Sienese School, c. 1370: *Madonna and Child, the Crucifixion, and Saints*. Raleigh, N.C. (p. 56)

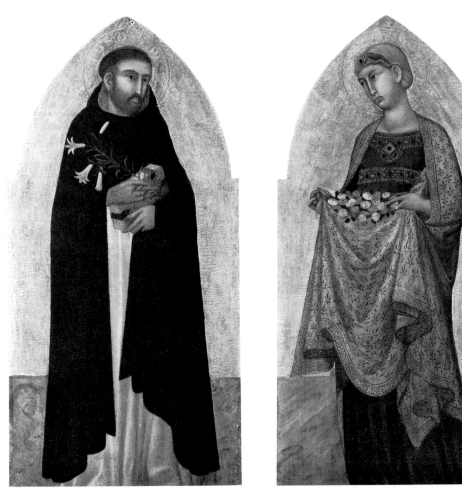

Figs. 147–148 (K 1355 B, C) Lippo Vanni: *St. Dominic; St. Elizabeth of Hungary*. Coral Gables, Fla. (p. 57)

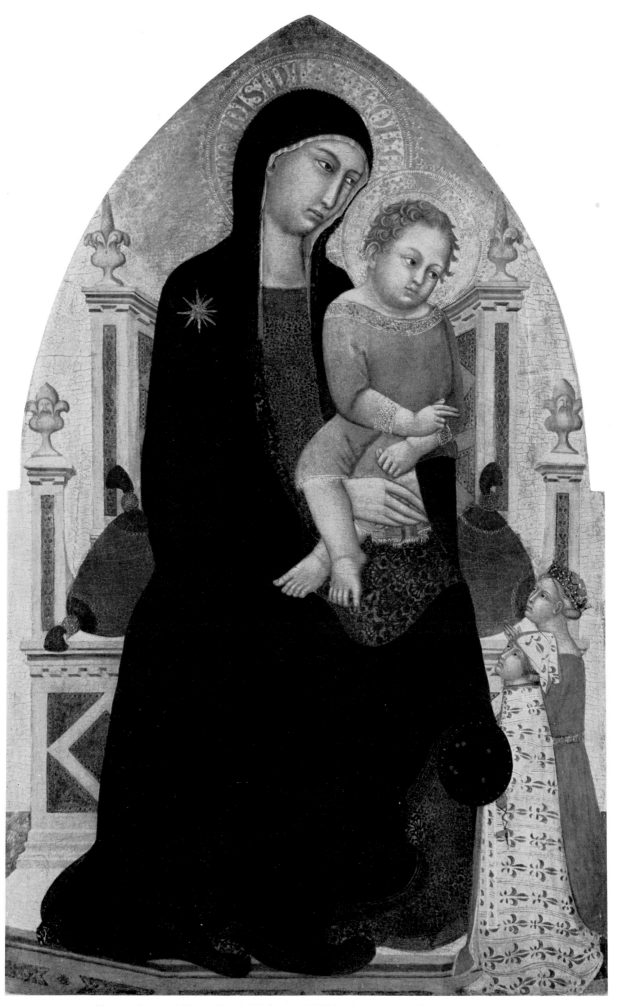

Fig. 149 (K 1355 A) Lippo Vanni: *Madonna and Child with Donors*. Coral Gables, Fla. (p. 57)

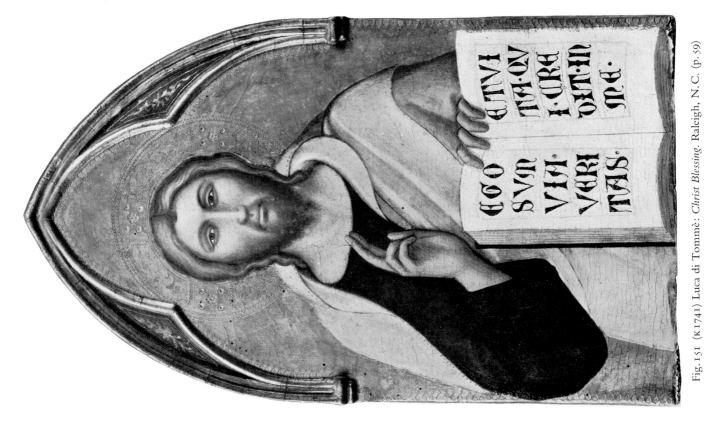

Fig. 151 (K1741) Luca di Tommè: *Christ Blessing*. Raleigh, N.C. (p. 59)

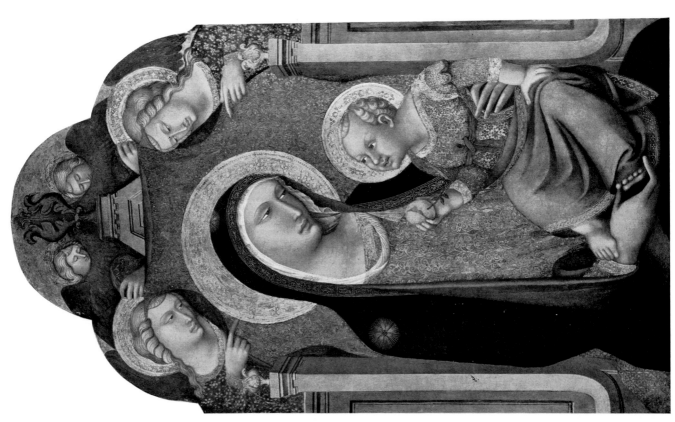

Fig. 150 (K1085) Niccolò di Ser Sozzo Tegliacci: *Madonna and Child with Angels*.
Tucson, Ariz. (p. 58)

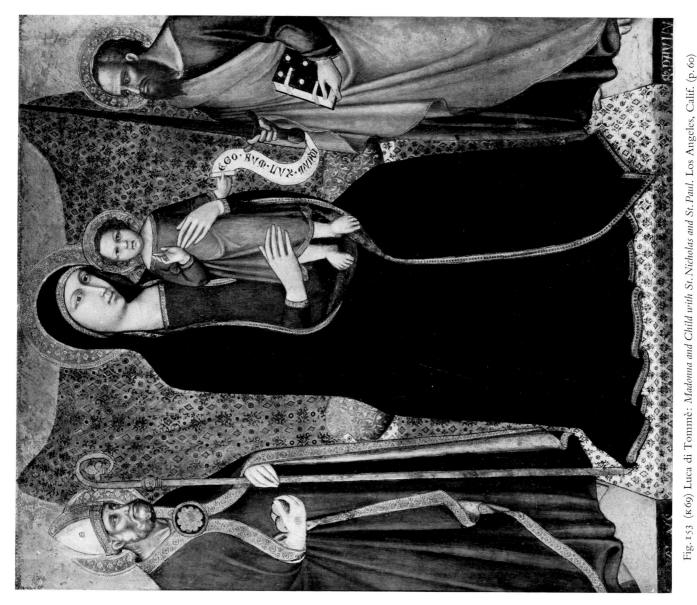

Fig. 153 (κ 69) Luca di Tommè: *Madonna and Child with St. Nicholas and St. Paul*. Los Angeles, Calif. (p. 60)

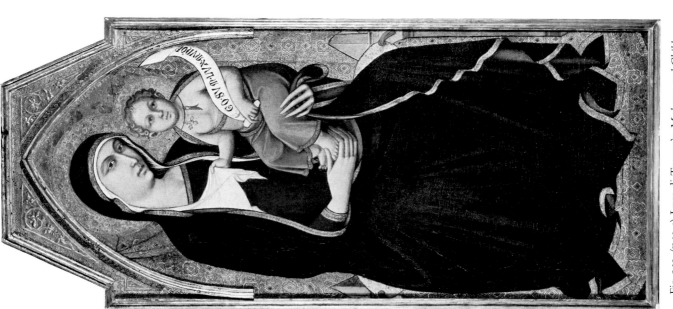

Fig. 152 (κ M-4) Luca di Tommè: *Madonna and Child*. Ponce, Puerto Rico (p. 60)

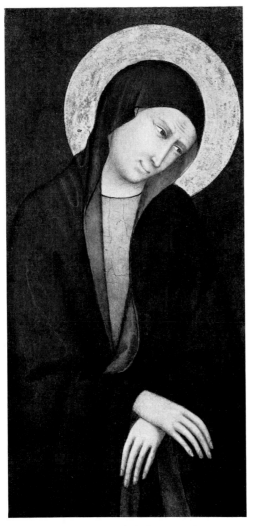

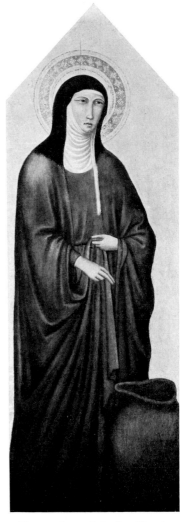

Fig. 154 (K 1234) Andrea Vanni:
The Mourning Madonna. Madison, Wis. (p. 58)

Fig. 155 (K 1007) Andrea Vanni:
St. Clare. Claremont, Calif. (p. 58)

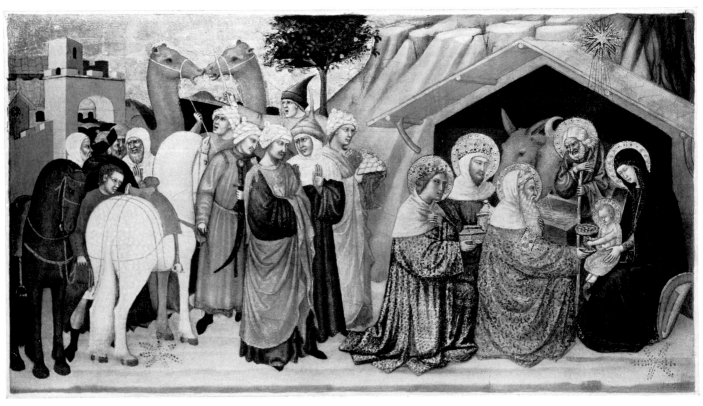

Fig. 156 (K 233) Andrea Vanni: *The Adoration of the Magi*. New Orleans, La. (p. 57)

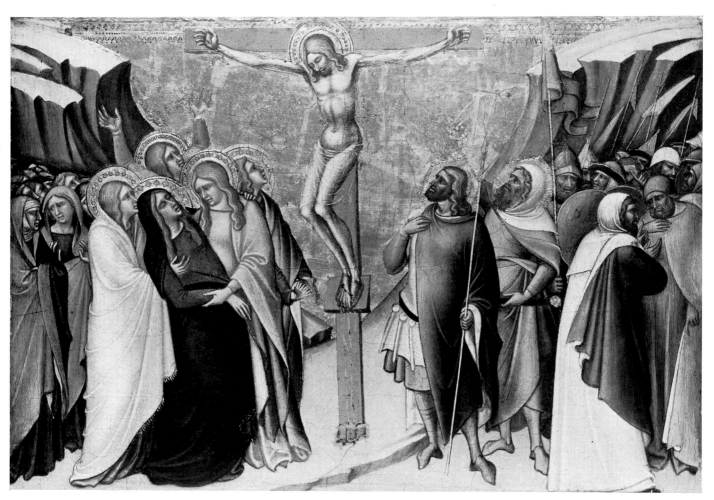

Fig. 157 (K34) Luca di Tommè: *The Crucifixion*. San Francisco, Calif. (p. 59)

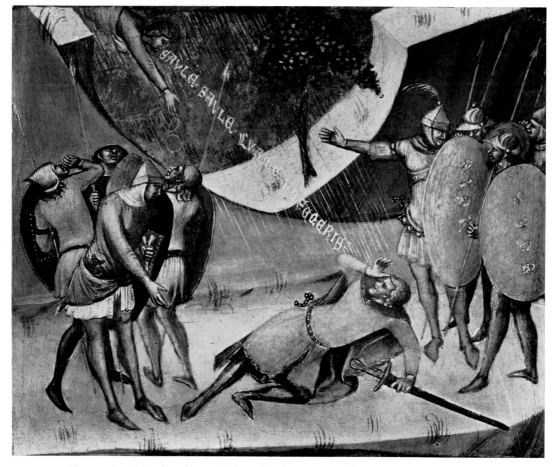

Fig. 158 (K373) Studio of Luca di Tommè: *The Conversion of St. Paul*. Seattle, Wash. (p. 60)

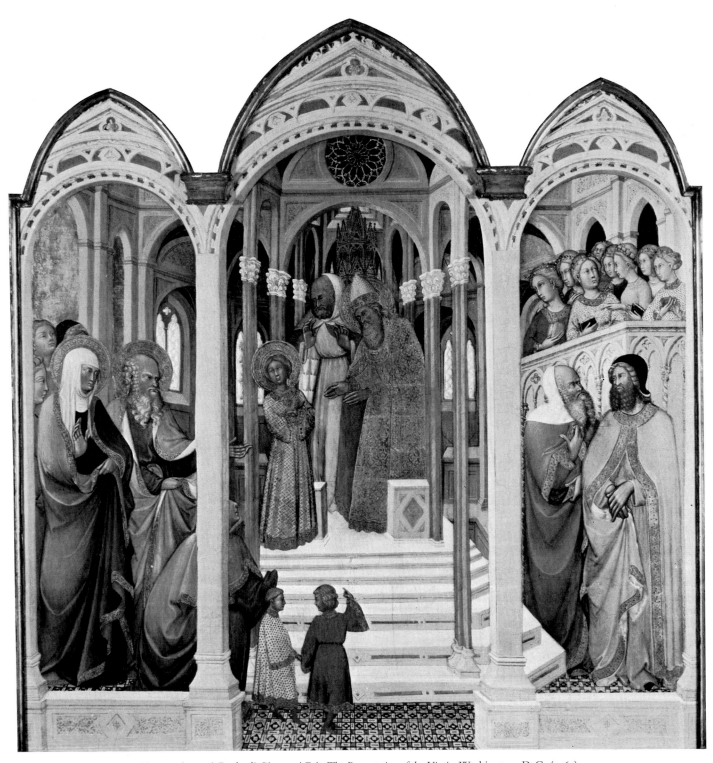

Fig. 159 (K 2045) Paolo di Giovanni Fei: *The Presentation of the Virgin*. Washington, D.C. (p. 62)

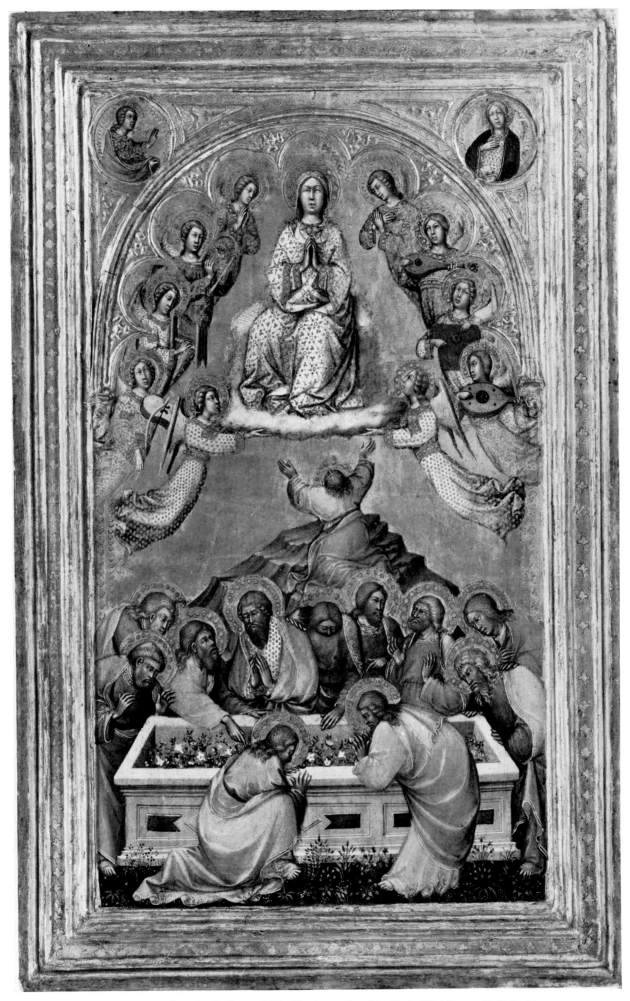

Fig. 160 (K1547) Paolo di Giovanni Fei: *The Assumption of the Virgin*. Washington, D.C. (p. 61)

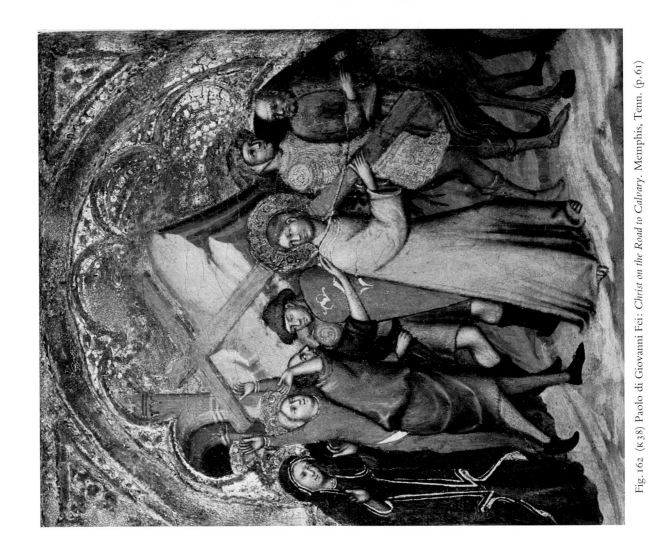

Fig. 162 (κ38) Paolo di Giovanni Fei: *Christ on the Road to Calvary*. Memphis, Tenn. (p.61)

Fig. 161 (κ187) Paolo di Giovanni Fei: *Madonna and Child with Two Angels, St. Francis, and St. Louis of Toulouse*. Atlanta, Ga. (p.62)

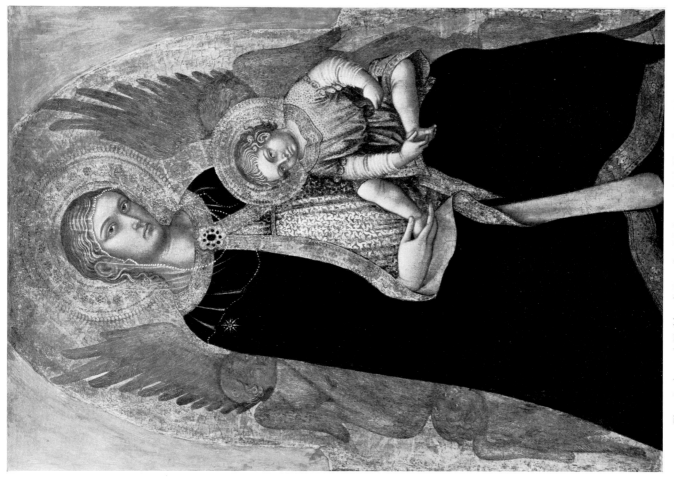

Fig. 164 (K1179) Taddeo di Bartolo: *Madonna and Child*. Tulsa, Okla. (p. 63)

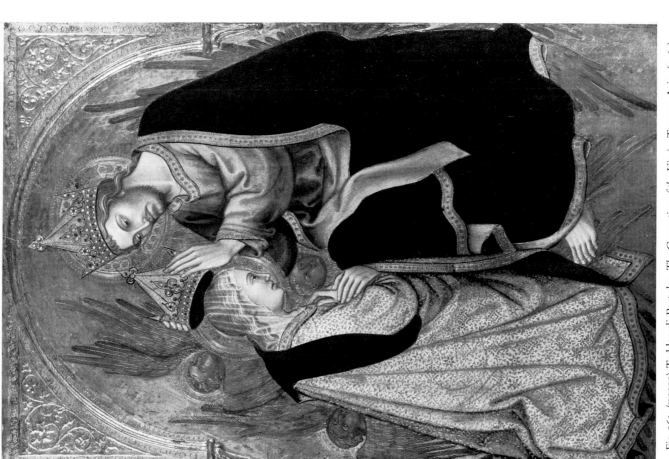

Fig. 163 (K1292) Taddeo di Bartolo: *The Coronation of the Virgin*. Tucson, Ariz. (p. 63)

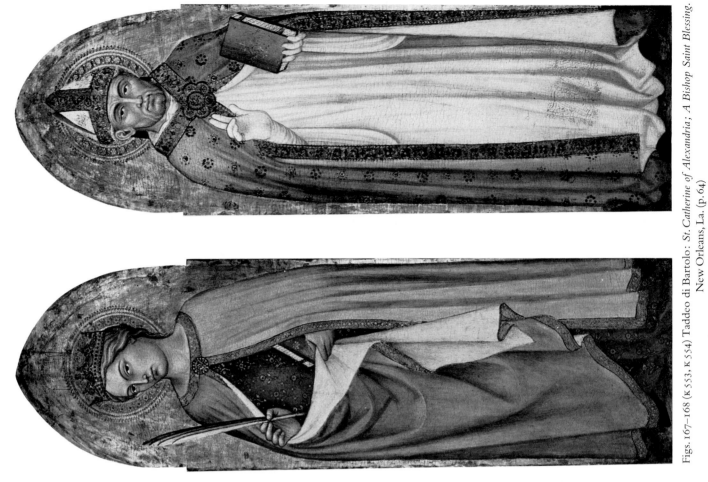

Figs. 167–168 (K 553, K 554) Taddeo di Bartolo: *St. Catherine of Alexandria; A Bishop Saint Blessing.*
New Orleans, La. (p. 64)

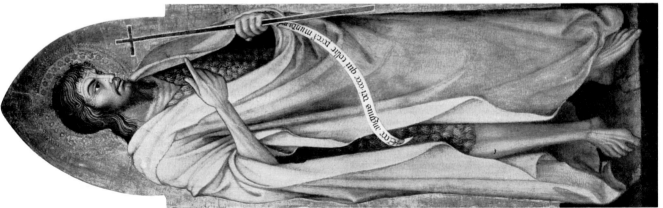

Figs. 165–166 (K 551, K 552) Taddeo di Bartolo: *St. James Major; St. John the Baptist.*
Memphis, Tenn. (p. 63)

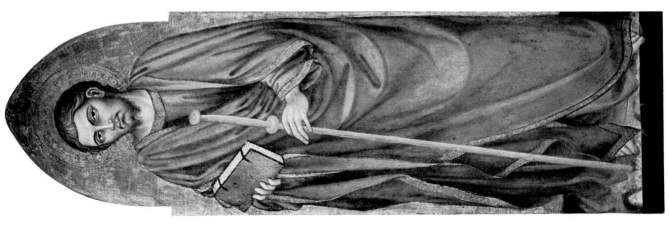

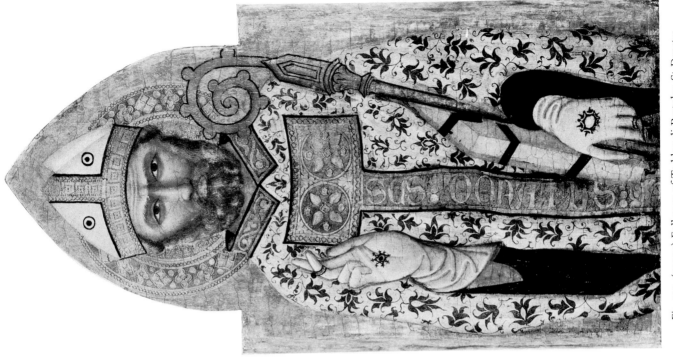

Fig. 170 (κ 1075) Follower of Taddeo di Bartolo: *St. Donatus*. San Antonio, Tex. (p. 64)

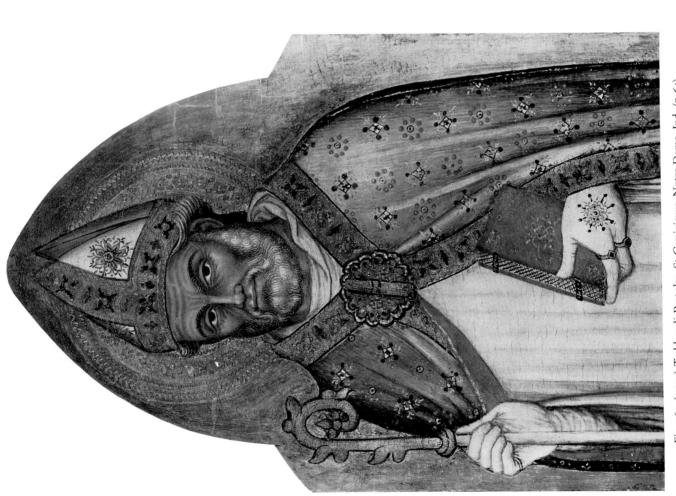

Fig. 169 (κ 104) Taddeo di Bartolo: *St. Geminianus*. Notre Dame, Ind. (p. 64)

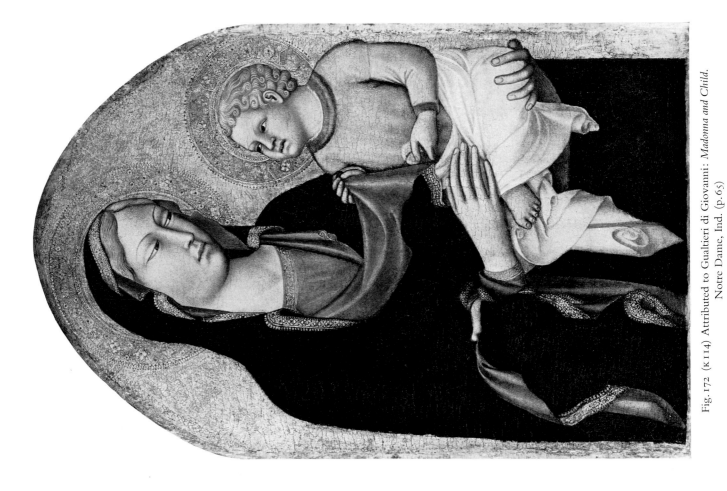

Fig. 172 (k114) Attributed to Gualtieri di Giovanni: *Madonna and Child.*
Notre Dame, Ind. (p. 65)

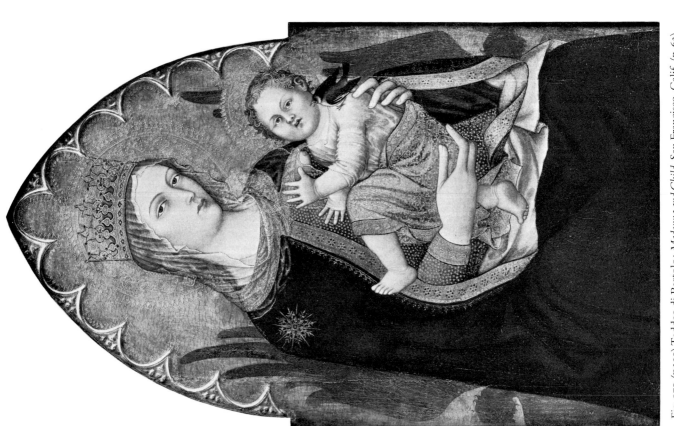

Fig. 171 (k310) Taddeo di Bartolo: *Madonna and Child.* San Francisco, Calif. (p. 63)

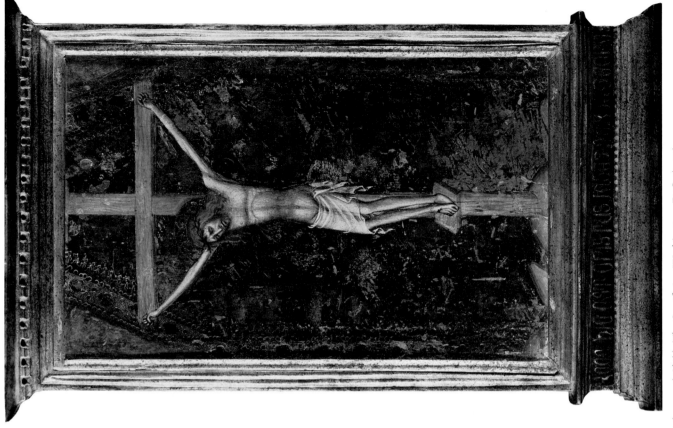

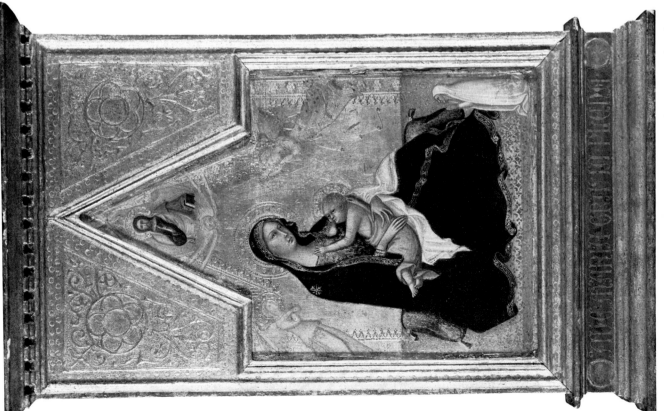

Figs. 173–174 (κ23, obverse and reverse) Andrea di Bartolo: *Madonna and Child*; *The Crucifixion.* Washington, D.C. (p.66)

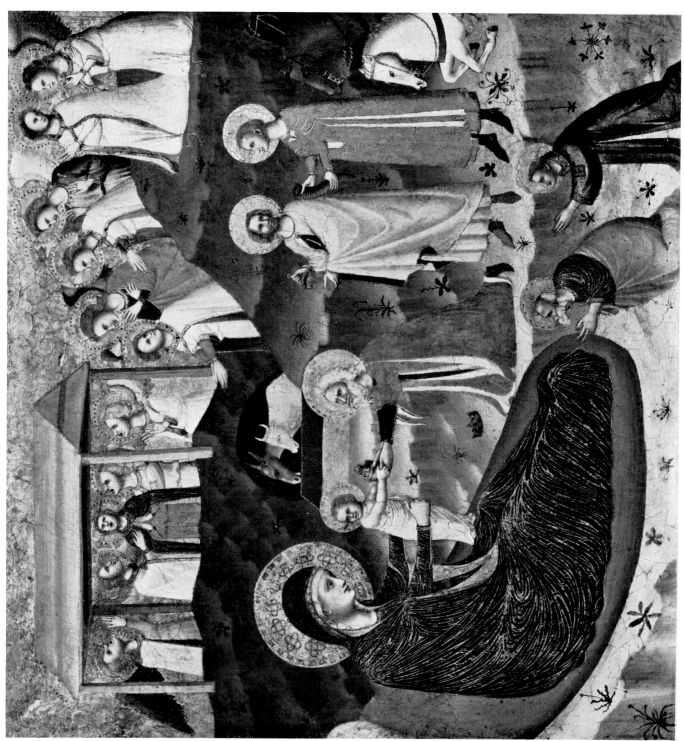

Fig. 187 (K 1084) Master of the Blessed Clare: *The Adoration of the Magi*. Coral Gables, Fla. (p. 70)

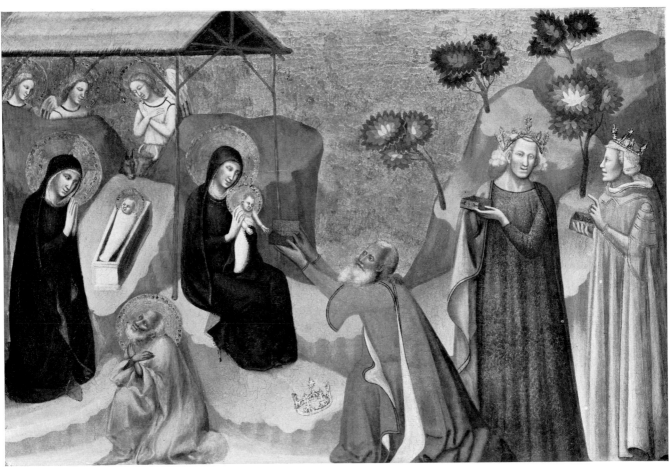

Fig. 188 (K 1170) Jacopino di Francesco: *The Nativity and the Adoration of the Magi*. Raleigh, N.C. (p. 71)

Fig. 189 (K 1166) Jacopino di Francesco: *St. Mary Magdalene Washing Christ's Feet*. Raleigh, N.C. (p. 71)

Fig. 190 (K 1169) Jacopino di Francesco: *St. Catherine of Alexandria Freed from the Wheel*. Raleigh, N.C. (p. 71)

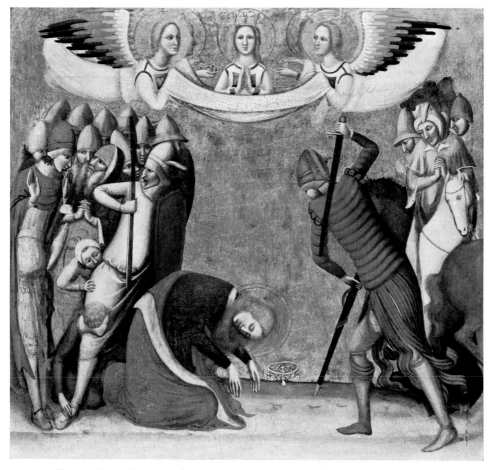

Fig. 191 (K 1167) Jacopino di Francesco: *The Beheading of St. Catherine of Alexandria*.
Raleigh, N.C. (p. 71)

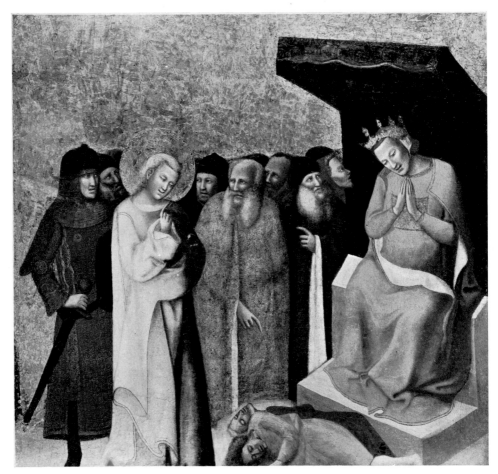

Fig. 192 (K 1168) Jacopino di Francesco: *A Miracle of St. John the Evangelist*. Raleigh, N.C. (p. 71)

Figs. 193–194 (K 1195) Michele di Matteo: *Mater Dolorosa; St. John the Evangelist*. Columbia, Mo. (p. 73)

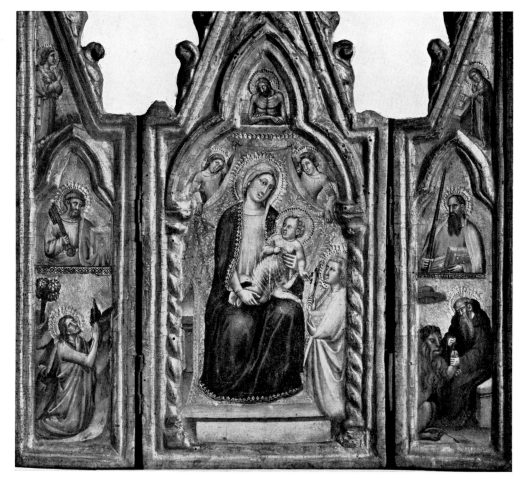

Fig. 195 (K 1201) Simone dei Crocifissi: *Madonna and Child with Saints*. Athens, Ga. (p. 72)

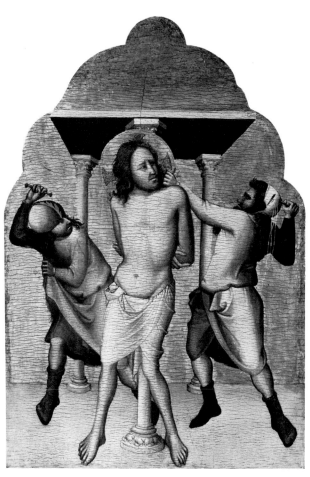

Fig. 196 (K 1206) Dalmasio: *The Flagellation*.
Seattle, Wash. (p. 71)

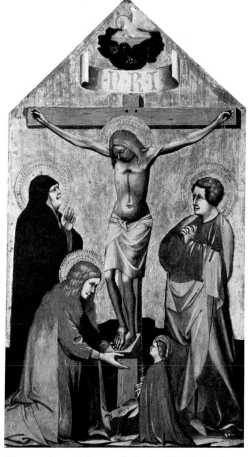

Fig. 197 (K 1209) Jacopo di Paolo: *The Crucifixion*.
Nashville, Tenn. (p. 72)

Figs. 199–200 (K 177, K 176) Attributed to Turino di Vanni: *St. Lucy and St. Agnes; A Bishop Saint and St. Francis.*
Birmingham, Ala. (p. 74)

Fig. 198 (K 102) Cecco di Pietro: *St. Jerome in His Study.* Raleigh, N.C. (p. 73)

Fig. 202 (K153) Angelo Puccinelli: *Tobit Blessing His Son*. Tulsa, Okla. (p. 74)

Fig. 201 (K1174) Cecco di Pietro: *Madonna and Child*. Portland, Ore. (p. 73)

Figs. 215–216 (K135, K136) Veronese School, Early XV Century: *The Annunciation and the Nativity*; *Legend of a Saint*. New York, Mrs. Rush H. Kress (p. 78)

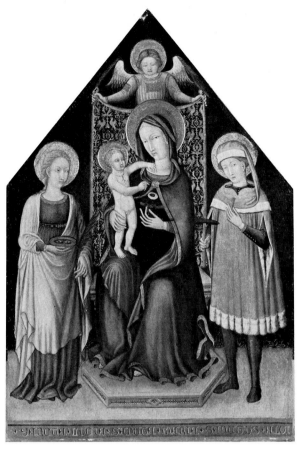

Fig. 217 (K 1162) Master of Staffolo: *Madonna and Child with St. Lucy and St. Eligius*. Claremont, Calif. (p. 79)

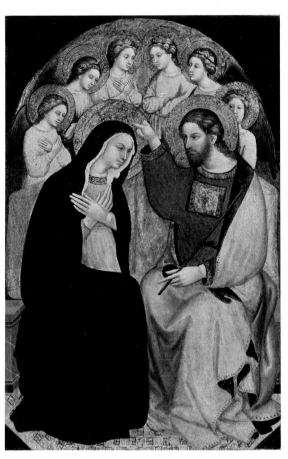

Fig. 218 (K 59) Pietro di Domenico da Montepulciano: *The Coronation of the Virgin*. Washington, D.C. Howard University (p. 79)

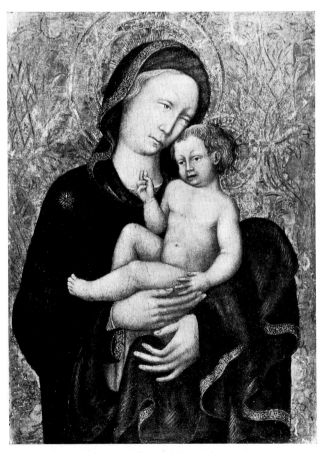

Fig. 219 (K 123) Follower of Michele Giambono: *Madonna and Child*. Tucson, Ariz. (p. 80)

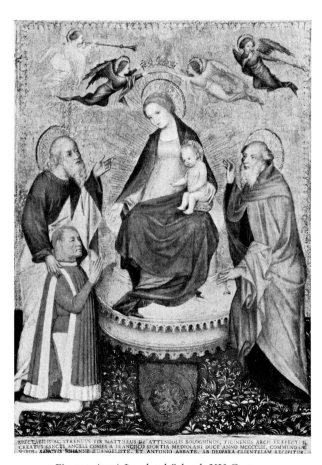

Fig. 220 (K 22) Lombard School, XV Century: *Madonna and Child with Saints and Donor*. Raleigh, N.C. (p. 80)

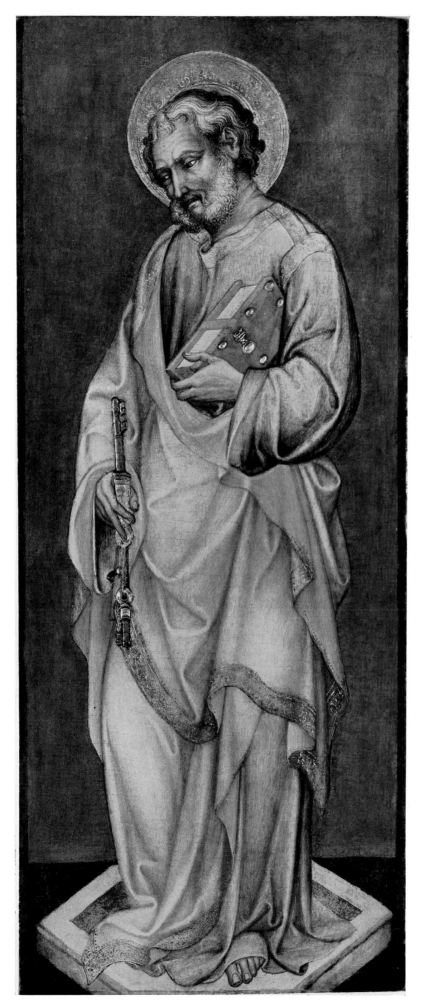

Fig. 221 (K 178) Michele Giambono: *St. Peter*. Washington, D.C. (p. 79)

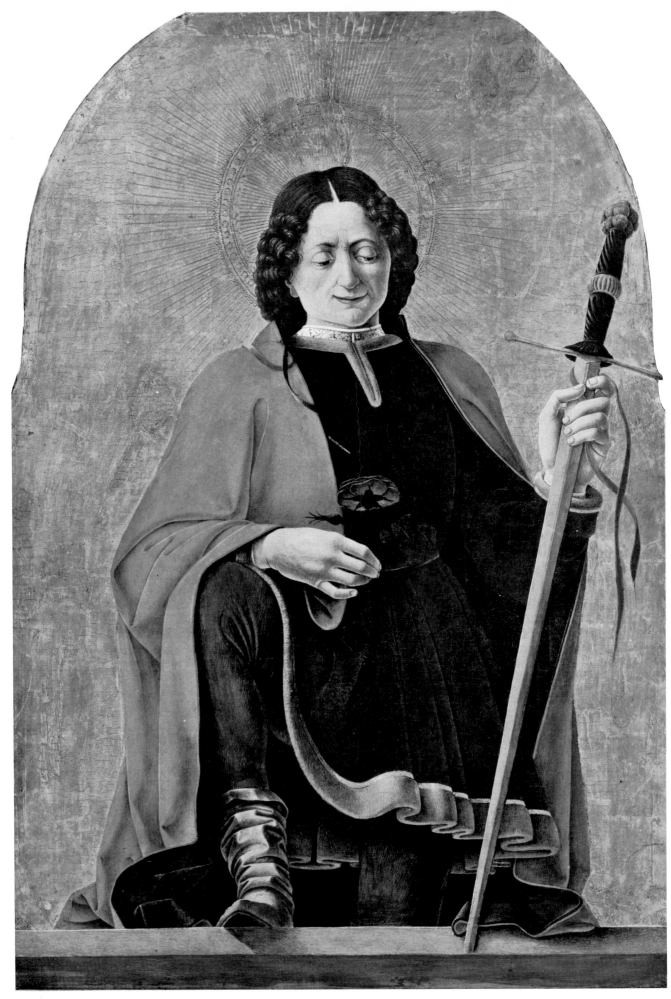

Fig. 222 (K416) Francesco del Cossa: *St. Florian*. Washington, D.C. (p. 83)

Fig. 223 (K417) Francesco del Cossa: *St. Lucy*. Washington, D.C.

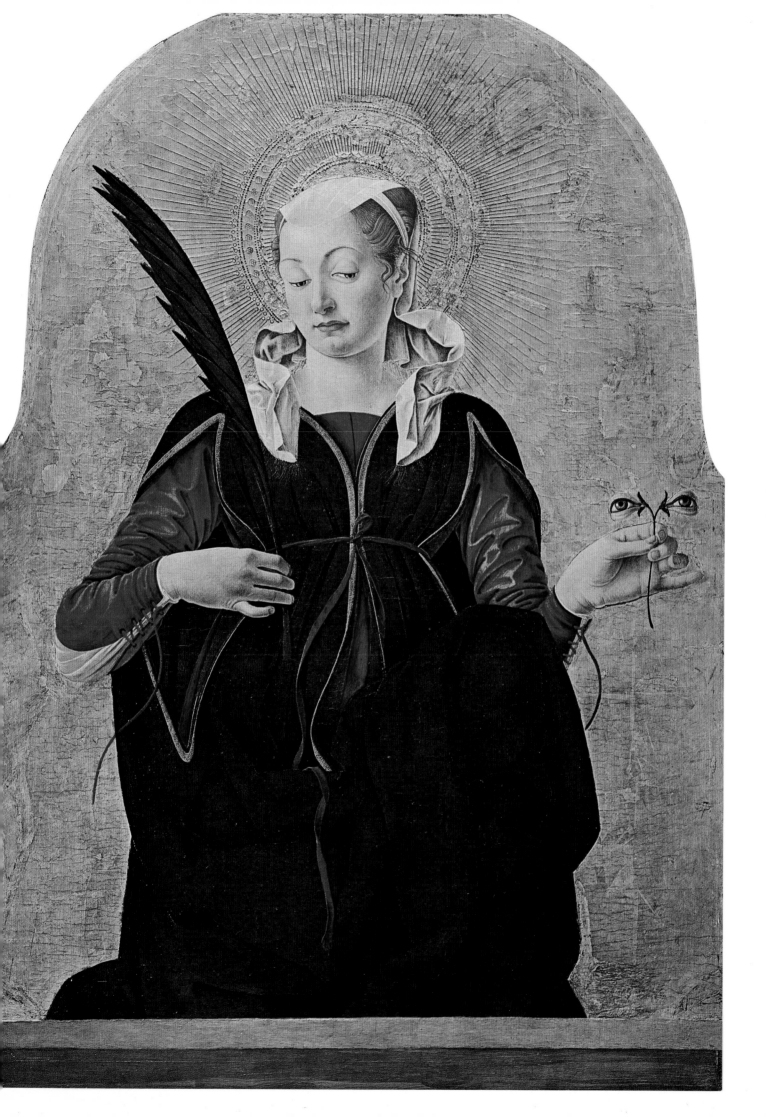

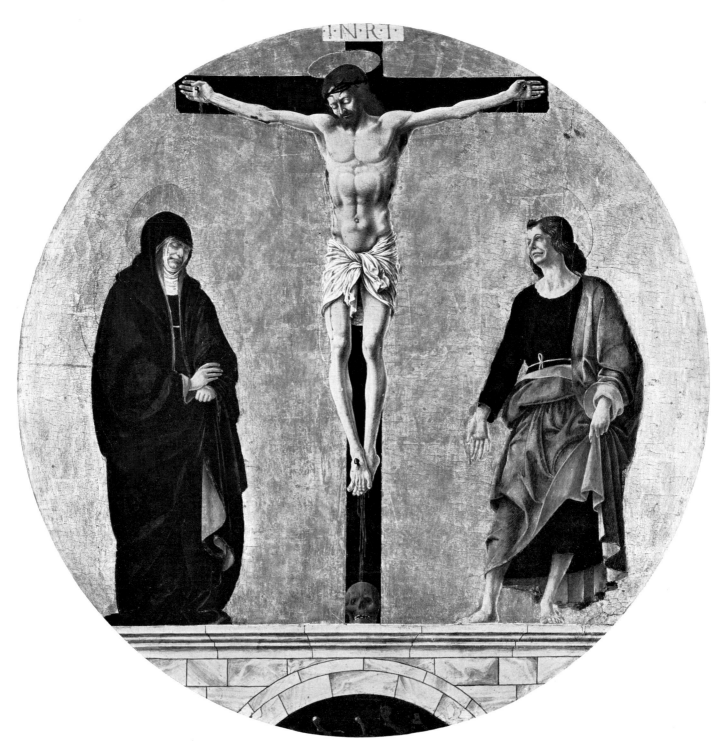

Fig. 224 (K 1361) Francesco del Cossa: *The Crucifixion*. Washington, D.C. (p. 84)

Fig. 225 (K 1373) Cosimo Tura: *Madonna and Child in a Garden*. Washington, D.C. (p. 81)

Figs. 226–229 (K 1429) Cosimo Tura: *The Annunciation with St. Francis and St. Maurelius.* Washington, D.C. (p. 82)

Fig. 231 (K 1245) Attributed to Baldassare d'Este: *Francesco II Gonzaga, Fourth Marquis of Mantua.*
Washington, D.C. (p. 83)

Fig. 230 (K 1082) Attributed to Cosimo Tura: *Portrait of a Man.* Washington, D.C. (p. 82)

Fig. 232 (K 408) Ercole Roberti: *Giovanni II Bentivoglio*. Washington, D.C. (p. 86)

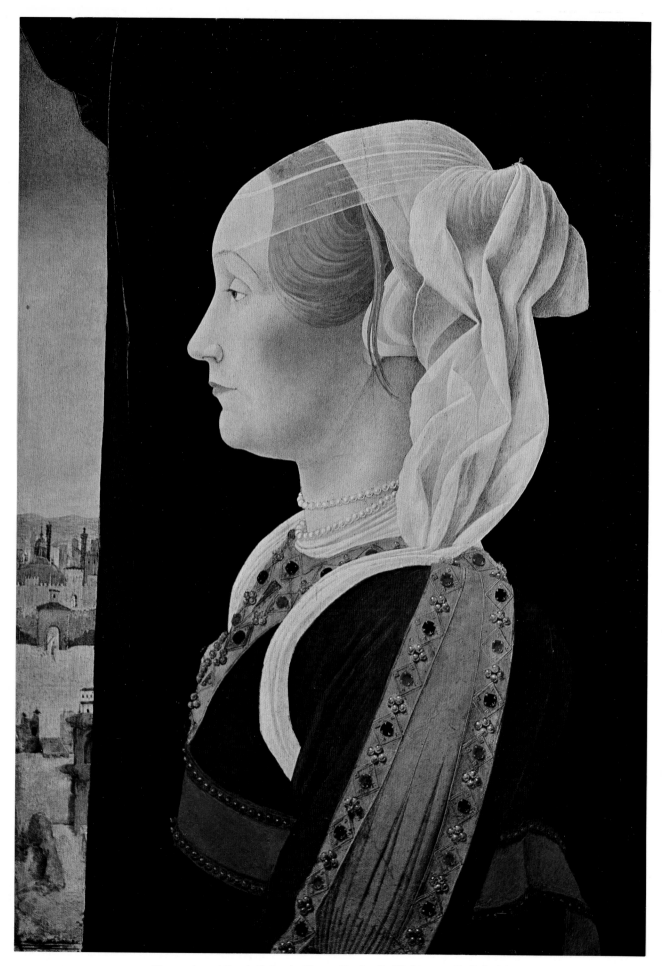

Fig. 233 (κ 409) Ercole Roberti: *Ginevra Bentivoglio*. Washington, D.C. (p. 86)

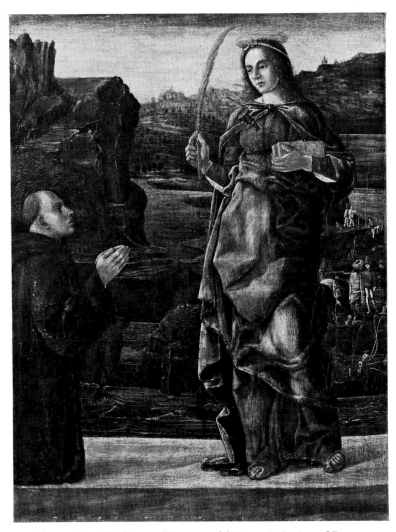

Fig. 234 (K 334) Follower of Francesco del Cossa: *St. Justina and Donor.*
Madison, Wis. (p. 85)

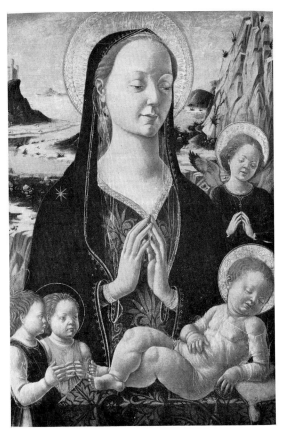

Fig. 235 (K 241) Attributed to Francesco del Cossa:
Madonna and Child with Angels. Washington, D.C. (p. 85)

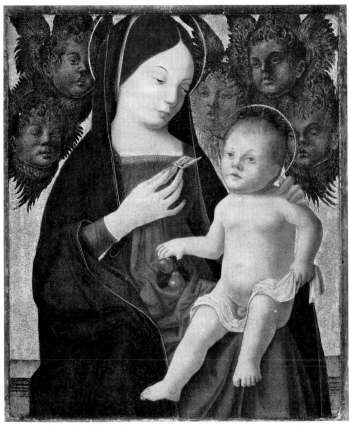

Fig. 236 (K 387) Ferrarese School, Late XV Century: *Madonna and Child.*
Lewisburg, Pa. (p. 86)

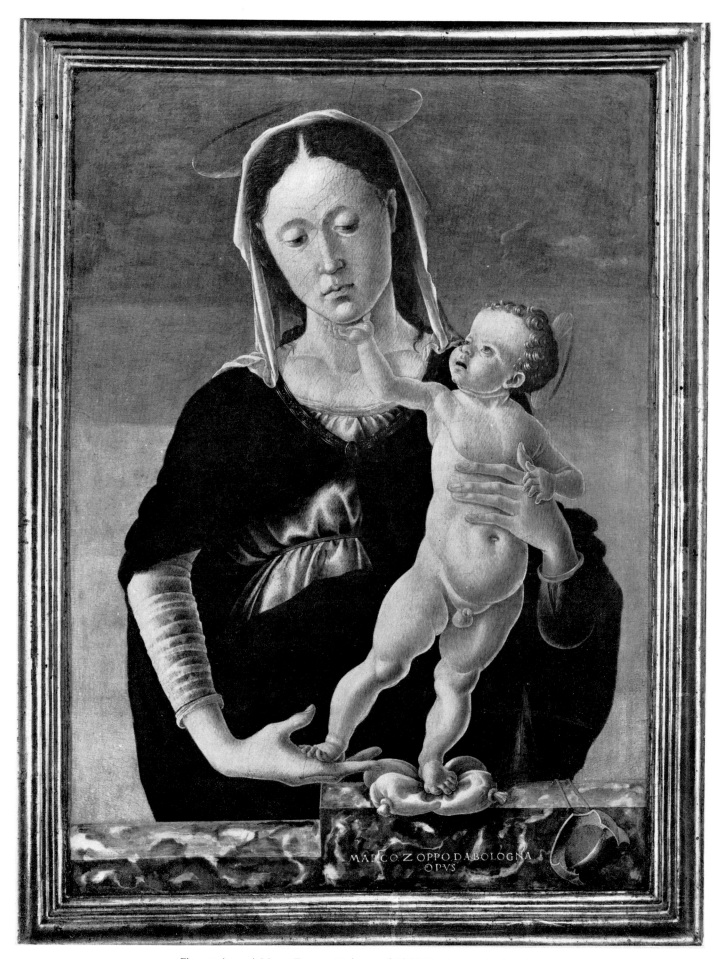

Fig. 237 (K 2033) Marco Zoppo: *Madonna and Child*. Washington, D.C. (p. 87)

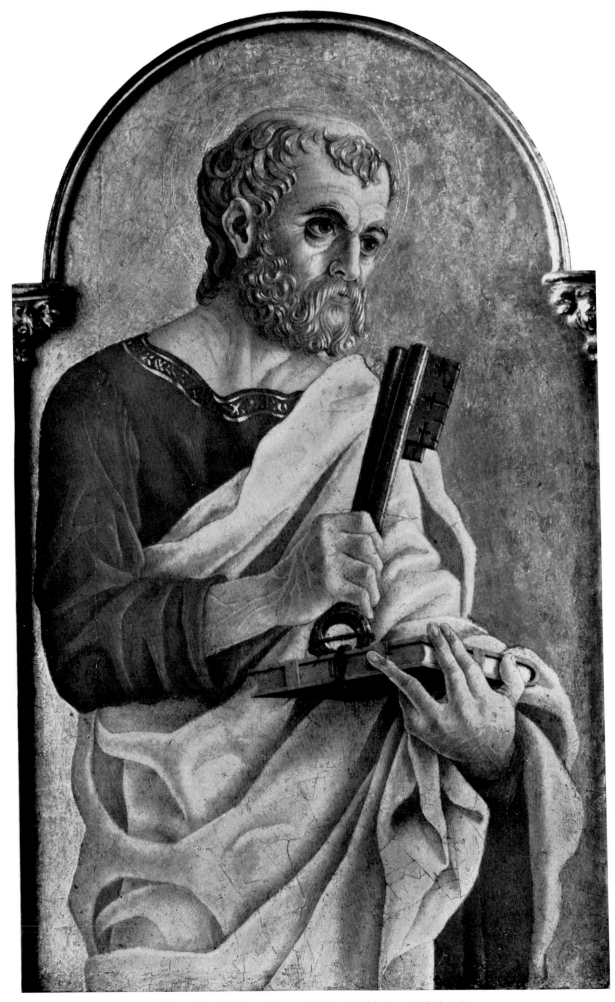

Fig. 238 (κ 489) Marco Zoppo: *St. Peter*. Washington, D.C. (p. 87)

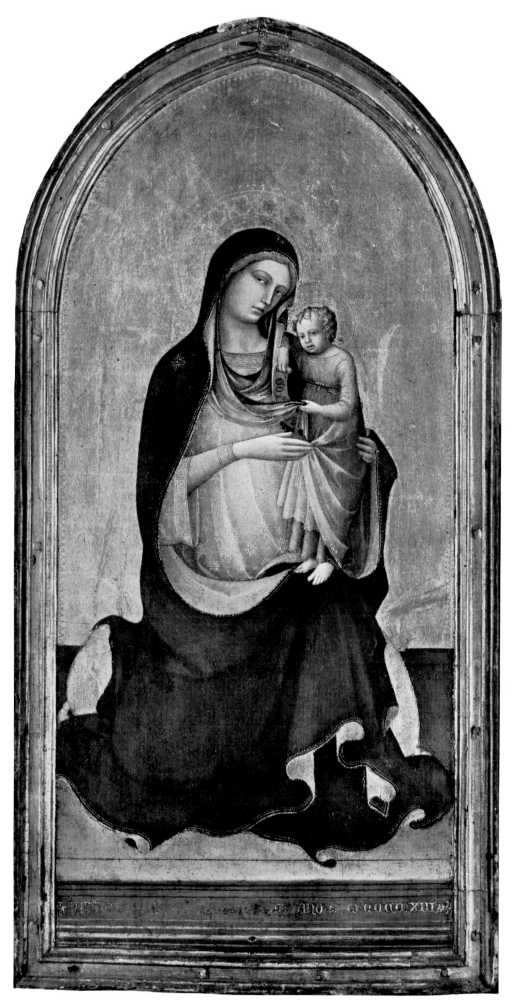

Fig. 239 (κ 1293) Lorenzo Monaco: *Madonna and Child*. Washington, D.C. (p. 89)

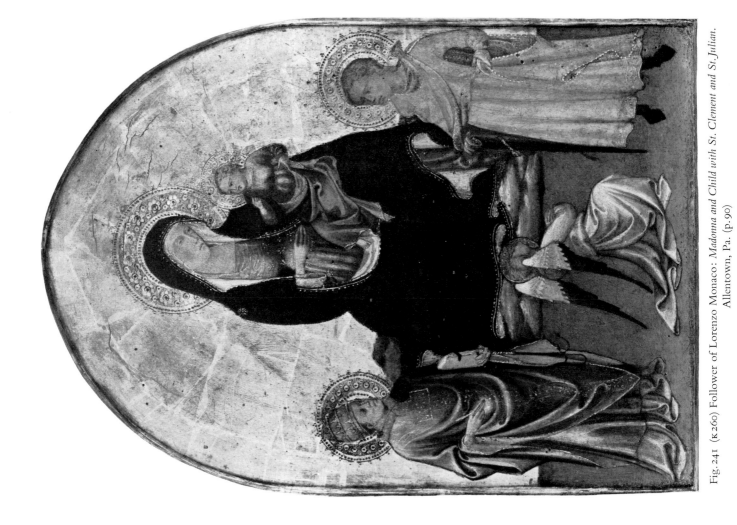

Fig. 241 (K 260) Follower of Lorenzo Monaco: *Madonna and Child with St. Clement and St. Julian.*
Allentown, Pa. (p. 90)

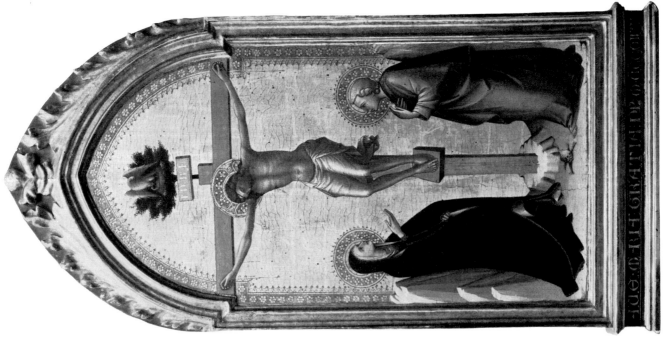

Fig. 240 (K 1654) Follower of Lorenzo Monaco: *The Crucifixion.*
Seattle, Wash. (p. 90)

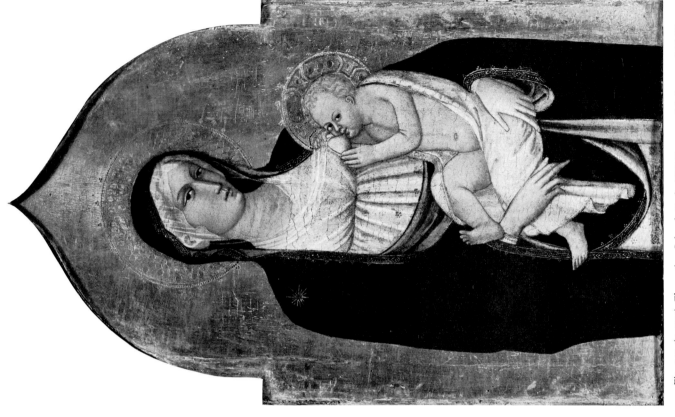

Fig. 243 (K 1072) Florentine School, Early XV Century: *Madonna and Child*.
Montgomery, Ala. (p. 91)

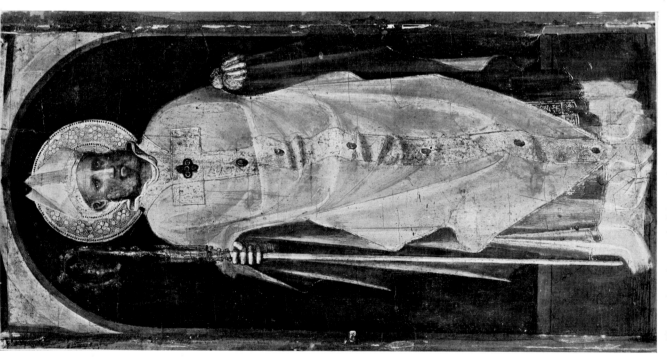

Fig. 242 (K 525) Master of the Bambino Vispo: *St. Nicholas of Bari*.
El Paso, Tex. (p. 90)

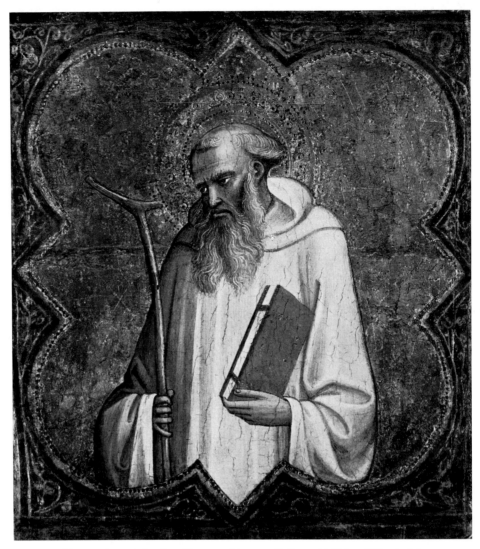

Fig. 244 (K 1047) Studio of Lorenzo Monaco: *St. Romuald*. Tulsa, Okla. (p. 89)

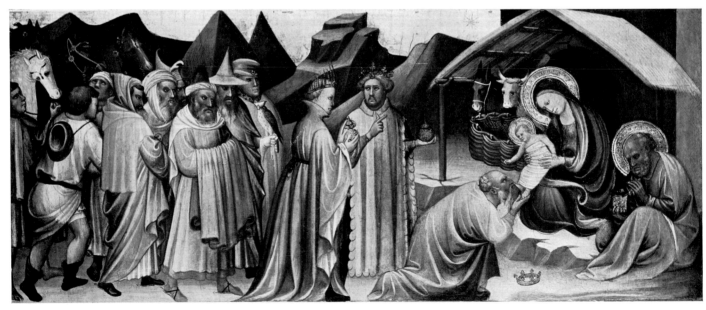

Fig. 245 (K 1135) Master of the Bambino Vispo: *The Adoration of the Magi*. Kansas City, Mo. (p. 91)

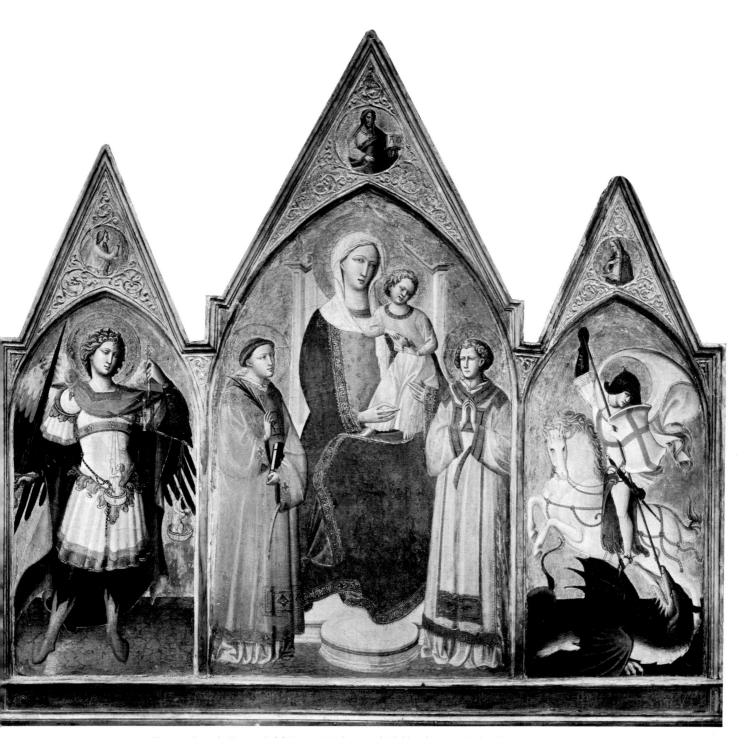

Fig. 246 (K 300) Giovanni dal Ponte: *Madonna and Child with Saints*. Columbia, S.C. (p. 92)

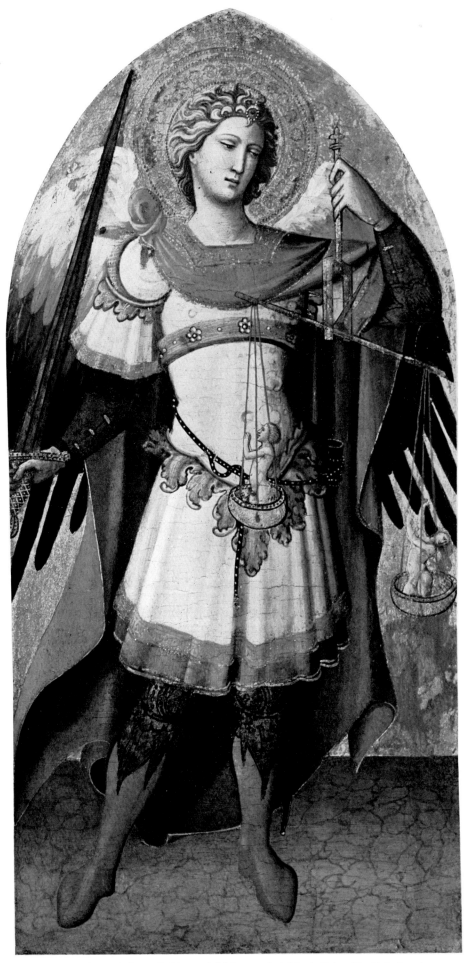

Fig. 247 (K 300, left panel) Giovanni dal Ponte: *St. Michael*. Columbia, S.C. (p. 92)

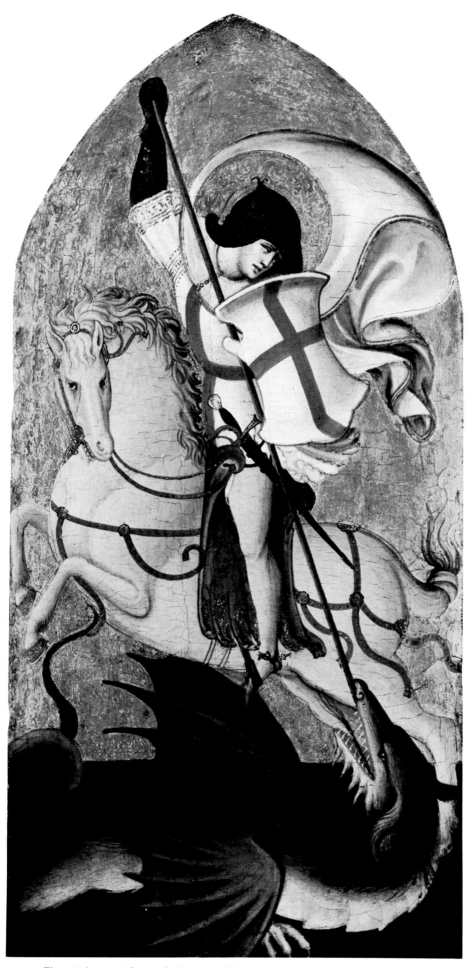

Fig. 248 (K 300, right panel) Giovanni dal Ponte: *St. George*. Columbia, S.C. (p. 92)

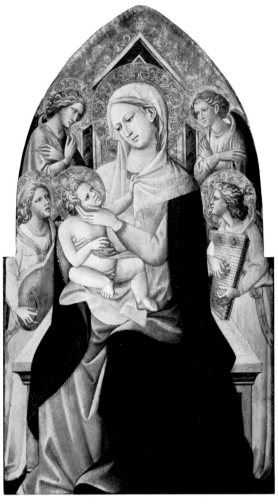

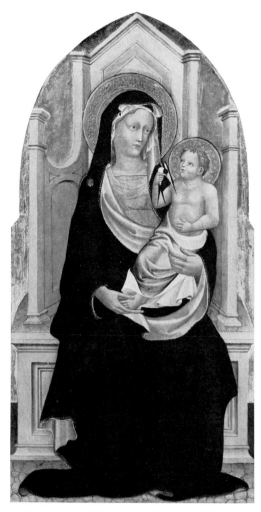

Fig. 249 (K 1556) Giovanni dal Ponte: *Madonna and Child with Angels*. San Francisco, Calif. (p. 92)

Fig. 250 (K 543) Francesco d'Antonio: *Madonna and Child*. Denver, Colo. (p. 92)

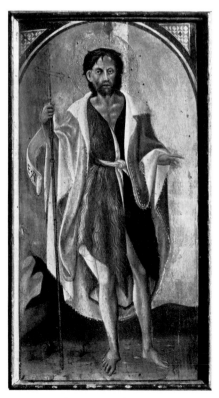

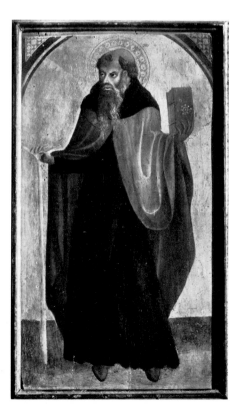

Figs. 251–252 (K 1015 A, B) Francesco d'Antonio: *St. John the Baptist; St. Anthony Abbot.*
Tucson, Ariz., St. Philip's in the Hills (p. 93)

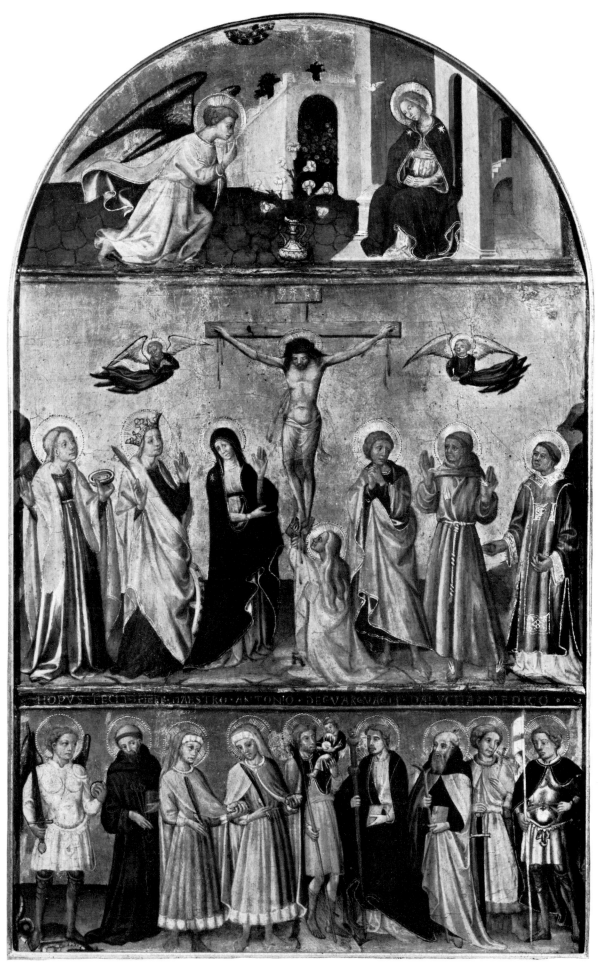

Fig. 253 (κ 1046) Francesco d'Antonio: *The Annunciation, the Crucifixion, and Saints*. Montgomery, Ala. (p. 93)

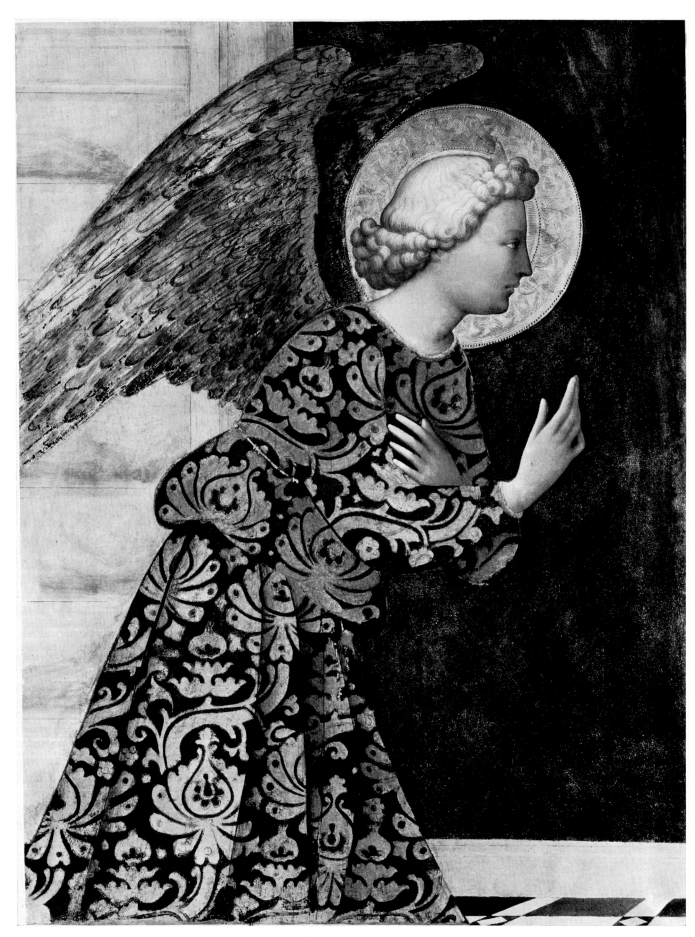

Fig. 254 (κ414) Masolino: *The Archangel Gabriel*. Washington, D.C. (p. 94)

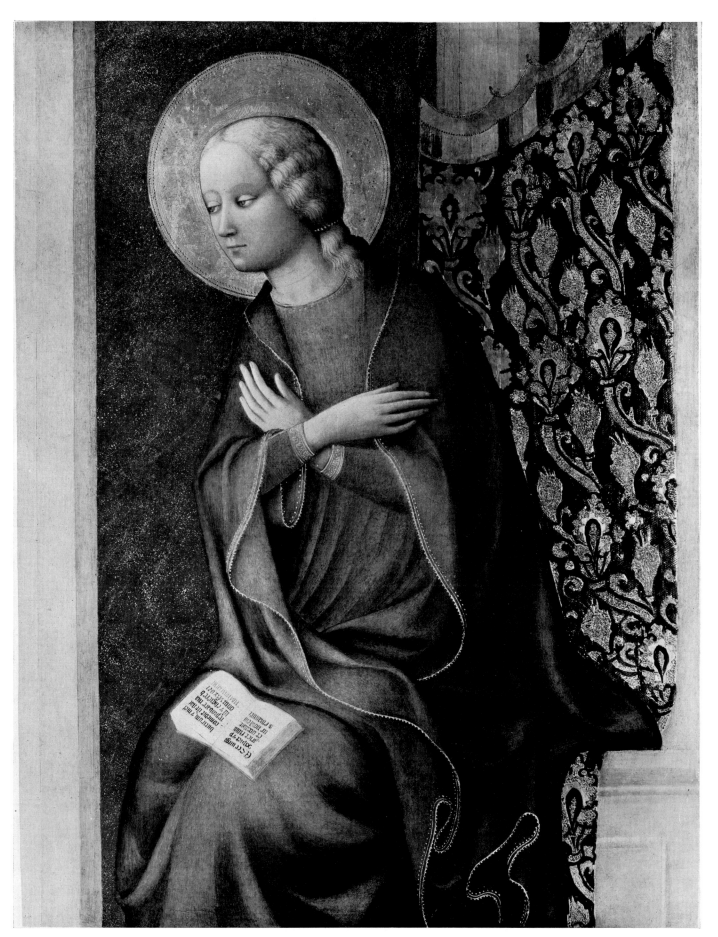

Fig. 255 (κ415) Masolino: *The Virgin Annunciate*. Washington, D.C. (p.94)

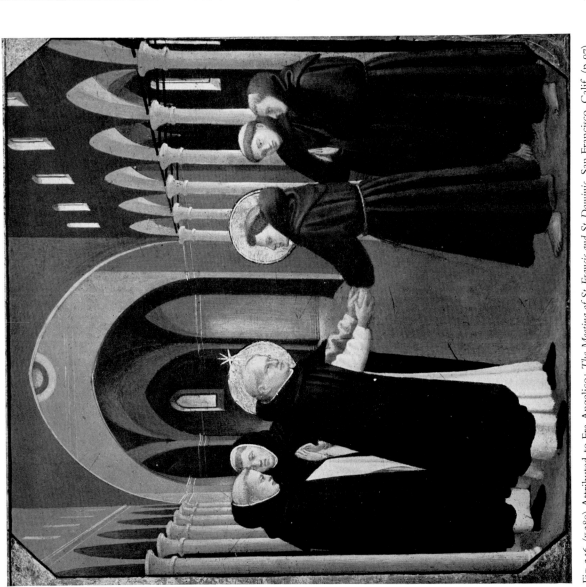

Fig. 256 (K 289) Attributed to Fra Angelico: *The Meeting of St. Francis and St. Dominic.* San Francisco, Calif. (p. 97)

Fig. 257 (K 477) Attributed to Fra Angelico: *The Entombment.* Washington, D.C. (p. 97)

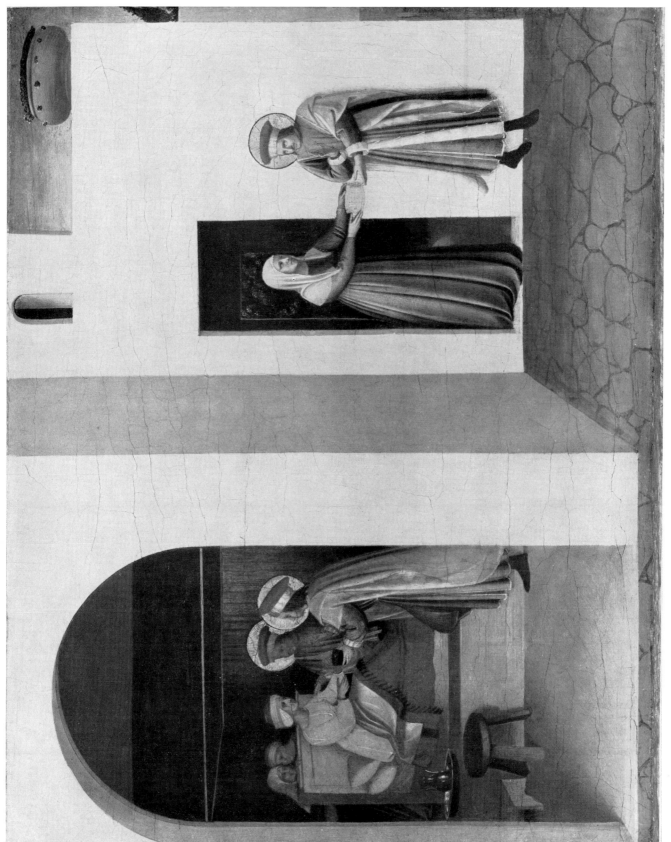

Fig. 258 (κ 1387) Fra Angelico: *The Healing of Palladia by St. Cosmas and St. Damian.* Washington, D.C. (p. 94)

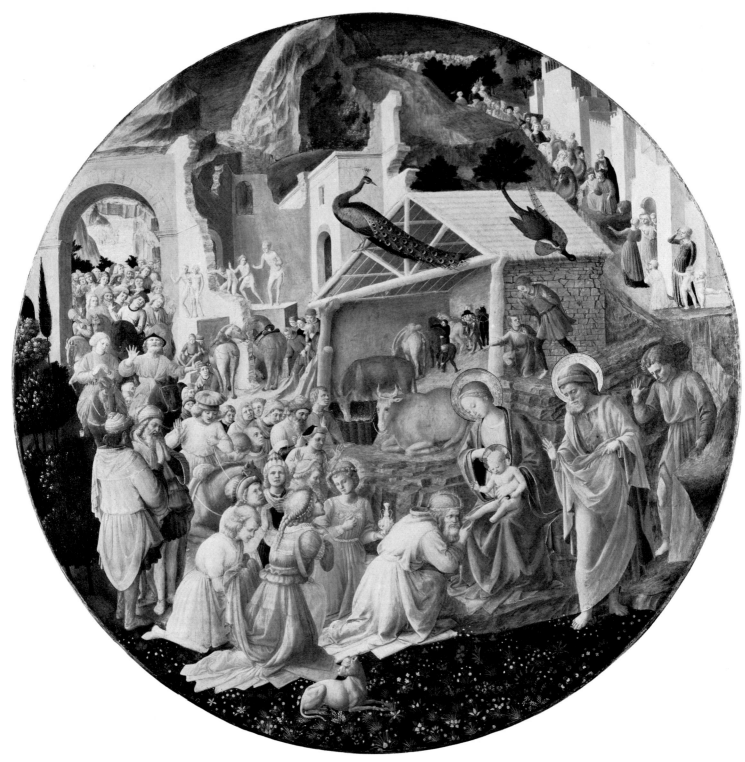

Fig. 259 (K 1425) Fra Angelico and Fra Filippo Lippi: *The Adoration of the Magi*. Washington, D.C. (p. 95)

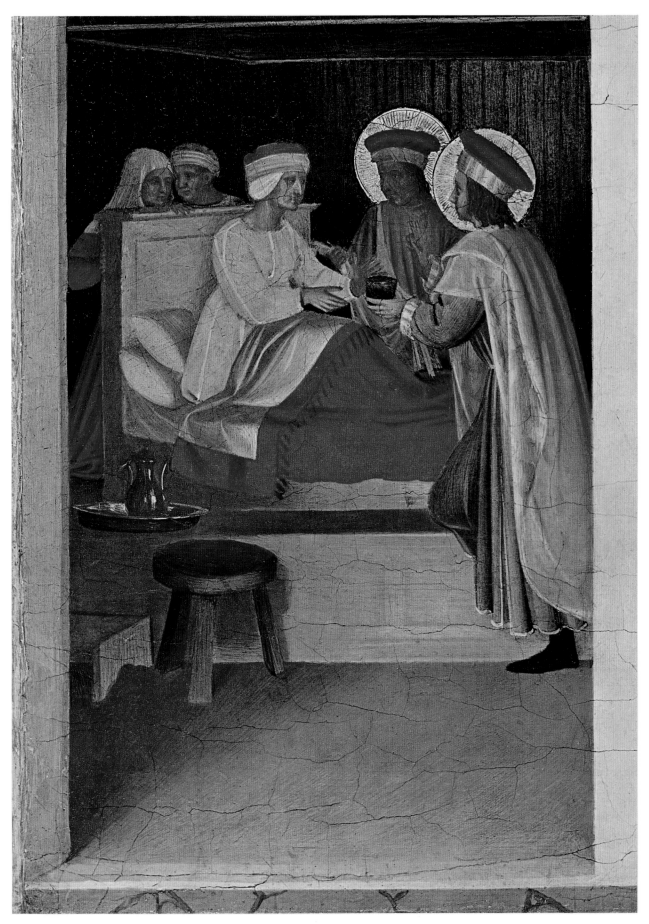

Fig. 262 Detail from Fig. 258

Fig. 263 (κ 491, reverse) Apollonio di Giovanni: *Two Putti.*
Raleigh, N.C. (p.98)

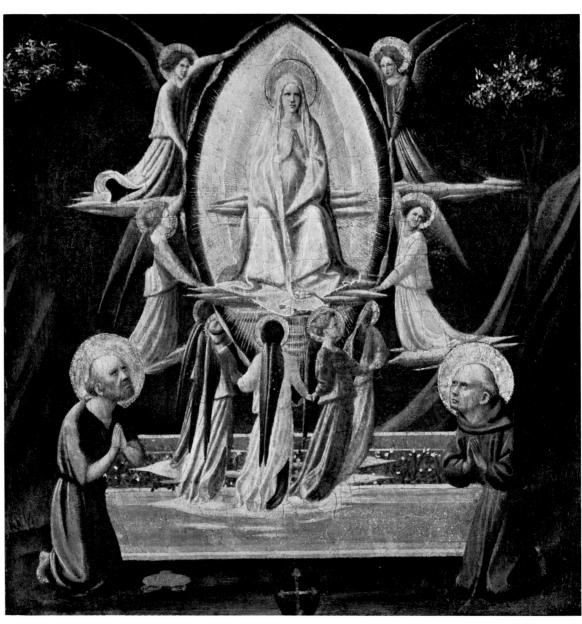

Fig. 264 (κ 234) Andrea di Giusto: *The Assumption of the Virgin with St. Jerome and St. Francis.* Tulsa, Okla. (p.98)

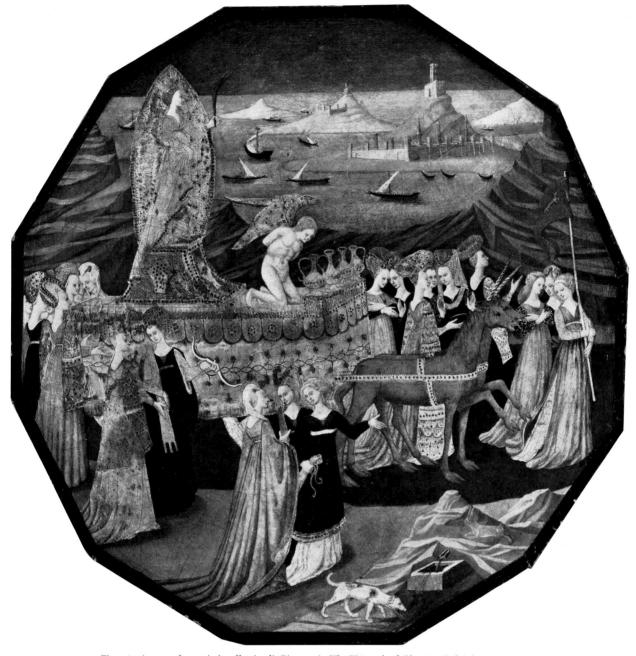

Fig. 265 (K491, obverse) Apollonio di Giovanni: *The Triumph of Chastity*. Raleigh, N.C. (p. 98)

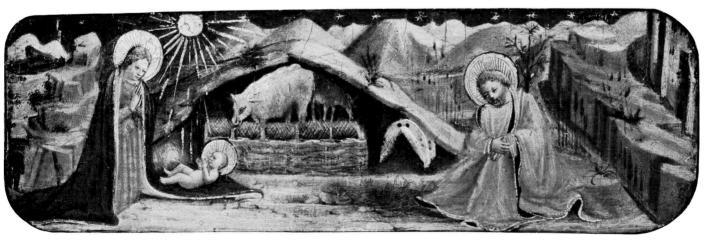

Fig. 266 (K420) Andrea di Giusto: *The Nativity*. Allentown, Pa. (p. 99)

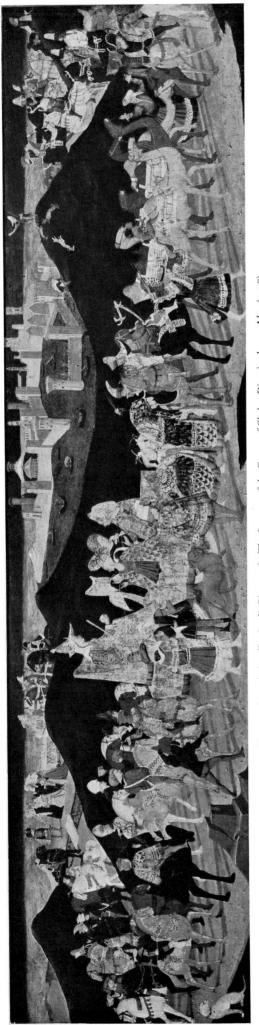

Fig. 267 (K251) Apollonio di Giovanni: *The Journey of the Queen of Sheba*. Birmingham, Ala. (p. 98)

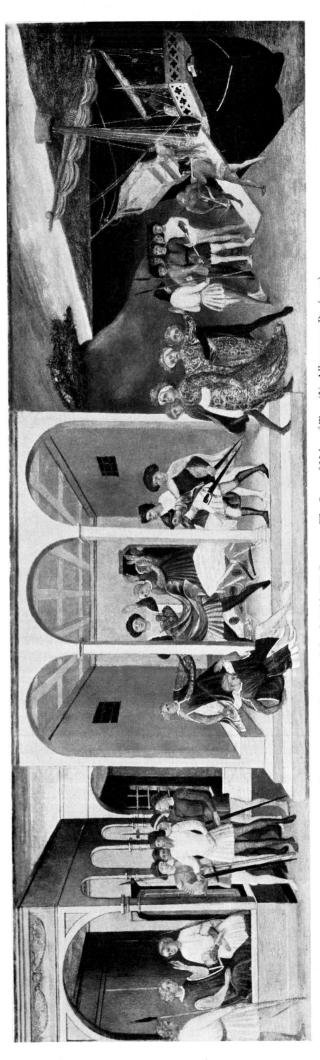

Fig. 268 (K103) Florentine School, Mid-XV Century: *The Story of Helen of Troy* (?). Allentown, Pa. (p. 99)

Fig. 269 (к 275) Circle of the Master of the Griggs Crucifixion: *Scenes from a Legend*. Brunswick, Me. (p. 100)

Fig. 270 (к 170) Master of the Griggs Crucifixion: *Scene in a Court of Love*. Madison, Wis. (p. 99)

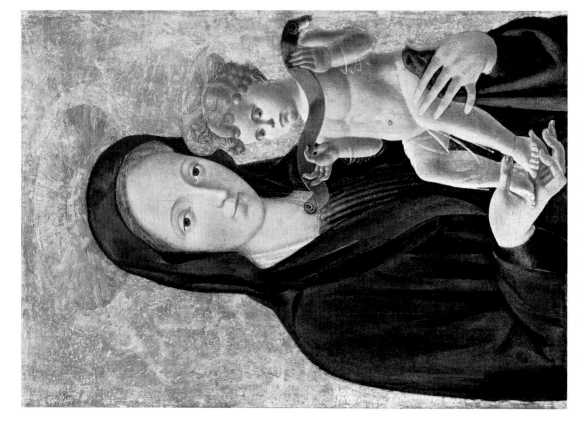

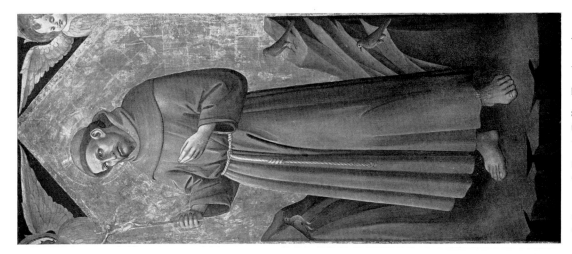

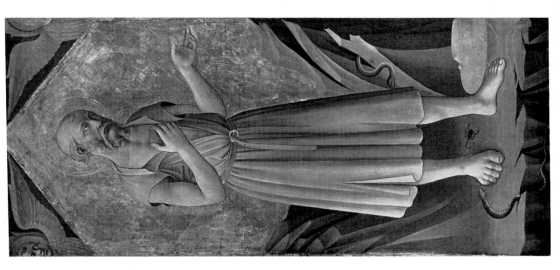

Fig. 273 (K 518) Attributed to Paolo Uccello: *Madonna and Child.* Raleigh, N.C. (p. 101)

Figs. 271–272 (K 159, K 158) Domenico di Michelino: *St. Jerome; St. Francis.* Dallas, Tex. (p. 101)

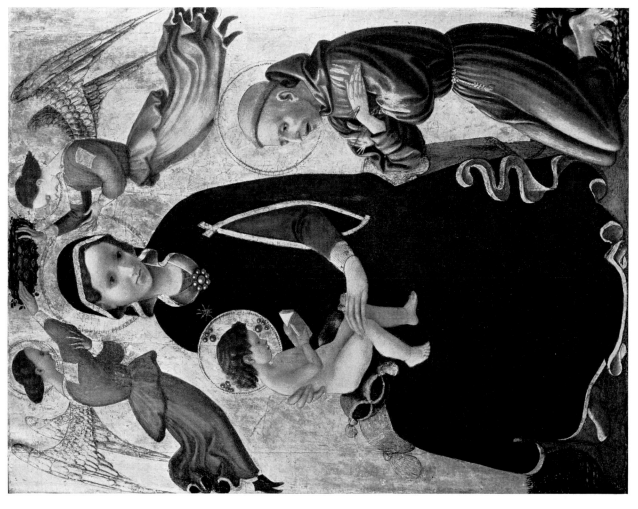

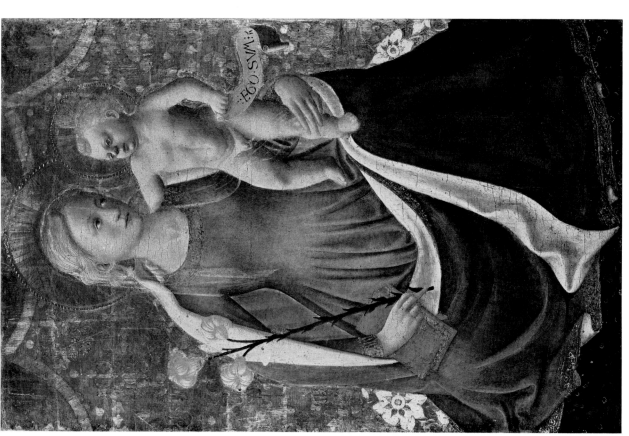

Fig. 275 (K 320) Follower of Paolo Uccello: *Madonna and Child with St. Francis.*
Allentown, Pa. (p. 102)

Fig. 274 (K 1720) Master of the Buckingham Palace Madonna: *The Madonna of Humility.*
Tucson, Ariz. (p. 100)

Fig. 276 Detail from Fig. 277

Fig. 277 (K 490) Follower of Paolo Uccello: *Episodes from the Myth of Theseus*. Seattle, Wash. (p. 102)

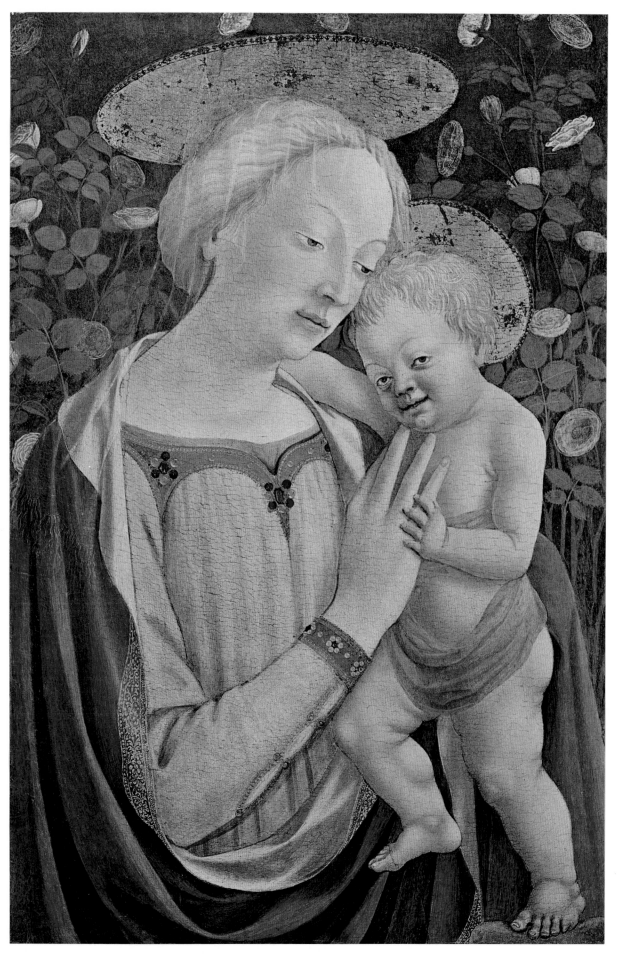

Fig. 278 (K410) Domenico Veneziano: *Madonna and Child*. Washington, D.C. (p. 103)

Fig. 279 (K 278) Domenico Veneziano: *St. Francis Receiving the Stigmata*. Washington, D.C. (p. 103)

Fig. 280 (K 1331) Domenico Veneziano: *St. John in the Desert*. Washington, D.C. (p. 103)

Fig. 282 (ĸ 1188) Paolo Schiavo: *The Crucifixion*. Athens, Ga. (p. 105)

Fig. 281 (ĸ 216) Paolo Schiavo: *The Flagellation*. Ponce, Puerto Rico. (p. 105)

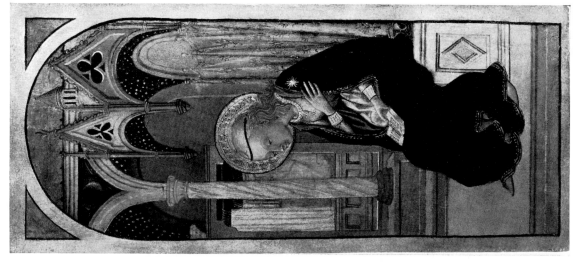

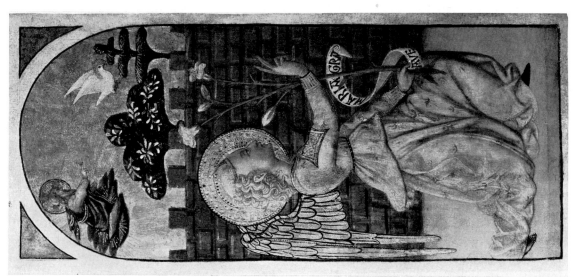

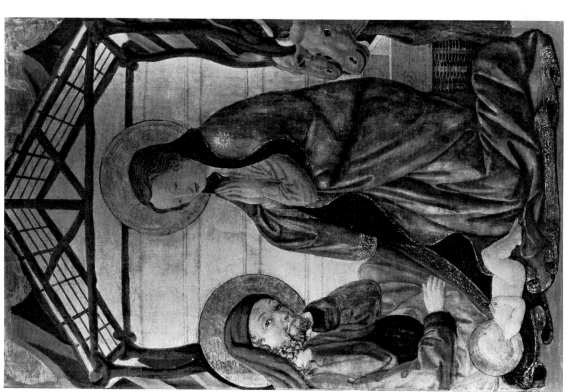

Fig. 283 (K 1128) Giovanni di Francesco: *The Nativity*. Berea, Ky. (p. 104)

Figs. 284–285 (K 1145 A, B) Master of Fucecchio: *The Annunciation*. Seattle, Wash. (p. 105)

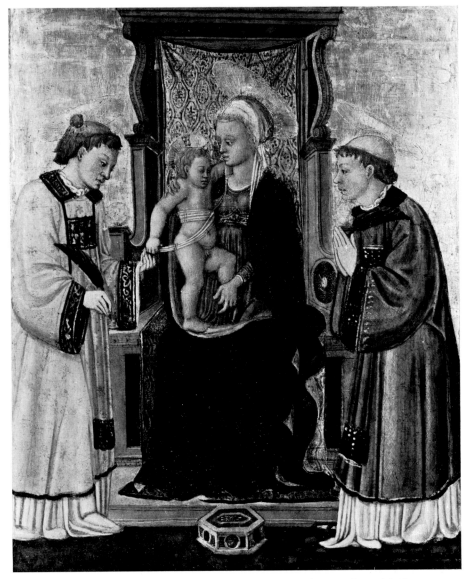

Fig. 286 (κ 1148) Master of Fucecchio: *Madonna and Child with St. Stephen and St. Lawrence.*
Lewisburg, Pa. (p. 106)

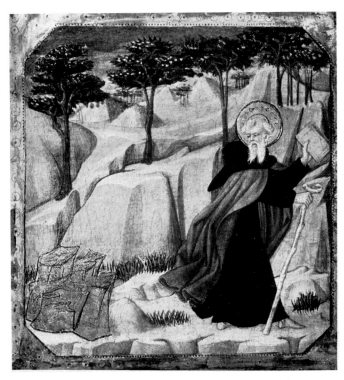

Figs. 287–288 (κ 1108 A, B) Master of Fucecchio: *St. Anthony Abbot Tempted by Gold; St. Bernardine of Siena Preaching.* Birmingham, Ala. (p. 106)

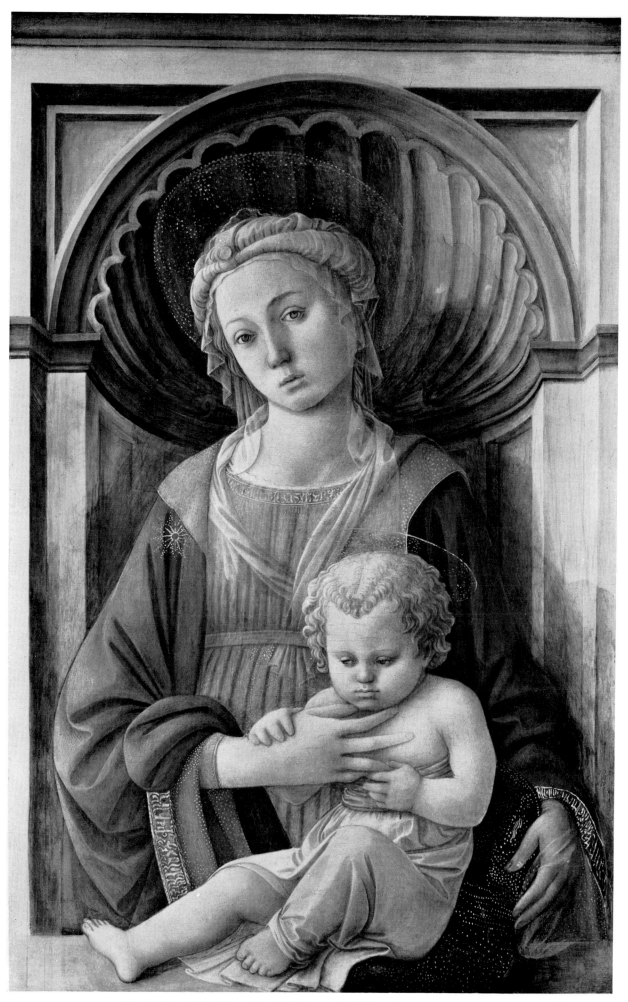

Fig. 289 (κ 510) Fra Filippo Lippi: *Madonna and Child*. Washington, D.C. (p. 106)

Fig. 290 (K 1342) Fra Filippo Lippi: *St. Benedict Orders St. Maurus to the Rescue of St. Placidus.* Washington, D.C. (p. 107)

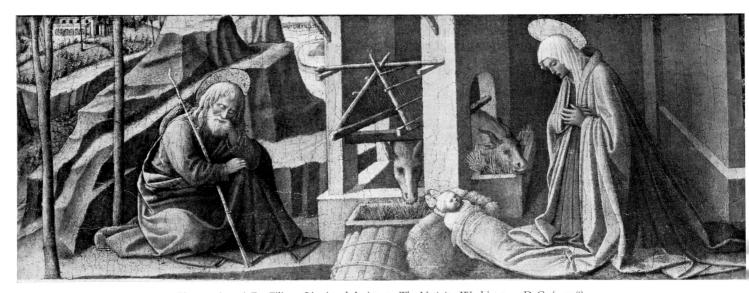

Fig. 291 (K 497) Fra Filippo Lippi and Assistant: *The Nativity.* Washington, D.C. (p. 108)

Fig. 292 Detail from Fig. 290

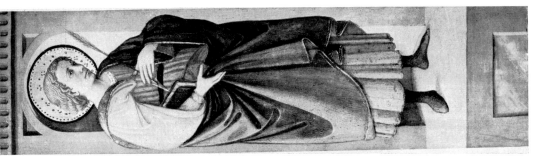

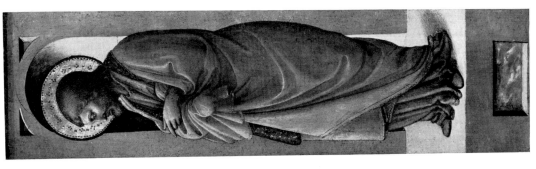

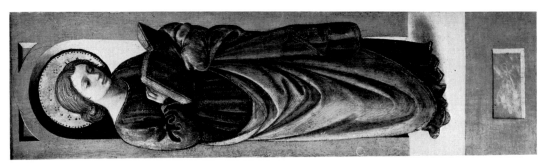

Figs. 297–298 (K 503 A, B) Fra Diamante: *Two Saints*. Athens, Ga. (p. 109)

Figs. 293–296 (K 441 A, B, C, D) Fra Diamante: *Four Saints*. Honolulu, Hawaii (p. 109)

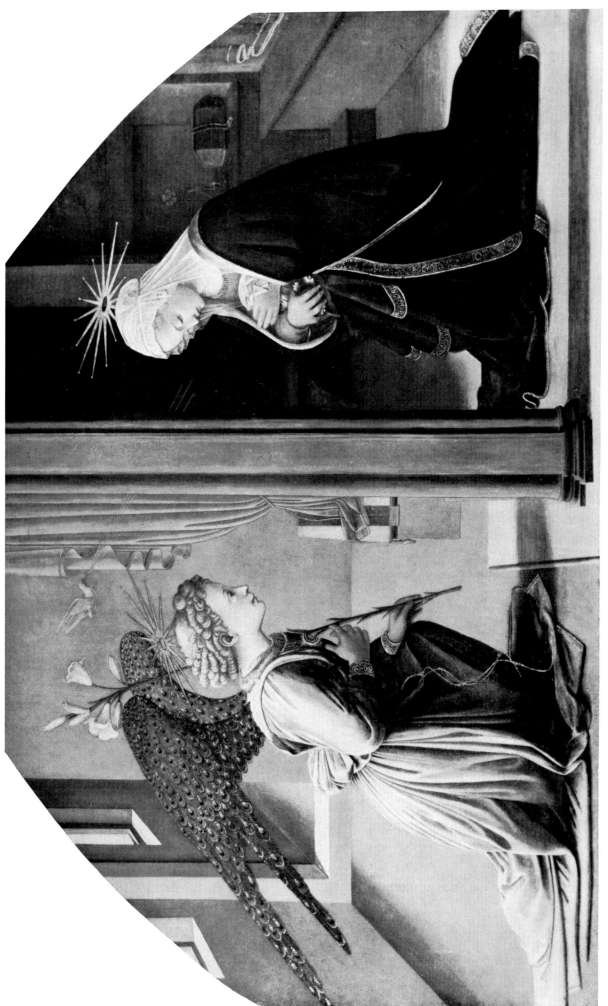

Fig. 299 (K 1241) Fra Filippo Lippi: *The Annunciation*. Washington, D.C. (p. 107)

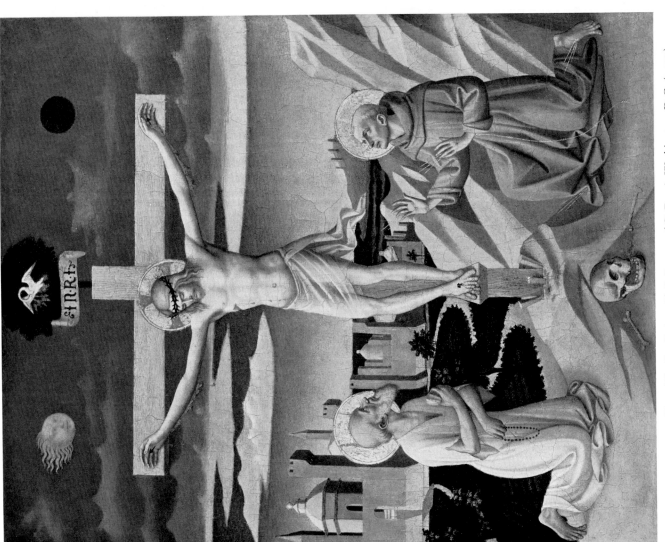

Fig. 301 (κ485) Pesellino: *Madonna and Child.* Denver, Colo. (p. 110)

Fig. 300 (κ230) Pesellino: *The Crucifixion with St. Jerome and St. Francis.* Washington, D.C. (p. 110)

Fig. 302 (κ 540) Pesellino and Studio: *The Seven Liberal Arts.* Birmingham, Ala. (p. 110)

Fig. 303 (κ 541) Pesellino and Studio: *The Seven Virtues.* Birmingham, Ala. (p. 110)

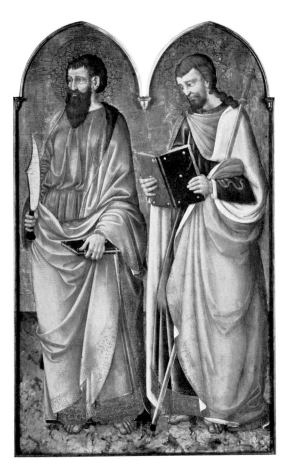

Fig. 304 (K 1325) Follower of Fra Filippo Lippi:
Madonna and Child Enthroned.
New Orleans, La. (p. 108)

Fig. 305 (K 1143) Neri di Bicci: *St. Bartholomew and
St. James Major.* Lawrence, Kans. (p. 113)

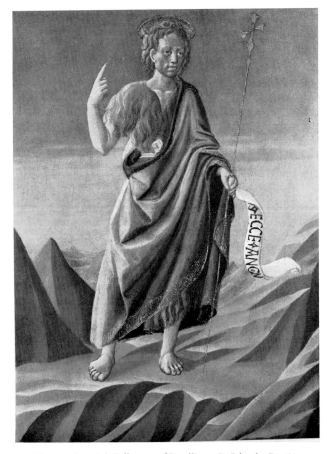

Fig. 306 (K 528) Follower of Pesellino: *Madonna and Child
with Angels.* Berea, Ky. (p. 111)

Fig. 307 (K 1187) Follower of Pesellino: *St. John the Baptist.*
Bloomington, Ind. (p. 111)

Fig. 308 (K 1728) Neri di Bicci: *St. Anthony Abbot*. Denver, Colo. (p. 113)

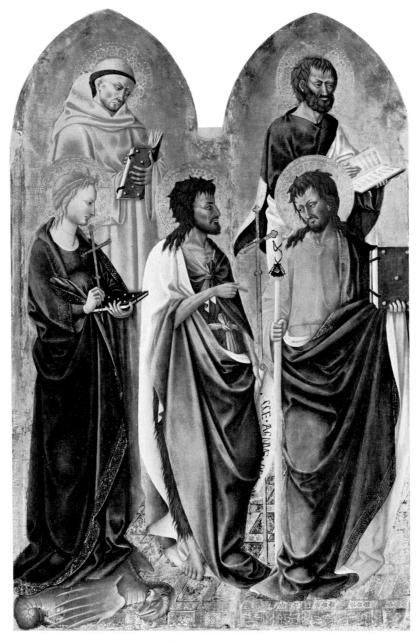

Fig. 309 (K254) Neri di Bicci: *Five Saints*. Oberlin, Ohio (p. 112)

Fig. 310 (K1003) Neri di Bicci: *The Martyrdom of St. Apollonia*. Claremont, Calif. (p. 113)

Fig. 311 (K 1334) Style of Alesso Baldovinetti: *The Annunciation*.
Notre Dame, Ind. (p. 114)

Fig. 312 (K 402) Pier Francesco Fiorentino: *Madonna and Child*.
Washington, D.C. (p. 114)

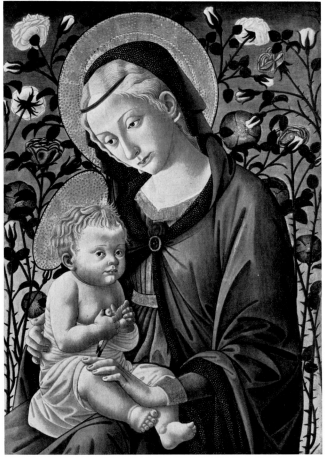

Fig. 313 (K 321) Pseudo Pier Francesco Fiorentino: *Madonna and Child*.
Tulsa, Okla. (p. 115)

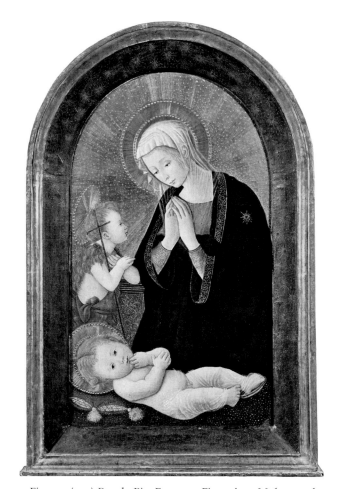

Fig. 314 (K 57) Pseudo Pier Francesco Fiorentino: *Madonna and
Child*. New York, Samuel H. Kress Foundation (p. 115)

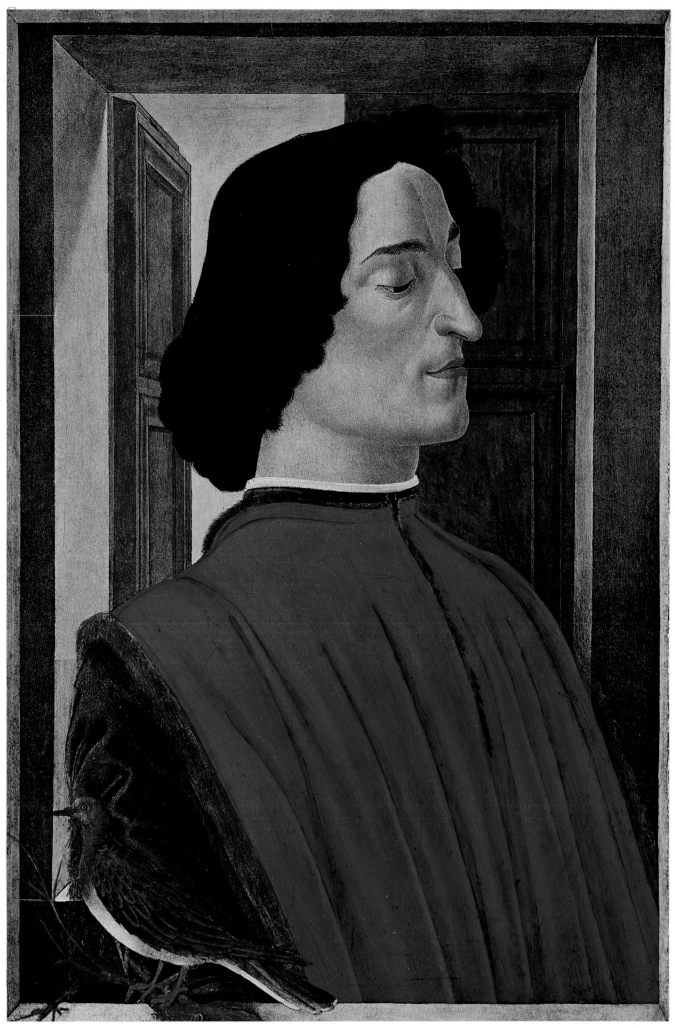

Fig. 335 (K 1644) Botticelli: *Giuliano de'Medici*. Washington, D.C. (p. 121)

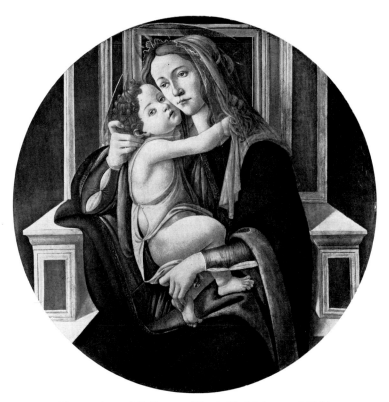

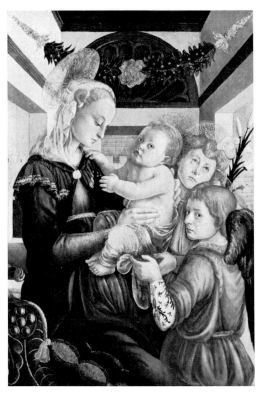

Fig. 336 (K 1240) Follower of Botticelli: *Madonna and Child.*
El Paso, Tex. (p. 124)

Fig. 337 (K 1311) Attributed to Botticelli: *Madonna and Child with Angels.* Washington, D.C. (p. 123)

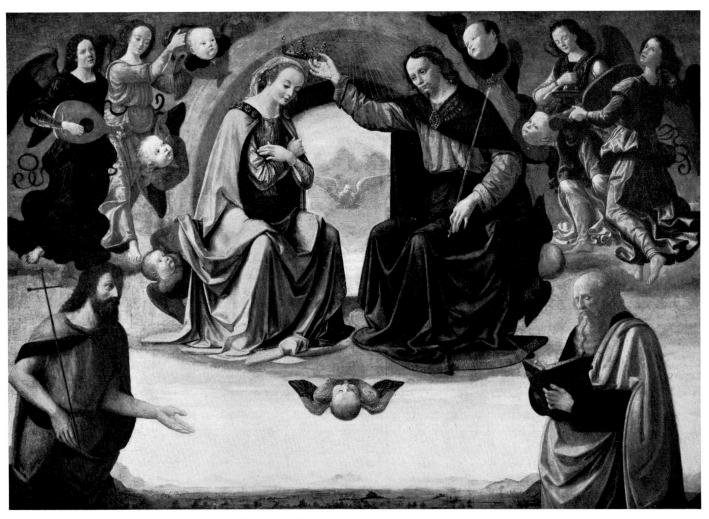

Fig. 338 (K 1726) Studio of Domenico Ghirlandaio: *The Coronation of the Virgin.* Denver, Colo. (p. 126)

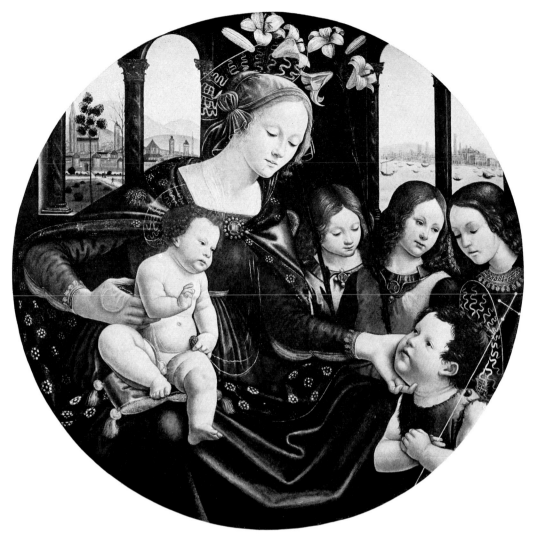

Fig. 339 (K 267) Follower of Domenico Ghirlandaio: *Madonna and Child with St. John and Angels.*
Birmingham, Ala. (p. 127)

Fig. 340 (K 1147) Studio of Domenico Ghirlandaio:
Madonna and Child. Hartford, Conn. (p. 126)

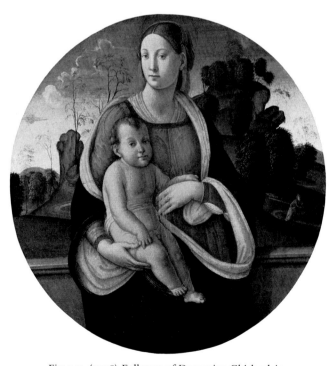

Fig. 341 (K 298) Follower of Domenico Ghirlandaio:
Madonna and Child. Charlotte, N.C. (p. 126)

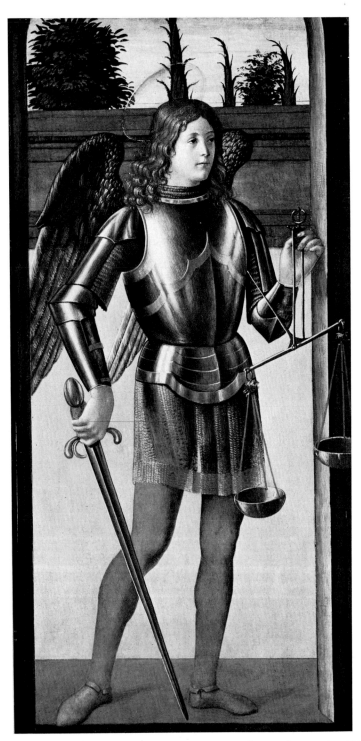
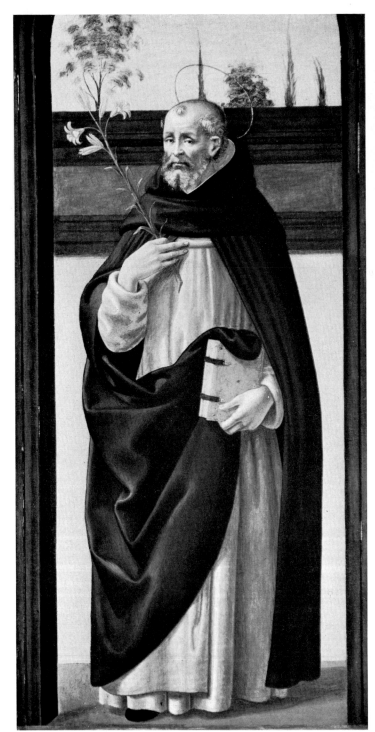

Figs. 342–343 (K 487 B, A) Follower of Domenico Ghirlandaio: *St. Michael; St. Dominic.* Portland, Ore. (p. 127)

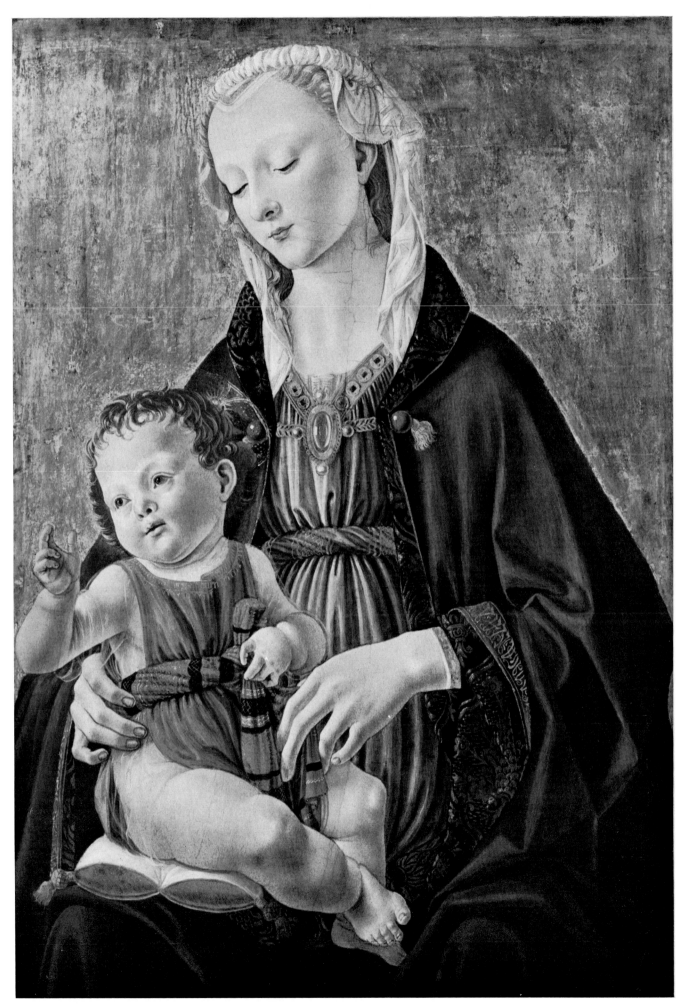

Fig. 344 (K 2076) Domenico Ghirlandaio: *Madonna and Child*. Washington, D.C. (p. 125)

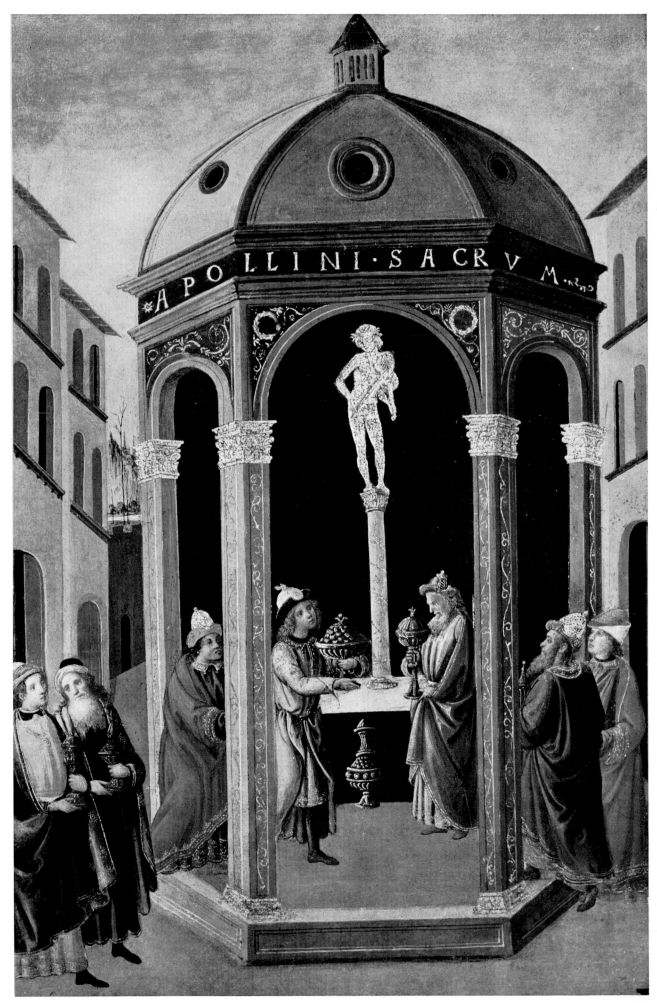

Fig. 345 (K 77) Master of the 'Apollini Sacrum': *A Tribute to Apollo*. Atlanta, Ga. (p. 128)

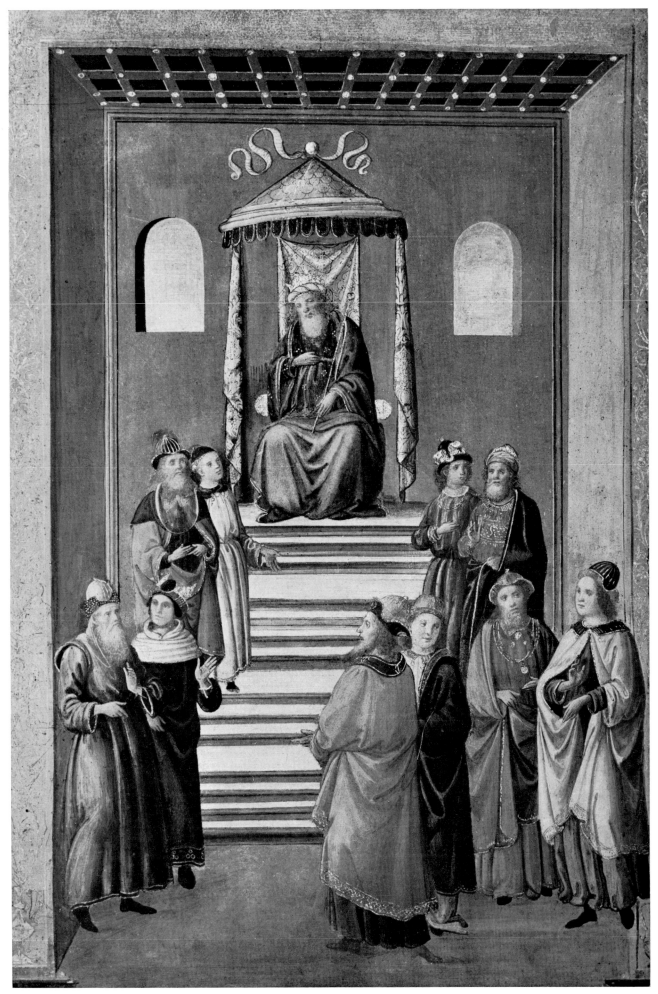

Fig. 346 (K 79) Master of the 'Apollini Sacrum': *A King with His Counselors*. Atlanta, Ga. (p. 128)

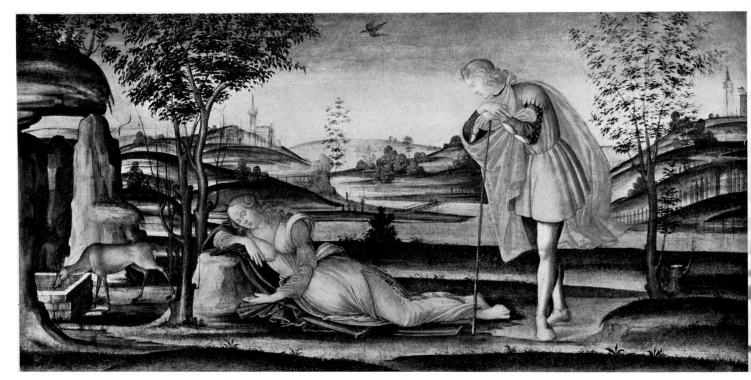

Fig. 347 (K1721A) Master of the Apollo and Daphne Legend: *Daphne Found Asleep by Apollo*. New York, Samuel H. Kress Foundation (p. 129)

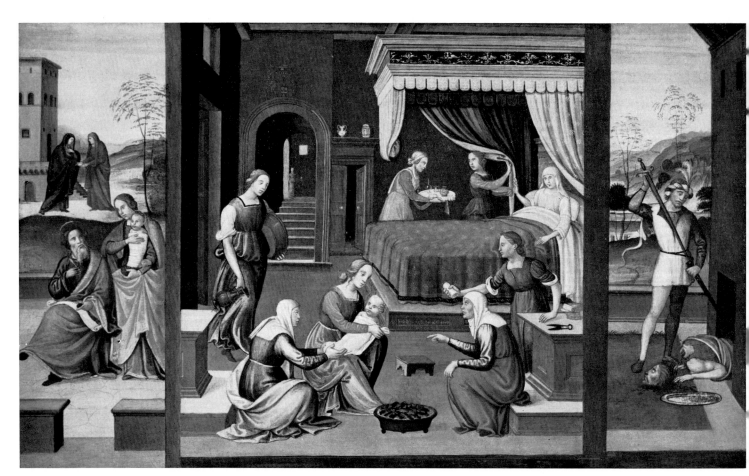

Fig. 348 (K1152A) Master of the Apollo and Daphne Legend: *The Birth of St. John the Baptist*. Washington, D.C., Howard University (p. 130)

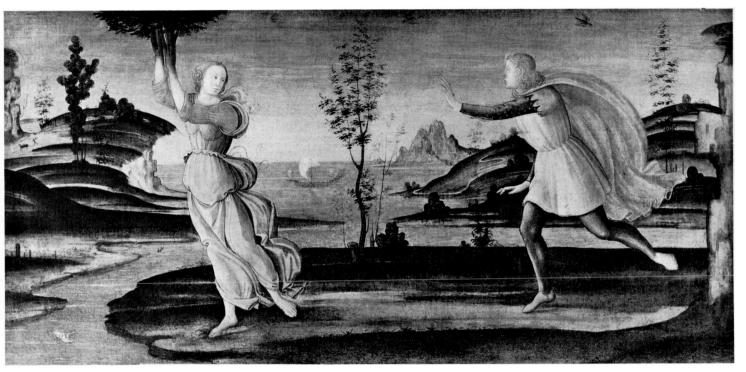

Fig. 349 (K 1721B) Master of the Apollo and Daphne Legend: *Daphne Fleeing from Apollo*. New York, Samuel H. Kress Foundation (p. 129)

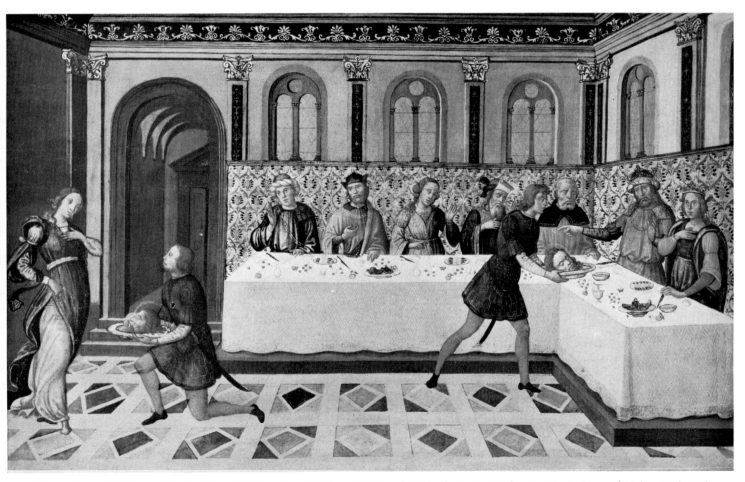

Fig. 350 (K 1152 B) Master of the Apollo and Daphne Legend: *The Martyrdom of St. John the Baptist*. Washington, D.C., Howard University (p. 130)

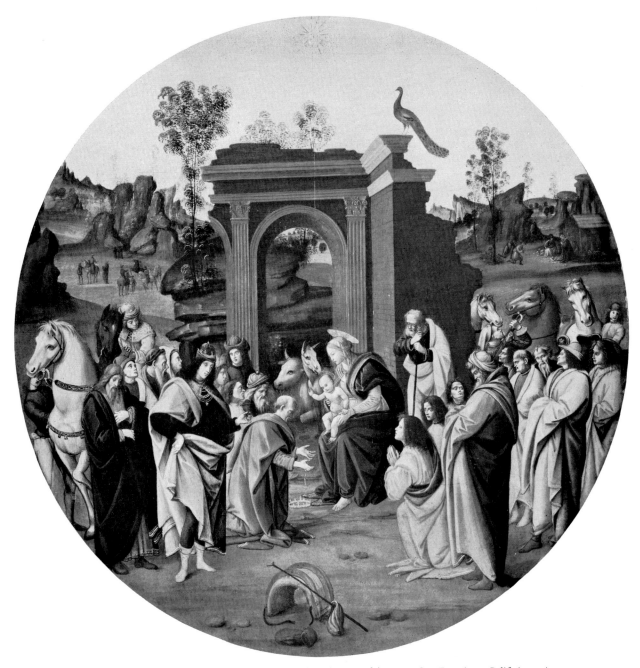

Fig. 351 (K 363) Bartolommeo di Giovanni: *The Adoration of the Magi*. San Francisco, Calif. (p. 129)

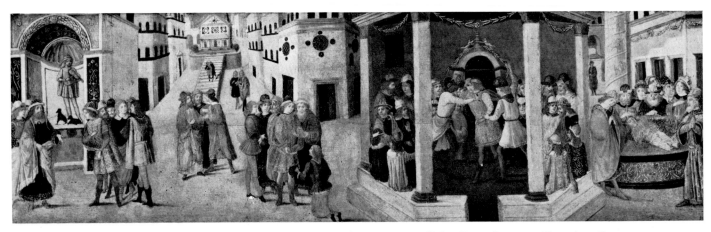

Fig. 352 (K 1929) Master of the 'Apollini Sacrum': *The Assassination of Julius Caesar*. Lawrence, Kans. (p. 128)

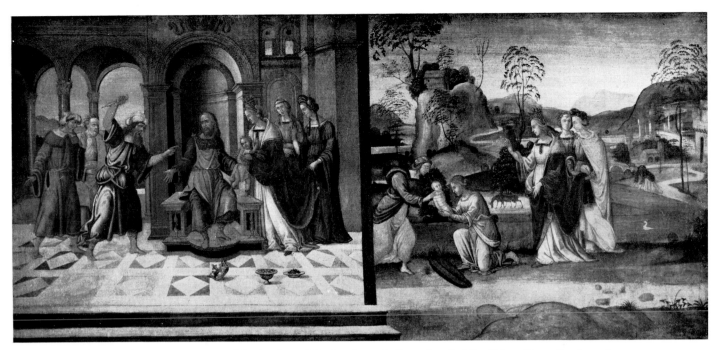

Fig. 353 (K 1616) Master of the Apollo and Daphne Legend: *Scenes from the Life of Moses*. Berea, Ky. (p. 130)

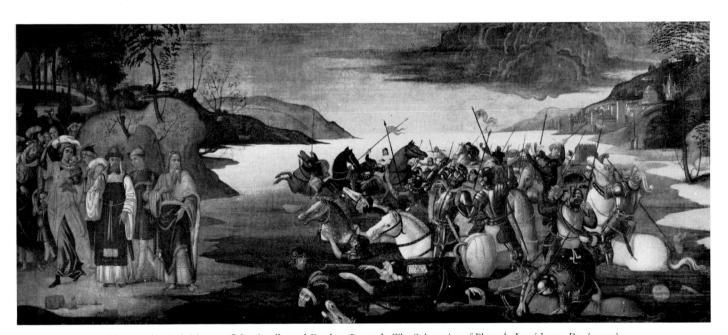

Fig. 354 (K 1617) Master of the Apollo and Daphne Legend: *The Submersion of Pharaoh*. Lewisburg, Pa. (p. 130)

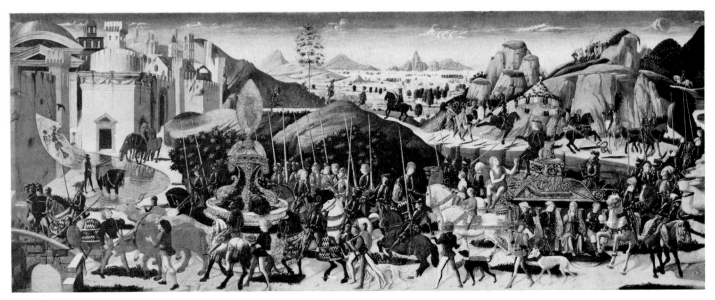

Fig. 355 (K 299) Biagio d'Antonio da Firenze: *The Triumph of Scipio Africanus*. Washington, D.C. (p. 132)

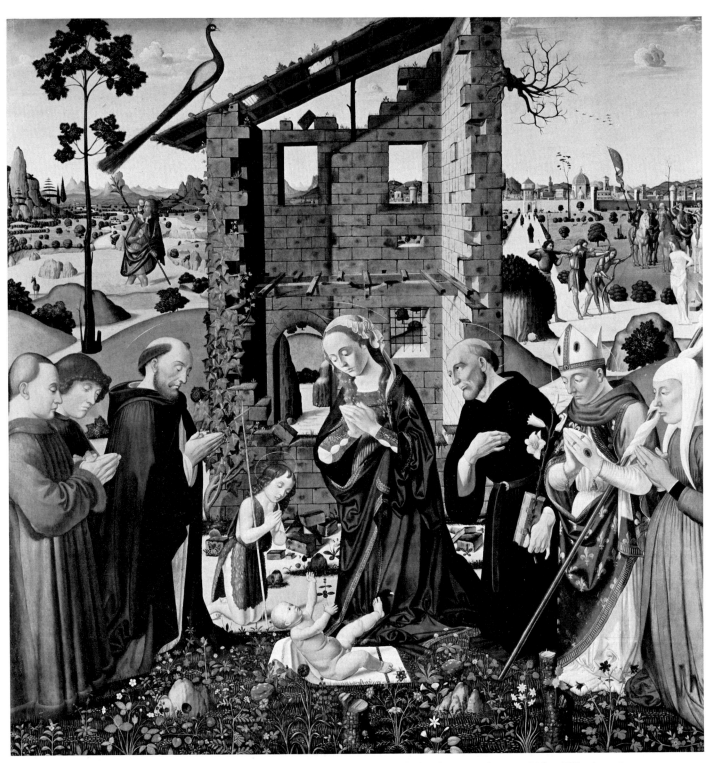

Fig. 356 (K 1088) Biagio d'Antonio da Firenze: *The Adoration of the Child with Saints and Donors*. Tulsa, Okla. (p. 131)

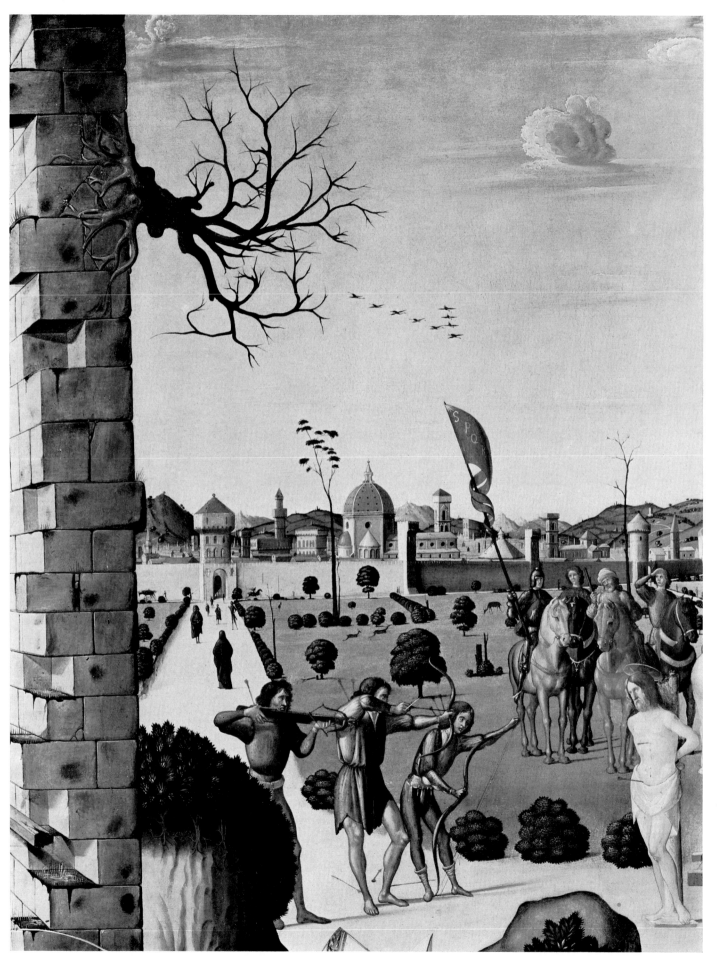

Fig. 357 Detail from Fig. 356

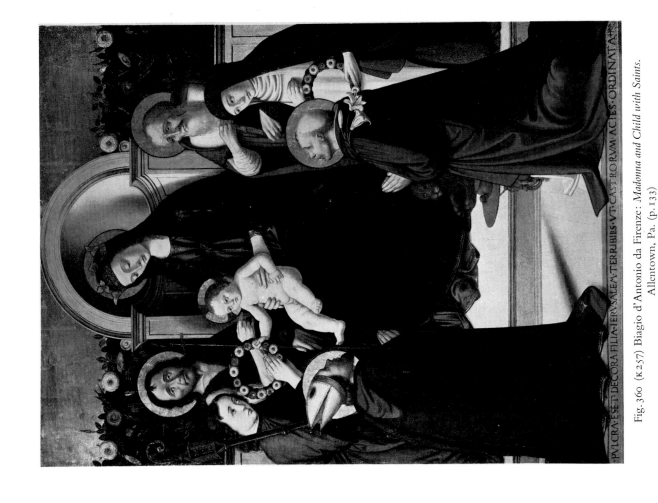

Fig. 360 (K257) Biagio d'Antonio da Firenze: *Madonna and Child with Saints.*
Allentown, Pa. (p. 133)

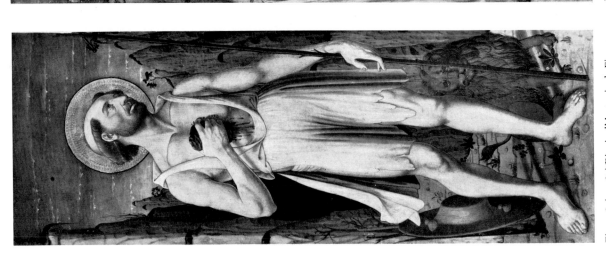

Fig. 359 (K1139) Biagio d'Antonio da Firenze:
The Archangel Raphael with Tobias.
Ponce, Puerto Rico (p. 132)

Fig. 358 (K1184) Biagio d'Antonio da Firenze:
St. Jerome. Brunswick, Me. (p. 132)

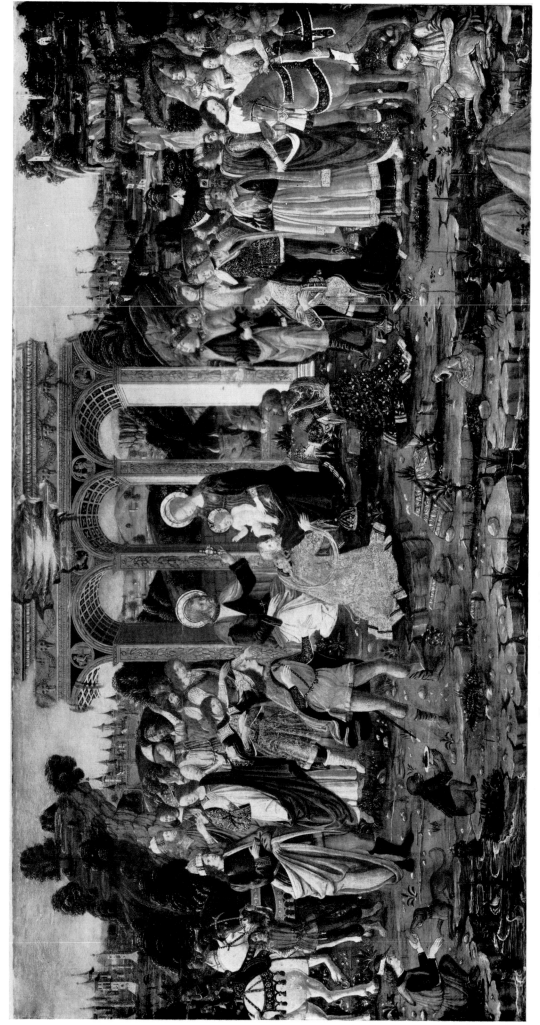

Fig. 361 (K316) Jacopo del Sellaio: *The Adoration of the Magi.* Memphis, Tenn. (p. 134)

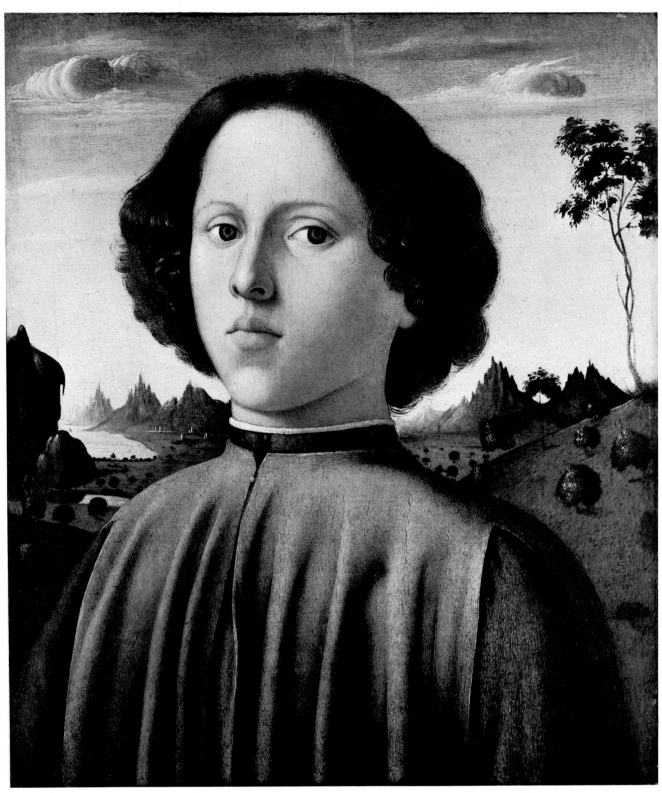

Fig. 362 (K 326) Biagio d'Antonio da Firenze: *Portrait of a Boy*. Washington, D.C. (p. 132)

Fig. 381 Detail from Fig. 380

Fig. 382 (K 1568) Sassetta and Assistant: *The Death of St. Anthony*. Washington, D.C. (p. 141)

Fig. 383 (κ 443) Sassetta: *Madonna and Child*. Washington, D.C. (p. 140)

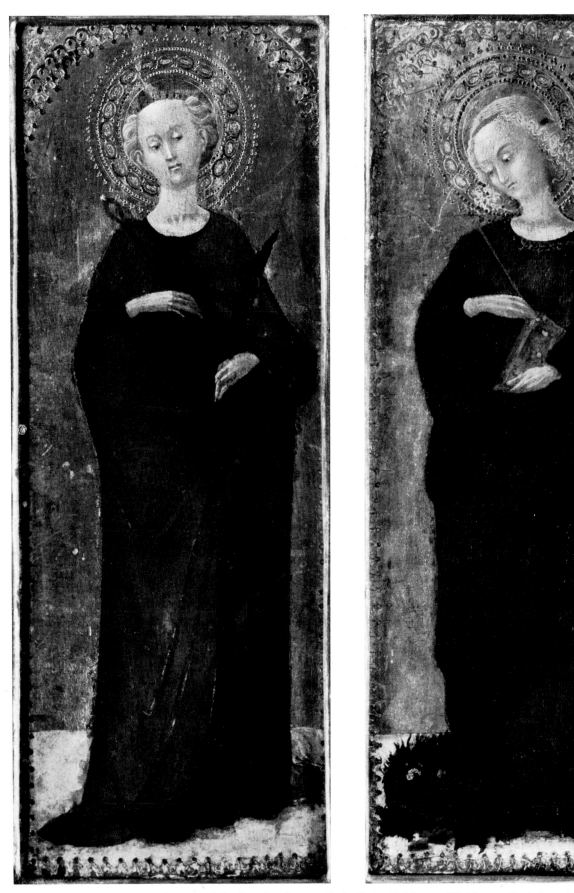

Figs. 384–385 (κ 1285 A, B) Attributed to Sassetta: *St. Apollonia; St. Margaret*. Washington, D.C. (p. 143)

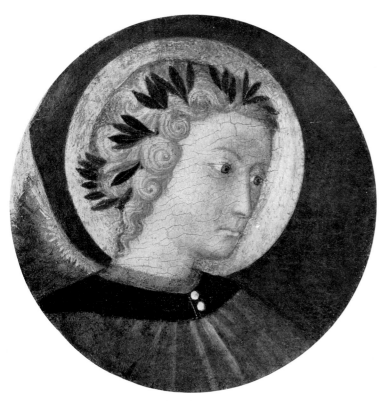

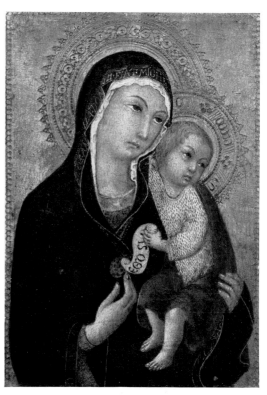

Fig. 386 (K 425) Studio of Sassetta: *Head of an Angel.*
Lawrence, Kans. (p. 144)

Fig. 387 (K 1036) Sano di Pietro: *Madonna and Child.*
New York, Samuel H. Kress Foundation (p. 145)

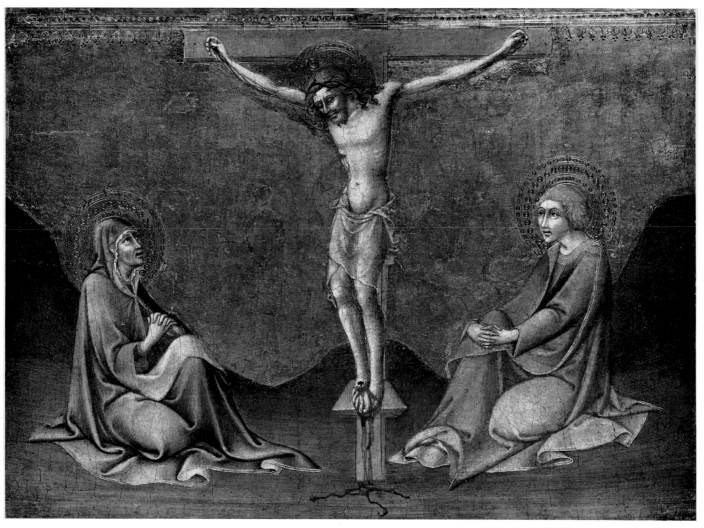

Fig. 388 (K 88) Sano di Pietro: *The Crucifixion.* Washington, D.C. (p. 144)

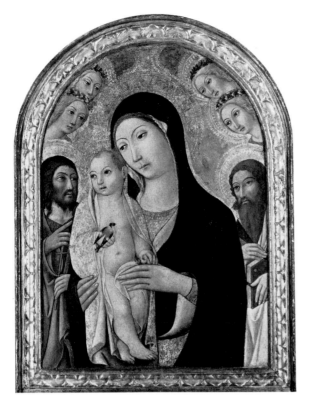

Fig. 389–390 (K 522 obverse and reverse) Sano di Pietro: *Madonna and Child with Saints and Angels; Emblem of St. Bernardine.*
El Paso, Tex. (p. 145)

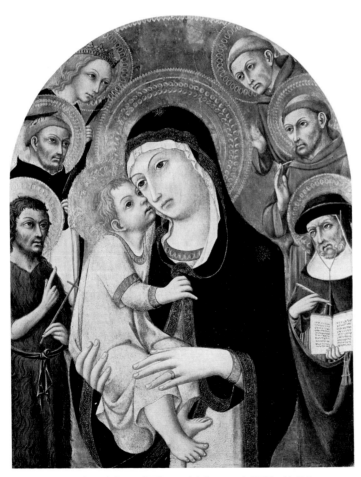 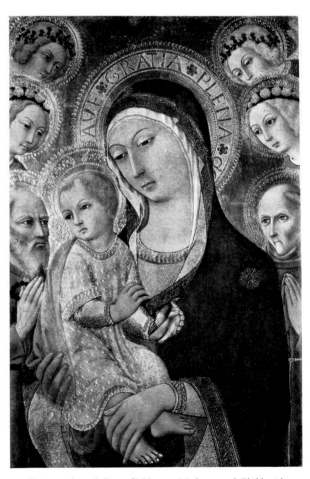

Fig. 391 (K 286) Sano di Pietro: *Madonna and Child with Saints.*
Coral Gables, Fla. (p. 145)

Fig. 392 (K 492) Sano di Pietro: *Madonna and Child with Saints and Angels.* Washington, D.C. (p. 146)

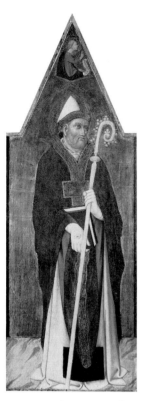
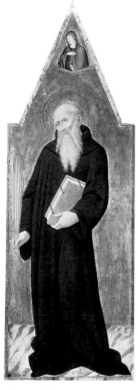

Figs. 393–394 (K 101, K 100) Sano di Pietro:
St. Augustine; St. Benedict. Birmingham, Ala. (p. 146)

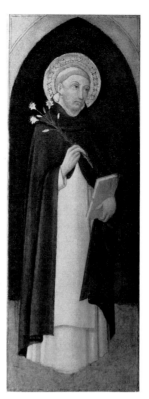
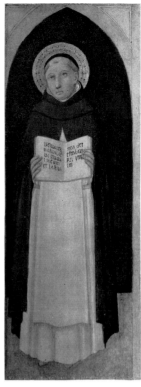

Figs. 395–396 (K 1155, K 1156) Follower of Sano di Pietro:
St. Dominic; St. Thomas Aquinas. Tucson, Ariz. (p. 147)

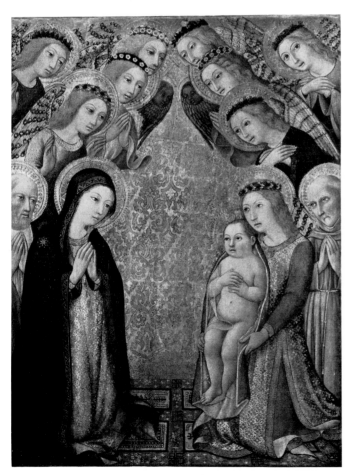

Fig. 397 (K 311) Sano di Pietro: *The Adoration of the Child.*
Amherst, Mass. (p. 146)

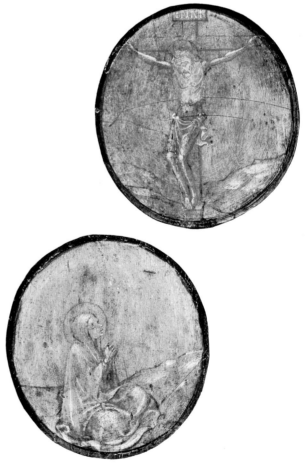

Figs. 398–399 (K 1434 reverse of side panels) Sienese School, c. 1400:
The Mourning Madonna; Christ on the Cross. El Paso, Tex. (p. 147)

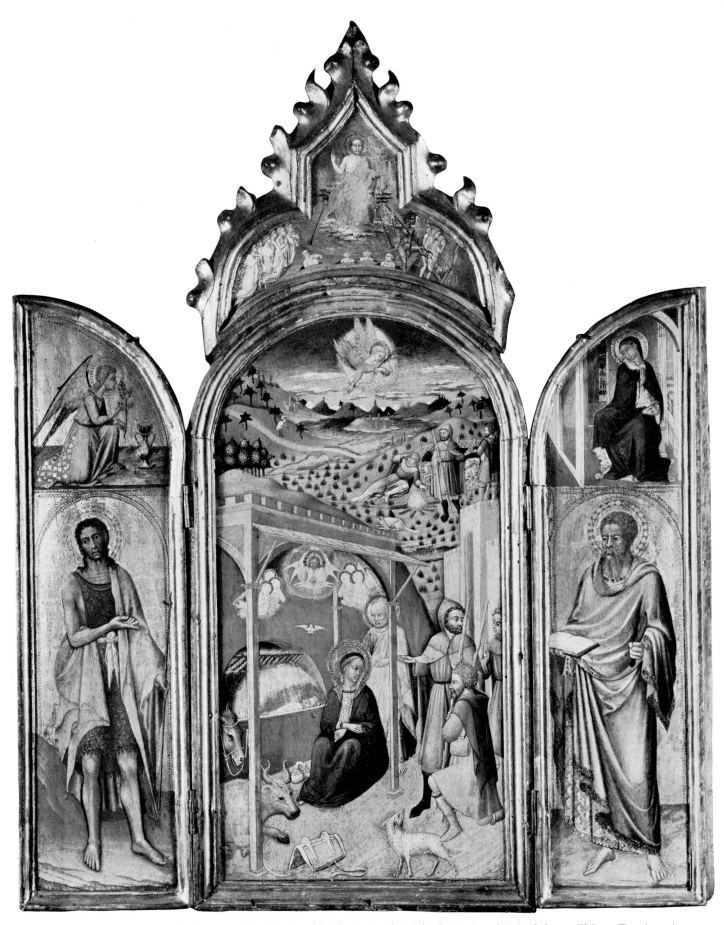

Fig. 400 (K 1434) Sienese School, *c.* 1440: *The Adoration of the Shepherds with St. John the Baptist and St. Bartholomew*. El Paso, Tex. (p. 147)

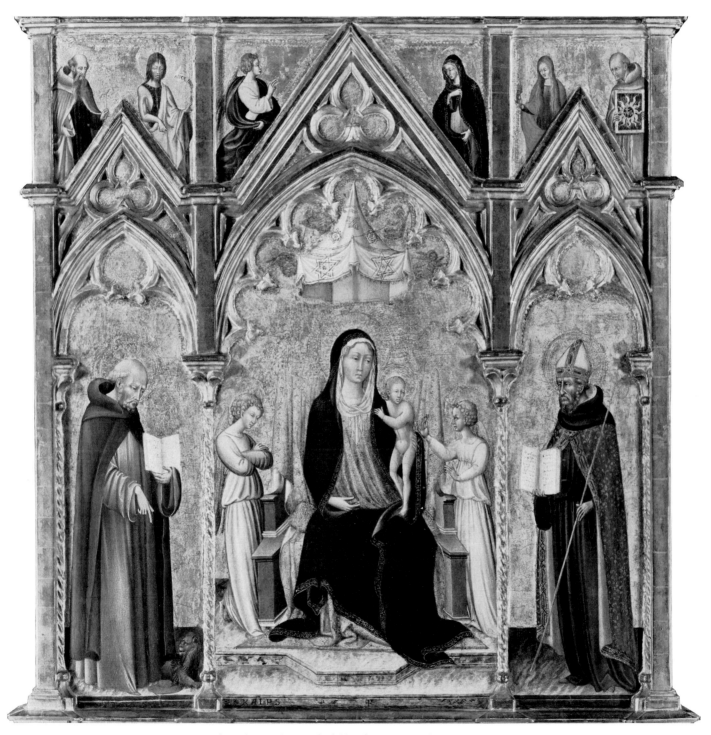

Fig. 401 (K432) Giovanni di Paolo: *Madonna and Child with St. Jerome and St. Augustine*. Kansas City, Mo. (p. 148)

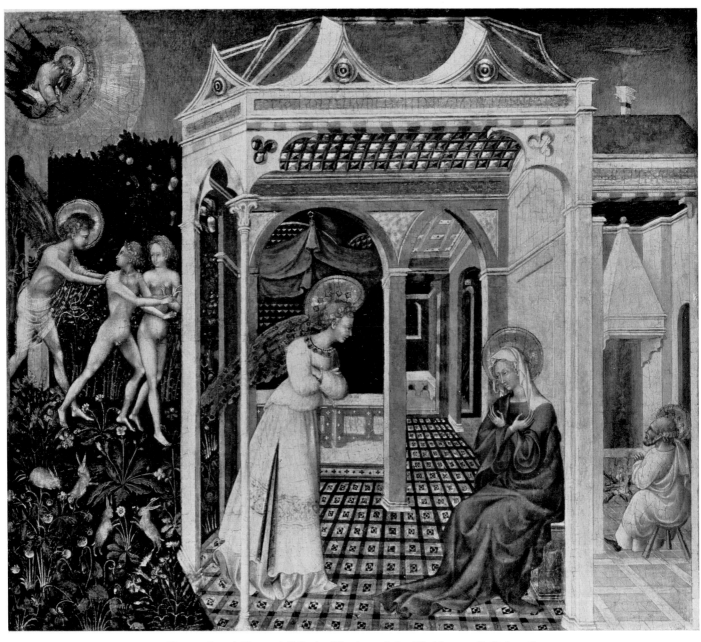

Fig. 402 (K412) Giovanni di Paolo: *The Annunciation*. Washington, D.C. (p. 148)

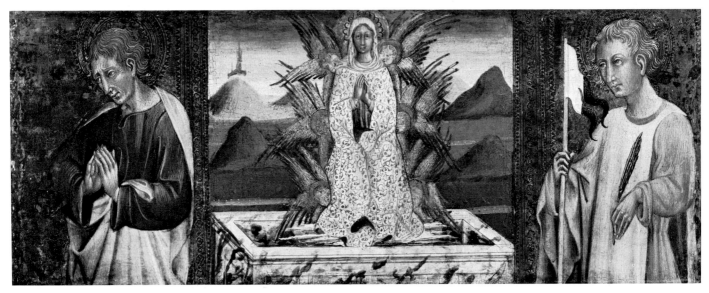

Fig. 403 (K500) Giovanni di Paolo: *The Assumption of the Virgin*. El Paso, Tex. (p. 149)

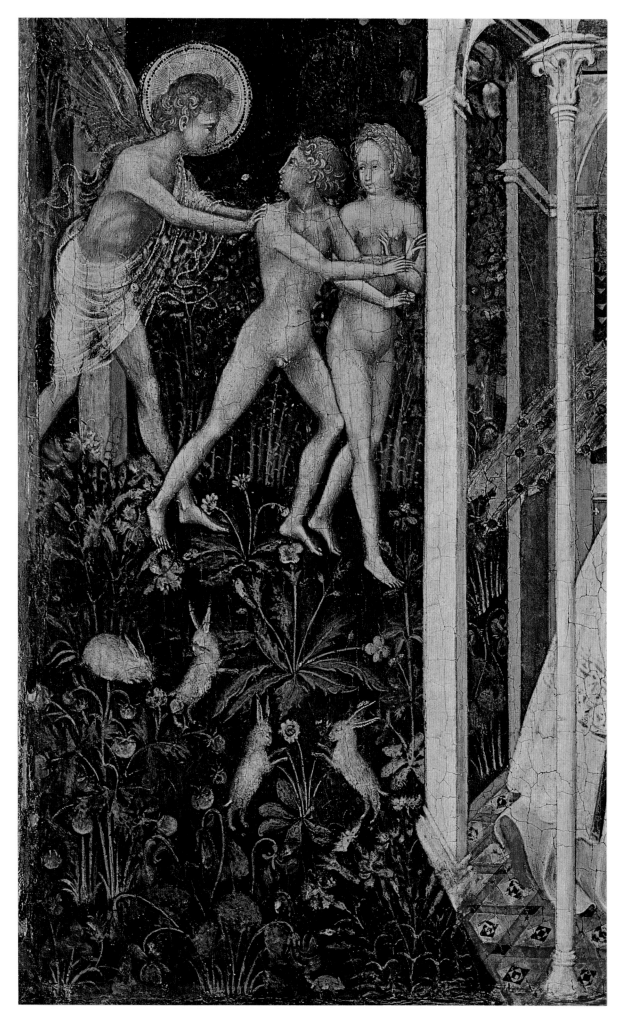

Fig. 404 Detail from Fig. 402

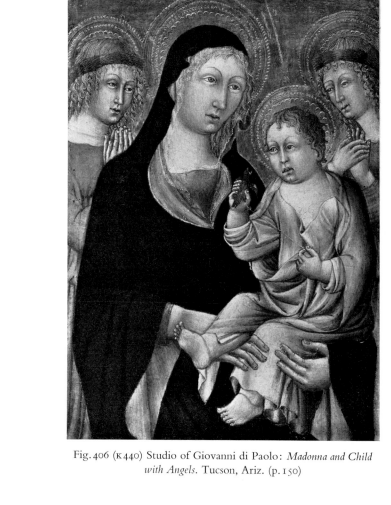

Fig. 405 (K 1094) Giovanni di Paolo: *St. Luke the Evangelist.*
Seattle, Wash. (p. 149)

Fig. 406 (K 440) Studio of Giovanni di Paolo: *Madonna and Child with Angels.* Tucson, Ariz. (p. 150)

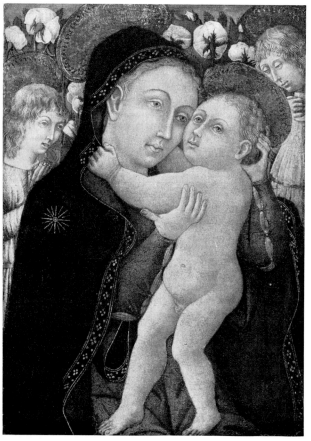

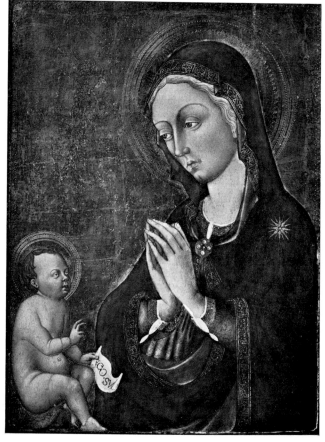

Fig. 407 (K 1053) Studio of Giovanni di Paolo: *Madonna and Child with Angels.* Madison, Wis. (p. 150)

Fig. 408 (K 1142) Follower of Giovanni di Paolo: *Madonna Adoring the Child.* Staten Island, N.Y. (p. 150)

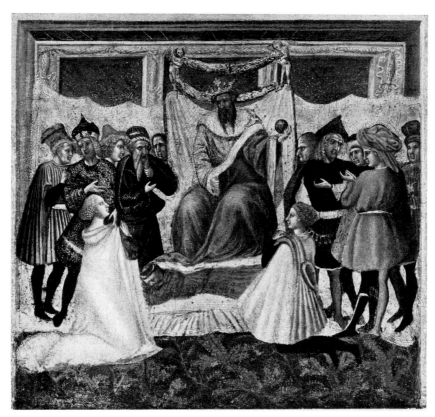

Fig. 409 (K 269) Attributed to Lorenzo Vecchietta: *A Judgment Scene.*
Bridgeport, Conn. (p. 151)

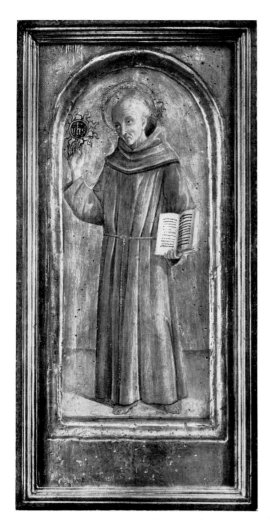

Fig. 410 (K 1235) Follower of Lorenzo Vecchietta:
St. Bernardine. Brunswick, Me. (p. 152)

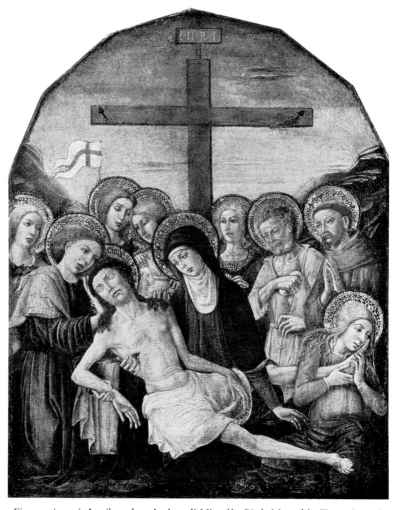

Fig. 411 (K 290) Attributed to Andrea di Niccolò: *Pietà.* Memphis, Tenn. (p. 152)

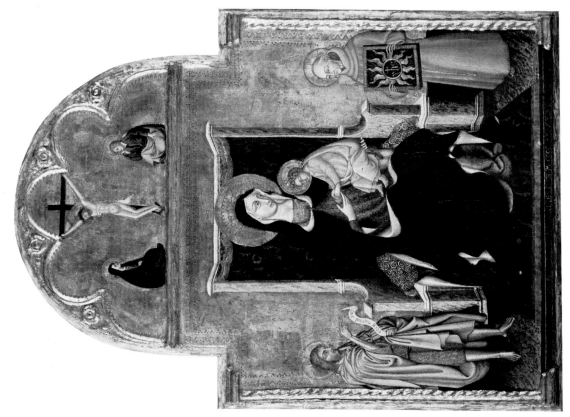

Fig. 413 (K1120) Pellegrino di Mariano: *Madonna and Child with St. John the Baptist and St. Bernardine of Siena*. Memphis, Tenn. (p. 151)

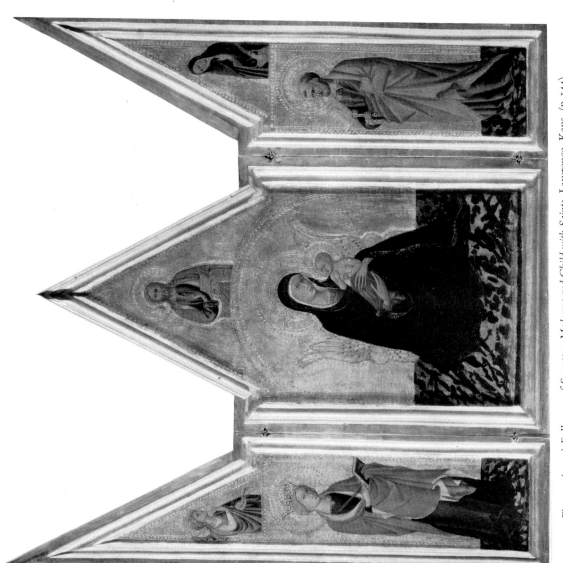

Fig. 412 (K444) Follower of Sassetta: *Madonna and Child with Saints*. Lawrence, Kans. (p. 144)

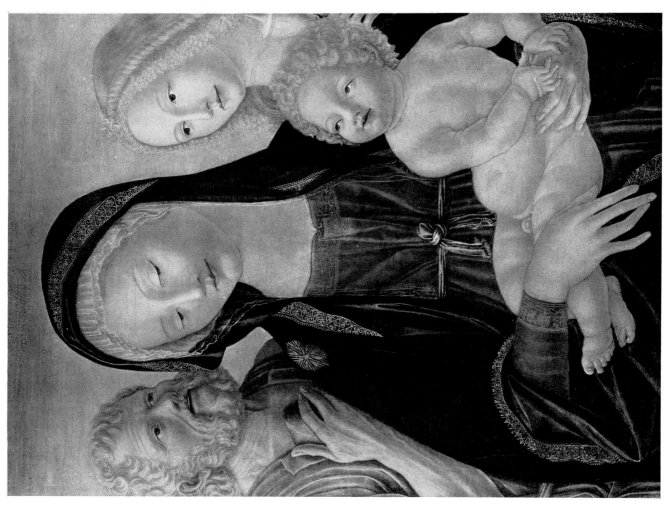

Fig. 415 (K411) Neroccio de'Landi: *Madonna and Child with St. Jerome and St. Mary Magdalene.*
New York, Metropolitan Museum of Art (p. 155)

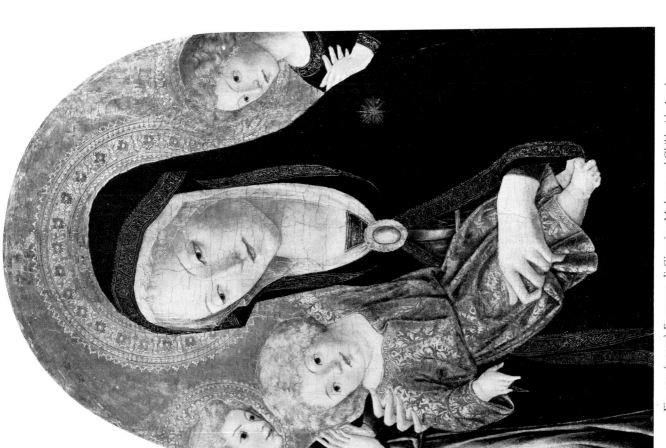

Fig. 414 (K1370) Francesco di Giorgio: *Madonna and Child with Angels.*
Coral Gables, Fla. (p. 153)

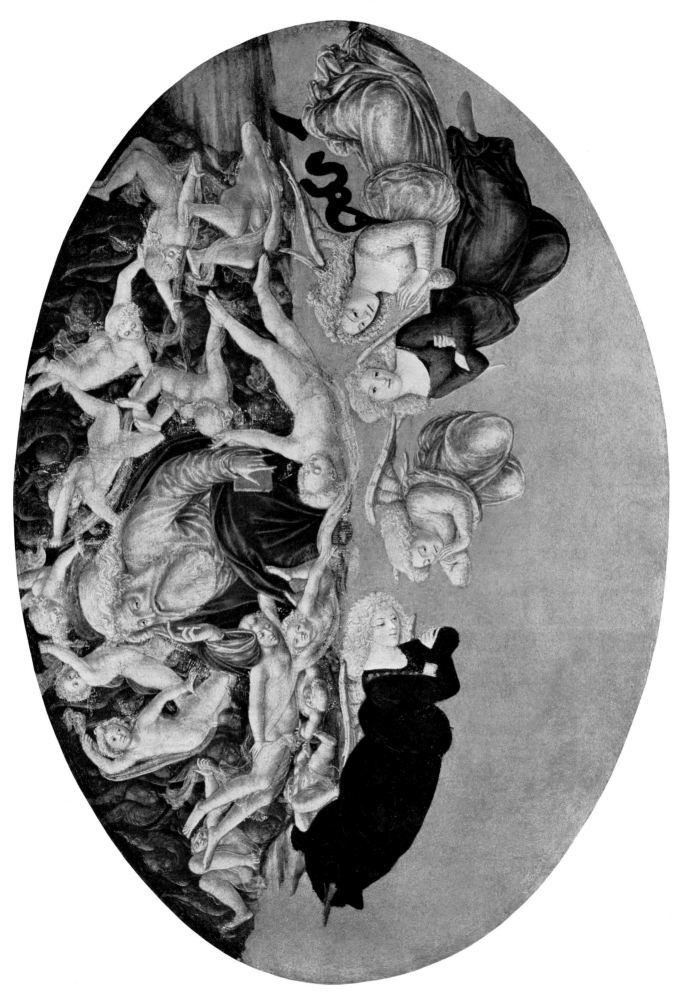

Fig. 416 (κ1356) Francesco di Giorgio: *God the Father Surrounded by Angels and Cherubim.* Washington, D.C. (p.153)

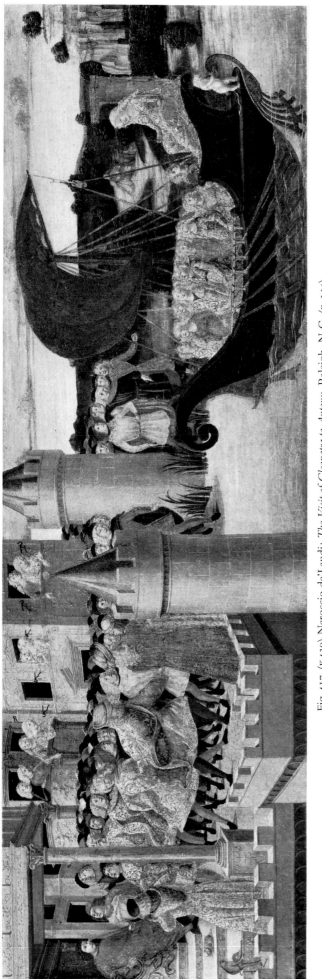

Fig. 417 (K439) Neroccio de'Landi: *The Visit of Cleopatra to Antony*. Raleigh, N.C. (p. 154)

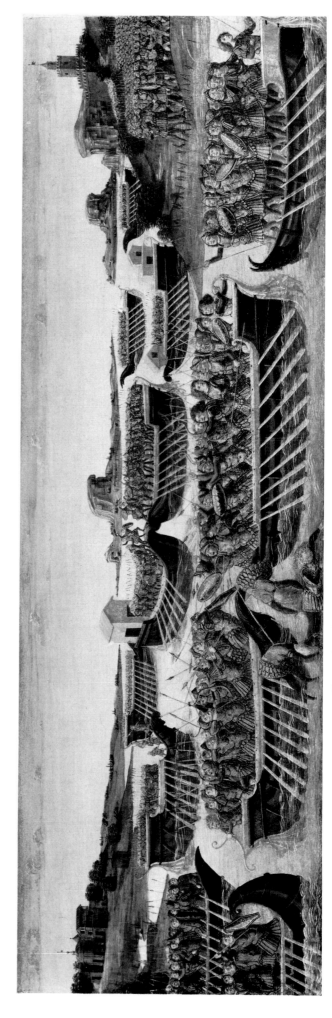

Fig. 418 (K438) Neroccio de'Landi: *The Battle of Actium*. Raleigh, N.C. (p. 154)

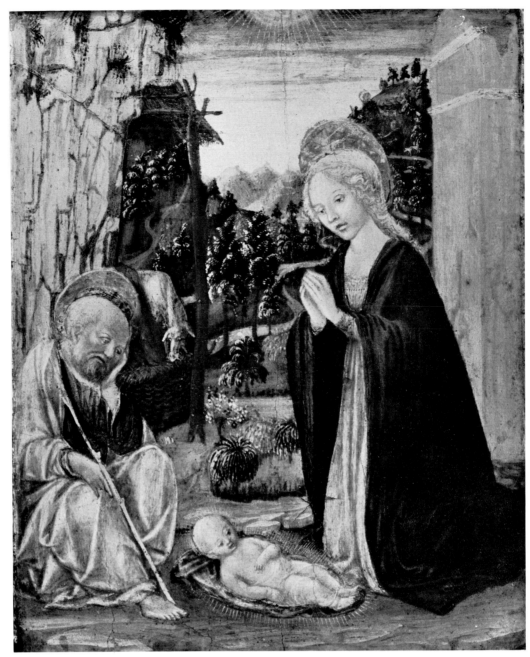

Fig. 419 (κ1564) Francesco di Giorgio: *The Nativity*. Atlanta, Ga. (p. 153)

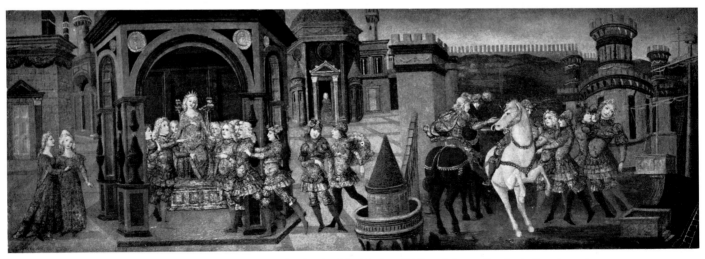

Fig. 420 (κ530) Studio of Francesco di Giorgio: *The Meeting of Dido and Aeneas*. Portland, Ore. (p. 154)

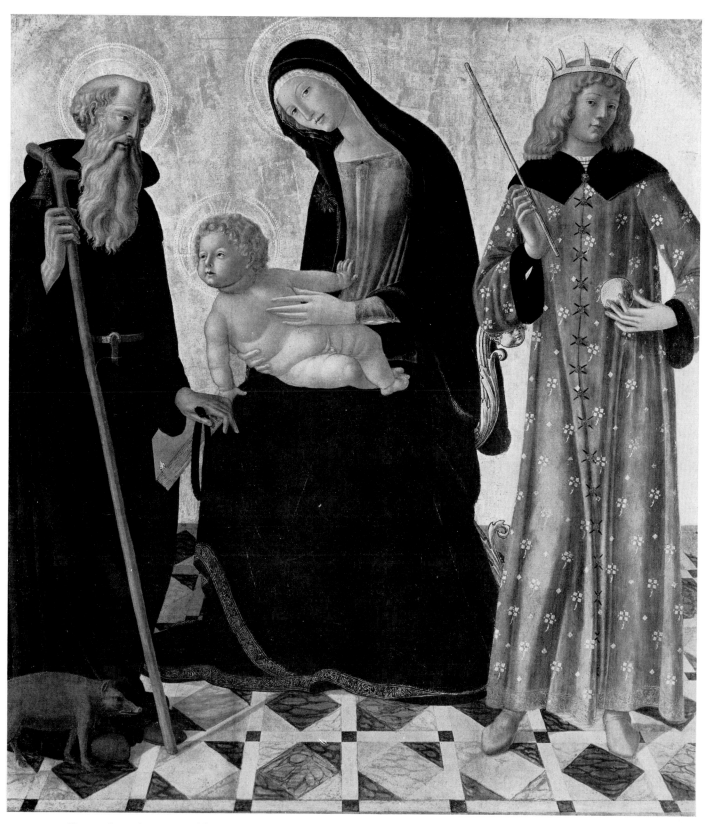

Fig. 421 (κ 1346) Neroccio de'Landi: *Madonna and Child with St. Anthony Abbot and St. Sigismund*. Washington, D.C. (p. 155)

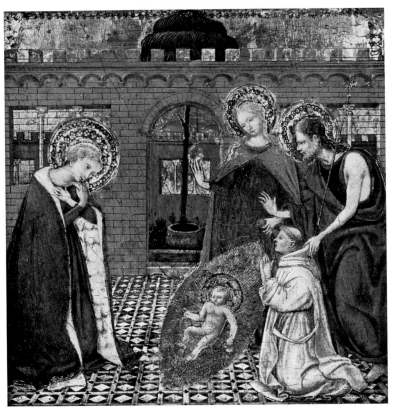

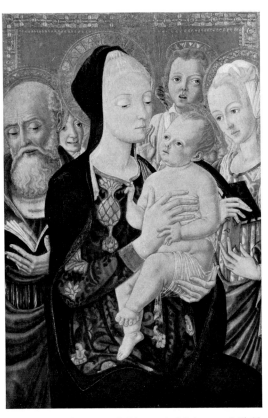

Fig. 422 (K 1901) Follower of Neroccio de'Landi: *Madonna and Child with Saints.*
Notre Dame, Ind. (p. 156)

Fig. 423 (K 517) Matteo di Giovanni: *Madonna and Child
with Saints and Angels.* Washington, D.C. (p. 156)

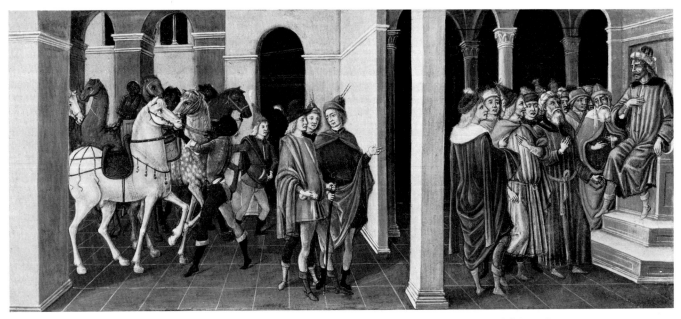

Fig. 424 (K 1745A) Matteo di Giovanni: *The Magi before Herod.* San Francisco, Calif. (p. 157)

INDEXES

INDEX OF CHANGES OF ATTRIBUTION

Old Attribution	Kress Number	New Attribution
Amadeo da Pistoia	K 1024	'Alunno di Benozzo,' p. 117, Fig. 320
Amadeo da Pistoia	K 1025	'Alunno di Benozzo,' p. 118, Fig. 319
Andrea da Firenze	K 263	Master of the Fabriano Altarpiece, p. 29, Fig. 68
Andrea di Giusto	K 269	Attributed to Vecchietta, p. 151, Fig. 409
Baldovinetti	K 402	Pier Francesco Fiorentino, p. 114, Fig. 312
Balduccio, Matteo	K 222	Girolamo di Benvenuto, p. 162, Fig. 448
Baronzio	K 1312	Master of the Life of St. John the Baptist, p. 68, Fig. 182
Baronzio	K 264	Master of the Life of St. John the Baptist, p. 69, Fig. 184
Baronzio	K 1084	Master of the Blessed Clare, p. 70, Fig. 187
Bartolo di Fredi	K 2045	Paolo di Giovanni Fei, p. 62, Fig. 159
Bartolommeo di Giovanni	K 77	Master of the 'Apollini Sacrum,' p. 128, Fig. 345
Bartolommeo di Giovanni	K 79	Master of the 'Apollini Sacrum,' p. 128, Fig. 346
Bartolommeo di Giovanni	K 1721A, B	Master of the Apollo and Daphne Legend, p. 129, Figs. 347, 349
Cimabue (?)	K 361	Italian School, c. 1300, p. 6, Fig. 11
Cimabue (?)	K 324	Italian School, c. 1300, p. 6, Fig. 12
Cimabue, Contemporary of	K 1189	Tuscan School, Late XIII Century, p. 6, Fig. 8
Cossa, Francesco del	K 387	Ferrarese School, Late XV Century, p. 86, Fig. 236
Daddi, Bernardo	K 197	Master of San Martino alla Palma, p. 30, Fig. 71
Daddi, Bernardo, Follower of	K 263	Master of the Fabriano Altarpiece, p. 29, Fig. 68
Domenico di Michelino	K 540	Pesellino and Studio, p. 110, Fig. 302
Domenico di Michelino	K 541	Pesellino and Studio, p. 110, Fig. 303
Domenico Veneziano (?)	K 1187	Follower of Pesellino, p. 111, Fig. 307
Duccio, Follower of	K 309	Master of San Torpè, p. 18, Fig. 38
Duccio, Follower of	K 592	Master of the Goodhart Madonna, p. 18, Fig. 40
Emilian School, c. 1370	K 527	Follower of Barnaba da Modena, p. 12, Fig. 17
Florentine School, c. 1350	K 1925	Follower of Bernardo Daddi, p. 28, Fig. 63
Florentine School, c. 1370/80	K 64	Follower of Orcagna, p. 32, Fig. 72
Florentine School, Last Third of XIV Century	K 66, 67	Giovanni del Biondo, p. 36, Figs. 83–84
Florentine School, Second Half of XIV Century	K M–2, M–3	Master of the Orcagnesque Misericordia, p. 38, Figs. 89–90
Florentine School, c. 1400	K 1190	Follower of Bicci di Lorenzo, p. 47, Fig. 119
Florentine School, First Half of XV Century	K 275	Circle of the Master of the Griggs Crucifixion, p. 100, Fig. 269
Florentine School, c. 1440	K 320	Follower of Paolo Uccello, p. 102, Fig. 275
Florentine School, c. 1470	K 1722	Follower of Verrocchio, p. 119, Fig. 324
Florentine School, End of XV Century	K 1152A, B	Master of the Apollo and Daphne Legend, p. 130, Figs. 348, 350
Florentine School, c. 1500	K 1616, 1617	Master of the Apollo and Daphne Legend, p. 130, Figs. 353–354
Francesco di Giorgio	K 439	Neroccio de'Landi, p. 154, Fig. 417
Gaddi, Agnolo	K 156	Studio of Orcagna, p. 32, Fig. 77
Gaddi, Agnolo	K 261	Master of the St. Verdiana Panel, p. 41, Fig. 104
Giacomo del Pisano	K 1053	Studio of Giovanni di Paolo, p. 150, Fig. 407
Giotto, School of	K 1430	Tuscan School, XIV Century, p. 31, Fig. 65
Giovanni del Biondo	K 1121	Florentine School, Late XIV Century, p. 38, Fig. 88
Italian School (Central), XIII Century	K 1301	Modern Imitation of XIII Century Italian School [not catalogued]
Jacopo di Paolo da Bologna	K 102	Cecco di Pietro, p. 73, Fig. 198
Lippi, Fra Filippo	K 516	Modern Copy after Fra Filippo Lippi [not catalogued]
Lippi, Fra Filippo and Assistants	K 441A, B, C, D	Fra Diamante, p. 109, Figs. 293–296
Lorenzetti, Pietro	K 1302	Master of the Ovile Madonna ('Ugolino Lorenzetti'), p. 54, Fig. 145
Luca di Tommè	K 1085	Tegliacci, p. 58, Fig. 150
Mainardi	K 267	Follower of Domenico Ghirlandaio, p. 127, Fig. 339
Mariotto di Nardo	K 333	Lorenzo di Niccolò, p. 44, Fig. 117

Old Attribution	*Kress Number*	*New Attribution*
Maso	K74	Attributed to Jacopo di Cione, p. 33, Fig. 82
Master of the Jarves Cassoni	K251	Apollonio di Giovanni, p. 98, Fig. 267
Master of the Jarves Cassoni	K491	Apollonio di Giovanni, p. 98, Figs. 263, 265
Master of the Jarves Cassoni	K528	Follower of Pesellino, p. 111, Fig. 306
Master of the Osservanza Altarpiece	K1568	Sassetta and Assistant, p. 141, Fig. 382
Master of the Perticaia Triptych	K1119	Follower of Niccolò di Pietro Gerini, p. 43, Fig. 107
Master Wenceslaus	K1777	Follower of Gentile da Fabriano, p. 78, Fig. 214
Memmi, Lippo	K459	Attributed to Barna da Siena, p. 50, Fig. 128
Memmi, Lippo (?)	K23	Andrea di Bartolo, p. 66, Figs. 173–174
Montaione Master	K1930	Master of the Clarisse Panel, p. 13, Fig. 34
Orcagna	K296	Attributed to Jacopo di Cione, p. 33, Fig. 78
Pacchiarotto, Giacomo	K1283	Cozzarelli, p. 160, Fig. 438
Parentino, Bernardo	K334	Follower of Francesco del Cossa, p. 85, Fig. 234
Pellegrino di Mariano	K444	Follower of Sassetta, p. 144, Fig. 412
Pisan School, XIII Century	K431	Venetian School, c. 1300, p. 7, Fig. 14
Riminese School, XIV Century	K201	Tuscan School, First Half of XIV Century, p. 30, Fig. 70
Roberti, Ercole	K1245	Attributed to Baldassare d'Este, p. 83, Fig. 231
Rossello di Jacopo Franchi	K525	Master of the Bambino Vispo, p. 90, Fig. 242
Rossello di Jacopo Franchi	K170	Master of the Griggs Crucifixion, p. 99, Fig. 270
Scaletti	K387	Ferrarese School, Late XV Century, p. 86, Fig. 236
Sienese School, Beginning of XIV Century	K577	Follower of Duccio, p. 15, Fig. 33
Sienese School (Niccolò di Segna ?)	K1102	Follower of Segna di Buonaventura, p. 17, Fig. 30
Sienese School, XIV Century	K40, 41	Niccolò di Segna, p. 17, Figs. 36–37
Sienese School, XIV Century	K292	Attributed to the Master of San Torpè, p. 19, Fig. 39
Sienese School, c. 1340	K1364	Studio of the Master of the Ovile Madonna ('Ugolino Lorenzetti'), p. 55, Fig. 140
Sienese School, XIV Century	K1014	Andrea di Bartolo, p. 66, Fig. 178
Simone Martini	K511	Lippo Memmi, p. 49, Fig. 126
Spinello Aretino, Close Follower of	K373	Studio of Luca di Tommè, p. 60, Fig. 158
Tommaso da Modena	K102	Cecco di Pietro, p. 73, Fig. 198
Tuscan Painter, Second Third of XIV Century	K463	Follower of Bernardo Daddi, p. 29, Fig. 67
Ugolino da Siena	K3	Segna di Buonaventura, p. 16, Fig. 32
Ugolino da Siena	K219	Sienese School, Early XIV Century, p. 16, Fig. 35
Utili	K1088	Biagio d'Antonio da Firenze, p. 131, Figs. 356–357
Utili	K299	Biagio d'Antonio da Firenze, p. 132, Fig. 355
Utili	K326	Biagio d'Antonio da Firenze, p. 132, Fig. 362
Vanni, Lippo	K373	Studio of Luca di Tommè, p. 60, Fig. 158
Vecchietta	K290	Attributed to Andrea di Niccolò, p. 152, Fig. 411
Virgil Master	K251	Apollonio di Giovanni, p. 98, Fig. 267
Virgil Master	K528	Follower of Pesellino, p. 111, Fig. 306

ICONOGRAPHICAL INDEX

RELIGIOUS SUBJECTS

A. ARCHANGELS

GABRIEL
Masolino, p. 94, Fig. 254
Simone Martini, p. 48, Fig. 121

MICHAEL
Daddi, Follower of, p. 28, Fig. 60
Francesco d'Antonio, p. 93, Fig. 253
Ghirlandaio, Domenico, Follower of, p. 127, Fig. 342
Giovanni dal Ponte, p. 92, Figs. 246, 247
Lorenzetti, Pietro, Attributed to, p. 51, Fig. 130
Master of the Goodhart Madonna, p. 18, Fig. 40

RAPHAEL
Biagio d'Antonio da Firenze, p. 132, Fig. 359
Lippi, Filippino, p. 135, Fig. 369
Puccinelli, p. 74, Fig. 202

B. OLD TESTAMENT

ESTHER
(?) Vecchietta, Attributed to, p. 151, Fig. 409

EXPULSION FROM THE GARDEN OF EDEN
Giovanni di Paolo, p. 148, Figs. 402, 404

HAMAN
(?) Vecchietta, Attributed to, p. 151, Fig. 409

HOLOFERNES
Matteo di Giovanni, p. 157, Fig. 426

ISAIAH
Gaddi, Taddeo, p. 23, Fig. 52

JUDITH
Matteo di Giovanni, p. 157, Fig. 426

MOSES
Master of the Apollo and Daphne Legend, p. 130, Figs. 353–354

SAMSON
Pesellino and Studio, p. 110, Fig. 303

SHEBA, QUEEN OF
Apollonio di Giovanni, p. 98, Fig. 267

SOLOMON
Pesellino and Studio, p. 110, Fig. 303

TOBIAS
Biagio d'Antonio da Firenze, p. 132, Fig. 359
Lippi, Filippino, p. 135, Fig. 369

TOBIT
Puccinelli, p. 74, Fig. 202

C. NEW TESTAMENT

ADORATION OF THE MAGI
Angelico, Fra, and Fra Filippo Lippi, Frontispiece; p. 95, Figs. 259–261
Bartolommeo di Giovanni, p. 129, Fig. 351
Jacopino di Francesco, p. 71, Fig. 188
Master of the Bambino Vispo, p. 91, Fig. 245
Master of the Blessed Clare, p. 70, Fig. 187
Master of the Straus Madonna, p. 41, Fig. 103
Pacino di Buonaguida, p. 23, Fig. 50
Sellaio, p. 134, Fig. 361
Vanni, Andrea, p. 57, Fig. 156

ADORATION OF THE SHEPHERDS
Sienese School, c. 1440, p. 147, Fig. 400

AGONY IN THE GARDEN
Benvenuto di Giovanni, p. 158, Fig. 428
Pacino di Buonaguida, p. 23, Fig. 50
Tuscan School, XIV Century, p. 31, Fig. 65

ANGEL AT THE TOMB
Bicci di Lorenzo, Follower of, p. 47, Fig. 119

ANNUNCIATION
Baldovinetti, Style of, p. 114, Fig. 311
Bicci di Lorenzo, Follower of, p. 47, Fig. 119
Cozzarelli, p. 159, Fig. 435
*Daddi, Follower of, p. 28, Fig. 63
*Fei, p. 61, Fig. 160
Florentine School, Mid-XIV Century, p. 34, Fig. 73
Francesco d'Antonio, p. 93, Fig. 253
Giovanni del Biondo, p. 36, Fig. 91; p. 37, Fig. 85
Giovanni di Paolo, p. 148, Figs. 401–402, 404
*Giovanni dal Ponte, p. 92, Fig. 246
*Jacopo del Casentino and Assistant, p. 25, Fig. 57
Lippi, Fra Filippo, p. 107, Fig. 299
Masolino, p. 94, Figs. 254–255
Master of Fucecchio, p. 105, Figs. 284–285
Orcagna, Studio of, p. 32, Fig. 77
*Sano di Pietro, p. 146, Figs. 393–394
*Sassetta, Follower of, p. 144, Fig. 412
Sienese School, c. 1440, p. 147, Fig. 400
*Simone dei Crocifissi, p. 72, Fig. 195
Simone Martini, p. 48, Fig. 121
Tura, p. 81, Fig. 225; p. 82, Figs. 227–228
*Venetian School, c. 1300, p. 7, Fig. 14
Veronese School, Early XV Century, p. 78, Fig. 215

*The figure or scene is a minor part of the picture.

ANNUNCIATION TO THE SHEPHERDS
 Daddi, Follower of, p. 28, Fig. 63
 Gentile da Fabriano, Follower of, p. 78, Fig. 214
 Sienese School, c. 1440, p. 147, Fig. 400
ASSUMPTION OF THE VIRGIN
 Andrea di Giusto, p. 98, Fig. 264
 Fei, p. 61, Fig. 160
 Giovanni di Paolo, p. 149, Fig. 403
BAPTISM OF CHRIST
 Master of the Life of St. John the Baptist, p. 69, Fig. 184
 Pacino di Buonaguida, p. 23, Fig. 50
 Tuscan School, XIV Century, p. 31, Fig. 65
BETRAYAL AND CAPTURE OF CHRIST
 Italian School, c. 1300, p. 6, Fig. 12
 Pacino di Buonaguida, p. 23, Fig. 50
 Venetian School, c. 1300, p. 7, Fig. 14
CALLING OF THE APOSTLES PETER AND
 ANDREW
 Duccio, p. 14, Fig. 28
CHRIST AMONG THE DOCTORS
 Pacino di Buonaguida, p. 23, Fig. 50
CHRIST BEFORE PILATE
 Pacino di Buonaguida, p. 23, Fig. 50
 Venetian School, c. 1300, p. 7, Fig. 14
CHRIST CARRYING THE CROSS
 Benvenuto di Giovanni, p. 158, Fig. 429
 Fei, p. 61, Fig. 162
CHRIST IN LIMBO
 Benvenuto di Giovanni, p. 158, Fig. 431
 Pacino di Buonaguida, p. 23, Fig. 50
CORONATION OF THE VIRGIN
 Gaddi, Agnolo, p. 40, Figs. 98–99
 Ghirlandaio, Domenico, Studio of, p. 126, Fig. 338
 Giovanni da Bologna, p. 10, Fig. 22
 Lippi, Filippino, p. 135, Fig. 370
 Orcagna, Follower of, p. 32, Fig. 72
 Paolo Veneziano, p. 7, Fig. 13
 Pietro di Domenico da Montepulciano, p. 79, Fig. 218
 Taddeo di Bartolo, p. 63, Fig. 163
CRUCIFIXION: CRUCIFIX
 'Alunno di Benozzo,' p. 117, Fig. 318
 Andrea di Bartolo, p. 66, Figs. 174, 178
 Barnaba da Modena, Follower of, p. 12, Fig. 17
 Battista da Vicenza, Attributed to, p. 74, Fig. 203
 Benvenuto di Giovanni, p. 158, Fig. 430; p. 159, Fig. 433
 Botticelli, Attributed to, p. 124, Fig. 327
 Cossa, p. 84, Fig. 224
 Cozzarelli, p. 160, Fig. 434
 Daddi, Attributed to, p. 26, Fig. 69
 — Follower of, p. 28, Fig. 63
 Duccio, Follower of, p. 15, Fig. 25
 Florentine School, Mid-XIV Century, p. 34, Fig. 73

 Francesco d'Antonio, p. 93, Fig. 253
 Giotto, Follower of, p. 22, Figs. 48, 51
 Italo-Byzantine School, XIV Century Style, p. 12, Fig. 15
 Jacopo del Casentino and Assistant, p. 25, Fig. 57
 Jacopo di Paolo, p. 72, Fig. 197
 Lorenzetti, Pietro, Follower of, p. 52, Fig. 141
 Lorenzo di Bicci, p. 46, Fig. 115
 Lorenzo Monaco, Follower of, p. 90, Fig. 240
 Lorenzo di Niccolò, p. 44, Fig. 110
 Luca di Tommè, p. 59, Fig. 157
 Mariotto di Nardo, p. 46, Fig. 118
 Martino di Bartolommeo, p. 65, Fig. 179
 Master of the Fabriano Altarpiece, p. 29, Fig. 68
 Master of the Orcagnesque Misericordia, p. 38, Figs. 89–90
 Master of the Ovile Madonna, p. 55, Fig. 142
 Matteo di Giovanni, p. 157, Fig. 427
 Nuzi, p. 75, Fig. 204
 Pacino di Buonaguida, p. 23, Fig. 50
 — Follower of, p. 23, Fig. 49
 Paolo Veneziano, p. 8, Fig. 10
 *Pellegrino di Mariano, p. 151, Fig. 413
 Pesellino, p. 110, Fig. 300
 Riminese School, Late XIV Century, p. 69, Fig. 186
 Rosselli, p. 121, Fig. 326
 Sano di Pietro, p. 144, Fig. 388
 Schiavo, p. 105, Fig. 282
 Sienese School, c. 1370, p. 56, Fig. 146
 Sienese School, c. 1440, p. 147, Fig. 399
 Tuscan School, First Half of XIV Century, p. 30, Fig. 70
 Tuscan School, XIV Century, p. 31, Fig. 65
 Venetian School, c. 1300, p. 7, Fig. 14
 Venetian School, Late XIV Century, p. 11, Fig. 16
DEPARTURE FOR BETHLEHEM
 (?) Cozzarelli, p. 159, Fig. 435
FLAGELLATION
 Dalmasio, p. 71, Fig. 196
 Master of San Martino alla Palma, p. 30, Fig. 71
 Pacino di Buonaguida, p. 23, Fig. 50
 Schiavo, p. 105, Fig. 281
 Tuscan School, XIV Century, p. 31, Fig. 65
FLIGHT INTO EGYPT
 Pacino di Buonaguida, p. 23, Fig. 50
HEROD
 Gozzoli, p. 116, Fig. 317
 Master of the Apollo and Daphne Legend, p. 130, Fig. 350
 Matteo di Giovanni, p. 157, Fig. 424
HERODIAS
 Gozzoli, p. 116, Fig. 317
 Master of the Apollo and Daphne Legend, p. 130, Fig. 350
HOLY TRINITY
 'Alunno di Benozzo,' p. 118, Fig. 319
 Bicci di Lorenzo, Follower of, p. 47, Fig. 119

*The figure or scene is a minor part of the picture.

LAST JUDGMENT
*Sienese School, c. 1440, p. 147, Fig. 400

LAST SUPPER
Italian School, c. 1300, p. 6, Fig. 11

MADONNA: MADONNA AND CHILD [not indexed except in scenes from their lives]

MOCKING OF CHRIST
Pacino di Buonaguida, p. 23, Fig. 50

NATIVITY
Andrea di Giusto, p. 99, Fig. 266
Bicci di Lorenzo, p. 47, Fig. 120
Botticelli, p. 122, Fig. 333
— and Assistants, p. 122, Fig. 332
— Attributed to, p. 123, Fig. 331
Daddi, Follower of, p. 28, Fig. 63
Francesco di Giorgio, p. 153, Fig. 419
Giovanni di Francesco, p. 104, Fig. 283
Girolamo di Benvenuto, p. 161, Fig. 447
Jacopino di Francesco, p. 71, Fig. 188
Lippi, Fra Filippo, and Assistant, p. 108, Fig. 291
Pacino di Buonaguida, p. 23, Fig. 50
Rosselli, p. 120, Fig. 325
Veronese School, Early XV Century, p. 78, Fig. 215

NATIVITY OF THE VIRGIN
Andrea di Bartolo, p. 66, Fig. 176

NOLI ME TANGERE
Bicci di Lorenzo, Follower of, p. 47, Fig. 119
*Gherardo del Fora, p. 138, Fig. 366

PASSION SYMBOLS
Sellaio, p. 134, Fig. 363

PIETÀ: ENTOMBMENT: DEAD CHRIST
'Alunno di Benozzo,' p. 117, Fig. 320
Andrea di Niccolò, Attributed to, p. 152, Fig. 411
Angelico, Fra, Attributed to, p. 97, Fig. 257
*Barnaba da Modena, Follower of, p. 12, Fig. 18
Jacopo di Cione, Attributed to, p. 33, Fig. 78
Lippi, Filippino, p. 136, Fig. 371
Master of the St. Verdiana Panel, p. 41, Fig. 104
Pacino di Buonaguida, p. 23, Fig. 50
*Simone dei Crocifissi, p. 72, Fig. 195
Tuscan School, XIV Century, p. 31, Fig. 65

PRESENTATION IN THE TEMPLE
Jacopo del Casentino, p. 24, Fig. 56
Pacino di Buonaguida, p. 23, Fig. 50

PRESENTATION OF THE VIRGIN
Andrea di Bartolo, p. 66, Fig. 177
Fei, p. 62, Fig. 159

RESURRECTION
Benvenuto di Giovanni, p. 158, Fig. 432
Pacino di Buonaguida, p. 23, Fig. 50

SALOME
Gozzoli, p. 116, Fig. 317
Master of the Apollo and Daphne Legend, p. 130, Fig. 350

SUPPER AT EMMAUS
*Sellaio, p. 134, Fig. 363

VISITATION
*Master of the Apollo and Daphne Legend, p. 130, Fig. 348
Pacino di Buonaguida, p. 23, Fig. 50

D. SAINTS

AGATHA
Francesco d'Antonio, p. 93, Fig. 253
Master of the Stratonice Cassoni, p. 139, Fig. 367

AGNES
Andrea di Niccolò, Attributed to, p. 152, Fig. 411
Daddi, p. 26, Fig. 61
Sienese School, c. 1370, p. 56, Fig. 146
Turino di Vanni, Attributed to, p. 74, Fig. 199

ALBERT THE GREAT, BLESSED
(?) Girolamo di Benvenuto, p. 161, Fig. 442

AMBROGIO SANSEDONI, BLESSED
Girolamo di Benvenuto, p. 161, Fig. 446

ANDREW
Daddi, p. 26, Fig. 61
Duccio, p. 14, Fig. 28
Lorenzetti, Pietro, Follower of, p. 53, Fig. 138
Lorenzo Veneziano, Attributed to, p. 9, Fig. 24
Orcagna, Follower of, p. 32, Fig. 72

ANSANUS
(?) Giovanni di Paolo, p. 149, Fig. 403

ANTHONY ABBOT
*Barnaba da Modena, Follower of, p. 12, Fig. 18
Cozzarelli, p. 161, Fig. 437
Cristiani, Follower of, p. 40, Fig. 102
Daddi, Follower of, p. 28, Fig. 63
Florentine School, Mid-XIV Century, p. 34, Fig. 73
Francesco d'Antonio, p. 93, Figs. 252–253
Giovanni da Milano, p. 39, Fig. 97
Giovanni di Paolo, p. 148, Fig. 401
Giusto de'Menabuoi, p. 39, Fig. 96
Lombard School, XV Century, p. 80, Fig. 220
Lorenzetti, Pietro, Follower of, p. 53, Fig. 137
Lorenzo di Niccolò, p. 44, Fig. 117
Master of Fucecchio, p. 106, Fig. 287
Master of the St. Verdiana Panel, p. 41, Fig. 104; p. 42, Fig. 105
Neri di Bicci, p. 113, Fig. 308
Neroccio de'Landi, p. 155, Fig. 421
Niccolò di Tommaso, Follower of, p. 35, Fig. 74
Orcagna, Follower of, p. 32, Fig. 72
Sassetta and Assistant, p. 141, Figs. 378–382
Sienese School, c. 1370, p. 56, Fig. 146
Spinello Aretino, Studio of, p. 45, Fig. 116

*The figure or scene is a minor part of the picture.

ANTHONY OF PADUA
Cozzarelli, p. 161, Fig. 437
Guariento, p. 10, Fig. 19
(?) Master of the Orcagnesque Misericordia, p. 38, Fig. 90
Sano di Pietro, p. 145, Fig. 391

APOLLONIA
Neri di Bicci, p. 113, Fig. 310
Sassetta, Attributed to, p. 143, Fig. 384

AUGUSTINE
Giovanni di Paolo, p. 148, Fig. 401
(?) Girolamo di Benvenuto, p. 161, Fig. 443
Giusto de'Menabuoi, p. 39, Fig. 92
Lippi, Filippino, p. 136, Fig. 374
Sano di Pietro, p. 146, Fig. 393

BARTHOLOMEW
Andrea di Bartolo, Studio of, p. 67, Fig. 180
Master of San Torpè, Attributed to, p. 19, Fig. 39
Neri di Bicci, p. 113, Fig. 305
Orcagna, Follower of, p. 32, Fig. 72
Sano di Pietro, p. 145, Fig. 389
Sienese School, Mid-XIV Century, p. 56, Fig. 143
Sienese School, c. 1440, p. 147, Fig. 400

BENEDICT
Daddi, Follower of, p. 28, Fig. 60
Lippi, Fra Filippo, p. 107, Fig. 290
*(?) Margaritone, p. 3, Fig. 1
Sano di Pietro, p. 146, Fig. 394

BERNARD
Neri di Bicci, p. 112, Fig. 309
Sano di Pietro, p. 146, Fig. 397

BERNARDINE
*Giovanni di Paolo, p. 148, Fig. 401
Master of Fucecchio, p. 106, Fig. 288
Pellegrino di Mariano, p. 151, Fig. 413
Sano di Pietro, p. 146, Figs. 390, 392, 397
Vecchietta, Follower of, p. 152, Fig. 410

BONA OF POGGIBONSI, BLESSED
Lippi, Filippino, and Assistants, p. 137, Fig. 372

CATHERINE OF ALEXANDRIA
Barnaba da Modena, Follower of, p. 12, Figs. 17–18
(?) Daddi and Assistant, p. 26, Fig. 62
(?) Daddi, Attributed to, p. 27, Fig. 59
Daddi, Follower of, p. 28, Fig. 63
Florentine School, Mid-XIV Century, p. 34, Fig. 73
Francesco d'Antonio, p. 93, Fig. 253
Giovanni del Biondo, p. 37, Figs. 85, 87
Giusto de'Menabuoi, p. 39, Fig. 93
Jacopino di Francesco, p. 71, Figs. 190–191
Jacopo del Casentino and Assistant, p. 25, Fig. 57
Master of the Ovile Madonna, p. 54, Fig. 145
Master of the St. Verdiana Panel, p. 41, Fig. 104; p. 42, Fig. 105

Matteo di Giovanni, p. 156, Fig. 423
Niccolò di Segna, p. 17, Fig. 37
Niccolò di Tommaso, Follower of, p. 35, Fig. 74
Orcagna, Follower of, p. 32, Fig. 72
(?) Sassetta, Follower of, p. 144, Fig. 412
Sienese School, c. 1370, p. 56, Fig. 146
Taddeo di Bartolo, p. 64, Fig. 167

CATHERINE OF SIENA
'Alunno di Benozzo,' p. 117, Fig. 318
Gherardo del Fora, p. 138, Fig. 366
Girolamo di Benvenuto, p. 163, Fig. 440
Matteo di Giovanni, p. 157, Fig. 425

CHRISTINA
Venetian School, Early XIV Century, p. 9, Fig. 23

CHRISTOPHER
Barnaba da Modena, Follower of, p. 12, Fig. 17
*Biagio d'Antonio da Firenze, p. 131, Fig. 356
Cozzarelli, p. 161, Fig. 436
Francesco d'Antonio, p. 93, Fig. 253

CLARE
Lorenzetti, Pietro, Attributed to, p. 52, Fig. 131
Vanni, Andrea, p. 58, Fig. 155

CLEMENT
Lorenzo Monaco, Follower of, p. 90, Fig. 241

COSMAS
Angelico, Fra, p. 94, Figs. 258, 262
Francesco d'Antonio, p. 93, Fig. 253
Master of the Rinuccini Chapel, p. 35, Figs. 79–81

DAMIAN
Angelico, Fra, p. 94, Figs. 258, 262
Francesco d'Antonio, p. 93, Fig. 253
Master of the Rinuccini Chapel, p. 35, Figs. 79–81

DIONYSIUS
(?) Master of the Goodhart Madonna, p. 18, Fig. 40

DOMINIC
Angelico, Fra, Attributed to, p. 97, Fig. 256
(?) Biagio d'Antonio da Firenze, p. 131, Fig. 356
Biagio d'Antonio da Firenze, p. 133, Fig. 360
Ghirlandaio, Domenico, Follower of, p. 127, Fig. 343
Sano di Pietro, Follower of, p. 147, Fig. 395
Vanni, Lippo, p. 57, Fig. 147

DONATUS
Lippi, Filippino, p. 136, Fig. 373
Taddeo di Bartolo, Follower of, p. 64, Fig. 170

DOROTHY
(?) Daddi and Assistant, p. 26, Fig. 62
Lorenzo di Niccolò, p. 44, Fig. 117
Master of the St. Verdiana Panel, p. 42, Fig. 105

ELIGIUS
Master of Staffolo, p. 79, Fig. 217

*The figure or scene is a minor part of the picture.

ELIZABETH OF HUNGARY
 (?) Daddi and Assistant, p. 26, Fig. 62
 Lippi, Filippino, and Assistants, p. 137, Fig. 372
 Vanni, Lippo, p. 57, Fig. 148

FLORIAN
 Cossa, p. 83, Fig. 222

FRANCIS
 'Alunno di Benozzo,' p. 118, Fig. 319
 Andrea di Giusto, p. 98, Fig. 264
 Andrea di Niccolò, Attributed to, p. 152, Fig. 411
 Angelico, Fra, Attributed to, p. 97, Fig. 256
 Daddi and Assistant, p. 26, Fig. 62
 Domenico di Michelino, p. 101, Fig. 272
 Domenico Veneziano, p. 103, Fig. 279
 Fei, p. 62, Fig. 161
 Francesco d'Antonio, p. 93, Fig. 253
 Giotto and Assistants, p. 21, Fig. 46
 Guariento, p. 10, Fig. 19
 Jacopo del Casentino and Assistant, p. 25, Fig. 57
 Lippi, Filippino, and Assistants, p. 137, Fig. 372
 Lorenzo di Niccolò, p. 44, Fig. 117
 Master of the Orcagnesque Misericordia, p. 38, Fig. 90
 Pesellino, p. 110, Fig. 300
 Sano di Pietro, p. 145, Fig. 391
 Sellaio, p. 133, Fig. 364
 Sienese School, Mid-XIV Century, p. 56, Fig. 143
 Tura, p. 82, Fig. 226
 Turino di Vanni, Attributed to, p. 74, Fig. 200
 Uccello, Follower of, p. 102, Fig. 275
 *Venetian School, c. 1300, p. 7, Fig. 14

GEMINIANUS
 (?) Taddeo di Bartolo, p. 64, Fig. 168
 Taddeo di Bartolo, p. 64, Fig. 169

GEORGE
 Daddi, Studio of, p. 27, Fig. 64
 Francesco d'Antonio, p. 93, Fig. 253
 Giovanni dal Ponte, p. 92, Figs. 246, 248

GILES
 Guariento, p. 10, Fig. 19

HELENA
 Spinello Aretino, Studio of, p. 45, Fig. 116

JAMES MAJOR
 Daddi, Follower of, p. 28, Fig. 63; p. 29, Fig. 67
 Francesco d'Antonio, p. 93, Fig. 253
 Master of the St. Verdiana Panel, p. 41, Fig. 104
 Neri di Bicci, p. 112, Fig. 309; p. 113, Fig. 305
 (?) Niccolò di Tommaso, Follower of, p. 35, Fig. 74
 Pesellino and Studio, p. 110, Fig. 303
 Simone Martini and Assistants, p. 48, Fig. 124
 Taddeo di Bartolo, p. 63, Fig. 165

JAMES MINOR
 Master of St. Francis, p. 4, Fig. 3

JEROME
 Andrea di Giusto, p. 98, Fig. 264
 Andrea di Niccolò, Attributed to, p. 152, Fig. 411
 Biagio d'Antonio da Firenze, p. 132, Fig. 358; p. 133, Fig. 360
 Cecco di Pietro, p. 73, Fig. 198
 Domenico di Michelino, p. 101, Fig. 271
 Giovanni di Paolo, p. 148, Fig. 401
 Girolamo di Benvenuto, p. 161, Figs. 441, 447
 Lippi, Filippino, p. 137, Fig. 375
 (?) Matteo di Giovanni, p. 156, Fig. 423
 Neroccio de'Landi, p. 155, Fig. 415
 Pesellino, p. 110, Fig. 300
 Rosselli, p. 120, Fig. 325
 Sano di Pietro, p. 145, Fig. 391; p. 146, Fig. 392
 Sellaio, p. 133, Fig. 364
 Simone dei Crocifissi, p. 72, Fig. 195
 Veneto-Byzantine School, Late XIV Century, p. 11, Fig. 26

JOACHIM
 Andrea di Bartolo, p. 66, Fig. 175

JOHN THE BAPTIST
 Biagio d'Antonio da Firenze, p. 131, Fig. 356; p. 133, Fig. 360
 Cimabue, Attributed to, p. 5, Fig. 9
 Daddi, p. 26, Fig. 61
 — and Assistant, p. 26, Fig. 62
 — Studio of, p. 27, Fig. 64
 — Follower of, p. 28, Fig. 63
 Domenico Veneziano, p. 103, Fig. 280
 Duccio, Follower of, p. 15, Figs. 25, 33
 Florentine School, Late XIV Century, p. 38, Fig. 88
 Francesco d'Antonio, p. 93, Fig. 251
 Ghirlandaio, Domenico, Studio of, p. 126, Fig. 338
 Ghirlandaio, Domenico, Follower of, p. 127, Fig. 339
 Giotto and Assistants, p. 21, Fig. 44
 Giovanni del Biondo, p. 37, Fig. 85
 Giovanni di Paolo, p. 148, Fig. 401
 Girolamo di Benvenuto, p. 161, Fig. 444
 Giusto de'Menabuoi, p. 39, Fig. 94
 Gozzoli, p. 116, Fig. 317
 Guariento, p. 10, Fig. 19
 Jacopo del Casentino and Assistant, p. 24, Fig. 54; p. 25, Fig. 57
 Jacopo di Cione, Attributed to, p. 33, Fig. 82
 Lorenzetti, Pietro, Follower of, p. 53, Fig. 134
 Lorenzo di Niccolò, p. 44, Fig. 110
 Master of the Apollo and Daphne Legend, p. 130, Figs. 348, 350
 Master of the Goodhart Madonna, p. 18, Fig. 40
 Master of the Life of St. John the Baptist, p. 68, Fig. 183; p. 69, Figs. 184, 185
 Master of San Torpè, Attributed to, p. 19, Fig. 39
 Memmi, p. 49, Figs. 126, 127
 Neri di Bicci, p. 112, Fig. 309
 Neroccio de'Landi, Follower of, p. 156, Fig. 422
 Orcagna, Follower of, p. 32, Fig. 72
 Pellegrino di Mariano, p. 151, Fig. 413

*The figure or scene is a minor part of the picture.

Pesellino, Follower of, p. 111, Fig. 307
Pier Francesco Fiorentino, Pseudo, p. 115, Fig. 314
Rosselli, p. 120, Fig. 325
Sano di Pietro, p. 145, Figs. 389, 391
Sellaio, p. 133, Fig. 368
— Follower of, p. 134, Fig. 365
Sienese School, c. 1370, p. 56, Fig. 146
Sienese School, c. 1440, p. 147, Fig. 400
Simone dei Crocifissi, p. 72, Fig. 195
Spinello Aretino, Studio of, p. 45, Fig. 116
Taddeo di Bartolo, p. 63, Fig. 166
Tuscan School, XIV Century, p. 31, Figs. 65
Venetian School, Late XIV Century, p. 11, Fig. 16

JOHN THE EVANGELIST
'Alunno di Benozzo,' p. 117, Fig. 318
Andrea di Bartolo, Studio of, p. 67, Fig. 181
*Barnaba da Modena, Follower of, p. 12, Fig. 18
(?) Diamante, Fra, p. 109, Fig. 293
Florentine School, Late XIV Century, p. 38, Fig. 88
Ghirlandaio, Domenico, Studio of, p. 126, Fig. 338
Giotto and Assistants, p. 21, Fig. 45
Giotto, Follower of, p. 22, Fig. 51
(?) Giovanni di Paolo, p. 149, Fig. 403
Jacopino di Francesco, p. 71, Fig. 192
Lombard School, XV Century, p. 80, Fig. 220
*(?) Lorenzetti, Pietro, Follower of, p. 53, Fig. 134
*(?) Margaritone, p. 3, Fig. 1
(?) Master of the Clarisse Panel, p. 13, Fig. 34
Master of the Franciscan Crucifixes, p. 4, Fig. 5
Master of the Orcagnesque Misericordia, p. 38, Figs. 89–90
Master of St. Francis, p. 4, Fig. 2
Michele di Matteo, p. 73, Fig. 194
Nardo di Cione, p. 34, Fig. 75
(?) Niccolò di Tommaso, Follower of, p. 35, Fig. 74
Nuzi, p. 75, Figs. 207–210
Orcagna, Follower of, p. 32, Fig. 72
Pesellino and Studio, p. 110, Fig. 303

JOHN GUALBERT
Benvenuto di Giovanni, p. 159, Fig. 433
Daddi, Follower of, p. 28, Fig. 60

JOSEPH
Giovanni di Paolo, p. 148, Fig. 402
[Joseph appears also in scenes of the Nativity, etc.]

JULIAN
Cristiani, Follower of, p. 40, Fig. 102
Francesco d'Antonio, p. 93, Fig. 253
Lorenzo Monaco, Follower of, p. 90, Fig. 241
Master of the St. Verdiana Panel, p. 42, Fig. 105

JUSTINA
Cossa, Follower of, p. 85, Fig. 234

LAWRENCE
Francesco d'Antonio, p. 93, Fig. 253

(?) Giovanni dal Ponte, p. 92, Fig. 246
Master of Fucecchio, p. 106, Fig. 286

LEONARD
Francesco d'Antonio, p. 93, Fig. 253

LOUIS IX OF FRANCE
Lippi, Filippino, and Assistants, p. 137, Fig. 372

LOUIS OF TOULOUSE
Biagio d'Antonio da Firenze, p. 131, Fig. 356
Fei, p. 62, Fig. 161

LUCCHESIUS OF POGGIBONSI, BLESSED
Lippi, Filippino, and Assistants, p. 137, Fig. 372

LUCY
Cossa, p. 83, Fig. 223
Daddi and Assistant, p. 26, Fig. 62
Jacopo del Casentino and Assistant, p. 24, Fig. 55
Jacopo di Cione, Attributed to, p. 33, Fig. 82
Master of the St. Verdiana Panel, p. 41, Fig. 104
Master of Staffolo, p. 79, Fig. 217
Orcagna, Follower of, p. 32, Fig. 72
Turino di Vanni, Attributed to, p. 74, Fig. 199

LUKE
Giovanni di Paolo, p. 149, Fig. 405
Master of the Orcagnesque Misericordia, p. 38, Fig. 89

MARGARET
Andrea di Niccolò, Attributed to, p. 152, Fig. 411
Daddi and Assistant, p. 26, Fig. 62
Daddi, Follower of, p. 28, Fig. 63
Girolamo di Benvenuto, p. 161, Fig. 445
(?) Master of the Clarisse Panel, p. 13, Fig. 34
Neri di Bicci, p. 112, Fig. 309
Sassetta, Attributed to, p. 143, Fig. 385
Segna di Buonaventura, Follower of, p. 17, Fig. 30

MARK
Master of the Orcagnesque Misericordia, p. 38, Fig. 89

MARY OF EGYPT
Gherardo del Fora, p. 138, Fig. 366
*(?) Sellaio, p. 133, Fig. 368

MARY MAGDALENE
Daddi, p. 26, Fig. 61
*Giovanni di Paolo, p. 148, Fig. 401
Jacopino di Francesco, p. 71, Fig. 189
(?) Lorenzetti, Pietro, Attributed to, p. 51, Fig. 130
Lorenzo di Niccolò, p. 44, Fig. 117
Master of the Clarisse Panel, p. 13, Fig. 34
Master of the Ovile Madonna, p. 54, Fig. 139
Neroccio de'Landi, p. 155, Fig. 415
— Follower of, p. 156, Fig. 422

MATTHEW
Master of the Orcagnesque Misericordia, p. 38, Fig. 89
Neri di Bicci, p. 112, Fig. 309
Simone Martini and Assistants, p. 48, Fig. 125

*The figure or scene is a minor part of the picture.

MAURELIUS
Tura, p. 82, Fig. 229

MAURUS
Lippi, Fra Filippo, p. 107, Figs. 290, 292

NICHOLAS OF BARI
Daddi, Follower of, p. 28, Fig. 63
Gentile da Fabriano, p. 77, Fig. 211
Lorenzo di Niccolò, p. 44, Fig. 110
Luca di Tommè, p. 60, Fig. 153
Master of the Bambino Vispo, p. 90, Fig. 242
Master of the St. Verdiana Panel, p. 42, Fig. 105

NICHOLAS OF TOLENTINO
Biagio d'Antonio da Firenze, p. 131, Fig. 356

PANCRAS
Daddi, Follower of, p. 28, Fig. 60

PAUL
Andrea di Bartolo, Studio of, p. 67, Fig. 180
Antonio Veneziano, p. 46, Fig. 114
Daddi, p. 26, Fig. 61
— and Assistant, p. 26, Fig. 62
— Follower of, p. 28, Fig. 63
Domenico di Bartolo, p. 140, Fig. 377
Florentine School, Mid-XIV Century, p. 34, Fig. 73
Giusto de'Menabuoi, p. 39, Fig. 92
Jacopo del Casentino and Assistant, p. 25, Fig. 57
Lorenzetti, Pietro, Attributed to, p. 51, Fig. 130
Luca di Tommè, p. 60, Fig. 153
— Studio of, p. 60, Fig. 158
Master of the St. Verdiana Panel, p. 41, Fig. 104
Orcagna, Follower of, p. 32, Fig. 72
Simone dei Crocifissi, p. 72, Fig. 195

PAUL THE HERMIT
Sassetta and Assistant, p. 141, Fig. 380

PETER
Andrea di Bartolo, Studio of, p. 67, Fig. 181
Cimabue, Attributed to, p. 5, Fig. 9
Cozzarelli, p. 161, Fig. 437
Daddi, p. 26, Fig. 61
— and Assistant, p. 26, Fig. 62
— Studio of, p. 27, Fig. 64
— Follower of, p. 28, Fig. 63
Domenico di Bartolo, p. 140, Fig. 377
Duccio, p. 14, Fig. 28
— Follower of, p. 15, Figs. 25, 33
Giambono, p. 79, Fig. 221
Jacopo del Casentino and Assistant, p. 25, Fig. 57
Jacopo di Cione, Attributed to, p. 33, Fig. 82
Lorenzetti, Pietro, Attributed to, p. 51, Fig. 130
Master of the St. Verdiana Panel, p. 41, Fig. 104
Nardo di Cione, p. 34, Fig. 75
Orcagna, Follower of, p. 32, Fig. 72
Pesellino and Studio, p. 110, Fig. 303

Sassetta, Follower of, p. 144, Fig. 412
Simone dei Crocifissi, p. 72, Fig. 195
Zoppo, p. 87, Fig. 238

PETER MARTYR
Gherardo del Fora, p. 138, Fig. 366
Sano di Pietro, p. 145, Fig. 391

PLACIDUS
Lippi, Fra Filippo, p. 107, Figs. 290, 292

PROSPER
Jacopo del Casentino, Follower of, p. 25, Fig. 58

ROCH
Cozzarelli, p. 161, Fig. 437

ROMUALD
Lorenzo Monaco, Studio of, p. 89, Fig. 244

ROSALIE
Andrea di Niccolò, Attributed to, p. 152, Fig. 411

SABINUS
(?) Master of the Clarisse Panel, p. 13, Fig. 34

SEBASTIAN
*Biagio d'Antonio da Firenze, p. 131, Figs. 356–357
Cozzarelli, p. 161, Fig. 436
(?) Diamante, Fra, p. 109, Fig. 295
Matteo di Giovanni, p. 157, Fig. 425

SIGISMUND
Neroccio de'Landi, p. 155, Fig. 421

SIMON
Simone Martini and Assistants, p. 48, Fig. 123

STEPHEN
(?) Giovanni dal Ponte, p. 92, Fig. 246
Lorenzo di Niccolò, Attributed to, p. 45, Fig. 108
Master of Fucecchio, p. 106, Fig. 286

THADDEUS
Simone Martini and Assistants, p. 48, Fig. 122

THOMAS AQUINAS
Giusto de'Menabuoi, p. 39, Fig. 95
Sano di Pietro, Follower of, p. 147, Fig. 396

URSULA
(?) Andrea di Niccolò, Attributed to, p. 152, Fig. 411
Cozzarelli, p. 161, Fig. 436
Gozzoli, p. 115, Fig. 315
(?) Master of the Stratonice Cassoni, p. 139, Fig. 367
Venetian School, Early XIV Century, p. 9, Fig. 23

VERDIANA
Master of the St. Verdiana Panel, p. 42, Fig. 105

VITALIS
Niccolò di Segna, p. 17, Fig. 36

ZENOBIUS
(?) Daddi, Studio of, p. 27, Fig. 64

*The figure or scene is a minor part of the picture.

PORTRAITS

ANDREAS (brother of King Ludwig I of Hungary)
(?) Vanni, Lippo, p. 57, Fig. 149

ATTENDOLI, MATTEO DE', OF BOLOGNA
Lombard School, XV Century, p. 80, Fig. 220

BENTIVOGLIO, GINEVRA
Roberti, p. 86, Fig. 233

BENTIVOGLIO, GIOVANNI II
Roberti, p. 86, Fig. 232

ELIZABETH, QUEEN OF HUNGARY
(?) Vanni, Lippo, p. 57, Fig. 149

FRANCESCO DA CASTIGLIONE, MONSIGNOR
Lippi, Filippino, Attributed to, p. 138, Fig. 376

GONZAGA, FRANCESCO II, FOURTH MARQUIS
OF MANTUA
Baldassare d'Este, Attributed to, p. 83, Fig. 231

LUDWIG I (the Great, of Hungary)
(?) Vanni, Lippo, p. 57, Fig. 149

MEDICI, GIULIANO DE'
Botticelli, p. 121, Fig. 335

PETRARCH'S LAURA
(?) Girolamo di Benvenuto, p. 162, Fig. 449

RAGNOLI, NICOLÒ
Biagio d'Antonio da Firenze, p. 131, Fig. 356

TORNABUONI, LUCREZIA
Ghirlandaio, Domenico, p. 125, Fig. 334

PROFANE SUBJECTS

ACTIUM
Neroccio de'Landi, p. 154, Fig. 418

AENEAS
Francesco di Giorgio, Studio of, p. 154, Fig. 420

ANTONY
Neroccio de'Landi, p. 154, Fig. 417

APOLLO
Master of the 'Apollini Sacrum,' p. 128, Fig. 345
Master of the Apollo and Daphne Legend, p. 129, Figs. 347, 349

ARISTOTLE
Pesellino and Studio, p. 110, Fig. 302

ARITHMETIC
Pesellino and Studio, p. 110, Fig. 302

ASTROLOGY (ASTRONOMY)
Pesellino and Studio, p. 110, Fig. 302

BOCCACCIO'S DECAMERON
(?) Master of the Griggs Crucifixion, p. 99, Fig. 270

CAESAR, JULIUS
Master of the 'Apollini Sacrum,' p. 128, Fig. 352

CALLISTO
Master of the Griggs Crucifixion, Circle of, p. 100, Fig. 269

CHARITY
Pesellino and Studio, p. 110, Fig. 303

CHASTITY
Apollonio di Giovanni, p. 98, Fig. 265

CICERO
Pesellino and Studio, p. 110, Fig. 302

CLEOPATRA
Neroccio de'Landi, p. 154, Fig. 417

CUPID
Girolamo di Benvenuto, p. 162, Fig. 448

DAPHNE
Master of the Apollo and Daphne Legend, p. 129, Figs. 347, 349

DIANA
Master of the Griggs Crucifixion, Circle of, p. 100, Fig. 269

DIDO
Francesco di Giorgio, Studio of, p. 154, Fig. 420

DIOCLETIAN
Niccolò di Pietro Gerini, p. 43, Fig. 109
(?) Niccolò di Pietro Gerini, p. 43, Fig. 113

ENDYMION
Master of the Griggs Crucifixion, Circle of, p. 100, Fig. 269

EUCLID
Pesellino and Studio, p. 110, Fig. 302

FAITH
Pesellino and Studio, p. 110, Fig. 303

FORTITUDE
Pesellino and Studio, p. 110, Fig. 303

GEOMETRY
Pesellino and Studio, p. 110, Fig. 302

GRAMMAR
Pesellino and Studio, p. 110, Fig. 302

HELEN OF TROY
(?) Florentine School, Mid-XV Century, p. 99, Fig. 268

HOPE
Pesellino and Studio, p. 110, Fig. 303

JUSTICE
Pesellino and Studio, p. 110, Fig. 303

LOGIC
Pesellino and Studio, p. 110, Fig. 302

MUSIC
Pesellino and Studio, p. 110, Fig. 302

PRISCIAN
Pesellino and Studio, p. 110, Fig. 302

PRUDENCE
Pesellino and Studio, p. 110, Fig. 303

PTOLEMY
Pesellino and Studio, p. 110, Fig. 302

PYTHAGORAS
Pesellino and Studio, p. 110, Fig. 302

RHETORIC
Pesellino and Studio, p. 110, Fig. 302

SCIPIO AFRICANUS
Biagio d'Antonio da Firenze, p. 132, Fig. 355
Pesellino and Studio, p. 110, Fig. 303

SOLON
Pesellino and Studio, p. 110, Fig. 303

TEMPERANCE
Pesellino and Studio, p. 110, Fig. 303

THESEUS
Uccello, Paolo, Follower of, p. 102, Figs. 276–277

TRIUMPH OF CHASTITY (PETRARCH)
Apollonio di Giovanni, p. 98, Fig. 265

TUBALCAIN
Pesellino and Studio, p. 110, Fig. 302

VENUS
Girolamo di Benvenuto, p. 162, Fig. 448

INDEX OF PREVIOUS OWNERS

ABDY, Sir William Neville
Attributed to Botticelli, p. 123, Fig. 331

ACTON, Arthur
Rosselli, p. 121, Fig. 326

AGNEW
Forentine School, Second Half of XV Century, p. 119, Fig. 323
Girolamo di Benvenuto, p. 162, Fig. 449

ALBERTI
Follower of Giotto, p. 22, Fig. 48

ALDROVANDI
Filippino Lippi, p. 136, Figs. 373–374

ALLENDALE, Viscount
Sassetta and Assistant, p. 141, Figs. 380–381

AMADEO
Italian School, c. 1300, p. 6, Figs. 11–12

AMARO
Studio of Giovanni di Paolo, p. 150, Fig. 407
Venetian School, c. 1300, p. 7, Fig. 14

ANONYMOUS SALES
Amsterdam
Nov. 22, 1929
Belbello da Pavia, p. 81, Fig. 206
London
April 26, 1929
Sano di Pietro, p. 146, Figs. 393–394
Dec. 10, 1937
Studio of Domenico Ghirlandaio, p. 126, Fig. 338
Paris
Dec. 16, 1929
Botticelli, p. 122, Fig. 333

Ullswater, England
Aug. 8, 1934
Attributed to Cimabue, p. 6, Fig. 9

ANTHONY
Sassetta and Assistant, p. 141, Figs. 380–381

ARTAUD DE MONTOR, Alexis-François
Attributed to Fra Angelico, p. 97, Fig. 256
Master of the Griggs Crucifixion, p. 99, Fig. 270

ASH, Rev. Dr.
Tuscan School, XIV Century, p. 31, Fig. 65

ASHBURNHAM, Earl of
Domenico di Bartolo, p. 140, Fig. 377
Matteo di Giovanni, p. 156, Fig. 423

ASSISI
San Francesco, Lower Church
Master of St. Francis, p. 4, Figs. 2–3

AUSTEN, Francis
Master of the Stratonice Cassoni, p. 139, Fig. 367

AUSTEN, John Francis
Botticelli and Assistants, p. 122, Fig. 332
Master of the Stratonice Cassoni, p. 139, Fig. 367

AVOGLI-TROTTI, Conte
Lombard School, XV Century, p. 80, Fig. 220
Simone dei Crocifissi, p. 72, Fig. 195

AYNARD, Édouard
Fra Filippo Lippi, p. 107, Figs. 290, 292
Sellaio, p. 134, Fig. 361

BACHE, Jules S.
Master of the Bambino Vispo, p. 91, Fig. 245

BACHSTITZ
 Follower of Barnaba da Modena, p. 12, Fig. 18
 Fra Filippo Lippi, p. 107, Fig. 299

BAGNO, Marchesa (Rome)
 Modern Imitation of XIII Century Italian School [K1301, not
 catalogued]

BARCLAY, Colonel
 Master of the Buckingham Palace Madonna, p. 100, Fig. 274

BARDINI, Stefano
 Attributed to Fra Angelico, p. 97, Fig. 257
 Giambono, p. 79, Fig. 221
 Filippino Lippi and Assistants, p. 137, Fig. 372
 Master of the Ovile Madonna, p. 54. Fig. 139

BARGAGLI-PETRUCCI
 Follower of Neroccio de'Landi, p. 156, Fig. 422

BARKER, Alexander
 Fra Angelico and Fra Filippo Lippi, Frontispiece; p. 95,
 Figs. 259-261
 Gentile da Fabriano, p. 76, Fig. 212

BATTERSEA, Lord
 Florentine School, c. 1475, p. 119, Fig. 328

BEAUMONT, Wentworth Blackett, later First Lord Allendale
 Sassetta and Assistant, p. 141, Figs. 380-381

BELLESI, Giuseppe
 Francesco d'Antonio, p. 93, Fig. 253
 Agnolo Gaddi, p. 40, Figs. 98-99
 Studio of Lorenzo Monaco, p. 89, Fig. 244
 Master of the Apollo and Daphne Legend, p. 130, Figs. 348, 350
 Master of the Fabriano Altarpiece, p. 29, Fig. 68
 Master of the Ovile Madonna, p. 55, Fig. 142
 Matteo di Giovanni, p. 157, Fig. 426
 Sano di Pietro, p. 145, Fig. 391; p. 146, Figs. 393-394

BENI, Conte U.
 Cossa, p. 83, Figs. 222-223

BENSON, Robert H. and Evelyn
 Duccio, p. 14, Fig. 28
 Giovanni di Paolo, p. 148, Figs. 402, 404
 Girolamo di Benvenuto, p. 162, Fig. 449
 Filippino Lippi, p. 135, Fig. 369; p. 136, Fig. 371

BERENSON, Bernard
 Domenico Veneziano, p. 103, Fig. 280

BERLIN
 Kaiser Friedrich Museum
 Fra Filippo Lippi, p. 106, Fig. 289
 Staatliche Museen
 Attributed to Botticelli, p. 123, Fig. 331

BERMUDEZ, Comte de
 Palmerucci, p. 56, Fig. 144

BERN, Louis-Philippe
 Circle of the Master of the Griggs Crucifixion, p. 100, Fig. 269

BERNARD
 Studio of Domenico Ghirlandaio, p. 126, Fig. 338

BIANCO
 Giovanni da Milano, p. 39, Fig. 97

BLAYDS, Mr.
 Andrea Vanni, p. 57, Fig. 156

BLIVES, Comte Roger de
 Girolamo di Benvenuto, p. 163, Fig. 440

BLOCH, Vitale
 Andrea Vanni, p. 57, Fig. 156

BÖHLER, Julius
 Fra Angelico, p. 94, Figs. 258, 262
 Follower of Barnaba da Modena, p. 12, Fig. 18
 Domenico Veneziano, p. 103, Figs. 278-279
 Francesco d'Antonio, p. 92, Fig. 250
 Lombard School, XV Century, p. 80, Fig. 220
 Master of the Ovile Madonna, p. 54, Fig. 145
 Pesellino, p. 110, Fig. 301
 Veronese School, Early XV Century, p. 78, Figs. 215-216

BOLOGNA
 Santa Maria in Borgo
 (?) Master of the Franciscan Crucifixes, p. 4, Figs. 4-5

BONDI, Max
 Attributed to Jacopo di Cione, p. 33, Fig. 82
 Master of the 'Apollini Sacrum,' p. 128, Figs. 345-346
 Taddeo di Bartolo, p. 63, Fig. 171

BONDY, Oscar
 Follower of Bernardo Daddi, p. 28, Fig. 63

BOSCHINI
 Guariento, p. 10, Fig. 19

BOTTENWIESER, P.
 Giovanni di Paolo, p. 149, Fig. 403

BOURBON DEL MONTE, Marchese
 Follower of Niccolò di Tommaso, p. 35, Fig. 74

BRADY, Mrs. Nicholas F.
 Attributed to Botticelli, p. 123, Fig. 337

BRAUER, Godefroy
 Master of the Ovile Madonna, p. 54, Fig. 145

BRENTANO, Arthur
 Tuscan School, XIV Century, p. 31, Fig. 65

BRETT, John Watkins
 Master of the Stratonice Cassoni, p. 139, Fig. 367

BRIZZI, Mariano Rovaro
 Lucchese School, c. 1200, p. 3, Fig. 6

BROUX-GILBERT, M.
 Attributed to Botticelli, p. 123, Fig. 331

BROWN, Lady Florence
 Follower of Gozzoli, p. 116, Fig. 316

BUCK, Fejer de
 Master of San Martino alla Palma, p. 30, Fig. 71

BUCKLAND, Commander Virgoe
 Daddi, p. 26, Fig. 61

BUCKLEY, W.
Fra Diamante, p. 109, Figs. 293–298

BURNS, Mrs. Walter
Attributed to Fra Angelico, p. 97, Fig. 256

BUTLER, Charles
Daddi and Assistant, p. 26, Fig. 62
Follower of Lorenzo Monaco, p. 90, Fig. 240

CACCIALUPI, Conte Augusto
Sassetta and Assistant, p. 141, Figs. 378–379

CANESSA
Attributed to Pietro Lorenzetti, p. 51, Fig. 130
Taddeo di Bartolo, p. 63, Fig. 163

CARRINGTON, Hugh B.
Andrea Vanni, p. 57, Fig. 156

CASTELLANI
Lucchese School, c. 1200, p. 3, Fig. 6

CASTELLINO, Professor Niccolò
Master of the 'Apollini Sacrum,' p. 128, Fig. 352

CERNUSCHI, Enrico
Fra Filippo Lippi, p. 107, Figs. 290, 292

CHABRIÈRE-ARLÈS, Max
Sienese School, c. 1440, p. 147, Figs. 398–400

CHALANDON, Georges
Attributed to Fra Angelico, p. 97, Fig. 256

CHEETHAM, Hon. J. F.
Florentine School, Second Half of XV Century, p. 119, Fig. 323

CHIESA, Achillito
Follower of Daddi, p. 28, Fig. 60
Dalmasio, p. 71, Fig. 196
Follower of Agnolo Gaddi, p. 40, Fig. 100
Guariento, p. 10, Fig. 19
Jacopo del Casentino, p. 24, Fig. 56
Jacopo di Paolo, p. 72, Fig. 197
Fra Filippo Lippi, p. 107, Fig. 299
Attributed to Pietro Lorenzetti, p. 51, Fig. 130; p. 52, Fig. 131
— Follower of, p. 52, Fig. 141
Attributed to Lorenzo Veneziano, p. 9, Fig. 20
Luca di Tommè, p. 59, Fig. 157
Master of the 'Apollini Sacrum,' p. 128, Fig. 352
Studio of Orcagna, p. 32, Fig. 77
Paolo Veneziano, p. 8, Fig. 10
Pellegrino di Mariano, p. 151, Fig. 413
Studio of Sassetta, p. 144, Fig. 386
Follower of Sassetta, p. 144, Fig. 412
Schiavo, p. 105, Fig. 281
Attributed to Uccello, p. 101, Fig. 273

CHIGI ALBANI DELLA ROVERE, Principe
Cozzarelli, p. 161, Figs. 436–437
Girolamo di Benvenuto, p. 161, Figs. 441–446

CHIGI-ZONDADARI, Marchese
Fei, p. 61, Fig. 160

CIACCHERI, Signora
Girolamo di Benvenuto, p. 162, Fig. 449

CINI, Conte Vittorio
Botticelli, p. 121, Fig. 335
Gozzoli, p. 116, Fig. 317

CLARK, H. M.
Fei, p. 62, Fig. 159

CLEMENTE, De
Michele di Matteo, p. 73, Figs. 193–194

COCK, Victor de
Rosselli, p. 120, Fig. 330

COLNAGHI
Attributed to Cimabue, p. 5, Fig. 9
Master of the Stratonice Cassoni, p. 139, Fig. 367

COLOGNE
Wallraf-Richartz Museum
Giovanni di Paolo, p. 149, Fig. 403
Follower of Segna di Buonaventura, p. 17, Fig. 30
Simone Martini and Assistants, p. 48, Figs. 122–125

CONESTABILE
Follower of Giotto, p. 22, Fig. 51

CONINGHAM. William
Fra Angelico and Fra Filippo Lippi, Frontispiece; p. 95, Figs. 259–261

CONTINI BONACOSSI
'Alunno di Benozzo,' p. 117, Figs. 318, 320; p. 118, Fig. 319
Andrea di Bartolo, p. 66, Figs. 173–178
— Studio of, p. 67, Figs. 180–181
Andrea di Giusto, p. 98, Fig. 264; p. 99, Fig. 266
Attributed to Andrea di Niccolò, p. 152, Fig. 411
Attributed to Fra Angelico, p. 97, Fig. 256
Antonio Veneziano, p. 46, Fig. 114
Apollonio di Giovanni, p. 98, Figs. 263, 265, 267
Attributed to Barna da Siena, p. 50, Fig. 128
Follower of Barnaba da Modena, p. 12, Figs. 17–18
Bartolommeo di Giovanni, p. 129, Fig. 351
Attributed to Battista da Vicenza, p. 74, Fig. 203
Benvenuto di Giovanni, p. 158, Fig. 428
Biagio d'Antonio da Firenze, p. 132, Figs. 355, 358–359, 362; p. 133, Fig. 360
Bicci di Lorenzo, p. 47, Fig. 120
— Follower of, p. 47, Fig. 119
Attributed to Botticelli, p. 124, Fig. 327
Cecco di Pietro, p. 73, Figs. 198, 201
Cenni di Francesco, p. 42, Fig. 101
Attributed to Cimabue, p. 5, Fig. 9
Follower of Cimabue, p. 6, Fig. 7
Attributed to Cossa, p. 85, Fig. 235
Follower of Cossa, p. 85, Fig. 234
Cozzarelli, p. 159, Fig. 435; p. 160, Figs. 434, 439; p. 161, Figs. 436–437
Follower of Cristiani, p. 40, Fig. 102
Daddi, p. 26, Fig. 61

— Attributed to, p. 27, Fig. 59
— Studio of, p. 28, Fig. 66
— Follower of, p. 28, Fig. 60; p. 29, Fig. 67
Dalmasio, p. 71, Fig. 196
Fra Diamante, p. 109, Figs. 293–298
Domenico di Michelino, p. 101, Figs. 271–272
Domenico Veneziano, p. 103, Fig. 279
Follower of Duccio, p. 14, Fig. 27; p. 15, Figs. 25, 33
Fei, p. 61, Figs. 160, 162; p. 62, Fig. 161
Ferrarese School, Late XV Century, p. 86, Fig. 236
Florentine School, Mid-XIV Century, p. 34, Fig. 73
Florentine School, Late XIV Century, p. 38, Fig. 88
Florentine School, Early XV Century, p. 91, Fig. 243
Florentine School, Mid-XV Century, p. 99, Fig. 268
Florentine School, Second Half of XV Century, p. 119, Fig. 323
Florentine School, c. 1475, p. 119, Fig. 328; p. 120, Fig. 321
Francesco d'Antonio, p. 92, Fig. 250; p. 93, Figs. 251–252
Francesco di Giorgio, p. 153, Fig. 419
— Studio of, p. 154, Fig. 420
Agnolo Gaddi, p. 40, Figs. 98–99
— Follower of, p. 40, Fig. 100
Gentile da Fabriano, p. 76, Fig. 213; p. 77, Fig. 211
— Follower of, p. 78, Fig. 214
Gherardo del Fora, p. 138, Fig. 366
Domenico Ghirlandaio, p. 125, Figs. 334, 344
— Studio of, p. 126, Figs. 338, 340
— Follower of, p. 126, Fig. 341; p. 127, Figs. 339, 342–343
Giambono, p. 79, Fig. 221
— Follower of, p. 80, Fig. 219
Follower of Giotto, p. 22, Figs. 48, 51
Giovanni del Biondo, p. 36, Figs. 83–84, 91; p. 37, Figs. 85, 87
— Attributed to, p. 37, Fig. 86
Giovanni da Bologna, p. 10, Fig. 22
Giovanni di Francesco, p. 104, Fig. 283
Giovanni da Milano, p. 39, Fig. 97
Giovanni di Nicola da Pisa, p. 50, Fig. 129
Giovanni di Paolo, p. 148, Fig. 401; p. 149, Figs. 403, 405
— Studio of, p. 150, Figs. 406–407
— Follower of, p. 150, Fig. 408
Giovanni dal Ponte, p. 92, Figs. 246–249
Girolamo di Benvenuto, p. 161, Figs. 441–447; p. 162, Fig. 448; p. 163, Fig. 440
Giusto de'Menabuoi, p. 39, Figs. 92–96
Follower of Gozzoli, p. 116, Fig. 316
Attributed to Gualtieri di Giovanni, p. 65, Fig. 172
Guariento, p. 10, Fig. 19
Italian School, c. 1300, p. 6, Figs. 11–12
Italo-Byzantine School, XIV Century Style, p. 12, Fig. 15
Jacopo del Casentino, p. 24, Fig. 56
— and Assistant, p. 24, Figs. 54–55; p. 25, Fig. 57
— Follower of, p. 25, Fig. 58
Attributed to Jacopo di Cione, p. 33, Figs. 78, 82
Jacopo di Paolo, p. 72, Fig. 197
Filippino Lippi, p. 136, Figs. 373–374; p. 137, Fig. 375
— and Assistants, p. 137, Fig. 372
— Attributed to, p. 138, Fig. 376

Fra Filippo Lippi and Assistant, p. 108, Fig. 291
Lombard School, XV Century, p. 80, Fig. 220
Attributed to Pietro Lorenzetti, p. 51, Fig. 130; p. 52, Fig. 131
Follower of Pietro Lorenzetti, p. 52, Figs. 133, 136, 141; p. 53, Figs. 134, 137–138
Lorenzo di Bicci, p. 46, Fig. 115
Lorenzo Monaco, p. 89, Fig. 239
— Follower of, p. 90, Fig. 241
Lorenzo di Niccolò, p. 44, Figs. 110, 117
— Attributed to, p. 45, Fig. 108
Attributed to Lorenzo Veneziano, p. 9, Figs. 20, 24
Luca di Tommè, p. 59, Figs. 151, 157; p. 60, Figs. 152–153
— Studio of, p. 60, Fig. 158
Lucchese School, c. 1200, p. 3, Fig. 6
Mariotto di Nardo, p. 46, Fig. 118
Martino di Bartolommeo, p. 65, Fig. 179
Master of the 'Apollini Sacrum,' p. 128, Figs. 345–346
Master of the Apollo and Daphne Legend, p. 129, Figs. 347, 349; p. 130, Figs. 348, 350, 353–354
Master of the Bambino Vispo, p. 91, Fig. 242
Master of the Buckingham Palace Madonna, p. 100, Fig. 274
Master of the Fabriano Altarpiece, p. 29, Fig. 68
Master of Fucecchio, p. 105, Figs. 284–285; p. 106, Figs. 286–288
Master of the Goodhart Madonna, p. 18, Fig. 40
Master of the Griggs Crucifixion, p. 99, Fig. 270
— Circle of, p. 100, Fig. 269
Master of the Life of St. John the Baptist, p. 69, Figs. 184–185
Master of the Orcagnesque Misericordia, p. 38, Figs. 89–90
Master of the Ovile Madonna, p. 54, Fig. 139
Master of the Rinuccini Chapel, p. 35, Figs. 79–81
Master of the St. Verdiana Panel, p. 41, Fig. 104; p. 42, Fig. 105
Master of San Martino alla Palma, p. 30, Fig. 71
Master of San Torpè, p. 18, Fig. 38
— Attributed to, p. 19, Fig. 39
Master of the Stratonice Cassoni, p. 139, Fig. 367
Master of the Straus Madonna, p. 41, Fig. 103
Matteo di Giovanni, p. 157, Figs. 424–427
Michele di Matteo, p. 73, Figs. 193–194
Neri di Bicci, p. 112, Fig. 309; p. 113, Figs. 305, 308, 310
Neroccio de'Landi, p. 154, Figs. 417–418
Niccolò di Pietro Gerini, p. 42, Fig. 106; p. 43, Figs. 109, 113
— Follower of, p. 43, Fig. 107; p. 44, Fig. 111
Niccolò di Segna, p. 17, Figs. 36–37
Follower of Niccolò di Tommaso, p. 35, Fig. 74
Nicolò da Voltri, p. 13, Fig. 29
Nuzi, p. 75, Figs. 204–205, 207–210
Studio of Orcagna, p. 32, Fig. 77
Follower of Orcagna, p. 32, Fig. 72
Pacino di Buonaguida, p. 23, Fig. 50
— Follower of, p. 23, Fig. 49
Palmerucci, p. 55, Fig. 132; p. 56, Fig. 144
Paolo Veneziano, p. 8, Fig. 10
Pellegrino di Mariano, p. 151, Fig. 413
Pesellino, p. 110, Figs. 300–301
— and Studio, p. 110, Figs. 302–303
— Follower of, p. 111, Figs. 306, 307

Pseudo Pier Francesco Fiorentino, p. 115, Figs. 313–314
Pietro di Domenico da Montepulciano, p. 79, Fig. 218
Puccinelli, p. 74, Fig. 202
Riminese School, Late XIV Century, p. 69, Fig. 186
Rosselli, p. 120, Fig. 325; p. 121, Fig. 326
— Studio of, p. 121, Fig. 329
Sano di Pietro, p. 144, Fig. 388; p. 145, Figs. 387, 389–391; p. 146,
 Figs. 392–394, 397
— Follower of, p. 147, Figs. 395–396
Sassetta, p. 140, Fig. 383
— and Assistant, p. 141, Fig. 382
— Studio of, p. 144, Fig. 386
— Follower of, p. 144, Fig. 412
Schiavo, p. 105, Figs. 281–282
Segna di Buonaventura, p. 16, Fig. 32
— Follower of, p. 17, Fig. 30
Sellaio, p. 133, Figs. 364, 368; p. 134, Figs. 361, 363, 450
— Follower of, p. 135, Fig. 365
Sienese School, Early XIV Century, p. 16, Fig. 35
Sienese School, Mid-XIV Century, p. 56, Fig. 143
Simone dei Crocifissi, p. 72, Fig. 195
Spinello Aretino, p. 45, Fig. 112
— Studio of, p. 45, Fig. 116
Taddeo di Bartolo, p. 63, Figs. 163–164, 171; p. 64, Fig. 169
— Follower of, p. 64, Fig. 170
Attributed to Turino di Vanni, p. 74, Figs. 199–200
Tuscan School, Late XIII Century, p. 6, Fig. 8
Tuscan School, First Half of XIV Century, p. 30, Fig. 70
Attributed to Uccello, p. 101, Fig. 273
Follower of Uccello, p. 102, Figs. 275–277
Andrea Vanni, p. 57, Fig. 156; p. 58, Figs. 154–155
Attributed to Vecchietta, p. 151, Fig. 409
Follower of Vecchietta, p. 152, Fig. 410
Venetian School, c. 1300, p. 7, Fig. 14
Venetian School, Early XIV Century, p. 9, Figs. 23
Venetian School, Late XIV Century, p. 11, Fig. 16
Veneto-Byzantine School, Late XIV Century, p. 11, Fig. 26
Follower of Verrocchio, p. 119, Fig. 324
Zoppo, p. 87, Fig. 238

COOK COLLECTION
 Fra Angelico and Fra Filippo Lippi, Frontispiece; p. 95,
 Figs. 259–261
 Benvenuto di Giovanni, p. 158, Figs. 429–432
 Francesco di Giorgio, p. 153, Fig. 419
 Master of the Apollo and Daphne Legend, p. 130, Figs. 353–354
 Tura, p. 82, Figs. 226–229
 Zoppo, p. 87, Fig. 237
CORSI, Arnaldo
 Pier Francesco Fiorentino, p. 114, Fig. 312
CORSINI, Principe
 Follower of Verrocchio, p. 119, Fig. 324
COSTABILI
 Cossa, p. 84, Fig. 224
CRAVEN, E. L.
 Follower of Duccio, p. 15, Fig. 25

CRAWFORD AND BALCARRES, Earl of
 Botticelli and Assistants, p. 122, Fig. 332
CREIGHTON, Dr. Mandell
 Master of the Apollo and Daphne Legend, p. 130, Figs. 353–354
CURRIE, L.
 Giovanni del Biondo, p. 37, Fig. 85
CURTIS, Mrs. Ralph W.
 Master of Fucecchio, p. 105, Figs. 284–285
DAL, DE, DEL, DI (separate)
 See under name following
D'ATRI
 Segna di Buonaventura, p. 16, Fig. 32
DEDALO GALLERY
 Master of the 'Apollini Sacrum,' p. 128, Fig. 352
 Master of the Clarisse Panel, p. 13, Fig. 34
DEMOTTE
 Biagio d'Antonio da Firenze, p. 132, Figs. 358–359
DINI, Guiseppe and Marziale
 Duccio, p. 14, Fig. 28
DONATI
 Studio of Giovanni di Paolo, p. 150, Fig. 406
DONDI DALL'OROLOGIO, Marchese Galeazzo
 Giambono, p. 79, Fig. 221
DOUGLAS, R. Langton
 Attributed to Fra Angelico, p. 97, Fig. 256
 Cozzarelli, p. 159, Fig. 435
 Master of the Blessed Clare, p. 70, Fig. 187
 Matteo di Giovanni, p. 156, Fig. 423
 Neroccio de'Landi, p. 155, Fig. 415
 Attributed to Sassetta, p. 143, Figs. 384–385
DOUINE, Mme.
 Fra Filippo Lippi, p. 107, Figs. 290, 292
DOULTON, Sir Henry
 Daddi, p. 26, Fig. 61
DRAGO, Principe del
 Master of the Clarisse Panel, p. 13, Fig. 34
DREY, A. S.
 Giovanni di Paolo, p. 149, Fig. 403
DREY, Paul
 Fra Angelico and Fra Filippo Lippi, Frontispiece; p. 95,
 Figs. 259–261
 Tura, p. 82, Figs. 226–229
DREYFUS, Gustave
 Modern Copy after Fra Filippo Lippi [K 516, not catalogued]
 Follower of Pesellino, p. 111, Fig. 306
 Roberti, p. 86, Figs. 232–233
DUBOIS
 Fra Angelico and Fra Filippo Lippi, Frontispiece; p. 95,
 Figs. 259–261

DURLACHER
Studio of Daddi, p. 28, Fig. 66
Giovanni di Paolo, p. 149, Fig. 403
Girolamo di Benvenuto, p. 161, Fig. 447
Taddeo di Bartolo, p. 63, Fig. 171

DUVEEN
Fra Angelico, p. 94, Figs. 258, 262
— Attributed to, p. 97, Fig. 257
Biagio d'Antonio da Firenze, p. 131, Figs. 356–357
Attributed to Botticelli, p. 123, Figs. 331, 337
Follower of Botticelli, p. 124, Fig. 336
Cossa, p. 83, Figs. 222–223
Daddi and Assistant, p. 26, Fig. 62
Domenico di Bartolo, p. 140, Fig. 377
Domenico Veneziano, p. 103, Fig. 278
Duccio, p. 14, Fig. 28
Francesco di Giorgio, p. 153, Fig. 416
Gentile da Fabriano, p. 76, Fig. 212
Giotto, p. 20, Figs. 41–42
Giovanni di Paolo, p. 148, Figs. 402, 404
Girolamo di Benvenuto, p. 162, Fig. 449
Gozzoli, p. 115, Fig. 315
Modern Imitation of XIII Century Italian School [K 1301, not catalogued]
Filippino Lippi, p. 135, Figs. 369–370; p. 136, Fig. 371
Fra Filippo Lippi, p. 106, Fig. 289; p. 107, Fig. 299
— Follower of, p. 108, Fig. 304
— Modern Copy after [K 516, not catalogued]
Masolino, p. 94, Figs. 254–255
Master of the Blessed Clare, p. 70, Fig. 187
Master of the Life of St. John the Baptist, p. 68, Fig. 182
Master of the Ovile Madonna, p. 54, Fig. 145
Matteo di Giovanni, p. 156, Fig. 423
Memmi, p. 49, Fig. 126
Nardo di Cione, p. 34, Fig. 75
Neroccio de'Landi, p. 155, Fig. 415
Follower of Pesellino, p. 111, Fig. 306
Pier Francesco Fiorentino, p. 114, Fig. 312
Roberti, p. 86, Figs. 232–233
Rosselli, p. 120, Fig. 330
Sassetta and Assistant, p. 141, Figs. 380–381
Tegliacci, p. 58, Fig. 150
Attributed to Tura, p. 82, Fig. 230
Style of Verrocchio, p. 118, Fig. 322

EASTLAKE, Charles Lock
Sano di Pietro, p. 145, Fig. 391

EDGEWORTH
Domenico Veneziano, p. 103, Fig. 278

EHRICH
Sano di Pietro, p. 146, Figs. 393–394

FABBRI, Pio
Giovanni dal Ponte, p. 92, Figs. 246–248

FAENZA
San Michele
Biagio d'Antonio da Firenze, p. 131, Figs. 356–357

FARRER, Sir William J.
Giovanni di Paolo, p. 148, Figs. 402, 404

FASSINI, Baron
Follower of Duccio, p. 14, Fig. 27
Nuzi, p. 75, Figs. 207–210

FAWCUS, Dormer
Lippo Vanni, p. 57, Figs. 147–149

FENOUIL
Master of the Ovile Madonna, p. 55, Fig. 142

FERGUSSON-BUCHANAN, Col. C. J.
Francesco d'Antonio, p. 93, Fig. 253

FERRARA
Casa Boschini
Guariento, p. 10, Fig. 19
San Gilio (Egidio)
Guariento, p. 10, Fig. 19

FERRONI, Conte
Cecco di Pietro, p. 73, Fig. 201

FLORENCE
Accademia
Fra Angelico, p. 94, Figs. 258, 262
Carmine
Fra Diamante, p. 109, Figs. 293–298
Confraternity of the Purification of the Virgin
Gozzoli, p. 116, Fig. 317
Palazzo Guicciardini
Fra Angelico and Fra Filippo Lippi, Frontispiece; p. 95, Figs. 259–261
Palazzo Rucellai
Follower of Daddi, p. 28, Fig. 60
Palazzo della Signoria (Vecchio)
Fra Filippo Lippi, p. 107, Fig. 299
San Marco
Fra Angelico, p. 94, Figs. 258, 262
San Niccolò Oltrarno
Gentile da Fabriano, p. 77, Fig. 211
San Pancrazio
Follower of Daddi, p. 28, Fig. 60
Santa Lucia dei Magnoli
Domenico Veneziano, p. 103, Figs. 279, 280
Santi Apostoli
Spinello Aretino, p. 45, Fig. 112
Santissima Annunziata
Neri di Bicci, p. 112, Fig. 309

FORESTI, Pietro
Biagio d'Antonio da Firenze, p. 132, Figs. 358–359

FORTI, Vittorio
Matteo di Giovanni, p. 157, Figs. 424, 427

FOULC, Edmond
Follower of Fra Filippo Lippi, p. 108, Fig. 304

FRASCIONE
Florentine School, Early XV Century, p. 91, Fig. 243

GALITZIN, Prince
Studio of Daddi, p. 28, Fig. 66
Giovanni del Biondo, p. 37, Fig. 85

GALLI, Conte Giuseppe
Puccinelli, p. 74, Fig. 202

GALLO, Claudio
Master of the Fabriano Altarpiece, p. 29, Fig. 68

GENTNER, M.
Follower of Pesellino, p. 111, Fig. 307
Schiavo, p. 105, Fig. 282

GHERARDESCA, Conte della
Girolamo di Benvenuto, p. 162, Fig. 448

GIUGGIOLI, Tito
Segna di Buonaventura, p. 16, Fig. 31

GIUSTINIANI, Contessa
Andrea di Bartolo, p. 66, Figs. 175–177
Attributed to Jacopo di Cione, p. 33, Fig. 82
Sano di Pietro, p. 144, Fig. 388

GNECCO
Giovanni di Paolo, p. 149, Fig. 405

GOLDMAN, Henry
Attributed to Fra Angelico, p. 97, Fig. 257
Daddi and Assistant, p. 26, Fig. 62
Gentile da Fabriano, p. 76, Fig. 212
Giotto, p. 20, Figs. 41–42
Nardo di Cione, p. 34, Fig. 75

GOODEN AND FOX
Sano di Pietro, p. 145, Fig. 391

GOUDSTIKKER, J.
Giotto and Assistants, p. 21, Figs. 43–46
Memmi, p. 49, Fig. 126

GOZZADINI
Jacopino di Francesco, p. 71, Figs. 188–192

GRAHAM, William
Florentine School, Second Half of XV Century, p. 119, Fig. 323
Domenico Ghirlandaio, p. 125, Fig. 334

GRASSI, Giuseppe
Filippino Lippi, p. 137, Fig. 375

GRASSI, Luigi
Attributed to Fra Angelico, p. 97, Fig. 257

GRAUPE, P.
Belbello da Pavia, p. 81, Fig. 206

GRICCIOLI
Francesco di Giorgio, p. 153, Fig. 414

GUALANDI, Michelangelo
Giovanni da Bologna, p. 10, Fig. 22

GUICCIARDINI PALACE
Fra Angelico and Fra Filippo Lippi, Frontispiece; p. 95, Figs. 259–261

HAAS
Guariento, p. 10, Fig. 19

HAHN
Bartolommeo di Giovanni, p. 129, Fig. 351

HALLYN
Neroccio de'Landi, p. 154, Figs. 417–418

HAMBOURG, Mrs. Mark
Domenico Ghirlandaio, p. 125, Fig. 334

HAMILTON, Carl W.
Biagio d'Antonio da Firenze, p. 131, Figs. 356–357
Domenico Veneziano, p. 103, Fig. 280

HAREWOOD, Earl of
Simone Martini, p. 48, Fig. 121

HARRIS, Henry
Zoppo, p. 87, Fig. 238

HAZLITT
Domenico Ghirlandaio, p. 125, Fig. 344

HEKKING, W.
Follower of Domenico Ghirlandaio, p. 127, Fig. 339

HERCOLANI, Marchese Filippo
Biagio d'Antonio da Firenze, p. 131, Figs. 356–357

HITCHCOCK, Mrs. L. W.
Follower of Daddi, p. 28, Fig. 60

HOLLAND, Lord
Niccolò di Segna, p. 17, Figs. 36–37

HOSKINS, G. A.
Master of the Blessed Clare, p. 70, Fig. 187

HOUSMAN, Frederick
Filippino Lippi, p. 136, Fig. 371

HOWARD, H.
Master of the Stratonice Cassoni, p. 139, Fig. 367

HUTTON, Edward
Fei, p. 62, Fig. 159
Neroccio de'Landi, p. 154, Figs. 417–418
Pesellino, p. 110, Fig. 301
Sassetta, p. 140, Fig. 383

INGENHEIM, Count von
Masolino, p. 94, Figs. 254–255
Nardo di Cione, p. 34, Fig. 75

INTERNATIONAL FINANCING CO.
Botticelli and Assistants, p. 122, Fig. 332
Sienese School, c. 1370, p. 56, Fig. 146

JANDOLO, Ugo
Attributed to Jacopo di Cione, p. 33, Fig. 82

KAHN, Otto H.
Master of the Blessed Clare, p. 70, Fig. 187
Master of the Life of St. John the Baptist, p. 68, Fig. 182

KANN, Alphonse
Francesco di Giorgio, p. 153, Fig. 416

KAUFMANN, Professor Richard von
Benvenuto di Giovanni, p. 159, Fig. 433

KELLER, Albert
Fra Angelico, p. 94, Figs. 258, 262

KERR-LAWSON
Spinello Aretino, p. 45, Fig. 112

KLEINBERGER
Biagio d'Antonio da Firenze, p. 132, Fig. 362
Cozzarelli, p. 159, Fig. 435
Guariento, p. 10, Fig. 19
Master of the Bambino Vispo, p. 91, Fig. 245

KNOEDLER
Attributed to Gualtieri di Giovanni, p. 65, Fig. 172
Follower of Neroccio de'Landi, p. 156, Fig. 422
Paolo Veneziano, p. 7, Fig. 13

LAMMI, Pompeo
Follower of Duccio, p. 14, Fig. 27

LARCADE
Taddeo di Bartolo, p. 63, Fig. 163

LARDEREL, Conte Di
Master of the Straus Madonna, p. 41, Fig. 103

LEE OF FAREHAM, Viscount
Sano di Pietro, p. 146, Fig. 397

LEHMAN, Philip
Cossa, p. 84, Fig. 224
Francesco di Giorgio, p. 153, Fig. 416
Follower of Taddeo Gaddi, p. 24, Fig. 53
Attributed to Ambrogio Lorenzetti, p. 51, Fig. 135
Margaritone, p. 3, Fig. 1
Master of the Franciscan Crucifixes, p. 4, Figs. 4–5
Studio of the Master of the Ovile Madonna, p. 55, Fig. 140
Master of St. Francis, p. 4, Figs. 2–3
Orcagna and Jacopo di Cione, p. 31, Fig. 76
Segna di Buonaventura, p. 16, Fig. 31
Simone Martini and Assistants, p. 48, Figs. 122–125
Lippo Vanni, p. 57, Figs. 147–149

LESLIE, Sir John
Fra Damante, p. 109, Figs. 293–298

LEVY
Master of the Bambino Vispo, p. 91, Fig. 245

LEWISOHN, Frederick
Rosselli, p. 120, Fig. 330

LEZZE, Comtesse de
Fra Filippo Lippi and Assistant, p. 108, Fig. 291

LINCOLN, Earl of
Master of the Apollo and Daphne Legend, p. 130, Figs. 348, 350
Matteo di Giovanni, p. 157, Fig. 426

LIPPMANN, Dr. Friedrich
Cozzarelli, p. 159, Fig. 435

LOCKER-LAMPSON, Godfrey
Follower of Pesellino, p. 111, Fig. 306

LOTHIAN, Marquess of
Filippino Lippi, p. 135, Fig. 370

LUCCA
Monastery of San Cerbone
Master of the Ovile Madonna, p. 54, Fig. 145

MACAULAY, William J. Babington
Attributed to Botticelli, p. 123, Fig. 337

MACKAY, Clarence H.
Duccio, p. 14, Fig. 28
Matteo di Giovanni, p. 156, Fig. 423
Pier Francesco Fiorentino, p. 114, Fig. 312
Style of Verrocchio, p. 118, Fig. 322

MACKENZIE, Sir Kenneth Muir
Domenico Ghirlandaio, p. 125, Fig. 334

MAGI, I.
Neroccio de'Landi, p. 155, Fig. 421

MAMELI
Follower of Uccello, p. 102, Figs. 276–277

MANENTI
Daddi, p. 26, Fig. 61

MARCHAND, Lucien
Matteo di Giovanni, p. 157, Fig. 425

MARINUCCI, Cav. Enrico
Bicci di Lorenzo, p. 47, Fig. 120
Michele di Matteo, p. 73, Figs. 193–194
Nuzi, p. 75, Figs. 204–205
Venetian School, Early XIV Century, p. 9, Fig. 23

MASSON
Lorenzo Monaco, p. 89, Fig. 239

MATTHIESEN
Attributed to Tura, p. 82, Fig. 230

MAX, Édouard-Alexandre
Giotto, p. 20, Figs. 41–42

MEDICI
Fra Angelico and Fra Filippo Lippi, Frontispiece; p. 95, Figs. 259–261
Attributed to Fra Angelico, p. 97, Fig. 257

MELZI D'ERIL, Duchessa
Attributed to the Master of San Torpè, p. 19, Fig. 39
Pesellino, p. 110, Fig. 300

MIHALYFFY, Mme.
Style of Baldovinetti, p. 114, Fig. 311

MISSIESSI, Comtesse de
Sienese School, c. 1370, p. 56, Fig. 146

MONT, Frederick
Filippino Lippi, p. 136, Fig. 371

MORELLI, A.
Master of the Fabriano Altarpiece, p. 29, Fig. 68

MORI, C. W.
Giotto and Assistants, p. 21, Figs. 43–46

MURRAY, Charles Fairfax
Duccio, p. 14, Fig. 28
Florentine School, Mid-XIV Century, p. 34, Fig. 73
Giovanni del Biondo, p. 37, Fig. 87
Giovanni di Paolo, p. 148, Figs. 402, 404
Luca di Tommè, p. 60, Fig. 153
Pellegrino di Mariano, p. 151, Fig. 413

MURRAY, John E.
Florentine School, Mid-XIV Century, p. 34, Fig. 73

NARDUS, Leo
Attributed to Cossa, p. 85, Fig. 235
Follower of Domenico Ghirlandaio, p. 127, Fig. 339

NEMES, Marczell von
Attributed to Botticelli, p. 123, Fig. 331
Attributed to Cossa, p. 85, Fig. 235
Sellaio, p. 134, Fig. 361

NEUMANN, Karl
Attributed to Andrea di Niccolò, p. 152, Fig. 411

NEVIN, Dr. Robert Jenkins
Sassetta and Assistant, p. 141, Figs. 378–379

NEWCASTLE, Seventh Duke of
Master of the Apollo and Daphne Legend, p. 130, Figs. 348, 350
Matteo di Giovanni, p. 157, Fig. 426

NEWHOUSE
Studio of Daddi, p. 27, Fig. 64

NEWMAN
Giovanni del Biondo, p. 37, Fig. 87
Neri di Bicci, p. 112, Fig. 309

NICCOLINI
Giovanni di Nicola da Pisa, p. 50, Fig. 129

NORTHESK, Earl of
Neroccio de'Landi, p. 154, Figs. 417–418

NOSEDA, Aldo
Andrea Vanni, p. 58, Fig. 154

OBERGAVERING, Mrs. Herbert
Follower of Domenico Ghirlandaio, p. 127, Figs. 342–343

ODESCALCHI
Master of the Clarisse Panel, p. 13, Fig. 34

O'KANE, Sir Augustus
Follower of Pietro Lorenzetti, p. 52, Fig. 136

OLDENBERG, Dr.
Veronese School, Early XV Century, p. 78, Figs. 215–216

ORIOLA, Conte
Memmi, p. 49, Fig. 126

OTTLEY, William Young
Master of the Ovile Madonna, p. 55, Fig. 142

OUROUSSOFF, Prince Léon
Florentine School, Mid-XIV Century, p. 34, Fig. 73
Master of the Life of St. John the Baptist, p. 68, Fig. 182

PAAR, Graf Louis
'Alunno di Benozzo,' p. 117, Fig. 318

PADELLETTI, Dr.
Studio of the Master of the Ovile Madonna, p. 55, Fig. 140

PALMIERI-NUTI
Andrea Vanni, p. 58, Fig. 154

PANCIATICHI, Marchese
Biagio d'Antonio da Firenze, p. 132, Figs. 358–359

PAOLINI, Paolo
Cecco di Pietro, p. 73, Fig. 198
Follower of Duccio, p. 15, Fig. 25
Fei, p. 62, Fig. 161
Attributed to Gualtieri di Giovanni, p. 65, Fig. 172

PARAVEY, M.
Botticelli, p. 122, Fig. 333

PARTINI
Andrea di Giusto, p. 98, Fig. 264

PASINI
Master of the Life of St. John the Baptist, p. 69, Fig. 184

PATRIZI, Marchese Bernardo
Filippino Lippi, p. 137, Fig. 375

PEARSON, Walter P.
Master of the Bambino Vispo, p. 91, Fig. 245

PEDULLI, Federico
Domenico di Michelino, p. 101, Figs. 271–272

PICCOLOMINI, Conte Silvio
Sano di Pietro, p. 146, Fig. 392

PICCOLOMINI PALACE
Master of the Clarisse Panel, p. 13, Fig. 34

PICCOLOMINI BELLANTI, Cav. Antonio
Girolamo di Benvenuto, p. 162, Fig. 449

PINI
Giovanni del Biondo, p. 36, Fig. 91

PIOT, Eugène (Paris)
Modern Copy after Fra Filippo Lippi [K 516, not catalogued]

PISA
San Domenico
Francesco d'Antonio, p. 92, Fig. 250
San Francesco
Attributed to Cimabue, p. 5, Fig. 9

PITT-RIVERS, General Fox
Margaritone, p. 3, Fig. 1

PLATT, Dan Fellows
Cozzarelli, p. 160, Fig. 438
Attributed to Daddi, p. 26, Fig. 69
Francesco di Giorgio, p. 153, Fig. 414
Taddeo Gaddi, p. 23, Fig. 52
Jacopino di Francesco, p. 71, Figs. 188–192
Master of Staffolo, p. 79, Fig. 217
Sassetta and Assistant, p. 141, Figs. 378–379
Attributed to Sassetta, p. 143, Figs. 384–385
Taddeo di Bartolo, p. 63, Figs. 165–166; p. 64, Figs. 167–168
Venetian School, Late XIV Century, p. 11, Fig. 21

POURTALÈS, Comtesse Hubert de
Tegliacci, p. 58, Fig. 150
Style of Verrocchio, p. 118, Fig. 322

POURTALÈS-GORGIER, Comte de
Fra Angelico, p. 94, Figs. 258, 262

PRATT, Harold I.
 Master of the Life of St. John the Baptist, p. 68, Fig. 183
 Sienese School, c. 1440, p. 147, Figs. 398–400
 Tura, p. 81, Fig. 225

PRIDEAUX
 Attributed to Botticelli, p. 123, Fig. 331

PUCCINI, Niccolò
 Gentile da Fabriano, p. 77, Fig. 211

PUCCINI, Cav. Tommaso
 Gentile da Fabriano, p. 77, Fig. 211

RAMBOUX, Johann Anton
 Giovanni di Paolo, p. 149, Figs. 403, 405
 Follower of Segna di Buonaventura, p. 17, Fig. 30
 Simone Martini and Assistants, p. 48, Figs. 122–125

RAPOLANO
 Cappella di San Bartolommeo
 Neroccio de'Landi, p. 155, Fig. 421
 Pievania delle Serre
 Neroccio de'Landi, p. 155, Fig. 421

RAVASCO
 Cecco di Pietro, p. 73, Fig. 198

RAYNAUD, Mme.
 Botticelli, p. 122, Fig. 333

RICHMOND, George
 Girolamo di Benvenuto, p. 161, Fig. 447

RICHMOND, John
 Girolamo di Benvenuto, p. 161, Fig. 447

RIGHINI, Contessa
 Jacopo del Casentino and Assistant, p. 24, Figs. 54–55

RIMINI
 Monastero degli Angeli
 Master of the Blessed Clare, p. 70, Fig. 187

RINGLING
 Master of the Ovile Madonna, p. 54, Fig. 145

ROBINSON, Sir J. Charles
 Benvenuto di Giovanni, p. 158, Figs. 429–432
 Giovanni di Paolo, p. 148, Figs. 402, 404

ROCCHI, Chev. Prof. Mariano
 Style of Baldovinetti, p. 114, Fig. 311

ROME
 Seminario Teutonico
 Master of St. Francis, p. 4, Figs. 2–3
 Vatican Gallery
 Biagio d'Antonio da Firenze, p. 133, Fig. 360
 Master of the Life of St. John the Baptist, p. 69, Fig. 184
 Master of the St. Verdiana Panel, p. 41, Fig. 104
 Neri di Bicci, p. 112, Fig. 309
 Studio of Spinello Aretino, p. 45, Fig. 116
 Attributed to Vecchietta, p. 151, Fig. 409

ROSENBERG AND STIEBEL
 Zoppo, p. 87, Fig. 237

ROSENFELD, Ernst
 Follower of Fra Filippo Lippi, p. 108, Fig. 304

ROSSELLI, Avv. Lodovico
 Master of the Clarisse Panel, p. 13, Fig. 34

ROUS, William Keith
 Agnolo Gaddi, p. 40, Figs. 98–99

RUCELLAI PALACE
 Follower of Daddi, p. 28, Fig. 60

RUSSELL, Rev. J. Fuller
 Andrea Vanni, p. 57, Fig. 156

SABIN, Frank T.
 Florentine School, Second Half of XV Century, p. 119, Fig. 323
 Domenico Ghirlandaio, p. 125, Fig. 334

SACHS, Arthur
 Neroccio de'Landi, p. 155, Fig. 421

SALOMON, William
 Pier Francesco Fiorentino, p. 114, Fig. 312

SALTING, George M.
 Girolamo di Benvenuto, p. 162, Fig. 449

SALVADORI, G.
 Jacopo del Casentino, p. 24, Fig. 56

SANDERSON, Arthur
 Girolamo di Benvenuto, p. 162, Fig. 449

SANGIORGI
 Master of the Life of St. John the Baptist, p. 69, Fig. 185

SAN GIOVANNI VALDARNO
 Santa Maria delle Grazie
 Giovanni del Biondo, p. 36, Figs. 83–84

SAN QUIRICO D'ORCIA
 Cloister of the Collegiata
 Follower of Duccio, p. 14, Fig. 27

SARTORIS, E. J.
 Gentile da Fabriano, p. 76, Fig. 212

SARTY, Comte de
 Follower of Botticelli, p. 124, Fig. 336

SAXE-MEININGEN, Dukes of
 Gozzoli, p. 115, Fig. 315
 Neroccio de'Landi, p. 155, Fig. 415

SCHICKLER, Baron Arthur de
 Tegliacci, p. 58, Fig. 150
 Style of Verrocchio, p. 118, Fig. 322

SCHIFF, Mortimer L.
 Follower of Duccio, p. 15, Fig. 25

SCHINASI, Leon
 Giotto and Assistants, p. 21, Figs. 43–45

SCHOENEMANN
 Attributed to Baldassare d'Este, p. 83, Fig. 231

SCOTT, Mrs. E. L.
 Domenico Ghirlandaio, p. 125, Fig. 344

SEDELMEYER, Charles
Attributed to Botticelli, p. 123, Figs. 331, 337

SELIGMAN
Neroccio de'Landi, p. 155, Fig. 421

SERGARDI-BIRINGUICCI, Baron
Studio of Daddi, p. 27, Fig. 64

SESTIERI
Follower of Duccio, p. 14, Fig. 27
Sassetta and Assistant, p. 141, Fig. 382

SHAW, J. Quincy
Attributed to Baldassare d'Este, p. 83, Fig. 231

SIENA
Cathedral
Duccio, p. 14, Fig. 28
Fei, p. 62, Fig. 159
Larniano Chapel
Sano di Pietro, p. 146, Fig. 392
Monastery of Sant'Eugenio
Francesco di Giorgio, p. 153, Fig. 414
Palazzo Piccolomini
Master of the Clarisse Panel, p. 13, Fig. 34

SIMON, Henri
Memmi, p. 49, Fig. 127

SLOCHEM, Van
Attributed to Daddi, p. 26, Fig. 69

SMITH
Botticelli and Assistants, p. 122, Fig. 332

SOLLY, Edward
Fra Filippo Lippi, p. 106, Fig. 289

SOMERSET, Henry Charles Somers
Daddi and Assistant, p. 26, Fig. 62

SOMERVELL, Graham Charles
Daddi and Assistant, p. 26, Fig. 62

SPINA
Andrea Vanni, p. 58, Fig. 155

SPINK AND SONS
Follower of Barnaba da Modena, p. 12, Fig. 18

SPIRIDON, Joseph
Cossa, p. 83, Figs. 222-223

STARK, J.
Daddi, p. 26, Fig. 61

STEFANI
Tuscan School, First Half of XIV Century, p. 30, Fig. 70

STEINMEYER
Pesellino, p. 110, Fig. 301
Sassetta, p. 140, Fig. 383

STEPHENS, Mrs. Frederic
Giotto and Assistants, p. 21, Fig. 47

STERBINI, Giulio
Biagio d'Antonio da Firenze, p. 133, Fig. 360
Fei, p. 61, Fig. 162

Master of the Life of St. John the Baptist, p. 69, Figs. 184-185
Master of the Ovile Madonna, p. 54, Fig. 145
Master of the St. Verdiana Panel, p. 41, Fig. 104
Neri di Bicci, p. 112, Fig. 309
Studio of Spinello Aretino, p. 45, Fig. 116
Attributed to Vecchietta, p. 151, Fig. 409

STETTINER
Master of the Clarisse Panel, p. 13, Fig. 34

STIRLING, Captain
Daddi and Assistant, p. 26, Fig. 62

STOGDON, Rev. William
Biagio d'Antonio da Firenze, p. 131, Figs. 356-357

STRAUS, Percy S.
Fra Filippo Lippi, p. 107, Fig. 299

STROGANOFF, Count Gregory
Sellaio, p. 133, Fig. 364

STURANI, Conte
Cenni di Francesco, p. 42, Fig. 101

SULLEY
Follower of Domenico Ghirlandaio, p. 127, Fig. 339

TADDEI
Tuscan School, Late XIII Century, p. 6, Fig. 8

TADINI-BUONINSEGNI
Giovanni di Paolo, p. 148, Fig. 401

TALLEYRAND, Marquis de
Studio of Daddi, p. 28, Fig. 66

TIMBAL, Louis Charles
Modern Copy after Fra Filippo Lippi [K516, not catalogued]
Roberti, p. 86, Figs. 232-233

TORNABUONI
Gherardo del Fora, p. 138, Fig. 366

TORRINI
Lippo Vanni, p. 57, Figs. 147-149

TOSCANELLI, Giuseppe
Francesco d'Antonio, p. 92, Fig. 250
Pellegrino di Mariano, p. 151, Fig. 413
Pesellino and Studio, p. 110, Figs. 302-303
Follower of Pesellino, p. 111, Fig. 306

TRIVULZIO, Principe
Sellaio, p. 133, Fig. 368
Veneto-Byzantine School, Late XIV Century, p. 11, Fig. 26

TUCHER, Heinrich Freiherr von
Benvenuto di Giovanni, p. 159, Fig. 433

VAL, Monseigneur Del
Master of St. Francis, p. 4, Figs. 2-3

VALLOMBROSA
Monastery
Daddi, p. 26, Fig. 61

VANDEUVRE, Baron de
Follower of Botticelli, p. 124, Fig. 336

VENIER
Follower of Vecchietta, p. 152, Fig. 410

VENTURI, Lionello
Simone Martini, p. 48, Fig. 121

VERNON, Granville Edward Harcourt
Sassetta and Assistant, p. 141, Figs. 380–381

VISCONTI
Biagio d'Antonio da Firenze, p. 132, Fig. 355
Master of the Griggs Crucifixion, p. 99, Fig. 270

VOLPI, Comm. Elia
Giovanni del Biondo, p. 36, Fig. 91
Martino di Bartolommeo, p. 65, Fig. 179
Neroccio de'Landi, p. 155, Fig. 421

WAGNER, Henry
Master of the Ovile Madonna, p. 55, Fig. 142

WALLIS
Daddi and Assistant, p. 26, Fig. 62

WEINBERGER, Emile
Francesco d'Antonio, p. 92, Fig. 250

WEITZNER, J.
Follower of Daddi, p. 28, Fig. 63

WHITE, Frederick Anthony
Sano di Pietro, p. 145, Fig. 391

WIDENER, P. A. B.
Follower of Domenico Ghirlandaio, p. 127, Fig. 339

WILDENSTEIN
Style of Baldovinetti, p. 114, Fig. 311
Benvenuto di Giovanni, p. 158, Figs. 429–432
Botticelli, p. 121, Fig. 335; p. 122, Fig. 333
Fei, p. 62, Fig. 159

Gentile da Fabriano, p. 76, Fig. 212
Giotto and Assistants, p. 21, Figs. 43–46
Gozzoli, p. 116, Fig. 317
Fra Filippo Lippi, p. 107, Figs. 290, 292
— Follower of, p. 108, Fig. 304
Follower of Lorenzo Monaco, p. 90, Fig. 240
Master of the Life of St. John the Baptist, p. 68, Fig. 183
Memmi, p. 49, Fig. 127
Sienese School, c. 1440, p. 147, Figs. 398–400
Tura, p. 81, Fig. 225

WILLS, Howel
Sano di Pietro, p. 145, Fig. 391

WILSON, Richard
Girolamo di Benvenuto, p. 161, Fig. 447

WITTGENSTEIN, Prince Ludwig
Bartolommeo di Giovanni, p. 129, Fig. 351
Pesellino and Studio, p. 110, Figs. 302–303

WORNUM, Ralph
Margaritone, p. 3, Fig. 1

WORTHINGTON, Mrs.
Cozzarelli, p. 160, Fig. 434

ZARA
Santa Domenica
Lucchese School, c. 1200, p. 3, Fig. 6

ZINCOURT (?)
Fra Angelico, p. 94, Figs. 258, 262

ZINK, Mr.
Follower of Jacopo del Casentino, p. 25, Fig. 58

ZOTTO, Dal
Paolo Veneziano, p. 7, Fig. 13

NUMERICAL INDEX

KM-2	Master of the Orcagnesque Misericordia, p. 38, Fig. 89
K3	Segna di Buonaventura, p. 16, Fig. 32
KM-3	Master of the Orcagnesque Misericordia, p. 38, Fig. 90
K4	Giovanni di Nicola da Pisa, p. 50, Fig. 129
KM-4	Luca di Tommè, p. 60, Fig. 152
KM-5	Palmerucci, p. 55, Fig. 132
KX-7	Attributed to Filippino Lippi, p. 138, Fig. 376
K17	Niccolò di Pietro Gerini, p. 43, Fig. 109
K22	Lombard School, XV Century, p. 80, Fig. 220
K23	Andrea di Bartolo, p. 66, Figs. 173–174
K27	Follower of Pietro Lorenzetti, p. 52, Fig. 141
K29	Riminese School, Late XIV Century, p. 69, Fig. 186
K33	Florentine School, Mid-XIV Century, p. 34, Fig. 73
K34	Luca di Tommè, p. 59, Fig. 157
K38	Fei, p. 61, Fig. 162
K40	Niccolò di Segna, p. 17, Fig. 36
K41	Niccolò di Segna, p. 17, Fig. 37
K44	Follower of Niccolò di Tommaso, p. 35, Fig. 74
K54	Florentine School, c. 1475, p. 120, Fig. 321
K56	Follower of Sellaio, p. 134, Fig. 365
K57	Pseudo Pier Francesco Fiorentino, p. 115, Fig. 314
K59	Pietro di Domenico da Montepulciano, p. 79, Fig. 218
K63	Attributed to Giovanni del Bionzo, p. 37, Fig. 86
K64	Follower of Orcagna, p. 32, Fig. 72
K65	Venetian School, Late XIV Century, p. 11, Fig. 16
K66	Giovanni del Biondo, p. 36, Fig. 83
K67	Giovanni del Biondo, p. 36, Fig. 84
K69	Luca di Tommè, p. 60, Fig. 153
K74	Attributed to Jacopo di Cione, p. 33, Fig. 82
K77	Master of the 'Apollini Sacrum,' p. 128, Fig. 345
K79	Master of the 'Apollini Sacrum,' p. 128, Fig. 346
K84	Andrea di Bartolo, p. 66, Fig. 177
K85	Andrea di Bartolo, p. 66, Fig. 176
K86	Andrea di Bartolo, p. 66, Fig. 175
K88	Sano di Pietro, p. 144, Fig. 388
K93	Mariotto di Nardo, p. 46, Fig. 118
K100	Sano di Pietro, p. 146, Fig. 394
K101	Sano di Pietro, p. 146, Fig. 393
K102	Cecco di Pietro, p. 73, Fig. 198
K103	Florentine School, Mid-XV Century, p. 99, Fig. 268
K104	Taddeo di Bartolo, p. 64, Fig. 169
K106	Master of the Ovile Madonna, p. 54, Fig. 139
K108	Follower of Cristiani, p. 40, Fig. 102
K110	Martino di Bartolommeo, p. 65, Fig. 179
K112	Italo-Byzantine School, XIV Century Style, p. 12, Fig. 15
K114	Attributed to Gualtieri di Giovanni, p. 65, Fig. 172
K123	Follower of Giambono, p. 80, Fig. 219
K135	Veronese School, Early XV Century, p. 78, Fig. 215
K136	Veronese School, Early XV Century, p. 78, Fig. 216
K153	Puccinelli, p. 74, Fig. 202
K156	Studio of Orcagna, p. 32, Fig. 77
K157	Follower of Pietro Lorenzetti, p. 52, Fig. 133
K158	Domenico di Michelino, p. 101, Fig. 272
K159	Domenico di Michelino, p. 101, Fig. 271
K168	Cozzarelli, p. 160, Fig. 439
K170	Master of the Griggs Crucifixion, p. 99, Fig. 270
K174	Spinello Aretino, p. 45, Fig. 112
K176	Attributed to Turino di Vanni, p. 74, Fig. 200
K177	Attributed to Turino di Vanni, p. 74, Fig. 199
K178	Giambono, p. 79, Fig. 221
K179	Giusto de'Menabuoi, p. 39, Fig. 92
K187	Fei, p. 62, Fig. 161
K197	Master of San Martino alla Palma, p. 30, Fig. 71
K198	Attributed to Daddi, p. 27, Fig. 59
K199	Giovanni da Milano, p. 39, Fig. 97
K201	Tuscan School, First Half of XIV Century, p. 30, Fig. 70
K204	Follower of Daddi, p. 28, Fig. 60
K205A, B, C, D	Nuzi, p. 75, Figs. 207–210
K209	Filippino Lippi and Assistants, p. 137, Fig. 372
K216	Schiavo, p. 105, Fig. 281
K219	Sienese School, Early XIV Century, p. 16, Fig. 35
K222	Girolamo di Benvenuto, p. 162, Fig. 448
K230	Pesellino, p. 110, Fig. 300
K231A, B	Giusto de'Menabuoi, p. 39, Figs. 93–94
K233	Andrea Vanni, p. 57, Fig. 156
K234	Andrea di Giusto, p. 98, Fig. 264
K241	Attributed to Cossa, p. 85, Fig. 235
K250	Follower of Gozzoli, p. 116, Fig. 316
K251	Apollonio di Giovanni, p. 98, Fig. 267
K254	Neri di Bicci, p. 112, Fig. 309
K256	Studio of Spinello Aretino, p. 45, Fig. 116
K257	Biagio d'Antonio da Firenze, p. 133, Fig. 360
K259	Giovanni del Biondo, p. 37, Fig. 85
K260	Follower of Lorenzo Monaco, p. 90, Fig. 241
K261	Master of the St. Verdiana Panel, p. 41, Fig. 104
K263	Master of the Fabriano Altarpiece, p. 29, Fig. 68
K264	Master of the Life of St. John the Baptist, p. 69, Fig. 184
K265	Follower of Pietro Lorenzetti, p. 52, Fig. 136
K267	Follower of Domenico Ghirlandaio, p. 127, Fig. 339
K268	Cenni di Francesco, p. 42, Fig. 101
K269	Attributed to Vecchietta, p. 151, Fig. 409
K275	Circle of the Master of the Griggs Crucifixion, p. 100, Fig. 269
K277	Attributed to Pietro Lorenzetti, p. 51, Fig. 130
K278	Domenico Veneziano, p. 103, Fig. 279
K283	Duccio, p. 14, Fig. 28
K285	Paolo Veneziano, p. 8, Fig. 10
K286	Sano di Pietro, p. 145, Fig. 391
K289	Attributed to Fra Angelico, p. 97, Fig. 256
K290	Attributed to Andrea di Niccolò, p. 152, Fig. 411
K292	Attributed to the Master of San Torpè, p. 19, Fig. 39

K296 Attributed to Jacopo di Cione, p. 33, Fig. 78

K298 Follower of Domenico Ghirlandaio, p. 126, Fig. 341

K299 Biagio d'Antonio da Firenze, p. 132, Fig. 355

K300 Giovanni dal Ponte, p. 92, Figs. 246–248

K309 Master of San Torpè, p. 18, Fig. 38

K310 Taddeo di Bartolo, p. 63, Fig. 171

K311 Sano di Pietro, p. 146, Fig. 397

K316 Sellaio, p. 134, Fig. 361

K320 Follower of Uccello, p. 102, Fig. 275

K321 Pseudo Pier Francesco Fiorentino, p. 115, Fig. 313

K324 Italian School, c. 1300, p. 6, Fig. 12

K326 Biagio d'Antonio da Firenze, p. 132, Fig. 362

K333 Lorenzo di Niccolò, p. 44, Fig. 117

K334 Follower of Cossa, p. 85, Fig. 234

K342A, B Filippino Lippi, p. 136, Figs. 373–374

K361 Italian School, c. 1300, p. 6, Fig. 11

K363 Bartolommeo di Giovanni, p. 129, Fig. 351

K364 Agnolo Gaddi, p. 40, Figs. 98–99

K369 Florentine School, c. 1475, p. 119, Fig. 328

K372 'Alunno di Benozzo,' p. 117, Fig. 318

K373 Studio of Luca di Tommè, p. 60, Fig. 158

K387 Ferrarese School, Late XV Century, p. 86, Fig. 236

K402 Pier Francesco Fiorentino, p. 114, Fig. 312

K405 Simone Martini, p. 48, Fig. 121

K408 Roberti, p. 86, Fig. 232

K409 Roberti, p. 86, Fig. 233

K410 Domenico Veneziano, p. 103, Fig. 278

K411 Neroccio de'Landi, p. 155, Fig. 415

K412 Giovanni di Paolo, p. 148, Figs. 402, 404

K414 Masolino, p. 94, Fig. 254

K415 Masolino, p. 94, Fig. 255

K416 Cossa, p. 83, Fig. 222

K417 Cossa, p. 83, Fig. 223

K418 Filippino Lippi, p. 135, Fig. 369

K420 Andrea di Giusto, p. 99, Fig. 266

K424 Sellaio, p. 134, Figs. 363, 450

K425 Studio of Sassetta, p. 144, Fig. 386

K428 Giovanni da Bologna, p. 10, Fig. 22

K429 Antonio Veneziano, p. 46, Fig. 114

K431 Venetian School, c. 1300, p. 7, Fig. 14

K432 Giovanni di Paolo, p. 148, Fig. 401

K438 Neroccio de'Landi, p. 154, Fig. 418

K439 Neroccio de'Landi, p. 154, Fig. 417

K440 Studio of Giovanni di Paolo, p. 150, Fig. 406

K441A, B, C, D Fra Diamante, p. 109, Figs. 293–296

K443 Sassetta, p. 140, Fig. 383

K444 Follower of Sassetta, p. 144, Fig. 412

K445 Lorenzo di Bicci, p. 46, Fig. 115

K446 Jacopo del Casentino, p. 24, Fig. 56

K447 Attributed to Pietro Lorenzetti, p. 52, Fig. 131

K459 Attributed to Barna da Siena, p. 50, Fig. 128

K460 Master of the Life of St. John the Baptist, p. 69, Fig. 185

K463 Follower of Daddi, p. 29, Fig. 67

K472 Gentile da Fabriano, p. 76, Fig. 212

K473 Giotto, p. 20, Figs. 41–42

K477 Attributed to Fra Angelico, p. 97, Fig. 257

K478 Nardo di Cione, p. 34, Fig. 75

K482 Gozzoli, p. 115, Fig. 315

K485 Pesellino, p. 110, Fig. 301

K486 Gentile da Fabriano, p. 77, Fig. 211

K487A, B Follower of Domenico Ghirlandaio, p. 127, Figs. 342–343

K489 Zoppo, p. 87, Fig. 238

K490 Follower of Uccello, p. 102, Figs. 276–277

K491 Apollonio di Giovanni, p. 98, Figs. 263, 265

K492 Sano di Pietro, p. 146, Fig. 392

K495 Follower of Barnaba da Modena, p. 12, Fig. 18

K496 Matteo di Giovanni, p. 157, Fig. 426

K497 Fra Filippo Lippi and Assistant, p. 108, Fig. 291

K500 Giovanni di Paolo, p. 149, Fig. 403

K501 Sellaio, p. 133, Fig. 368

K503A, B Fra Diamante, p. 109, Figs. 297–298

K510 Fra Filippo Lippi, p. 106, Fig. 289

K511 Memmi, p. 49, Fig. 126

K513 Sassetta and Assistant, p. 141, Figs. 380–381

K515 Rosselli, p. 120, Fig. 330

K516 Modern Copy after Fra Filippo Lippi [not catalogued]

K517 Matteo di Giovanni, p. 156, Fig. 423

K518 Attributed to Uccello, p. 101, Fig. 273

K522 Sano di Pietro, p. 145, Figs. 389–390

K525 Master of the Bambino Vispo, p. 90, Fig. 242

K526 Attributed to Lorenzo Veneziano, p. 9, Fig. 20

K527 Follower of Barnaba da Modena, p. 12, Fig. 17

K528 Follower of Pesellino, p. 111, Fig. 306

K530 Studio of Francesco di Giorgio, p. 154, Fig. 420

K535 Gentile da Fabriano, p. 76, Fig. 213

K537 Follower of Giotto, p. 22, Fig. 51

K539 Follower of Giotto, p. 22, Fig. 48

K540 Pesellino and Studio, p. 110, Fig. 302

K541 Pesellino and Studio, p. 110, Fig. 303

K543 Francesco d'Antonio, p. 92, Fig. 250

K545 Benvenuto di Giovanni, p. 158, Fig. 428

K551 Taddeo di Bartolo, p. 63, Fig. 165

K552 Taddeo di Bartolo, p. 63, Fig. 166

K553 Taddeo di Bartolo, p. 64, Fig. 167

K554 Taddeo di Bartolo, p. 64, Fig. 168

K560 Venetian School, Late XIV Century, p. 11, Fig. 21

K563 Follower of Agnolo Gaddi, p. 40, Fig. 100

K568 Attributed to Lorenzo Veneziano, p. 9, Fig. 24

K572 Jacopo del Casentino and Assistant, p. 25, Fig. 57

K577 Follower of Duccio, p. 15, Fig. 33

K591 (formerly K8917) Attributed to Botticelli, p. 124, Fig. 327

K592 Master of the Goodhart Madonna, p. 18, Fig. 40

K616 Belbello da Pavia, p. 81, Fig. 206

K1002 Rosselli, p. 120, Fig. 325

K1003 Neri di Bicci, p. 113, Fig. 310

K1004 Niccolò di Pietro Gerini, p. 42, Fig. 106

K1007 Andrea Vanni, p. 58, Fig. 155

K1014 Andrea di Bartolo, p. 66, Fig. 178

K1015A, B Francesco d'Antonio, p. 93, Figs. 251–252

K1016 Attributed to Lorenzo di Niccolò, p. 45, Fig. 108

K 1024 'Alunno di Benozzo,' p. 117, Fig. 320

K 1025 'Alunno di Benozzo,' p. 118, Fig. 319

K 1036 Sano di Pietro, p. 145, Fig. 387

K 1045 Master of the Ovile Madonna, p. 55, Fig. 142

K 1046 Francesco d'Antonio, p. 93, Fig. 253

K 1047 Studio of Lorenzo Monaco, p. 89, Fig. 244

K 1053 Studio of Giovanni di Paolo, p. 150, Fig. 407

K 1054 Master of the St. Verdiana Panel, p. 42, Fig. 105

K 1072 Florentine School, Early XV Century, p. 91, Fig. 243

K 1073 Studio of Rosselli, p. 121, Fig. 329

K 1074 Sienese School, Mid-XIV Century, p. 56, Fig. 143

K 1075 Follower of Taddeo di Bartolo, p. 64, Fig. 170

K 1078 Girolamo di Benvenuto, p. 162, Fig. 449

K 1082 Attributed to Tura, p. 82, Fig. 230

K 1084 Master of the Blessed Clare, p. 70, Fig. 187

K 1085 Tegliacci, p. 58, Fig. 150

K 1088 Biagio d'Antonio da Firenze, p. 131, Figs. 356–357

K 1089 Studio of Daddi, p. 27, Fig. 64

K 1091 Guariento, p. 10, Fig. 19

K 1093 Lorenzo di Niccolò, p. 44, Fig. 110

K 1094 Giovanni di Paolo, p. 149, Fig. 405

K 1102 Follower of Segna di Buonaventura, p. 17, Fig. 30

K 1108A, B Master of Fucecchio, p. 106, Figs. 287–288

K 1109 Veneto-Byzantine School, Late XIV Century, p. 11, Fig. 26

K 1119 Follower of Niccolò di Pietro Gerini, p. 43, Fig. 107

K 1120 Pellegrino di Mariano, p. 151, Fig. 413

K 1121 Florentine School, Late XIV Century, p. 38, Fig. 88

K 1122A, B Giusto de'Menabuoi, p. 39, Figs. 95–96

K 1128 Giovanni di Francesco, p. 104, Fig. 283

K 1135 Master of the Bambino Vispo, p. 91, Fig. 245

K 1138 Follower of Jacopo del Casentino, p. 25, Fig. 58

K 1139 Biagio d'Antonio da Firenze, p. 132, Fig. 359

K 1142 Follower of Giovanni di Paolo, p. 150, Fig. 408

K 1143 Neri di Bicci, p. 113, Fig. 305

K 1145A, B Master of Fucecchio, p. 105, Figs. 284–285

K 1147 Studio of Domenico Ghirlandaio, p. 126, Fig. 340

K 1148 Master of Fucecchio, p. 106, Fig. 286

K 1150 Giovanni del Biondo, p. 37, Fig. 87

K 1152A, B Master of the Apollo and Daphne Legend, p. 130, Figs. 348, 350

K 1155 Follower of Sano di Pietro, p. 147, Fig. 395

K 1156 Follower of Sano di Pietro, p. 147, Fig. 396

K 1158 Sellaio, p. 133, Fig. 364

K 1160 Follower of Niccolò di Pietro Gerini, p. 44, Fig. 111

K 1161 Giovanni del Biondo, p. 36, Fig. 91

K 1162 Master of Staffolo, p. 79, Fig. 217

K 1166 Jacopino di Francesco, p. 71, Fig. 189

K 1167 Jacopino di Francesco, p. 71, Fig. 191

K 1168 Jacopino di Francesco, p. 71, Fig. 192

K 1169 Jacopino di Francesco, p. 71, Fig. 190

K 1170 Jacopino di Francesco, p. 71, Fig. 188

K 1171 Master of the Rinuccini Chapel, p. 35, Figs. 79–81

K 1173 Cozzarelli, p. 160, Fig. 434

K 1174 Cecco di Pietro, p. 73, Fig. 201

K 1176 Studio of Andrea di Bartolo, p. 67, Fig. 180

K 1177 Studio of Andrea di Bartolo, p. 67, Fig. 181

K 1179 Taddeo di Bartolo, p. 63, Fig. 164

K 1184 Biagio d'Antonio da Firenze, p. 132, Fig. 358

K 1187 Follower of Pesellino, p. 111, Fig. 307

K 1188 Schiavo, p. 105, Fig. 282

K 1189 Tuscan School, Late XIII Century, p. 6, Fig. 8

K 1190 Follower of Bicci di Lorenzo, p. 47, Fig. 119

K 1195 Michele di Matteo, p. 73, Figs. 193–194

K 1197 Nuzi, p. 75, Fig. 204

K 1201 Simone dei Crocifissi, p. 72, Fig. 195

K 1206 Dalmasio, p. 71, Fig. 196

K 1209 Jacopo di Paolo, p. 72, Fig. 197

K 1224A, B Follower of Pietro Lorenzetti, p. 53, Figs. 137–138

K 1225 Venetian School, Early XIV Century, p. 9, Fig. 23

K 1226 Nuzi, p. 75, Fig. 205

K 1228 Bicci di Lorenzo, p. 47, Fig. 120

K 1234 Andrea Vanni, p. 58, Fig. 154

K 1235 Follower of Vecchietta, p. 152, Fig. 410

K 1237 Follower of Pietro Lorenzetti, p. 53, Fig. 134

K 1240 Follower of Botticelli, p. 124, Fig. 336

K 1241 Fra Filippo Lippi, p. 107, Fig. 299

K 1242 Filippino Lippi, p. 135, Fig. 370

K 1245 Attributed to Baldassare d'Este, p. 83, Fig. 231

K 1262 Follower of Pacino di Buonaguida, p. 23, Fig. 49

K 1282 Style of Verrocchio, p. 118, Fig. 322

K 1283 Cozzarelli, p. 160, Fig. 438

K 1285A, B Attributed to Sassetta, p. 143, Figs. 384–385

K 1286 Cozzarelli, p. 159, Fig. 435

K 1287 Girolamo di Benvenuto, p. 161, Fig. 447

K 1289 Follower of Duccio, p. 15, Fig. 25

K 1290 Studio of Daddi, p. 28, Fig. 66

K 1292 Taddeo di Bartolo, p. 63, Fig. 163

K 1293 Lorenzo Monaco, p. 89, Fig. 239

K 1295 Girolamo di Benvenuto, p. 163, Fig. 440

K 1296 Jacopo del Casentino and Assistant, p. 24, Fig. 54

K 1297 Jacopo del Casentino and Assistant, p. 24, Fig. 55

K 1300 Daddi and Assistant, p. 26, Fig. 62

K 1301 Modern Imitation of XIII Century Italian School [not catalogued]

K 1302 Master of the Ovile Madonna, p. 54, Fig. 145

K 1311 Attributed to Botticelli, p. 123, Fig. 337

K 1312 Master of the Life of St. John the Baptist, p. 68, Fig. 182

K 1325 Follower of Fra Filippo Lippi, p. 108, Fig. 304

K 1331 Domenico Veneziano, p. 103, Fig. 280

K 1334 Style of Baldovinetti, p. 114, Fig. 311

K 1342 Fra Filippo Lippi, p. 107, Figs. 290, 292

K 1343 Memmi, p. 49, Fig. 127

K 1346 Neroccio de'Landi, p. 155, Fig. 421

K 1347 Margaritone, p. 3, Fig. 1

K 1348 Follower of Taddeo Gaddi, p. 24, Fig. 53

K 1349 Segna di Buonaventura, p. 16, Fig. 31

K 1350 Simone Martini and Assistants, p. 48, Fig. 122

K 1351 Simone Martini and Assistants, p. 48, Fig. 123

K 1352 Simone Martini and Assistants, p. 48, Fig. 124

K 1353 Simone Martini and Assistants, p. 48, Fig. 125

K 1354 Attributed to Ambrogio Lorenzetti, p. 51, Fig. 135

K 1355A, B, C Lippo Vanni, p. 57, Figs. 147–149

K 1356 Francesco di Giorgio, p. 153, Fig. 416

K 1357 Master of the Franciscan Crucifixes, p. 4, Fig. 4

K 1358 Master of the Franciscan Crucifixes, p. 4, Fig. 5

K 1359 Master of St. Francis, p. 4, Fig. 3

K 1360 Master of St. Francis, p. 4, Fig. 2

K 1361 Cossa, p. 84, Fig. 224

K 1363 Orcagna and Jacopo di Cione, p. 31, Fig. 76

K 1364 Studio of the Master of the Ovile Madonna, p. 55,
 Fig. 140

K 1367 Sassetta and Assistant, p. 141, Fig. 378

K 1368 Sassetta and Assistant, p. 141, Fig. 379

K 1369 Attributed to Daddi, p. 26, Fig. 69

K 1370 Francesco di Giorgio, p. 153, Fig. 414

K 1372 Taddeo Gaddi, p. 23, Fig. 52

K 1373 Tura, p. 81, Fig. 225

K 1387 Fra Angelico, p. 94, Figs. 258, 262

K 1388 Domenico di Bartolo, p. 140, Fig. 377

K 1410 Attributed to Botticelli, p. 123, Fig. 331

K 1424 Giotto and Assistants, p. 21, Fig. 47

K 1425 Fra Angelico and Fra Filippo Lippi, Frontispiece; p. 95,
 Figs. 259–261

K 1429 Tura, p. 82, Figs. 226–229

K 1430 Tuscan School, XIV Century, p. 31, Fig. 65

K 1432 Botticelli, p. 122, Fig. 333

K 1434 Sienese School, c. 1440, p. 147, Figs. 398–400

K 1435 Master of the Life of St. John the Baptist, p. 68,
 Fig. 183

K 1441 Giotto and Assistants, p. 21, Fig. 45

K 1442 Giotto and Assistants, p. 21, Fig. 43

K 1443 Giotto and Assistants, p. 21, Fig. 46

K 1444 Giotto and Assistants, p. 21, Fig. 44

K 1546 Master of the Straus Madonna, p. 41, Fig. 103

K 1547 Fei, p. 61, Fig. 160

K 1549 Attributed to Cimabue, p. 5, Fig. 9

K 1556 Giovanni dal Ponte, p. 92, Fig. 249

K 1564 Francesco di Giorgio, p. 153, Fig. 419

K 1568 Sassetta and Assistant, p. 141, Fig. 382

K 1616 Master of the Apollo and Daphne Legend, p. 130,
 Fig. 353

K 1617 Master of the Apollo and Daphne Legend, p. 130,
 Fig. 354

K 1644 Botticelli, p. 121, Fig. 335

K 1647A, B, C, D Benvenuto di Giovanni, p. 158, Figs. 429–432

K 1648 Gozzoli, p. 116, Fig. 317

K 1654 Follower of Lorenzo Monaco, p. 90, Fig. 240

K 1715 Lucchese School, c. 1200, p. 3, Fig. 6

K 1716 Follower of Cimabue, p. 6, Fig. 7

K 1717 Pacino di Buonaguida, p. 23, Fig. 50

K 1718 Daddi, p. 26, Fig. 61

K 1719 Niccolò di Pietro Gerini, p. 43, Fig. 113

K 1720 Master of the Buckingham Palace Madonna, p. 100,
 Fig. 274

K 1721A, B Master of the Apollo and Daphne Legend, p. 129,
 Figs. 347, 349

K 1722 Follower of Verrocchio, p. 119, Fig. 324

K 1723 Florentine School, Second Half of XV Century, p. 119,
 Fig. 323

K 1724 Gherardo del Fora, p. 138, Fig. 366

K 1725 Domenico Ghirlandaio, p. 125, Fig. 334

K 1726 Studio of Domenico Ghirlandaio, p. 126, Fig. 338

K 1727 Filippino Lippi, p. 137, Fig. 375

K 1728 Neri di Bicci, p. 113, Fig. 308

K 1734 Rosselli, p. 121, Fig. 326

K 1741 Luca di Tommè, p. 59, Fig. 151

K 1742 Palmerucci, p. 56, Fig. 144

K 1743A, B Cozzarelli, p. 161, Figs. 436–437

K 1744A, B Girolamo di Benvenuto, p. 161, Figs. 441–446

K 1745A, B Matteo di Giovanni, p. 157, Figs. 424, 427

K 1746 Matteo di Giovanni, p. 157, Fig. 425

K 1747 Nicolò da Voltri, p. 13, Fig. 29

K 1777 Follower of Gentile da Fabriano, p. 78, Fig. 214

K 1779 Attributed to Battista da Vicenza, p. 74, Fig. 203

K 1833 Benvenuto di Giovanni, p. 159, Fig. 433

K 1889 Filippino Lippi, p. 136, Fig. 371

K 1895 Paolo Veneziano, p. 7, Fig. 13

K 1901 Follower of Neroccio de' Landi, p. 156, Fig. 422

K 1925 Follower of Daddi, p. 28, Fig. 63

K 1929 Master of the 'Apollini Sacrum,' p. 128, Fig. 352

K 1930 Master of the Clarisse Panel, p. 13, Fig. 34

K 2033 Zoppo, p. 87, Fig. 237

K 2045 Fei, p. 62, Fig. 159

K 2063 Follower of Duccio, p. 14, Fig. 27

K 2067 Master of the Stratonice Cassoni, p. 139, Fig. 367

K 2076 Domenico Ghirlandaio, p. 125, Fig. 344

K 2142 Sienese School, c. 1370, p. 56, Fig. 146

K 2155 Botticelli and Assistants, p. 122, Fig. 332

K 8917 See K 591

INDEX OF PLACES

ALLENTOWN, Pa., Allentown Art Museum
 Andrea di Giusto, p. 99, Fig. 266
 Biagio d'Antonio da Firenze, p. 133, Fig. 360
 Florentine School, Mid-XIV Century, p. 34, Fig. 73
 Florentine School, Mid-XV Century, p. 99, Fig. 268
 Florentine School, c. 1475, p. 120, Fig. 321
 Giovanni del Biondo, p. 37, Fig. 87
 Lorenzetti, Pietro, Follower of, p. 52, Fig. 136
 Lorenzo di Bicci, p. 46, Fig. 115
 Lorenzo Monaco, Follower of, p. 90, Fig. 241
 Niccolò di Tommaso, Follower of, p. 35, Fig. 74
 Riminese School, Late XIV Century, p. 69, Fig. 186
 Spinello Aretino, p. 45, Fig. 112
 Uccello, Follower of, p. 102, Fig. 275
 Venetian School, Late XIV Century, p. 11, Figs. 16, 21

AMHERST, Mass., Amherst College
 Cozzarelli, p. 160, Fig. 439
 Mariotto di Nardo, p. 46, Fig. 118
 Sano di Pietro, p. 146, Fig. 397

ATHENS, Ga., University of Georgia
 Diamante, Fra, p. 109, Figs. 297–298
 Giusto de'Menabuoi, p. 39, Figs. 92–96
 Lorenzetti, Pietro, Attributed to, p. 52, Fig. 131
 Schiavo, p. 105, Fig. 282
 Simone dei Crocifissi, p. 72, Fig. 195

ATLANTA, Ga., Atlanta Art Association Galleries
 Fei, p. 62, Fig. 161
 Francesco di Giorgio, p. 153, Fig. 419
 Lorenzo Veneziano, Attributed to, p. 9, Fig. 24
 Master of the 'Apollini Sacrum,' p. 128, Figs. 345–346
 Master of the St. Verdiana Panel, p. 42, Fig. 105
 Niccolò di Segna, p. 17, Figs. 36–37

BEREA, Ky., Berea College
 Cristiani, Follower of, p. 40, Fig. 102
 Giovanni di Francesco, p. 104, Fig. 283
 Master of the Apollo and Daphne Legend, p. 130, Fig. 353
 Master of San Martino alla Palma, p. 30, Fig. 71
 Pesellino, Follower of, p. 111, Fig. 306

BIRMINGHAM, Ala., Birmingham Museum of Art
 Apollonio di Giovanni, p. 98, Fig. 267
 Ghirlandaio, Domenico, Follower of, p. 127, Fig. 339
 Lorenzo di Niccolò, p. 44, Fig. 117
 Lorenzo Veneziano, Attributed to, p. 9, Fig. 20
 Master of Fucecchio, p. 106, Figs. 287–288
 Master of the Goodhart Madonna, p. 18, Fig. 40
 Master of the St. Verdiana Panel, p. 41, Fig. 104
 Master of the Stratonice Cassoni, p. 139, Fig. 367
 Niccolò di Pietro Gerini, p. 43, Fig. 113
 Nuzi, p. 75, Fig. 204
 Pesellino and Studio, p. 110, Figs. 302–303

Sano di Pietro, p. 146, Figs. 393–394
 Sellaio, p. 134, Figs. 363, 450
 Turino di Vanni, Attributed to, p. 74, Figs. 199–200
 Tuscan School, Late XIII Century, p. 6, Fig. 8
 Verrocchio, Follower of, p. 119, Fig. 324

BLOOMINGTON, Ind., Indiana University
 Gaddi, Taddeo, Follower of, p. 24, Fig. 53
 Matteo di Giovanni, p. 157, Fig. 426
 Pesellino, Follower of, p. 111, Fig. 307
 Venetian School, Early XIV Century, p. 9, Fig. 23

BRIDGEPORT, Conn., Museum of Art, Science and Industry
 Lorenzetti, Pietro, Follower of, p. 53, Figs. 137–138
 Vecchietta, Attributed to, p. 151, Fig. 409

BRUNSWICK, Me., Walker Art Museum, Bowdoin College
 Barnaba da Modena, Follower of, p. 12, Fig. 17
 Biagio d'Antonio da Firenze, p. 132, Fig. 358
 Gherardo del Fora, p. 138, Fig. 366
 Master of the Griggs Crucifixion, Circle of, p. 100, Fig. 269
 Nuzi, p. 75, Fig. 205
 Vecchietta, Follower of, p. 152, Fig. 410

CAMBRIDGE, Mass., Fogg Art Museum (for study)
 Italian School, XIII Century, Modern Imitation of [K1301, not catalogued]
 Lippi, Fra Filippo, Modern Copy after [K516, not catalogued]
 Palmerucci, p. 55, Fig. 132

CHARLESTON, S. C., Gibbes Art Gallery
 Sellaio, Follower of, p. 134, Fig. 365

CHARLOTTE, N. C., Mint Museum of Art
 Ghirlandaio, Domenico, Follower of, p. 126, Fig. 341

CLAREMONT, Calif., Pomona College
 Barnaba da Modena, Follower of, p. 12, Fig. 18
 Italo-Byzantine School, XIV Century Style, p. 12, Fig. 15
 Master of Staffolo, p. 79, Fig. 217
 Neri di Bicci, p. 113, Fig. 310
 Niccolò di Pietro Gerini, Follower of, p. 44, Fig. 111
 Vanni, Andrea, p. 58, Fig. 155

COLORADO SPRINGS, Colo., Colorado Springs Fine Arts Center
 Niccolò di Pietro Gerini, p. 42, Fig. 106

COLUMBIA, Mo., University of Missouri
 'Alunno di Benozzo,' p. 117, Fig. 318
 Michele di Matteo, p. 73, Figs. 193–194

COLUMBIA, S. C., Columbia Museum of Art
 Botticelli, Attributed to, p. 123, Fig. 331
 Cimabue, Follower of, p. 6, Fig. 7
 Cozzarelli, p. 161, Fig. 437
 Daddi, Studio cf, p. 27, Fig. 64
 Giovanni dal Ponte, p. 92, Figs. 246–248

Master of the Ovile Madonna, p. 54, Fig. 139
Matteo di Giovanni, p. 157, Fig. 425
Rosselli, p. 120, Fig. 325

CORAL GABLES, Fla., Joe and Emily Lowe Art Gallery,
 University of Miami
 Cozzarelli, p. 159, Fig. 435
 Francesco di Giorgio, p. 153, Fig. 414
 Master of the Blessed Clare, p. 70, Fig. 187
 Sano di Pietro, p. 145, Fig. 391
 Tuscan School, First Half of XIV Century, p. 30, Fig. 70
 Vanni, Lippo, p. 57, Figs. 147–149

DALLAS, Tex., Dallas Museum of Fine Arts
 Domenico di Michelino, p. 101, Figs. 271–272

DENVER, Colo., Denver Art Museum
 'Alunno di Benozzo,' p. 118, Fig. 319
 Francesco d'Antonio, p. 92, Fig. 250
 Gentile da Fabriano, Follower of, p. 78, Fig. 214
 Ghirlandaio, Domenico, Studio of, p. 126, Fig. 338
 Giovanni da Bologna, p. 10, Fig. 22
 Girolamo di Benvenuto, p. 162, Fig. 448; p. 163, Fig. 440
 Jacopo di Cione, Attributed to, p. 33, Fig. 78
 Neri di Bicci, p. 113, Fig. 308
 Niccolò di Pietro Gerini, p. 43, Fig. 109
 Pesellino, p. 110, Fig. 301

EL PASO, Tex., El Paso Museum of Art
 Botticelli, Follower of, p. 124, Fig. 336
 Giovanni di Paolo, p. 149, Fig. 403
 Jacopo del Casentino and Assistant, p. 24, Figs. 54–55
 Lippi, Filippino, p. 137, Fig. 375
 Lorenzetti, Ambrogio, Attributed to, p. 51, Fig. 135
 Lucchese School, c. 1200, p. 3, Fig. 6
 Martino di Bartolommeo, p. 65, Fig. 179
 Master of the Bambino Vispo, p. 90, Fig. 242
 Nicolò da Voltri, p. 13, Fig. 29
 Sano di Pietro, p. 145, Figs. 389–390
 Sellaio, p. 133, Fig. 364
 Sienese School, c. 1440, p. 147, Figs. 398–400

HARTFORD, Conn., Trinity College
 Ghirlandaio, Domenico, Studio of, p. 126, Fig. 340
 Lorenzetti, Pietro, Follower of (Possibly Tegliacci), p. 53,
 Fig. 134

HONOLULU, Hawaii, Honolulu Academy of Arts
 Diamante, Fra, p. 109, Figs. 293–296
 Gozzoli, Follower of, p. 116, Fig. 316
 Segna di Buonaventura, p. 16, Fig. 32

KANSAS CITY, Mo., William Rockhill Nelson Gallery of Art
 Daddi and Assistant, p. 26, Fig. 62
 Giovanni di Paolo, p. 148, Fig. 401
 Jacopo del Casentino, p. 24, Fig. 56
 Master of the Bambino Vispo, p. 91, Fig. 245
 Memmi, p. 49, Fig. 127

LAWRENCE, Kans., University of Kansas
 Cenni di Francesco, p. 42, Fig. 101
 Master of the 'Apollini Sacrum,' p. 128, Fig. 352

Neri di Bicci, p. 113, Fig. 305
Palmerucci, p. 56, Fig. 144
Sassetta, Studio of, p. 144, Fig. 386
Sassetta, Follower of, p. 144, Fig. 412

LEWISBURG, Pa., Bucknell University
 Ferrarese School, Late XV Century, p. 86, Fig. 236
 Giovanni del Biondo, p. 36, Fig. 91
 Girolamo di Benvenuto, p. 161, Figs. 441–443
 Master of the Apollo and Daphne Legend, p. 130, Fig. 354
 Master of Fucecchio, p. 106, Fig. 286
 Spinello Aretino, Studio of, p. 45, Fig. 116

LINCOLN, Nebr., University of Nebraska
 Andrea di Bartolo, Studio of, p. 67, Figs. 180–181

LITTLE ROCK, Ark., Arkansas Arts Center
 Lorenzo di Niccolò, Attributed to, p. 45, Fig. 108

LOS ANGELES, Calif., Los Angeles County Museum of Art
 Florentine School, Late XIV Century, p. 38, Fig. 88
 Luca di Tommè, p. 60, Fig. 153

MADISON, Wis., University of Wisconsin
 Cossa, Follower of, p. 85, Fig. 234
 Cozzarelli, p. 160, Fig. 438
 Giovanni di Paolo, Studio of, p. 150, Fig. 407
 Master of the Griggs Crucifixion, p. 99, Fig. 270
 Vanni, Andrea, p. 58, Fig. 154

MEMPHIS, Tenn., Brooks Memorial Art Gallery
 Andrea di Niccolò, Attributed to, p. 152, Fig. 411
 Duccio, Follower of, p. 15, Fig. 25
 Fei, p. 61, Fig. 162
 Florentine School, Second Half of XV Century, p. 119, Fig. 323
 Giovanni del Biondo, p. 37, Fig. 85
 Lippi, Filippino, and Assistants, p. 137, Fig. 372
 Master of the Clarisse Panel, p. 13, Fig. 34
 Pellegrino di Mariano, p. 151, Fig. 413
 Sellaio, p. 134, Fig. 361
 Taddeo di Bartolo, p. 63, Figs. 165–166
 Tuscan School, XIV Century, p. 31, Fig. 65

MONTGOMERY, Ala., Huntingdon College
 Florentine School, Early XV Century, p. 91, Fig. 243

MONTGOMERY, Ala., Montgomery Museum of Fine Arts
 Francesco d'Antonio, p. 93, Fig. 253

NASHVILLE, Tenn., George Peabody College for Teachers
 Andrea di Bartolo, p. 66, Fig. 178
 Bicci di Lorenzo, Follower of, p. 47, Fig. 119
 Jacopo di Paolo, p. 72, Fig. 197

NEW ORLEANS, La., Isaac Delgado Museum of Art
 Battista da Vicenza, Attributed to, p. 74, Fig. 203
 Daddi, Follower of, p. 28, Fig. 60
 Giovanni del Biondo, Attributed to, p. 37, Fig. 86
 Girolamo di Benvenuto, p. 161, Figs. 444–446
 Italian School, c. 1300, p. 6, Fig. 11
 Lippi, Fra Filippo, Follower of, p. 108, Fig. 304
 Taddeo di Bartolo, p. 64, Figs. 167–168
 Vanni, Andrea, p. 57, Fig. 156

NEW YORK, N. Y., Mrs. Rush H. Kress
Belbello da Pavia, p. 81, Fig. 206
Lippi, Filippino, Attributed to, p. 138, Fig. 376
Veronese School, Early XV Century, p. 78, Figs. 215–216

NEW YORK, N. Y., Samuel H. Kress Foundation
Master of the Ovile Madonna, p. 55, Fig. 142
Master of the Apollo and Daphne Legend, p. 129, Figs. 347, 349
Pier Francesco Fiorentino, Pseudo, p. 115, Fig. 314
Sano di Pietro, p. 145, Fig. 387
Veneto-Byzantine School, Late XIV Century, p. 11, Fig. 26

NEW YORK, N. Y., Metropolitan Museum of Art
Master of the Orcagnesque Misericordia, p. 38, Figs. 89–90
Neroccio de'Landi, p. 155, Fig. 415

NOTRE DAME, Ind., University of Notre Dame
Baldovinetti, Style of, p. 114, Fig. 311
Gualtieri di Giovanni, Attributed to, p. 65, Fig. 172
Master of the Fabriano Altarpiece, p. 29, Fig. 68
Neroccio de'Landi, Follower of, p. 156, Fig. 422
Rosselli, p. 121, Fig. 326
Taddeo di Bartolo, p. 64, Fig. 169

OBERLIN, Ohio, Allen Memorial Art Museum, Oberlin College
Neri di Bicci, p. 112, Fig. 309

PONCE, Puerto Rico, Museo de Arte de Ponce
Biagio d'Antonio da Firenze, p. 132, Fig. 359
Duccio, Follower of, p. 15, Fig. 33
Florentine School, c. 1475, p. 119, Fig. 328
Giovanni del Biondo, p. 36, Figs. 83–84
Luca di Tommè, p. 60, Fig. 152
Niccolò di Pietro Gerini, Follower of, p. 43, Fig. 107
Orcagna, Studio of, p. 32, Fig. 77
Pacino di Buonaguida, Follower of, p. 23, Fig. 49
Schiavo, p. 105, Fig. 281

PORTLAND, Ore., Portland Art Museum
Barna da Siena, Attributed to, p. 50, Fig. 128
Botticelli, Attributed to, p. 124, Fig. 327
Cecco di Pietro, p. 73, Fig. 201
Daddi, Follower of, p. 28, Fig. 63
Francesco di Giorgio, Studio of, p. 154, Fig. 420
Ghirlandaio, Domenico, Follower of, p. 127, Figs. 342–343
Italian School, c. 1300, p. 6, Fig. 12
Nuzi, p. 75, Fig. 207
Segna di Buonaventura, Follower of, p. 17, Fig. 30

RALEIGH, N. C., North Carolina Museum of Art
Apollonio di Giovanni, p. 98, Figs. 263, 265
Benvenuto di Giovanni, p. 159, Fig. 433
Botticelli and Assistants, p. 122, Fig. 332
Cecco di Pietro, p. 73, Fig. 198
Giotto and Assistants, p. 21, Figs. 43–47
Giotto, Follower of, p. 22, Fig. 48
Guariento, p. 10, Fig. 19
Jacopino di Francesco, p. 71, Figs. 188–192
Lippi, Filippino, p. 136, Figs. 373–374
Lombard School, XV Century, p. 80, Fig. 220

Lorenzo di Niccolò, p. 44, Fig. 110
Luca di Tommè, p. 59, Fig. 151
Master of the Rinuccini Chapel, p. 35, Figs. 79–81
Master of San Torpè, Attributed to, p. 19, Fig. 39
Neroccio de'Landi, p. 154, Figs. 417–418
Nuzi, p. 75, Figs. 208, 210
Segna di Buonaventura, p. 16, Fig. 31
Sienese School, Early XIV Century, p. 16, Fig. 35
Sienese School, c. 1370, p. 56, Fig. 146
Uccello, Attributed to, p. 101, Fig. 273

SAN ANTONIO, Tex., Witte Memorial Museum
Taddeo di Bartolo, Follower of, p. 64, Fig. 170

SAN FRANCISCO, Calif., M. H. De Young Memorial Museum
Angelico, Fra, Attributed to, p. 97, Fig. 256
Antonio Veneziano, p. 46, Fig. 114
Bartolommeo di Giovanni, p. 129, Fig. 351
Daddi, Attributed to, p. 27, Fig. 59
Giovanni dal Ponte, p. 92, Fig. 249
Jacopo di Cione, Attributed to, p. 33, Fig. 82
Luca di Tommè, p. 59, Fig. 157
Matteo di Giovanni, p. 157, Figs. 424, 427
Taddeo di Bartolo, p. 63, Fig. 171

SEATTLE, Wash., Seattle Art Museum
Daddi, Studio of, p. 28, Fig. 66
Daddi, Follower of, p. 29, Fig. 67
Dalmasio, p. 71, Fig. 196
Giovanni di Paolo, p. 149, Fig. 405
Lorenzetti, Pietro, Attributed to, p. 51, Fig. 130
Lorenzo Monaco, Follower of, p. 90, Fig. 240
Luca di Tommè, Studio of, p. 60, Fig. 158
Master of Fucecchio, p. 105, Figs. 284–285
Master of the Life of St. John the Baptist, p. 69, Fig. 185
Master of San Torpè, p. 18, Fig. 38
Master of the Straus Madonna, p. 41, Fig. 103
Uccello, Follower of, p. 102, Figs. 276–277

STATEN ISLAND, N. Y., Staten Island Institute of Arts and Sciences
Giovanni di Paolo, Follower of, p. 150, Fig. 408
Jacopo del Casentino, Follower of, p. 25, Fig. 58

TEMPE, Ariz., Arizona State University
Bicci di Lorenzo, p. 47, Fig. 120

TUCSON, Ariz., St. Philip's in the Hills
Francesco d'Antonio, p. 93, Figs. 251–252
Giotto, Follower of, p. 22, Fig. 51

TUCSON, Ariz., University of Arizona
Cozzarelli, p. 160, Fig. 434
Gaddi, Agnolo, Follower of, p. 40, Fig. 100
Giambono, Follower of, p. 80, Fig. 219
Giovanni di Paolo, Studio of, p. 150, Fig. 406
Jacopo del Casentino and Assistant, p. 25, Fig. 57
Master of the Ovile Madonna, Studio of, p. 55, Fig. 140
Master of the Buckingham Palace Madonna, p. 100, Fig. 274
Pacino di Buonaguida, p. 23, Fig. 50

Sano di Pietro, Follower of, p. 147, Figs. 395–396
Taddeo di Bartolo, p. 63, Fig. 163
Tegliacci, p. 58, Fig. 150

TULSA, Okla., Philbrook Art Center
'Alunno di Benozzo,' p. 117, Fig. 320
Andrea di Giusto, p. 98, Fig. 264
Biagio d'Antonio da Firenze, p. 131, Figs. 356–357
Cozzarelli, p. 161, Fig. 436
Gentile da Fabriano, p. 76, Fig. 213
Girolamo di Benvenuto, p. 161, Fig. 447
Lorenzetti, Pietro, Follower of, p. 52, Fig. 141
Lorenzo Monaco, Studio of, p. 89, Fig. 244
Orcagna, Follower of, p. 32, Fig. 72
Pier Francesco Fiorentino, Pseudo, p. 115, Fig. 313
Puccinelli, p. 74, Fig. 202
Rosselli, p. 120, Fig. 330
Taddeo di Bartolo, p. 63, Fig. 164

WACO, Tex., Baylor University
Lorenzetti, Pietro, Follower of, p. 52, Fig. 133

WASHINGTON, D. C., Howard University
Master of the Apollo and Daphne Legend, p. 130, Figs. 348, 350
Pietro di Domenico da Montepulciano, p. 79, Fig. 218

WASHINGTON, D. C., National Gallery of Art
Andrea di Bartolo, p. 66, Figs. 173–177
Angelico, Fra, p. 94, Figs. 258, 262
Angelico, Fra, and Fra Filippo Lippi, Frontispiece; p. 95, Figs. 259–261
Angelico, Fra, Attributed to, p. 97, Fig. 257
Baldassare d'Este, Attributed to, p. 83, Fig. 231
Benvenuto di Giovanni, p. 158, Figs. 428–432
Biagio d'Antonio da Firenze, p. 132, Figs. 355, 362
Botticelli, p. 121, Fig. 335; p. 122, Fig. 333
— Attributed to, p. 123, Fig. 337
Cimabue, Attributed to, p. 5, Fig. 9
Cossa, p. 83, Figs. 222–223; p. 84, Fig. 224
— Attributed to, p. 85, Fig. 235
Daddi, p. 26, Fig. 61
— Attributed to, p. 26, Fig. 69
Domenico di Bartolo, p. 140, Fig. 377
Domenico Veneziano, p. 103, Figs. 278–280
Duccio, p. 14, Fig. 28
— Follower of, p. 14, Fig. 27
Fei, p. 61, Fig. 160; p. 62, Fig. 159
Francesco di Giorgio, p. 153, Fig. 416
Gaddi, Agnolo, p. 40, Figs. 98–99

Gentile da Fabriano, p. 76, Fig. 212; p. 77, Fig. 211
Ghirlandaio, Domenico, p. 125, Figs. 334, 344
Giambono, p. 79, Fig. 221
Giotto, p. 20, Figs. 41–42
Giovanni di Paolo, p. 148, Figs. 402, 404
Girolamo di Benvenuto, p. 162, Fig. 449
Gozzoli, p. 115, Fig. 315; p. 116, Fig. 317
Lippi, Filippino, p. 135, Figs. 369–370; p. 136, Fig. 371
Lippi, Fra Filippo, p. 106, Fig. 289; p. 107, Figs. 290, 299
— and Assistant, p. 108, Fig. 291
Lorenzo Monaco, p. 89, Fig. 239
Margaritone, p. 3, Fig. 1
Masolino, p. 94, Figs. 254–255
Master of the Franciscan Crucifixes, p. 4, Figs. 4–5
Master of the Life of St. John the Baptist, p. 68, Figs. 182–183; p. 69, Fig. 184
Master of the Ovile Madonna, p. 54, Fig. 145
Master of St. Francis, p. 4, Figs. 2–3
Matteo di Giovanni, p. 156, Fig. 423
Memmi, p. 49, Fig. 126
Nardo di Cione, p. 34, Fig. 75
Neroccio de'Landi, p. 155, Fig. 421
Orcagna and Jacopo di Cione, p. 31, Fig. 76
Paolo Veneziano, p. 7, Fig. 13; p. 8, Fig. 10
Pesellino, p. 110, Fig. 300
Pier Francesco Fiorentino, p. 114, Fig. 312
Roberti, p. 86, Figs. 232–233
Sano di Pietro, p. 144, Fig. 388; p. 146, Fig. 392
Sassetta, p. 140, Fig. 383
— and Assistant, p. 141, Figs. 378–382
— Attributed to, p. 143, Figs. 384–385
Sellaio, p. 133, Fig. 368
Simone Martini, p. 48, Fig. 121
— and Assistants, p. 48, Figs. 122–125
Tura, p. 81, Fig. 225; p. 82, Figs. 226–229
— Attributed to, p. 82, Fig. 230
Verrocchio, Style of, p. 118, Fig. 322
Zoppo, p. 87, Figs. 237–238

WILLIAMSTOWN, Mass., Williams College Museum of Art
Gaddi, Taddeo, p. 23, Fig. 52
Giovanni da Milano, p. 39, Fig. 97
Giovanni di Nicola da Pisa, p. 50, Fig. 129
Venetian School, c. 1300, p. 7, Fig. 14

WINTER PARK, Fla., Morse Gallery of Art, Rollins College
Rosselli, Studio of, p. 121, Fig. 329
Sienese School, Mid-XIV Century, p. 56, Fig. 143

INDEX OF ARTISTS

Alunno di Benozzo,' p. 117, Figs. 318, 320; p. 118, Fig. 319
Andrea di Bartolo, p. 65; p. 66, Figs. 173–178
— Studio of, p. 67, Figs. 180–181
Andrea di Giusto, p. 98, Fig. 264; p. 99, Fig. 266
Andrea di Niccolò, Attributed to, p. 152, Fig. 411
Angelico, Fra, p. 94, Figs. 258, 262
— and Fra Filippo Lippi, Frontispiece; p. 95, Figs. 259–261
— Attributed to, p. 97, Figs. 256–257
Antonio Veneziano, p. 46, Fig. 114
Apollonio di Giovanni, p. 98, Figs. 263, 265, 267

Baldassare d'Este, Attributed to, p. 83, Fig. 231
Baldovinetti, Style of, p. 114, Fig. 311
Barna da Siena, Attributed to, p. 50, Fig. 128
Barnaba da Modena, Follower of, p. 12, Figs. 17–18
Bartolommeo di Giovanni, p. 129, Fig. 351
Battista da Vicenza, Attributed to, p. 74, Fig. 203
Belbello da Pavia, p. 81, Fig. 206
Benvenuto di Giovanni, p. 158, Figs. 428–432; p. 159, Fig. 433
Biagio d'Antonio da Firenze, p. 131, Figs. 356–357; p. 132, Figs. 355, 358–359, 362; p. 133, Fig. 360
Bicci di Lorenzo, p. 47, Fig. 120
— Follower of, p. 47, Fig. 119
Botticelli, p. 121, Fig. 335; p. 122, Fig. 333
— and Assistants, p. 122, Fig. 332
— Attributed to, p. 123, Figs. 331, 337; p. 124, Fig. 327
— Follower of, p. 124, Fig. 336

Cecco di Pietro, p. 73, Figs. 198, 201
Cenni di Francesco, p. 42, Fig. 101
Cimabue, Attributed to, p. 5, Fig. 9
— Follower of, p. 6, Fig. 7
Cossa, p. 83, Figs. 222–223; p. 84, Fig. 224
— Attributed to, p. 85, Fig. 235
— Follower of, p. 85, Fig. 234
Cozzarelli, p. 159, Fig. 435; p. 160, Figs. 434, 438–439; p. 161, Figs. 436–437
Cristiani, Follower of, p. 40, Fig. 102

Daddi, p. 25; p. 26, Fig. 61
— and Assistant, p. 26, Fig. 62
— Attributed to, p. 26, Fig. 69; p. 27, Fig. 59
— Studio of, p. 27, Fig. 64; p. 28, Fig. 66
— Follower of, p. 28, Figs. 60, 63; p. 29, Fig. 67
Dalmasio, p. 71, Fig. 196
Diamante, Fra, p. 109, Figs. 293–298
Domenico di Bartolo, p. 140, Fig. 377
Domenico di Michelino, p. 101, Figs. 271–272
Domenico Veneziano, p. 103, Figs. 278–280
Duccio, p. 14, Fig. 28
— Follower of, p. 14, Fig. 27; p. 15, Figs. 25, 33

Fei, p. 61, Figs. 160, 162; p. 62, Figs. 159, 161
Ferrarese School, Late XV Century, p. 86, Fig. 236
Florentine School, Mid-XIV Century, p. 34, Fig. 73
Florentine School, Late XIV Century, p. 38, Fig. 88
Florentine School, Early XV Century, p. 91, Fig. 243
Florentine School, Mid-XV Century, p. 99, Fig. 268
Florentine School, Second Half of XV Century, p. 119, Fig. 323
Florentine School, c. 1475, p. 119, Fig. 328; p. 120, Fig. 321
Francesco d'Antonio, p. 92, Fig. 250; p. 93, Figs. 251–253
Francesco di Giorgio, p. 152; p. 153, Figs. 414, 416, 419
— Studio of, p. 154, Fig. 420

Gaddi, Agnolo, p. 39; p. 40, Figs. 98–99
— Follower of, p. 40, Fig. 100
Gaddi, Taddeo, p. 23, Fig. 52
— Follower of, p. 24, Fig. 53
Gentile da Fabriano, p. 76, Figs. 212, 213; p. 77, Fig. 211
— Follower of, p. 78, Fig. 214
Gherardo del Fora, p. 138, Fig. 366
Ghirlandaio, Domenico, p. 124; p. 125, Figs. 334, 344
— Studio of, p. 126, Figs. 338, 340
— Follower of, p. 126, Fig. 341; p. 127, Figs. 339, 342–343
Giambono, p. 79, Fig. 221
— Follower of, p. 80, Fig. 219
Giotto, p. 20, Figs. 41–42
— and Assistants, p. 21, Fig. 43–47
— Follower of, p. 22, Figs. 48, 51
Giovanni del Biondo, p. 36, Figs. 83–84, 91; p. 37, Figs. 85, 87
— Attributed to, p. 37, Fig. 86
Giovanni da Bologna, p. 10, Fig. 22
Giovanni di Francesco, p. 104, Fig. 283
Giovanni da Milano, p. 39, Fig. 97
Giovanni di Nicola da Pisa, p. 50, Fig. 129
Giovanni di Paolo, p. 148, Figs. 401, 402, 404; p. 149, Figs. 403, 405
— Studio of, p. 150, Figs. 406–407
— Follower of, p. 150, Fig. 408
Giovanni dal Ponte, p. 91; p. 92, Figs. 246–249
Girolamo di Benvenuto, p. 161, Figs. 441–447; p. 162, Figs. 448 449; p. 163, Fig. 440
Giusto de'Menabuoi, p. 38; p. 39, Figs. 92–96
Gozzoli, p. 115, Fig. 315; p. 116, Fig. 317
— Follower of, p. 116, Fig. 316
Gualtieri di Giovanni, Attributed to, p. 65, Fig. 172
Guariento, p. 10, Fig. 19

Italian School, XIII Century, Modern Imitation of [K1301, not catalogued]
Italian School, c. 1300, p. 6, Figs. 11–12
Italo-Byzantine School, XIV Century Style, p. 12, Fig. 15

Jacopino di Francesco, p. 71, Figs. 188–192

Jacopo del Casentino, p. 24, Fig. 56
— and Assistant, p. 24, Figs. 54–55; p. 25, Fig. 57
— Follower of, p. 25, Fig. 58
Jacopo di Cione and Orcagna, p. 31, Fig. 76
Jacopo di Cione, Attributed to, p. 33, Figs. 78, 82
Jacopo di Paolo, p. 72, Fig. 197

Lippi, Filippino, p. 135, Figs. 369–370; p. 136, Figs. 371, 373–374;
 p. 137, Fig. 375
— and Assistants, p. 137, Fig. 372
— Attributed to, p. 138, Fig. 376
Lippi, Fra Filippo, p. 106, Fig. 289; p. 107, Figs. 290, 299
— and Fra Angelico, Frontispiece; p. 95, Figs. 259–261
— and Assistant, p. 108, Fig. 291
— Follower of, p. 108, Fig. 304
— Modern Copy after [K 516, not catalogued]
Lombard School, XV Century, p. 80, Fig. 220
Lorenzetti, Ambrogio, Attributed to, p. 51, Fig. 135
Lorenzetti, Pietro, Attributed to, p. 51, Fig. 130; p. 52, Fig. 131
— Follower of, p. 52, Figs. 133, 136, 141; p. 53, Figs. 134, 137–138
'Lorenzetti, Ugolino,' see Master of the Ovile Madonna
Lorenzo di Bicci, p. 46, Fig. 115
Lorenzo Monaco, p. 89, Fig. 239
— Studio of, p. 89, Fig. 244
— Follower of, p. 90, Figs. 240–241
Lorenzo di Niccolò, p. 44, Figs. 110, 117
— Attributed to, p. 45, Fig. 108
Lorenzo Veneziano, Attributed to, p. 9, Figs. 20, 24
Luca di Tommè, p. 59, Figs. 151, 157; p. 60, Figs. 152–153
— Studio of, p. 60, Fig. 158
Lucchese School, c. 1200, p. 3, Fig. 6

Margaritone, p. 3, Fig. 1
Mariotto di Nardo, p. 46, Fig. 118
Martino di Bartolommeo, p. 65, Fig. 179
Masolino, p. 93; p. 94, Figs. 254–255
Master of the 'Apollini Sacrum,' p. 128, Figs. 345–346, 352
Master of the Apollo and Daphne Legend, p. 129, Figs. 347, 349;
 p. 130, Figs. 348, 350, 353–354
Master of the Bambino Vispo, p. 90, Fig. 242; p. 91, Fig. 245
Master of the Blessed Clare, p. 70, Fig. 187
Master of the Buckingham Palace Madonna, p. 100, Fig. 274
Master of the Clarisse Panel, p. 13, Fig. 34
Master of the Fabriano Altarpiece, p. 29, Fig. 68
Master of the Franciscan Crucifixes, p. 4, Figs. 4–5
Master of Fucecchio, p. 105, Figs. 284–285; p. 106, Figs. 286–288
Master of the Goodhart Madonna, p. 18, Fig. 40
Master of the Griggs Crucifixion, p. 99, Fig. 270
— Circle of, p. 100, Fig. 269
Master of the Life of St. John the Baptist, p. 68, Figs. 182–183; p. 69,
 Figs. 184–185
Master of the Orcagnesque Misericordia, p. 38, Figs. 89–90
Master of the Ovile Madonna, p. 53; p. 54, Figs. 139, 145; p. 55,
 Fig. 142
— Studio of, p. 55, Fig. 140
Master of the Rinuccini Chapel, p. 35, Figs. 79–81

Master of St. Francis, p. 4, Figs. 2–3
Master of San Martino alla Palma, p. 30, Fig. 71
Master of the St. Verdiana Panel, p. 41, Fig. 104; p. 42, Fig. 105
Master of San Torpè, p. 18, Fig. 38
— Attributed to, p. 19, Fig. 39
Master of Staffolo, p. 79, Fig. 217
Master of the Stratonice Cassoni, p. 138; p. 139, Fig. 367
Master of the Straus Madonna, p. 41, Fig. 103
Matteo di Giovanni, p. 156, Fig. 423; p. 157, Figs. 424–427
Memmi, p. 49, Figs. 126–127
Michele di Matteo, p. 73, Figs. 193–194

Nardo di Cione, p. 34, Fig. 75
Neri di Bicci, p. 112, Fig. 309; p. 113, Figs. 305, 308, 310
Neroccio de'Landi, p. 154, Figs. 417–418; p. 155, Figs. 415, 421
— Follower of, p. 156, Fig. 422
Niccolò di Pietro Gerini, p. 42, Fig. 106; p. 43, Figs. 109, 113
— Follower of, p. 43, Fig. 107; p. 44, Fig. 111
Niccolò di Segna, p. 17, Figs. 36–37
Niccolò di Tommaso, Follower of, p. 35, Fig. 74
Nicolò da Voltri, p. 13, Fig. 29
Nuzi, p. 75, Figs. 204–205, 207–210

Orcagna and Jacopo di Cione, p. 31, Fig. 76
Orcagna, Studio of, p. 32, Fig. 77
Orcagna, Follower of, p. 32, Fig. 72

Pacino di Buonaguida, p. 22; p. 23, Fig. 50
— Follower of, p. 23, Fig. 49
Palmerucci, p. 55, Fig. 132; p. 56, Fig. 144
Paolo Veneziano, p. 7, Fig. 13; p. 8, Fig. 10
Pellegrino di Mariano, p. 151, Fig. 413
Pesellino, p. 109; p. 110, Figs. 300–301
— and Studio, p. 110, Figs. 302–303
— Follower of, p. 111, Figs. 306–307
Pier Francesco Fiorentino, p. 114, Fig. 312
— Pseudo, p. 115, Figs. 313–314
Pietro di Domenico da Montepulciano, p. 78; p. 79, Fig. 218
Puccinelli, p. 74, Fig. 202

Riminese School, Late XIV Century, p. 69, Fig. 186
Roberti, p. 86, Figs. 232–233
Rosselli, p. 120, Figs. 325, 330; p. 121, Fig. 326
— Studio of, p. 121, Fig. 329

Sano di Pietro, p. 144, Fig. 388; p. 145, Figs. 387, 389–391; p. 146,
 Figs. 392–394, 397
— Follower of, p. 147, Figs. 395–396
Sassetta, p. 140, Fig. 383
— and Assistant, p. 141, Figs. 378–382
— Attributed to, p. 143, Figs. 384–385
— Studio of, p. 144, Fig. 386
— Follower of, p. 144, Fig. 412
Schiavo, p. 105, Figs. 281–282
Segna di Buonaventura, p. 16, Figs. 31–32
— Follower of, p. 17, Fig. 30

Sellaio, p. 133, Figs. 364, 368; p. 134, Figs. 361, 363, 450
— Follower of, p. 134, Fig. 365
Sienese School, Early XIV Century, p. 16, Fig. 35
Sienese School, Mid-XIV Century, p. 56, Fig. 143
Sienese School, c. 1370, p. 56, Fig. 146
Sienese School, c. 1440, p. 147, Figs. 398–400
Simone dei Crocifissi, p. 72, Fig. 195
Simone Martini, p. 48, Fig. 121
— and Assistants, p. 48, Figs. 122–125
Spinello Aretino, p. 45, Fig. 112
— Studio of, p. 45, Fig. 116

Taddeo di Bartolo, p. 62; p. 63, Figs. 163–166, 171; p. 64, Figs. 167–169
— Follower of, p. 64, Fig. 170
Tegliacci, p. 58, Fig. 150
— Possibly Tegliacci, see Follower of Pietro Lorenzetti, p. 53, Fig. 134
Tura, p. 81, Fig. 225; p. 82, Figs. 226–229
— Attributed to, p. 82, Fig. 230
Turino di Vanni, Attributed to, p. 74, Figs. 199–200

Tuscan School, Late XIII Century, p. 6, Fig. 8
Tuscan School, First Half of XIV Century, p. 30, Fig. 70
Tuscan School, XIV Century, p. 31, Fig. 65

Uccello, Attributed to, p. 101, Fig. 273
— Follower of, p. 102, Figs. 275–277

Vanni, Andrea, p. 57, Fig. 156; p. 58, Figs. 154–155
Vanni, Lippo, p. 57, Figs. 147–149
Vecchietta, Attributed to, p. 151, Fig. 409
— Follower of, p. 152, Fig. 410
Venetian School, c. 1300, p. 7, Fig. 14
Venetian School, Early XIV Century, p. 9, Fig. 23
Venetian School, Late XIV Century, p. 11, Figs. 16, 21
Veneto-Byzantine School, Late XIV Century, p. 11, Fig. 26
Veronese School, Early XV Century, p. 78, Figs. 215–216
Verrocchio, Style of, p. 118, Fig. 322
Verrocchio, Follower of, p. 119, Fig. 324

Zoppo, p. 87, Figs. 237–238

SAMUEL H. KRESS FOUNDATION

FOUNDED BY SAMUEL H. KRESS IN 1929

Trustees